Artists on the Left

American Artists and the Communist Movement 1926–1956

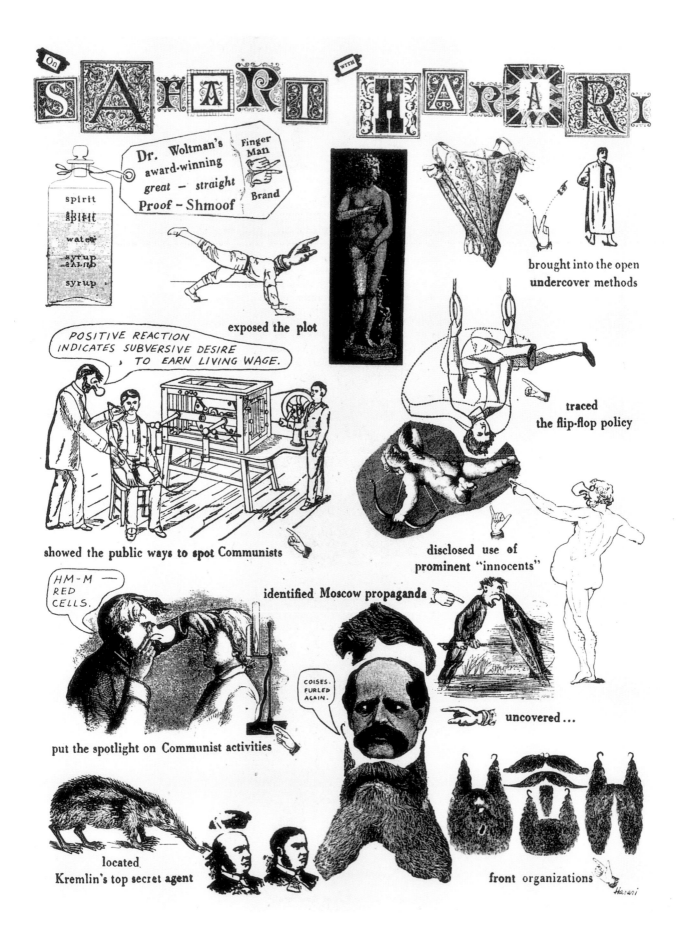

Artists on the Left

American Artists and the Communist Movement 1926–1956

Andrew Hemingway

Yale University Press • New Haven and London

Designed by Elizabeth McWilliams

Printed in Singapore

Library of Congress Cataloging-in-Publication Data

Hemingway, Andrew.
 Artists on the left : American artists and the Communist
movement, 1926–1956 / Andrew Hemingway.
 p. cm.
Includes bibliographical references and index.
 ISBN 0-300-09220-2 (alk. paper)
 1. Art – Political aspects – United States. 2. Communism
and art – United States. 3. Art, American – 20th century.
 I. Title: American artists and the Communist movement,
1926–1956. II. Title.
 N72.P6 H46 2002
 324.273'75'0887 – dc21
 2002003010

A catalogue record for this book is available from
The British Library

Frontispiece: Hananiah Harari, *On Safari with Harari*, from
New Masses, 1 July 1947, Marx Memorial Library, London.

Contents

Contents

Acknowledgements

Research for this book was supported by grants from the Dean of Arts Travel Fund, the Dean of Social and Historical Sciences Travel Fund, and the Graduate School of University College London, the Central Research Fund of the University of London, and the British Academy. A Leverhulme Research Fellowship in 1996–7 was crucial to both research and writing.

My interest in the Communist cultural movement in the United States has its beginnings in the American Studies Programme at Ealing College of Higher Education in the early 1980s. So, first of all, I must thank my former colleague Frank McMahon for encouraging me to develop my fascination with American history and culture in a more scholarly direction, and for the many rewarding conversations I have had with him about these things over the years.

I began research on what became the book project in 1988, just after joining University College London. The History of Art department there has provided an enormously stimulating and supportive environment, and I am deeply grateful to my colleagues for making it so despite all the pressures that the ill-conceived and expedient policies of successive governments have put on the British university system over the last two decades.

Staff at numerous institutions have helped me with my research. I cannot list them all here, but I must at least mention the following: Beth Joffrion, Nancy Malloy and Judy Throm at the Archives of American Art; Marc Pascale and Daniel Schulman at the Art Institute of Chicago; Becky Hart at the Detroit Institute of Arts; Phyllis Rosenzweig and Judith Zilczer at the Hirshhorn Museum and Sculpture Garden, Washington, D.C.; Tish Collins and Mary Rosser at the Marx Memorial Library, London; Dina Young at the Missouri Historical Society; Lyn Pudney at the Smithsonian American Art Museum; Peter R. Griffith at the Springfield Museums; Ellen Sragow of the Sragow Gallery, New York; Kathleen Manwaring at the Bird Library, Syracuse University; Andrew H. Lee and Gail Malmgreen at the Tamiment Institute Library of New York University; Betsy Hughes at the University of Arizona Museum of Art; Lesley Budgen in the Interlending Department at University College London Library; Ellen Demsch at the Davison Art Center, Wesleyan University; Deedee Wigmore of Wigmore Fine Art, New York; Phillip A. Robertson at the T. W. Wood Gallery & Arts Center, Montpelier, Vt; and Linda Freaney at the Woodstock Artists Association. In Chicago, the staff at a number of high schools were generous with their time when I visited to see WPA artworks, particularly: Dean Schultz at Bloom High School, Connie Kieffer at Highland Park High School, Flora Doody at Lane Technical High School and Georgia Rodwell-Brooks at Lucy Flower Vocational Academy. Some further specific debts are acknowledged in the notes to the text.

Material in the book was presented in lectures and seminars at a number of institutions, and I am grateful to friends and colleagues at the following who allowed me to try out ideas on them and their students, or even on the public: the Art Institute of Chicago; Barnard College, New York; King's College London; Ithaca College; Northwestern University; Open University; Polish Academy of Arts and Sciences, Warsaw; University of Birmingham; University of Leeds; University of Missouri, Columbia; Washington University, Saint Louis; and Winchester School of Art. I also want to thank especially Ida Rodríguez Prampolini and Leticia López Orozco for inviting me to speak at the conference on Muralism in the Americas at the Insituto de Investigaciones Estéticas at the Universidad Nacional Autonóma de México in 2000, an event that changed my perspective on everything.

For the last six years I have co-chaired the Seminar on Comparative Labour and Working-Class History at the University of London's Institute of Historical Research. I owe a great debt to Rick Halpern for inviting me to join in organising this and for all he has taught me since. The seminar has been a crucial forum for socialist history in London, and I am grateful to all those who have helped to make it such, and especially to Andy Strouthous and Keith Flett, both for their consistent insights and their amazing tolerance of our forays into cultural history.

Without the support and encouragement of some of the survivors of the Communist movement, this book would be much poorer. Sadly, in the nature of things, some of those I spoke to have not survived to see its publication. I am grateful to the following: Lloyd Brown, the late Milton Brown, Bernarda Bryson, Louis Harap, the late Jacob Kainen, Jack Levine, Annette Rubinstein, the late Meyer Schapiro, the late Harry Sternberg and Anthony Toney. To Charles Keller and Joseph Solman I owe a special debt. I am also grateful to the following relatives of participants: Lillian Ben-Zion, Michael Biddle, Andrew Bolotowsky, Earl Davis, Andrew Dintenfass, Ruth Kainen, Lillian Milgram, Nancy Neel, Louise Reisman, Rose Shain and Anita Toney.

One of the pleasures of moving into the field of US history and culture has been the friendships and intellectual interchanges with others working in the area that have resulted. In this regard, I must particularly acknowledge the encouragement and stimulus I have received over the years from Al Fried, Pat Hills, Garnett McCoy, Angela Miller and Alan Wallach. Al Fried and Pat Hills both read this book in manuscript, and responded with characteristic generosity. Others from whose conversation I have benefited include Pamela Allara, Paul Buhle, Michael Denning, Anthony Lee, Diana Linden, Fraser Ottanelli, Jack Salzman, Bob Sampson, Liz Seaton and Alan Wald. At University College London I have been fortunate to work with a succession of gifted graduate students whose research and questions have prompted me to fresh thinking, namely: Warren Carter, Michael Corris, Morgan Falconer, Jennifer Golden and Nancy Jachec. Without the enterprise and dedication of Makiko Yamanashi, I simply could not have covered Japanese-American artists to the extent I have, and an important strand in Communist culture would again have been ignored. She was everything one could wish for in a research assistant.

Additionally, a number of friends have provided a continuing stimulus to my thinking on questions of art history and socialist politics in the course of writing the book, notably: David Bindman, Stephen Eisenman, Briony Fer, Tamar Garb, Josephine Gear, Tom Gretton, Paul Jaskot, Janet Koenig, Stanley Mitchell, Fred Orton, Alex Potts, John Roberts, Jake Rosen, Fred Schwartz, Greg Sholette, Peter Smith and Karl Werckmeister.

At Yale University Press, Gillian Malpass has been consistently supportive and encouraging and Elizabeth McWilliams was a real pleasure to work with on the book's design.

My family have put up with the extended periods of self-absorption and the protracted absences that research on a book like this requires. I am grateful to my mother, Audrey Hemingway, and my children, Mary and Frankie, for their continuing affection and tolerance through it all.

Carol Duncan has been my companion almost from the inception of this project. She has been unwavering in her enthusiasm and support, and I have benefited from her good humour, her driving skills (which include teaching me to drive on the right side) and her critical insights. Quite simply, I could not have done it without her.

Introduction: The Left Movement in the Arts

Argument

In this book I argue that the years between the late 1920s and the mid-1950s saw the rise and decline of what may be described as a left movement in American art. Although this movement had antecedents in the Ashcan School and the work of socialist artists associated with *The Masses* magazine over the years 1911 to 1917, it was distinguished from that precedent by an allegiance to the example of the Russian Revolution and its orientation to a Leninist politics. Indeed, what gave it some measure of coherence and direction was the institution of the American Communist party (hereafter CPUSA). It is thus the changing patterns of Communist influence in the arts that define the parameters of my study: from the dramatic rise in the Party's prestige among intellectuals that accompanied the onset of the Great Depression to its effective demise in the late 1950s as result of state persecution and internal crisis. However, it is important to be clear from the outset that the artists concerned gave the Communist Party their support in varying degrees and for different periods of time. For some it was a political lodestar for almost all of their careers, for others it stood more as a symbol of their commitment to certain aesthetic and ethical ideals, and for many more it was the object of their enthusiasm only during the economic and social dislocations of the Depression. In other words I am concerned both with active Communists and with fellow-travellers, and with some who might have been uncomfortable with either label but who none the less moved in the cultural milieu that the Party helped to create. It is also important to note that the Party did not call into being the forms of artistic practice that were described variously as 'revolutionary art' or 'social art' – although it had considerable influence on some of it. The economic and political crises of the 1930s and 1940s drove many artists to consider how they could produce art of social relevance independently of the Communist movement, and some who became involved continued to produce such art after they broke with or distanced themselves from it. If I give the Party much prominence

in what follows, it is because it was – for better or worse – the most powerful ideological and organisational force on the left for more than two decades, and a major influence in American culture.

What I have called the left movement in the arts is not a movement in the normal sense art historians use that term, in that it cannot be defined simply in terms of a common style or iconography, although it had implications in relation to both. Rather, it will be described here in terms of a succession of institutional initiatives, an evolving critical discourse and a range of practices that seemed to correspond to a type of political commitment in complex and varying ways. It was a movement that never had a clearly defined programme, but which did entail certain fundamental assumptions about the social purpose of art – even if the implications of these assumptions were variously interpreted. The starting point of this movement is taken to be marked symbolically by the founding of the magazine *New Masses* in 1926.

Historians of American literature have long acknowledged the influence of the Communist movement on the novels, poetry and theatre of the 1930s, and a whole succession of studies have addressed this phenomenon.[1] By contrast, while historians of twentieth-century American art customarily allow that the CPUSA had some ill-defined connection with Social Realism, there have been few substantial studies either of the organisations through which this was effected or of how the CP's shifting aesthetic ideology was registered in artistic practices.[2] Further, such studies as there are have tended to be confined to the mythically 'Red Decade' of the 1930s. Recent developments in American historical studies have made clear that the 1930s and 1940s need to be treated together if the long-term trajectory of the American political economy is to be effectively understood. This is also the case in relation to the history of culture and, specifically, in relation to the Communist cultural movement. To dwell only on that movement's heyday without examining the reasons for its long-term decline is to miss a large part of its historical signifi-

cance. Indeed, this book demonstrates the error of the widespread assumption that the ending of the Popular Front in 1939 also marked the end of significant Communist influence among American cultural workers. It shows that the real demise of the cultural movement came in the late 1940s, and was the effect of state repression and developments in Soviet policy associated with the Cold War rather than the collapse of 1930s anti-fascism. The crisis of the CPUSA in 1956–7 was only the *coup de grâce* after several years in which the Party's main effort had gone into sheer survival. None the less, it is an appropriate symbolic terminus, and political art of stature continued to be produced by artists associated with the Party in various ways in the 1950s. Such a long perspective not only gives the story of Communist culture in the United States a somewhat different moral, but also indicates that the picture of the American cultural field in the postwar years we get from recent historiography has serious gaps.

Rationale

A number of considerations motivated the writing of this book. One is the belief that the sheer extent of Communist cultural influence among artists in the period makes it a phenomenon worth historical attention. Although there has been much art-historical work devoted to American art and politics in the 1940s and 1950s – most of it focussing on Abstract Expressionism – to date such scholarship has assumed the only left that matters in these years is the anti-Stalinist left.[3] Insofar as such work has addressed the Communist cultural movement at all, it has done so on the basis of what appears to be very limited knowledge of its institutions, ideology and practices. But in fact this is only one symptom of a larger lack of interest in the broader artistic field within which Abstract Expressionism appeared, a lack that arises because that movement is generally assumed to comprehend the only art of the period that merits serious attention. Not only is this assumption dubious in itself, it also leads to a distorted account of the art it privileges.

By extension, a second motive is the desire to offer some corrective to the mystifications and limits that the dominance of the modernist narrative continues to impose on our understanding of twentieth-century art. That is, the book offers a challenge to the modernist history institutionalised after the Second World War, which received its tightest and most influential rationale in the apodeictic teleology of Greenbergian criticism. In so doing, it departs from the preoccupations of the estab-lished social history of art of the postwar years on the grounds that it has remained too preoccupied with the terms of this narrative, and has consequently not lived up to the requirements of a Marxist perspective. Simply put, in its preoccupation with art of quality, most social history of art takes the bourgeois category of art too much for granted, and turns itself into an appendage of that it supposedly seeks to critique.[4] It falls into the trap of the Social Democratic cultural history that Walter Benjamin castigated so brilliantly in his essay on Eduard Fuchs, an essay that has not been superseded as a laying out of the ground rules for a materialist history of art.[5] For the most part, the social history of art has become just another celebration of the same old masterworks, even if it alters the grounds of discrimination somewhat. It thus lacks the radical scepticism towards the category of taste necessary to a truly dialectical history.

Such an approach of necessity has nothing to say about the work of the artists that are the subject of this book, work that represents a groping towards that alternative vision of cultural modernity which underpinned much of the most exciting art of the last century. That is, it was produced by artists who sought to overcome the inbuilt conservatism of the bourgeois concept of aesthetic disinterestedness to produce art that might function not only as a source of pleasure but also as social or political critique.[6] The art discussed here thus represents a test case for the problems and limits of left activism in the visual arts under both its revolutionary and its reformist aspects. Additionally, because of the particular conjunction between artist activists and the state under the New Deal, it also poses complex questions about the nature of cultural democracy: questions such as how the arts can be accommodated to the requirements of general accessibility, the proper mechanisms of state cultural patronage and the proper limits of state control, and what expectations may reasonably be placed on a democratic public. Conversely, the cultural programmes of the Roosevelt administration raised issues about the relationship between the market and individual freedom. In the postwar period the two were increasingly collapsed together according to a banal ideological formula in which the first supposedly guaranteed the second. But for a moment in American history there was a widespread belief that the state was a better guarantor of a democratic culture than the market. To see things in this way, however, democracy had to mean more than just consumer choice: it also meant the individual should take on not just the rights but also the responsibilities of citizenship and participation in a democratic society in the fullest sense of the term.

At one level, then, this book is an exercise in historical recovery – yet another contribution to that ongoing struggle to redress Americans' recurrent amnesia regarding their radical heritage. On another, it is an attempt to explain how a whole range of artistic production came to be consigned to museum stores and hidden away in little-known private collections. Perhaps more tendentiously yet, it tries to offer a case for treating some of this work as not aesthetically valueless. Finally, and perhaps most importantly, I assume that the art with which I am concerned is part of the legacy of a century of socialist politics and Communist experiment, which the left, as it enters a new millennium, must confront, both as a burden and as a potential resource.

Scope and Organisation

The history of the CPUSA in the period covered by this book can be divided into a sequence of phases corresponding to the larger shifts in Party strategy consequent on the changing imperatives of Soviet foreign policy. These several phases can be summarised as: the Third Period, 1928–35; Popular Front, 1935–9; Nazi–Soviet Pact, 1939–41; Wartime Coalition, 1941–5; and Cold War, 1945 onwards. Although each of these brought implications for the Party's cultural activities, for the purposes of this study they will be considered under three headings. Thus, Part I deals with the Third Period, Part II with the Popular Front and Part III with the period from 1939 up to the Party's implosion as a result of the crisis of 1956–7. The reason for considering the last three phases together is that despite the revival of the Party's fortunes in the Second World War, the progressive element within the Democratic Party, on which its indirect influence on electoral politics depended, was in an increasingly weak position from the late 1930s onwards. The ending of the Popular Front and the winding down of the New Deal arts projects coincided. Together these developments meant the circumstances of Communist cultural activity were fundamentally transformed. Further, the history of the Party's attempts to adapt to the break-up of the New Deal coalition and to the increasingly conservative turn of the American polity in the 1940s suggests a narrative with a certain unity, and one that also has an interpretative value.

The book is premised on a model of individual agency that stresses the role of institutions and ideology in defining the parameters of subjective choices. Each of its three parts is oriented round accounts of the institutions through which the Party sought to organise cultural work, and of the aesthetic discourse it promoted through public lectures and debates, art criticism and book-length publications. The analysis of artistic practices is largely integrated with that of institutions and ideology, with the result that artistic careers are considered only in summary terms, and the focus is more on the significance of works than on lives. I recognise that my concern to provide a broad political narrative of a movement in which organisation and ideology were central means that I have not been able to do justice to the complex meanings of many individual art objects. I hope to remedy this lack in some degree in a separate study.

It is a truism that the kinds of art that were dominant in the United States in the 1930s were naturalistic and that a key concern of much contemporary criticism was the promotion of imagery of American life and of what was perceived as a tradition of native realism. Such art dominated in the art programmes of the New Deal, and in the major public art exhibitions – the Carnegie International, the Chicago Annual, the regular Whitney Museum shows, and so on. While modernism (in various forms) was not nearly so marginal as has often been suggested, it was widely perceived as a paradigm of artistic practice that was either exhausted or inappropriate to the particular cultural conditions of the United States. The reasons for this are complex, but central among them were the contraction of the art market and the massive federal patronage initiatives, together with a widespread wave of anti-modernism in the broad sense linked with a search for native American cultural traditions. Given that plenty of artists without any revolutionary commitment were producing ostensibly 'realist' images of the American Scene, one of the problems for artists on the left was to develop a distinctive practice in this environment that would amount to more than just a social iconography. Although the book is centrally concerned with the left movement, it also seeks to show how its identity was produced in relation to the wider field of artistic practices.

Stalinism and the Question of Larger Significance

The story I have to tell is one of negation or, if you prefer, defeat. Some will doubtless see it as a redundant narrative of artists who miscalculated politically, morally and aesthetically. After all, its main *dramatis personae* refused to see the murderous tyranny that the USSR became for what it really was, accepted – at least in some degree – the political values of what became one of

the most doctrinaire and conservative of Stalinist parties, and in most cases rejected experimental modernism in pursuit of a politically instrumental art or an art of human content in 'outmoded' styles. The issue of Stalinism cannot be evaded in a study of this kind, and I do not agree with those historians of the American left who wish to discard the term because it has too often served as the cover for kneejerk anti-Communism in the US. Of course, if I did not feel that the Party's enemies had their own prejudices and blindnesses I would not have bothered to write this book.

At one level, I take Stalinism to stand for a distinctive form of pseudo-Marxist discourse that was fostered and partly enunciated by the Soviet leader from which it takes its name. More broadly, Stalinism denotes the policies and actions of the Soviet state and its satellites under Stalin.[7] Now, the strategies and organisational forms of the foreign Communist parties obviously cannot be separated from the history of the Communist Party of the Soviet Union, and the central debate among historians of the CPUSA has been the extent to which the Party was simply an instrument of Moscow.[8] The view taken here is that whatever the delusive example of the Russian experience and the crudely self-interested policies the Soviet leadership imposed via the Comintern and later the Cominform, the CPUSA did fight its own struggles under circumstances the Soviet party did not make. Further, I share the position of revisionist historians who have argued that earlier histories place too much stress on the policies and statements of the Party leadership, and give too little attention to the actual experiences of the rank and file.[9] (Recent 'revelations' about the leadership's complicity in Soviet espionage activities have no real bearing on this.[10]) This is not to offer an apologia for the Party, merely to acknowledge that it did serve as a focus for socialist aspirations, however much it warped them through its dumb subservience to Moscow. If the Party was always more than the policy of its leaders, so too the art that emerged from the Party's orbit is rarely reducible to an equivalent of the frequently dogmatic and arid pronouncements of its cultural functionaries. That is, if those I am concerned with maintained a loyalty to the Soviet Union or even to the person of Stalin, they did not thereby practise a Stalinist aesthetic for the most part. For if there was one

thing nearly all of them agreed on about the form of social art, it was that it would have to be specifically adapted to the circumstances of a non-revolutionary society, and draw on native American traditions – otherwise it could be neither popular nor effective. Like those literary scholars who have reassessed the proletarian literature movement in recent years, I wish to analyse the left movement in the visual arts in relation to the specific demands of Communist politics in the United States rather than measure it against some abstract model of Stalinism. Seen in this way, it appears to me more ingenious, complex and engaging than has so far been acknowledged.

Note on Limits

There are two main limitations. Firstly, although some murals in other cities will be discussed, the book is confined primarily to activities in New York. This undoubtedly creates a somewhat misleading impression of a cultural movement that was a focus for leftist artists in a number of US cities. However, it is my belief that the most important institutions for the visual arts were in New York, and that much of the really interesting art was produced and first exhibited there.[11] To have given detailed accounts of developments in Chicago and San Francisco (to take two obvious omissions) would have lengthened an already long book, and added nothing fundamentally different to the picture. This is not to say that studies on the conditions in other cities would not be worthwhile – given the variations in US regional history they certainly would. But I doubt if they would cause me to alter the case I have tried to make. Secondly, my research has been confined to the CP's English-language press. Again this is partly due to the problems of scale, but is also a reflection of the limits of my linguistic competence. For instance, other scholars will have to do work on the Yiddish-language magazines and papers, which would certainly add another dimension to the work of Gropper and some other artists who figure in these pages.[12] Finally, the book is concerned very largely with painting and graphic art. The sculpture of the left does get some passing mentions, but it too raises problems that demand a separate study.[13]

Part I: 'Revolutionary Art':
The CPUSA and the Arts in the 'Third Period'

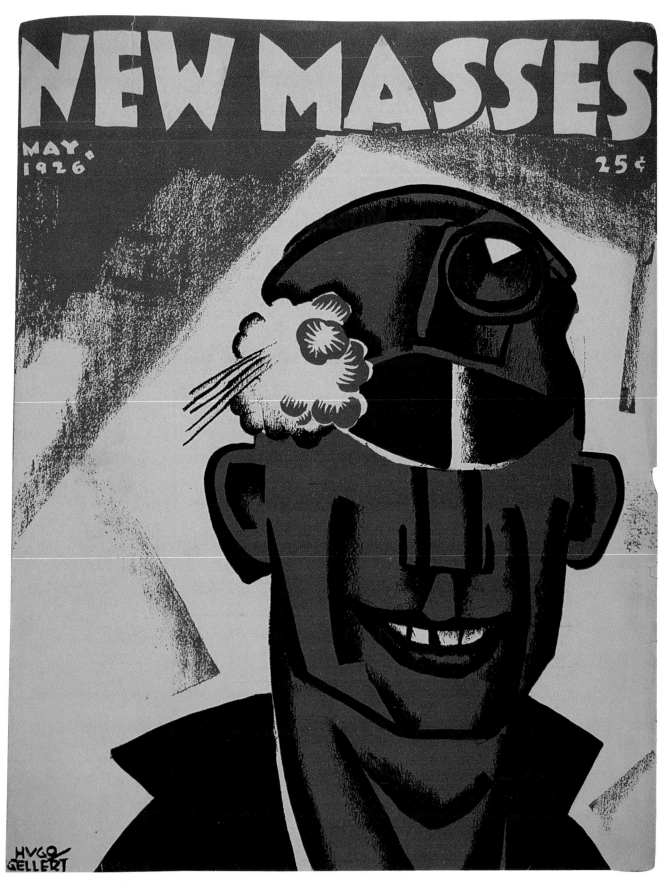

2 Hugo Gellert, cover of *New Masses*, May 1926, Marx Memorial Library, London.

1 *New Masses* and the Cultural Movement in the Third Period

Emerging out of a scene of intense factionalism in 1919 and numerically dominated by foreign-language speakers, the political formation that became the American Communist movement did not operate as a single party until 1923. A movement that at the outset had more than 40,000 members was so harassed by government agencies and so internally riven that by 1925 it had only 7,200. After a revival in the late 1920s, membership fell to near this figure again as a result of the expulsion of Jay Lovestone and his followers in 1929. The Communist Party (CP) was thus hardly in a position to act as the focus for a broad cultural tendency in these years even had it aspired to. However, as Harvey Klehr has pointed out, it was in the Party's first decade that a Leninist leadership cadre was formed, many of whom remained prominent within it for years afterwards.[1] This is in some degree true of the cultural cadre as well. The writers Joseph Freeman, Michael Gold, V. J. Jerome, A. B. Magil and Isidor Schneider all began their association with the Party in the 1920s, as did a number of prominent artists including Hugo Gellert, William Gropper and Louis Lozowick.

The takeoff in the CP's influence among the intelligentsia was manifestly connected with the onset of the Depression, and the increasingly conspicuous role it played in strikes, unemployed organisations and street demonstrations. The organisational work of Communists in strikes at Gastonia, North Carolina (1929); at the Carnegie coal mines in Western Pennsylvania and Harlan County, Kentucky (1931); in the massive and bloody street demonstrations against unemployment in New York (March 1930), Detroit (March 1932), Saint Louis (July 1932) and other cities; and in the hunger marches on Washington of 1931 and 1932 all contributed to the Party's reputation for courage and militancy.[2] In the 1932 presidential elections the votes cast for the Communist candidates William Z. Foster and James Ford numbered 102,991, and in that year Party membership finally rose securely above the 10,000 level.

While the Party's electoral appeal was clearly not great, Foster and Ford were backed by a group of prominent writers and intellectuals organised under the title of the League of Professional Groups for Foster and Ford. The League produced a 10,000 word pamphlet *Culture and the Crisis*, which advised that the Socialist Party could only serve as a distraction from the real choice between socialism and fascism, and that 'A vote for any party but the Communist Party is worse than a wasted vote. It is a vote for the class enemies of the workers.' Intellectual workers shared a common interest with other workers, for capitalism was 'destructive of all culture', while Communism 'desires to save civilization and its cultural heritage from the abyss to which the world crisis is driving it.'[3] Among the fifty-two signatories of this 'Open Letter' were Sherwood Anderson, Erskine Caldwell, Countee Cullen, Sidney Hook, Langston Hughes, Lincoln Steffens and Edmund Wilson. After the election the League dropped the reference to Foster and Ford from its title and sought to continue as a liaison between intellectuals and the Party. However, most of those involved were not CP members, and attempts by the Party to direct the League and attacks on individuals associated with it (notably Hook) meant that those who stood forward to endorse Communist candidates in the mid-term elections of 1934 were far fewer in number.[4]

Life as a Communist for the average Party member was an endless sequence of branch or club meetings, prescribed discussions and fund raising. The tedium of Party rituals helps to explain the rapid turnover in membership. This is not to say that there were no psychological compensations, and many of those who passed through it bore witness to what Vivian Gornick describes as the 'deeply felt' 'wholeness of the CP world.'[5] However, many Communist artists and writers who were Party members found it almost impossible to pursue their own creative work because of the demands placed upon them by what one writer described as 'continual picket-lines, sit-down strikes,

work-stoppages, Communist party and union assignments from which we cannot gain the slightest exemption.'[6] Perhaps for this reason, most did not join and thus were not subject to Party discipline. The tensions between these 'fellow-travellers' and actual Party members were played out within successive front organisations,[7] and also within the critical discourse the movement generated. In part they account for its vitality.

In a report to the Communist Party's cultural fraction in November 1932, the writer Joseph Freeman observed: 'we have not in this country in the English language basic Marxian writings which throw light on the questions of art and literature.'[8] Although by this time an increasing volume of Marxist statements on these matters was beginning to appear in translation, Freeman's remark points to a basic problem: the implications of Marxism for both artistic practice and aesthetics are far from straightforward and the CPUSA could offer little substantive guidance regarding either.[9] The Party had no original theorists of its own in any area, while its Soviet mentor as yet offered no single authoritative position on the arts. Yet given the totalising nature of Communism as a belief system, a kind of aesthetic discourse had perforce to be articulated within the Communist press.

As the 'Central Organ of the Communist Party of the USA', the Party's national English-language newspaper, the *Daily Worker*, played a key role in the dissemination of Communist culture. In the late 1920s and early 1930s it printed serialised translations of Soviet novels and short stories, as well as poems and stories by American Communists. It carried statements by luminaries of international Communism such as Henri Barbusse, Johannes Becker and Maxim Gorkii. And it had regular theatre and cinema and (occasional) book reviews. But like the movement for which it spoke, the *Daily Worker* of the late 1920s was dour and inward-looking, preoccupied with factional disputes. After Earl Browder's effective takeover of the leadership in 1930 (he did not actually become the CP's General Secretary until 1934), Clarence Hathaway became editor and it began to become more like a normal paper.[10] The most striking new developments came in August 1933 when the *Worker* changed from a four-page to a six-page paper on weekdays, and from a six-page to an eight-page paper on Saturdays. This move was preceded by a sustained attempt to solicit readership involvement with requests for readers to send in reports, criticisms and suggestions. The editors pledged to make the paper more interesting 'by shortening our articles, eliminating stereotyped phrases, simplifying our language, &c.' Among the suggestions that seem to have been acted on were that the

paper should start to carry short stories 'from the everyday struggles of the workers' and a 'cartoon of the comics type'.[11] Movie reviews became longer, a column on radio was added, and there was more sports coverage. A new woman's column, 'In the Home', mixed menu suggestions and dress designs with political news, and there was even medical advice from a 'Doctor Luttinger'.

Historians of Communist culture have tended to draw most on the magazine *New Masses*, which functioned as a national forum of American Communism for more than twenty years. However, its pre-eminent status as a cultural register is misleading, for the *Daily Worker* was just as important, and substantive theoretical articles, as well as reports and reviews, appeared within its pages. It was also an important focus for Communist artists, and the Party made much of the attainments of staff cartoonists such as Jacob Burck and Fred Ellis. Having said this, it was in *New Masses* that the key aesthetic debates of the Third Period were voiced, and the group around the magazine initiated the John Reed Clubs, which were the main institutional base for Communist and fellow-travelling artists and writers up to 1935. In this chapter I consider the development of *New Masses* in these years, and sketch the rise and fall of the clubs.

The Early *New Masses*

Launched in May 1926 by a mixed group of liberals and radicals with money from the Garland Fund, *New Masses* was initially conceived as a successor to two earlier magazines that had sought to fuse culture and socialist politics, *The Masses* (1911–17) and *The Liberator* (1918–24), and there was considerable continuity of personnel between the three.[12] At the same time, it would draw on the experimental artistic culture epitomised by *The Seven Arts* (1916–17). Among the roster of talented and prominent writers who were editors or contributing editors of *New Masses* in 1926 were Sherwood Anderson, Van Wyck Brooks, Stuart Chase, John Dos Passos, Theodore Dreiser, Max Eastman, Langston Hughes, Claude McKay, Lewis Mumford, Eugene O'Neill, Carl Sandburg, Upton Sinclair, Genevieve Taggard and Edmund Wilson. Early contributors also included Nathan Asch, Meridel Le Sueur and William Carlos Williams. The artist editors were Maurice Becker, Cornelia Barns, Glenn Coleman, Stuart Davis, Adolf Dehn, Hugo Gellert, H. J. Glintenkamp, William Gropper, Louis Lozowick, Boardman Robinson, John Sloan and Art Young – all of whom had done work for *The Masses* or *The Liberator*

or both.[13] It should be noted that despite the male chauvinism of some of its leading figures, women writers were a major presence in the magazine, if not on its editorial board.[14]

Joseph Freeman, who was one of the founding group, later recalled that among the fifty-six involved only two were members of the Communist Party and 'less than a dozen' were sympathetic to it. In fact, while three of the six original editors were Communists (Freeman, Gellert and Gold), Freeman's claim that the artists and writers set the tone and determined that it would be ' "artistic and literary" ' and not ' "political" ' seems correct. As he stated elsewhere: 'the New Masses started as the frank heir of the bohemian-rebel old Masses.'[15] It was initially conceived to address 'the INTELLECTUAL HOMELESS' rather than the masses as such, and its brief was to 'satirize, criticize, and CREATE our world of the modern'. Titles considered had included 'Dynamo' and 'The New World', and an early editorial programme reads like a modernist manifesto:

> The editors of the magazine must bear constantly in mind that we live in a world of smoke and steel, a hard, virile, industrial world, demanding as hard, as virile, as steely an expression.

While the programme assumed that 'we are all opposed to capitalism', the prime function of the magazine would not be a negative one but an attempt to give expression to 'contemporary existence'. Enthusiasm for the Russian Revolution was another common assumption, because 'as creative artists' the editors were 'in the very nature of things, on the side of the liberal, radical, and working-class forces' in the great social struggle going on in the world. This touchingly naive notion of artistic fellowship indicates that the editors had not understood the divisive implications of the Bolshevik model. They were soon to learn.[16]

The first volume of the magazine did indeed resemble the old *Masses*. Slightly larger and on better paper than succeeding volumes, it also had colour printing. Gellert's cover for the first issue of May 1926 appropriately shows a grinning miner with a cockade or flower in his helmet in red and black on a white ground (fig. 2). The cover of the second issue was a design of modern city women's legs by Stuart Davis. And the August issue carried a drawing by Boardman Robinson of two young women wrestling on a beach, printed in pink, that represents a proletarian beach scene of the type associated with John Sloan in a style more suggestive of Matisse. The thoroughly modernist tone of the sequence was continued in Lozowick's city design, printed in black and blue over white, for the October cover. With some

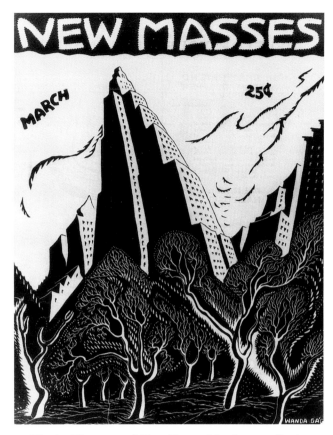

3 Wanda Gág, cover of *New Masses*, March 1927, Tamiment Institute Library, New York University.

4 Fred Ellis, *The Paymaster*, from *Red Cartoons 1929*, reprinted from the *Daily Worker*, Tamiment Institute Library, New York University.

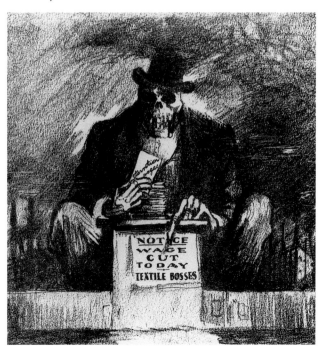

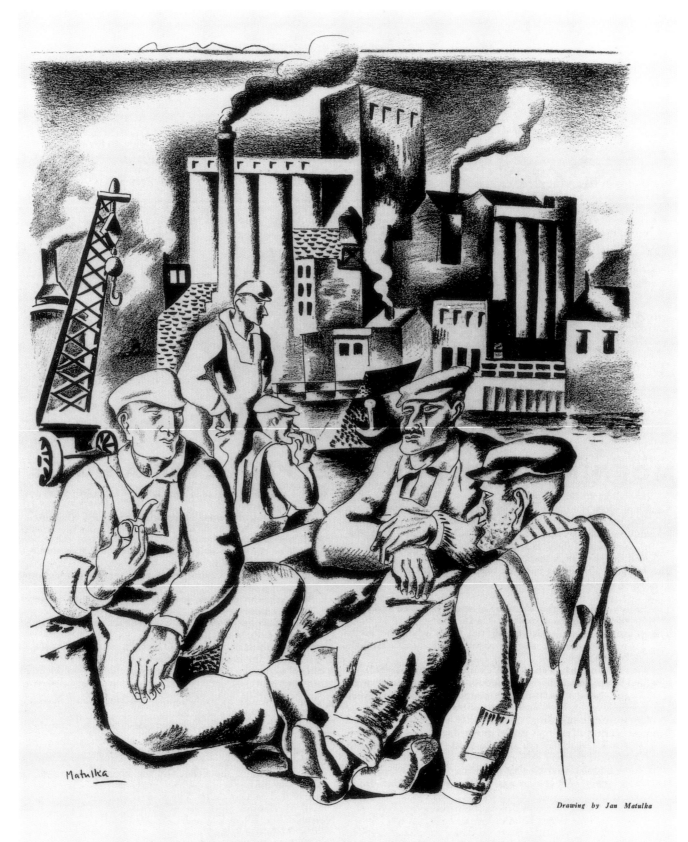

"I see where Babe Ruth draws down seventy thousand a year. That's a lotta jack all right."
"Yeah; us workin' classes is on the up-and-up."

Drawing by Jan Matulka

5 Jan Matulka, '*I see where Babe Ruth draws down seventy thousand a year . . .*', from *New Masses*, April 1927, Tamiment Institute Library, New York University.

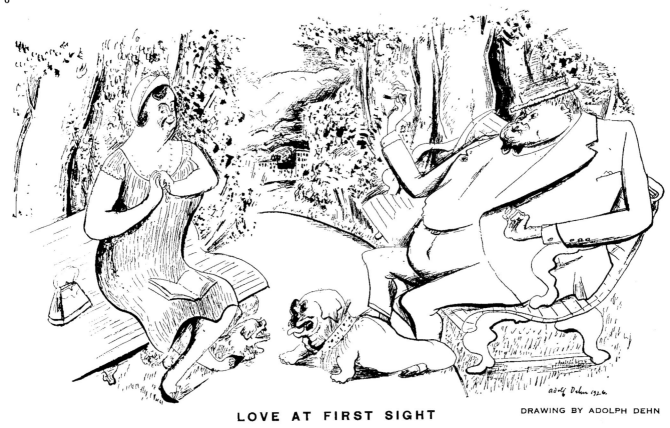

LOVE AT FIRST SIGHT

DRAWING BY ADOLPH DEHN

6 Adolf Dehn, *Love at First Sight*, from *New Masses*, August 1926, Marx Memorial Library, London.

notable exceptions, such as Wanda Gág's wonderful image of rearing skyscrapers for March 1927 (fig. 3) and Theodore Scheel's mechanised worker of January 1930, or the photographs by Tina Modotti that fronted four issues in 1928–9, *New Masses* rarely looked so visually striking on the outside again.[17]

When the German Communist Ludwig Renn sent a message of fraternal greetings to *New Masses* in 1930 he observed that 'the graphic portion' of the magazine 'still manifests vestiges of an expressionism which does not always harmonize with the "true-to-reality" writing of its contributors.'[18] In fact, by the end of 1935 the list of artists whose work had appeared in *New Masses* could be extended to Phil Bard, Mabel Dwight, John Groth, Jacob Kainen, Herb Kruckman, Russell Limbach, Jan Matulka, Walter Quirt, Anton Refregier, Louis Ribak, Theodore Scheel, William Siegel, Mitchell Siporin and Harry Sternberg among others.[19] Most of these artists did not practise the kind of Daumieresque style of crayon cartooning developed by *The Masses* artists, which, as used by Burck and Ellis (fig. 4), remained the dominant mode in the *Daily Worker*.[20] Indeed, the work

of several represented an attempt to adapt experimental modernist techniques to graphic satire and political illustration.

Stuart Davis, the most consistent modernist associated with *New Masses*, ceased to contribute after July 1926 and dropped off the editorial board in the spring of 1929. In any case the Cubist mannerisms of Davis's few cartoons made them far less effective as social satires than his graphics of *The Masses* period.[21] Jan Matulka (1890–1972), whose Paris studio Davis rented in 1928–9, had a more substantial involvement with the magazine, contributing twenty-four illustrations over the years 1926 to 1930.[22] A competent practitioner of Cubism, Matulka's contributions to *New Masses* varied from what seem to have been independent lithographs, to directly political cartoons and dry social commentaries.[23] In a drawing for the April 1927 issue (perhaps made with lithographic crayon; fig. 5) the grain silos and other buildings of a waterfront fuse into an oppressive Cubistic background for a scene of working men on a break. One man has a patched overall and another a patched elbow, and their postures work with the flowing

lines of the drawing to suggest lassitude after labour. The image thus offers a telling counterpoint to the ironic conversation, redolent of working-class humour:

> 'I see where Babe Ruth draws down seventy thousand a year. That's a lotta jack all right.'
> 'Yeah; us workin' classes is on the up-and-up.'

After 1930 *New Masses* may have become more reluctant to use such imagery, but the modernist element continued in cartoons and satirical drawings exemplified in the contributions of Dehn and Gropper. Adolf Dehn (1895–1968), who was a contributing editor from 1926 to 1933, had been the leading figure in a group of radical students at the Minneapolis Art Institute in the 1910s, which included Arnold Blanch, Wanda Gág, Harry Gottlieb and Elizabeth Olds. In 1917 he moved to New York and joined the *Masses* circle. Imprisoned as a conscientious objector during the war, from 1921 to 1929 he travelled in Europe, making a living through illustrations for German and American magazines. Dehn was fascinated by Weimar culture, and hoped to join the staff of the satirical journal *Simplicissimus* – though he was disappointed in this regard. George Grosz admired his work, and the affinity between them is well illustrated in the graphic *Love at First Sight*, published in August 1926 (fig. 6). Dehn's line is not as incisive as that of Grosz and tends more to the arabesque and the playful, but there is a comparable use of expressive distortion and a deployment of physical grotesques to suggest moral ugliness. However, Dehn was one of the most experimental American printmakers of his generation, and his interest was as much in the print as art object as it was in pictorial propaganda.[24] By contrast, Gropper, to whom I shall return in Chapter Three, fully embraced the propagandist's role, although he was no less knowing in his assimilation of modernist devices. The point is that in *New Masses* political cartoons and images with the visual character of art prints existed side by side. No single stylistic mode was ever dominant.

From the beginning, *New Masses* was centrally concerned with both literature and criticism, carrying short stories and poems as well as articles of literary theorising by writers and critics. Book reviews were a consistent feature, but it also printed criticism of art, theatre, cinema, dance and music – sometimes as occasional items, sometimes as regular columns. The range of the magazine in its early years was remarkable, as was the intellectual energy it projected. It carried articles on the Machine Age, sex, Freud, cinema, jazz and all that was hottest in contemporary culture. Like the old *Masses* it was deeply concerned with the 'New Woman'

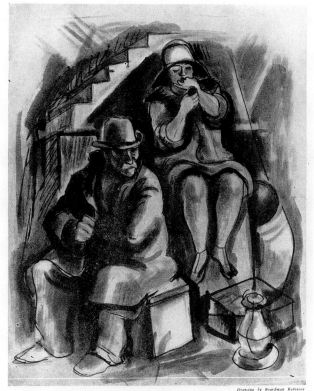

THE NIGHT WATCHMAN'S DAUGHTER

7 Boardman Robinson, *The Nighwatchman's Daughter*: 'Your mother never used no lipstick' 'Yeah, wasn't it fierce the way them dames went around exposin' their features', from *New Masses*, August 1927, Tamiment Institute Library, New York University.

and the transformation of sexual mores – and printed numerous graphic satires around that theme including Boardman Robinson's *The Nightwatchman's Daughter* (fig. 7), which sums up a whole generational shift in the caption: ' "Your mother never used no lipstick"/"Yeah, wasn't it fierce the way them dames went around exposin' their features." ' The Soviet connection was manifested through translations of stories by Isaac Babel, an article by Lunacharsky, and Trotsky's tribute to the poet Yessenin. But in these years *New Masses* also carried articles by writers unsympathetic to Communism, such as Ezra Pound and Allen Tate, whom it denounced as fascistic in the following decade – as it did some of its more independent Marxist contributors including Max Eastman and V. F. Calverton.[25] Initially, it seems to have been unaware of, or unabashed by, the marginalisation of Trotsky in the USSR, and published a paean to *Literature and Revolution* when it appeared in translation in 1926.[26]

New Masses was more than just a magazine, it was also the focus for a social milieu and a grand project

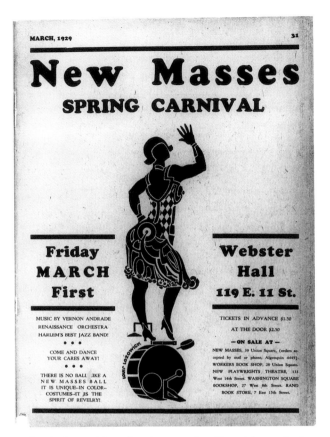

8 Louis Lozowick, advertisement for *New Masses* Spring Carnival, *New Masses*, March 1929, Tamiment Institute Library, New York University.

to form an alternative American culture. From the beginning it laid on dances and balls which projected a light-hearted side of the Communist movement, such as the Workers' and Peasants' Costume Ball of December 1926, the Anti-Obscenity Ball of March 1927, the Russian Anniversary Ball of December 1927 ('Ditch Your Duties Bring Your Cuties') or the *New Masses* Costume Ball of December 1928, at which 'Jazz – Hot and Blue' by 'the best, most mournful JAZZ BAND in Harlem' was promised. These occasions were partly fund-raisers for a magazine that limped along from one deficit to the next, but they also served an important social function and became a regular feature of the movement's cultural life. Lozowick's advertisement for the *New Masses* Spring Carnival of 1929, where the Savoy Wild Cats – 'The Pride of Lenox Avenue' in Harlem – were playing, illustrates that not only had Communists embraced the jazz craze but also that they were not uninterested in the colloquial meanings of 'jazz'. Lozowick's figure wears a cutaway flapper dress, provocatively pushes back her rump, and has a promi-

nently defined nipple (fig. 8). 'DANCING' was promised 'TILL 3 A.M.' The serious debates among Party critics around the social significance of jazz do not seem to have diminished its appeal among the rank and file.[27]

Mike Gold and the Proletarian Aesthetic

The liberals and radicals in the *New Masses* editorial group were sharply divided, and in 1927 the former tried to remove Michael Gold from the board – ostensibly on grounds of inefficiency but at least equally because of his uncompromising commitment to revolutionary literature.[28] The move was defeated, and after a financial crisis in the spring of 1928 Gold took over as main editor, and for the next two years his conception of proletarian culture dominated the magazine. Coincidentally, this development shortly preceded the announcement of the new Third Period line at the Sixth World Congress of the Comintern in July–August 1928. According to the new line, the world capitalist economy was entering a general crisis that would issue in internecine wars amongst the imperialist states and 'gigantic class battles'. What this came to mean was that the principle enemy of the working class was to be understood as social democratic parties and trade union leaderships who were misleading it as to its objective interests, and were designated 'social-fascists' – a position represented through the slogans 'Class Against Class' and 'United Front from Below'. These slogans certainly matched the tenor of proletarianism as expressed in *New Masses* and elsewhere, but the attitude of American Communists to their would-be allies among the bourgeois artistic and literary intelligentsia was less intransigent than they suggest.[29]

Mike Gold was born Itzok Granich on New York's Lower East Side in 1893, the son of Jewish immigrants, and adopted his pseudonym during the Red Scare of 1919–20. Gold's father was a small-time entrepreneur whose business and health failed, forcing young Granich to earn a living by various menial occupations. In 1914 he was converted to socialism through hearing the Wobbly orator (and later Communist) Elizabeth Gurley Flynn at an unemployment demonstration in Union Square, where he got his head bloodied by a cop's truncheon and bought his first copy of *The Masses*. He was so excited by the magazine that he moved to Greenwich Village and began to support himself as a journalist – or so the story goes. In January 1921 he became an editor for *The Liberator*, where his essay 'Towards Proletarian Art' appeared the following month.[30] It is an extra-

ordinary statement – almost like a Futurist manifesto – which fuses a kind of Nietzschean vitalism with an image of a new proletarian culture based largely on Walt Whitman's writings. The recent Bolshevik Revolution and the revolutionary upsurges across the Europe that accompanied the end of the war, together with the great American strike wave of 1919–20, all must have contributed to the apocalyptic tone of its opening: 'In blood, in tears, in chaos and wild, thunderous clouds of fear the old economic order is dying.' Gold describes social revolution as a kind of irrepressible life force, and as the religion of the masses. Art is an expression of this life force through which men and women 'express their divinity'. Intellectuals have turned this life force into something aristocratic and sick – only through contact with the masses can it be rejuvenated:

> The art ideals of the capitalistic world isolated each artist as in a solitary cell, there to brood and suffer silently and go mad. We artists of the people will not face Life and Eternity alone. We will face it among the people.
> We must lose ourselves again in this sanity. We must learn through solidarity with the people what Life is.

The idea that bourgeois art (and the bourgeoisie as a class) was 'sick' or decadent was to become one of the characteristic tropes of proletarian criticism. And what made it so was its tone of despair and self-regarding individualism. By contrast, the new proletarian art was optimistic and collective. Needless to say, there was an element of deep romanticism in all this. Contrasting the masses with intellectuals Gold wrote: 'Masses are never pessimistic. Masses are never sterile. Masses are never far from the earth. Masses are never far from heaven. Masses go on – they are the eternal truth. Masses are simple, strong and sure.'[31] Such was the resonance of this word.

Gold was, of course, looking to the USSR, where a new proletarian culture had 'begun forming its grand outlines against the sky.' And what he took to be Soviet culture was the Prolet'kult movement. Prolet'kult had orginated with a splinter group called Vpered (Forward), which broke away from the Bolshevik wing of the Russian Social Democratic Party after the 1905 Revolution. Its chief ideologue, Alexander Bogdanov, argued that collective conditions of work in the modern mass production industries would give rise to a new collective proletarian culture that would inevitably replace the individualistic culture of the bourgeois epoch. The political struggle for socialism demanded as its counterpart a cultural struggle, which should be undertaken by distinct and independent organisations. After the revolution of

February 1917, groups for promoting proletarian culture sprang up all over Russia, and had begun to be co-ordinated by a central committee just before October. However, by the end of the Civil War the Party leadership had become concerned about the degree of independence exercised by Prolet'kult and in 1920 the organisation was subordinated to the People's Commissariat for Education. Although Prolet'kult had a membership of about 400,000 in 1922, by this time it was already beginning to be superseded by other groups such as VAPP, the All-Russian Association of Proletarian Writers.[32]

American Communists learned about Prolet'kult early on. John Reed was American representative at a Prolet'kult meeting in Moscow in 1920, and a book titled *Proletcult* by the British Marxists Eden and Cedar Paul was published in New York in the following year. Although largely an account of the Worker's Education Movement in Britain, this did contain a brief chapter on the Russian organisation, and called on socialists everywhere to join the Third International and 'establish a Red Proletcult International.' While it had little to say on 'Proletarian Art' as such, it warmly defended the concept, asking rhetorically:

> Can we not foresee, in communist society . . . a revival of that conjuncture of labour and imagination which we conceive to be the true social basis of art? And when there is superadded the quickening and enfranchisement of the spirit that will derive from the disappearance of the numerous inward conflicts which underlie the surface of capitalist society, may we not anticipate such a blossoming of art as the world has never known?

The Pauls' identification with the Bolshevik model of proletarian dictatorship may have been based in part on misconceptions, but in failing to understand the full implications of Leninism they are unlikely to have been unusual among left-wing socialists of their generation, many of whom were properly sickened by the accommodation parliamentary socialists had reached with bourgeois governments that had sent working men to be slaughtered in their millions in an imperialist war, and found the Russian example appealing by contrast. It is unlikely that Gold and his Greenwich Village comrades had any superior understanding of the matter. Moreover, the Pauls' vitalist conception of social agency and their view of revolution as a poetic act are strikingly close to his.[33]

Joseph Freeman later observed of the 1920s: 'We were always three or four years behind events, and operated with vague rumours, assumptions, hopes, in

the light of which we interpreted all the partially reported actions of the October Revolution from phase to phase.'[34] Certainly by 1930 – and probably well before – it was known that the CPSU regarded the theoretical premises of Prolet'kult as erroneous, and that the party opposed the attempt to 'develop purely hot-house proletarian literature'.[35] (Of course, it was committed to organising and promoting art and literature among the proletariat.) Gold himself visited the USSR in 1925, but seems not to have picked up on the Politburo's insistence that under capitalism the proletariat 'as a culturally oppressed class' could not develop its own artistic form or style, for, in an otherwise enthusiastic appraisal of Trostky's *Literature and Revolution*, he took issue with Trotsky's argument that there neither was, nor could be, a proletarian art: 'It is not a matter of theory; it is a fact that a proletarian style is emerging in art. It will be as transitory as other styles; but it will have its day.'[36]

In the early years of *New Masses* it was possible to maintain a kind of generalised proletarianism of the Gold type without understanding the nuances of Soviet debates on the arts or their sociological and political implications. Indeed, the Cultural Revolution that accompanied the first Five Year Plan, with its class war rhetoric and attacks on the old intelligentsia, and the corresponding supremacy of RAPP (Russian Association of Proletarian Writers) in the literary sphere, may well have seemed like a reassertion of Prolet'kult positions.[37] All this is not to say that Gold's stance did not come in for attack for its 'childish nihilism.'[38] Moreover, just as important as reports on Soviet developments was the culture of the American Socialist Party and the Industrial Workers of the World (IWW), of which leading cadres were veterans.[39]

Since 1917 Gold had been working on a book about his childhood, which after being published in bits and pieces in various magazines finally emerged as his only novel, *Jews Without Money*, in 1930 (although 'novel' does not really suggest the character of this collection of sketches of life on the Lower East Side). He had already articulated the rationale for such a book in 'Towards Proletarian Art', and grounded it in his social being: 'I was born in a tenement. That tall, sombre mass, holding its freight of obscure human destinies, is the pattern in which my being has been cast.'[40] This insistence on art rooted in the immediately observed verities of everyday working-class 'Life' (with a capital 'L'), and utilising the simplest and most direct of devices was another leitmotiv of the proletarian aesthetic. Obsessed with what he saw as the emptiness of much modern literature, Gold believed that a new revolutionary culture would emerge organically from the toiling masses, who through the force of their experience would evolve novel artistic forms. Proletarian writing was inevitably a realism – a literature of facts, and it was supremely functional, in contrast to bourgeois art: 'Swift action, clear form, the direct line, cinema in words; this seems to be one of the principles of proletarian realism. It knows exactly what it believes and where it is going; this makes for its beautiful youthful clarity.' Concern with style was a distraction, and vaguely emasculating. Rather: 'Utility, propaganda, will create a beauty of form in the proletarian poems, plays and novels of the future'.[41]

Under Gold's editorship *New Masses* aimed to be 'a kind of sublimated workers' correspondence' and claimed that it was 'the only link between the younger intellectuals and revolutionary workers' in the United States.[42] To some extent its appeal was answered, and the magazine did showcase material by a number of worker writers. However, none of these became a figure of major significance, and although the Party provided a focus for talented writers of working-class origins such as Jack Conroy and Richard Wright, by the mid-1930s 'Proletarian Literature' had come to mean writing from a working-class perspective informed by Marxist theory rather than writing necessarily from the working class.[43]

'I just don't like cerebral art, and don't believe I ever will', Gold once wrote. Indeed, like some nineteenth-century realists he felt uncomfortable with any kind of aestheticism: 'Art is a hunk of cheese, an old maid's dreams, if it is weaker than the life around it.' Not only did he make considerable efforts to eschew anything resembling Greenwich Village bohemianism – to be a truly virile worker type – but at times he was straightforwardly hostile to middle-class writers – figures of inadequate masculinity – who allied themselves with the movement but maintained an aesthetic stance.[44] Such rejection of bohemianism as a kind of directionless and confused middle-class defiance was commonplace among the Party's critics, who sought to counterpose to the undisciplined individualistic artist of bourgeois myth the ideal of a purposeful artist worker allying him or herself with the great collective forces of world revolution.[45] Having said this, the Party needed allies in the middle class, and Gold's extreme stance was representative of a strand in CP culture rather than Party policy. His anti-intellectualism and his tendency to appear as a kind of literary hatchet man for the Party viewpoint (a position he did not hold) offended more sensitive Communist writers, and his hostility to any self-conscious concern with style was always countered by other regular writers for the magazine. The continuing

struggle between Gold and his critics can be seen as symptomatic of the larger position of *New Masses* torn between the need to appeal to a wide proletarian audience, but also wanting to be associated with a progressive and sophisticated art that would gain respect outside the closed circles of the CP world.

The Future and the Past: USSR versus USA

Central to Communist ideology was a vision of the USSR as paradise in the making, and this was disseminated through both *New Masses* and the *Daily Worker*. Until 1934 the fullest reporting of Soviet economic and social policy appeared in the latter, where the Dnieperstroi Dam was a 'New Milestone in the Triumphant Building of Socialism', 'Soviets Spend 2 Billion Dollars for Social Insurance' in a year, and 'Russian Workers Eat Three Meals a Day'. Soviet propaganda about the First Five Year Plan and the collectivisation of agriculture was accepted uncritically, and Stalin's speeches, printed at length, were taken as true representations of these processes. The extraordinary changes of Stalin's 'revolution from above' helped to reinforce the revolutionary aspect of the Soviet image. The oppressive labour regime created by the industrialisation drive and the immiseration (and sometimes starvation) of the peasantry – the return to a rural regime resembling feudalism, but even more brutal – were ignored or misunderstood.[46] Instead, attractive graphics of smiling Russian workers adorned the covers of *New Masses* (fig. 9), while their photographs appeared in the *Daily Worker*. Poems were published to celebrate the Dnieperstroi. Mike Gold and others wrote glowing reports of a joyous yet serious nation, in which song and literature pervaded life.[47] It was not that there was no struggle and suffering in the USSR – indeed, struggle and suffering were represented as extreme in translated Soviet novels such as Feodor Gladkov's *Cement* (1929). It was rather that the moral superiority of the Soviet system ensured all difficulties would always be overcome. The harsh character of Soviet rhetoric was justified by the magnitude of the tasks faced by the Soviet people, and it conferred a certain avant-garde character on those who emulated it outside the USSR.[48]

Some artist contributors to *New Masses* and the *Daily Worker* could stand as experts on the Soviet regime and as witnesses to its triumphs. William Gropper (1897–1977), a founding editor of *New Masses*, who, like Gold, had grown up in the tenements of New York's Lower East Side, visited the USSR in 1927 with

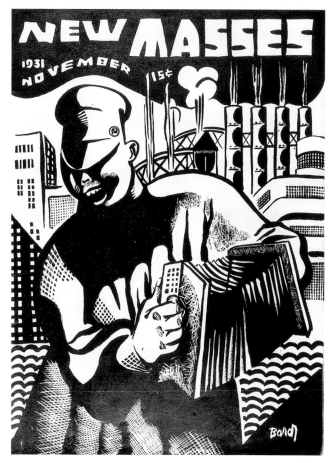

9 Phil Bard, cover of *New Masses*, November 1931, Marx Memorial Library, London.

Theodore Dreiser and Sinclair Lewis, and spent a year travelling and making sketches, returning full of enthusiasm. One fruit of his travels was a publication, *56 Drawings of the USSR*, that appeared in 1929 at $2.00, 'without captions, ready to frame'.[49] Louis Lozowick (1892–1973), another founding editor who was a member of the editorial board with Gold from July 1931 to February 1933, was particularly well equipped to act as a cultural ambassador. Born in the Ukraine, he had attended the Kiev Art School before emigrating to the United States in 1906. After studying at the National Academy of Design and taking a degree at Ohio State University, Lozowick returned to Europe and moved in avant-garde circles in Paris, Berlin and Moscow in the early 1920s. His familiarity with the new Soviet art (on which he published numerous articles and a short book in 1925) and his fluency in Yiddish, Ukrainian and Russian suited him to be a Soviet tour guide as well as International Secretary to the John Reed Club. In 1931 Lozowick was a member of an 'international writers

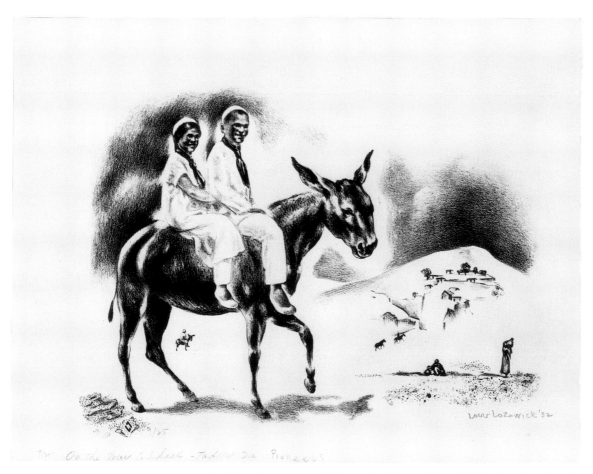

10 Louis Lozowick, *On the Way to School, Tajikistan*, 1932, lithograph, $7^{1}/_{8} \times 9 \; {}^{5}/_{8}$ in., Smithsonian American Art Museum, Gift of Adele Lozowick © 1932, Lee Lozowick. Illustrated in *New Masses*, 2 October 1934.

brigade' that toured through Soviet Asia. The drawings he made provided the basis for lithographs of Tajikistan, which both as a group and sometimes within a single image juxtapose traditional Tajik lifestyle with the emblems of modernisation – tractors, airplanes and so forth. Women are represented with and without veils; young pioneers ride to school on a donkey. These images suggest a magical transformation in a picturesque environment rather than a desperately poor Muslim region being wrenched into the twentieth century (fig. 10). Several of them were reproduced in *New Masses* to accompany reports by Joshua Kunitz, who had also been on the trip.[50]

The counterpart to this ecstatic vision of the USSR was an insistent emphasis on the poverty and humiliations of working-class life in the United States. During its first years *New Masses* alternated between a kind of fascination with the scale, pace and excitements of the American city and images of its exploitation, and decadence. In an early issue Gold likened America to a

private train rushing across the continent to Hollywood on 'the slippery rails of History'. The parable ends with a Grosz-like vision of a train wreck that breaks open and eviscerates the decadent bodies of the passengers: 'Life exploded like a bomb'.[51] In 1930 he described New York as 'Hell on the Hudson', 'a monstrosity born out of the capitalist system', and asserted that: 'One of the first acts of a workers revolution would be to decentralize New York. The city would inevitably sink to man-size under a co-operative social order.' Yet he also confessed that like other New Yorkers he was fascinated by it 'in the way a coke-fiend is drawn to his poison.' As he wrote, riveters were 'clattering next door on a new skyscraper': 'It is the harsh cruel song of New York.'[52] Such literary images were the accompaniment of the urban visual imagery to which I referred earlier. The most telling correspondence with Gold's vision of the city is in two lithographs by Lozowick illustrated later that year: *Birth of a Skyscraper* (fig. 11) and *Construction*.[53] From the mid- to late 1920s, Lozowick had specialised in an

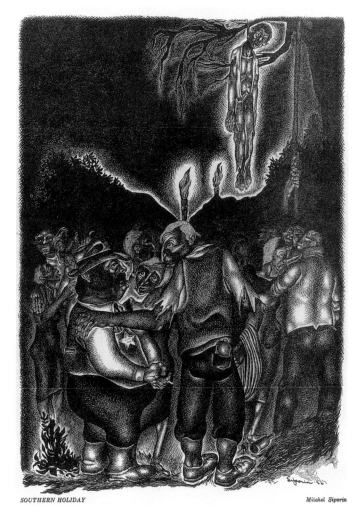

11 Louis Lozowick, *Birth of a Skyscraper*, 1930, lithograph, 12³/₁₆ ×
8⁵/₈ in., Smithsonian American Art Museum, Gift of Adele Lozowick
© 1930, Lee Lozowick. Illustrated in *New Masses*, September 1930.

12 Mitchell Siporin, *Southern Holiday*, from *New Masses*, April
1931, Tamiment Institute Library, New York University.

imagery of the modern urban and industrial scene that
looked pristine and was often unpeopled, an imagery
that seems cognate with that of artists such as Demuth
and Sheeler who had no left-wing commitments and
who, in the case of Sheeler, was deeply involved with
corporate advertising and the fashion world. However,
as Virginia Marquardt has shown, under the influence of
developments in Soviet painting and the thinking of
American Communists such as Gold, he now added to
his repertoire a type of scene in which the role of labour
in making the urban world was dramatically pictured.
Birth of a Skyscraper might stand for the view from
Gold's window, while *Construction* (an image of the
excavations for New York's subway) implies very liter-
ally that all rests on labour.[54]

With the onset of the Depression, Machine Age
imagery largely disappeared from *New Masses*, and
most pictures in the magazine showed the working class
abased from the effects of enforced unemployment and
its accompaniments, cold and hunger. When labour was
heroic, it was primarily in the figures of resistant strikers
and marchers in cartoons. To at least one Soviet com-
mentator, this imagery was misguided, a 'passive
registration of the facts of class "oppression"', that
amounted to 'complete repudiation of the revolutionary
class struggle' and 'an advocacy of passiveness and non-
resistance' (see fig. 12).[55] Although their responses were
couched in different terms, this was also the effect
imagery of the Depression had on many American
critics, both inside and outside Party circles.

New Masses and the International Union of Revolutionary Writers

At the end of 1930, *New Masses* and the John Reed Club sent a six-man delegation to the Second Conference of Revolutionary and Proletarian Writers at Kharkov in the Ukraine, which was attended by representatives from twenty-two countries.[56] The occasion was organised by the International Bureau of Revolutionary Literature (IBRL), set up at the first such conference in 1927 to act as a kind of literary international for the promotion of proletarian writing. At Kharkov the IRBL renamed itself the International Union of Revolutionary Writers (IURW), and the John Reed Clubs subsequently affiliated with this body.

The position pronounced by the IURW at Kharkov was that the proletarian revolution in the USSR had awakened 'the class consciousness of the proletariat in bourgeois countries', and this made possible the exportation of some Soviet cultural forms such as the worker correspondents movement and the Blue Blouses propaganda troupes, although inevitably a true proletarian culture could be built only after the bourgeois countries too had undergone successful revolutions. From 1931 to 1935 the IURW sought to coordinate and foster an international proletarian culture partly through its journal *Literature of the World Revolution* (renamed *International Literature* in 1932), which reproduced paintings, graphics and sculptures, as well as printing stories, excerpts from novels, poems and critical writings. The 'International Chronicle' section carried frequent reports on Communist cultural developments in the United States, mainly culled from the pages of the *Daily Worker* and *New Masses*.[57]

The US delegation returned with a ten-point 'Program of Action' to improve the work of the magazine and the clubs.[58] This pushed *New Masses* in two almost conflicting directions. On the one hand the emphasis on the 'strengthening of the theoretical aspects of our work' led to a narrowing of those who could be included in its pages and to the exclusion of some independent leftists such as Eastman and Calverton. But the insistence that the activity of club and magazine be widened both by 'extending the proletarian base' and winning over 'radicalized intellectuals' led to a more conciliatory attitude to fellow-travellers, providing they did not criticise the Soviet Union. This stance surprised Gold and gave ammunition to those in the cultural movement who were opposed to what was described in Communist parlance as sectarianism and leftism.[59] The formal subservience of *New Masses* to the IURW was reflected in the admonitory resolution on the work of the magazine which it received and printed in 1932. Some improvement, but still not good enough was the gist of this.[60] In fact A. Elistratova's appraisal of the magazine in *International Literature*, on which the resolution was based, was even more damning, emphasising the limitations of the magazine's theoretical work, and specifically criticising graphics by Bard (see fig. 9), Gellert, Gropper, Lozowick, Siporin (see fig. 12) and others in terms I quoted in the previous section. While the writers and artists singled out rejected these criticisms, no refutation was published.[61]

What the IURW in Moscow evidently failed to realise was the deep divisions within the cultural movement and the lack of resources for sustained theoretical and critical work. The *New Masses* editors seemed incapable of working as a team, and the income of the magazine was so small that it was unable to pay contributors. By early 1931 it was again in crisis. After repeated personal attacks Gold withdrew from active editorial involvement, and Freeman, one of the Party's most capable literary functionaries, was brought in to save the magazine.[62] Freeman concluded that the Party needed to articulate a clear policy on cultural work and to put out a mouthpiece that could rival Calverton's *Modern Quarterly*, which had became a monthly in 1932, and served as a forum for independent leftists such as Eastman, Hook and Lovestone, who used its pages to lambast both the Soviet Union and the CPUSA. *New Masses* had sought to be a 'proletarian magazine of creative art and literature', but it needed to become 'a more serious organ dealing with political theoretical, economic, and literary problems' (*sic*), that would appeal to a readership outside Party circles.[63] An internal Party memorandum 'Concerning the Reorganization of the Literary and Professional Sections of the Movement', probably dating from 1933, argued that the character of *New Masses* as it stood made it unsuited to appeal to the growing number of 'middle class fellow travellers' drawn to the movement as the crisis of the Depression deepened, and whose interests and outlook were very different from those of the 'proletarian or proletarianized writers and artists'. It could not effectively serve both constituencies. This statement partly reflected the tensions between the editorial group of the magazine and the New York John Reed Club who epitomised the latter category. By early 1932 relations between the two were described as in 'crisis', and they were resolved, in part, by giving the Club its own magazine in *Partisan Review*.[64]

Freeman struggled to get out *New Masses*, he claimed 'practically alone', for two years. In the summer of 1933

he was sent on a speaking tour to the Midwest and West Coast to revitalise the John Reed Clubs there, and from October to December no *New Masses* appeared. At the beginning of the following year it re-emerged as a weekly and thereby acquired more the character of a current affairs publication. This was not the 'theoretical magazine' Freeman had envisaged, and he was quickly dropped from the board, and moved over to *Partisan Review*, which was set up in early 1934.[65] Those who favoured the transformation of *New Masses* wanted 'the literary' subordinated to 'the political' partly as a strategy to widen the readership, and the editors claimed that the circulation increased from 6,000 to 25,000 between September 1933 and January 1935. Earl Browder described the changes as follows: 'The *New Masses* . . . is no longer primarily a cultural organ. It is a *political* weekly with strong cultural interests . . .' Directed primarily at the middle class, its objective was to forge links between them and the proletariat.[66]

In effect, *New Masses* articulated the Party's position on political issues (with which there could be no public disagreement), but continued to reflect the wide differences of opinion among Communists and fellow-travellers on cultural matters. As Browder put it, the Party aimed 'to give political guidance directly to its members in all fields of work, including the arts', but there was 'no fixed "Party line" by which works of art can automatically be separated into sheeps and goats.'[67] While this 'guidance' was sometimes rather heavy-handed (and became increasingly so after 1945) the General Secretary's description of the situation is essentially accurate.

The Rise and Fall of the John Reed Clubs

The campaign to promote and organise proletarian art was grounded in a world of socialist cafeterias, cooperative apartments, holiday camps and workers' clubs. To some extent it drew on pre-existing working-class cultural organisations that were as much ethnic as political in orientation, and which were mainly the heritage of the vibrant socialist culture of the pre-war days.[68] In September 1929 Gold printed 'A Letter to Workers' Art Groups' in *New Masses*, inviting them to join a national league that would be affiliated with an international organisation for workers' art.[69] From the October issue responses began to appear from groups such as the Bronx Hungarian Workers' Club, the Workers' Laboratory Theatre of New York, the Spartacus Film

League and Finnish Theatre groups in Wisconsin. Over the next two years a whole variety of other workers' clubs and cultural organisations wrote in, including the Japanese Workers' Camera Club, the Workers' Dance Group, the New York Proletbuhne, the Lithuanian Federation of Proletarian Art and many more. It will be evident from their titles that many of these organisations were ethnically based, and many that were not had ethnic sections – as late as 1933, 70 per cent of the Party was foreign born.

The setting up of the John Reed Club (JRC) in New York was announced in November 1929. Its genesis is obscure, but it certainly emerged from the *New Masses* group and was probably inspired by the revolutionary cultural organisations in the USSR and Germany. It was not a Communist Party club and Hugo Gellert described the 'vast majority of its members' as 'only sympathisers'. In fact, like many other Communist initiated bodies it was run by a clandestine Party fraction. Membership was open to '[a]ny writer, artist and worker in any of the cultural fields, subscribing to the declaration of purposes and the ultimate triumph of the working class'. Having said this, new members had to be voted in by a two-thirds majority at a general meeting, and the club's constitution allowed for disciplinary proceedings. The purposes of the club were described in its constitution as:

to work within all cultural mediums for the international revolutionary labor movement,

to clarify and crystallize our own theories of art and their relation to the revolutionary labor movement,

to struggle against all art and literature rooted in bourgeois ideology,

to help further an international movement of revolutionary cultural workers,

to serve as a protective and welfare organization for its members.[70]

Within two months of starting, club members had arranged an art exhibition and organised a music school at the Workers' Co-operative House in the Bronx, shown films at the club's rooms, were training a workers' ballet for the Lenin Memorial pageant, and lecturing at the Workers' School. On 28 December 1929, the JRC, together with Workers' International Relief, put on a 'big Red Art Night' at the Labor Temple on Second Avenue and 14th Street, with proceeds to go to striking Illinois miners and 'the Soviet tractor fund'. A preview of the programme promised the following:

Red poets, novelists, playwrights, will read from their work; several critics will talk, there will be a new movie from Soviet Russia, a ballet of negro and white

workers, a play by a group of Japanese proletarian artists, and satirical songs by Horace Gregory, illustrated in the sentimental manner with lantern slides by Gropper.

In May 1930, club members marched in the New York May Day parade and provided 'cartoon-posters' for other contingents; its press committee worked in support of International Labor Defense, putting on benefit entertainments at the club and at Camp Nitgedaiget, one of several workers' summer camps. Members also cooperated with Proletpen, the Jewish Proletarian writers' group, to put on a celebration at Carnegie Hall for the Yiddish comic writer Moshe Nadir that reportedly filled the hall to overflowing.[71]

Descriptions of the ambience of the club generally refer to the rooms at 450 Sixth Avenue to which it moved in the autumn of 1932, or to those at 430 Sixth Avenue where it relocated in the following October. Malcolm Cowley has given us a vivid picture of the first of these:

> My first impression was of hot yellow light, noise, excitement, and clutter. Coats lay in heaps on kitchen chairs. Young men, mostly in cotton flannel shirts, stood arguing in groups, or leaned over chessboards, or sat in corners reading *The New Masses*. There were a few older men, a few negroes, but no women . . . If women had been there, they might have insisted on sweeping the floor, which was deep in dust and calico-spattered with cigarette stubs and scraps of paper. As I stood watching, still more young men came tramping up the stairs, some of them looking like Russian workers – or like Mike Gold – with caps perched back over shocks of hair. Many of them wore leather jackets.

Cowley was reminded of the Café du Dôme, the meeting place of Parisian literary society in the 1920s. 'For men of a new generation, the John Reed Club had become "the place"', and he emphasised that it was both a meeting place and a career route for the poor young writers of working-class origins coming to maturity in the Depression. William Phillips, who was for a time secretary to the club, has also stressed its social aspect, even claiming that it was reputed to have 'the best dance floor in the city'. It evidently played a similar social role for artists, and Raphael Soyer recalled that it gave him the opportunity 'to participate as an artist with other artists' and offered 'an outlet from my own self-involvement'. For Soyer, and doubtless for many others, it provided a political education. Cowley implies that the camaraderie of the club was essentially male,

and certainly men dominated its proceedings. However, Bernarda Bryson, who attended the club in 1934, has described Cowley's description of 'no women' as 'incredible', and insists that there were plenty of women members. Minutes of the executive 'Buro' from 1934 do indicate that a number of women artists played an active role, including Sara Berman, Katherine Gridley and Anne Wolfe, but the club had no feminist agenda. Although many members of the club were Jewish, it was formed at a time when the foreign-language groups had been dissolved and the Party frowned on Yiddishkeyt. Indeed, the club opened in the same year that the Party approved Arab attacks on Jewish settlers in Palestine, with predictable effects on the standing of Communists in the Jewish community. Formally, at least, class subsumed all other identities.[72]

The Workers' Art initiative and the John Reed Club were conceived as part of an international movement, but the real impetus to bring the work of the American cultural movement more in line with that of other countries (and pre-eminently with that of Germany) came from the Kharkov Conference. One effect of the instruction to establish 'closer contacts with revolutionary cultural organisations in other countries' was that the work of JRC artists was shown at exhibitions in the USSR and some of it was purchased for Soviet museums.[73] Beyond this, the key injunctions of the ten point 'Program of Action' the US delegates brought back from Kharkov were: '3. The John Reed Club and the *New Masses* to take the initiative in organizing on a national scale a federation of all cultural groups in all languages' and '6. The strengthening of the contacts of the John Reed Club with its members outside of New York and the organization of branches wherever possible.'[74]

It was in direct response to Point 3 that in June 1931 the first convention of the newly founded Workers' Cultural Federation of New York (WCF) was held. This was attended by 265 delegates from 130 diverse organisations claiming to represent a membership of around 20,000. The objective of the WCF was to adopt the technical devices of 'the entire cultural apparatus of capitalism' – the press, libraries, movies, radio and so on – and use them to develop a mass proletarian culture. Such a culture already existed in some degree, but it was too 'uncoordinated' and was too much restricted to foreign-language workers in the large cities.[75] Harvey Klehr seems to be correct in his observation that the WCF 'barely got off the ground', and this was almost certainly because the projected organisation was over ambitious in conception, aiming to bring together too many different kinds of grouping. But having said this, as late as

July 1932 the John Reed Clubs were described as an 'integral part' of the WCF, and an internal document advised them to consider their specific task as 'the building of the WCF in each district.'[76] It is likely that the clubs, made up predominantly of fellow-travellers, could not undertake this kind of work, and the IURW simply underestimated the differences between the United States and Germany where the Party was much larger. To understand these limitations we may note the damning judgement on the John Reed Club membership of a Party document from early 1932, which claimed 'the majority' were 'neither intellectuals, nor workers nor professional revolutionists' (sic), rather they were undisciplined 'bohemians' and *hangers on of the art world*', who consistently disrupted the clubs' activities and should be expelled.[77]

Efforts to strengthen contacts with clubs outside New York and establish others were somewhat more successful. However, to begin with the clubs seemed to have been organised on local initiative, and had no standard constitution.[78] The Chicago club began at some point in late 1930, and by January of the following year had already formed a Blue Blouse Group, an International Orchestra and a Lecture Bureau, and was arranging a combined art exhibition with the *New Masses* artists. Clubs were formed in Detroit in April 1931 and in Philadelphia in August of that year. By early 1932 they had appeared in Boston and Cleveland and the Workers Cultural Council of Seattle was promising to set one up. A list prepared for the First JRC National Conference on 28–9 May 1932 records delegates from New York, Boston, Philadelphia, Detroit, Chicago, San Francisco, Hollywood, Portland, Seattle, Baltimore, Washington, Carmel (California) and the Jack London Club of Newark. (There were also clubs in Cleveland and Pittsburgh, but these did not participate.) Altogether, these claimed to represent a combined membership of around 735. Some of the clubs, such as those of Carmel, Seattle, and Portland, had memberships of less than 20, but all the others for which numbers are given had between 50 (Chicago) and 160 members (New York).[79]

The 1932 conference was held in the Lincoln Center Auditorium in Chicago. Oakley Johnson's report for *New Masses* opens with a quotation from Gold that defines the 'two main *directives*' (my emphasis) given out at Kharkov as (1) 'to create a proletarian literature', and (2) to 'bring in ... those who are of the middle class' into 'every workers' cultural group'. Around this second point there were marked divisions between some of the younger club members and older cadre such as Gold and Freeman. The conference sought to give

urgency to its appeal to the middle class (and also, doubtless, to draw on widespread anxieties) by passing a resolution against war that was effectively a condemnation of pacifism and a call for support of the USSR.[80] But as well as making pronouncements on global issues, it also adopted a 'General Program of Activities' with quite specific directives as to how the clubs should make themselves 'functioning center[s] of proletarian culture'. Particularly germane in this context are the directives to artists, who were instructed, among other things, to publish portfolios of drawings and lithographs, to arrange at least annual club exhibitions, to exhibit in both workers' clubs and in bourgeois galleries 'whenever the opportunity presents itself to submit revolutionary work', to exchange exhibitions with other JRC clubs and organise travelling shows and to paint murals for workers' club and organisation headquarters.[81] Perhaps as a result, from 1932 there was a marked increase in the public presence of JRC artists.

Again taking up on the Kharkov injunctions, the conference established a federal structure for the clubs, which were to be autonomous 'within the general supervision and direction' given by a National Executive Board elected annually. The organisation was to be divided into four regional sections and to have a national office based in New York. Despite the provision for an annual conference none took place for more than two years, and delegates to a Midwestern conference in 1933 complained that the National Board had failed to function properly. An internal party document described the situation as follows:

> Each local JRC functions locally, haphazardly, and independently. They aid the party in special campaigns. Some of them put out little mimeographed magazines that in reality fulfill no need. . . . At the best these branches are locally directed and comprised of a few dozen people.

As for the National Committee, it 'was organized in a platonic fashion. It never functioned and its present state has no prospect of functioning.' This was because there was no financial base for the national office, which was unable to collect dues or find any other way of raising funds.[82]

The picture of the JRCs that emerges from Joseph Freeman's correspondence during his 1933 organising trip is one of energy and enthusiasm, but also near chaos. On 7 August he reported from Chicago to Alexander Trachtenberg, the Party's cultural commissar:

> There are various types of JRC's [sic], unequal in composition, in function, in development. The Chicago

JRC holds in the midwest a position analogous to that of NY in the east – a position of leadership. Its composition is also very much the same ... writers and artists, with the artists in the lead as the strongest and best organized group. The clubs outside Chicago – like the clubs outside New York – are primarily cultural groups rather than organizations of writers and artists.

These other clubs ranged from that of Detroit, which had writers, artists, dance and theatre groups, to that of Kalamazoo, which did no cultural work at all and had just nominated a candidate for mayor. Freeman emphasised the political and ideological confusion of the membership, and the perceived failure of the Party to provide fundamental theoretical literature. As a result there was no real counter-influence to *Modern Monthly*, the Lovestoneite *Workers Age* and the Trotskyist *Militant*, which were read widely even by Party members. The artists Freeman spoke to seem to have felt that the Midwest conference had been far too dominated by organisational discussions, while key ideological questions had been neglected. One Detroit painter delegate observed to him that he had learned many things – 'everything, in fact, EXCEPT HOW TO PAINT REVOLUTIONARY PICTURES'. This, of course, was guidance that the Party was scarcely in a position to provide.[83]

A new national secretariat was set up by members of the New York club in February 1934, and in April a monthly *JRC Bulletin* was initiated.[84] One of the secretariat's members, Alan Calmer, wrote to Freeman in that month that none of the promises of the New York club – 'money, office, etc.' – had been fulfilled, and that 'not more than about fifteen clubs' were 'functioning in any sort of way.' In a letter of September he wrote bitterly that 'the writers and artists leadership around here don't give a fuck about the whole thing' – the 'thing' in question being the second national conference, which was held in Chicago in September 1934. By this time both Freeman and Calmer had concluded that the problems of the clubs were insoluble because of the divisions between 'skilled' and 'unskilled' within them, and the conflicts between artists and writers, especially in the New York club. The answer seemed to be to organise craft-based groups that would be loosely united through a general cultural federation. This was in effect a premonition of what did happen.[85]

Despite the upbeat tone in which *New Masses* reported the 1934 national conference, only forty-odd delegates attended (representing 1,200 members), and the number of clubs was not given. If a second surviving list of clubs dates from this time, then they were still active in Boston, Buffalo, Carmel (California), Chicago, Cleveland, Davenport (Ohio), Detroit, Grand Rapids, Hartford, Hollywood, Indianapolis, Kalamazoo, Lakewood (Ohio), Mena (Arkansas), Milwaukee, New Haven, New York, Oklahoma City, Philadelphia, Saint Louis, Santa Fe, Seattle and Youngstown. Certain 'shortcomings' in the work of the clubs were acknowledged, including 'narrowness, leftism', 'the degeneration of meetings into business meetings and factional arguments' and the lack of broad national leadership. Undoubtedly, the most important speech at the conference was that made by Alexander Trachtenberg who, speaking for the Party's Central Committee, charged the JRC National Committee to organize a National Writers' Congress within the next eight months: 'In the light of a gathering of this magnitude, sectarian tendencies will vanish, and a basis will be formed for a higher type of writers' organization, to be followed by a similar action uniting American artists.' Effectively this meant the dissolution of the clubs, although not all members may have immediately understood this, and some protested that the decision had been made without any consultation with the membership.[86]

In January 1935 the 'Call for an American Writers' Congress' appeared in *New Masses* above sixty-four signatures of writers and intellectuals, close to or in the Party. Those who attended the Congress, it was stressed, would come not as delegates but as individuals, each representing 'his own personal allegiance'. Although the Congress would be the 'voice of many thousands of intellectuals, and middle class people allied with the working class', the differences between its structure and that of the John Reed Clubs indicate a real shift in objectives. The attempt to organise a mass-based proletarian culture had been abandoned. This is confirmed by the absence of any references to proletarian literature in the 'Call'. The Writers' Congress was held in New York in April, and established the League of American Writers as an affiliate of the IURW, thereby nullifying the role of the JRCs for writers. By the end of 1934 the artists seem to have been running the New York club and making most use of its rooms. Although a Buro meeting on 17 December noted that it was imperative for both groups to remain in the same organisation, in early 1935 the Artists' Group began putting out its own monthly bulletin. While the Artists' Group continued to be active in 1935, the 'Call' for an American Artists' Congress that appeared in the 'Revolutionary Art' number of *New Masses* in October signalled its demise.[87]

It remains to consider here one last aspect of the work of the New York club, namely the John Reed Club

School of Art. There were well established precedents in art education directed at a proletarian constituency in the art classes of the New York Ferrer School and the Educational Alliance, the latter being described in 1930 as 'the nation's most proletarian art school.'[88] From its first beginnings the club's artists had conducted art classes at workers' clubs, but in the autumn of 1931 a school was set up in the JRC rooms, which at that time consisted of sketch classes on three evenings a week. The 'General Program of Activities' of the 1932 conference designated this 'the national John Reed Club School of Art', and called on Artists' Groups elsewhere to set up their own schools. An advertisement for the school in 1933 appealed to potential students: 'Learn to depict the exciting events of present day life with the tutelage of well-known artists.' When the club moved to 430 Sixth Avenue in October of that year, the school was re-organised and given a floor to itself over the other rooms. Classes were added in drawing, painting, sculpture, political cartoon, lithography, poster and fresco. There were also classes for children. In October 1934, the School became a full-time institution with a curriculum of morning, afternoon, evening and week-end classes. Enrolment increased so much that the club rooms were no longer adequate, and one year later it moved to 131 West 14th Street, where it had the top three floors of a five-storey building. The top two floors were studios while the lower one comprised the office, lecture hall and gallery. Enrolment was 395 in 1935. In addition to the studio courses, in early 1933 the school began a series of monthly lectures, to which Jerome Klein, Lozowick, Lewis Mumford and Meyer Schapiro contributed among a virtual roll call of Communist artists and critics. Fees were low and the school was run largely by volunteer staff. In both 1933–4 and 1935–6 it operated at a small loss. Despite the confident tone of its publicity, the school was not without problems, and a 1935 report on its workings by Anton Refregier complained of the low level of political development in the students and called for the organisation of a Party fraction among them.[89] However, unlike the JRC itself, the School of Art survived the changeover to the People's Front and, reconstituted as the American Artists School, it remained an important centre for Communist artists and their allies until 1941.

From what has been said above, it will be clear that any notion of the John Reed Clubs as a tightly organised sectarian grouping collapses in the face of the evidence of internal documents and the correspondence of those who tried to lead them. Rather, the clubs made up a loose federation of diverse bodies on which Party workers such as Freeman and Calmer struggled to impose some kind of common direction. In the circumstances there was no chance that 'artistic creation' would be 'systemized, organized, "collectivized," and carried out according to the plans of a central staff like any other soldierly work' as Eastman claimed in *Artists in Uniform*.[90] In fact, writers and artists were largely left to try to work out their own paths to revolutionary art. I am not suggesting that the leaders of the cultural fraction saw this as a desirable state of affairs, merely that they did not have the resources to change it.

2 Defining Revolutionary Art: Cultural Criticism in the Third Period

This chapter analyses the models of revolutionary art current in the Third Period, drawing mainly on *New Masses* and *Art Front*, the magazine of the Artists' Union of New York. To simplify somewhat, these magazines represent respectively the standpoints of the 'proletarian and proletarianized' artists and the artist fellow-travellers.

Lessons of Soviet Culture

Given the status of the USSR as 'the hope of the world', where the atmosphere was as inspirational as that of Pericles' Athens,[1] the example of Soviet culture was obviously crucial. But the lessons to be drawn from it were far from simple, and were inevitably confused by distance and false preconceptions. In 1930 Freeman, Kunitz and Lozowick published a substantial illustrated account of the Soviet arts with the title *Voices of October*. Perhaps with some uneasy awareness that the contemporary maelstrom in the USSR was rendering the perceptions he had formed in 1926–7 already obsolete, Freeman observed in the first chapter: 'Soviet life changes rapidly; what is true today may no longer be true tomorrow. Where social life is so consciously and ruthlessly directed by the organized working class, decades may be leaped over in a year.' *Voices of October* covered developments up to the New Economic Policy, and first reports of the Five Year Plan indicated 'that a new period of development in Soviet life has opened, to be followed, it may be assumed, by a new turn in Soviet art and literature.'[2] Indeed!

The chapter on 'Soviet Painting and Architecture' by Lozowick is notably brief, giving short accounts of how Futurism and Constructivism (in effect parts of Lozowick's own past) were superseded, and describing the realist-oriented AKhRR (Association of Artists of Revolutionary Russia) as 'the most imposing' tendency of the decade. In fact, this was already an outdated or at best simplified view. As a result of the Cultural Revolution, by 1930 AKhRR was embattled and in crisis, and in 1928 it had changed its name to AKhR (Association of Artists of the Revolution).[3] The reporting of these competing artistic and literary tendencies was sagely non-judgemental. Freeman stressed in his introduction that the aim of the book was 'neither to praise nor to condemn', 'not so much to interpret Soviet Russia as to let Soviet Russia interpret itself.' But this was certainly a naive hope in the context, and such non-partisan intentions could not prevent the book from becoming almost immediately problematic. This was a fate that would in any case have been ensured by its too favourable references to Trotsky's *Literature and Revolution*.[4]

After the landmark April Decree of 1932, 'On the Reconstruction of Literary and Radical Organizations', all the competing artistic groupings in the USSR were dissolved. Having said this, the decree did not end debate or lead to the straightforward resolution of a single Socialist Realist aesthetic. Indeed, the period from the beginning of 1931 to the end of 1935 has been described as one of relative liberalism in Soviet literary culture, and the continuing struggle to define a socialist aesthetic reverberated in confused echoes in the American movement.[5] To some extent these developments could be followed through the pages of *International Literature*, and the IURW also dispatched mimeographed documents to brief the leaders of its American affiliate. The significance of the April Decree and the end of RAPP received particular attention, partly because these events were cited by critics of the USSR such as Max Eastman as the culmination of a process by which 'every manifestation of strong and genuine creative volition, every upthrust of artistic manhood, in the Soviet Union, has been silenced, or banished, or stamped out, or whipped into line among the conscripted propaganda writers in the service of the political machine.'[6] Eastman's article 'Artists in Uniform' in the *Modern Monthly* of August 1933 prompted a two-part rebuttal from Kunitz in *New*

Masses explaining that the dissolution of artistic groupings, like the discrediting of the Constructivists and the LEF group, was the effect of popular forces not a bureaucratic imposition. The implications of the April Decree and of Socialist Realism for the visual arts were addressed by Lozowick in a series of lectures at the John Reed Club Art School in 1934.[7]

In the context, the Soviet Writers' Congress of 1934 could not but be the object of considerable interest. Initially *New Masses* printed a two-part report by Moissaye J. Olgin, editor of the *Morning Freiheit*, describing the Congress as a joyous pageant in which delegations from the Young Pioneers, the Red Army and workers' shock brigades all enthusiastically participated.[8] Excerpts from the Congress speeches appeared in both *New Masses* and *Partisan Review* in 1934–5, and in the run-up to the American Writers' Congress of 1935 (an event that inaugurated Popular Front cultural strategy in the United States) *New Masses* published a further first-hand account by the poet Robert Gessner, which emphasised the intensity of debate and differences between some of the speakers. Gessner hailed the demise of RAPP, described misleadingly as 'a bureaucratic organization which had arbitrarily ruled out all fellow-travellers', and claimed that its departure made possible the 'vigor and freedom of self-criticism' at the congress. The challenge for American writers was to adapt the vision of 'socialist realism' to American circumstances.[9] No surprise then that when International Publishers issued a major anthology of *Proletarian Literature in the United States* in 1935, Olgin hailed it in the *Daily Worker* as exemplifying just that.[10] It is easy to be cynical about the 1934 Writers' Congress because of what it led to, and to see the responses of Olgin and Gessner as naive. But students of Soviet literature have emphasised the scale of the occasion, the disparate nature of the speeches and the widespread hope that 'a genuinely new and great literature' was imminent. After the austerities of Proletarian Literature, it seemed to mark a turn to a broader and more complex notion of literary and artistic quality, in the USA as in the USSR.[11]

Soviet developments in the visual arts were not followed as closely as those in literature. Indeed, art reviews were not a regular feature in *New Masses* before the latter part of 1934, and until then they were largely confined to the activities of the John Reed Clubs and written mainly by artists themselves, except for occasional reviews by left-wing intellectuals such as Meyer Schapiro and Mark Graubard (a biologist at Columbia University). From late 1934 to the end of 1935, the John

Reed Club artist Stephen Alexander provided the first frequent 'Art' column, a development that may reflect the increasingly public profile of left-wing artists as a result of the club's exhibitions and the activities of the Artists Union.[12]

In the late 1920s and early 1930s one could find more information about Soviet art in the mainstream art magazines,[13] than in *New Masses*, and even the exhibitions of Soviet art in the United States in 1924, 1929 and 1934–6 received surprisingly little attention in the Communist press. The first two of these were shown at a gallery in Grand Central Station in New York and were sponsored by Amtorg, the Soviet trading corporation. According to the *Daily Worker*, the 1929 exhibition was attended by 'over 150,000 *workers*' (my emphasis) and $125,000 worth of goods were sold, mainly craft items. However, despite the presence of 140 paintings, 101 graphic works and 37 sculptures, the display prompted only a brief notice in *New Masses*.[14] While it aimed to be comprehensive and included modernist works by Altman, El Lissitsky and Tatlin, the catalogue introduction emphasised the importance of AKhR and a foreword by Christian Brinton applauded the small presence of 'Cezannism' (*sic*), 'the bane of the art world', and of 'the blighting abstractions of cubism'. The 1934–6 exhibition, which was organised by the Pennsylvania Museum of Art, the College Art Association and the American Russian Institute for Cultural Relations with the Soviet Union, was a travelling show comprising 60 paintings and 163 graphics. The catalogue essay, again by Brinton, virtually reproduced current Soviet ideology, claiming that Soviet painting represented a continuation of an established tradition of 'Slavic realism' originating in the nineteenth century. Unlike that of 1929, the exhibition contained no modernist works, and Brinton asserted that by 1924 'modernism as such was a dead issue in the USSR'.[15]

Lozowick's commentary on the exhibition was, as he put it, 'a note' rather than a review, in which he sought to explain the absence of modernist works with reference to the history of Soviet arts policy, giving considerable attention to AKhR and the factional struggles of the late 1920s. Modernism had not been 'legislated out of existence', rather it had failed to strike roots in 'the broad masses of the workers'. The April Decree ended a period of unhealthy factionalism, and Socialist Realism was not promulgated by administrative fiat, but came as 'a logical development from wide discussion in response to an immediate social need; and it is by no means universally accepted.' Lozowick emphasised the economic

security and public status of Soviet artists, their sense of social responsibility, and the widespread 'growth of creativity' among 'workers of farm and factory'.[16] However, whether or not such conditions existed in the USSR, they did not exist in the United States and there are few indications that the Soviet model was seen as appropriate for the American context. Indeed, in November 1935 the cartoonist and printmaker Russell Limbach wrote in *New Masses* that the 'American artist has nothing to learn from his comrades in the USSR in the field of the graphic arts', and likened Soviet paintings to illustrations in the *Saturday Evening Post*.[17]

Mexican Revolutionary Art

By contrast, the art of the Mexican Mural Renaissance was extensively discussed and held up in some respects as exemplary.[18] This was partly to do with its sheer proximity and topicality. Many American artists visited Mexico in the 1920s and 1930s, attracted by its broader culture as well as by its contribution to modern art.[19] Further, the presence of the three main muralists in the United States in the 1930s, and the controversies their work there provoked, made their achievement both a challenge and a standard. This was especially the case with leftists, for whom the mural seemed almost the necessary form for a revolutionary popular art. But responses to Orozco, Rivera and Siqueiros were rendered complex by manifest differences between them, particularly in their relations with the Communist movement.

Initially *New Masses*'s response to Rivera was laudatory. Dos Passos centred a 1927 report on the muralists around a contrast between the art of the New York galleries, full of 'little pictures', 'stuff a man's afraid to be looking at', 'a few private sensations and experiments framed and exhibited'; and 'a challenge shouted in the face of the rest of the world'. Rivera's murals in the Secretariat of Education were 'passionate hieroglyphics of every phase of the revolution'.[20] Two years later the magazine printed a poetic tribute to the artist that claimed he painted 'the living principle' of the 'mighty word . . . REVOLUTION!'[21] But such views were soon to become untenable, for in 1929 Rivera was expelled from the Mexican Communist Party and at Kharkov he was condemned for 'advocating a right-wing program.'[22] His sins were compounded by his willingness to work for American capitalist patrons and his association with both Trotskyism and the Lovestoneite Communist Party Majority Opposition, for which he made a sequence of mural paintings on American history to decorate the New Workers School in New York in 1933.[23] In addition he published statements in the *Modern Quarterly* of the renegade Calverton that articulated an independent theory of revolutionary art, and criticised contemporary Soviet art elsewhere as dominated by academic painters who were 'intellectual lackeys of Sir Joseph Stalin'.[24]

To begin with, however, Rivera seems to have sought friendly relations with American Communist artists, and he agreed to address a public meeting under the auspices of the John Reed Club on 1 January 1932. If the club's leadership had expected Rivera to make a *mea culpa* they were evidently disappointed. His speech, translated from the French by Lozowick, who also chaired the meeting, was violently heckled by the *Daily Worker* editors William Dunne and Harrison George among others. According to one report, Frida Kahlo – the artist's 'petite but peppery little wife' – almost got into a fist fight with the hecklers before Lozowick could restore order.[25] The following month, a four-page appraisal of Rivera's work by 'Robert Evans' appeared in *New Masses*. In actuality this was written by Freeman, who had been *Tass* correspondent in Mexico in 1929, and whose first wife, Ione Robinson, worked as an assistant on the National Palace murals. Freeman's article was not dismissive but it argued that the qualities in Rivera's better work derived from the energies of the Mexican Revolution rather than from any special personal capacity: 'The stupendous frescoes in the Secretariat live with the power of the Mexican masses' – yet at the same time they are 'vast caricatures' that are 'intellectual, remote, and devoid of feeling'. However, as Rivera aligned himself with 'the bankruptcy of petit bourgeois agrarianism' and began to sell his talents to 'Chicago and California millionaires' his work had gone into decline. 'Cut off from the revolutionary workers and peasants', he could only 'regain the motive power of his art' by returning to the Communist fold.[26]

Perhaps as a result of some genuine confusion, Freeman accused Rivera of making changes to his National Palace mural to accommodate his governmental patrons, changes he had not in fact made. It was thus easy for Rivera to discredit the charge by reproducing the relevant portion of the mural together with the preliminary sketch in the Lovestoneite *Workers Age*.[27] But Freeman's article also represented the larger failings of a proletarian ontology, according to which healthy art only arose from contact with the masses, and the sole route to that necessary source was through the Communist movement. The upshot of this was that Rivera's

Detroit Industry murals of 1932–3, arguably the greatest socialist art of the period in the Western hemisphere outside Mexico, were passed over virtually in silence in the Communist press. Predictably, in the latter half of the decade Rivera's work was interpreted most sympathetically by independent leftists such as Meyer Schapiro and the Lovestoneite Bertram Wolfe, who became his biographer.[28] The Party's phobia of Trotskyism, which was essentially an insensible reflex of struggles in the USSR, meant that it was unable to offer any measured appraisal of the most controversial political artist of the time, and the confusions the situation caused are illustrated by the fact that at the same time as it ostracised the artist, the John Reed Club organised meetings and picketing to protest against the destruction of his Rockefeller Center Mural.[29]

If artistic role models were to be gauged in terms of ostensive commitment to Party discipline, then the Mexican artist most worthy of emulation was Siqueiros. In a long article, presumably occasioned by the artist's arrival in New York in 1934 and his exhibition at Alma Reed's Delphic Studios in mid-March of that year, Freeman's second wife, Charmion von Wiegand, stressed that for Siqueiros art was only 'one form of revolutionary agitation' among others, and that his commitment to the revolutionary movement was constant.[30] That May New Masses published a long attack on Rivera by Siqueiros, which charged him with being a 'Saboteur of . . . Collective Work', 'An Agent of the Government' and an 'Aesthete of Imperialism' among other things. The Detroit Industry murals were 'ideologically obscure' works in an 'opportunistic technique', effectively determined by their patron.[31] Siqueiros's own technical experiments were described with considerable sympathy by von Wiegand, who argued that '[m]ore than any of the Mexican painters, perhaps Siqueiros has managed to fuse the revolutionary content and form in his art', and contrasted his work with the 'painfully academic' technique of 'many Soviet painters'.[32] However, Siqueiros insisted upon being judged on his outdoor murals, and the three he had executed in the United States in 1932 were all in California and were represented at the Delphic Studios show only by photographs. For von Wiegand, one picture alone in the exhibition 'gave some indication of the artist's powers in this direction', and that was the Proletarian Victim (Museum of Modern Art, New York), in fact an image of a woman martyr of the Chinese Revolution painted in Duco enamel on burlap. Further, although his theories were 'highly suggestive' and might 'possibly mark a turning point in art', she complained of a 'romanticism'

and 'a certain lack of discipline' in his approach that needed to be curbed. An artist with such an intransigent approach to easel painting and bourgeois patronage offered a difficult model. And intransigence in such things became distinctly unfashionable during the Popular Front.[33]

Ironically, it was Orozco, the most politically equivocal and pessimistic of the muralists who offered the least problematic exemplar. The strength of his appeal may have been partly to do with the sheer impact and accessibility of his work – the murals at the New School of Social Research (1930–31) and Dartmouth College (1932–4) and the publications of his prints. Further, Orozco was understood as a 'modern' – but a modern who produced a monumental didactic art.[34] Despite the pessimism of his work, he was also an ally, showing at John Reed Club exhibitions in 1933–4 and making occasional contributions to New Masses. Anita Brenner's 1933 article on Orozco for the magazine described him as 'wholly a revolutionary' in that 'all the forces of his nature set him squarely against the status quo', while at the same time acknowledging that he saw himself as a free agent who was not committed to either side of the struggle. When von Wiegand reviewed the Dartmouth frescoes two years later, she described the artist's viewpoint as 'humanitarian' and 'semi-anarchist'. The murals were critical of 'bourgeois civilization' without showing any way for the working class to move beyond it. But this, she reasoned, was an effect of the 'frozen ivory tower' where they were located. Orozco had been 'unconsciously' influenced by the environment and as a result his frescoes were 'iconoclastic rather than revolutionary'. None the less, it was 'no exaggeration to say that . . . in regard to color, composition, organic relation to architecture, and grandeur of concept', they 'surpass by far any other frescoes in this country.' In the issue of 19 November 1935, Stephen Alexander described Orozco as 'the greatest artist of our time in the Western hemisphere', contrasting him with that 'cheaply opportunistic business man' Rivera. Orozco, it seemed, appealed because his work looked so angry and uncompromising. Alexander dwelt at some length on the ambiguities of meaning in Orozco's works but found the violence of their style in itself revolutionary. This was an interesting perception – something like a valorisation of Orozco in terms of an ostronanie effect. For von Wiegand too, Orozco's form was infused with 'the directive energy of struggle', whereas Rivera's approach was essentially decorative and static. As I shall show, these evaluative judgements tie in with a whole current in Communist art criticism of the mid-1930s.[35]

Proletarian Artists versus 100 per cent Americanism: Art Criticism in *New Masses* up to 1935

Part of my argument in this chapter is that the Cultural Revolution in the USSR, and the reaction against it, had considerable repercussions in the American Communist movement. The enforced collectivisation of agriculture and the First Five Year Plan involved some return to the spirit of the Civil War years – a formative period for many among the Soviet leadership cadre – and one feature of the phase around 1930 was a use of military-style slogans reminiscent of that time. In the United States, a comparable slogan 'Art is a Weapon in the Class Struggle!' (often abbreviated to 'Art is a Weapon!') was widely invoked in the aftermath of the Kharkov Conference.[36] It is a slogan that seems essentially congruent with Gold's model of proletarian literature as a functional literature, propagandistic by virtue of its simple truth to facts. Unsurprisingly, there was a similar emphasis on use in the art criticism of *New Masses* in the Third Period, which continued after the demise of RAPP and the cognate artist bodies associated with it.

As James Murphy has shown, the position of Communist literary critics on modernism was far more nuanced than has been generally acknowledged. Gold, for instance, praised *transition* in 1928 for being full of 'a furious anarchistic spirit' and a sort of 'desperate honesty that seems pathological in a world built on lies.'[37] However, we have also seen that all kinds of aestheticism were suspect from the proletarian perspective, and there was a persistent tendency to view the use of modernist formal devices as signifying an evasion of reality symptomatic of bourgeois degeneracy. This caused problems for a sophisticated and cosmopolitan artist such as Lozowick, whose graphic imagery, while readily legible, sought to articulate a politicised vision through stylistic devices that were associated with an aestheticised fantasy of the Machine Age (fig. 13). In February 1929 Lozowick had an exchange in *New Masses* as to whether or not 'Machine Art' was bourgeois, and the following year a letter from one Vern Jessup praised the cartoons in *New Masses* but complained:

> Too often our artists go 'arty.' Take Lozowick: an almost perfect technician, his drawings have a neutral static quality about them. In the *New Masses* they're proletarian art. What do you call them when they appear in the bourgeois business magazines as they do?

13 Louis Lozowick, *Tanks, #2 (Steel Plant)*, 1929, lithograph, 14⁵/₈ × 9 in., Smithsonian American Art Museum, Museum Purchase. Illustrated in *New Masses*, February 1932, as *Industrial Scenery – New Jersey*.

Replying, Lozowick took the opportunity to make a general statement about revolutionary art. Firstly, he pointed out that working in a capitalist society it was impossible for the artist not to be involved in capitalist institutions: 'since art embodies an ideology, the difficulty is how far the artist can travel without compromising his revolutionary convictions.' Secondly, he asked whether the weapon of caricature was to be the only aspect of revolutionary art, or whether the artist should strive to make 'a lasting contribution . . . to what is now perhaps vaguely called proletarian culture?' 'To ask the question is to answer it', he concluded.[38] Of course it did providing one could register some notion of aesthetic quality distinct from immediate political utility.

Jessup's criticism anticipated in more down-to-earth terms the viewpoint of the IURW 'Resolution on the Work of New Masses for 1931', which observed:

> Very often, in the drawings published in the magazine, we find revolutionary content sacrificed for esthetic innovations and experiments in form together with a fetishistic approach to capitalistic technique and its underestimation of the consciousness and militancy of the revolutionary movement with corresponding overestimation of the might of American capitalism . . .

The suspicion that this was directed against Lozowick is confirmed by the manuscript version among the artist's papers in which the accusations are tied to names.[39] Virginia Marquardt has argued convincingly that such criticisms affected both Lozowick's statements and his work, so that the artist himself began to enunciate a stern critique of modernism, at the same time as he argued for a 'synthetic style' of revolutionary art that 'profited by the experiments of the last twenty-five years'.[40] Yet despite his wide knowledge and longstanding commitment to the Communist cause, Lozowick did not become the model proletarian artist – in part because he was too cosmopolitan, too much the intellectual. The artists who played this role in Stephen Alexander's *New Masses* art column of 1934–5 had a narrower formation. To explain this it is necessary to sketch the larger configurations and dynamics of the American art scene as Alexander saw it.

In his first review for the magazine, Alexander set out the historical situation as follows. The Armory Show had initiated a struggle between 'the Academy' and 'the Moderns' in American art, in which the latter were ultimately successful, so that in the years 1928–32 modernist art had become a popular investment among the rich bourgeoisie who wanted 'a quick veneer of "culture"'. (The reader should note here that the category of modernism was more expansive in the early 1930s than in current usage, and for some critics encompassed artists such as Hopper and Burchfield.) Alexander judged that this process had brought a 'new vitality' into American art. But recently there had emerged a new nationalist concern with identifying native traditions which he particularly associated with Holger Cahill and Thomas Craven: 'Today this national chauvinism, 100-percentism, is strongly entrenched and gaining rapidly.' Alexander had certainly identified a real trend, represented by Cahill's *American Folk Art* exhibition at the Museum of Modern Art in 1932–3, and articles in the influential *Magazine of Art* – although he did not observe its relationship with the American modernist discourse of the 1920s, and ignored important differences between Cahill and the vulgarly nationalistic Craven. To understand his reaction, it must be remembered that in 1934 the Communist Party still viewed the New Deal as incipiently fascistic and all forms of nationalism were seen as cognate with fascist ideology. For Alexander the deepening economic crisis had driven the capitalist class to try and bolster 'its cracking economic foundations' by 'frantic patrioteering in the cultural field.'[41]

In this world of simple polarities, another force had emerged (dialectically) in a grouping of artists 'united in their desire to use their art to serve the ends of [the] new revolutionary class coming to power' – actually the artists of the John Reed Club. Although they varied in their 'technical equipment', they had a common aim that was far more profound than formal differences such as those that separated moderns from academics: 'The ideological content, the subject, the social implications, the emotional impact . . . all these are for us important factors, *along with "formal" or technical considerations*, in the sum total evaluation of a painting, drawing, or sculpture' (emphasis in the original). None of these artists was concerned primarily with 'decoration' or technical display. Expanding on this theme in a later review, Alexander asserted that 'We believe that an art which raises the revolutionary consciousness of the masses, which gives fine plastic and graphic expression to the class struggle . . . is the most useful kind of art for our purposes, hence for us the "highest" form of art.' From this perspective, abstract painting, premised on a denial of the 'validity of the "subject"' was simply sterile.[42]

The nativist '100 percentism' that Alexander saw as the latest trend in American bourgeois culture was represented in painting by Thomas Hart Benton and Grant Wood. Benton he characterised (aptly) as 'a shrewd politician', who knew how to play the '"native son" business for all it's worth', and while he acknowledged his capacity to 'organize a picture' he found his art 'basically tabloid' in character. Benton's imagery of America suggested that 'AMERICAN LIFE HAS NO MEANING . . . DON'T TRY TO FIGURE IT OUT', and Alexander equated it to Huey Long's populism. His historical murals such as *The Cultural and Industrial History of the State of Indiana* (fig. 14) were a falsification, that offered 'school book versions of history'.[43] Grant Wood, too, had 'shrewdly taken advantage of the rising tide of national chauvinism'. Alexander again acknowledged the artist's technical accomplishment, and found that his work 'comes closer than that of any other to being a popular

14 Thomas Hart Benton, *The Cultural and Industrial History of the State of Indiana: Panel X – Parks, the Circus, the Klan, the Press*, 1933, egg tempera on canvas, 12 × 9 ft, Indiana University Art Museum, Bloomington. © T. H. Benton and R. P. Benton Testamentary Trust/Licensed by VAGA, New York, N.Y.

art' because of its conservative style (fig. 15), at the same time pointing to the essentially synthetic character of Wood's Americanism. Wood knew how to ' "play dumb" ', but his 'truth and authenticity' were put on to please rich patrons, and he deliberately ignored the real truths of his native Iowa: 'farm foreclosures, milk strikes, pitched battles between farmers and state troopers, sheriffs' sales, etc.' Considering the hokey folksy image of Wood that the Ferargil Galleries projected in the catalogue to its 1935 show of the artist's work, Alexander's response was acute enough. And it is also worth noting that Wood's corn-pone pose and sales pitch irritated critics in the liberal *Magazine of Art*.[44] At a visual level, *New Masses* offered a critique of the Regionalist vision by illustrating a very different vision of the American Scene, represented notably in Eugene Morley's powerful lithograph *Hard Coal Landscape* (fig. 17), in which the

bones of a miner mingle with the debris of a pit cave-in in the foreground of a desolate industrial view.

To these false visions of American life and history, Alexander counterposed the truths painted by proletarian artists such as Jacob Burck and Joe Jones. Burck (1907–82) was born in Poland, but grew up in Cleveland where he worked at various odd jobs and attended the School of Art. In 1924 he moved to New York on a scholarship from the Citizens' Culture Committee and studied with Albert Sterner and Boardman Robinson. He entered the revolutionary movement in 1926 and began drawing for the *Daily Worker* in the following year, becoming staff cartoonist in 1929. His cartoons were a regular feature in the annual volumes of *Red Cartoons* that the *Daily Worker* printed from 1926 to 1930, and in 1935 the paper published a 248-page selection of his work under the title *Hunger and Revolt* (fig. 16),

15 (*right*) Grant Wood, *Young Corn*, 1931, oil on masonite, 24⅛ × 30 in., Cedar Rapids Iowa Community School District Collection, on permanent loan to Cedar Rapids Museum of Art.

17 (*facing page*) Eugene Morley, *Hard Coal Landscape*, lithograph, from *New Masses*, 24 September 1935, Marx Memorial Library, London.

16 (*right*) Jacob Burck, *The Lawmakers*, from *Hunger and Revolt* (1935), Tamiment Institute Library, New York University.

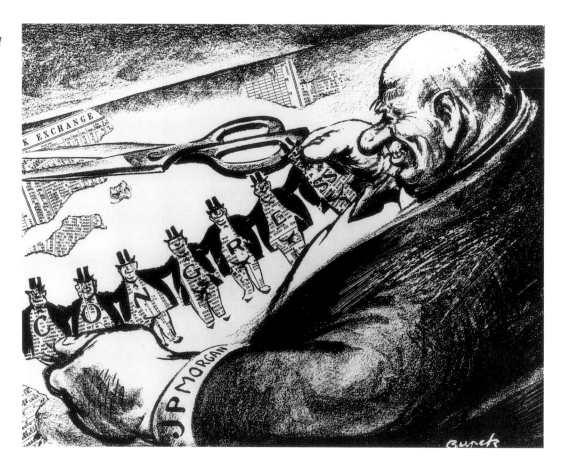

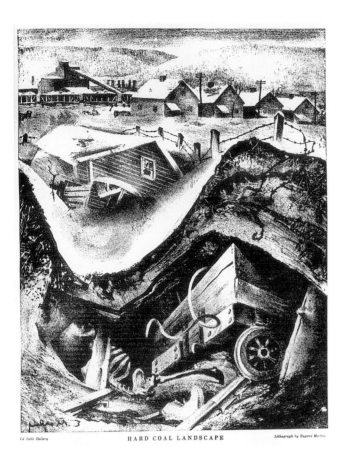

which had an introduction by Henri Barbusse and section introductions by Communist luminaries such as Langston Hughes and John Strachey.[45] Unfortunately, I have been unable to locate any of his early paintings, but to judge from photographs they used simplified human forms to represent a directly emotive subject matter of popular resistance and socialist construction. Both *Death of a Communist* (fig. 18, exhibited at the Society of Independent Artists show in 1932) and *The New Deal* use upturned compositions with strong diagonals and close-up viewpoints that put the spectator almost in the picture. The simple block-like forms of strikers and soldiers in the latter suggest a familiarity with Cubist spatial constructions which correlates with Burck's assertion that the revolutionary artist could not ignore 'plastic discoveries produced by bourgeois art'.[46] Like other Communist artists such as Phil Bard, Hugo Gellert and Anton Refregier, Burck seems to have regarded mural painting as the key form of public art at this time. The medium was topical, partly because of the prestige of Rivera, whose retrospective at the Museum of Modern Art (MOMA) in 1931–2 had attracted a record number of visitors,[47] and debates around mural decora-

tions in corporate buildings such as the Rockefeller Center and the Kaufmann Store in Pittsburgh. In 1932 MOMA opened its new building on West 53rd Street with a show of mural painting, from which cartoons by Gellert and Gropper were almost excluded because of their unflattering portrayals of Andrew Mellon, J. P. Morgan, J. D. Rockefeller and other multi-millionaires as gangster types, dependent on troops, cops and hired thugs to protect their loot.[48]

Such artists were concerned to counter what Alexander called the perversion of the 'public character of the mural' by the capitalist class. In 1935 Burck and Edward Laning showed together two groups of murals in the gallery of the Art Students League. The theme of Burck's five panels was that of socialist construction in the USSR (fig. 19). Initially destined for the offices of Intourist in New York, they were eventually shipped for its Moscow travel agency and displayed at the Museum of Modern Western Art and Kauchuk Workers' Club in 1936. Although Burck had not yet seen the great socialist experiment at first hand, Alexander emphasised the veracity of his vision on the basis of his own experiences of the Soviet Union: 'here is the exultant, indomitable spirit of the *new man* and *new woman*, the socialist worker, a new type of human being, whose heroic achievements are writing the epic of history. I was amazed to see these people with whom I had worked come to life'. The quality of the artist's insight came from a 'sustained and intensive revolutionary training' and a deep commitment. His murals were apparently painted by electric light at night 'in a room scarcely wider than one of the panels' and where he could not stand back far enough to see them properly. They were also 'painted under terrific pressure of other work'. The overcoming of these difficulties made Burck's own achievement heroic, Alexander implied – perhaps analogous to that of Soviet workers who surpassed their production targets, we might suppose.[49]

Responding to the accusation of propaganda levelled against revolutionary art by Benton's defender Thomas Craven, Burck claimed that unlike the 'form of trickery employed by manufacturers', propaganda for the revolutionary meant 'the expounding and expression of the historical materialist conception of human life, or society.' It was therefore a propagation of the truth and entailed a close involvement with 'the life and struggles of the workers'. While Benton was a 'pragmatist', who tailored his art to suit the art trade, the revolutionary artist was not satisfied to focus on the 'mere surface appearances' of social life. Rather, 'Revolutionary art aims to tear off the surface veil of things and expose the

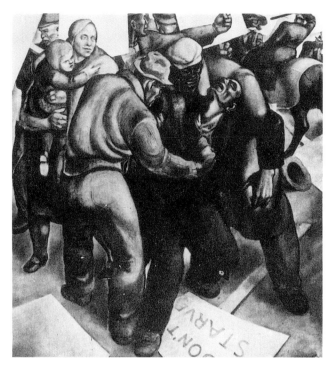

18 Jacob Burck, *Death of a Communist*, from Sheldon Cheney, *Expressionism in Art* (1934).

19 Jacob Burck, photograph of artist with mural panel *Completion of the (Turksib) Railroad*, from *International Literature*, March 1935, Marx Memorial Library, London.

thing itself in its naked reality.' (This is of course a perennial trope of realist aesthetics.) I suspect that Burck's differentiation between kinds of propaganda may have been informed by Lukács 'Propaganda or Partisanship', published in *Partisan Review* in the issue of April–May 1934 and hailed in the *Daily Worker* as an 'outstanding piece of criticism'. This asserted that the 'proletarian revolutionary writer' 'rejects the dilemma of "pure art" versus "propaganda art"' because '[h]e does not need to distort, rearrange or "tendentiously" color reality, for his portrayal – if it is a correct dialectical one – is founded upon the perception of those tendencies . . . that make themselves felt in objective evolution.' This essay may also help to account for Alexander's stress on Burck's capacity for 'characterization', and his ability to understand his subject 'in all its social and psychological implications'. Like Lukács's ideal of committed writing, Burck's art aspired to nullify the distinction between propaganda and truthful representation.[50]

Joe Jones (1909–63) offered a somewhat different type of the proletarian artist.[51] While Burck was Jewish and very much part of the New York Communist scene, Jones was a Midwesterner of Welsh and German parentage, born in Saint Louis. He left school at fourteen and was apprenticed to his house-painter father. Around the age of eighteen he began experimenting with painting as an art, and quickly attracted attention locally by winning a series of prizes in the Saint Louis Art Guild exhibitions. He gained yet more publicity in 1932 when he received a commission to paint a mural in the reception room of Radio Station KMOX in the city. In the following year the Guild gave him a solo show of twenty-five works. Jones described himself as 'self-taught', and at the time of his first show declared his lack of interest in the type of 'harmless imitations of French art of the last century' that most Americans were painting. 'For four years I've studied nothing but the old masters', he claimed.[52] Yet to judge from Washington University's 1932 *Landscape*, he had actually been studying varieties of modernist art, since the upturned perspective and decorative flattened forms are unmistakably Cubist in origin – although Jones may have come to them via the works of contemporary American artists such as Andrew Dasburg, and not understood their lineage. In a later interview, Jones admitted that until 1935 his main contact with other artists had been through art magazines.

'Brash, boisterous, irrepressible' was how one critic described Jones at the time of his New York debut, and a friend spoke of his 'particular flair for personal publicity'.[53] Not only his work, but also his bold prono-

20 Joe Jones *et al.*, *Social Protest in Old Saint Louis* (detail), 1934, mural in old Saint Louis Court House, from *International Literature*, no. 2, 1934, Marx Memorial Library, London.

uncements and increasingly combative political stance received much publicity through the Saint Louis press and, as his career progressed, through national magazines such as *Time* and *Fortune*. In 1933 ten local businessmen and art lovers formed themselves into a 'Joe Jones Club' to support the artist, and paid for him to travel to Provincetown, Massachusetts, to study at the artists' colony there. Jones had already expressed radical sympathies before he left and on his return announced that he had become a Communist. His new political convictions were directly manifested in his art which became as a result unsaleable – much to the irritation of his patrons. Instead: '[l]iving on a houseboat propped on the ruined levee, with black industrial Saint Louis all around him, he paints, fiercely, angrily.'[54]

Jones's career in the mid-1930s can be charted in considerable detail from an extensive correspondence with his liberal patron Elizabeth Green, who supported him financially and acted as his confidant and mentor in some degree. He could hardly have achieved the career success he did without her backing, and yet they disagreed on politics to such an extent that in October 1934 he declined to visit her to avoid 'distastfull polemics' (*sic*): 'I can respect your viewpoint on social problems, but at the same time I insist on this same privilage' (*sic*).[55] It was with funds raised by Green from 'civic minded persons' that Jones set up an art class for unemployed youths in a room of the old Saint Louis Court House, which had been handed over to the local Art League after legal officialdom moved out. Not that the League approved of the new class, and its secretary complained that Jones was teaching 'an art of protest against the existing industrial and political order' in 'the modernistic style'. A further cause of controversy was the Soviet posters with which the room was decorated.[56]

The Unemployed Art Group found an appropriate focus in a collective mural of *Social Protest in Old Saint Louis* (fig. 20), 17 × 37 feet, done in chalk on beaverboard nailed to the wall. Based on a cartoon by Jones but executed by a group of twelve students, this centred on an image of black riverfront workers loading a paddle steamer. To the left unemployed workers lounge in front of a pawnshop adorned with the NRA blue eagle, while to the right an African American baptism under the Eads bridge merges into a Communist-led demonstration in the nut-pickers strike of 1932. The choice of motif was highly significant, since the Party had played a key organising role in the strike, regarded as exemplary because it had mobilised African American women, who (it was claimed) had moved from a passive religious outlook to militant union consciousness as a result of their experience. The conjunction with the baptism may be an allusion to the fact that the organisers had respected the religious convictions of the women.[57]

The site of the Court House was deeply symbolic of racial politics in itself in that slaves had once been auctioned on its stairs and it was associated with the infamous Dred Scott decision of 1857. Jones's group was made up of both white and African Americans, and he was reported as saying that it was appropriate that 'Negroes whose forebears were slaves at the Courthouse should find [there] the ultimate in freedom of artistic expression.' According to his later account, the mural had to be defended against the 'local riot squad' by four hundred workers, and a local fascist group's attempt to tear down both posters and mural was beaten off by the art class itself. In December 1934 Saint Louis's Director of Public Safety closed the class on the grounds that it was 'a center for Communist activities', saying he would permit it to resume only if it dissociated itself from Jones.[58]

Writing about the artist in 1935, Alexander claimed that 'Jones has come by his Communism as naturally as he has come by the normal heritage of the average worker, manual or intellectual, today – that is, through insecurity, unemployment, class justice and the terrific struggle for existence.'[59] Yet while he stated that Marxian theory 'fits my temperament and understanding better than any other philosophical approach', Jones was not an ideologue in the same way as Burck. This is not to say he was not a capable public speaker and lecturer, but rather that his priorities differed. Jones did not have a career as a cartoonist, and in order to end his financial dependence on Elizabeth Green, he needed to make a living through selling pictures and prints. When he visited New York in February–March 1935 to arrange a solo exhibition, he was clear that he did not want to show at the John Reed Club, and initially hoped that either the Downtown or Rehn Gallery would take him on. He seems to have ended up at Herman Baron's ACA Gallery (which had close connections with the club) as a last resort, and was understandably disappointed when more than two months after the exhibition ended Baron had sold only one painting, despite very favourable reviews from prominent cultural commentators such as Lewis Mumford and Archibald MacLeish.[60]

Jones's conception of Communist art was also correspondingly different. Writing to Green from New York he observed: 'The revolutionary pictures here are full of political satire or on the other hand sickles & hammers proving to the observor there contempt for capitalism and there belief in the c.p.' (sic). By contrast, his own work was unique because the 'revolutionary element' was 'a natural objective development', 'that is not warped by bias to any party', except insofar as a

painter dealing with the 'militant struggle of the working class' must refer to 'such slogans [as] are used by the Communists.'[61] Jones's concern to make an art that organically expressed a militant working-class perspective has confused interpretation in some degree. For instance, Karal Ann Marling has described the Midwestern agricultural views that he began producing from 1934 as 'Regionalist' and emphasised his professed enthusiasm for the beauties of Missouri. However, there was more to being a Regionalist than simply a specialisation in Midwestern subject matter. As Alexander well understood there was also a conservative populist ideology, and this Jones emphatically did not share.[62] Moreover, there are significant differences between the iconography of Jones's work and that of the Regionalists. Indeed Alexander described him precisely in 1935 as an anti-Regionalist, for when Jones painted a landscape it was 'straighforward, honest observation', unlike the 'slick waxen lies of a Grant Wood'. His panel *The New Deal* 'strikingly dramatized the meaning of the NRA for workers', and thus contrasted with the 'St Vitus-like chaos which pervades the form and content of Benton's murals'.

22 (*left*) Joe Jones, *Wheat*, 1934, oil on canvas, whereabouts unknown, from *Magazine of Art*, January 1935, New York Public Library.

21 (*facing page*) Joe Jones, *We Demand*, 1934, oil on canvas, 4 × 3 ft, Courtesy The Butler Institute of American Art, Youngstown, Ohio.

Roustabouts (see fig. 23) was a 'skilfully conceived portrayal of Negro exploitation', which contrasted with Benton's 'patronizing attitude towards the Negro, whom he views as a picturesque "native" '.[63]

How valid was Alexander's interpretation? Jones certainly did produce directly propagandistic pictures such as *We Demand* (fig. 21), which represents a line of marching protesters led by a burly worker holding in his outsized fist a placard referring to the Communist-initiated Workers' Unemployment Insurance Bill of 1934 (HR 7598).[64] However, other pictures mentioned by Alexander are more subtle. For instance *Wheat* (fig. 22), the landscape Jones exhibited at the Whitney Museum's Second Biennial of Contemporary American Painting in 1934–5, depicts a tractor drawing a harvester through a vast expanse of field. Not only does this suggest a kind of modern mechanised agriculture which never intrudes into Wood's Iowa or Curry's Kansas imagery, but one need only recall the extraordinary description of tractor power in chapter five of Steinbeck's *Grapes of Wrath* (1939) or the dramatic footage of Pare Lorentz's 1936 film *The Plow That Broke the Plains* to realize how redolent such an image could be of

a whole process of technological change and social dislocation. (It could also, of course, symbolise the promise of collectivised agriculture, as in photographs of Soviet mechanised harvesters in the *Daily Worker*.[65]) That such pictures were intended to instruct, as well as to please, was quite clear to Archibald MacLeish at the time. The high horizon line and dramatic atmosphere reinforce the idea that this scene is not simply a rural idyll but is pregnant with a different order of things. In that sense, we might compare it with Lozowick's brooding industrial architecture and city views.

Roustabouts (fig. 23), as Alexander observed, 'has a fine mural quality' in its simplified forms, and the canvas now in the Worcester Art Museum is the preliminary study for a mural-size oil which was also shown in the 1935 ACA exhibition.[66] At a primary level, the painting represents African American workers unloading a barge on the Saint Louis waterfront, but beyond this it schematically suggests a whole order of racial and class relationships through the contrast between the white supervisor, who stands with hands in pockets, looking on, and the black workers. While the supervisor's broad face is in light, all of the latter either have their backs to

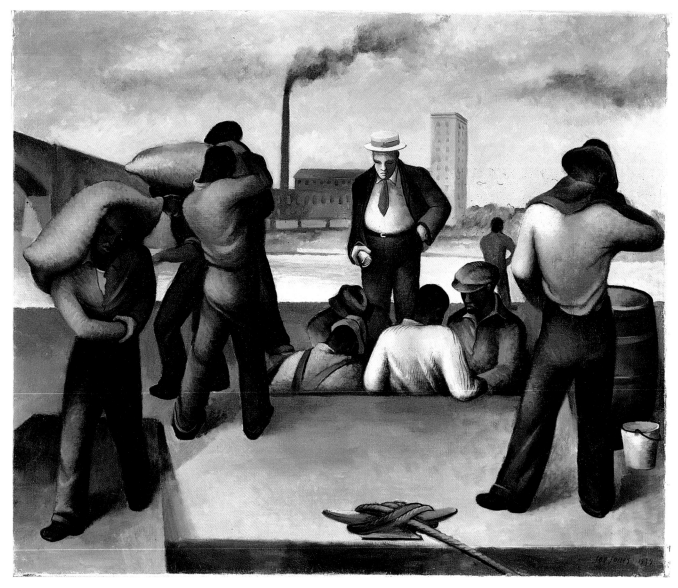

23 Joe Jones, *Roustabouts*, 1934, oil on canvas, 25 × 29⁷/₈ in., Worcester Art Museum, Worcester, Massachusetts, Gift of Aldus Higgins.

the viewer or have shadowed or averted faces, suggesting a kind of sullen resistance. Predominantly greyish tones reinforce the oppressive atmosphere. Although Jones damned Rivera as a 'bourgeois reactionary' and criticised his Detroit murals,[67] he may yet have learnt something from the simplified forms of Rivera's figure types and his shallow spatial constructions. At any rate, Jones's simple imagery of oppositions and his direct technique were understood to be the language of proletarian art, while Benton's writhing forms suggested a superficial energy but offered no insight into underlying social relations. The latter were also in some sense

undignified, suggesting the compositional artifice of the painter rather than simple realities of fact. I am extrapolating a little from Alexander's text but, I think, not inappropriately. Finally, considering how self-conscious Jones was about his identity as a Missourian, we might see *Roustabouts* as a kind of riposte to the caricatural representation of an African American in an earlier Saint Louis waterfront scene, namely George Caleb Bingham's *The Jolly Flatboatmen in Port* (Saint Louis Art Museum) of 1857.

In August 1935 Jones painted a series of mural panels at the radical Commonwealth College at Mena,

Arkansas, which was warmly praised by the Communist leader 'Mother' Ella Reeve Bloor.[68] Not many artists could manage his combination of political activism and artistic energy, or his apparently successful integration of form and political concern. Indeed, the problem of revolutionary art seemed far from resolved at the beginning of the Popular Front. In a special 'Art Issue' of *New Masses* in October 1935, one Thomas S. Willison asserted that no 'satisfactory' or 'classic' representation of even such well-tried themes as 'the demonstration, the picket-line and the unemployed' or 'personifications of the ruling class' had yet been achieved. Willison explained the situation partly as an effect of the preoccupation of modern painting with formal problems. Not that modernist achievements should be ignored. Rather, 'the tradition of conscious formal freedom established by the art of the last thirty years' needed to be translated into a new plane and context that would transform the idea of 'artistic independence' through a sense of responsibility to a new audience. A 'snapshot' approach was not adequate to comprehend contemporary social realities, which entailed more than the perception of single events. Instead the artist must develop 'formal devices' 'capable of widening and deepening the scope of the meanings in a representation.' To date, the revolutionary cartoon and mural had been far more successful in this regard than the easel picture: 'in their most realistic aspect they are much less realistic than the corresponding easel-pictures and often recall the creations of abstract art; but they are, in consequence, far more compact or extensive, pointed or thorough, in their realism.'[69] It will be evident that Willison means 'naturalistic' in the second use of the term 'realistic' in this passage, and that its sense hinges on the realist/naturalist distinction, a distinction crucial in current Marxist aesthetics, which received its most sophisticated formulation from Lukács.

This discussion will, I hope, have given some indication as to why Willison favoured the mural as a revolutionary art form. It may seem strange that he should have linked what has often been regarded as the acme of high art with the political cartoon but both, after all, are didactic media which usually rely on simple symbolic juxtapositions. The world of Burck's cartoons is not so different from that of his mural designs. By contrast, historically speaking, easel painting was essentially a private and individualistic art. However, the reasons for Willison's specific reservations about the leftist easel painting of the early 1930s should become clearer in the next chapter.

Art Front

Given the collective mobilisation of artists in the 1930s, and their sense of themselves as a distinct interest group pitted against critics, dealers and museums, it is not surprising that the more politically conscious should have wanted their own publication. The growth of the Artists' Union of New York (which will be described in Chapter Four) provided the institutional base that made such a publication financially feasible. Its title, *Art Front*, would have signified its political complexion for those who had heard of the Soviet LEF group, although the immediate inspiration may have been the Chicago John Reed Club's militant magazine *Left Front* (1933–4). The proletarian artist did appear in *Art Front*'s pages, but it was fellow-travellers who dominated. And their emphasis was less on immediate utility than on pictorial aesthetics. Rather than considering art as a form of propaganda, they argued for its cognitive value in broader and more diffuse terms. At the centre of their opposition to the narrowly instrumentalist model of proletarian art was the conviction that certain types of modernist form were inherently progressive, or even revolutionary.

Art Front ran somewhat irregularly from November 1934 to December 1937. Printed on poor paper and selling for a nickel, it looked like a union newspaper, and the large size of the first volume (11 × 16 inches) made it suitable for holding up at demonstrations. *Art Front* was conceived as a revamped version of *Art Forum*, a small publication put out by Herman Baron, who is listed as managing editor in the first issue and remained a member of the editorial board until January 1936. During the same period Stuart Davis served as editor-in-chief, while others who played a continuing and active role included Hugo Gellert, Jacob Kainen, Ethel Olenikov, Harold Rosenberg, Joseph Solman, Max Spivak and Charles Humboldt (Clarence Weinstock).[70] (Although four women were listed in the initial editorial group, Olenikov was the only one to play a long-term role.) After an editorial crisis at the beginning of 1936, Joseph Solman was elected as managing editor and held that post until January 1937 when he was succeeded by Humboldt. In his pioneering study of the magazine, Gerald Monroe argued that the crisis of early 1936 was primarily to do with differences between the modernists and Social Realists on the board. However, the minutes of a board meeting of 22 January suggest that the issue was more one of intractable personality conflicts and recriminations over maladministration.[71] In this section I deal with the magazine until Humboldt's takeover,

24 Stuart Davis, *Salt Shaker*, 1931, oil on canvas, 49⁷/₈ × 32 in., Museum of Modern Art, New York, Gift of Edith Gregor Halpert. Exhibited at the Whitney Museum's *Abstract Painting in America* exhibition, 1935. © Estate of Stuart davis/Licensed by VAGA, New York, N.Y.

both because I do not want to overstep the temporal framework of Part I too much and because there were marked changes in the magazine in 1937. But before I consider the critical discourse of *Art Front*, a little must be said on its editors-in-chief.

Born in 1892, Stuart Davis was older and more cosmopolitan than many of the artists of the John Reed Club and the Artists' Union. He was already a socialist in the pre-war days, and had contributed to *The Masses*, *The Liberator* and *New Masses*. His work as a painter bespoke a complex engagement with the Modern Movement (fig. 24), and he was widely regarded as one of the most gifted and individual modernist painters working in the United States. As such, Davis was the logical

choice to write the catalogue introduction for the Whitney Museum's *Abstract Painting in America* exhibition of February–March 1935. Davis was not only a sophisticated painter but was also acute and theoretically reflexive – as his numerous published statements and more than 10,000 pages of unpublished notes and journals testify.[72] Additionally he was a conversationalist of great wit, a convivial personality who could carry his liquor and a man whose wide circle of friends ranged from Holger Cahill to Arshile Gorky and John Graham. These qualities, together with his political convictions, help to explain his success as an activist in the 1930s. Although commentators on Davis have argued that he was not a 'doctrinaire' Marxist, in my view this is incorrect. In the 1930s Davis was precisely that. But he was an independent Marxist thinker, albeit one working largely within the framework of Third International Marxism except when it came to art. Given these limits, Davis was probably more widely and deeply read in Marxism than most of his artist contemporaries in the US. The claim that Davis's theory owed something to Deweyan Pragmatism – with which I agree – does not mean that he did not enunciate Marxian positions in an essentially dogmatic rhetoric. Given the difficulty of his position as both activist and modernist, perhaps he had to adopt such a style. In October 1935 he noted that 'Marxism or historical materialism . . . is the only scientific social viewpoint', and he did not abandon this position until the end of the decade.[73]

Monroe sees Solman's editorship as bringing with it a new latitude in editorial policy, consistent with the Popular Front. While there may be some truth in this, he assumes too sharp a distinction between modernists and Social Realists, and *Art Front* had given plenty of space to modernist viewpoints under Davis's editorship, as one might expect. Although never a member of the John Reed Club, Joseph Solman came from a background comparable to that of many of its members. Born in Vitebsk in 1909, the son of a tailor, he emigrated to the United States in 1912 and grew up in Jamaica, Long Island. In the late 1920s he studied at the Academy and Art Students League, and he has described the opening of the Museum of Modern Art in 1929 as his Armory Show – that is, it made of him a convert to modernism. When he exhibited a Daumieresque painting *Bootblack* at the John Reed Club's *Social Viewpoint in Art* exhibition in 1933, it was, he has said, simply because he was flattered to be asked rather than from any strong political commitment. However, Solman also contributed to a benefit show for *New Masses* in December 1933 and he has remained a contributor to left-wing causes through-

out his career. His work of the mid-1930s brings together an interest in the New York urban scene (which had precedents in the work of artists he admired as a student such as George Luks and Jerome Myers) with a sophisticated modernist sense of pictorial design partly derived from a study of German Expressionism (fig. 25). Appropriately, in 1933 he had a joint exhibition with Alice Neel, and in 1935 his studio was the setting for the founding of The Ten group. Solman was thus, like Davis, a modernist artist who did not believe that sympathy with Communist politics need qualify a commitment to modernism, but rather regarded the two as in some respects kindred.[74]

Art Front reflected the diversity of viewpoint among left-wing artists in a way *New Masses* never really did. This was doubtless in part because it was an artist-run magazine, but also because the Artists' Union was a non-sectarian body. Even so, the political orientation of *Art*

Front was never in doubt. As I shall show, in the mid-1930s it treated the federal art projects as symptomatic of what it took as the reactionary character of the New Deal, and in May 1936 it published an article calling for a unified Farmer-Labor Party, entirely in line with the current CP position.[75] However, it also offered a space within which a whole group of the most talented artist writers and critics on the left came together to set out their differences. Davis's editorial correspondence makes it clear that he specifically sought the controversial and the topical, and Solman continued this policy. And contributors were not confined to union members.

In some important respects, the criticism of *Art Front* and *New Masses* overlapped. The magazine printed a lengthy denunciation of Rivera, which described him as 'a willing prostitute who makes his work pay', while Stephen Alexander's criticisms of Regionalism were matched by a wonderfully splenetic riposte by Davis to

25 Joseph Solman, *Union Square*, 1936, oil on canvas, 26 × 36 in., collection of Mr and Mrs Max Margulis, courtesy of Mercury Gallery, Boston, Mass.

Time's lengthy article on Regionalism and regional art of December 1934. But unlike *New Masses*, *Art Front* did give Benton and Curry space to respond to criticism. The next issue published a letter by the latter responding to Davis's scathing description of his work, and also carried Benton's answers to a ten-point questionnaire the editors had sent him. Alongside this it printed a sustained critique of Benton's claims to offer a true picture of American society by Burck, who, like Alexander, accused him of painting an essentially 'tabloid art'.[76] My main concern here, however, is not with the continuities between *New Masses* and *Art Front* but with how they were different, and the key distinction to be made is that *Art Front* permitted far more open exchanges around the value of modern painting, and specifically around Surrealism and those tendencies labelled 'abstraction'. This makes it a far more accurate register of the divisions within the artistic left.

Surrealism certainly met the criterion of topicality, and it had been controversial since Miró's *Dog Barking at the Moon* entered the Gallatin Collection in 1929.[77] The first collective exhibition of Surrealist painting in the United States, *Newer Super Realism*, had been shown at the Wadsworth Atheneum in December 1931, and exhibited in New York in a much revised form at the Julien Levy Gallery the following January. Levy showed a sequence of individual Surrealists over 1932–6, and in the last of these years came the Museum of Modern Art's huge exhibition of *Fantastic Art, Dada, Surrealism*. Dalí visited the United States several times in the 1930s, and in 1934 his *Enigmatic Elements in a Landscape* received an honourable mention at the Carnegie International, a competition in which the first prize went to Peter Blume's *South of Scranton* (Metropolitan Museum of Art, New York), a work many mistook for Surrealist.[78] It was this event, together with the evident influence of Surrealism among American painters such as Blume, that occasioned Alexander's indictment of Surrealism in *New Masses* in December of that year. Alexander explained Surrealism as a reaction of modernist artists against 'the obvious sterility of abstract painting, which denied validity to the "subject."' While acknowledging the differences among the Surrealist artists, Alexander found Dalí's 'exquisitely-painted phantasmagoria' the epitome of the movement. By taking 'dreams and hallucinations of the insane as his idea of "reality"', Dalí was simply evading the terrible realities of the class struggle, and his paintings were 'significant only as a pathologic symptom of a decaying society.'[79]

Art Front permitted different judgements on Surrealism to appear, and although the overwhelming weight of them was equally negative, they were more complex and had greater analytical depth. In the second issue, Davis's friend the modernist painter John Graham claimed that Surrealism as 'abstract art' (an important qualification) was 'truly revolutionary' because 'it teaches the unconscious mind – by means of transposition – revolutionary methods, thus providing the conscious mind itself with material necessary for arriving at revolutionary conclusions.' However, in line with his own practice, Graham excluded '[b]ookkeeping and story-telling methods' from having this value.[80] In the same issue, Davis reviewed an exhibition of Dalí's work at the Levy Gallery. Although Monroe characterises Davis's review as favourable, this is to miss its negative moment. For while Davis concedes Dalí a 'native skill in the reproduction of common optical effects unique among artists of his day' and praises the psychological insight of his work, he also stressed that it is 'in no sense revolutionary' being entirely dependent on the conventions of the past. The form of his art is entirely familiar:

> We contemplate a desert of the familiar bric-à-brac of human hopes and realities and through them a man wanders with a dust cloth and a moth spray. In these scenes a man looks only backward and the sun is setting. Artists who intend to continue will have to change trains.[81]

But even this conceded too much to Dalí for many Communists, and the next issue contained a more sustained and scholarly appraisal of Dada and Surrealism by Jerome Klein, who wrote for the *New York Post* and had taught art history in the Fine Arts faculty at Columbia University until he was fired for his political views.[82] While Klein acknowledged Dada as an 'anti-bourgeois movement within the orbit of bourgeois ideology', it was truly political only in Germany. With regard to Surrealism, he carefully distinguished between Breton's ostensibly revolutionary stance and his inability to adapt 'the Surrealist process' to any concrete revolutionary objective. Breton offered only 'a pseudo-dialectical resolution of the contradictions between inner and outer reality,' while the Surrealists' emphasis on 'subjective technique' could not solve problems that were 'ultimately social'. In actuality, 'far from playing a critical, destructive role', in their 'flight from external reality', the movement had only created a 'new set of illusions', which functioned as 'so many tid-bits for a jaded idle upper class.'[83]

Was there anything in the devices developed by the Surrealist painters that the revolutionary could utilise? Critics were forced to address this question both by the

26 Louis Guglielmi, *Portrait and Background* (*Phoenix*), 1935, oil on canvas, 30 × 25 in., Sheldon Memorial Art Gallery, University of Nebraska-Lincoln, NAA-Nelle Cochrane Woods Memorial.

work of artists retrospectively labelled Social Surrealists who exhibited with the John Reed Club, and by the claims of the Post-Surrealists of California. The most negative judgement came from Margaret Duroc, who criticised Social Surrealist works by Walter Quirt and O. Louis Guglielmi at a John Reed Club show of December 1935 from the standpoint of revolutionary proletarianism, declaring that 'Surrealism is a false medium for the revolutionary artist. It uses an occult language which needlessly separates the artist from his audience. And the sexual interpretation of the disorders of the present system is certainly to be rejected.' Yet as Guglielmi's *Portrait and Background* (fig. 26) illustrated, the Social Surrealists largely eschewed the sexual symbolism of Surrealism (which is not, of course, to say that elements in the painting cannot be read in such terms, only that such symbolism is not overt).[84] Rather they took over the principle of montage, thereby allowing paintings to

make a kind of formulation through improbable or impossible juxtapositions that single moment naturalistic imagery could not. This was precisely what the Post-Surrealist Grace Clements claimed in an article on the new movement of March: 'By the use of provocative forms objects of simple or ordinary character, when inter-related or juxtaposed, may create an entirely new and significant meaning.' For Clements, Surrealism and Cubism, together with 'Cézanne's classicism', offered the basis of a new form that corresponded to the expressive requirements of revolutionary art. Such an ambitious and heterogeneous synthesis was certainly beyond the artists concerned, and when Solman reviewed an exhibition of the group's works at the Brooklyn Museum that summer he found them primarily reminiscent of Surrealism and only Clements's contributions showed an attempt to give precise pictorial definition to social critique.[85]

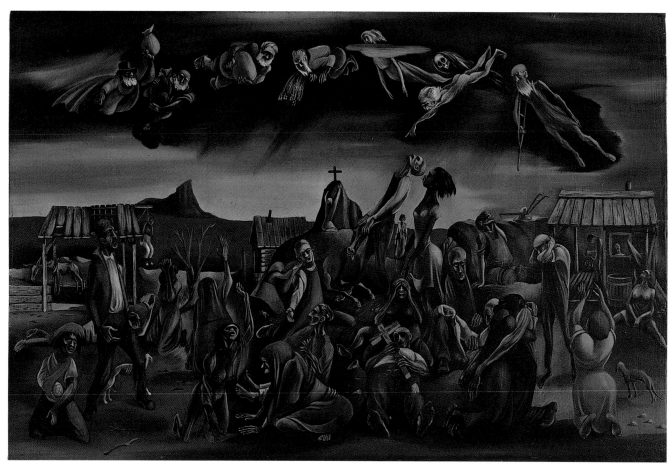

27 Walter Quirt, *Give Us This Day Our Daily Bread, or, Terrorization of Poor Through Religion*, oil on masonite, 12¹/₂ × 18³/₄ in., Wadsworth Athenaeum Museum of Art, Hartford, Connecticut, Gift of Mr and Mrs Leopold Godowsky (1957.203).

Guglielmi was a marginal figure in the Communist cultural movement in 1935, but Walter Quirt (1902–68) was certainly not. Born at Iron River in Michigan, he studied and then worked as an instructor at the Layton School of Art in Milwaukee from 1924 to 1928. When he came to New York in 1929, it was already with 'a keen knowledge and interest in the American labor movement', and he quickly became a leading activist in the John Reed Club. In the early 1930s he contributed drawings and cartoons to *New Masses*, and by 1931 was staff artist to the Trade Union Educational League's paper, *Labor Unity*. From 1930, cartoons and illustrations by Quirt began to appear frequently in the *Daily Worker*, and between August 1933 and January 1934 he produced an innovative adventure strip called 'Jim Martin'. At the least, Quirt's status as a 'noted proletarian artist' demanded that his adoption of Surrealist devices be taken seriously.[86] Assessing his solo exhibition at the Julien Levy Gallery in 1936, Humboldt began by

observing that easel painting offered the artist fewer communicative opportunities than murals or graphics, but given that its audience was 'more limited and "experienced"', he must 'exert his imagination in a way calculated to satisfy them.' The revolutionary artist was 'a merciless marauder', who would take anything from current science that was useful to him. Humboldt claimed that the 'devastated landscape' of paintings such as *Give Us This Day Our Daily Bread* (fig. 27), a satire on the delusions of religion, was derived from the symbol of the 'Waste Land which has touched all of modern poetry'. But while the modern bourgeois poet could not identify his enemies, Quirt knew and illustrated his. This radically distinguished his work from that of the Surrealists, to whom, in actuality, he owed little.[87]

If Quirt epitomised the left's attempts to assimilate Surrealism, Davis exemplified its problematic relationship with Cubist modernism. Indeed, his work seems the

polar opposite of that of artists such as Burck and Jones – a modernist easel painting grounded in Synthetic Cubism, which for all its references to the American scene smacked of the modern 'French' tradition so many critics, of different political persuasions, were now claiming was exhausted. Davis's main protagonist was Humboldt, and since he will play a substantive role in my narrative I must introduce him properly. Humboldt (1910–64) was born Clarence Weinstock, the son of conservative middle-class parents, and spent his childhood in Washington Heights in upper Manhattan. At fifteen he ran away from home, and over the next decade travelled widely in the United States and Europe. In her obituary notice of Humboldt, his close friend Annette Rubinstein says that in the 1920s he went to Paris to study painting, but while there decided his main interest was in art criticism. The story of how Humboldt became involved with the Artists' Union and *Art Front* has the ring of legend, or at least of a much repeated tale. Disembarking in New York after a second trip to Europe, he immediately ran into an artists' picket line. A painter on it whom he knew called to him to join in and so began his introduction to a way of life he never thereafter abandoned as a Communist activist and writer. Whatever the sources of his commitment, Humboldt had a very wide knowledge of literature, art and philosophy, and became one of the most impressive intellectuals associated with American Communism. At the age of twenty-four he may have seemed, as Jacob Kainen later described him, 'a voluble zealot', but the acuteness of his intelligence was already evident.[88]

The occasion for the opening shot in the debate over abstraction was Davis's introduction to the Whitney's 1935 exhibition. This is a brief statement which contains only faint hints of a correlation between abstraction and radical politics. (The museum cut down the longer version Davis had submitted and gutted its more political elements.) Most significant in this regard is Davis's claim that the Armory Show had destroyed the Academy's 'strangle hold on critical art values', and established the 'right to free expression'. (This is hardly adequate as history, but the point is that this was how Davis saw it.) In its aftermath, 'a small group of abstract painters and sculptors' had acted as a leaven to further 'the revolution of aesthetic opinion' the Armory Show initiated. This revolution, encapsulated in abstract art, rested on the axiom that art is not an 'imitation' of nature, but 'an understanding and interpretation of nature in various media.' Paraphrasing Cézanne, Davis defined pictures as 'expressions which are parallel to nature', adding, for good measure, 'and parallel lines

never meet.' For this reason, painters needed to study first and foremost the 'material reality' of their medium as a 'two-dimensional plane surface', and they should do so in a spirit 'wholeheartedly scientific'. The key question to ask of a picture was not one of likeness but rather: ' "Does this painting which is a defined two-dimensional surface convey to me a direct emotional or ideological stimulus?" '[89] In an effective critique of this position published in April's *Art Front*, Humboldt argued that Davis's definition of painting as a 'two-dimensional medium' was too narrowly material and therefore reductive. Moreover, if the systems of art and nature were strictly parallel and non-convergent, how could there be any analogy between them? The key issue that Davis had skimmed over was that of meaning, 'the element in terms of which nature and art are united'. Although he did not use the term, Humboldt criticised abstract art as a semiotic system. Davis and other abstractionists, he said, relied on the 'naive hope' that the spectator would make 'the same interpretation of . . . colour forms that the artist did.' Yet in reality: '*No meaning is the equivalent of any meaning*.' Such an arbitrary sign system might work in a more stable society, but in one as riven as the contemporary capitalist world it could only function effectively for a small group of rich patrons.[90]

Davis's reply, in the following issue, suggests that he was flustered, and it lacks the coherence of most of his published statements. He conceded that there might be limitations to his 'Introduction', but ascribed these to the brevity the Whitney had forced on him. His use of the term 'parallel with nature' might be incorrect in relation to 'philosophical usage', but he did not mean to imply by it 'that because painting was a quality distinct from its sources, it had no connection with them', and appealed to the quality of his own works to justify his position. Seeking to give more political resonance to his claims, he now described academic values as 'bourgeois academic traditions', and asserted that in 'the materialism of abstract art in general, is implicit a negation of many ideals dear to the bourgeois heart.' Artists were forced to work with the materials of bourgeois culture to produce a revolutionary art, and abstract artists had made key 'technical contributions'. Quoting from an unpublished portion of his 'Introduction', he claimed:

> If the historical process is forcing the artist to relinquish his individualistic isolation and come into the area of life problems, it may be the abstract artist who is best equipped to give vital artistic expression to such problems – because he has already learned to

abandon the ivory tower in his objective approach to his materials.[91]

It is important to be clear here that Humboldt was not an enemy of modernist painting. Rather, he too hoped that a new and superior modern art would emerge through the identification of artists with the revolutionary struggle. This is evident from his exchange over Léger with the modernist painter Balcomb Greene of the following year.[92] According to Greene, the revolutionary process must embrace all aspects of life, including the artistic; any other conception of it deformed the wholeness of the human personality, which revolution was supposed to realise. Concomitant with the rationalisation of all social functions, the truly revolutionary artist was a specialist, whose work inevitably 'must often fall beyond the comprehension of most people', who had to be educated to understand it. Léger, himself a true 'man of the people', exemplified this new artist type. The idea that 'all creative activity must be specific agitation' was a sign of an immaturity in revolutionary theory. Humboldt, too, addressed the 'humanity' of modernist painting, but found it more symptomatic of the limitations of bourgeois society, and the psychological and ideological formations these generated. He affirmed the achievements of Léger's art: 'No one can rise above it without studying him and his contemporaries.' But at the same time he emphasised the alienation and self-absorption of the modern artist, living in a world dominated by the commodity form. This alienation led to a literature and art that were the product of closed intellectual circles, preoccupied by 'mysteries and festishes', exemplified in the work of Joyce and Picasso. In Léger's paintings, the effect of the supremacy of exchange value over use value was reflected in the form: 'The individuality of objects known and understood, the enormous variety of meanings in nature and society, are reduced to one structural conception arrived at by an aesthetic approach to the materials of science.' Because of this domination of the commodity form, his works only promised a freedom that had not yet been achieved. An art of freedom could only arise 'when the subject matter is itself free, that is, when objects need no longer be seen in relationships that in turn enslave the artist and us.'[93] This position is almost identical with that which Meyer Schapiro enunciated at the American Artists' Congress in the following month.

In conclusion, it seems appropriate to note the diversity and complexity of the critical positions adopted by artists and critics in and around the Communist movement at this time. Political commitment might give rather simple imperatives to artists, but these imperatives were mediated both through complex social networks and through a deeply divided artistic field that was already saturated with contending ideologies around issues such as Americanism, realism and modernism. While accepting Communist politics in some broad sense, artists fashioned their different aesthetics to accommodate them. Even in the Third Period, the CPUSA had no single coherent aesthetic to give.

3 Revolutionary Art on Display:
The John Reed Clubs and the Whitney Museum

As I said in the introduction, my aim is to treat the art associated with the Communist movement as a social practice. From this perspective it is essential to take into account the different contexts of its display. That is, we need to consider both how exhibitions organised by Communist artists differed from those in museums and commercial galleries, and how these spaces affected the relationships set up between works by artists associated with the Communist movement and those by artists who were not. The various display situations partly made the aesthetic experience what it was, and were regarded as crucial by artists and critics at the time. In the first section I look at the evidence as to how art-works functioned in the context of the John Reed Club exhibitions, and in the second at how works by the same artists functioned outside that context – specifically in the exhibitions of the Whitney Museum of American Art.

John Reed Club Art Exhibitions

In the club's early years the display strategies of the JRC artists were distinctive and set them apart markedly from their 'bourgeois' contemporaries. The first of their exhibitions was held not in a gallery but at the United Workers' Co-operative Apartments on Bronx Park East in December 1929. Participating artists included Burck, Ellis, Gellert, Gropper, Eitaro Ishigaki, Gan Kolski, Lozowick, Matulka, Morris Pass, Refregier, Louis Ribak, Esther Shemitz, Otto Soglow, Art Young and others unspecified. With the exception of Ishigaki and Shemitz, all these artists would have been known to readers of *New Masses*. In January 1930 a second travelling show of forty-two drawings, paintings and lithographs started its tour at the Borough Park Workers' Club on 43rd Street in Brooklyn, and was subsequently shown at four other clubs in Brownsville, Williamsburg, the Bronx and downtown Manhattan. The artists responded to workers' questions at symposia accompanying each of the exhibits. Something of the same orientation is suggested by reports of a collaborative exhibition with Proletpen, the Party's Yiddish cultural group, that took place at the Proletpen headquarters on 106 East 14th Street in April 1931. Comprising 'nearly 100 paintings, drawings and cartoons' by around thirty artists, this was attended by some 2,000 workers, and 'special evenings of lectures, discussions, recitations and poetry readings' were held in conjunction with it. More than 500 workers' schoolchildren from Brooklyn and the Bronx were brought in on special days to see the show. However, increasingly displays of the artists' works were confined to the John Reed Club rooms and to art galleries.[1]

TWENTY JOHN REED CLUB ARTISTS ON PROLETARIAN AND REVOLUTIONARY THEMES (1932)

Exhibitions of members' work had been shown at the club since the summer of 1930, and a gallery was established there by early 1932. But there are no significant records of these occasions, and here I confine myself to the sequence of group shows from 1932 through 1935 for which catalogues have survived.[2] The first of these, *Twenty John Reed Club Artists on Proletarian and Revolutionary Themes*, was not shown at the club but at the ACA Gallery at 1269 Madison Avenue in November 1932. The ACA, which consisted of one 11 × 15 foot room, had only been open since August and was the conception of Herman and Ella Baron. For two decades it was the most important commercial venue for left-wing artists. A Lithuanian immigrant, Baron (d. 1961) was gassed while serving in the First World War and suffered continuously from poor health. After the war he studied at New York University, where he met the Communist writer and critic Harry Potamkin, who later introduced him to the John Reed Club. When he contributed to the little magazine *S.4.N.* in 1922 (along

28 Hugo Gellert, 'Secret of Primary Accumulation', from *Karl Marx' Capital in Lithographs*, 1933, lithograph, Tamiment Institute Library, New York University.

with e. e. cummings and Kenneth Burke) he was described as a 'New York accountant', but he later ran a monthly trade paper that helped support the ACA Gallery in its early years. His wife, Ella Block, assisted him with the gallery until his death, and maintained it on her own for a while afterwards.[3] Several of those I have spoken to who knew Baron have emphasised the importance of the gallery as a social centre where the coffee pot was always ready.[4]

Twenty John Reed Club Artists on Proletarian and Revolutionary Themes comprised thirty-six paintings, drawings and lithographs by twenty-one (not twenty) artists – Albert Abramowitz, Bard, Mark Baum, Joseph Biel, Burck, Dehn, Gellert, Gropper, William Hernandez, Ishigaki, Limbach, Lozowick, Moses Oley, Quirt, Refregier, Philip Reisman, Ribak, William Siegel, Soglow, Raphael Soyer and Max Spivak.[5] Only a few of the exhibits can be identified, but a substantial proportion seem to have been drawings and prints, and many of the exhibitors were cartoonists and illustrators for the Communist press. This again suggests how impor-

tant directly political work was for Communist artists at this time. Refregier, who made easel paintings and murals as well as illustrating Party pamphlets, recalled that: 'Doing cartoons was not a separate activity from our painting or from our lives'.[6]

Four of the exhibits which can be identified, at least in type, were illustrations from Hugo Gellert's *Karl Marx' Capital in Lithographs* (fig. 28) – the precise pages are not specified. Gellert (1892–1985), who was born in Budapest, emigrated with his family to the United States in 1907. He studied at the National Academy of Design, and thereafter worked in a lithography workshop producing film and theatre posters. Lithographic crayon remained the key medium of his art. Radicalised by the First World War (in which he lost a cousin and a brother), he became an open Communist and stayed one for the rest of his life. In notes for a talk from 1945 or 1946 he wrote: 'Being a Communist and being an artist are the two cheeks of the same face and, as for me, I fail to see how I could be either one without also being the other.'[7] Gellert's work for *The Masses* and for commercial publications such as *The Dial* and *Pearson's Magazine* in the early 1920s was in a flattened decorative style, which was modernist in derivation, as were his early designs for *New Masses*. He frequently contributed lithographic portraits in which a few broad crayon strokes define the basic features, leaving the head disembodied in the midst of a plane of white. There are occasional intimations of Cubism in the reductiveness and angularity of the drawing, but this is a Cubism filtered through Art Deco. Indeed, Gellert's murals such as '*Us Fellas Gotta Stick Together*' – *Al Capone* (shown at the Museum of Modern Art's 1932 mural exhibition) and his 1928 fresco for the Proletcos Cafeteria in Union Square[8] convert the class struggle into superficial decorative motifs. (It was entirely fitting that four years later he should also paint murals for the Center Theatre at Rockefeller Center.)

Karl Marx' Capital in Lithographs is a set of sixty lithographs, published in a limited edition portfolio in 1933 and as a book in 1934. In the book version excerpts from *Capital* face each illustration, particularly relevant sentences being italicised. The 'transformation of arable land into sheep-walks' is represented through an image of two sheep; the effects of agricultural enclosures and poor relief through a begging woman with a baby; 'the historical process whereby the produced is divorced from the means of production' by a gigantic Henry Ford embracing factory buildings towering over a worker in overalls, and so on. Capitalists are bloated money bags, labour power is clenched fists, the fertility

of the earth is a pregnant woman. The sequence is overwhelmingly banal, and Gellert's only sign for the potential power of the working class is a distended and grotesque male musculature. With their small square heads and enormous fists, his workers look like stormtroopers in overalls. It is interesting that the only public intervention Earl Browder made in *New Masses* in connection with the visual arts was to defend Gellert's *Capital in Lithographs* against criticisms that it was made up of 'lifeless symbols', and depended on a conception of illustration 'too rigid and conventionalized' to be adequate to Marx's text. Significantly, Browder's intervention was firmly rebuffed on the grounds that the General Secretary did not have competence as an art critic.[9]

Another stalwart of the *New Masses* group who showed four works, almost certainly all drawings, was Gropper. Although he painted two murals for the Schenley Corporation in 1934, and one for the Hotel Taft in New York the following year, Gropper's full ambitions as a painter did not become evident until after 1935, and during the Third Period he appeared primarily as one of the premier Communist cartoonists. (As these commissions show, the revolutionary artist could also move between the revolutionary movement and commercial patrons on whom he largely depended for a livelihood.[10]) *New Masses* offered Gropper a space where he could experiment with larger images and more subtle techniques than were possible or appropriate in the newspapers he worked for, and in the early years of the magazine he contributed some strikingly modernist cartoons (fig. 29). However, as in his newspaper work, these gave way to a more naturalistic idiom which in larger terms might be compared with Neue Sachlichkeit. The simple brushed ink drawing was his favoured mode for observations of tenement life and the sweatshop. Synthetic Cubism made possible the upturned perspec-

29 William Gropper, *Hedley's Little Sunshine Committee*, from *New Masses*, October 1926, Marx Memorial Library, London.

tive, the fragmentary outlines and expressive distortions of drawings such as *Sweatshop – 1932* (fig. 30), which was probably one of the four works he showed at the ACA. But the effect is less striking than the evocation of misery and the claustrophobic space of the workplace, and such works precisely exemplify that subordination of form to larger social and political concerns for which Alexander and others called.[11]

Other artists on show, such as Bard and Quirt, represented the younger generation of proletarian artists who were establishing themselves as a kind of artistic cadre. Phil Bard (1912–66) had walked into the *New Masses* office with a folio of drawings in mid-1930 and joined 'the group of revolutionary artists who believe that if art is any good at all, it should also be good for chalk-talks at workers clubs, demonstration posters and cartoons in the *Daily Worker*.' He had worked as a cartoon animator for Krazy Kat Studios, and now began contributing cartoons to the *Daily Worker*, *New Masses* and *Labor*

Unity. He also produced two illustrated pamphlets for the Young Communist League, which are simple narratives of working-class youths achieving political consciousness. The style of these is raw and crude, but it suggests a kind of communicative urgency that would have been lost in a more elaborate and finished technique. There is a similar quality to Bard's early *New Masses* cartoons such as *"So I'm Yellah, Am I?"* (fig. 31), with its angular silhouettes and arbitrary shading. His ACA exhibit, *For Refusing to Starve*, is likely to have been in the same idiom. Again, the range of this artist's activities is notable. In 1931 he designed a 13-foot monument to the first Five Year Plan for the workers holiday site at Camp Kinderland, and in 1934 executed a mural sequence covering more than 500 square feet for the *Daily Worker*'s volunteer room at the Workers Center.[12]

Overall, the titles of the exhibits suggest a militant-looking display, and this is confirmed both by Baron's

30 William Gropper, *Sweatshop – 1932*, from *New Masses*, April 1932, Tamiment Institute Library, New York University.

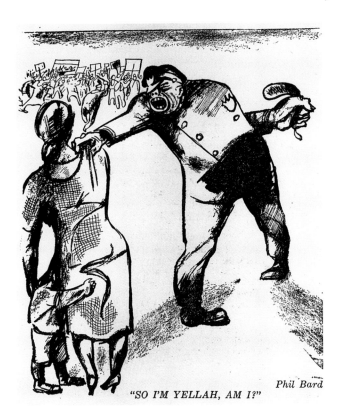

31 Phil Bard, '*So I'm Yellah, Am I?*', from *New Masses*, August 1931, Tamiment Institute Library, New York University.

32 Eitaro Ishigaki, *Unemployed*, c. 1932, $32^{11}/_{16} \times 29^{1}/_{2}$ in., whereabouts unknown.

reminiscences and by contemporary reviews. Baron himself described the works as 'crude to the point of painfulness', and recalled that visitors entering the gallery were confonted by 'a large canvas of a gory lynching scene'. However, crude is not how one would describe the prints of Gellert and Lozowick,[13] or Gropper's drawings, and it was the oils (fig. 32) that Thomas Linn, writing in the *New York Times,* found particularly 'heavy-handed', and 'less art than homily', at the same time as he acknowledged the skill in drawings and lithographs by Quirt, Soyer and Lozowick. According to Baron, the exhibition made 'a terrific impact on the gallery's neighborhood patrons' (the ACA was still uptown on swanky Madison Avenue) and he recalled that he lost customers for his picture-framing business as a result. However, he did manage to sell one of Gropper's drawings to the record producer John H. Hammond.[14]

THE SOCIAL VIEWPOINT IN ART (1933)

The second JRC exhibition took place downtown in 'a bare loft' in the club's rooms at 450 Sixth Avenue in early 1933 and was very different from the ACA show in

conception. It may well have been an attempt to 'take forward "fellow travelers"' in reponse to the policy decisions of the 1932 national convention, and the title of the show, *The Social Viewpoint in Art*, was intentionally elastic. However, the announcement of the exhibition in the *Daily Worker* suggests that it was also conceived to highlight the difference between 'the revolutionary viewpoint on the one hand, and the unclear though sympathetic social viewpoint on the other'. This is confirmed by the brief catalogue introduction, which claimed that many of the invited artists 'simply depict the scene around them', while the JRC artists were 'striving to create an art that will not only illustrate the social scene, but will express its most significant element, the revolutionary class struggle.' To make the point, the works by JRC members were distinguished by signs from those of the invited participants. At an opening attended by 500 people, Burck, Lozowick and Ralph Pearson all gave addresses on the theme of revolutionary art, so that the exhibition's pedagogic intent must have been transparent.[15]

Much larger than the ACA exhibition, this second show had 200 works in a range of different media (including sculptures) by 100 artists. Some of the main-

33 (*right*) Thomas Hart Benton, *The Engineer's Dream*, 1931, oil on panel, 29⅞ × 41¾ in., Memphis Brooks Museum of Art, Memphis, Tennessee; Eugenia Burton Whitnel Funds, 75.1. © T. H. Benton and R. P. Benton Testamentary Trust/Licensed by VAGA, New York, N.Y.

34 (*facing page top*) Isabel Bishop, *Fourteenth Street*, 1932, oil on canvas, 14 × 26 in., private collection.

stays of the JRC were absent or barely represented: for instance, Gropper did not show, and Gellert and Burck showed only one work each. Lozowick exhibited five lithographs of Soviet Tajikistan, but these hardly looked militant. In contrast, there was a group of artists not connected with the left who had several exhibits, notably Thomas Hart Benton (4), John Steuart Curry (1), Kenneth Hayes Miller (4) and Isabel Bishop (3). In addition, George Grosz and Käthe Kollwitz were represented by 4 works each, and Orozco and Siqueiros by 4 and 1 respectively. A number of older American leftists – Maurice Becker, Boardman Robinson, Eugene Higgins and the recently deceased Glenn Coleman – were also included. It fell largely on the younger, less well-known artists of the John Reed Club to advance the new revolutionary art.[16]

I want to consider this diverse display under three heads: (1) social scene imagery by artists without any left commitments; (2) social scene imagery by politicised artists and (3) pictures that explicitly manifested a political standpoint. Among the first, the four works by Benton and the four by Miller particularly attracted the disapproval of Meyer Schapiro when he reviewed the exhibition for *New Masses*. Benton's work he described as ' "American Life" ' 'conceived as a meaningless, turbulent activity', 'arranged in banal and cynical contrasts, rendered in a pretentiously virile manner.' Miller's work was dismissed as 'fat shoppers issuing from department

stores.' Schapiro referred to Benton's Whitney Museum murals of 1932 to define the artist's social vision, but he was clearly correct that the pictures Benton showed in *The Social Viewpoint in Art* of a trainwreck, cowboys, African Americans shooting crap and cotton picking were essentially picturesque Americana (fig. 33). (Although Schapiro does not mention it, he can hardly have failed to notice that Benton's Whitney panel *Political Business and Intellectual Ballyhoo* included a caricatural Jewish type holding a copy of *New Masses*.[17]) And while Miller's pseudo-Florentine matrons out shopping could be interpreted as a satire on an overstuffed bourgeoisie, they are too classicised and Junoesque to be effective as such, and Miller's politics were actually quite conservative.[18] By contrast, his pupil Isabel Bishop did represent emphatically proletarian types, almost invariably in the shape of unemployed working men and shop girls in the region of 14th Street and Union Square. But if, as I suspect, the *Fourteenth Street* Bishop showed at the Reed Club was the picture illustrated here (fig. 34), then it is evident that it was essentially a modern genre painting of minor social intercourse. Like many of Bishop's paintings, this suggests a tenderness for ordinary folk at the same time as it turns them into picturesque matter. Whatever its value as painting, it hardly signifies a definite political stance.[19]

Under the second head, we might place the works shown by Marsh (2), Laning (1), Reisman (5) and

Sternberg (4). Like Bishop, both Marsh and Laning had studied with Miller, and his clearly articulated compositional structures and obvious references to Renaissance and Baroque art were a key influence on their work. However, both artists at times displayed a concern with political and social realities that brought them closer to the ethos of revolutionary art.

Partly because of his patronage by the Whitney Museum, Marsh (1898–1954) is well known as a painter of New York low life, and also as a gifted printmaker. He came from a well-to-do background and was Yale educated, and his work is associated with a voyeuristic vision of working-class sexuality and popular pleasures. His friend Lloyd Goodrich described his personal politics as 'somewhat left of centre', but claimed his art was 'completely apolitical'. However, this claim bears discussion. Like many of the artists we have been considering, Marsh started as a newspaper and magazine illustrator, working for the New York *Daily News*, and later for the *New Yorker*, *Esquire* and other magazines. But he had also contributed to *The Liberator* and *New Masses*, and was listed among the 'art staff' of the latter in January 1934. It is hard to see some of Marsh's early contributions to *New Masses*, such as the two drawings representing the White Terror in Roumania which appeared in the issue of November 1926, as anything but political, and he also provided social satires among which were the brilliant cartoon of bloated plutocrats in *Attaboy!* of the

35 Reginald Marsh, *Attaboy!*, from *New Masses*, April 1927, Tamiment Institute Library, New York University.

53

36 Reginald Marsh, *Tenth Avenue at 27th Street*, 1931, etching, from the portfolio '30 etchings and engravings' restruck in 1969, sheet: 13 $^1/_{16}$ × 15 $^9/_{16}$ in., plate: 7 $^3/_4$ × 10 $^7/_8$ in., Collection of Whitney Museum of American Art, original plate donated by William Benton, 69.97.8.

37 Edward Laning, *Unlawful Assembly, Union Square*, 1931, tempera on composition board, 14$^1/_8$ × 36 in., Collection of Whitney Museum of American Art, New York, Gift of Isabel Bishop, 84.59.

following April (fig. 35). However, with the exception of a single image of police clubbing demonstrators in April 1933, he did not contribute between December 1927 and February 1934. I have no explanation as to why this might be, but it was clearly not the effect of some estrangement between Marsh and the John Reed Club, since he exhibited there with Jacob Burck (a personal friend) in January 1932 and was on the faculty of the Art School in 1933–4. Marsh was certainly not as apolitical in his art as Goodrich claimed, but it is possible he was not at ease socially with the young Jewish radicals of the Club and refused to accept the sectarian polarities that made socialists and independent Marxists like Calverton 'social fascists'. (In 1932 he had taken part in an exhibition 'to further socialism through art' at the Socialist Rand School.[20])

It is unclear whether Marsh showed paintings or prints at the *Social Viewpoint in Art*, and several of his motifs were developed in both media. Whichever, *Tenth Avenue* (fig. 36) was an image of unemployed men lounging on a street corner, most of them too dejected even to eye up the office girl or prostitute crossing the street near them. *Locomotives* is likely to have been an etching or lithograph of railway workers in the Erie Yards in Jersey City.[21] Although Marsh's perspective and figure groupings are sharply defined, the idiom is essentially that of genre painting, and street corner scenes such as *Tenth Avenue* had been a common Ashcan School subject.

His friend Laning, by contrast, was one of those concerned to revive a grand style of muralism – but a grand style applied to modern American subjects. Born in Petersburg, Illinois, in 1906, Laning studied at the Chicago Art Institute, before moving to New York and becoming a student at the Art Students League where Miller taught. Laning's style at this time was characterised by tight drawing, crisply defined spatial structures and harsh, bright colours. Within patterns derived from Renaissance and Baroque painting, he fitted well-dressed crowds, beggars on 14th Street, street vendors selling hats on 34th Street and holiday makers in Central Park. At the John Reed Club, he showed a small tempera panel titled *Unlawful Assembly* (fig. 37), representing mounted police breaking up the great Communist-organised unemployment demonstration in Union Square of 6 March 1930. This is an accomplished painting, but the precisely calculated style makes it less emotionally immediate than some of the other works on show.[22]

In comparison with Marsh and Laning, Philip Reisman (1904–92) and Harry Sternberg (b. 1904) were far more the type of the proletarian artist, and for a time they shared a studio together.[23] Reisman was a prominent member of the John Reed Club and had been an occasional contributor to *New Masses* since 1928. His family had emigrated from Poland in 1908, and like many others settled in the slums of the Lower East Side. He took part-time jobs as a soda jerk and waiter to support himself while studying at the Art Students League from 1922 to 1927. Sternberg, the child of Austro-Hungarian parents, was actually born on the Lower East Side and had a similar succession of odd jobs in his student days. Although he contributed to *New Masses* as early as 1927, Sternberg was not a member of the club.[24] Like the artists of the 'Fourteenth Street School', both found their subjects partly in lower downtown New York although Sternberg roamed more widely. Reisman's early paintings and studies of the Bowery represent a social world that also drew Marsh, and a 1934 tempera panel of *Store Windows* takes the same motif as Miller's *Fourteenth Street* (also in the exhibition) but accentuates the social contrasts. However, where Reisman's work differs from that of these artists is in his preoccupation with themes from the immigrant proletarian milieu he knew so well. In this respect, he is like Gold's model proletarian artist who finds his subject in immediate experience, and, as I have shown elsewhere, there are striking parallels between some of his motifs and images in *Jews Without Money*.

The five works Reisman contributed to *The Social Viewpoint in Art* were probably all etchings – although it is impossible to be certain of this since he sometimes developed the same motif in both paintings and prints. Reisman studied etching with Harry Wickey in 1927–8, but never achieved any technical dexterity. His simple additive compositions and clumsy drawing may stand as some kind of equivalent to Gold's notion of a proletarian art unconcerned with issues of style, and simply a 'natural flower' of its environment. *Soda Fountain* (fig. 38), no. 139 in the exhibition, was a record of Reisman's own experience of underpaid tedious labour. It is arguable that such images bespeak direct experience in their gauche perspectives and seemingly random accumulations of detail and explicit refusal of the artful mannerisms of Marsh and Laning. While that is certainly how the *Daily Worker's* art critic saw them, they still hardly amount to more than artless genre imagery.[25]

The titles of Sternberg's four exhibits suggest that they too were etchings. In fact, Sternberg had also studied the medium with Wickey, although he was far more adept than Reisman and in 1933 was appointed instructor in etching, lithography and composition at the Art Students League. The works he showed were a street

38 (above) Philip Reisman, *Soda Fountain*, 1928, etching, 4 × 4 in., College Art Collections, University College London.

40 (facing page) Harry Sternberg, *Construction*, 1932, etching and aquatint, 10⅛ in. diameter, 13⅞ × 10⅞ in. plate mark, Susan Teller Gallery, New York.

39 (below) Walter Quirt, *The Future Belongs to the Workers*, 1933, oil on gesso panel, whereabouts unknown, from *Creative Art*, March 1933.

scene, *Broadway #1*; two images of locomotives and railroad workers, very close to Marsh's prints of such motifs; and a tondo composition of a riveter silhouetted against a background of towering skyscrapers titled *Construction* (fig. 40). While *Broadway #1* is broadly comparable in theme to Bishop's *Fourteenth Street* (see fig. 34), it is far more suggestive of urban anomie in its compression and bustle – appropriately, considering that it represents midtown at Broadway and 42nd Street. In his prints of labour Sternberg tends to bring his figures nearer in the foreground plane than Marsh, and this gives them an heroic aspect Marsh's lack. However, if such prints inject a conscious proletarianism into the genre of the urban picturesque they still work within the limits of its naturalistic conventions. The heavily phalli-cised hero of *Construction*, whose body seems to thrust aside the buildings of corporate New York and make them dance to his rhythms, does step outside those con-ventions and brings us closer to the idiom of the cartoon and the mural. This was also a characteristic of Stern-berg's other more directly political prints of this period.[26]

Among the paintings and sculptures that impressed reviewers as 'tirades or homilies' were contributions from Bard, Nicolai Cikovsky, Camilo Egas, Irwin D. Hoffman, Ben Kopman, Paul Meltsner, Orozco, Quirt, Refregier, Ribak, Siegel and Adolf Wolff. I have been unable to locate most of these works but some were reproduced in the art press so that we can at least form an impression of them.[27] Quirt's *The Future Belongs to the Workers* (fig. 39) was a carefully painted small panel, only 10 × 18 inches. The clearly articulated indus-trial landscape and formalised groupings are reminiscent of Quattrocento painting, but injected into this is a new

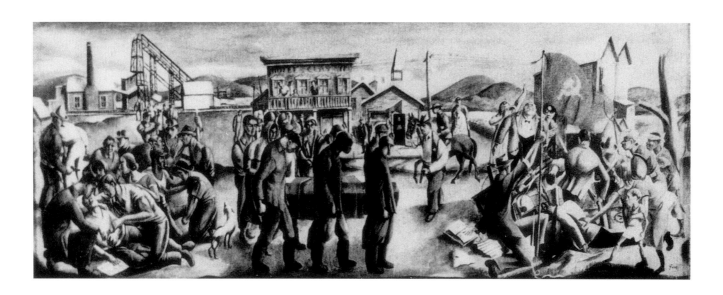

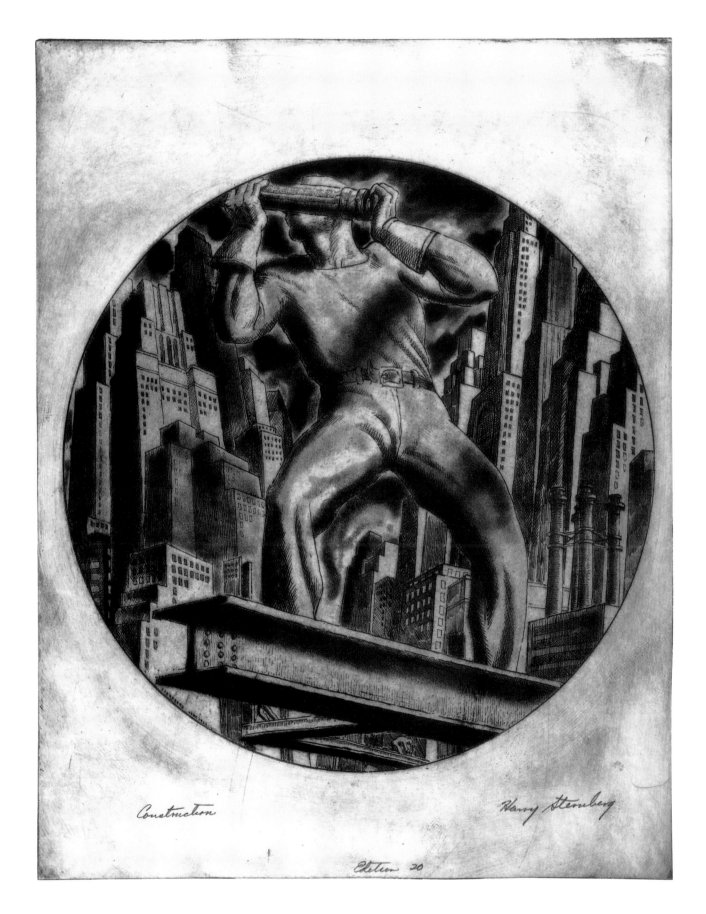

Construction Harry Sternberg

Edition 20

41 Nicolai Cikovsky, 'We Want Bread!', whereabouts unknown, from *International Literature*, January 1935, Marx Memorial Library, London.

42 Irwin D. Hoffman, *Miner's Child*, whereabouts unknown, from *Creative Art*, March 1933.

mythical narrative of rising class consciousness, from the martyrdom of the worker through to the mixed racial group rallying round the Communist banner on the right.[28] By contrast, Nicolai Cikovsky's '*We Want Bread!*' (fig. 41) appears to be in a more straight-forwardly naturalist style. Although he was a member of the John Reed Club by 1931, Cikovksy was at the start of a successful career. In 1930–31, he had two one-man shows at the Daniel Gallery, and in the second of these years his painting *Valley* won the Harris bronze medal at the Chicago Annual. '*We Want Bread!*' is really a some-what academic conception, and contrasts with the compressed space and dramatic gestures of Hoffman's *Miner's Child* (fig. 42) and *In Dixieland*, which are reminiscent of German Expressionist devices.[29]

It will be evident that there was no commonality of approach even among those who were most intent in getting over a directly political message. The catalogue claimed that 'the present period demands the creation of a new art – an art not necessarily new in form, but new in expression.' In fact, among the 200 works on show, only Stuart Davis's *French Factory* (fig. 43) seems to have been overtly modernist in technique, and it clearly looked out of place to the reviewers – 'a pale, linear, disemotionalized construction'. Indeed, Anita Brenner, writing in *The Nation*, praised the political ambition of the exhibition but accused the club's artists of not understanding that the forms of modernist paint-ing were in themselves revolutionary devices: 'they cannot adequately and movingly paint or carve their time and place in the technical and emotional terms of another age.'[30]

This, however, was not the complaint of Meyer Schapiro's review. Schapiro acknowledged that the exhibition was 'the first large important enterprise of the club in promoting an active revolutionary art', but found that 'More than half the objects shown express no revolutionary ideas; and of the rest, only a few reenact for the worker in simple plastic language the crucial situations of his class.' The problem was partly that the 'social viewpoint in art' was an empty category, that could accommodate almost anything. However, Schapiro's main objection was that the JRC artists were trying to make a united front with the wrong people, and specifically with Benton, whom he accused of the same 'vague liberalism' as his critical defender Thomas Craven. As he noted, 'the concern with American life' was 'to some degree a chauvinistic response of American critics and painters to the competition of French art' (as indeed was the technical conservatism of painters such as Marsh and Laning).[31] The exhibition

he would have liked would have been a small show comprising:

a carefully prepared series of pictures, illustrating phases of the daily struggle . . . It could have included examples of cooperative work by artists – series of prints, with a connected content for cheap circulation; cartoons for newspapers and magazines; posters; banners; signs; illustrations of slogans; historical pictures of the revolutionary tradition of America. Such pictures have a clear value in the fight for freedom.

Responding for the exhibition committee, Jacob Burck accused Schapiro of not wanting a united front at all, and therefore of taking a sectarian position. His stance was also 'Trotskyist' because he did not seem to accept painting as 'a legitimate medium for revolutionary cultural expression' – proletarian art must 'await the final victory of the working class', and in the meantime only agitational art would do. Although Schapiro was not a Trotskyist (at this point or later), Burck's accusation was otherwise close to the mark.

For Schapiro, the key issue was that social viewpoints expressed in the paintings were 'too various' to offer guidance. Reportedly, '[t]he undogmatic character of the exhibition was the despair of the more uncompromising members of the club',[32] and while Schapiro was probably not a club member, he seems to have identified with this faction. At a symposium at the exhibition on 10 February, Schapiro (speaking in the guise of his *nom de plume* John Kwait) argued that 'vital propaganda can be great art, and . . . the revolutionary artist does not only devote himself to propaganda but builds a monument and makes a record of the present struggles of the workers, and glorifies their part in building a new social order.' However, this uncompromising conception of the revolutionary artist's role was difficult to reconcile with the desire of artists to make paintings of recognisable quality in the here and now that would also be saleable. As for the dichotomy between utility and quality, Schapiro suggested it did not exist. The latter would simply come through the former. One might have expected Burck, of all people, to have agreed with him on this, but like many artists he may have made quite a firm distinction between his ephemeral cartoon work and his paintings. Perhaps, more to the point, Schapiro's criticism, in its unyielding attitude to wavering artists and intellectuals, was simply out of step with JRC national policy.[33]

Its scale and the publicity it received ensured that *The Social Viewpoint in Art* did a great deal to establish the John Reed Club as a presence in the New York art scene. It also reportedly drew so many visitors that it had to be

43 Stuart Davis, *Adit No. 2* (exhibited as *French Factory*?), 1928, oil on canvas, 28⅞ × 23¾ in., courtesy, Museum of Fine Arts, Boston, Gift of the William H. Lane Foundation, 1990.394. © Stuart Davis/Licensed by VAGA, New York, N.Y.

extended for two weeks, and was attended in droves by members of 'trade unions and workers' organizations'.[34] But as a tactic for bringing artist fellow-travellers into the movement, it does not seem to have been much of a success. Given the terms within which it was conceived this is hardly surprising, since the works of the non-members were included mainly to serve as a foil to those of the members. Benton, Bishop, Marsh, Miller and Curry never exhibited with the club again, and later exhibitions were smaller and more narrowly focussed.

HUNGER FASCISM WAR (1933–1934)

The second annual show, *Hunger Fascism War: The World Crisis Expressed in Art*, which was on display from 8 December 1933 to 7 January 1934, took its title from the codewords of the party's critique of the New Deal. It comprised 120 works by 77 artists (selected from a much larger number submitted by 140), of whom

over half were not club members according to the *Daily Worker*. However, according to Lozowick's review, despite being smaller it was 'in some respects superior' to its predecessor because the theme was 'less diffuse' and the works more consistently displayed 'a militant class consciousness'. The exhibition was opened with a lecture by Freeman on 'Art and the Revolution', and further lectures were scheduled throughout its duration.[35]

Significantly, I think, Lozowick starts his review with the contributions of George Biddle and Laning, who were already successful gallery artists and probably not club members. (Although we should note that the *Daily Worker*'s review specifically attributed to Laning a 'Marxian viewpoint'.[36]) Biddle (1885–1973) came from an *haut bourgeois* Philadelphia family, and had graduated with a law degree from Harvard before he went to Paris and began studying art. He returned to the Americas in 1926, and two years later travelled round Mexico with Rivera. Despite his patrician connections, Biddle responded positively to the intense politicisation of the 1930s art world, participating in the new collective organisations and approving the growth of political awareness among artists. Yet he was emphatic that he was not a Communist, and he was, in actuality, an ardent New Deal liberal. This position was entirely incongruous with the current CPUSA line, but Biddle was doubtless welcomed by the JRC as a left-moving intellectual who needed to be wooed. He, in turn, favoured the club because it was the 'one gallery in New York' where artists could appropriately hang works that addressed serious social themes.[37]

Biddle's commitment to a species of progressivism was entirely consonant with a deeply felt loathing of social injustice and poverty, and he had already exhibited a lithograph on the theme of Sacco and Vanzetti at *The Social Viewpoint in Art*.[38] *Hunger*, which he showed in *Hunger Fascism War*, was the melodramatic large canvas later retitled *Starvation* (fig. 44). Although in oil, this aspires to the monumentality and simplicity of a mural. Biddle's other exhibit, *Tom Mooney*, was presumably his portrait lithograph of the imprisoned labour martyr.[39] Lozowick found that *Hunger* suggested 'an element of despair, of defeatism'. By comparison, Laning's *Relief* – which showed supercilious-looking bourgeois hurrying by a resentful crowd outside a relief station – presented 'a wider perspective by a skilful confrontation and characterization of the two classes at war.'[40] This points to one of the central requirements of revolutionary art: the artist was expected to show 'the will to struggle'. Too much concentration on misery and suffering was seen as a kind of romantic indulgence.

44 George Biddle, *Starvation*, 1933, oil on canvas, collection of Michael Biddle.

The club artists whom Lozowick singled out for a combination of 'militant ideology' and 'good pictorial quality' included Bryson, Cikovsky, Seymour Fogel, Gropper, Hoffman, Kopman, Hideo Noda, Orozco, Quirt, Ribak, Shahn, Stavenitz, Chuzo Tamotzu and Sol Wilson.[41] However, he also emphasized the unevenness of the display, and the difficulty of the objective: 'The aim to depict hunger, Fascism, war not as congealed facts but as dynamic processes, to describe them not merely empirically but from a definite class viewpoint . . . is a very difficult as well as a high aim.' One picture on show that attempted to address these problems was Philip Evergood's *Mine Disaster* (fig. 45),[42] a large painting, 39 × 69 inches, that clearly demonstrates the artist's cosmopolitan training. Educated mainly in England, Evergood attended the Slade School of Art in 1921–3. Between 1923 and 1931 he divided his time between the United States and Europe, including periods in Paris, where he studied with André Lhote and Stanley Hayter, and visits to Italy and Spain. He returned to the United States for good in 1931, and in 1933 attended forums at the John Reed Club. However, he did not join, perhaps partly because he was a member of the parallel Pierre Degeyter Club for musicians, for whose meeting rooms

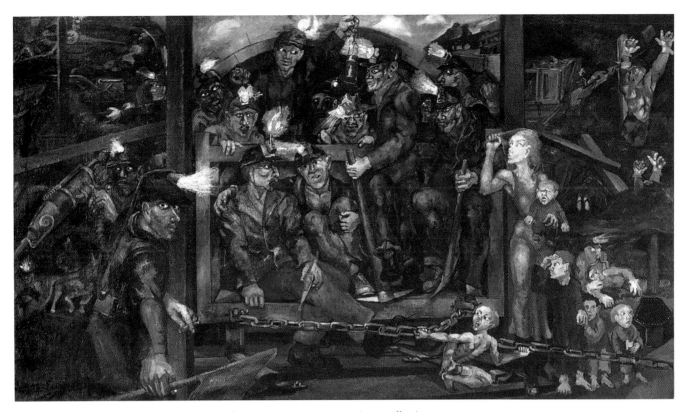

45 Philip Evergood, *Mine Disaster*, 1933, oil on canvas, 39 × 69 in., private collection.

he painted a mural. In formal terms, the basis of Evergood's aesthetic had been laid in the 1920s, when he painted chiefly biblical subjects in a style described not inaptly by the *New York Herald Tribune* 'as suggestive of Delacroix, and that hints from Picasso.' That is to say, it was painterly, in a high key of colour and indicated a familiarity with the spatial ambiguities and expressive drawing of Picasso's Blue and Pink Periods. But if the foundations of the style were already there, it was now turned to new effect – and not just because of the shift from biblical to contemporary social themes. In particular, in 1933–4 Evergood sharpened his colour and began to use it in a more discordant way.[43]

Mine Disaster, which may have been prompted by the wave of union organising and strikes that swept through the coalfields in 1933, is divided into three sections described by the artist as 'Labor in Darkness, the Rescue Squad & Tragedy of Entombment'.[44] In the left-hand section miners toil with rock drills behind a foreground figure who holds a red flag but also incongruously smokes a cigarette. On the right the disaster itself takes place. Figures are shown disappearing or half buried after a cave-in, while a rescuer in a respirator seeks to pull clear a wounded miner placed suggestively near a

black coffin. In the centre the rescue squad prepares to descend, but the tragedy facing the miner's family in the left foreground is already foretold by that coffin. The complex narrative structure of the picture partly reflects Evergood's engagement with mural painting at this time, and effectively this is an adaptation of formal devices from Trecento and Quattrocento painting to new purposes. In the context of the John Reed Club, Evergood's near grotesque proletarian types, his *faux-naif* spatial effects and garish colour may well have seemed incongruously Expressionistic, and Lozowick made no mention of the painting in his review despite its scale and evident ambition. Indeed, he may have seen in it something akin to those 'utterly non-revolutionary motifs, decadent by their nature' for which Elistratova had criticised Siporin's *Southern Holiday* (see fig. 12) in 1932, and passed over it in silence.[45]

Despite his criticisms of some of the exhibits, Lozowick generally approved of *Hunger Fascism War*. But it does not seem to have had much success with the mainstream art world, being scarcely reviewed outside the Communist press.[46] Two general issues arise in connection with the second annual exhibition, although they are not peculiar to it. Firstly, there is the role of

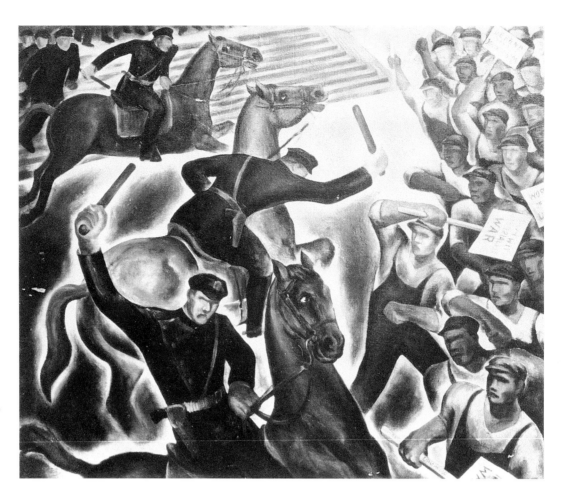

46 (*right*) Eitaro Ishigaki, *Unemployed Demonstration (American Cossacks)*, 1932, oil on canvas, 35 × 41³/₄ in., Museum of Western Art, Moscow.

47 (*facing page*) Hideo Noda, *Scottsboro Boys*, 1933, watercolour and gouache, 10⁵/₈ × 16¹/₈ in., Shinano Dessin Museum, Japan.

Japanese artists within the club. Eitaro Ishigaki (1893–1958) – who was a founding member – contributed to all of the club's main exhibitions, and Chuzo Tamotzu (1888–1975) was seen as sufficiently important to be considered for inclusion in a series of monographs on revolutionary artists projected by the International Bureau of Revolutionary Artists.[47] Ishigaki, who had emigrated to the US in 1909 was already active in Greenwich Village radical circles at the time of the First World War, and he and Tamotzu (who came in 1920) both showed with the Society of Independent Artists in the twenties. In a departure from the New York genre scenes that comprised most of his exhibits hitherto, in 1929 Ishigaki sent in *Undefeated Arm* (National Museum of Art, Tokyo), a composition centring on the forearm of a brawny worker, who wields a mighty hammer against a chain. Ishigaki had clearly converted to the ideal of revolutionary art, and throughout the early 1930s he produced poster-like canvases on revolutionary themes (fig. 46). '*I Will Not Speak*', a picture of a naked female revolutionary being tortured with a cigarette, Ishigaki's contribution to *Hunger Fascism War*, does not seem to have survived.[48]

More interesting than either Ishigaki or Tamotzu is Hideo Noda (1908–1939). Born in California but mainly educated in Japan, Noda had watched Rivera painting *The Making of a Fresco* in the California School of Fine Arts while he was a student there, and was one of Rivera's assistants at Rockefeller Center. In 1931 he moved to the east coast at the suggestion of Arnold Blanch, and settled in Woodstock. Among his artist acquaintances were Grosz and Kuniyoshi, and his summary drawing style and montage-like compositions suggest the influence of the former, while his colouring and use of emphatic painterly textures suggest that of the latter. Noda showed five works at *Hunger Fascism War*, of which none can be securely identified. However, the tempera now known as *Scottsboro Boys* (fig. 47) may be the exhibit titled *Alabama* or a related work. Overlaid on the realities of New York depicted here – the El, the barber's shop, the homeless men sleeping on newspapers – are ghostly figures, one of whom represents Haywood Patterson, who was sentenced to death for a second time in April 1933, only to be reprieved in June. Through their fragmentary compositions and strange perspectives, such works suggested a far more

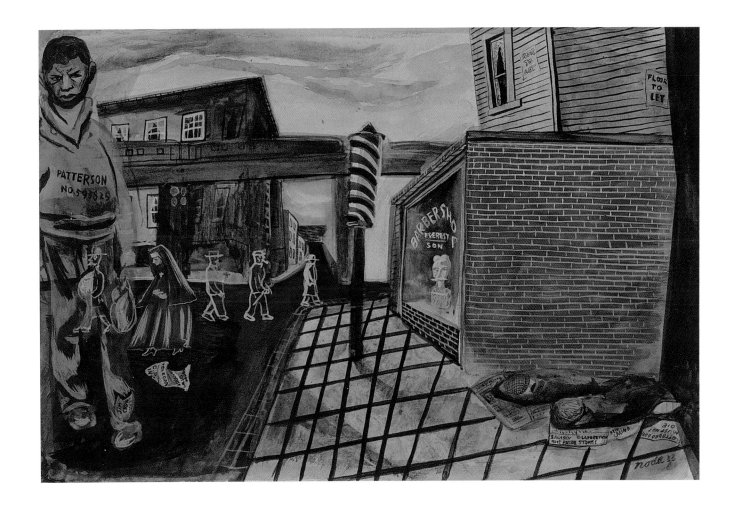

complex and subjective notion of revolutionary consciousness than the works of Ishigaki and the other stalwarts of proletarianism. In 1934, Noda returned to Japan, apparently to work for the Communist underground there.[49]

Concern over Japanese expansionism in Manchuria and China, and the role of Japanese Americans in sustaining the Communist Party of Japan, gave a kind of topicality to Japanese American art, which explains why the ACA Gallery put on an exhibition devoted to it in early 1935.[50] However, there remains a question as to whether the orientation of Japanese American artists was primarily to Japanese cultural groups, such as the Japanese Proletarian Artists' League and the Japanese Workers' Camera Club, and only secondarily to the JRC. This is partly a question of how ethnicity was negotiated within the Communist movement generally, to which the current state of research does not permit an answer.

The second issue is that of the women members. In addition to established women artists such as Peggy Bacon (who had contributed to both *The Liberator* and *New Masses*) and Lydia Gibson (the wife of Robert Minor),[51] the John Reed Club had also provided a space

for less well-known figures such as the gifted Bernarda Bryson (b. 1903) and Sara Berman (1892–1978), both of whom showed in *Hunger Fascism War*. Bryson had joined the Communist Party in Columbus, Ohio, before moving to New York, and had helped organise an unemployment march there. Although she played an important role as an artist activist, she was not a member of the club and has recalled being 'repelled' by the sectarian intolerance of some of its members. Such attitudes eventually caused her to leave the Communist movement, but at the time of *Hunger Fascism War* she was, to judge from her *Daily Worker* review, fully identified with it.[52]

Berman, who was among the club's charter members, came out of the same East European Jewish culture as many of them. Born in Russian Poland, she had studied art and travelled in Europe before emigrating to the United States in her teens, where she became a garment worker and organiser for the International Ladies Garment Workers' Union. Berman's loose Expressionistic style is comparable to that of a number of other artists of the left at this time, including Evergood, Kainen and Solman. What seems significant here

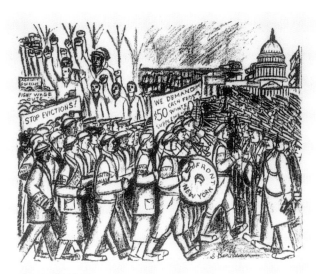

RED FRONT

48 Sara Berman, drawing of the Battle of Wilmington, from *New Masses*, January 1933, Tamiment Institute Library, New York University.

is that the work of women artists within the club was never seen to need any separate attention in reviews. The fact that Berman took part in the Hunger March on Washington in December 1932 and, along with several other Party members, was injured by the police in the so-called Battle of Wilmington called forth no comment on her gender (fig. 48).[53] That the category of proletarian artist was heavily masculinised there is no doubt. But the Party's commitment to involving women in the struggle and its nominal devotion to sexual equality meant women could not be excluded from it, and their contribution to proletarian literature could hardly be gainsaid. What could not be articulated, at least in print, were the special problems women revolutionary arists faced as such.

A third annual, *Revolutionary Front – 1934*, was staged in November–December of the same year. Although Alexander's review in *New Masses* claimed that this was 'by far the most successful' JRC exhibition to date, the fact that it comprised only fifty-seven works by forty-nine artists suggests that the club was diminishing in importance as an exhibition centre and Buro minutes from the end of 1934 recommended that group shows be put on outside the club's rooms.[54]

STRUGGLE FOR NEGRO RIGHTS (1935)

The last of the JRC shows to be discussed here was also the most politically focussed. *Struggle for Negro Rights*, which was held at the ACA Gallery in March 1935, was

organised by the club in conjunction with the Artists' Union, Artists Committee of Action, the League of Struggle for Negro Rights (LSNR), International Labor Defense (ILD) and The Vanguard. All these organisations were initiated by or linked with the Communist Party. The LSNR, which had been set up by the Party in 1930, mainly organised protests against lynching, but it also ran a campaign against workplace discrimination in Harlem in 1934. The Vanguard was a group of Harlem intellectuals and artists centred on Louise Thompson (who later became a Party leader) and the sculptor Augusta Savage. As well as sponsoring political forums and various artistic activities, it set up a Marxist study circle. Aaron Douglas, the only black artist on the exhibition organising committee, was a member of this. Although earlier John Reed Club exhibitions had included several works directed against lynching and racial oppression, the circumstance that prompted the staging of *Struggle for Negro Rights* was a call for an anti-lynching exhibition put out by the National Association for the Advancement of Colored People (NAACP). That *Struggle for Negro Rights* was initiated as a rival to the NAACP's show was made explicit in the committee's own appeal statement.[55]

To understand this seemingly distasteful jockeying for position over the most horrific aspect of American racism, we need to consider relations between the NAACP and the Communist Party in the early 1930s. Partly as a result of Comintern promptings, the CPUSA had given increasing attention to the special problems of 'Negro oppression' since 1928. The Comintern had effectively imposed on the Party a Stalinist interpretation of African Americans as a subject national minority that should be encouraged to struggle for self-determination within the so-called Black Belt – a string of counties across the Southern states in which African Americans were the majority population. In 1930–31 the Party began to increase its activities among African Americans through the LSNR, the Trade Union Unity League and the Unemployed Councils in Chicago and Harlem. These activities were given a new urgency by the upsurge in lynchings in the early 1930s.

While the NAACP offered an explanation of lynching in class terms as the product of the economic deprivation of Southern whites, it did not share the Communist view of it as a practice deliberately orchestrated by the Southern ruling class 'to terrorize the Negro into submission'.[56] However, the action that brought the Communist Party into direct conflict with the NAACP was the defence campaign for the Scottsboro Boys – nine young African Americans who were framed for and

eventually convicted of raping two young white women in Alabama in 1931. The role of the Communist-dominated International Labor Defense in defending the victims, and the numerous direct action protests organised by the Party to prevent a legal lynching, were strongly criticised by the predominantly middle-class NAACP, despite the fact that its own tactics were completely ineffectual. Although the reputation of the ILD was tarnished when its lawyers attempted to bribe a witness in autumn 1934, the energy of the Communists' Scottsboro campaign helped to make the Party an increasingly significant force in Harlem politics.[57] Another factor that contributed to its rising status was the ILD's defence of Angelo Herndon, a young black Communist who was arrested in 1931 after organising unemployed demonstrations in Atlanta, Georgia, and sentenced to twenty years on a chain gang for 'inciting to insurrection'. Herndon wrote the introduction, 'Pictures Can Fight!', for the *Struggle for Negro Rights* catalogue, and in it accused the NAACP of barring the ILD and LSNR from any role in its exhibition.[58]

It will come as no surprise that Alexander's review of the exhibition in *New Masses* paired and contrasted it with the NAACP's *An Art Commentary on Lynching*. Alexander drew an analogy between the exhibitions and two contrasting African American characters in the Theatre Union play *Stevedore*, one a ' "bad nigger" ' who resists oppression, and the other a ' "good nigger" ' who is obsequious and a 'spineless traitor to his people and his class'.[59] On the basis of the racial composition of the exhibitors, this hardly seems a fair judgement. Several of those who showed at *An Art Commentary on Lynching* were black, but while Herndon's catalogue introduction implies that some of those exhibitors in *Struggle for Negro Rights* were, Alexander's review strangely does not name them. Although Aaron Douglas was on the committee for the exhibition, he did not show, and indeed, among the forty-four artists whose work had been selected by 'a jury composed of Negro and White representatives from labor and art groups', I have been able to identify none as African American.[60] However, one thing that may have distinguished the list of exhibitors was the large numbers of Jewish Americans among the ACA group, and the experience of anti-Semitism gave Jewish artists a kind of emotional identification with other kinds of racial oppression.

Alexander did acknowledge an overlap between the two exhibitions, and praised works by Biddle, Cadmus and Marsh in the NAACP show. (In fact, five artists showed in both.) However, *Struggle for Negro Rights* was inevitably marked by an overall effect of greater

49 Hugo Gellert, *The Scottsboro Legal Lynching – The Face of the NAACP, with the Arms of the Bosses*, from *New Masses*, February 1932, Marx Memorial Library, London.

militancy – the 'absence of religious "praying pictures", and more important, the presence of "fighting pictures".' Whether this was actually the case we cannot tell, but within the logic of Communist criticism it had to be claimed as so. Predictably, Alexander preferred works that '*explain* lynching graphically and plastically', and these included exhibits by Burck, Gellert (fig. 49), Hilton, Quirt and Siegel. Perhaps because the artist showed in both exhibitions, Alexander did not include in this list Sternberg's lithograph *Southern Holiday* (fig. 50), which seems precisely to meet these requirements. As Marlene Park has observed, the pillars and factory chimneys amplify the image of castration. But they also do more than this. The pillars symbolise the decaying Southern aristocracy in their broken and fractured forms – flaking stucco reveals mundane brick. The plantation aristocracy gives way to the ominous chimneys of the new industrial South towering behind, which demands the terrorisation of the black proletariat. The little church in the shadow of the factory is complicit in this order of things. This concatenation of forces has produced the hideously mutilated figure who looms out towards us from the immediate foreground. Alexander may have been unsettled by the sexual explicitness of Sternberg's image, and neither did he mention Evergood's powerful drawing '*That's the Man!*' (fig. 52), which vividly critiques the myth that lynching was caused by African American males insulting or raping white women.[61]

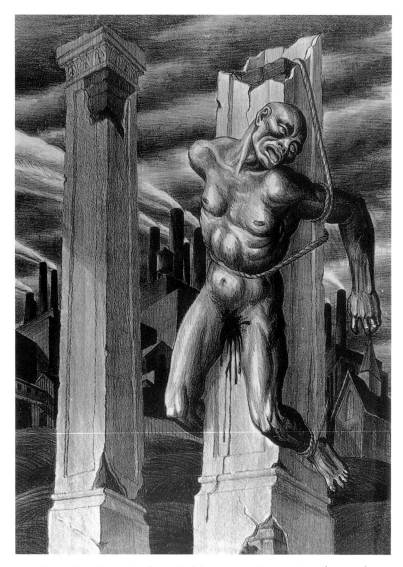

50 Harry Sternberg, *Southern Holiday*, 1935, lithograph, 21³/₄ × 15³/₄ in., Endowment Association Art Collection, Edwin A. Ulrich Museum of Art, Wichita State University, Wichita, Kansas.

51 Aaron Goodelman, *Necklace*, bronze, 23 × 6 × 4 in., museum purchase, Kristie A. Jayne Fund with the co-operation of the Goodelman family, 1990–158, The Jewish Museum of New York/Art Resource, N.Y.

Another work from the show that merits discussion is Aaron Goodelman's bronze *Necklace* (fig. 51). Goodelman (1890–1978) emigrated to the United States from Bessarabia in 1904 and had an extended academic training, during which he supported himself by various factory jobs. The form of *Necklace* draws on the type of fragmented figures initiated by Rodin and developed by numerous early twentieth-century sculptors. Again I note the willingness of artists in and around the party to utilise modernist devices when occasion demanded. (Chaim Gross, Minna Harkavy and Nat Werner are other instances among the sculptors.) Like Evergood's lynch victim, the figure in *Necklace* is youthfully slender, almost androgynous in quality, with diminutive genitals. The arms crossed over behind the back not only create a satisfying formal symmetry but

also reinforce the effect of powerlessness. Closed eyes and passive expression give dignity to the figure, and this is reinforced by the exaggeratedly noble forehead. Rather than the agony that wracks the figure in Noguchi's *Sculpture* (or in an Orozco lithograph that was also shown), Goodelman suggests a nobility that the noose is powerless to disturb. It as if he had systematically sought to counter every offensive stereotype of the black male: excessive sexuality, emotional display, intellectual deficiency.[62]

We might see the *Struggle for Negro Rights* as sharpening those divisions that had already emerged at *The Social Viewpoint in Art* exhibition. Benton, Curry and Marsh all chose to exhibit at the NAACP show but not at the ACA, and none of them played any role in the later Communist-sponsored organisations of the Popular

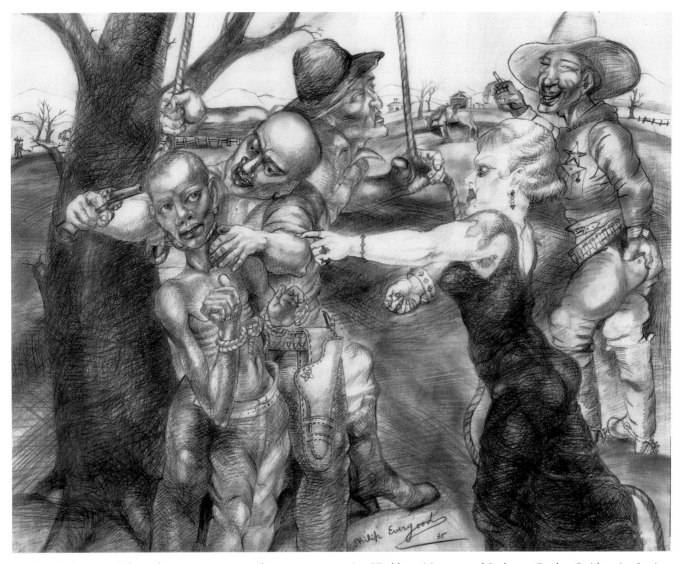

52 Philip Evergood, '*That's the Man!*', 1935, pencil on paper, 19 × 26 in., Hirshhorn Museum and Sculpture Garden, Smithsonian Institution, Washington, D.C., Gift of Joseph H. Hirshhorn, 1966.

Front. The final John Reed Club exhibition was probably *The Capitalist Crisis*, displayed at the ACA Gallery in November 1935, but this was a small affair which seems to have attracted little notice outside the Communist press.[63]

John Reed Club Artists outside the Clubs

In the early 1930s the presence of the John Reed Club artists outside the club's own space was distinguished by a novel strategy that matched attempts to define a new artistic identity through showings at workers' clubs. This was the exhibition of collective paintings on propagandistic themes. In all, six of these were shown over

the years 1930–35 at the Society of Independent Artists' annual exhibition. The Society was set up in 1917 to establish a jury-free exhibition on the model of the French Société des Artistes Indépendants. It had always been a problematic space for more established artists because of the range of work it admitted and the presence of amateur artists, but the absence of a jury and its reputation as some kind of 'Academy of the Left' (counterposed to the National Academy of Design) made it a viable venue for large works that would have been impossible to exhibit at any of the main juried shows. There is frustratingly little information about the JRC collective exhibits and, as far as I know, none has survived. However, it is clear from contemporary photographs and press descriptions that they were basically caricatures blown up to something like mural scale. *An*

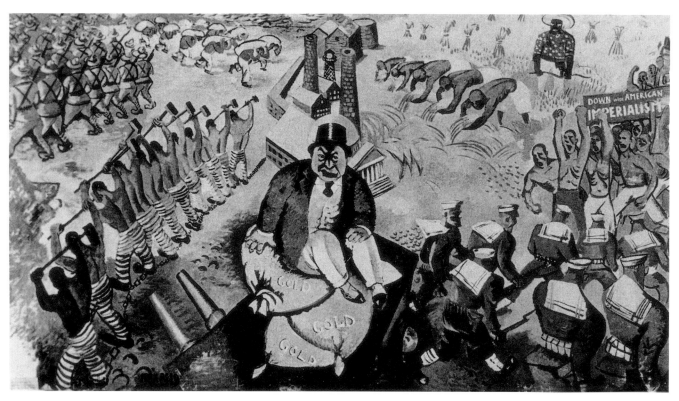

53 John Reed Club artists, *Oppression of American Imperialism in Colonial Countries*, from *Creative Art*, May 1933.

American Landscape, shown in 1930, is a scene of cops beating demonstrators in front of an urban scene loosely suggestive of lower Manhattan. The following year ten artists collaborated on a 'huge canvas . . . satirizing President Hoover, who is depicted driving a donkey-drawn cart labeled "USA"'; *America Today* of 1932 was a long canvas illustrating the competing forces in the current struggle; and 1933 saw the *Oppression of American Imperialism in Colonial Countries* (fig. 53), in which American soldiers and sailors defend a bloated figure of capital seated on money bags amid a landscape of toiling workers. Raphael Soyer recalled that the sketches for the collective exhibits were usually by Gropper, and those of 1931 and 1933 are directly related to cartoons by him from *New Masses*. The ending of the practice coincided with the growing involvement of left-wing artists with the federal art projects, which offered space for a new kind of public art outside the confines of the gallery altogether.[64]

At the other extreme of this model of cooperative revolutionary art was the work of the committed artists who achieved increasing recognition as genre painters in the early 1930s, particularly those who had attracted the support of the Whitney Museum.[65] Notable among them were Nicolai Cikovsky, Harry Gottlieb, Louis

Ribak and Raphael Soyer. I want to focus on Soyer (1899–1987) here because his work brings the problems associated with this type of art most sharply into focus. Soyer's family emigrated from southern Russia in 1912, settling in a poor neighbourhood in the Bronx. Raphael and his brothers Moses (1899–1974) and Isaac (1907–1981) were all encouraged to pursue art, and he studied at a succession of schools between 1914 and 1923. In the winter of 1926–7 he joined the Whitney Studio Club, and by 1931 had sold five paintings and a drawing to the Whitney collection. Nor was his appeal limited to the Whitney support system. In 1932 he won the M. V. Kohnstamm Prize at the Chicago Annual for *The Subway*, and in the following year his *Girl in a White Blouse* was bought by the Metropolitan Museum.[66]

Soyer's reportoire at this time comprised New York street scenes, portraits of his family and images of dancers and models. A review of his first solo exhibition of 1929 in *The Arts* referred to his 'mercilessly frank realism' – an understandable description given the ungainly foreshortened pose and dirty foot of his 1928 *Odalisque* (Columbus Museum of Art), which seems like a proletarian riposte to Matisse's serpentine decorative figures. Soyer acknowledged the influence of Degas

(whose compositional structures are echoed in some of his works) and of Eakins – whose uningratiating portrait idiom he sought to emulate. *The Arts*'s reviewer had observed that his style was 'strangely un-"modern"', while simultaneously praising its formal sophistication.[67] It would not have been unreasonable to see Soyer's work as essentially cognate with that of other Whitney stalwarts such as Alexander Brook and Emil Ganso, however superior in subtlety, and this was how Kainen positioned it in an acerbic appraisal of Brook's work in 1936.[68]

With the encouragement of his politically active wife, Rebecca, and Nicolai Cikovsky, Soyer began attending the John Reed Club in late 1929, and subsequently became a Party member. He showed a work titled *No Help Wanted* at the ACA's *Twenty John Reed Club Artists* exhibition, and *Park Bench* at the *Social Viewpoint in Art*. But with the exception of an unidentified sketch shown at an unjuried exhibition in 1935 this seems the extent of his exhibition history with the club.[69] Soyer later wrote that while the JRC 'helped me to acquire a progressive world view . . . I did not let it change my art, which never became politically slanted.' If Soyer meant by this that he did not produce a specifically propagandistic painting this is broadly true, but it seems unlikely that he would have concentrated so much on images of the unemployed in the early 1930s without the impetus of his political involvement. However, this was only one aspect of his work, as his exhibits at the Whitney Biennials showed.[70]

The Whitney Museum opened in 1931, and held biennial shows of Contemporary American Paintings and alternately of Contemporary American Sculpture, Watercolors and Prints from 1932 to 1936. (From 1937 until 1948 the exhibitions were annuals.) The Biennials had evolved out of the exhibitions of the Whitney Studio Club, and participation was by invitation only. It is important to keep in mind the ambience of the museum in those early years, which comprised four townhouses on West 8th Street, joined together and '[d]ecorated with the fastidiousness of a boudoir', as Forbes Watson put it. The architectural effect struck him as 'partly private, partly domestic, partly public', its scale and decor limiting it to 'the modest household picture.' Even allowing for Watson's personal pique at having been excluded from the museum's management and the acrimony caused by the ending of his affair with its director Juliana Force, his description seems to have been a just one.[71] The Whitney offered a very different kind of space from the John Reed Club's 'bare loft' at 450 Sixth Avenue, and from the tiny ACA Gallery.

In aesthetic terms the museum was most closely associated with the 'New York Realists' of the Ashcan School, although it promulgated no explicit aesthetic philosophy beyond a kind of expansive Americanism. While it put on the show of *Abstract Painting in America* in 1935 and gave support to some modernists, such as Davis and Hartley, its exhibitions of the 1930s were dominated by 'American Scene' painting in its various manifestations. This reflected the preferences of its patron and staff. Such preferences did not, however, exclude artists of the left since there was some overlap between the American realist aesthetic formulated by writers such as Lloyd Goodrich in the 1920s and that of Social Realism – however different their ideological imperatives. Further, the Whitney Studio and Whitney Studio Club, out of which the museum grew, had come about through Gertrude Whitney's fascination with Greenwich Village bohemia as an alternative to the stifling mores of patrician society, and the radical affiliations of figures such as Henri and Sloan had presumably been part of their appeal. Although the tenor of Communist politics was very different and for many seemed to demand a rigorous integration of artistic and political practice alien to the Ashcan group, this did not prevent the Whitney supporting selected Communist artists through invitations to exhibit or purchases.

The first biennial of *Contemporary American Painting*, shown from November 1932 to January 1933, had included several artists associated with the John Reed Club, among whom were Cikovsky, Kopman,[72] Laning, Raphael Soyer and Tamotzu. However, none of their works had the combative character of their exhibits in JRC shows. By contrast with '*We Want Bread!*' (see fig. 41), shown later in January 1933 at the *Social Viewpoint in Art* exhibition on Sixth Avenue, Cikovsky sent in a landscape to the Whitney. The titles of Tamotzu's JRC exhibits suggest a comparable contrast with his *House in the Woods* on Eighth Street. And Laning's *Unlawful Assembly* (see fig. 37), whatever its limitations as revolutionary art, looked decidedly more challenging than the gaily coloured canvas of shoppers titled *Fourteenth Street* that the museum bought from the first biennial. Given that the invited participants were allowed to select the work they wanted to show, one can only assume that the artists chose not to use the Whitney's space for political statements.

More JRC associates showed at the first biennial of *Sculpture, Watercolors and Prints* which ran from December 1933 to January 1934. Although the titles of works by Ribak, Dehn, Sternberg and Reisman indicate their exhibits were innocuous, and Raphael Soyer exhib-

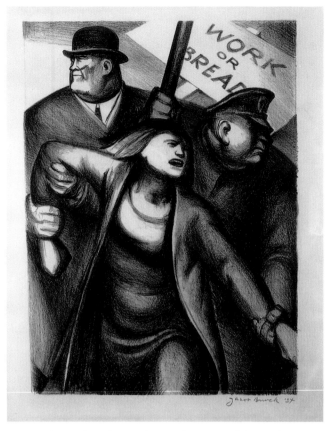

54 Jacob Burck, *The Lord Provides*, 1934, lithograph, image: 11$^{15}/_{16}$ × 8$^{7}/_{8}$ in.; sheet: 13 × 17$^{15}/_{16}$ in., © The Cleveland Museum of Art, 1999, Gift of Mrs Malcolm L. McBride, 1944.329.

55 Nicolai Cikovsky, *East River*, from *New Masses*, 1 October 1935, Marx Memorial Library, London. This appears to be a lithograph of the oil painting *On the East River*.

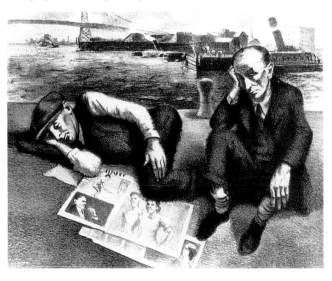

ited lithographs of a self-portrait and a model seated at a table,[73] there were more characteristic JRC images by Burck (fig. 54), Gropper and Lozowick.[74] In line with this more acerbic element, Biddle sent in his lithograph *Sacco and Vanzetti: In Memoriam*. Perhaps encouraged by the purchase of both Gropper's drawings, the tone of some of the paintings at the second biennial of *Contemporary American Painting* was rather more cognate with that of JRC exhibits than that at the first. Cikovsky now showed *Unemployment*, a work that may be tentatively identified with the painting *On the East River* (fig. 55), which he included in his solo exhibition at the Downtown Gallery in February–March 1935, and had probably shown as *Eastside Landscape* at *Revolutionary Front – 1934* the previous year.[75] Laning's tempera panel *On Our Way* was a grotesque image of three workers stumbling through a wasted landscape, bearing on their backs figures symbolic of the military, politicians, the bourgeoisie, labour bureaucracy and the church.[76] Although the museum acquired none of these works, it displayed its liberal propensities by buying a small canvas of a lynching by the Philadelphia artist Julius Bloch, which had been shown at the NAACP's *An Art Commentary on Lynching*.

This involvement with the most prestigious museum of contemporary American painting, with its genteel and intimate decor, did not sit comfortably with the JRC's rhetoric of 'Art as a Weapon', and exposed divisions among those in and around the club. In 1935 the Whitney held an historical exhibition of American genre painting that culminated in a group of contemporary paintings, including Soyer's *In the City Park* (fig. 56) and several other works by JRC members. Jerome Klein's review in *Art Front* paired the show with the ACA's concurrent *Social Scene* exhibition to which Soyer also contributed. At the Whitney, Klein quipped, the contemporaries are 'chiefly of the Coney Island persuasion' – presumably referring to the type of turbulent urban scene associated with Marsh, and seeking to taint such artists with the commercial tawdriness of working-class New Yorkers' summer resort. (In fact, the only images of Coney Island on display were an etching by Paul Cadmus and an aquatint by George 'Pop' Hart.) For Klein these artists were drawn to 'the street' as 'an exciting spectacle'. By contrast, the ACA show 'begins on about the level where the Whitney Museum show ends': 'While Raphael Soyer's park bench unemployed must be considered right up against the barricades at the Whitney, his East River lounging "lumpen" definitely constitute a rearguard action at the ACA.' Neither were the works by Soyer's brothers in the *Social Scene* any

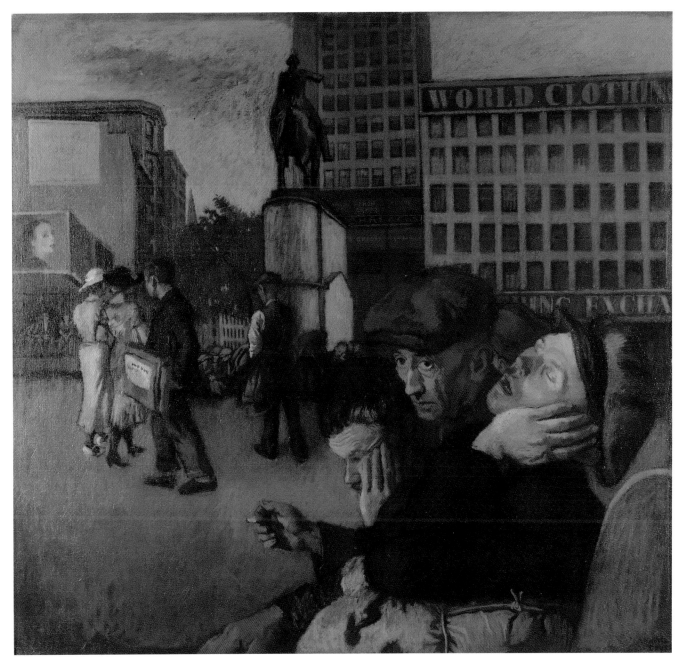

56 Raphael Soyer, *In the City Park*, 1934, oil on canvas, 38 × 40 in., private collection, New York.

'closer to the front lines'. 'The Soyers have taken a step to the left, and there they are poised – they have looked out from the studio into the street, but they have not yet stepped down into it. To take a further step is to represent the will to struggle.' For Klein, pictures of relief demonstrations by Cikovsky and Abraham Harriton[77] had begun to do this, 'because they have effected a clean break with idealist esthetics not merely in content, but also in form and execution.' '[R]ealists of Coney Island stripe' were concerned only with surfaces, the revolutionary artist must seek to represent the 'deeper realities of the world they live in.' And in doing so, they should make their art 'at once a record and an instrument for changing the world in a progressive sense.'[78]

It is easy to see the reasons for Klein's complaint. Cikovsky's unemployed riverfront workers, disposed apathetically next to society photographs in a magazine,

and Soyer's homeless men lounging in Union Square, seem to signify primarily boredom, lassitude and defeat.[79] Neither image gave any indication of how such bodies might be transformed into the brawny and indomitable proletarian heroes of say Gellert's cartoons or Lozowick's *Mid-air*. This was in fact very akin to one of the besetting problems of proletarian literature. As Paula Rabinowitz has pointed out, the image of the hungry unemployed worker and the virile revolutionary was basic to the appeal that Communism had for writers and intellectuals during the Depression. But even writers who represented the abject poverty of working-class life on the basis of first-hand experience and were as committed as Gold and Conroy found it hard to give a convincing account of the formation of a militant consciousness, of how one became the other.[80]

Klein's comments, nevertheless, also suggest that Soyer's naturalism simply did not match with the variant of Marxist ideology current in the Communist movement. At a higher level, the issues his type of painting raises were addressed contemporaneously in relation to the novel by Lukács in the German magazine *Linkskurve* (a magazine certainly read in the John Reed Clubs), that is, issues around the distinction between surface realities and the deeper truths of social processes I showed Burck making in the last chapter. Works such as *In the City Park*, because of their attention to individual particularities and commonplace situations, and because of their focus on the pathos of unemployment and homelessness, seemed to treat the subjection of the proletariat as a given. In Lukács's terms, they were limited to the representation of appearances and thus failed to show the social dynamics that produced such phenomena and that ultimately pointed towards their supersedence. Such art was conceived as a mirror rather than as a weapon. We may register this in the four hands in the foreground, not one of which is a fist and none of which holds anything more militant than a cigarette. The almost square format of the canvas is also significant in the way it compresses the space around the figures – a metaphor of their limited horizons.[81]

This was partly a question of genre. Working in a mode derived from history painting Burck and Ishigaki could represent Communist organisers, militant workers, soldiers and peasants as heroic. But such heroics were almost incompatible with the size and mode of urban genre painting. Well suited to representing differentiated individuals as stereotypes, it was ill-adapted to collective action. Further, while large scale demands a collective audience and public space, the genre painting seems addressed more to the attention

and empathy of individual viewers in the home or gallery. This is not to say that genre painting could not be a politicised mode, but rather that it addressed politics at a fairly low level, and often through symbolism and allusion so as not to disrupt the illusion that it showed the ordinary and typical. It is unlikely that Soyer set out to paint a genre painting in the mode of a David Blythe or Richard Caton Woodville, but in taking up models of naturalistic modern life painting developed in nineteenth-century France he inadvertently (or consciously – it does not matter which) adopted a mode that came out of the genre tradition. The inclusion of Soyer's work in the Whitney's 1935 show was thus entirely appropriate, and not just because of its size but also because of its ironic humour, cognate with that of Degas despite the differences in their ostensive politics. The sleeping figure with his mouth open might be transposed from a resting ballerina by the latter – although its moral impact is very different. More clearly pointed is the contrast between the emasculated forms of the slumped or hunched scrawny men in their shabby rumpled clothes and the smart office girls in summer dresses. The pathetic bundle of possessions tied up with string on the seat is mocked by the stores and advertising poster in the background. Soyer gets closest to the political in the lounging figures around the base of the monument to Washington, symbolic father of the American republic. To these, at least, the promises of equality, liberty and the pursuit of happiness remain unfulfilled.[82]

Did Klein overlook or choose to ignore Soyer's irony, or was there something more? Probably the latter, for my argument is that the undercurrent of sexual longing implicit in this and other contemporary street scenes by Soyer was not only extraneous to the proletarian aesthetic but also ran directly counter to the current mythology of proletarian love. Soyer's stylish office workers have nothing to do with the sturdy mothers of proletarian fiction or their pre-maternal counterpart, the feisty union girl, who has no fear of the cops and gives as good as she gets on the picket line. We might surmise that Klein passed over this aspect of the work because his own ideological fantasy could not contain the intimations of a more obdurate reality that Soyer's picture suggests. Lurking behind Klein's word 'lumpen' was perhaps a suspicious distaste for the unorganised unemployed.[83] A distaste prompted by the differences between them and say Gleb and Dasha, the proletarian couple of Gladkov's *Cement*, which had been serialised in the *Daily Worker* in 1929.[84] Gleb, a massive worker whose body was a living monument scarred by labour and the armed struggle, who made up in proletarian

instinct for what he lacked in active intelligence. Dasha, who sacrificed both her home and her own child because devotion to the Party counted for more. How could Soyer's figures be the material from which such types were made? If anything they resemble the aimless drifters of contemporary novels such as Nelson Algren's *Somebody in Boots* or Edward Dahlberg's *Bottom Dogs*.[85] We might surmise that the realities of proletarian existence intimated by his work threatened to rupture the Communist mythos, rather than support it. I admit this is speculation. But the contrast I have drawn between the character of Soyer's figures and the imagery of Communist ideology is not.

When Joe Solman reviewed the Second Biennial of *Sculpture, Watercolors and Pastels* for *Art Front* in 1936 he assumed the same caustic tone as Klein. 'We' had always had the 'distinct suspicion', he wrote, that the Whitney was 'just a more flashily dressed Academy, with a few old rebels and still fewer new ones thrown in.' Both the 'socially vigorous picture' and more extreme abstract art would have looked out of place among the museum's 'red plush and silver-starred decorations'. Despite the presence of an image of the unemployed by Harry Gottlieb and a gouache of waterfront workers by Harriton, the Whitney exuded 'a mild, innocuous, middle-class sort of contentment'.[86] It is hard to imagine the groups of workers who reportedly attended the JRC exhibitions visiting the place. But had they actually done so they could meet with culture only through the largesse of a philanthropic sector of the *haute bourgeoisie*, in spaces it defined and controlled. Even when it was intruded into such an environment the 'socially vigorous picture' could hardly be effective, because, as Klein and Solman intimated, the institutional setting spoke more loudly than one or two works admitted as a token gesture to current trends.

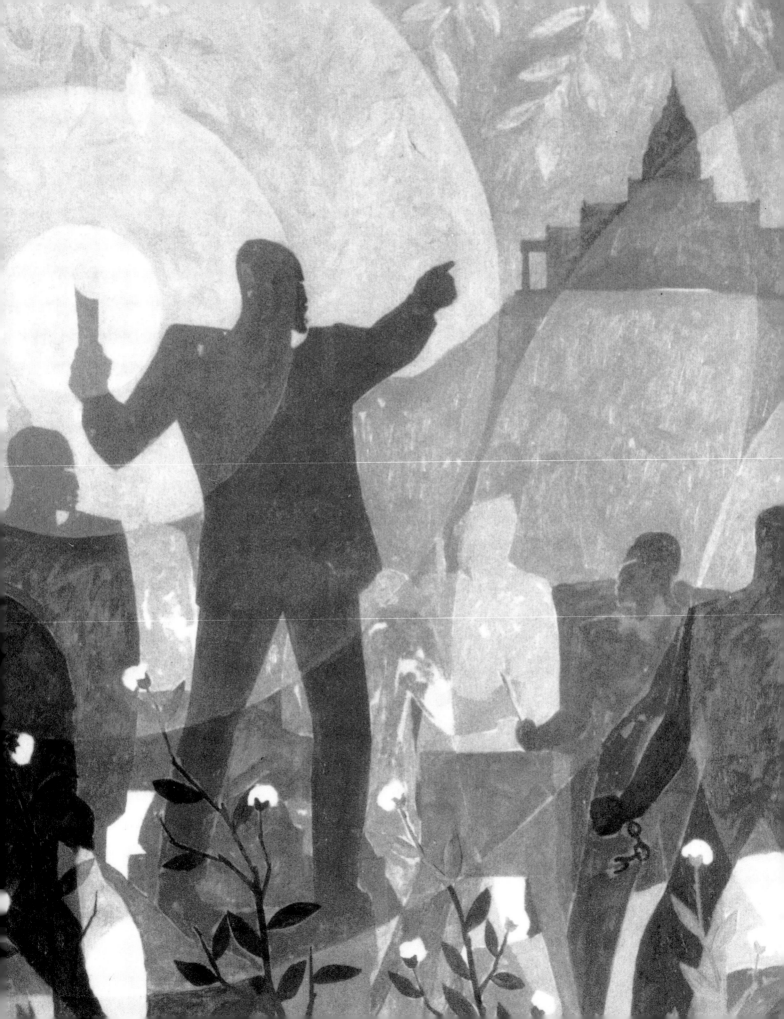

4 Communist Artists and the New Deal (1): The Federal Art Projects before the People's Front

In the last chapter I considered ways in which works by artists associated with the Communist movement functioned in the different environments of the John Reed Club and Whitney Museum exhibitions. The question addressed in this chapter is related, namely: what meanings did works by these same artists acquire when they were produced in the context of the first of the New Deal art projects? However, before I tackle this it is necessary to look at Communist attitudes to the projects more broadly, and at the problems of interpretation and strategy they posed.

There were four main art projects: the Public Works of Art Project (1933–4), the Treasury Section of Fine Arts (1934–43), the Treasury Relief Art Project (1935–8) and the Works Progress Administration Federal Art Project (1935–43). Vast, both in scale and ideological import, they seemed to promise a fundamental transformation in the nature of patronage and long-term relations between artists and the state. The projects provided a framework within which a number of Communist-initiated artists groups operated, notably the Unemployed Artists' Group and its successor the Artists' Union. In some degree these offered an alternative to the John Reed Clubs, and the Union's magazine *Art Front* was for a while the most important forum of leftist artists. The possibilities of the projects – and their simple appeal to destitute cultural workers – forced Communist artists and critics to rethink their attitudes to the New Deal, at the same time as the pressure of larger events obliged the Party leadership to modify its stance towards the Roosevelt administration.

The CPUSA and the New Deal

The arrival in the White House in March 1933 of a charismatic president, committed to wide-ranging experiments to end the Depression, caused the Communist Party problems in terms of both analysis and strategy. Hoover may not have been quite the callous exponent of laissez-faire individualism of later myth, but his reluctance to increase public spending to reduce unemployment, his meagre advances of federal money for relief of the destitute and his unwillingness to use the resources of the state to regulate further the economy made him look simply the tool of reactionary financial and corporate interests. The image of General MacArthur's assault on the unarmed veterans of the Bonus Army with bayonets, tear gas and tanks in July 1932, within sight of the Capitol, fixed the president's reputation as indurate and inhumane.[1] By contrast with Hoover's insistence that the Depression was only a temporary malfunction of an otherwise healthy system that could be treated largely by voluntary efforts, the Roosevelt administration began with a flurry of legislation including the Emergency Banking Act, Agricultural Adjustment Act and National Industrial Recovery Act (NIRA). The setting up of the Federal Emergency Relief Administration (FERA), Public Works Administration (PWA), Tennessee Valley Authority and Civilian Conservation Corps initiated a wave of federal relief and public works spending on a massive scale.

If the administration's programme lacked ideological cohesion and parts of it proved unworkable, it signalled the beginning of an epochal shift in the state's role in American society. The scale of this shift was made possible in part through the support that the Democratic Party (and Roosevelt as an individual) received from a new generation of politically active working-class voters drawn from among more recent immigrant stock and African Americans. This working-class electorate expected the state to provide unemployment relief, labour protection and social security in a way even their immediate forebears had not – it was the price of their political loyalty.[2] Communist Party efforts to organise the unemployed from 1930 onwards contributed to form this expectation in some degree. The Party's aim was to recruit to the revolutionary movement those who

had most cause to be dissatisfied with capitalism, but its grand rhetorical pronouncements on international issues and the class struggle tended only to alienate, while its active role in resisting evictions and organising rent strikes and relief demonstrations gained it widespread respect if not much in the way of membership. Despite its revolutionary pretensions, the Party adopted the essentially reformist goal of a federal social insurance act, the campaign for which Browder described as 'a central task' in July 1933.[3]

Still committed to the policy of dual unionism at the beginning of the Roosevelt administration and relentless in its criticisms of the AFL leadership,[4] the Party was also wrongfooted by the upsurge of union militancy sparked by the National Industrial Recovery Act. The main aim of the act was to suspend anti-trust legislation and set up codes of fair competition that would reduce the anarchy of the market and rationalise production. Although there was a federal regulatory agency in the National Recovery Administration (NRA), the codes were to be drawn up and administered mainly by the trade associations of the industries themselves. To secure the support of the AFL for this, the act also had provisions to guarantee minimum wages and maximum hours, and the right of workers to engage in collective bargaining through unions of their own choice (clause 7a). It was certainly not Roosevelt's intention to encourage labour militancy, but 7a seemed to give the state's endorsement to union activity, and contributed to a huge upsurge in membership and the great wave of strikes for union recognition that swept across the country in 1933–4.[5]

In order to quell labour disputes, Roosevelt had set up the National Labor Board (NLB) under the chairmanship of Senator Robert Wagner, which was authorised to mediate between unions and employers under the terms of the NIRA. Not only did employers consistently seek to evade the Board's rulings but its work was also obstructed by the administrators of the NRA, General Hugh Johnson and Donald Richberg, who opposed the principle of majority choice and interpreted 7a as a licence for company unions. Wagner became convinced that the only way to create industrial democracy and remedy gross inequality lay in state protection of union rights. The Labor Relations Bill he introduced in the Senate in March 1934 was neutered in the committee stage, but after the mid-term elections in November returned a Congress dominated by Democrats and progressives, Wagner introduced a second bill that would outlaw 'yellow dog' contracts and set up a permanent National Labor Relations Board (NLRB) with statutory powers to enforce employers to recognise unions chosen by workers themselves. This became the Wagner Act, which the president signed into law in July 1935, although the bill had received little support from the administration and had been opposed by employers throughout the committee hearings in both House and Senate.[6]

Since agencies set up by the government (the NLB and later the NLRB) seemed to be acting against the interests of capital, these developments have posed a considerable interpretative challenge to neo-Marxists and other state theorists seeking to define the relationship between the state and corporate power.[7] Lacking any consistent theory in this area, the CPUSA could see the state only in the crudest terms as the direct instrument of capital, and produce expedient formulations in response to the latest pronouncements from the Comintern that seemed palpably inadequate to the realities of the situation.[8]

In July 1933 Browder told an Extraordinary Party Conference that 'to label everything capitalist as fascism results in destroying all distinctions between various forms of capitalist rule',[9] but in practice Party spokesmen made no significant distinctions of this type in relation to the Roosevelt regime for several years. At the XIII Plenum of the Executive Committee of the Communist International in November–December 1933, a whole succession of Communist dignitaries described the New Deal as a fascistic attempt to save the system from the effects of the general crisis of capitalism. Browder was one of the speakers at this occasion, and here I draw mainly on his various statements from 1933–6 collected in *Communism in the United States* (1935) and *The People's Front* (1938).[10] According to the General Secretary, Roosevelt, like Hitler, was simply the executive of finance capital entering its fascistic phase, and disguised his real aims by 'unprecedented demagogery'. While the administration handed out 'tens of billions of dollars' to banks and corporations, the real burden of the crisis was being born by the 'impoverished masses' who were forced to shoulder new tax burdens. Public works projects such as the Civilian Conservation Corps and the Tennessee Valley Authority were actually preparations for war. As was the NRA. But the NRA was also a 'trustification' of the economy analogous to Mussolini's corporate state, and the labour provisions of clause 7a were designed to create 'state-controlled labor unions closely tied up with and under the direction of the employers.'

Workers' support for the Democrats in the 1934 elections caused no change in this evaluation. Neither did the clear opposition to the New Deal from conservative

businessmen and elements in the Democratic Party itself, who set up the American Liberty League in August of that year as a focus for their activities. From the Party's perspective, Roosevelt and the Liberty League shared the same goals – they simply differed over how to achieve them. Indeed, in Browder's words: 'Roosevelt, and the bourgeoisie generally, try to draw some advantages out of their mounting inner differences and difficulties.'[11] The invalidation of the NRA and the Agricultural Adjustment Act by the Supreme Court in 1935 were seen as symptoms of a petty squabble among equally conservative groups. Even the Wagner and Social Security Acts and setting up of the massive WPA relief programme were read merely as sops to buy off the working class.

The enunciation of the Popular Front line at the Seventh World Congress of the Comintern in August 1935 led to some greater discrimination between Roosevelt and his opponents, but the Comintern continued to underestimate the radicalism of New Deal measures and offered no systemic explanation of social democracy that might have permitted a more nuanced analysis of their significance. The CPUSA was exhorted to work towards a 'people's front' against fascism through a national Farmer-Labor Party that would be an alternative to both Republicans and Democrats, uniting a whole range of lower social groupings around a programme that was neither socialist nor Communist but called for a range of progressive social legislation and opposition to the banks and corporate power. However, it became clear in the run-up to the 1936 elections that the newly formed Committee for Industrial Organization and the existing state-based farmer-labour parties intended to back Roosevelt, and although the Party did run its own candidate in the presidential contest and continued to insist that Roosevelt was ultimately 'no barrier to reactionary forces', it sought increasingly to work with both these groups in the hope of eventually building a true third-party alternative. By August 1936 it had moved towards tacit support of the president as the only electable alternative to a fascistic Republican Party led by Alf Landon – actually a moderate. Thus while in June 1936 Browder was still warning that 'it is a fatal mistake to depend upon Roosevelt to check the advances of Wall Street', the following month he conceded that Roosevelt had tried to impose some restraint upon the 'short-sighted greed' of monopoly capital. He later declared the November election results 'a smashing defeat for reaction', which heralded a split in a Democratic Party that was now perceived to unite both 'progressive and reactionary elements'. This description was

accurate enough, but it was also a tactical response to the massive swing of working-class voters to the Democrats in 1936. Even so Roosevelt was still not be trusted because his constant inclination to choose the middle of the road was as likely to lead him to the right as to the left.[12]

I shall examine subsequent developments in the Party's position on Roosevelt in a later chapter. My purpose here has simply been to indicate that the line taken in the Third Period and early phase of the People's Front did not seem to offer much of a framework for participation in the federal art programmes, to which I now turn.

The Federal Art Projects, 1933–1935

The history of the New Deal art projects has been described in several studies, and there is no need to rehearse it again in any detail.[13] Here I shall only sketch the operation of the Public Works of Art Project (PWAP) and the setting up of the Treasury Section of Fine Arts, the Treasury Relief Art Project (TRAP) and the Works Progress Administration (WPA) Federal Art Project in relation to the larger relief policies of the administration, before analysing in more depth the ideology around federal art.

As mentioned earlier, the new president immediately reversed Hoover's policy of not giving federal money to the states for unemployment relief by setting up the Federal Emergency Relief Administration through an act of May 1933. Its director, Harry Hopkins, was one of the most liberal of Roosevelt's advisors and a hate figure for conservatives. FERA was a grant-in-aid programme administered largely through existing state agencies. However, the ambition of Hopkins and other progressive social workers in the administration was to substitute 'work relief' for 'direct relief' (or dole) on the grounds that the latter sapped the morale of the unemployed and led to an erosion of skills; therefore the work involved in work relief should match the skills of the employee (diversification). This work relief principle was a fundamental premiss of three of the main federal art programmes. The problem was that because work relief inevitably entailed something far closer to real wage rates and was far more expensive to administer, it did not find much support among conservatives at state level; indeed, in some states the very principle of relief was resisted by local politicians. Although FERA aimed to encourage work relief, the initiatives it took in that direction had limited take-up. In several states relief

payouts to clients were miserly, in some areas they were given food orders rather than cash, and in the South blacks were usually paid about half of what whites received.[14] Conservative attitudes in many states in the South and West also made it very hard to achieve some aims of the WPA Federal Art Project.

That FERA was inadequate to meet the scale of the crisis was evident by the autumn of 1933. In November, Hopkins secured $400 million to set up the Civil Works Administration (CWA), a work relief programme to be administered on a purely federal basis. By 18 January 1934 the CWA had a workforce of 4.2 million. It had no means test and workers did not have to come from the relief rolls. Moreover, it paid PWA wages, which approximated union rates and in some localities were higher than the prevailing wage levels for similar work. Opposition to the CWA, particularly from Southern industrialists and farmers, together with the drain it made on the federal budget, led to its closedown on 31 March 1934.

CWA projects were overwhelmingly in construction, and thus gave work mainly to the unskilled. Its wage structure made no provision for semi-skilled, clerical or professional workers. Moreover the funds utilised were authorised under the 1933 NIRA and could not be used except for construction purposes. However, by drawing on funds that had been allocated for FERA, Hopkins was able to set up the Civil Works Service Progamme (CWS), a white-collar programme that paid CWA wage rates, though only to relief clients. Among CWS projects were cultural programmes in New York and a number of other places, although these were mainly of an educational nature.[15] The most important cultural initiative of the CWA was the Public Works of Art Project, headed by Edward Bruce. This was a federally administered programme, set up in December 1933 with a grant to the Treasury Department to employ artists on the embellishment of public buildings. PWAP lasted four and a half months and cost $1,312,117. It employed 3,749 artists, who produced 15,663 art and craft objects, including 706 murals and mural sketches, 3,821 oils, 2,938 watercolours, 1,518 prints and 647 sculptures.[16]

With the closedown of CWA, the Public Works of Art Project also officially ended (although it was allotted funds by FERA to wind up its activities). Simultaneously, Bruce began to press for the establishment of a Division of Fine Arts within the Treasury, paid for from Treasury and PWA funds. In this he was able to draw on the support of Henry and Elinor Morgenthau, the Secretary of the Treasury and his wife, and both Franklin and Eleanor Roosevelt, all of whom were sympathetic to a public art project. However, use of PWA funds proved

impossible, and in September 1934 a more modest initiative, a Section of Painting and Sculpture (renamed the Section of Fine Arts in 1938) was established within the Treasury Procurement Division. Morgenthau's order setting up the Section did not prescribe that every new building would be decorated, but where Section and architects agreed, a sum amounting to about one per cent of the overall cost could be reserved for art works. Difficulties with architects and bureaucrats forced the Section to make its case building by building, and many went undecorated. None the less, over 1934–43, the Section commissioned 1,116 murals and 301 sculptures, which decorated 1,118 buildings in 1,083 cities. But in themselves these figures do not indicate the full scope of its activities, for the Section relied on a controversial competition system, which drew in far more artists than ever received commissions.[17]

Unlike the PWAP and the WPA Federal Art Project, the Treasury Section was not a relief programme. It employed artists on what it regarded as criteria of competence to secure the best art available. Because the Section's brief did not permit it to decorate existing federal buildings, in May 1935 Bruce applied to the newly established WPA for relief funds to hire unemployed artists to work on these, and in July 1935 the Treasury Relief Art Project was set up under the directorship of Olin Dows. However, WPA relief conditions were incompatible with Bruce and Dows's notions of quality, and they effectively sought to evade the relief principle, hiring artists on a highly selective basis in numbers that fell far short of their quota. Relations between TRAP and the WPA Fine Art Project were strained, especially in New York City, where there was open rivalry between the two. TRAP was also sharply attacked by artists' organisations for its elitist policies. In all it produced only 89 mural and sculpture projects, together with more than 10,000 easel paintings and prints.[18]

The Works Progress Administration was established by Executive Order on 6 May 1935 to supervise and coordinate federal work relief programmes, and funded from the $4.8 billion assigned for that purpose by the Emergency Relief Appropriation Act of that year. (The continuation of the agency was dependent on annual appropriations, and on supplementary appropriation bills to meet shortfalls.) It was a compromise between the principles of FERA and CWA in that it was designed to remove 3.5 million people off the relief rolls by employing them at a security wage. Unlike FERA it was an entirely federal programme: every individual taken on by the WPA became a federal employee. However,

because the WPA could never give work to more than a third of those unemployed there was a requirement that ninety per cent of those hired be taken from the relief rolls. (For the arts projects initially 25 per cent could be non-relief.) This meant both that it was difficult to hire the necessary supervisory staff and also that workers had to undergo the humiliation of a means test. By the time it ended in 1943 more than 8 million people had worked for the WPA, and at its height it employed 3.3 million people per month. Because WPA projects were administered state by state and required local sponsorship the efficiency of their operation varied considerably and they also became embroiled with political corruption at state level. Seen as a massive vehicle for New Deal influence, they were a focus for conservative opposition to the administration, and the arts projects in particular came to symbolise all that was most wasteful and 'un-American' about the WPA. That is, the culture of projects stood for a kind of Americanism that many conservatives rejected.[19] From the other side, the impermanency of the WPA, the low wage rates and arbitrary lay-offs of its later years contributed to worker discontent and led to numerous strikes and demonstrations.

Hopkins always intended that the arts should be part of the WPA, and in the event four projects were established under the general title of 'Federal One', for art, music, theatre and writing. (To these a fifth, the Historical and Records Survey Project, was later added.) The Federal Art Project (FAP) was headed by Holger Cahill throughout its period of existence from 1935 to 1943. Unlike the Section, the FAP operated from the principle of relief rather than that of quality, and partly for this reason its ideological framework was rather different. (This is not to say that norms of quality did not operate within it, but they were more flexible.) The project was organised into eight divisions, of which only the mural, easel, graphics and sculpture divisions concern me. At its largest in 1936 it employed about 5,000 artists across the nation, and about 10,000 were on its rolls at one time or another. Unlike the Treasury Section, which was tightly run from Washington, the FAP was decentralised and operated on a regional basis – although until 1939 regional FAP directors were responsible to the Washington office and not to the WPA state administrators. But having said this, it should be noted that WPA FAP activity was concentrated disproportionately in New York. Of an estimated total budget of $35 million spent on the FAP, about $16.6 million went to New York State, and an overwhelming share of that to the city. In 1937 almost 45 per cent of all artists employed on the FAP were working there. Overall the WPA produced 2,500 murals, 108,000 paintings, 18,000 sculptures and 200,000 prints from 11,000 designs, as well as 2 million posters and the 23,000 historic records of the Index of American Design.[20]

The Ideology of Federal Art

Having indicated something of the scale of the art projects, I now turn to their ideological rationale, which has been dealt with less satisfactorily in the published scholarship.[21] That there were differences between the governing ideals of the Treasury projects and the WPA FAP was very evident to contemporaries, and these differences have received attention in several studies. In the most extreme of these, Belisario Contreras's *Tradition and Innovation in New Deal Art* (1983), the Treasury Section and the WPA FAP are represented as manifestations of the outlooks of their respective directors: the one elitist and concerned with tradition and permanency; the other democratic and concerned to promote openness and innovation. There is a measure of truth in this, and one should not underestimate the individual roles of Bruce and Cahill. But the institutional constraints under which they operated were in many ways pre-given, and more weight should be accorded the differences between their sources of funding and the outlook of those who controlled them – the Treasury and its fiscally conservative secretary Morgenthau in the case of the Section, and the WPA headed by the liberal Hopkins in that of the FAP.

A basic problem with nearly all the existing scholarship is that it does not work from any articulate theory of the New Deal state. The single exception to this, Jonathan Harris's *Federal Art and National Culture* (1996), recognises the problem but operates with such a crudely instrumental model that it does not much advance matters.[22] Harris adopts the discredited corporate liberal conception of the New Deal as an essentially conservative reform programme, spicing it up with concepts culled from Althusser, Poulantzas and Foucault so as to sustain an interpretation of the federal art projects as a disciplinary mechanism designed to mould docile model citizens in the interests of an emergent corporate capitalism. In his account the power of the state only ever works one way, and citizenship itself is an oppressive category. But things look rather different if one sees the state in more complex terms as an overlapping set of institutions with a certain autonomy, bound primarily to the interests of the most powerful class groups, but also

sometimes responsive to the demands of the disadvantaged – as it must be to maintain legitimacy and limit social discontent. Because for Harris the state is simply an instrument of capital, he cannot register the ways in which both the New Deal and the WPA were in some degree affected by popular pressures – notably organised labour at large in the case of the former, and the Workers' Alliance, an organisation of the unemployed that came to function as a labour union, in the case of the latter.[23] It also makes no difference that the later 1930s were a period when the American working class was especially militant and well organised, even if only in pursuit of reformist goals; or that to command its loyalty the Roosevelt administration was obliged to enact social legislation and maintain high levels of relief spending. Yet in actuality, this was a moment in which there was a confluence between the democratic idealism of figures in the administration and the ambitions of labour leaders such as Sidney Hillman to create a genuine industrial democracy.[24] In the event the hopes of the Congress of Industrial Organizations (CIO) leadership to build a new relationship of the state, capital and labour were only very partially realised, and the progressive elements in the Democratic Party were increasingly stymied by the alliance of racist Southern Democrats and reactionary Republicans that formed after the 1938 elections. But that is partly a story of the 1940s and the effect of a different set of circumstances – it should not lead us to underestimate what working-class power achieved in the previous decade.

In brief, I am interested in the ways in which the various art projects seem in some ways responsive to radical pressures. This is not to say that they were not instruments of the state, or to deny that they could function as propaganda agencies for the New Deal, but they also (particularly the WPA FAP) came to stand for ideals that many artist workers identified with and saw as politically progressive. Some of this identification may be seen as an ideological effect in the pejorative sense, yet we should also take into account the possibilities for real empowerment the projects offered. In what follows I explore the overlap between the ideological framing of the projects by their administrators and statements by artists of the left, as well as the divergences.

To begin with, it is important to note the class status of those who initiated the New Deal art projects, since had they not spoken the language of the governmental elite they could hardly have had the influence they did. As is well known, George Biddle suggested to his old schoolfriend Roosevelt that the government should sponsor younger artists to represent the 'social revolu-

tion' in the United States in a letter of May 1933 – although the idea of state support for destitute artists was quite widely mooted at the time, and Biddle's letter should not be elevated to the status of single cause for what followed. I referred to Biddle's background and education in the last chapter, and it is also worth noting that while he denied any identification with the upper class, in his 1939 autobiography he recalled how much he had enjoyed socialising with the New Deal elite in Washington during the painting of his Justice Department mural in 1935. However, if Biddle became an ideologue for the New Deal it was purely by inclination, not by appointment.[25]

By contrast, Edward Bruce (1879–1943) had already demonstrated the aptitudes of a successful public servant.[26] A graduate of Columbia University law school, he followed a varied career in corporate law and business ventures in the Philippines and Asia before becoming a professional artist. He turned to art seriously after 1922, and spent the remainder of the 1920s living in Italy and France, using the work discipline he had acquired in business to perfect his craft. By 1930, Bruce was regarded as one of the leading American landscape painters of his generation. His first two one-person shows were sellouts, and by 1931 his canvases were fetching from $400 to $5,500.[27] In 1929 his painting Savoie Farm was bought by the French state (an event widely reported in the US), and in the same year his Pear Tree (Cleveland Museum of Art) received first honourable mention at the Carnegie International. He had been the subject of articles in the main art magazines and of a monograph in the Valori Plastici series. Moreover, he was articulate about his aesthetic and his work was warmly endorsed by his friend, the respected critic Leo Stein. In a characteristic critical trope, the Valori Plastici monograph hailed him as a modern, at the same time observing: 'His work is another witness to the axiom that tradition doesn't fetter modernity, but on the contrary, gives it natural freedom of expression'. When Creative Art appraised his landscapes in 1933 they were taken as representative of the trend towards 'a new objectivity', which marked the exhaustion of modernist experimentation – and more specifically of abstract art. By 1931, Bruce himself was saying that 'modern art is foreign to our real tastes', and claiming that if only Americans could overcome their 'inferiority complex' in relation to Europe, they would create a Renaissance. 'The unemployment problem serves as an admirable and practical excuse for starting such as movement', he declared.[28]

Bruce's conservative formalism, while 'modern', was anything but avant-garde – rather like that of Roger Fry.

His aesthetic, centred on perennial values and the mystique of taste, matched perfectly his social position and made him well-suited for the role of cultural manager. At the same time, his embrace of Americanism provided a tincture of contemporaneity, for having made his reputation primarily with Italian landscape subjects, after his return to the United States Bruce became an exponent of the American Scene and in 1932 had a successful exhibition of urban and industrial views at Milch Galleries (fig. 58). At the same time, his social trajectory and recently acquired position in the Treasury Department put him in just the right place in 1933 to become the key figure in promoting and running the first of the New Deal art projects.

Despite his business background, Bruce developed a deep personal commitment to Roosevelt and became an ardent partisan of what he saw as the 'idealism' of the New Deal programme, although he had some reservations about both to begin with.[29] In 1936 he worked to establish a Roosevelt Business and Professional League, probably as a counter to the Liberty League, and in that year he was reported in the press as observing offhandedly that the Republicans 'ought to be all killed off'.[30] Bruce was certainly not on the 'left' of the New Deal, yet it is worth remembering that some of his main artist friends, such as Maurice Sterne and Boardman Robinson, had worked for *The Masses* and *Liberator* and that he himself was fiercely anti-fascist.[31] In 1940 he described himself as having been 'intensely interested in the Negro cause for many years', and he was a supporter of the NAACP and a patron of its 1935 anti-lynching exhibition. He was disgusted by the Daughters of the American Revolution's refusal to let the black contralto Marian Anderson sing in Constitution Hall, and instigated the mural by Mitchell Jamieson in the basement of the Department of Interior building depicting her concert on the steps of the Lincoln Memorial.[32]

My point is that Bruce and the Section of Fine Arts were just as representative of New Deal cultural idealism as Cahill and the WPA Federal Art Project. Although the connection between New Deal culture and Dewey's philosophy is usually made in relation to Cahill (who openly claimed it as validation for the FAP), Bruce also made use of Dewey, despite the low opinion he held of him as an aesthetician.[33] If his adoption of Dewey in 1940 was opportunistic, there were yet real congruences in their positions, in that Bruce was deeply hostile to the plutocracy of art and wanted art to be a part of the everyday. His proposed Smithsonian Gallery of American Art was to have been 'a liberal organization', 'not a snobby museum': 'I want it just as different as

58　Edward Bruce, *Industry*, 1932, oil on canvas, 28 × 36 in., Collection of Whitney Museum of American Art, Exchange 34.4.

possible from the Museum of Modern Art which is the little snob which was recently dedicated by the Rockefellers and who have put their dead hand on it as on everything they touch.' He explicitly counterposed his murals in rural post offices to the Mellon-funded National Gallery of Art, which he described as a 'seventeen million dollar Mausoleum'.[34] Localism was part of the Section from the beginning, and was written into the Treasury Department Order setting it up in the requirement: 'So far as consistent with a high standard of art, to employ local talent.' On the wall of his Washington office Bruce had a map of the whole country marked with coloured pins representing projects in different stages of completion. 'Some day, there'll be a pin in every village', Bruce is quoted as saying, and also that he preferred 'one picture in a post office' to '100 in a gallery'.[35] In a key early speech, Bruce argued that '[g]reat art is not an isolated phenomena, but the flowering of a wide movement':

> I want to see the artist in this country of ours cease to be the retainer of a wealthy client, but a useful citizen taking his place as one who has a job to do and service to render. I want to take the snobbery out of art and make it part of the daily food of the average citizen.[36]

This populist rhetoric was accompanied by a distinctly anti-intellectual stance, the implications of which I shall work through in relation to the products of the Section. For the moment, I note only that the 'average citizen' was the ideological projection of a consensual democratic vision that those on the left were bound to contest.

Forbes Watson (1880–1940), whom Bruce appointed as technical director of the PWAP, came from a proper Boston family and had been educated at Harvard and Columbia law school. In 1913 he began a career as an art critic with the *New York Post*, and from 1923 to 1932 was editor of the progressive magazine *The Arts*. Watson had been deeply impressed by the Armory show, and under his direction *The Arts* was a committed champion of modernist tendencies, providing a space for statements and criticism by such artists as Benton, Brook, Dasburg, Hopper, Lozowick, Rivera, Sheeler, Zorach; and writers such as Anita Brenner, Waldemar George and Leo Stein. *The Arts* position was certainly pro-modernist, but several of its contributors were concerned to define an American tradition in the arts and identify its modern manifestations. For Watson, 'to choose a measuring scale in Paris by which to gage the modernity or lack of modernity of American artists can lead only to fallacies.' Artists such as Burchfield, Hopper, Kent, Speicher and Sloan were moderns, who 'breathe with American life'. This was because Americans, as a nation, remained concerned with the subject in art and did not much care for 'pure intellectual theorizing'. Like Bruce, Watson was centrally concerned with 'taste and refinement' – modernism was for him simply the contemporary art that embodied these qualities in an authentic manner.[37] Belief in these aesthetic certainties, together with his commitment to Americanism, made Watson an ideal ideologue for programmes intended to promote a unifying national culture under the auspices of a modernising reform administration.

In analysing the ideology of the Public Works of Art Project, I draw mainly on a sequence of articles of by Bruce, Biddle and Watson published in the *Magazine of Art*, the organ of the American Federation of Art (AFA), in 1934.[38] It is no coincidence that these articles appeared where they did, since the AFA (founded in 1909) was very much a product of progressivism. Consistent with its origins in the urban reform movement, the magazine covered urban and landscape design, as well as offering a wide range of articles on art-historical and contemporary artistic topics. The 'general reader' to whom it was addressed – like that of *The Arts* – was expected to be liberal and cultured. At the beginning of the decade the *Magazine of Art's* editor, Leila Mechlin, commented frequently on the 'ugliness and vulgarity' of contemporary art, which she saw as symptomatic of the cultural degeneracy of modern urban life. However, in January 1931 Mechlin was replaced by F. A. Whiting and thereafter the general tenor changed. The magazine

began to print reviews and articles more sympathetic to modernism by critics such as Dorothy Grafly, who like Forbes Watson found in the American Scene painting of Burchfield and Hopper 'a hearty, healthy, buoyant American art'.[39] Considering the AFA's longstanding commitment to public culture, it is not suprising that several of these contributors regarded contemporary easel painting as too limited in social vision, too domestic in scale and lacking in any sense of art's grander purposes. An appraisal of the Rockefeller Center in February 1933 acknowledged the value of a project that sought to unite so many arts in a common enterprise, but also regretted that rather than being an organic product of American culture, achieved democratically, it was the 'result of a fortune seeking to find monumental expression.' The *Magazine of Art* had effectively articulated the ideal of a democratic, publicly funded art before the New Deal art projects were announced, and may have had some influence on their conception.[40]

Bruce, Biddle and Watson all emphasised that the purpose of the PWAP was not merely relief: it also had a larger spiritual end, and was a step towards a far more expansive connection between government and the arts than had been known in the American polity hitherto. This new relationship was necessary because of the failings of the art market, not just in the current Depression, but in a much longer historical perspective. Watson in particular attacked what he described as a kind of star system in modern art fostered by the dealers, which perpetuated an unhealthy distance between artists and their audience. In fact this was not a new theme in Watson's writings, and as early as 1927 he had expressed concern about the development of an art oriented to 'strictly painting ideas' that could only appeal to 'a highly specialized public'.[41] The dealer system encouraged a kind of 'coarse-grained' showmanship, and was unfair to those who were not stars, and yet who were condemned to produce on speculation for an uncertain market. By contrast, the PWAP gave the artist a steady job paying workman's wages, thereby raising him to the 'dignity of the artisan'.[42] In a more extreme statement, delivered as an address at the AFA Convention in May, Watson attacked the excessive emphasis on individual personalities in the evaluation of earlier art and the corrupting effects of the market. More specifically he denounced the 'highly artificialized French art market', which promoted a 'decadent experimentation' that bespoke an attitude of solipsistic individualism. The art world had actually benefited from 'the cleansing waters of the depression', and now the PWAP was transforming the

artist from 'an arrant individualist' into a 'cooperative worker.'[43] To think that art could only be produced by a few geniuses was snobbism. In a democracy 'the life of the spirit may quite well be carried on by men whose names will not go down permanently in history.' The corollary to this social critique was both a swing from 'intellectual' to 'representational' art and a different conception of quality. The government's aim was not to sponsor masterpieces but to bring the artist 'into far closer touch with his community and thereby into closer touch with American life.' This could only result in a far deeper interpretation of American life in art.[44]

Biddle was more explicit in suggesting the social and political parameters of federal art than either Bruce or Watson. Not only were his convictions more to the left of the New Deal spectrum, but with no formal attachment to the administration he could afford to take a more radical stance. He too complained of the 'divorce of art from life', tracing the roots of this situation back to the late sixteenth century, since when the artist had lived 'very literally' 'in a state of prostitution.' The great mural art of the late Middle Ages had appealed to all classes with equal intensity because it had a common unifying theme. In the period of class antagonism and ideological conflict from which Western civilisation was emerging no such art had been possible. But now there was a new model in the Mexican Mural Renaissance, which showed what could still be done when artists with profound ideological convictions came together with a sympathetic government. Like Watson, Biddle characterised 'the social trend' of modern French art – 'the best art of twenty years ago' – as 'aristocratic, and essentially asocial.' However, the outlook of artists was changing. Instead of aesthetic problems and individuality, 'the best American art of today is not only conscious of life, it is deeply preoccupied with social problems.' The administration's recognition that it had an obligation to maintain art through the Depression marked the beginning of a new era. 'In the sphere of economics the old capitalistic idea of the vendibility of goods depending on the existence of a free market is being substituted by the idea of production according to serviceability.' (Biddle had clearly misunderstood the import of the NRA.) Such thinking was being extended to art through the PWAP, with 'serviceability to the community' becoming the new criterion of value. Artists should not fear the accusation of propaganda and neither should government. Indeed, as in the USSR and Mexico, the administration should use artists 'to educate the public to the new conditions of social life'.[45] Being more politically realistic, neither Bruce nor Watson wished to use the projects to propagandise openly for the administration, but it is none the less clear that the art they sought to promote was consonant with the ideology of the New Deal in certain key respects.

All three made much of the democratic character of PWAP patronage. In an article of March 1934 Bruce claimed that while in the past patronage was at the whim of some individual, an aristocrat or oligarch, in America 'a great democracy has become the patron of its artists', and this democracy had 'selected a group of the most competent people . . . to select the artists who will receive this patronage.' With the proviso that the art commissioned should be 'the American scene in all its phases', 'complete freedom was granted to the regional committees in the selection and employment of the artists.' Hidden behind these generalities was the Advisory Committee on Fine Arts to the Treasury that Bruce himself headed, and which had picked the chairs of the sixteen regional committees that ran the PWAP. I say 'hidden' but I do not mean this in a literal sense, since Watson had already explained in an article in January that the appointment of these chairs was 'endorsed by the directors of a dozen museums voting with the committee', and listing many of the personnel involved. Rather I mean 'hidden' in an ideological sense in that both assumed that what Watson described as committees 'made up of eminent museum directors and other distinguished members of the community actively interested in the advancement of art' were qualified to act as representatives of the American people because they had 'already proved their soundness of judgement and lack of bias.'[46] One might ask: by whose criteria? That is, the unquestioned assumption that such unrepresentative figures were qualified by their social status and professional experience alone obviated the need for any further form of democratic consultation – and specifically excluded artists themselves from any role in higher decision making. Such assumptions are fundamental to the ideology of that technocratic elite that imagines itself as selflessly dedicated to the national interest, and which Ralph Miliband identifies as central to the business of the state in bourgeois democracy.[47]

Reporting an exhibition of PWAP art at the Museum of Modern Art in November, Watson observed: 'In general the precious were antipathetic, realizing that the Public Works of Art Project was an attack upon them just as, in a broad way, the entire Public Works Administration is an attack upon the privileged.'[48] Presumably the 'precious' were hostile because of the democratic and popular character of the works. Back in March, Bruce had claimed that the art produced for the PWAP had 'a

fine quality of naturalness', which marked it as a 'native product.' While it was 'amazingly free from isms and fads and so-called modern influences', most of it was 'modern in the best sense': that is, it was an 'expression' by the artists of their reactions to 'the world around them.' Watson's characterisation of PWAP art was more sophisticated. He emphasised that 'freedom of expression' was the 'corner-stone' of the Project, associating it with the spirit of the Society of Independents' jury-free exhibitions, and he and Bruce both insisted that academic thinking should set no limits to the definition of public art – a significant point considering the status of the National Academy of Design and the power of academicians in the Commission of Fine Arts, which had federal authority in relation to the decoration of official buildings. The impartiality of the regional committees was the guarantee of this freedom of expression.

Both Watson and Bruce were drawing on that conception of Americanism in the arts which had been formulated in the previous decade in *The Arts*, according to which 'realism' was a national tradition, deeply rooted in American culture.[49] They also could have felt they were in tune with a widespread belief among critics that the era of 'art for art's sake' was over, and that the new trend was for 'art in the service of programmatic ideas.' However, it is worth noting that the exponents of this Americanism in the *Magazine of Art* wished to dissociate themselves from self-conscious nationalistic posturing of the Thomas Craven ilk, or from a belief that there was some intrinsic value in particular subjects: 'if we can create an art worth talking about it will not be because we possess factories and prairies and elevators and the rest of Americana, but because we are so fortunate as to possess artists.' Modernist aesthetics had been accepted to the degree that any Americanism would only be of value if it was pictured in a way that was significant in formal terms. Moreover the Americanism of the PWAP was liberal and pluralistic, it was not to be a narrow and xenophobic nationalism.[50]

The Public Works of Art Project was a product of the First New Deal, a phase in which the administration continued the managerial liberalism begun under Hoover, but pushed it much further and faster so that it was in effect qualitatively transformed. It seemed as if a new 'administrative state' was in the making, to borrow Alan Dawley's phase. New Deal ideologues such as Rexford Tugwell, Raymond Moley and Henry Wallace wished to use the power of the state to regulate corporate capital so as to achieve greater stability and order and thereby alleviate gross inequality. Like many

liberals, they were convinced that only social planning could save capitalism.[51] However unsystematic and embryonic, the statements by Bruce, Biddle and Watson I have been looking at rest on cognate assumptions about the failings of the market and the need for state intervention to manage production. There is no suggestion in them that the PWAP was impermanent or expedient, rather it seems to have been assumed that the state should from then on take a role in promoting the arts. Fused with these managerialist assumptions – and bolstering them in some degree – was a critique of the art trade that probably had its roots in Ruskinian criticism. This ideology betrayed the same contradiction as other forms of liberal managerialism in its simplistic identification of the bourgeois state with democratic expression.[52] The managerialists' unproblematic conception of a common national interest found a corollary in the PWAP concept of a unifying Americanism, that yet was somehow to be expressive of the rich variety of American communities.

As I shall show in Part II, Holger Cahill, the director of the WPA Fine Art Project, recast the ideology of federal art more in the spirit of the Second New Deal, thereby giving it greater coherence and a more radical cast. However, this could not resolve the central contradiction that the unitary culture projected by the ideology was belied by the massive and irreconcilable divisions within American society. These divisions were symbolised in complex and often indirect ways in the wide array of competing tendencies within the artistic field, and the central aim of Communist artists was, of course, to use art to define and differentiate some of them. When the administration of the projects was sufficiently flexible, various styles and ideological commitments could be accommodated under the principle of a democratic pluralism, although conflicts inevitably occurred. Further, during the Democratic Front, when the CPUSA explicitly espoused a form of Americanism itself, there was a significant overlap between the ideology of federal art and Party discourse. In the Third Period, however, when the New Deal was still seen by the Party as a fascistic initiative and all forms of nationalism were interpreted as cloaks for reaction, federal art was a much more problematic issue. Among innumerable visual and verbal attacks on the administration in 1934, *New Masses* commented on the PWAP:

> Altogether, this CWA plan exposes the perennial bourgeois piffle about 'pure art', 'self expression', 'art for art's sake', etc. . . . Now that it is clear to everyone, even artists, that capitalism is decaying and that NRA is a flop, our affable dictator is attempting to bribe the

molders of public opinion and channelizers of mass emotion with pitifully small handouts from the Federal Treasury.[53]

Despite this official posture, many leftist artists were attracted by the PWAP, if only to secure some source of income, and were thus obliged to consider the projects in more complex, or at least more practical, terms. The institutional base for Communist engagement with the PWAP lay in the Unemployed Artists' Goup and the Artists' Union, and it is to these I now turn.

The Artists' Union

Thanks mainly to the outstanding research of Gerald Monroe, the history of the Artists' Union is one of the best-known aspects of the 1930s art scene. At the time Monroe was writing his doctoral thesis (1971), many of those who had been active in the union were still alive and willing to be interviewed. The testimony he collected gives his account a vividness that is difficult to match, and which was only partially translated into the several articles he published on the subject. It would be pointless to recapitulate Monroe's comprehensive history, and my aim here is primarily to consider the relationship between the union and the Communist Party – fortunately an issue to which he gave careful consideration.[54]

The Artists' Union began as the Unemployed Artists Group (UAG) within the John Reed Club in the summer of 1933. It was reportedly initiated by the executive board of the club at the prompting of the Party's Cultural Committee. The leading figures included Phil Bard, Bernarda Bryson, Boris Gorelick, Balcomb and Gertrude Greene, James Guy, Ibram Lassaw, Michael Loew, Joseph Pandolfini, Max Spivak and Joseph Vogel. Of these, Bard, Gorelick and Spivak (who were members of the four-man executive board) and Bryson, the general secretary, were all Party members. The UAG was given a focus by the cultural programme of the Emergency Work Bureau of the Gibson Committee, which between December 1932 and September of the following year spent about $26,000 giving employment to around 100 artists.[55] Its first appearance as 'an organized body' was at a meeting of unemployed artists at the New School for Social Research on 27 October 1933 that had been arranged by Audrey McMahon of the College Art Association. Speaking from the floor, Bard called for the state to pay all artists a living wage and permit them to work in their own studios or, alternatively, to buy their completed works. In reply, Frederick

I. Daniels, the executive director of New York State's Temporary Emergency Relief Administration, expressed his personal sympathy for artists but otherwise made only vague promises.[56]

In the aftermath of the New School meeting, the UAG put out an 'open invitation' to all artists to 'join its ranks', and began the formation of an Artists' Council – an umbrella organisation, which claimed to represent eight bodies, including (improbably) the American Society of Painters, Sculptors and Engravers, the College Art Association, the National Academy of Design and the Whitney Museum. The object of the Artists' Council was 'to secure the means of existence for art and artists'. At its second meeting it drafted a petition, to be sent to Harry Hopkins, Frederick Daniels and Mayor La Guardia, calling for a programme of mural and sculptural decoration for public buildings; a federal purchasing programme that would lead to '[p]ermanent and travelling exhibitions of works in public schools, libraries, hospitals, rural districts and in all public buildings'; and a programme for the teaching of arts and crafts. How very nearly the WPA Federal Art Programme approached this conception will be evident from the section on the art projects in this chapter, and a footnote to the UAG statement in *Art Forum* claimed 'some of the ideas' in the plan had already been incorporated in the PWAP. The Artists' Union was later to claim that the setting up of the PWAP was the result of UAG pressure, but this seems unlikely.[57]

Once the PWAP was operating in New York, the UAG turned its attention to its administration, which was headed by the imperious personality of Juliana Force, Director of the Whitney Museum. Force infuriated the UAG both because she ran the New York region project more according to the principle of quality than that of relief and also – it was claimed – favoured artists with an established connection to the Whitney. Her high-handed treatment of UAG delegations did not help matters either. In protest, the UAG picketed the museum on 7 January 1934, and on eight further occasions between 15 February and the end of March. These demonstrations received quite a lot of press coverage, partly because Bernarda Bryson – who had worked as a journalist – called up the *New York Herald Tribune* and other papers in advance. Whatever their effectiveness in relation to the running of the PWAP, the UAG's campaign caused Force to close the museum six weeks before the end of its normal season.[58]

As many have testified, the picketing and confrontations with the police all contributed to the *esprit de corps* among artists, and in February of 1934 the UAG

transmuted into the Artists' Union and rented a loft on West 18th Street as its headquarters. By the autumn of 1934 its membership had passed 700, and this more than doubled after the start of the WPA Federal Art Project in the following year.[59] In the spring of 1935 it approached the AFL for affiliation, but it did not achieve true union status until the beginning of 1938 when it renamed itself United American Artists, and became an affiliate of the United Office and Professional Workers of America (CIO). According to its constitution, the purpose of the union was 'to unite all artists engaged in the practice of graphic and plastic arts in their struggle for economic security and to encourage a wider distribution and understanding of art.' However, although the constitution described it as 'a non-political, non-sectarian trade union', it insisted that 'private patronage cannot provide the means to satisfy these needs in this period of grave economic crisis', and called on the government to fulfill its obligations to artists as *unemployed workers* (my emphasis) by hiring them 'at professional trade union wages'. Other statements were rather less circumspect. In late 1934 the union reiterated that it was not aligned with any political party, while simultaneously asserting that 'The artist is one with the power that will transform this old and decadent world which holds nothing of hope in it into a new world where the artist, one with all workers, will be able to "function freely, aided by the wise appreciation of his fellow citizens."' This is of course the familiar cultural rhetoric of the Third Period, and a union contingent marched alongside contingents from the John Reed Club and Pen and Hammer at the 1934 May Day parade.[60]

Monroe has established through interviews with survivors that the leadership of the union was made up mainly of Party members and fellow-travellers. This does not mean that it was simply Party run, and 'decisions were made by the executive board and ultimately by the membership at the well attended Wednesday night meetings.' Party membership was not openly discussed, and influence was exerted through the established Communist procedure of a clandestine fraction, which met secretly to plan strategy. Not everyone on the executive was a member of this. Moreover, even some of the Party members balked at the rigidities of Leninist discipline. The freethinking Bernarda Bryson, who had joined the Party while she was still working as a journalist in Ohio, found herself brought up on charges for recommending Trotsky's *History of the Russian Revolution* to an aspiring convert, and deeply resented being told not to recognise Socialist Party members and Lovestoneites when they tried to speak

from the floor at meetings she was chairing. She found the 'people from 13th Street' 'insufferable' and quickly left. Max Spivak, another member of the initial executive, found himself branded as a 'Trostkyite' because of infractions of Party discipline. While Lee Krasner, who had been a Party sympathiser, began to read Trotsky as a reaction to being abused with the same term by a small group at one of the Wednesday night meetings. As Monroe has pointed out, it is symptomatic of the philistinism of the Party leadership that it should appoint an up and coming activist with no especial knowledge of the arts as its cultural liaison, and the high-handed manner of such dignitaries was deeply alienating. Having said all this, the coming of the Popular Front probably mellowed the Party's stance in the union, and Monroe claims that the number of 'registered Communists' within it rose from about sixty in early 1935 to 'approximately 500' at the start of 1939. In this period the fraction began to meet less frequently, and in early 1939 it was disbanded. Although the Party presence in the Artists' Union has to be taken into account, it is important to register that the bulk of its membership supported Party positions on state patronage, social security and anti-fascism out of a reasonable belief in their rightness and not because of some blind obeisance to a Party line. Party members doubtless did a lot of the tedious organisational chores but they could not provide the convictions that gave the union its energy and effectiveness.[61]

It was this collective enthusiasm and the identification with other workers that made union members such an active presence in demonstrations and on picket lines. In 1934–5 many of these were directed at the College Art Association (CAA), which administered the New York City Art Programme, first under the auspices of the Civil Works Service and later under that of the New York State Temporary Emergency Relief Administration.[62] A mass picket outside the CAA offices, after Audrey McMahon was appointed Regional Director of the WPA Federal Art Project, led to eighty-three artists and art teachers being arrested and spending a night in police cells.[63] Demonstrations were also directed at Mayor La Guardia and the city government by the Artists' Committee of Action to try and secure a Municipal Art Centre that would provide New York artists with a permanent gallery, as well as lecture and studio spaces. This organisation had emerged from the groups that came together to protest against the destruction of Rivera's Rockefeller Center mural and worked closely with the Artists' Union. It was a chaired by Gellert, and its main activists seem to have been members of the John

Reed Club – although its political complexion was partly concealed by an Advisory Committee that included John Dewey, Lewis Mumford, Lincoln Steffens and Alfred Stieglitz. By May 1934 it claimed more than seven hundred artists in its ranks.[64] Finally, artists joined picket lines in support of other workers, as in December 1935 when several were arrested outside May's department store in Brooklyn and held on a charge of conspiracy.[65]

The union was not a dour political organisation. While it did important work in building a leftist subculture among artists that was the basis for collective mobilisation, it was also a meeting place for those living on the edge of destitution to share their experiences, an organiser of dances and parties, and an important exhibition centre. Many of those who were members recalled the intense camaraderie it generated.

The Union Critique

The leading spokesperson for the union in the years 1934–5 was undoubtedly Stuart Davis, who became its president in 1934. I considered Davis's credentials as a Marxist in an earlier chapter. With these in mind I now turn to his statement 'The Standpoint of the Artists' Union', which appeared in the *Magazine of Art* in August 1935. As I noted, the administrators of the PWAP had sought to differentiate the project from the spirit of patronage, and Watson in particular had used the image of a corrupt market system in art (especially associated with France) as a foil to set off its virtues. As a Marxist, Davis approached the situation of the artist in class terms, and set out to give 'a factual description' of the 'social-economic relation of the artist body to society'. He began by stressing the artist's unavoidable dependency on bourgeois patrons who shared a broad middle-class culture, thus whether 'he' was 'an individualist, progressive or reactionary, in his painting theory' he had to work with 'a subject matter acceptable' to that culture, and market 'his product through channels' the bourgeoisie had established. The artist was exploited by patrons, dealers and museums alike, and the dealer system profited everybody but the artist. In addition, artists, like other sectors, were suffering from 'the chaotic conditions in capitalist world society today.' Abandoned by both patron and dealer, they were now forced to recognise their kinship with other workers: '[t]hrough their struggles in the Artists' Union the members have discovered their identity with the working class as a whole'. As a result they had

developed a new morale, which the 'efforts of the administration and its agents' was unable to break. The corollary to this insistence that the artist's condition could only be understood in relation to that of all society was the assertion that: 'A work of art is a public act', and a product of the artist's 'whole life experience' as 'a social being'. Consequently, exclusive definitions of quality by one or another group were static and invalid, for they did not recognise the complex potentialities of social development: 'The Artists' Union is initiating artists into a new social and economic relationship, and through this activity a quality will grow.'[66] 'The Standpoint of the Artists' Union' was a coded message, and Davis's position was stated in unequivocally Marxist terms in his private notes of that year. Further, in the genteel pages of the *Magazine of Art* Davis was restrained; in those of *Art Front* he took his gloves off.

From the standpoint of the Artists' Union relief measures were always inadequate (in actuality they were), and in themselves were never enough. As the first issue of *Art Front* announced, the union wanted a permanent federal art project. In the short term, however, it wanted artists to have not only better and more secure pay, sick leave and proper vacations but also complete control over their work. It particularly directed its attacks against the Municipal Art Commission, which had rejected mural designs by Ben Shahn and Lou Block for the Riker's Island Penitentiary, commissioned under the auspices of TERA. In July 1935 *Art Front* complained:

> The murals designed for public buildings by artists of the Public Works Division seem to meet approval in inverse order to their social and artistic worth. The few most significant designs have been turned down altogether. Of those accepted, recommended changes, deletions and 'suggestions' have brought the work to a state approaching vacuity before it could be executed.[67]

This being the union's position, it was hardly likely to look favourably on the tightly controlled administration of the Treasury Section. From the beginning it objected to the principle of giving out 'a few highly paid jobs on the undefinable basis of merit' when so many artists were in dire need, and it also recognised that the competition system would mean many artists expending time, effort and materials without reward: 'No artist, if at all realistic, will tolerate this denial of the principle that a man must be paid for his labor.'[68]

The occasion of Davis's main critique of the Section was an article by Forbes Watson, titled 'The Chance in a Thousand', of August 1935. In characteristically airy

prose, Watson accused artists of over-production and argued that the normal rules of supply and demand did not apply in the art market because '[s]uccess in the selling of art depends to a disproportionate extent upon the fame of the painter or sculptor.' The romantic appeal of art meant that '[t]he number who attempt to become artists has no discernible ratio to the demand for art', and the hierarchies within the artistic field caused many to attempt works ill-matched with their abilities, particularly in the area of mural painting. By contrast with the 'highly colored, overcrowded, bitterly disappointing competitive world' in which artists had been enmeshed, the Treasury Section offered a fair competition system in which impartial committees judged anonymous entries. Although there could be only one winner in each competition, those who did not win but demonstrated ability would be 'placed upon a list of future possible appointees.' The system gave artists 'a real chance' instead of a 'one-thousand-to-one' chance.[69]

Davis's brilliantly acerbic response focussed on the issues of quality and expert authority. He pointed both to Watson's patrician assumptions that authorised him to judge who was an artist and who was not, and their corollary in the appointment of regional committees made up of non-artists. In sum: 'Watson is resourceful in finding various angles from which to show his scorn of the artists as a class.' Moreover there was a continuity between Watson's disdain for the 'heterogeneous mob' of those who 'insist that they are artists', and the attacks on artists as 'Hobohemian Chiselers and Squawkers' that appeared in the reactionary Hearst press. Watson's paternalism was only a more calculated version of the same attitude, since for him the government was 'a kindly father' who had granted the artist 'the right to work at a smashed trade-union wage scale.' Citing Bruce, Davis claimed the Section was conceived as a palliative to revolution: 'if the Section brings art to the people, a sufficient distraction from the irritation of material deficiencies will be effected to offset possible protests of an annoying character.'[70] It will be clear, I hope, that Davis's position is entirely consonant with the larger position of the Communist Party on the New Deal prior to the People's Front.

Not surprisingly, Watson, who had attended an Artists' Union meeting at the beginning of the year and wrote a very positive appraisal of the February *Art Front*, became increasingly critical of Communist artists and in November described Davis as a 'Red'.[71] In fact, despite the element of truth in Watson's statements, Davis had identified their inconsistencies around the category of the worker. Taking the position of the prop-

ertied, Watson assumed that government demonstrated its benevolence through relief employment. Taking the position of a worker, Davis assumed that the government was simply an extension of the capitalist class being forced to make concessions by the organised working class. Any claims workers made against the government were justified since the bourgeois state was only a transitional arrangement. Moreover, Watson claimed quite wrongly that in employing artists as wage labourers the state conferred on them 'the dignity of the artisan', whereas actually their situation in the art market was more truly artisanal, albeit mediated through complex relationships with dealers who acted as middlemen. Watson implied that artists were effectively moving from an exploitative relationship to a non-exploitative one. Davis saw quite clearly that artists were exchanging one exploitative relationship for another.

Communists in the Public Works of Art Project

Helen Harrison has claimed that the John Reed Club artists 'responded enthusiastically' to the setting up of the PWAP, and that many of them 'sought to use it as a vehicle for the exhibition of support for the broader policies of the New Deal.'[72] It is true that numerous left-wing artists worked for the project in New York and elsewhere, and that some wrote letters to the administrators thanking them for their efforts. However, this is not the whole story, and against it needs to be set the complaints several left-wingers made about the incompetence and prejudice of project administrators, and the dissatisfaction expressed by administrators with the attitude of some of those with John Reed Club connections.[73] Harrison interprets Artists' Union protests in New York as being directed against the regional director, but this underestimates the ambitions of its members, who, according to the union spokesperson Bernarda Bryson, aimed 'to use the salaries CWA and PWA provide us for the encouragement of artistic propaganda against the existing system.'[74] It also ignores the fact that both the New York Artists' Union and the Artists and Writers' Union of California sent in radical demands for the reformation and continuation of the PWAP that are entirely consonant with CP policies on welfare and employment provision. Significantly, among the New York union's stipulations was an end to the requirement that artists sign an oath of allegiance before they could begin work.[75]

Moreover, Paul Meltsner and Maxwell Starr, the artists whom Harrison cites to exemplify those who produced murals affirming the New Deal, do not appear in records of club activities apart from exhibition catalogues, and may not have been members at all. Neither showed with the club before the *Social Viewpoint in Art* exhibition, and while Meltsner contributed one work to *Revolutionary Front – 1934*, Starr did not show again. Although both had joined the American Artists' Congress by February 1936, neither were signatories of the initial call in the previous year. Most tellingly, in contrast to their murals is the significant body of more critical work produced under PWAP auspices.[76]

Only a part of the records of the PWAP survive,[77] and in any case the project was too large to consider as a whole in this context. Here I shall discuss a few of the works produced by artists associated with the John Reed Club or *New Masses* for the New York region, the famous Coit Tower episode and the *National Exhibition of Art by the Public Works of Art Project* that was its most public manifestation at a national level.

NEW YORK PWAP

The published report of the PWAP asserted that the programme was designed to give artists 'the largest measure of freedom of expression and practically complete freedom to employ the medium best suited to their use' within the general area of 'The American Scene'. It further claimed that this thematic imperative accorded with the 'new nationalistic movement in our art' which was 'already at its height' before the project was set up.[78] As I have shown, a large part of the art shown at John Reed Club exhibitions was either urban genre or images of labour, and the continuum between this and American Scene painting had been a cause of complaint among proponents of revolutionary art. It is not surprising therefore that JRC exhibitors such as Mark Baum, Maurice Becker, Joseph Biel, Moses Oley, Louis Ribak and Isaac and Moses Soyer produced what seem to have been urban genre and views for the PWAP; or that Evergood, Hoffman and Lozowick produced images of labour. Nor need they have felt there was any betrayal of principle involved, since in some contexts such images could seem politically charged.

Others were more overt. Thus we find Nicolai Cikovsky submitting three oil sketches in his usual impressionistic style on the theme of 'Union Square – during the period of depression', one portraying a meeting (fig. 59), and two showing 'a statue of Lincoln [,] starving workers gathered around it.' Cikovsky hoped

59 Nicolai Cikovsky, *Union Square – During the Period of Depression*, 1934, oil on canvas, 20 × 16 in., whereabouts unknown.

60 Hendrick Glintenkamp, *Traffic – 7th Avenue Subway*, 1934, wood engraving, 7 × 5 in., Sheldon Memorial Art Gallery, University of Nebraska-Lincoln. UNL – Allocation of the U.S. Government, Federal Art Project of the Works Progress Administration.

these might be the basis for a mural, but in the event was only commissioned for a lithograph. Henry Glintenkamp, who also submitted sketches for a mural on themes of contemporary New York (including one depicting demonstrators titled 'Down with Imperialist War'), ended up making three woodcuts of the city. *Manhattan – Fulton Fish Market* is simply a scene of labour, but it pairs with a view of downtown skyscrapers inscribed *Manhattan – Temples of Mammon*, and in between the proof stage of *Traffic – 7th Avenue Subway* (fig. 60) and the final print, the artist smuggled in the *Daily Worker* and prominent hammer and sickle. Pele deLappe produced a street scene openly titled 'Anti-War demonstration at the Battery', while Chuzo Tamotzu submitted an oil on the theme of 'Anti-War.' Innocuous sounding titles could also disguise politically loaded images. Joseph Pandolfini's *Composition*, which he claimed represented a 'portion of the the "American Scene" portrayed as objectively as I may', is actually a comprehensive caricature of American justice in which a complacent-looking judge guarded by soldiers with bayonets holds what we may take to be a judgement on the Sacco and Vanzetti case in one hand and a money bag in the other, while death touches his shoulder with a skeletal hand. The foreground is occupied by a throng of top-hatted figures clutching money bags, counterposed to the mingled black and white workers on the right, and a sign signifying a sheriff's sale to the left. This cannot have been the American Scene Bruce had in mind.[79]

One especially interesting instance of politically motivated work being done within the project is provided by Philip Reisman. Having produced a New York scene on the theme of window dressers between December and February, Reisman asked in March if he might make 'a portfolio of twenty drawings, watercolours and gouaches, depicting the significant types, occupations, and landscapes, both rural and industrial, of the South', on the basis of a planned car journey through the region. The proposal (which was accepted) sounded like a contribution to the American Scene, but the etching *South* (fig. 61), which was produced in addition to the portfolio, is a conspectus of Southern oppression, incorporating cotton pickers, a chain gang, and a Ku Klux Klan lynching. Appropriately, it was shown at the JRC's *Struggle for Negro Rights* exhibition in the following year.[80]

At least one mural sequence with a leftist iconography was painted under the New York PWAP. The African American artist Aaron Douglas openly declared his Marxism and his admiration for the USSR in an inter-

61 Philip Reisman, *South*, 1934, etching and drypoint, $8^{13}/_{16}$ × $11^{13}/_{16}$ in., Metropolitan Museum of Art, Lent by the United States Government (Public Works of Art, Project, New York, Regional Committee), 1934. (L 3361.30).

view with the *New York Amsterdam News* in November 1934, although the paper advised that the influence of Marx would hardly be suspected in the four 'delicately beautiful' panels of his *Aspects of Negro Life* (Countee Cullen Branch, New York Public Library), if the artist had not advertised it. Douglas declared that he had been 'bolshevized by conditions', and emphasised the difference between this and his previous murals, causing his interviewer to acknowledge that 'in almost every panel there is some touch which reveals the difference between the old and new outlook of the artist.'[81] Indeed, the representation of a lynching to the left of the panel *An Idyll of the Deep South* (fig. 62) was a strong political statement at the time and was apparently disliked by the PWAP administration. Neither were the images of a black political activist (looking distinctly Lenin-like) and of the Ku Klux Klan in *Slavery through Reconstruction* (fig. 63) innocuous, and although they were not specifically Marxist in their connotations, the CPUSA was the most energetic force campaigning on African American issues in the 1930s. There is a predictable emphasis on black musicality throughout the series,[82] which ends with an image of the modern city where the central figure brandishes nothing more militant than a saxophone (fig. 64). The motif can be seen as harking back to the jungle dance depicted in the first panel, *The Negro in an African Setting*, the collectivity of tribal music having been transposed into the individuality of the jazz soloist – a motif that may also stand for the isolation of urban

62 Aaron Douglas, *An Idyll of the Deep South*, 1934, oil on canvas, 60 × 139 in., Schomburg Center for Research in Black Culture, Art & Artifacts Division, New York Public Library, Astor, Lenox and Tilden Foundations.

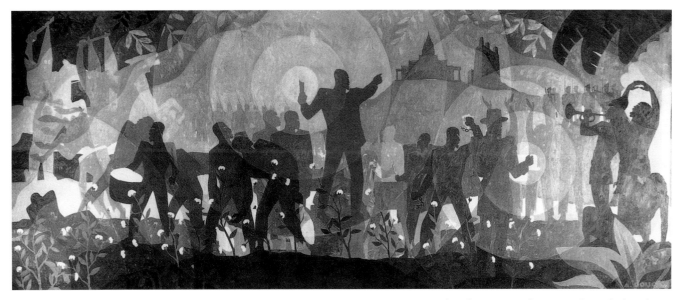

63 Aaron Douglas, *Slavery through Reconstruction*, 1934, oil on canvas, 60 × 139 in., Schomburg Center for Research in Black Culture, Art & Artifacts Division, New York Public Library, Astor, Lenox and Tilden Foundations.

life. But the forces of oppression are also represented here. The migrant with a suitcase entering the composition at the lower right wears ragged trousers and has no shoes, and is pursued by a threatening spectral hand. Moreover, the placing of the Statue of Liberty under the saxophonist's horn is an unmistakably ironic touch. The dejected figure on the lower left of the last panel makes the series seem to end on a note of defeat, and Douglas

had wanted to paint a fifth composition that would show the Marxist solution to Negro problems in the united struggle of black and white workers, but felt the PWAP administrators would have rejected the whole project had he proposed it. He described the murals as a 'folk drama of Negro life', and the calculated Africanicity of his style was a characteristic device of the Harlem Renaissance. Considering the Communist Party's view

64 Aaron Douglas, *The Song of the Towers*, 1934, oil on canvas, 9 × 9 ft, Schomburg Center for Research in Black Culture, Art & Artifacts Division, New York Public Library, Astor, Lenox and Tilden Foundations.

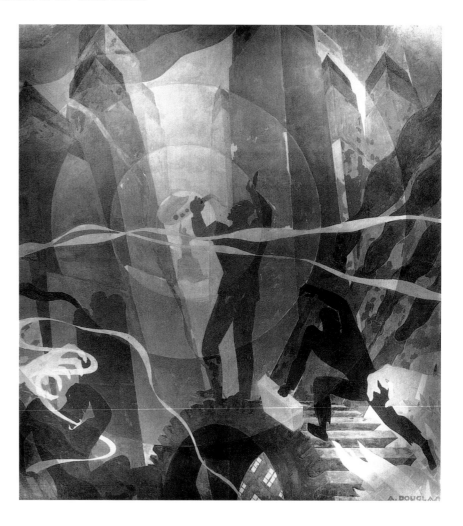

of African Americans as a subject nationality, and the interest of its cultural critics in 'Negro Songs of Protest', the formal and narrative conception of Douglas's mural may have matched better with Communist views than the *Amsterdam News* realised. Yet it must also be acknowledged that the Egyptianised style of the figures and the pastel colours do not correlate well with the muscular rhetoric of proletarianism.[83]

The ambiguities of left-wing art produced within PWAP were also in evidence in the most controversial mural sequence commissioned under the programme, to which I now turn.

THE COIT TOWER MURALS

The Coit Tower murals in San Francisco were destined to be a publicity symbol for the PWAP if for no other reason than the sheer scale and unity of the programme.[84] Painted for the most part in true fresco, they comprised 3,691 square feet of murals executed by twenty-six artists and nineteen assistants. Fortunately, mural painting in the Bay Area has been the subject of a major study by Anthony Lee, on which I draw heavily in what follows.[85] Conceived as a monument to a San Francisco benefactress, Lillie S. Coit, the Coit Tower stands atop Telegraph Hill overlooking the bay. The structure comprises a reinforced concrete tower of 180 feet in the form of a fluted column, resting on a base of 32 feet. At a meeting in December of 1933, shortly after the tower was completed, Regional Committee 15 of the PWAP, headed by Walter Heil (director of the California Palace of the Legion of Honour), decided on an ambitious plan to decorate the first and second floors. The frescoes were begun in early January and mainly completed by April, although some artists continued to add finishing touches into June.

Lee has argued persuasively that Rivera's two main California mural commissions of 1931, the *Allegory of California* in the City Lunch Club and *Making a Fresco* in the San Francisco Art Institute, offered leftist artists in

the Bay Area a crucial example of how to remodel the form of the public mural for new political ends. Within the quite severe constraints of available patronage and the nature of any potential audience, two artists in particular addressed this project, namely Victor Arnautoff and Bernard Zakheim. Arnautoff (1896–1979) was a leading figure among the radical element in the city's Russian colony, and Zakheim (1896–1988) a Jewish socialist of Polish extraction who, with his friend the poet Kenneth Rexroth, worked to organise its radical bohemia in the late 1920s.[86] The pair met in Mexico in 1930, where both had gone to study Rivera's work. Back in San Francisco they became a focus for those interested in the example of his art.

In 1933, Rexroth and Zakheim, together with Frank Triest, set up an Artists and Writers' Union in San Francisco. It may be, as Lee claims, that the relatively liberal strategy of the California Communist Party under Sam Darcy's leadership permitted a more latitudinarian cultural policy in the state,[87] but, as I have shown, the New York Artists' Union was hardly subject to Party discipline, and given the composition of its membership could not be. Thus when the San Francisco union held a meeting at the Coit Tower to protest against the destruction of Rivera's Rockefeller Center mural in February 1934 it did nothing out of the ordinary for a CP-sponsored organisation. Although Rivera's personal relations with Bay Area artists may have fed the feelings behind this, the protest was part of a national campaign in which the New York John Reed Club was also active.

Given the Communist connections of Zakheim and Arnautoff, it seems surprising that the conservative Regional Committee of the PWAP should have selected them for key roles in the Coit Tower decorations. None the less, Zakheim was allotted the overall conception and Arnautoff was charged with supervising the execution. The Committee may have thought that it could control the artists (most of whom were not radical anyway), and it could not have foreseen in December 1933 how the events leading up to the San Francisco General Strike in July would add an entirely new charge to Riveraesque public art, or serve as an incitement to radical artists to introduce contemporary references into their imagery.[88]

The struggle among the rank-and-file of the International Longshoremen's Association (ILA) and the conservative AFL leadership, waterfront employers and the city's business establishment had been going on since September 1933 when the National Labour Board had ruled that ILA members could not be fired for union membership. But it was not until May 1934 that the failure of the employers to negotiate seriously with the ILA led to a massive strike in the Pacific ports, which sparked off walkouts by other maritime workers. In dockside battles with the San Francisco police and National Guard on 28 May and 3 and 5 July, which spread from the Embarcadero up Telegraph Hill, many pickets were wounded by gunfire and four were killed. During the general strike of 16–19 July, the mayor proclaimed martial law and the National Guard was deployed with machine guns, tanks and artillery. Throughout the strike, the AFL leadership and San Francisco's business establishment claimed that labour unrest was being fomented by 'communistic agitators' but, in fact, the CP was essentially adaptive to the rank-and-file energies marshalled by Harry Bridges.[89]

It was right in the middle of these events that the PWAP Regional Committee noticed disturbing elements in some of the murals, notably those by Arnautoff, Zakheim and two others: John Langley Howard and Clifford Wight. (Wight was an English sculptor who had worked as Rivera's assistant, and later fought in Spain.) On 2 June Heil sent a telegram to Forbes Watson asking what he should do about 'details such as newspaper headlines and certain symbols which might be interpreted as Communist propaganda' that some artists had added to their designs 'at the last minute'. In a reply sent the same day, Bruce notified Heil that 'the objectionable features [must] be removed'.[90] Meanwhile the tower was closed and its opening to the public delayed. By 4 July the objections to Howard and Zakheim's murals had been dropped, but the Regional Committee continued to insist on the removal of a hammer and sickle emblem from Wight's.[91] Matters escalated as the San Francisco Art Commission expressed its disapproval of the murals as 'in opposition to the generally accepted tradition of native Americanism', and the Artists and Writers' Union organised a picket around the Tower to protest against the censorship and protect the murals from alteration. The conservative San Francisco press inevitably backed the view that 'Communist propaganda' must be removed, although some papers treated the episode as a 'tempest' in a 'teapot'.[92] In August sixteen of the artists wrote to Bruce and Lawrence W. Robert, Assistant Secretary of the Treasury, dissociating themselves from Wight, pledging their loyalty and calling for the Communist symbol to be removed.[93]

What about the murals themselves? Except for the four already mentioned, all the artists involved had produced entirely innocuous scenes of California life, representing themes of agriculture, hydroelectric power,

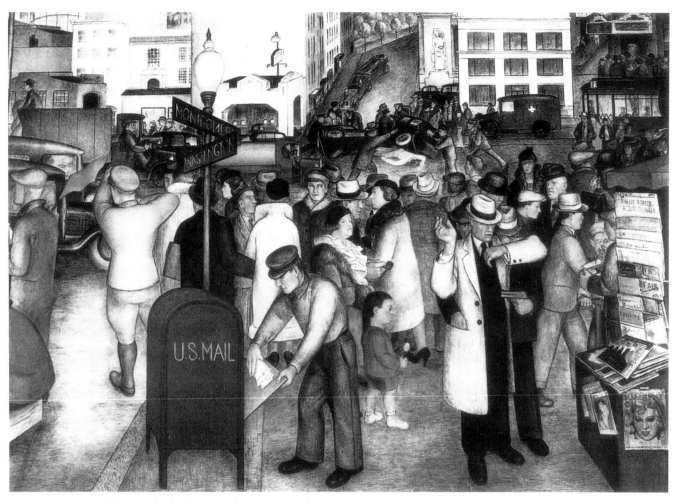

65 Victor Arnautoff, *City Life* (detail), 1934, fresco, 10 × 36 ft, Coit Tower, San Francisco.

dockyard workers, factories, department stores, colle-
giate sports, hunting, recreation and city streets. As was
observed at the time, 'they presented California as pow-
erful and productive, its machines well-oiled, its fields
and orchards bountiful, its people happy in the sun.'[94]
Not only was the style of the murals overtly Riveraesque
in parts but some motifs were directly borrowed. Thus
the clenched fist emerging out of the land in Fred
Olmsted Jr's *Power* derives directly from the over panels
of black and white races in Rivera's *Detroit Industry* –
although it lacks the intimation of anti-imperialist strug-
gle in the latter. Similarly, Ralph Stackpole's *Industries
of California* takes its layout from the main panels of the
north and south walls, but has nothing of the sense of
relentless movement that permeates Rivera's scheme.
Where *Detroit Industry* suggests a Promethean energy,
Industries of California signifies an order in which
science and technology are unproblematically harnessed

for human betterment and labour is a calm and orderly
process. Gordon Langdon provided an equally bene-
ficent image of a modernised agriculture and timber
industry in his *California Agricultural History*.

By contrast, Arnautoff, Howard, Wight and Zakheim
all included motifs that cast some doubt on this con-
spectus of prosperity and harmony, although objections
only seem to have been directed against the last three.
Yet, in fact, Arnautoff's 36-feet-long *City Life* (fig. 65),
which fills the largest and one of the best-lit walls in
the scheme, is like a corrective to the placid bourgeois
world of Lucien Labaudt's *Powell Street*, another
San Francisco street scene. Within a composite of down-
town views, Arnautoff compressed a whole panorama
of types and incidents, some of which suggest the under-
side of city life. Labour is prominently present in the
engineers on the left of the image and market porters to
the right, while in the upper distance is a scene of

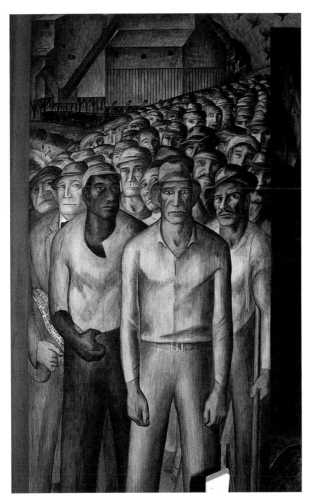

66 John Langley Howard, *California Industrial Scenes* (detail), 1934, fresco, 10 × 24 ft, Coit Tower, San Francisco.

demonstrators, black and white together, who have some resemblance to the workers in *The Internationale* (1928–30; Deutsches Historisches Museum, Berlin) by the German Communist Otto Griebel. Paired with this, on the far right, is a scene of working oilmen and a seated worker who stares confidently out at the viewer. In Howard's image California's industries are emphatically driven by the labour of men (with women performing a supporting role), and the bourgeosie is a ludicrous and pampered excrescence. The style of the work is somewhat naive, but the emphasis on the power of the collective is unmistakeable and effective.[95]

Bernard Zakheim managed to make something even of the unpropitious theme of the public library which he had been allotted in a dark corner of the outer walls. His is a relatively small mural (fig. 67), only 10 × 10 feet, squeezed between a panel of a scientist-inventor type and Susan Scheuer's bland scene of a newspaper office. The reading room interior to the left looks jolly enough, depicting absorbed readers and children with the funny pages from a newspaper, but the composition of the periodicals room on the right is more dynamic and here Zakheim inserted a whole sequence of provocative headlines indicative of both the domestic and international crises: 'Thousands Slaughtered in Austria' (a reference to the massacre of Socialists by the Dollfuss regime in February); 'Moratorium in North Dakota'; 'Home Foreclosures, Banks Refuse US Home Loan Bonds'; 'Oil Magnates Arrested Break NRA Code'. The way to understanding these developments is suggested by the figure reaching for a red bound volume of Marx's *Capital* from the shelves next to the window opening. (Significantly, this figure is a portrait of John Langley Howard.) These shelves contain a wide selection of left-wing authors, including Lion Feuchtwanger, Ilya Ehrenburg, John Strachey, Langston Hughes, Grace Lumpkin, Granville Hicks, Gorky and Bukharin. On the very top shelf a volume labelled Hitler is placed next to one labelled De Sade. By contrast with the absorption of the faces in the reading room, the faces of the three nearest figures on the right suggest a dawning consciousness and resolution.

In the event, however, it was only the murals by Clifford Wight that were actually changed in any particular. His contribution was relatively small, being four 10 × 4 feet panels of 'Leaders of California Life' representing a cowboy, a farmer, a surveyor and a steelworker. While undeniably accomplished as Riveraesque images of worker types, in themselves they are hardly revolutionary (although it is notable that with the exception of the cowboy they are thoroughly modern types –

gasometers and smoking factories. Just left of centre a traffic accident has occurred, and below it in the foreground a man is being relieved of his wallet at gunpoint. The nearest thing to propaganda is the working man to the right of the news kiosk, who stands adjacent to copies of *New Masses* and the *Daily Worker*, but one might also see the red work flag held by the blue overalled figure on the left as a sly piece of symbolism and a riposte to the ticker-tape machine atop the kiosk.

A far more direct threat was intimated by Howard's *California Industrial Scenes* (fig. 66), in which the imagery of hydroelectric power is accompanied with a migrant family camped next to their decrepit Ford. Next to this a group of affluent travellers, looking as if they might have been lifted from an anti-bourgeois caricature in *New Masses*, have alighted from a chauffeur-driven limousine. To the left of the design, the landscape of mining is fronted by serried tiers of sombre May Day

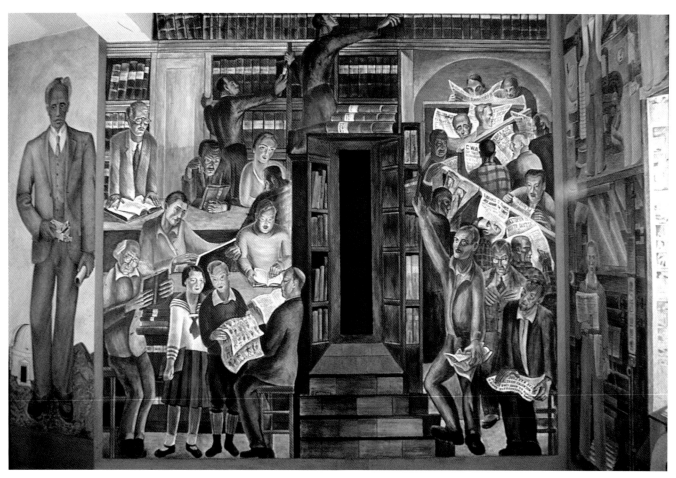

67 Bernard Zakheim, *Library*, 1934, fresco, 10 × 10 ft, Coit Tower, San Francisco.

Wight's farmer holds a wrench, not a pitchfork). As seen today, situated respectively opposite Maxine Albro's anaemic panorama of California agriculture and Stackpole's *Industries of California*, their impassive dignity is wasted. In any case, it was not the figures in themselves that caused alarm but a trio of decorative panels above the three windows framed by the *Surveyor* and the *Steelworker* (fig. 68), for which sketches had not been asked. These we know only from a contemporary newspaper description:

> Over the central window he stretched a bridge, at the center of which is a circle containing the Blue Eagle of the NRA. Over the right-hand window he stretched a segment of chain; in the circle . . . appears the legend, 'In God We Trust' – symbolizing the American dollar, or . . . capitalism. Over the left-hand window he placed a section of woven cable and a circle framing a hammer, a sickle, and the legend 'United Workers of the World', in short, Communism.[96]

Wight denied being a Communist and claimed, somewhat disingenuously, that '[T]he symbol of Communism is in no way an exhortation or propaganda, but a simple statement of an existing condition.'[97] However, he insisted that the window panels were integral to his work and refused to remove them. He was right. Effectively, his three symbols suggested three contending solutions to the present crisis, and the four dignified workers he had pictured beneath could only support the message associated with the hammer and sickle. Bruce did not need to see this first hand. He knew the PWAP could not sponsor the public display of Communism's most potent emblem and ordered the symbolic panels removed, thereby condemning Wight's figures to their present mute condition.[98]

Mild as the iconoclasm at the Coit Tower was when one considers what remained, it became a symbol of censorship within the federal art programmes.[99] It served as a warning that Communist artists would not work

68 Clifford Wight, *Steelworker*, 1934, fresco, 10 × 4 ft, Coit Tower, San Francisco.

with complete freedom as federal employees. Overt Communist symbols were out, and thereafter they would need to adopt more discreet strategies to disseminate their political beliefs. With the coming of the People's Front and the Party's gradual abandonment of revolutionary rhetoric, this became less of a problem.

THE PWAP NATIONAL EXHIBITION

The main public test for the PWAP was the *National Exhibition of Art by the Public Works of Art Project*, held at the Corcoran Gallery in Washington in April–May 1934. Given the scale of the project this was necessarily highly selective, but even so it included more than five hundred paintings, sculptures, prints and craft objects. The most controversial aspect, the public murals, were represented by six sample panels, with a selection of seventy-five photographs of completed murals and panoramas. Since the object of the show was

to convince the Washington establishment that federal funding for the arts produced public benefits, one would expect it to have been a sanitised version of what had been received – as one review commented: 'There would hardly be any bomb-throwing paintings contributed under Uncle Sam's patronage, nor would very many get thru the regional and national siftings that took place before the final group was assembled.' The reviewer contrasted the display with that of the Society of Independent Artists, which had 'any number of radical paintings to delight the scandal-mongers and irritate the Tories', and concluded that 'the PWA artists left their social views out of their pictures'.[100] Ironically, the only work to cause a scandal, Paul Cadmus's *The Fleet's In* (Naval Historical Center, Washington, DC), did so because of its sexual content, which provoked a retired admiral to complain it was a libel on the Navy. Pressure was put on Bruce by the Secretary of the Navy and the painting was not shown – but the incident was widely reported in the press.

Newspaper clippings collected by the project administrators suggest that the exhibition was favourably received by mainstream art critics, and taken to manifest both democratic ideals and the promise of the New Deal. The well respected Emily Genauer observed: 'These are pictures which represent the American scene, art for, by and of the people – designed for their buildings, created by their own artists and depicting their own lives.' While Helen Appleton Read of the *Brooklyn Eagle* claimed that 'a new spirit is immediately felt from the moment the visitor enters the galleries', and said of the murals that '[w]ithout in any case being propagandistic in the derogatory sense of the word, they are a definite brief for a new social order, based on the ideals of a true American democracy.' Interestingly, the exhibition was hailed in at least one union journal for foregrounding images of 'labour and industrial character', which it claimed were preponderant.[101]

The exhibition was also given an offical imprimatur by the president and Mrs Roosevelt, who spent an hour and a quarter in the Corcoran on 23 April selecting thirty-one pictures to be hung in White House offices, six more than Bruce had chosen for them. In a press interview, the president stated that he had been 'greatly impressed by the quality and themes displayed', and 'remarked especially that not one of the paintings has a despondent theme'. '[T]he paintings generally depicted life in a truly American way'. Significantly in the light of future developments, one of the paintings that Mrs Roosevelt added to Bruce's list was Julius Bloch's *Young Worker* (fig. 69), which she reportedly described as a

69 (*above*) Julius Bloch, *Young Worker*, 1934, where-abouts unknown, from the *Washington Post*, 27 March 1934.

70 (*right*) Russell Limbach, *Laying the Cornice Stone of the Cleveland Post Office*, 1934, lithograph, 17⁵/₈ × 12 in., © The Cleveland Museum of Art. Lent by the United States Government, 2536.1934.

71 (*facing page*) Louis Guglielmi, *Martyr Hill*, 1934, oil on canvas, 22 × 32¹/₈ in., Smithsonian American Art Museum, Transfer from US Department of Labor.

'swell picture', 'portraying infinite pathos' and her favourite work in the show.[102]

In fact, it was not the case that artists of the left had no presence in the Corcoran exhibition, and at least thirty of those represented can be so characterised on the basis of their contributions to JRC shows and other evidence. The works by such artists as Oley, Ribak and Isaac Soyer[103] probably just merged in with the general array of urban landscapes and genre scenes, while images such as Russell Limbach's *Laying the Cornice Stone of the Cleveland Post Office* (fig. 70),[104] Evergood's *Report on North River*,[105] or indeed Bloch's *Young Worker*, which might have functioned as symbols of worker's power or solidarity in the context of the John Reed Club or ACA gallery, at the Corcoran became innocuous metonyms of the American people. Although

Guglielmi's canvas *Martyr Hill* (fig. 71) amounts to a sombre meditation on the sacrifices of the Civil War, it was evidently too small and ambiguous to make an impact, and even Pandolfini's *Composition* attracted no comments. Curiously, however, the organisers chose to show the politically charged oil sketches by Cikovsky and Glintenkamp I discussed earlier and, perhaps more suprising, given the controversies around them, is that the Coit Tower murals by Arnautoff and Zakheim and Joe Jones's Old Saint Louis Court House mural were represented through photographs.[106] It seems likely that the organisers calculated (correctly) that the handful of such works included would be overwhelmed by the huge mass of mainstream American Scene imagery.

Another irony is that of the tiny group of sculptures on display (a mere eleven in all), the work that unques-

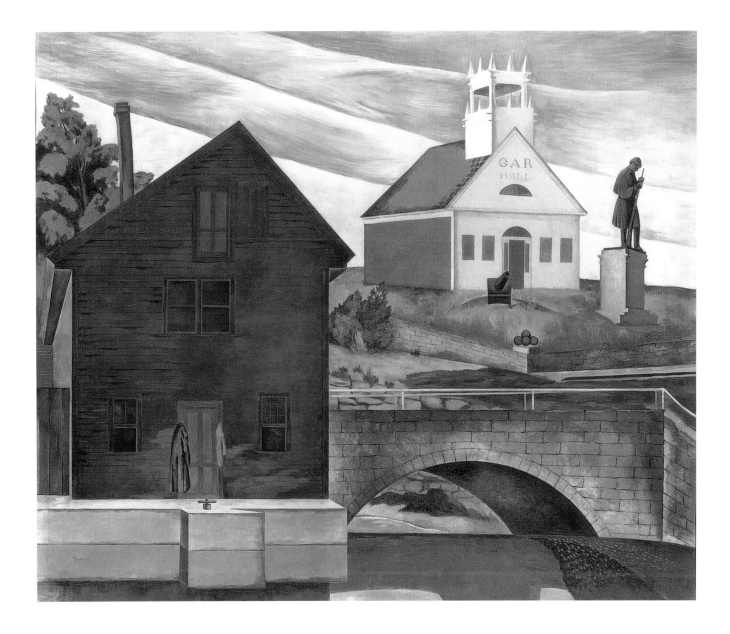

tionably stole the show was the plaster of Maurice Glickman's *Negro Mother and Child* (fig. 72). The president himself was so impressed by this that he observed it should be cast in bronze, and as such it now stands in a court of the Department of Interior Building.[107] While I have found no evidence that Glickman belonged to the John Reed Club, by 1936 he was active in the Artists' Union and American Artists' Congress, and three of his sculptures were illustrated in *New Masses* in 1937–8.[108] In its simple frontal poses and monumental form *Negro Mother and Child* exemplifies the modernised classicism characteristic of Glickman's art. It was the use of this style in an image of African Americans that made the sculpture stand for progressive values in the context. For not only did Glickman handle the figures in a way that connotes dignity within poverty, the

intimation of common humanity that classicism brings with it makes the sculpture speak powerfully against the injustice of a situation in which some went without shoes because of colour and class. Glickman himself described the woman's pose as 'asserting the instinct of mother-protection',[109] and although the figures hardly seem suppliant, neither do they suggest the 'will to struggle' so central to the notion of 'art as a weapon'. Further, given how masculinised the Communist model of struggle was, a representation of African American manhood through a boy still dependent on his mother was unlikely to appeal to Party critics.

In fact, the *Daily Worker* was scathing about the exhibition: 'Roosevelt Likes Paintings That Gloss Over Crisis' proclaimed its reviewer. Only the paintings by Cikovsky and Glintenkamp and a finely worked litho-

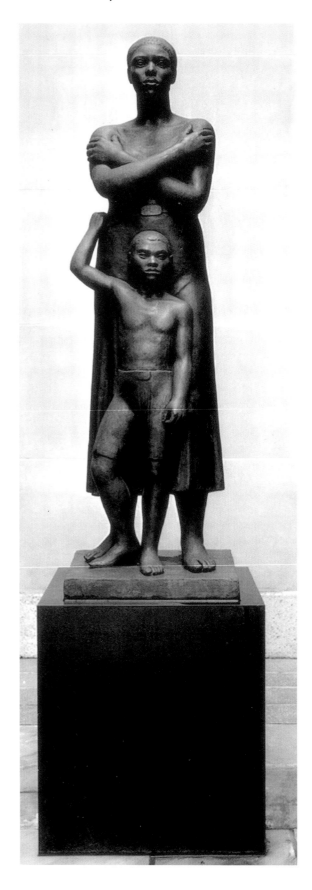

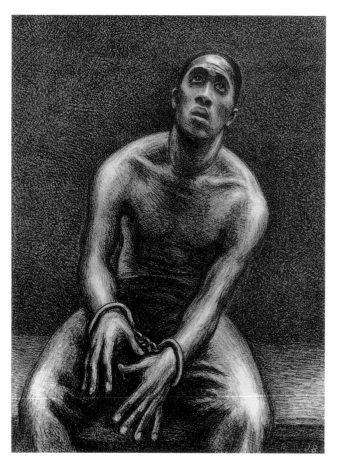

73 (*above*) Julius Bloch, *Prisoner*, 1934, lithograph, 13¼ × 9¾ in., Gift of John Taylor and Andrée Ruellan, Woodstock Artists Association, Permanent Collection, 75-05-01.

72 (*left*) Maurice Glickman, *Negro Mother and Child*, 1934, bronze, Department of Interior Building, Washington, D.C.

graph by Bloch of an African American prisoner (fig. 73) suggested that 'the masses' were 'awakening to their full stature of class consciousness.'[110] All the remainder showed simply that the artists had been bought off by the government. This contrasts in the most extreme way with the position the paper took on the federal art projects later in the decade. Indeed, one might see the success of Glickman's sculpture with the administration as prophetic of that area of overlap on issues of democracy and race within which Communists and more radical New Dealers were increasingly able to make common cause as the decade progressed, however much their ultimate goals and values diverged. Further, if the work of artists of the left had been largely overwhelmed in the context of the PWAP, as the federal art projects developed from autumn 1934 onwards they found more opportunities to use them to their advantage.

Part II: The Popular Front and the Transition to 'People's Art'

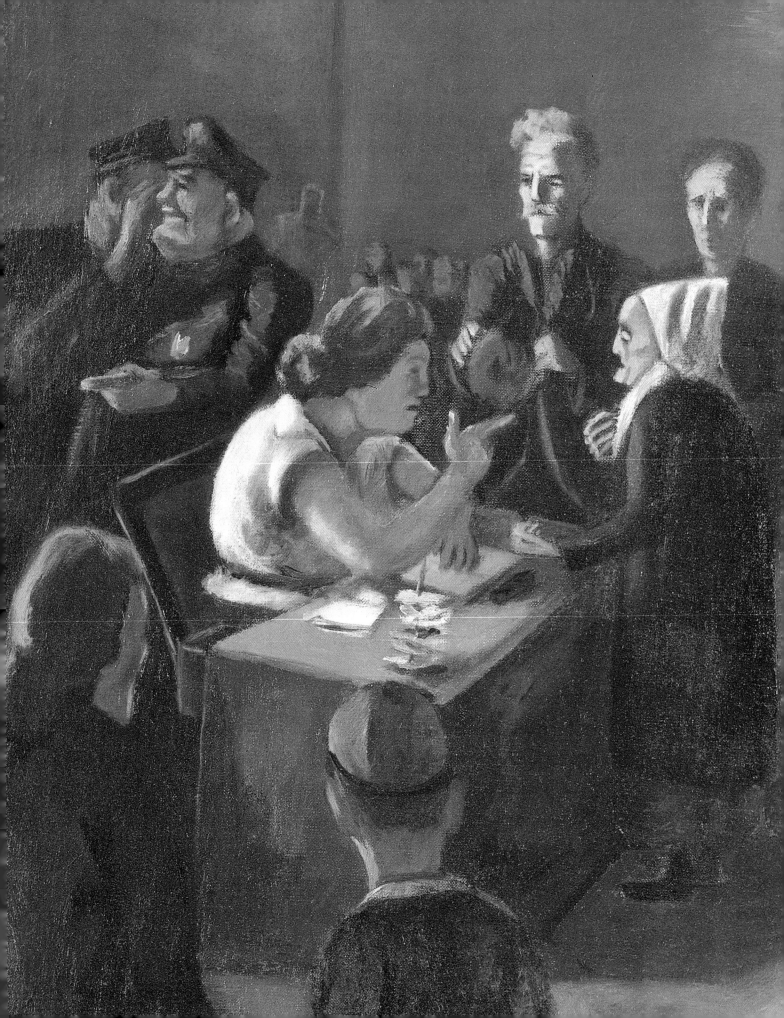

5 Cultural Criticism from the People's Front to the Democratic Front

As the 1930s wore on a relentless sequence of events contributed to the mounting sense of international crisis. The invasion of Ethiopa, continuing Japanese aggression in China, the Spanish Fascist rebellion, the Anschluss and the dismemberment of Czechoslovakia rendered the expansionist aims of fascism unmistakeable, at the same time as they displayed the barbarism of its methods. The unequivocal hostility of fascism towards Communism made defence of the first workers' state (so-called) the primary imperative, and forced a new recognition within the international movement that there was a difference between the forms of bourgeois rule: between 'a bourgeois dictatorship in the form of bourgeois democracy' or 'a bourgeois dictatorship in its open fascist form', as Dimitrov put it at the Seventh World Congress of the Comintern in August 1935. On this occasion he advised that the 'toiling masses in a number of capitalist countries' must now make a choice 'not between proletarian dictatorship and bourgeois democracy, but between bourgeois democracy and fascism' and, as a consequence, Communists should seek a united front of Communist and Social Democratic parties.[1] These developments were the basis for the shift in policy known internationally as the Popular Front, but initially termed the People's Front in the United States.

There being no large Social Democratic party in the United States, American Communists were recommended to establish a mass 'Workers' and Farmers' Party', which though *neither* Socialist *nor* Communist' would be anti-fascist, and directed against 'the banks, trusts, and monopolies'. It would also fight for 'genuine social legislation' and unemployment insurance.[2] In order to grasp the effects of this injunction, it is important to register that the transition to the Popular Front at an international level was not just affected by an imperative from the Soviet Politburo but was also, at least in part, a result of the specific experiences of individual Communist parties within the Comintern.[3] Correspondingly, there was a creative element in the CPUSA's efforts

to implement Comintern strategy in ways that acknowledged the specific conditions of the United States. In particular, the Party had to deal with two circumstances: the rebuff of its overtures to the declining Socialist Party, and the fact demonstrated by the 1936 election results that organised labour and working-class voters more generally had clearly come to see the Roosevelt administration as responsive to their particular interests. In an important report to the Party's Central Committee in June 1937, Browder argued that the crisis of the Depression had fundamentally altered the two-party system so that rather than merely representing 'regional differences among the bourgeoisie', the parties were now increasingly responsive to 'class stratification among the masses of the population.' Although CPUSA members should continue to work with the Farmer-Labor parties where they were strong, where 'mass trade unions and other progressive groups' were 'not yet ready' to do so, '[t]hey should encourage them to systematic and organized activity within the Democratic Party'.[4]

In accordance with this new perception, by the end of 1937 the Party's line had been transformed, and the People's Front retitled 'the Democratic Front', a term with a clearly American resonance. The Party convention in May 1938 took place in a hall where the Stars and Stripes mingled with the Red flag, and the proceedings opened with a playing of the Star Spangled Banner. According to *New Masses*, those expecting ' "foreign isms" and deep-dyed plots' at the occasion would be disappointed, rather it was one where 'Mr and Mrs Average American' had come together to discuss 'what needs to be done to unite the people for action in this critical hour.'[5] (A phrase that illustrates how 'people' was coming to replace 'class' as the embodiment of political agency in Communist discourse.) As the CPUSA tacitly abandoned its commitment to third party politics at national level, so it tied itself increasingly to support of Roosevelt. Communists worked with Democrats in some states, with Farmer-Labor parties in others, and in

New York state with the American Labor Party. Every-where the Party placed a new emphasis on electoral politics that helped give it a more respectable public profile, and led to a major reorganisation which made it more like a normal political party in some respects.

Like other groups in US society in the 1930s, the Party was concerned with the idea of a 'usable past'. (In part this was necessary to counter the manifestly conservative mythologies of American history that circulated through films and bestsellers – Margaret Mitchell's Pulitzer Prize-winning novel *Gone With the Wind* and the ensuing movie epitomising both.[6]) Seeking to show that it was not some alien importation but a genuine manifestation of American values and traditions, its political rhetoric now frequently emphasised continuities with the nation's revolutionary heritage, and sought to claim as its own such figures as Jefferson, Lincoln and Whitman.[7] Even the Moscow Trials and the war against the kulaks were justified by appeals to American history and traditions, while at the same time fealty to Stalin, the living embodiment of Marxism-Leninism, was made the touchstone of true commitment to democracy.

As the 'class against class' line was superseded, the rhetoric of proletarianism was largely given up, and there were marked changes in the language and contents of the *Daily Worker*. Party writers showed a new sympathy with mass sports, popular music and mainstream cinema. While the contents of the Party theoretical journal *The Communist* remained as dour as ever, it did change to a new format in 1937 which made it look like some tasteful scholarly magazine. A new style of Communist book appeared, intended to be 'clear', 'simple and appealing', of which Granville Hicks's *I Like America* (1938) is paradigmatic. Written mostly in the first person, and alternating rhetorically between singular and plural, this was a cleverly designed appeal from an individual to the 'middle middle class'.[8] It was probably a measure of the effectiveness of these tactics that an increasing proportion of the Party's membership was native born, but it also became more tolerant of ethnic differences and more respectful of organised religions. Altogether, these developments contributed to a substantial increase in membership, which rose from 30,000 in 1935 to 75,000 in 1938, without taking into account the 20,000 members of the Young Communist League. The largest element in this influx was made up of professional and white-collar workers, and there was also a significant growth in the number of women members, which rose from 16 per cent in 1933 to between 30 and 40 per cent by 1939. To make itself more appealing, the Party relaxed its Leninist discipline

in some degree, although the turnover of membership remained very high.[9]

By the criteria of numerical growth and public prominence the Democratic Front was a considerable success. Earl Browder enjoyed immense prestige within the Party, and his authority was virtually unchallenged; the only opposition to it came from Foster and a few others in the leadership who believed that in the rush to adjust to American circumstances the CPUSA had abandoned its revolutionary identity. There was a genuine problem here in that no real theoretical explanation was offered as to how present campaigns for 'Jobs', 'Security', 'Democracy' and 'Peace' would contribute to the eventual transition to socialism.[10] Defending the absence of argument about long-term goals, a *New Masses* editorial of 1938 claimed with characteristic woolliness: 'Our job is to rally the majority of the people on a positive program for peace, uniting those who believe in Socialism with those who do not as yet; there is no surer road to Socialism than the experiences gained in such a struggle.'[11]

While there is no reason to doubt that many Party members, like Dorothy Healey, found the changes in policy 'made sense . . . on an intuitive level',[12] the whole-hearted embrace of things American sometimes verged on the ludicrous, and the folksy populism of Party culture at its worst made it easy for its enemies on the left to charge it with opportunism and to paint its policies simply as a reflex of the Soviet Thermidor. For the Trotskyists and their intellectual allies, the American League Against War and Fascism and the numerous other front organisations were just so many ruses through which Communists cynically manipulated gullible liberals. From the beginning, proponents of the Democratic Front were obliged to defend their credentials as defenders of democracy in the face of mounting evidence of Stalinist tyranny, beginning with the Moscow Trials (1936–8) and reports that the Communists in Spain were both obstructing a revolutionary process and murdering their opponents. As the decade ended, the Party's seeming bad faith was confirmed by the Nazi–Soviet Pact, the partition of Poland and the Soviet invasion of Finland; and also by the shift of line on the Roosevelt administration as the Party – ever obedient to the imperatives of Soviet foreign policy – now discovered that there was nothing to choose between fascism and British and French imperialism, and that consequently the US should not take sides in the European conflict.[13]

In the remainder of this chapter, I analyse the character of criticism in *New Masses*, the *Daily Worker*, *Art*

Front and the publications of the Marxist Critics Group. While the context of the People's and Democratic Fronts was not conducive to theoretical rigour it did permit somewhat more flexible critical debates than those of the Third Period, particularly around the issue of modernism. But at the same time, the imperative towards the popular and hostility to intellectualism (which became particularly associated with 'Trotskyists') simply recast the Party's intolerance of criticism and dissent in a new form. As a result, at the same time as the growing body of Marxist work on aesthetics that was becoming available in translation made possible more sophisticated exchanges, it also began to calcify into a weapon that could be used to club dissident opinion. None the less, all that was richest in the cultural criticism that came out of the Communist movement was grounded in the experiences of the Popular Front.

New Masses, 1936–1940

In 1933, when proletarianism was at its height, *New Masses* asked an extraodinary question of its white-collar intellectual class readers: 'Based not on my words, or thoughts, but on the day-to-day acts of my life, would the working class leaders of the future American Soviet Government be justifed in putting me in a responsible job – or in a prison camp for class enemies?'[14] With the coming of the People's Front, the magazine began to make more sophisticated efforts to woo the middle class, and to this end there were several revisions in format. Correspondence between the then art editor, Crockett Johnson, and Rockwell Kent reveals that a new layout inaugurated by the issue of 15 September 1936 was designed to play down any signs of aggressive radicalism:

> The idea now is to go in for decorative covers that are not too blatant (and often non-committal) about our editorial viewpoint. Titles, when we use them, will pose a question whenever possible rather than dogmatically state a fact. The intention is of course not to deceive the prospective reader, but to try to avoid having him react unfavourably to our position as stated by headlines or an unpleasant or too strong political cartoon before he's bought the magazine and read all the facts we present.

Rather than 'the pugnacious type of political cartoon', the magazine would now reproduce 'drawings, woodblocks and lithographs of the American scene', interspersed with 'not-to-brutal caracatures of people' (*sic*).[15]

"Just ignore those blanks the postman left us. They are intended for idle persons who are a <u>burden</u> to society."

75 John Heliker, '*Just ignore those blanks the postman left us. They are intended for idle persons who are a* burden *to society*', from *New Masses*, 23 November 1937, Marx Memorial Library, London.

The conviction among Communist artists and critics that the artist's print should be an intrinsically popular medium was given a new focus by the Federal Art Project Graphics Division, and the late 1930s brought a tremendous flowering of left-wing printmaking. As a result, *New Masses* was able to draw on a whole range of American Scene prints by artists such as Mabel Dwight, Elizabeth Olds, Dan Rico[16] and Harry Sternberg. At the same time, it also secured drawings from a new cohort of artists, among whom were Ruth Gikow, Sid Gotcliffe, John Heliker and Georges Schreiber. Of these Heliker was the outstanding talent (fig. 75) and also one of *New Masses* most regular contributors in the years 1937–9.[17] Under Crockett Johnson's direction *New Masses* became a much more lively journal visually. Stalwarts of the Communist press such as Burck, Ellis and Limbach continued to contribute cartoons in the Daumieresque *Masses* mode, and Gropper's work remained a regular feature – although the motifs of Congressional villains and fascist leaders on which he concentrated in the second half of the decade became rather tired through over-use. However, Johnson also opened the magazine to a new modernist graphic style of which Ad Reinhardt was the most notable exponent. A successful commercial artist as well as a modernist painter, Reinhardt began working for *New Masses* in July 1936 and remained a contributor

"I fear His Holiness will be unable to rise this morning, sisters. You may pray for him—and General Mola's Moors."

76 Ad Reinhardt, cover from *New Masses*, 11 August 1936, Marx Memorial Library, London.

77 Abe Ajay, 'I fear His Holiness will be unable to rise this morning, sisters. You may pray for him – and General Mola's Moors', from *New Masses*, 29 September 1935, Marx Memorial Library, London.

and sometime art editor until 1945, using both his own name and a number of pseudonyms. At times his work was a regular feature, and he designed covers, cartoons, vignettes, maps and diagrams, often using new graphic devices such as Ben-day dots.[18] For the most part Reinhardt worked in black and white blocks, and made full use of the ambiguities of push and pull to produce Cubistic spatial effects. In the cover of the 'Election Quarterly' issue of 1936 (fig. 76) this technique unsettles the whole of the surface so that even the title reads in different planes. While the figures of political hoopla in the strip on the left are all clearly legible, the play of shapes about them matches the cacophony suggested by the shouting faces and street band. This is essentially Stuart Davis's modernist idiom applied to graphic decoration.

Reinhardt was not the only contributor whose work was overtly modernist, but most of the others used a more Expressionist mode. Thus in addition to Herb Kruckman, who continued to contribute regularly, Abe Ajay began providing extraordinarily reductive and effective cartoons, as well as occasional summary

graphics (fig. 77), and John Mackey introduced a Surrealist element in his 'Unnatural History' series of 1936 and even in more straightforward caricatural heads managed to produce quite unsettling effects (fig. 78). At the same time, the cartoons of Mischa Richter, who worked for *New Masses* in the years 1938–40, demonstrated that such hackneyed motifs as the top-hatted capitalist could still function effectively in the hands of a less over-worked talent than Gropper (fig. 79), and matched Heliker's drawings in their individual adaptations of Grosz's devices. That this modernist idiom was theorised as such is clear from an exchange between Ajay and the California artist and illustrator Maynard Dixon in the letters column in 1937. Responding to Dixon's claim that in the radical press the 'technique of a cartoon should be secondary to its intent' and his denial that 'extreme (that is, "modern") techniques are in themselves revolutionary', Ajay observed that 'Technique and intent cannot be separated with impunity' and 'nor must technical deviation be confused with "technical hokum".'[19]

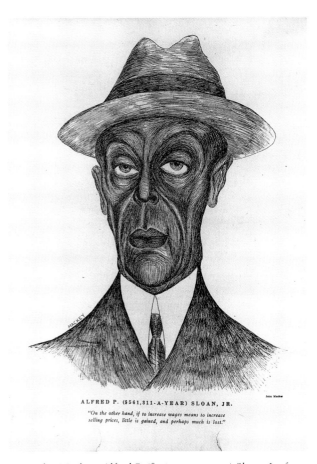

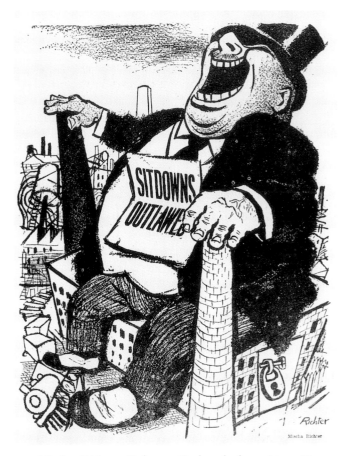

78 John Mackey, *Alfred P. ($561,311-a-year) Sloan, Jr.*, from *New Masses*, 18 January 1938, Marx Memorial Library, London.

79 Mischa Richter, *Sitdowns Outlawed*, from *New Masses*, 14 March 1939, Marx Memorial Library, London.

However, the problems of the magazine were not ones that could be solved by cosmetic improvements to its graphic quality alone. By August 1936 *New Masses'* editors were working on half salary and it could no longer afford to remunerate contributors. While paying tribute to the magazine, in an article of December Browder cautioned that it was still far from meeting the needs of the movement and warned against the 'remnants of sectarianism and doctrinaire approach'. In an internal memorandum of July 1937, Freeman (who had returned to the board) asserted that *New Masses* had been 'in more or less permanent crisis since the fall of 1935', and offered a plan for its revival that would place it 'in the forefront of American weeklies'. This would involve expanding the range of the magazine by extending its coverage of theatre and film, and starting a thirty-two page literary supplement. A resumé of an editorial conference in August set out plans for transforming it into 'a news weekly with widest possible coverage . . . modeled along general lines of *Time*' and with photojournalism defining the visual style. Although a literary

supplement did begin to appear in December and the range of contributors widened, *New Masses* could not afford colour covers and in the event did not begin to make more extensive use of photojournalism until early 1939.[20]

Despite the innovations of 1936–7, in the latter part of the decade *New Masses* seemed in continual financial crisis. An editorial of July 1938 asked for readers' suggestions as to how it could appeal to 'the middle class and professional people who should be reading the magazine and aren't', and later that month a subscription drive was announced to recruit 20,000 readers drawn from this strata. It is symptomatic that after the fascistic 'Radio Priest' Father Coughlin denounced the magazine as 'Bolshevik literature' in 1939, an editorial statement denied any direct connection with the Communist Party. *New Masses* was, it claimed, 'an independent, militant, anti-fascist journal of democratic opinion', 'affiliated to no political party.' It may well be a sign of the isolation of the magazine that in early 1939 it opened a club room on West 52nd Street, the Keynote Club, for plays, lec-

tures, symposia, concerts, films and art and photographic exhibitions.[21]

The problem was that the Democratic Front started to unravel almost as soon as it began. Initially it seemed as if the Civil War in Spain, which broke out in the summer of 1936, would unite Communists with the liberal allies they sought. The support of Germany and Italy for the Rebels, and the Soviet Union's aid to the Loyalists, appeared to place them clearly on the side of popular democracy against fascist aggression. Yet as early as January 1937 *New Masses* printed a lengthy denunciation of the POUM by the English novelist Ralph Bates, and six months later it reported that the Spanish Communist Party had demanded the extermination of fascists, Trotskyists and uncontrollables after an attempted 'putsch' in Catalonia. At the American Writers' Congress in June, where distinguished figures such as Hemingway and Archibald MacLeish spoke in support of the Spanish cause, 'several Trotskyists attacked the Soviet Union and the people's front in Spain'.[22] In CP discourse Trotskyism was represented as a perfidious heresy, even a disease, and it was increasingly invoked to explain both criticisms of the Popular Front from the left and the extreme measures the Soviet Union was taking against those it described as domestic opponents. Beginning in September 1936, *New Masses* printed a whole succession of squalid apologias for the Moscow Show Trials, as well as statements in support of their veracity signed by long lists of writers and artists. In 1938 it even offered the published testimony of the Trials as part of a subscription bargain.[23]

The Trials became the key symbol of the division within the left between those who saw that the Revolution had indeed been betrayed (to borrow Trotsky's phrase) and those who continued to fantasise that the USSR, whatever its faults, was the embodiment of human progress.[24] Although Philip Rahv was still reviewing for *New Masses* in May 1937, an editorial attacking the editors of the reformed *Partisan Review* as Trotskyist sympathisers appeared as early as mid-September. The new literary supplement was launched in December partly to counter any influence *Partisan Review* might have, and the first of these contained a barrage by Mike Gold, who, true to form, described the intellectual under capitalism as an emasculated type, afflicted by a 'frustrate, negative psychology' that made him particularly susceptible to Trotskyism, 'a nay-saying trend', 'which at present denies the whole current movement of the people's history.'[25] As writers and intellectuals such as Sinclair Lewis and Dos Passos began to criticise the USSR and the Communist movement at the end of the decade,

so their work, it was claimed, fell off and partook of the Trotskyist poison. Moreover, the 'fascists and Trotskyites join[ed] hands' to attack progressive writers such as Steinbeck and progressive Hollywood films such as *Juarez* and *Confessions of a Nazi Spy* because they feared 'the unifying force of literature itself.' Trotskyism was linked with 'pessimism and individualism', whereas 'the fulfilment of . . . liberation involves a loose identification with man in the mass.' The pessimism of Western intellectuals was the diametric opposite of Soviet faith in human potentialities, of 'socialist humanism.'[26]

As a consequence, Soviet culture needed to be defended against their carping criticisms. Thus Kunitz, recently returned from the USSR, sought to explain the virulence of attacks on Shostakovich, Melnikov and others that appeared in the Soviet press in 1936 at a lecture cum party at Webster Manor that May. 'Soviet art and letters', he suggested, were again 'in a state of violent perturbation', and 'the smug self-approval' that reigned after the dissolution of the proletarian artists' and writers' associations in 1932 had come to an end. The reason for the 'campaign against formalism and naturalism' was that some 'more established Soviet writers and artists had begun to grow a little soft, spoiled, and were beginning to lose vitalizing contact with . . . Soviet reality', with the result that they had sunk into the twin sins of formalism and naturalism. In the climate of the second Five Year Plan this absence of self-criticism was unacceptable. Just as the Stakhanovites breaking old standards in production had voiced the 'demand of the masses', so now artists were being called on to transcend earlier artistic achievements. Attempting to assuage liberal anxieties, Kunitz reported the response of a young Russian Communist to the virulence of the attacks: ' "Don't worry. There'll be no blood, prisons, no ruin and no darkness. The fellows who deserve it will be criticized – that's all." ' In fact, although Shostakovich and Melnikov survived, in the purge of writers and artists that began after the trial of the 'Trotskyite-Zinovievite United Centre' in August many did indeed lose their lives.[27]

The key point about Soviet art, it was claimed, was its organic connection with the Soviet masses. In a symptomatic article, Lozowick reported that when a group of twenty artists visited Stalingrad in August 1935, the 'workers organized a banquet for them', and 'staged a carnival with dancing and singing in the streets'. A letter to the artists, signed by 15,000 workers of the tractor factory, welcomed the forthcoming exhibition on the theme of the 'Industry of Socialism'. If the CPUSA's model of the relationship between social forces and the

state was inadequate in relation to the United States, how much more so was it in relation to the USSR! For whereas in the case of the former it regarded the state as simply the instrument of the ruling class (even though the tactics of the Popular Front belied this), in the case of the latter it was a direct manifestation of the will of the Soviet proletariat and peasantry. Thus Lozowick claimed that just as the revolution had 'abolished the private magnate in industry', so too it had 'abolished his blood-relative, the private dealer in art.' Since then, 'Social and public patronage had grown . . . in exact proportion with the economic progress of the country and the phenomenal cultural growth of the masses.'[28] This fantasy was the ideal model for what the Federal Art Project of the WPA should become.

Art Criticism in *New Masses*, 1936–1940

New Masses walked a tightrope in trying to balance its avowed respect for the USSR and the model of an increasingly regimented and conservative Soviet culture with the very varied practices of those it wished to claim as allies. Thus, in the late 1930s writers in the magazine regularly hailed Picasso as 'the greatest painter of modern times', and an editorial in August 1937 even claimed it was 'highly significant that minds in the vanguard of culture should take their stand boldy in the ranks of those who fight to stem the fascist cause.' Picasso's status was thus directly linked with his public pronouncements against the Spanish rebels, and later with the painting of *Guernica*.[29] Yet whatever the contingent factors, there was a new willingness to put a positive evaluation on modernist and experimental art. Isidor Schneider grudgingly acknowledged that even Surrealism might contribute 'some discoveries in technique' when he reviewed Julien Levy's monograph on the movement in 1936, while the magazine also gave space to a passionate defence of experimentalism by James Agee, who argued that much of the most important art of the century, from the novels of Joyce to the films of Eisenstein, had an oneiric quality. (Correspondingly, the magazine published qualified appraisals of Freud.[30]) In 1938 Charles Humboldt, who had begun to contribute occasional literary reviews to *New Masses* the previous year, sent in a letter defending difficult art against the philistine objections of readers' letters: 'I have no dispute with the taste of your correspondents', he wrote, 'but I should like to know how they come to speak for the people.' The 'essence of great art' 'from the

earliest ballads, work and ceremonial songs of Lorca and Mayakovsky, from the prehistoric cave drawings to Picasso's *Guernica*' was 'the radical transformation of nature'. There was nothing un-Marxist about difficult art, for: 'Art is no easier than life.'[31]

Just as the Party's literary critics dropped or modified the ideal of proletarian literature, so its art critics tended to relinquish that of revolutionary art for a more inclusive notion of 'social art', which became blander as the People's Front mutated into the Democratic Front. From the end of 1935 until April 1937 *New Masses* had no regular art critic, but in that year Charmion von Wiegand (1898–1983), Joseph Freeman's second wife, wrote a sequence of fourteen reviews for it. Von Wiegand exemplifies the fellow-travelling intellectual. She came from a well-to-do German American family and, before she married Freeman in 1931, had spent two years in the USSR working as a journalist, although she confessed that 'newspapers and politics . . . never could excite me much' and her primary ambition was as a painter. In the early 1930s she was already convinced that a true artist could not be involved with politics, and believed this explained why she found Orozco superior to Rivera.[32]

Von Wiegand probably had only a shallow grounding in Marxism, but she was widely read and familiar with the whole range of European art developments. Her criticism employed the familiar Marxist trope of the period that the greatest art is always the product of a rising class. Thus the bourgeoisie had produced significant achievements when it was a progressive force working to overthrow feudalism, but in the period of its decline its culture had become irredeemably decadent.[33] This crude application of Marx's stadial theory was modified by the idea that art was a special mode of cognition, and that some bourgeois artists had – in varying degrees – come to identify with the cause of the proletariat thereby producing work that continued to have significance. This was the let-out clause that allowed the positive appraisal of Dos Passos, for instance, and also licensed admiration for Picasso. In a symptomatic comparison of Picasso and de Chirico of January 1937, von Wiegand excused Picasso for working in no single style, claiming he was disoriented by the ideological confusions attendant on the crises of capitalism. Equating classicism in art with rationality and progress, she saw de Chirico's use of classic motifs as a Romantic corruption of the 'Greco-Roman heritage', whereas Picasso's work took off from the Renaissance, 'that robust period when the rising bourgeois class affirmed its faith in corporeal reality and set up the classic as its ideal'. Cubism was a 'great technical advance', but thematically

80 (*right*) Louis Ribak, *Home Relief Station*, 1935–6, oil on canvas, 28 × 36 in., Collection of Whitney Museum of American Art, New York, Purchase, 36.148.

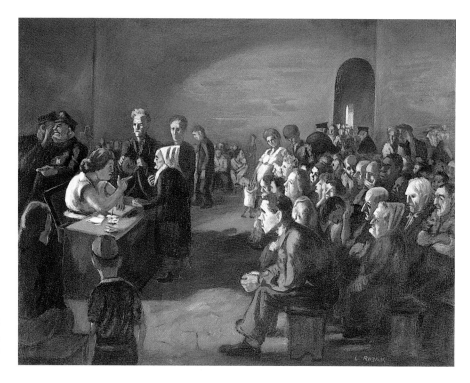

81 (*facing page*) James Turnbull, *Farm Woman*, 1936, oil and tempera on board, 4 × 3 ft, Woodstock Artists Association, Permanent Collection, 79-17-01.

Picasso's art was lacking in humanism and in this respect regressive. It was a limitation that arose because '[t]he ruling class of a dying society is totally unable to give any new content for a living art.' Yet elsewhere she characterised Picasso as 'one of the great tragic artists of our time', who struggled to inject humanism even into such improbable works as the Museum of Modern Art's *Bather by the Sea* (1929).[34]

For von Wiegand, form was 'the one and only true problem of western art', and she consistently emphasised the fertilising effects of modernist innovations, whether she was talking about modern architecture and design or Spanish Republican posters in which 'modern art functions efficiently and carries a message more adequately than the old-fashioned type of illustration.'[35] Concomitantly, the 'post-war generation' of American artists had '[t]hrough their emphasis on sensuous values and compositional organization raised the aesthetic standard of American painting.' When confronted with the wide array of styles within the American Artists' Congress and other group exhibitions of the left, von Wiegand looked for that same fusion of modernist form with social themes that she wanted from Picasso. But this was not a plea for programmatic painting. Commenting on the lack of art with 'a definite social program' in the Congress's First National Exhibition, she observed that 'although the artist may hold certain intellectual convictions, it is only when these convictions

become part of his emotional experience that he can integrate them with his life and art.'[36]

This position allowed von Wiegand considerable flexibility in her judgements, so that on the one hand she could describe Louis Ribak's naturalistic *Home Relief Station* (fig. 80) as 'an excellent example of the transition of contemporary painting from static recording to active social criticism', and on the other praise Stuart Davis's 'brilliant *Red Cart*' (see fig. 95). A 'struggle for new forms of expression' was widely apparent, and like several contemporary critics von Wiegand noted a distinct Expressionist trend, which was evident especially in the work of Joe Solman, Nahum Tschacbasov and other members of 'The Ten' group.[37]

Although von Wiegand claimed that 'the whole movement in plastic art since the turn of the century has been consistently away from representational painting', she could be impressed by 'direct and uncompromising realism'. Reviewing an exhibition of Midwestern artists at the ACA Gallery, she acknowledged that their 'feeling for illustration and satiric caricature' was a 'seeming backward aesthetic step', at the same time as suggesting that its parallels with 'American advertising art, magazine illustration, and the comic strip' meant it had the potential 'for real mass popularity'. Her judgement on the works in this show (fig. 81) reveals that fusion between Americanism and an imaginary model of Soviet culture I referred to earlier:

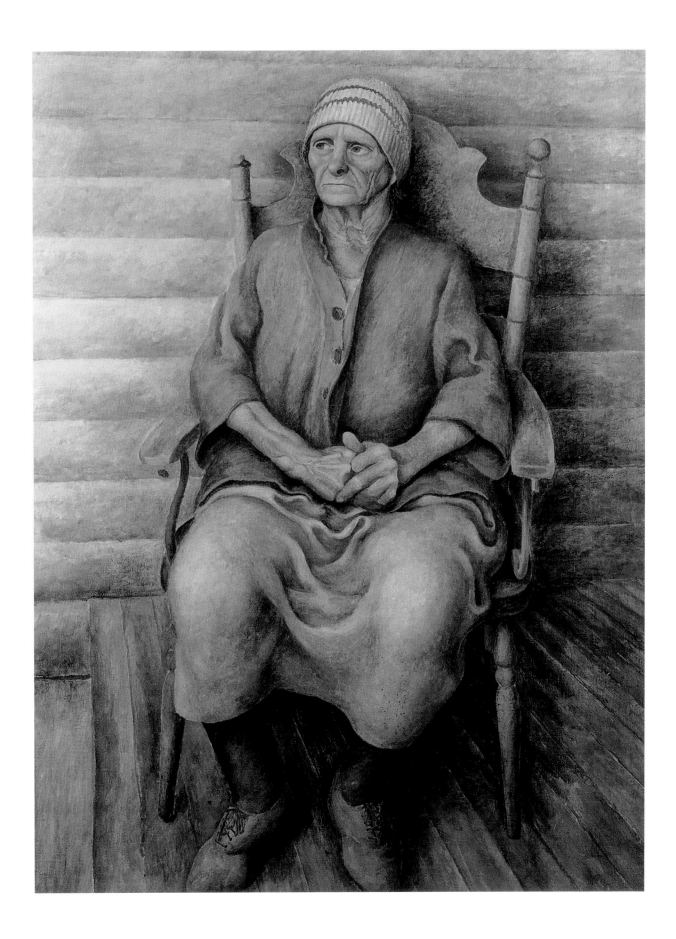

Something of the American pioneer spirit imbues these canvases with a harsh integrity; something of puritan tradition lurks in the rejection of sensuous values for literal fidelity to detail. A splendid portrait like that of James Turnbull's *Flood Refugee* carves out a new segment of reality akin in feeling to that captured by the Soviet films.[38]

This also indicates that what von Wiegand was looking for in art was work that produced the effect of an urgent contemporaneity, and this effect was not restricted to any single style form. But the comparison with Soviet film (and not painting) is also telling because, in private at least, she was insistent the USSR was still 'culturally in the 19th century', and that contemporary artists had to become technically progressive to be effective in the American context.[39]

New Masses put on its art critics the constraints of writing short reviews in the magazine column mode, and most of von Wiegand's contributions suffer from this limitation. As I shall show, she wrote more extended and interesting reviews for *Art Front*. After July 1937 she made but one further contribution to *New Masses*, a circumstance almost certainly connected with the increasing estrangement of her husband from the Party as a result of 'deviations' in his autobiographical account of the Communist literary movement, *An American Testament*.[40] But in any case she was unsuited for the role of *New Masses* critic by her independent judgements on things Soviet and her disdain for the Federal Art Project, which she believed had served only to entrench artists in outmoded practices. In 1937 she opined that Arshile Gorky was 'the only man who has done a fairly decent WPA mural. sofar' (*sic*).[41]

The art notices of Elizabeth McCausland, who wrote twenty-two reviews for *New Masses* between April 1937 and March 1939 under the pseudonym 'Elizabeth Noble', illustrate the stultifying effect the Democratic Front could have on Marxist criticism. A graduate of Smith College, from 1923 to 1935 McCausland was based in Springfield, Massachusetts, where she was on the staff of the liberal *Springfield Republican*. In the 1920s she was radicalised by her involvement with the Sacco–Vanzetti defence committee, the New Bedford textile strike and the campaign against child labour in New England. At the same time she was increasingly interested in art and began to write regular art criticism for her paper. McCausland moved to New York in 1935 and became active in the Artists' Union and American Artists' Congress. Whether or not she was a Party member herself, McCausland numbered several Communists among her friends, including the artists Harry

Gottlieb and Elizabeth Olds, and prominent Party women such as Grace Hutchins and Anna Rochester.[42]

McCausland's column would almost be better characterised as art reporting rather than art criticism. It is symptomatic of the moment that she wrote with particular enthusiasm about documentary photography and film, which essentially provided the benchmark of her aesthetic. In her view, documentary matched the contemporary mood because 'today we do not have a great deal of time for or patience with aloof and precious aesthetic meanderings': 'The critical battle of a decade ago over art for art's sake, non-communication and non-intelligibility today centers in the revelation of the document to the work of art.'[43] Photography had an important lesson for 'social artists' because it showed 'that to be a powerful social weapon a picture must be concrete and realistic, packed with tangible content.' Its example meant that a 'greater degree of observation' could be expected from social artists who should ground their work in direct observation.[44] This did not point McCausland to a narrow photorealist aesthetic but rather to a bland inclusiveness, and she welcomed the expansion of the themes of social art from 'the bum, the derelict' and 'the tenement'. In her reviews of the exhibitions of the American Artists' Congress and other collective bodies all her emphasis was on the value of the collective effort and no individual works were singled out for critique. She favoured thematic shows such as An American Group's *Roofs for Forty Million* because they produced a 'desirable unity of effect and intent' and worked to break down 'that old individualism and isolation of the artist.' The showing of the Second American Artists' Congress exhibition in Wanamaker's department store pleased her because more people would see it than if it had been shown in 'a dingy hired hall or in an even drearier museum.' McCausland anticipated that in the present period of 'transition' no one style would be 'appropriated by the social vanguard', but she also made no discrimination between those on offer. And despite all her comments on the example of the documentary mode she approved the abstract paintings exhibited at the Second Congress show. In 1939 she claimed that '[a]bstract artists in renouncing realistic subject matter, do not renounce an obligation to be socially useful', but worked to create 'psychologically pleasing and functional effects' that had application in 'industrial design, typography and architecture.' In some ways such inclusiveness was admirable, but it seemed to match ill with the Party's utter inflexibility on other issues and could look simply unintellectual and opportunistic.[45]

The Marxist Critics Group

Committed to attracting middle-class readers, the *New Masses* of the later 1930s was not the place for intensive debates on Marxist aesthetics and criticism, although they did intrude into its pages on occasion. With *Partisan Review* closed to them after June 1936, those who wanted to pursue theoretical issues needed another forum. They seem to have found it in some degree in the Marxist Critics Group, which was in existence from at least 1936 to 1939. The leading figure in this was probably Angel Flores, who had taught at Cornell University, was a contributing editor to *Art Front* and served on the faculty of the New York Workers' School in the late 1930s. Described in *New Masses* in September 1936 as 'a hardworking group of left-wing writers' who were 'making available in English important critical writing appearing in other languages',[46] the Group is probably best known for the series of twelve pamphlets it published, among which were translations of key Marxist texts such as Plekhanov's *Art and Social Life*[47] and Mikhail Lifshitz's *The Philosophy of Art of Karl Marx* (1938), and two contemporary American essays: Milton Brown's *Painting of the French Revolution* and Elie Siegmeister's *Music and Society* (both also 1938). From 1937 to 1939, it also published briefer pieces in its irregular journal *Dialectics*. Although the Group was committed to disseminating Soviet criticism, it did not do so in a spirit of bland reverence. Indeed, what is striking is the freedom Party writers assumed to make critical judgements on recent Soviet debates. For instance, the second pamphlet of the series, A. A. Smirnov's *Shakespeare* (1936), was greeted with an extremely sharp critique in *New Masses* that described it as 'an example of what to avoid if our criticism is not to degenerate into the laying of a dead hand on a live thing.'[48]

The contributions of the Marxist Critics Group that concern me here were written by the art historian Milton W. Brown (1911–98). His *Painting of the French Revolution* was a pioneering effort in Marxist art history, which, allowing for its brevity, stands up as well as other early examples of the genre by Frederick Antal and Francis Klingender. This was complemented by a theoretical essay on 'The Marxist Approach to Art' that appeared in *Dialectics* the year before.[49] Like Meyer Schapiro, who had advised him on the masters thesis out of which his pamphlet grew,[50] Brown saw the basic problem of Marxist art history as to formulate a social history of style that gave due weight to the development of artistic forms, which in some degree had a logic of its own. Given that style was 'the result of the struggle between content and the established historical stage of artistic development', how did different class ideologies achieve artistic form? Unless the complexities of 'technical and aesthetic development' in class societies were taken into account, it was impossible to 'explain the endless variations which art forms will take in the expression of the same fundamental ideas.' In *Painting of the French Revolution* Brown gave over a substantial section to establishing the 'Cultural–Aesthetic Background' – that 'almost inextricable weaving of cultural threads' – which made the revolutionary art of the period possible. For Brown, the fundamental artistic achievement of the Revolution, that which made its art 'epoch-making', was that it had conceived of art 'as a weapon in social struggle'. It had proved that 'art is capable of social activity.' But if the sources of French Revolutionary art were complex, so were the tasks facing the contemporary artist 'desirous of expressing a revolutionary content', who was faced with

> an artistic heritage of abstractionism, expressionism, theories of art for art's sake and of personal aesthetics, and a hundred other artistic and cultural traditions. Some of these must be immediately rejected, others accepted, still others transformed until finally a new style will emerge, a style fitted to the direct expression of revolutionary content.[51]

Brown's grasp of Marxism enabled him to see the history of artistic forms as a complex reflex of class struggles. However, his acceptance of its revolutionary teleology meant that he still anticipated the emergence of a world-historical proletarian style, and this essentially provided the touchstone of his work as a practical critic in the postwar period.

The Marxist Critics Group was a marginal body in the context of the Democratic Front. Its austere and erudite publications seem utterly remote from the celebration of 'native' American traditions and popular culture that filled the review columns of *New Masses*, and it may well represent a continuation from within the Party fold of that resistance to the excesses of Popular Frontism that was one of the motivations behind the *Partisan Review* break. But, at the least, it provided a space where serious Marxist work continued to be done and served as a training ground for a younger generation of critics.

Art Front's Last Year

Under Charles Humboldt's editorship, something of the same austere tone entered *Art Front*, which began to

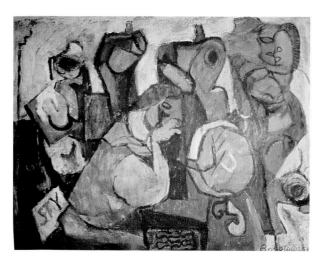

82 Ilya Bolotowsky, *Sweatshop*, c. 1934–5, oil on linen, 27⁵/₈ × 36¹/₂ in., collection Andrew Bolotowsky. © Estate of Ilya Bolotowsky/Licensed by VAGA, New York, N.Y.

83 Joseph Solman, *The Oculist*, 1937, oil on canvas, 25 × 34 in., Collection Eva Roman Haller.

foreground explicitly Marxist writing in a way it had not done in the past. Humboldt had been in England in 1934, when he took part in the famous demonstration against the British Union of Fascists' rally at Olympia in London. It was perhaps through contacts he made then that he was able to reprint essays by the English Marxists Francis Klingender and A. L. Lloyd that had appeared in a collection of essays *5 on Revolutionary Art* in 1936.[52]

The same emphatically Marxist tone pervades the responses to Dalí that Humboldt printed under the heading 'Surrealism and Reality: A Discussion' in March 1937. This starts with Dalí's statement 'I Defy Aragon', which accused Aragon of espousing proletarian art as a career move, mocked Socialist Realism – 'a new formula' that had 'all the stupidity' of its predecessor – and claimed Surrealism as the 'most advanced' development in the domain of aesthetics. In response, Humboldt sought to defend proletarian art by listing some of its literary achievements, and presented Socialist Realism as an 'extension' of proletarianism 'through a Marxist approach to the aesthetic experience.' It was 'not realism in the bourgeois sense, not naturalism', and neither was it 'propaganda' as such. Rather: '[t]he socialist realist projects experience saturated with values, with revolutionary meanings, values imbedded in experience, completely accessible only to the artist with a Marxist culture.' Moreover, when it came to matters of form, the social realist was 'no philistine': 'He may find that an artist like Leger [*sic*], by the revolutionary character of his form alone, is nearer a dialectical view of the modern world than a Dalí with his pseudo-revolutionary

self-conscious Unconscious framed in a reactionary technique.' To hammer home the point, Humboldt's response was accompanied with a more laboured statement by Samuel Putnam that argued Surrealism was essentially idealist in its philosophical premisses and thus fundamentally incompatible with Marxism: '[t]he only truly Marxist art is a socialist realism.' Yet if, as these statements suggest, Socialist Realism came to replace proletarian art as the key critical category among more informed commentators, its implications for artistic practice seemed if anything vaguer.[53]

The most interesting development in *Art Front's* appraisal of contemporary art in its later phase straddles the editorships of Solman and Humboldt, and that is the attempt to articulate the bases for an American Expressionism. This was partly occasioned by the exhibits of The Ten group, which had been set up in 1935 by a small band of artists dissatisfied with the gallery policy of their dealer Robert Godsoe. The Ten held monthly meetings at the studio of Joseph Solman on Second Avenue, and between December 1935 and the autumn of 1939 put on a total of eight exhibitions, with somewhat varying personnel. The group was not linked by any tightly defined aesthetic, but their art was painterly and at least partially modelled on the example of German Expressionism, which had been widely shown in New York galleries since the mid-1920s.[54] Of the nine founders, at least three – Ben-Zion, Solman and Nahum Tschacbasov – were involved with Communist-sponsored organisations and publications at some time. Moreover the group as a whole occasionally aligned itself with the Democratic Front, as in late 1937 when

'an auction sale of paintings, prints, and drawings' by them was organised at the Brooklyn Heights branch of the American League Against War and Fascism, the proceeds going to Spanish refugee children.[55] However, the reviewer of their first exhibition in *Art Front*, Herbert Lawrence, assumed that they were united not just by grounding in the modern 'tradition', but also in their 'effort to synthesise this tradition with contemporary realistic social needs.' While this seemed to work for some exhibits by Ben-Zion, Tschacbasov and even Rothko's *Woman Sewing*, it was manifestly inappropriate for others, and Lawrence concluded that 'the result here is only a statement of the problem'.[56]

Through her wide knowledge and contacts within the German emigré community, the left critic who was best equipped to address Expressionism was von Wiegand, who joined the editorial board in 1937. Her article 'Expressionism and Social Change', which appeared in November of the previous year, was the major attempt to theorise Expressionist art of the period within the American Communist movement. Von Wiegand's view of the social basis of Expressionism was fundamentally the same as that Lukács had advanced in his 1934 essay 'Expressionism: Its Significance and Decline'. The Expressionists 'belonged to the petit bourgeoisie', and were individuals disoriented by 'a period of great social change', who rebelled 'violently but without program'. Their revolt was essentially mystical and individualistic – '[t]hey reached beyond their own class only in their dreams' – and while '[t]hey sought to shatter the foundations of the old world', they 'could not break even the shackles of their own class.' Like Lukács, von Wiegand noted that Expressionist ideology could point towards fascism as easily as towards Communism, but unlike him she was not entirely dismissive of its formal devices, acknowledging that artists such as Brecht and Grosz, who had 'actively entered the class struggle', owed something to it. What made Expressionism relevant at this juncture was that now, 'after seven years of economic stagnation and unemployment', conditions in the United States were comparable to those that had given the movement its appeal in postwar Germany. Von Wiegand did not recommend the example of the Brücke group for its formal qualities, judging their work as 'a rather superficial interpretation of French experiments', but its spirit of 'activism' was relevant: 'Neither abstract art nor academic pictorialism are satisfactory means to embody the social struggle of our time as it assumes ever more dramatic and violent form in the United States. While the religious mysticism of German Expressionism is alien to us, its activism is a vehicle suited to American

vitality.' Among the American artists whose work she saw as pointing the way, were The Ten, Kopman, Kruckman, Alice Neel, Helen West Heller and the Midwestern painter Joseph Vavak.[57]

Von Wiegand's article provided the foundations for Jacob Kainen's evaluation of the second group show of The Ten at the Montross Gallery in the February 1937 *Art Front*. Kainen was born into a Russian Jewish immigrant family at Waterbury, Connecticut, in 1909 and studied at the Pratt Institute in the late 1920s, where he arrived with a bookish and knowledgeable reputation. He joined the John Reed Club in the early 1930s and attended the clubs' National Congress in 1934. The following year he was listed as the prospective author of a monograph on Hugo Gellert to be published by the International Union of Revolutionary Artists – a project that matches the emphatically Communist tone of his statements of the period. Yet in the early 1930s Kainen had also become friendly with young artists such as Gorelick, Solman and Neel, who were interested in Expressionism, and begun to move in the advanced modernist circle that included Davis, Graham and Gorky.[58]

In 'Our Expressionists', Kainen took the same line as von Wiegand, that while contemporary artists could forego the 'inner torment' of Expressionism, they needed to adopt its formal devices because the 'old, literal naturalism is failing to register esthetically in the face of vast social passions and portents of doom and regeneration.' However, when it came to particulars, Kainen found a falling off on the part of most of 'The Ten', which illustrates clearly that his expectations from them were not dissimilar to those of Herbert Lawrence. Bolotowsky's work had become 'aimlessly abstract', regrettably 'in the light of his very fine earlier Expressionist canvases of needle workers' (fig. 82), while Ben-Zion had not included 'anything as rich as his earlier "The Well" and "Lynching"'.[59] Solman was 'the most consistent painter in the show', although even with him, Kainen preferred the works in his recent one-man exhibition at Another Place of which he noted that '[t]he city, with all its accidental structural effects and social chaos has become his theme', praising their '[f]lat, vigorous color areas, emotional linear emphasis and unity of mood'.[60]

Like Davis, Solman composed his pictures from fragments of the urban scene: trucks, the elevated railway, gasometers, railroad signals, street lamps, barber's poles, shopfronts and signs. The generally low-toned dense colours he employed, and the roughly painted partial outlines, often in black, are certainly reminiscent of

some Brücke painting, but Solman's work also suggests a kind of prosaic urban poetry by the accented presence of signs: a huge eye hanging out over the sidewalk in *The Oculist* (1937; fig. 83) as if the city itself looked back at all those unseeing eyes; a naked woman juxtaposed with the El and a barber's pole on 23rd Street in *The Venus of 23rd Street* (1937), incongruously projecting the idea of desire into the grim locale; or the enigmatic pointing hand (a motif he used in several pictures) adjacent to the gasometer in *Avenue B* of the same year.[61] In relation to the effect of mystery these works project, it is worth considering Solman's observation that de Chirico had given his symbols 'a new and disquieting life' by placing them so they emerged 'silent, immobile, from some cavernous space.'[62]

It might seem incongruous that such works could be conceived as in some sense left-wing painting, but it is important to note, contra some interpretations, that Solman's work was not abstractionist in its conception. In 1939 he wrote to Kainen that '[t]here is so much to see, touch and feel that I seem more and more removed from abstract art', while observing simultaneously 'also I feel no nearer solving social problems with a paint-brush.'[63] Solman did not seek to address political issues through his art, but he did practise a species of urban realism within a modernist formal idiom. Moreover, as with Davis, the rejection of abstraction as idealist was a position with political resonance, and it corresponded with a belief in a democratically accessible modern painting grounded in common experience. As I shall show, Solman developed this position consistently in his postwar critical writings, and it remained the ideological underpinning of his practice. It was quite incongruous with the theoretical stances adopted by the most famous of his colleagues in The Ten in the 1940s, and their position also pointed to a different politics.

The difficulties of attempting to apply Expressionist devices to more politically charged themes was illustrated by the work of Nahum Tschacbasov, who according to Kainen had 'made Expressionism the vehicle for a militant proletarianism.' After pursuing a business career, Tschacbasov (1899–1984) took up art as a profession in 1930, and from 1932 to 1934 he studied in Paris with various modern painters, Léger among them. Although one of the founder members of The Ten, he quickly broke with the group and beginning in 1936 had a series of one-man exhibitions at the ACA Gallery. Tschacbasov's work of 1936–40 was dominated by social and political satires, including portraits of such figures as Neville Chamberlain and Henry Ford, images of schoolchildren in gas masks, chain gangs, lynchings

84 Nahum Tschacbasov, *Deportation*, 1936, oil on canvas, 32 × 48 in., Metropolitan Museum of Art, New York, Gift of Samuel S. Goldberg, 1945 (45.139).

and slum dwellings, and even of the Spanish Civil War and fascist deportations (fig. 84). (Not surprisingly, several of his pictures were reproduced in *New Masses*.) Kainen described *Thanksgiving* in his 1937 show as 'one of the really complete pictures of the past few seasons', and in the following year McCausland hailed his work as a 'successful attack on the main problem of the contemporary painter, the fusion of form and content.' Tschacbasov's evident commitment to the Party – in May 1936 he gave a mural-size canvas to its Abraham Lincoln Branch at Nostrand Avenue, Brooklyn – may have something to do with the attention given him, but his work did seem to stand as a truly modern engagement with social and political themes.[64] However, many of his paintings have diffuse, seemingly casual compositions, and he simply did not have Solman's grasp of modernist formal logic.[65]

The demise of *Art Front* at the end of 1937 seems to have been the result of a financial shake-up in the Artists' Union and not of some political decision,[66] but given the divisions that were beginning to appear within the Democratic Front it is symptomatic that the difficulties could not be overcome or that the Party official delegated to help sort out matters should wrongly accuse Humboldt of Trotskyism.[67]

The *Daily Worker*'s Art Column

For the editors of the *Daily Worker*, as for those of *New Masses*, the key challenge of the Popular Front was to increase circulation and produce a publication more in tune with the discourses of popular Americanism. To

this end a *Sunday Worker* was introduced in January 1936, described, symptomatically, as 'A Paper for the Entire Family', committed to speaking 'in language familiar to the American people'. The stress on family matched both the determination to accommodate more mainstream values and the conservative turn in Soviet family policy which was extensively reported in its pages. Insistent references to the slogan 'Communism is the Americanism of the Twentieth Century' were reinforced by frequent articles on US history that emphasised (and often misconstrued) the nation's revolutionary heritage. In 1936 the *Daily Worker* became less the Central Organ of the Communist Party-USA than the 'People's Champion of Liberty, Progress, Peace and Prosperity'.[68]

The Sunday paper gave space for more extended book reviews, but art criticism remained largely in the pages of the weekday paper. The *Daily Worker* reported on union activity within the WPA from its inception, and it also gave extensive coverage to collective organisations such as the Artists' Union and American Artists' Congress. As Party policy on the New Deal shifted in 1936–7, it began to give unqualified support to the WPA cultural programmes. The task of criticism in the paper was thus in part to act as cheerleader for the cultural movement as embodied in these organisations.

The *Daily Worker*'s art critic in the mid-1930s was the same Jacob Kainen, who between June 1934 and September 1938 wrote at least 106 reviews and other pieces for the paper.[69] As an artist and member of collective groupings, Kainen necessarily showed solidarity, but this did not inhibit him from making sharp qualitative judgements on the works of individual artists. The criteria he invoked were grounded in the basic critical polarity of proletarianism: on the one hand the requirement of social engagement (not necessarily direct political effectiveness), and on the other the need for revolutionary art to develop its own distinctive form. Kainen explicitly denied there was an ' "official" Marxist' position on art: 'I have never heard of Marxists who expected art to do more than reflect the social attitudes and the needs of the workers, farmers and their progressive allies. What plastic approach, what type of content and kindred questions are open to debate at all times.'[70] Among the wide range of artists associated with the left, no tendency stood out as the single correct course. Where Kainen differed from Stephen Alexander, however, was in his firm commitment to modern form – but not, of course, to the view that form could carry a revolutionary or progressive significance in itself. Picasso's Cubism was only 'social protest by implication', a rejection of 'the vulgar money-making tempo of bourgeois life'. Yet

although Picasso had been attacked by Marxist critics for escapism, his 'opening up' of 'new technical and plastic vistas was and is recognized as the greatest contribution of modern times to the vocabulary of art.'[71] Kainen could hope that Picasso would infuse expressive form with social and political meanings in his new work, but the course being pursued by most of the American Abstract Artists group seemed to point to nothing but a reactionary idealism, made worse by the efforts of Balcomb Greene and others to associate it with a ' "non-official" Marxism'. Their art was based on the fallacy of an aesthetic emotion distinctive and autonomous, and it was precisely 'lacking in the true modernity the artists set out to attain.' Significantly and appropriately, the most 'original and rewarding work' in their 1937 exhibition for Kainen was the sculptures of David Smith, which were 'rich in contemporary association' that made them 'really modern'.[72]

Kainen was clear that naturalism would no longer do at a time 'when most good painters find it necessary to depart from the naturalistic tradition to achieve emotional depth; when the naturalistic tradition itself is suspect because the problems it concerns itself with have been solved countless times'. When he sought to defend an essentially naturalistic painter such as Jones he did so because 'what he paints socially as well as plastically, enlarges and develops the naturalistic approach.'[73] This may seem a somewhat dubious argument, but Kainen was not alone in advancing it. He and others found a kind of rawness in Jones's work that was, to use his term, 'vital', and which was lacking in that of say Raphael Soyer. Gropper, conversely, could be admired because 'every element' in his pictures was ideologically motivated, and he was simply not interested in naturalistic form as an end.[74]

For Kainen, the whole burden of vitality was carried in paint as a medium and in an ill-defined quality of design, and neither in his own work of the time nor in his criticism did he really address the Cubist challenge to drawing and spatial construction – even when dealing with an artist who made as knowing a use of Cubist devices as Bolotowsky did in *Sweatshop* (see fig. 82), which rivals Gorky's work in this regard. Thus what he found most praiseworthy in the works of Max Weber was their 'utter dependence on the beauty of pigmentation to carry across their social and esthetic message.' It was this quality, too, that he responded to in the work of The Ten, particularly that of Solman and Ben-Zion (fig. 85); the others he generally found insufficiently engaged with social forces. Kainen's enthusiasm for Ben-Zion may also have arisen because the 'folk-like' character

85 Ben-Zion, *Glory of War*, 1935, oil on canvas, 38 × 51 in., collection Lillian Ben-Zion.

of his work (its knowing and highly sophisticated primitivism) and its Jewish themes could now be publicly approved as the Party relaxed its position on ethnic cultures. The artist's *Job*, 'a powerfully conceived canvas . . . steeped in the anguish of the Jewish people', epitomised for Kainen the spirit of a 1938 exhibition organised by the American Art section of the World Congress for Yiddish Culture.[75]

To veristic Surrealism Kainen was straightforwardly hostile, although he acknowledged that revolutionary artists could use 'fantasy and symbols to express a conscious revolutionary outlook'. But when he defended this practice in Quirt's work (see fig. 27), he also stressed the formal differences between it and Dalí's, claiming the former's 'brilliant technical gifts do not lead him to niggled photographic effects', and that 'one is always conscious of his plastic vigor and strong designing'. Cor-

respondingly, he disapproved of the technique of Peter Blume's much lauded *Eternal City* (fig. 86): 'There is no intention here to proscribe technical finish as unsuited for vigorous social utterances, but when there is no feeling for any quality but technical finish, when the social emotion is not communicated to the forms themselves, then we may legitimately feel disappointed.'[76] It is reasonable to ask why, if Kainen acknowledged the seminal formal significance of Cubism, he did not engage with it more. The obvious answer is that it was far from evident that Cubist form could be sufficiently 'humanized' to carry what were understood as social emotions, while it seemed clear that Expressionist form could.[77] Further, with the exception of Davis, Communist critics in the mid-1930s, however sympathetic to modernism, did not generally see a unitary logic in modernist formal developments. Arguably, they were right.

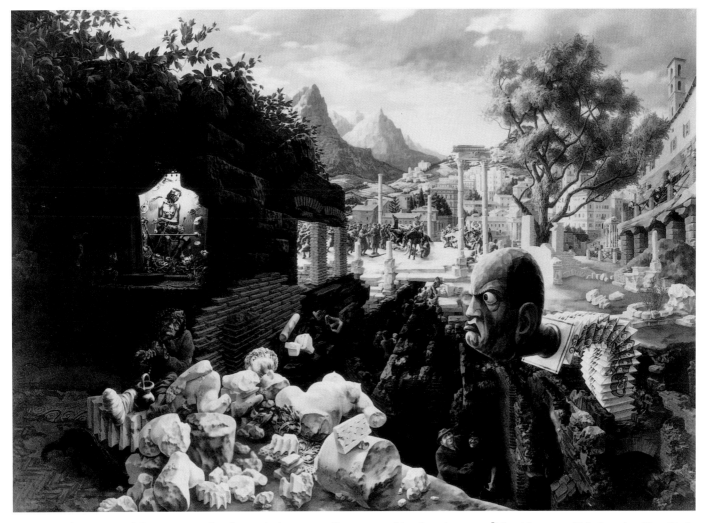

86 Peter Blume, *Eternal City*, 1934–7, dated on painting 1937, oil on composition board, 34 × 47⁷/₈ in., Museum of Modern Art, New York, Mrs Simon Guggenheim Fund. © Estate of Peter Blume/Licensed by VAGA, New York, N.Y.

Just as art criticism in *New Masses* became blander after von Wiegand ceased to write for it, so did that of the *Daily Worker* after Kainen's exit. The reviews of 'Marcia Minor', who wrote the bulk of the paper's art notices from June 1938 to January 1939, lack the critical edge of Kainen's, and do not suggest that tension between aesthetic and political criteria that drives his writing. In April 1939 the paper began to print a 'Midweek Review of the Arts', subsequently retitled 'Art Notes', by 'OMF', perhaps identical with the Oliver F. Mason who appeared in October. In July a Ray King also began to write for it, and for the next two years Mason and King contributed regularly, often reviewing the same exhibitions. Mason provided the general coverage of shows, while King gave more focussed critical analyses. The main development in their reviewing came in the period between the Nazi–Soviet Pact and US entry

into the war, when the Party's anti-war stance led to the adoption of a more revolutionary rhetoric and a breakdown of relations with many former fellow-travellers and liberal allies.[78] Attacks on Communists as no better than fascists, and cleavages in bodies such as the American Artists' Congress, led to a sharpening of tensions within the artistic field. The Party's critical turn on the Roosevelt administration also matched dismay at reductions in the federal art projects after 1939. The reflex of all this in the *Daily Worker*'s art criticism was an increasingly critical attitude towards art museums, complaints of a reactionary nationalism in the art press and attacks on individual critics such as Peyton Boswell, Henry McBride and Edward Alden Jewell.[79] However, these developments did not lead to a revival of proletarianism: rather they led to a greater insistence on internationalism and even stronger affirmations of modernism.

87 Jacob Kainen, *Unfurnished Room*, 1939, oil on canvas, 20 × 24 in., Collection of Whitney Museum of American Art, Gift of the Artist, 96.56.

For instance, the *Daily Worker* warmly endorsed a show of modern art at the ACA Gallery in September–October 1939, which was intended to counter editorial attacks on modern art in the Hearst press, and Picasso became even more an idol – to the extent that Mason defended the artist's 1939 retrospective at the Museum of Modern Art against what he represented as reactionary criticism by those who could not accommodate Picasso's turn to 'social art'.[80] Although Mason and King continued to endorse the work of Jones and Gropper, they also warmly suppported Expressionist artists such as Evergood, Solman, Tschacbasov and their erstwhile defender Kainen (fig. 87).[81] At the end of the decade, progressive art in the Communist press no more meant a simple realism than it had in 1935. Indeed, in December 1939 King questioned the very value of realism as a critical category. Arguing that developments of 'the past half-century have taken all the progressive character out of that watchword', he claimed it now only stood as a negative protest against 'surrealism, abstractionism, expressionism and the other modern dispensations' and questioned McCausland's appeal to the documentary norm: 'This is a photographer's approach. In painting, abstract design cannot be so readily divorced from form and color. Documentary realism is fatal because it kills the imagination.'[82] This was where the aesthetic debates of the Popular Front had issued. Changes in the political climate after the war put realism very much back on the critical agenda.

Conclusions

The critical discourse of the People's Front and Democratic Front phases is harder to characterise than that of the Third Period. The latter had foretold the emergence of proletarian art as a great period style, and whatever their divergences, none of those who sought to discern its features in contemporary developments had doubted it had some significant relationship to Soviet culture. The criticism that succeeded it was more expansive and less precise, both because the rhetoric of proletarianism was abandoned and because the vision of Soviet culture was now at least somewhat clouded by the attacks on Shostakovich, Melnikov and others, and well publicised fiascos such as the Palace of the Soviets design. It also reflected the contradictions of the CPUSA's strategy at a time when the party envisaged itself working within an alliance of progressive forces that included the CIO and social liberals, neither of which were even socialist in their political vision. The agency of 'the people' embraced a hoped for coming together of the middle class, farmers and proletarians, and 'People's culture' was a correspondingly diffuse category through which the earlier aspiration to a revolutionary art kept peeking.

Opposition to pictorial Americanism was undercut by the new turn, so that although Benton, Curry and Wood were still attacked, 'the left wing' was now said to have 'outgrown its primitive crudities' and transformed its conception of 'the worker as a hulking robot into a humanized credible portrayal of the sturdy American people.'[83] Thus while imagery of the Depression and of the varieties of labour continued to be produced and valued, without being juxtaposed to the image of capital it could easily slide into those other varieties of American Scene painting that it had seemed so necessary to distinguish from revolutionary art in the early 1930s. The murals at the 1932 Museum of Modern Art show and the collective paintings of the John Reed Club had been full of imagery that pitted workers and peasants against capitalists. Perhaps the most typical picture of the class enemy from the later 1930s is Gropper's *The Senate* (fig. 88), which was shown at the artist's solo exhibition in 1936, and bought for MOMA by its president, A. Conger Goodyear, for $400. In January 1938 *New Masses* offered a print of the picture with a subscription offer. Its image of a political windbag holding forth to a largely vacant chamber is cognate with the 'Tory' congressmen that people Gropper's cartoons of the period, and illustrates rather neatly the Party's new-found concern with Congress and the democratic political process.

88 William Gropper, *The Senate*, 1935, oil on canvas, 25 1/8 × 33 1/8 in., Museum of Modern Art, New York, Gift of A. Conger Goodyear.

The key problem of the period, at least in retrospect, seems to have been that of modernism. As I have shown, most critics on the left were prepared to accommodate modernism in some degree, and many were insistent on its value as a resource that would be transmuted via the revolutionary movement from the corrupt dross of bourgeois society into the true gold of proletarian art. Difficulties arose partly because the hostility of the Soviet state towards modernism could hardly be gainsaid after the mid-1930s, and also because of the continuing intolerance of critics towards anything that lacked a clearly legible subject. By contrast, the position of artists such as Davis was that bourgeois society in the phase of its decadence had produced great art, even that 'Cézanne, Matisse, Picasso, Leger [*sic*], Seurat, have produced the greatest paintings of all time.' For Davis it was only the work of Dalí and the Surrealists that reflected 'the neurotic and decadent side of contemporary capitalism' and this was manifested in their technique as much as their subjects.[84] This meant that bourgeois society had produced an art technically superior to Soviet art. At most such a position could only be a marginal one. Further, in its own way, Davis's stance was as exclusive as that of his opponents. In 1940 he wrote to George Biddle the 'simple fact is that modern and abstract art are the only contemporary expression in painting.' Thus while Davis warmly acknowledged that 'the Communist parties of the world and the Comintern are completely representative of the cause of the workers', he effectively denied that they provided leadership in aesthetic matters. That leadership was down to the individual modern artist acting as such.[85]

The Popular Front rhetoric of democracy appeared to give licence to creative Marxist thinking by figures such as Davis, but ultimately such licence was an illusion because that rhetoric was premised on a tactic, not a principle. Davis and others ultimately came up against the contradiction of an unreformed Stalinist party that dressed up its policies in democratic language but that continued to assume the right to define truth in all spheres of activity, and to adjudicate between what was progressive and what was not. During the Democratic Front it suited the Party to project an image of pluralism, but once the alliances of the 1930s broke down it quickly reverted to the old dogmatic certainties. Many of those who had entered the movement at this time had genuinely believed in its claims to be the continuator of the democratic tradition. After 1945 they discovered how much 'Browderism' (as the policies of the Popular Front and the war years were called in retrospect) had deceived them.

6 Social Art on Display: Organisations and Exhibitions

Like revolutionary art, social art was defined through a range of interconnected exhibition spaces, the key ones being those provided by bodies in which the Communist Party played a motivating role, namely the Artists' Union, the American Artists' Congress, the American Artists School, An American Group, Inc., and the ACA Gallery. A mere listing of these organisations indicates that social art had a broader institutional base than revolutionary art – as might be expected, given Popular Front strategy. As before, the annual exhibitions of the Whitney Museum will be used as a foil to help discriminate what was special about the shows of these collective bodies.

The American Artists' Congress

The American Artists' Congress has conventionally been seen as a response to the Comintern's shift to the Popular Front strategy in 1935,[1] but the chronology does not quite match with this. The phase from 1933 to mid-1935 was a transition period in Party tactics,[2] and Trachtenberg had already announced the plan to establish a 'higher type of writers' organisation' and a cognate body for artists at the national conference of the John Reed Clubs in September 1934. (The decision to do this was partly motivated by the clubs' evident shortcomings.) The idea of an American Artists' Congress was discussed at a meeting of the Party fraction of the John Reed Club in April 1935 (that is, before the Comintern Congress), with Trachtenberg in attendance. Twelve of those present were delegated the task of organising it, and Stuart Davis, who had joined the club the previous December, was given the job of forming a committee. After passing through various mutations the Organizational Committee began to meet weekly at the ACA Gallery in the summer of 1935.[3] Although the goal of the Congress was to bring together artists of 'recognized standing' under the banner of anti-fascism, almost all of those involved were established figures of the Communist left.[4]

The intitial 'Call' for the Congress was published in the 'Revolutionary Art' issue of *New Masses* on 1 October 1935. While a few among the 107 signatories were not leftists – among whom I count Ivan le Lorraine Albright, Paul Cadmus and Lewis Mumford – the overwhelming majority had already had some connection with the John Reed Club or acted as fellow-travellers in the course of the decade.[5] Among the latter one might instance the Woodstock-based artists George Ault and Henry Billings, who were both on the foundational committee.[6] The 'Call' was directed at 'those artists who realize that the cultural crisis is but a reflection of a world economic crisis' and thus understood that collective organisation was necessary to combat fascism. Specific concerns included the decline of traditional forms of patronage, the inadequacy of government programmes, the censorship of works of art such as Rivera's Rockefeller Center mural, and various violations of civil liberties. The objective of the Congress would be the formation of a permanent nation-wide artists' organisation, which would affiliate with 'kindred organizations throughout the world.'[7]

A version of the 'Call' that circulated after the first congress had been put back from December 1935 to 14–16 February 1936 had 380 signatories, who were still composed mainly of leftists, but now also included Norman Bel Geddes, George Biddle, Alexander Calder and James Johnson Sweeney among the liberal element. The effort to make the organisation appear as a genuine alliance is evident from the fact that the opening address to the Congress was delivered by Mumford, while Biddle chaired one of the sessions. However, the real complexion of the organisation was revealed in effusive statements on the position of the artist in the USSR from Margaret Bourke-White and Lozowick, and addresses appealing to artists to join ranks with organised labour from Heywood Broun of the American Newspaper

Guild and Francis J. Gorman of the United Textiles Workers, both of whom were fellow-travellers.[8]

The Public Session of the Congress was held in the New York Town Hall (erected by the League for Political Education in 1921), while the Open Sessions took place in the liberal ambience of the New School for Social Research. According to a Congress report, 'nearly two thousand people' attended the opening meeting, and 'hundreds more' had to be turned away. Four hundred members came from twenty-eight states, and there was also a delegation of thirteen from the Mexican League of Revolutionary Artists and Writers. It seems that speakers were advised to avoid 'any emphasis on extreme radicalism', and the Congress was conceived to help bring the uncommitted towards an understanding of the threat of fascism and their common interests with the workers.[9] Most of the papers from the Congress were subsequently published in an edition of 3,000 which sold at 50 cents.[10]

Many speeches were hortatory, while others were essentially reports on such matters as the work of the Artists' Union, the campaign for museums to give rental fees to exhibiting artists and the fight for a proper Municipal Art Center in New York. However, there were also important analytical statements, including Aaron Douglas's 'The Negro in American Culture' at the Public Session (the only paper by a black speaker), Meyer Schapiro's 'Social Bases of Art', a brilliant analysis of the sociological formation of contemporary artistic individualism, and Lynd Ward's critique of nationalistic culture 'Race, Nationality, and Art', which was probably directed partly against the Regionalists, although he did not name them.[11]

As Baigell and Williams have observed, the Congress – in line with its objectives – delivered no aesthetic prescriptions. Several contributors spoke on ways to expand the audience for art among the working masses through public murals, magazine illustration, mass-produced artists' prints and museum reform,[12] but stylistic differences were to be overlooked in the interests of 'collective solidarity'. As a later policy statement put it, while the Congress considered all aesthetic tendencies 'in their social and economic as well as their aesthetic aspects . . . [w]ithin the framework of this view, there is room for all schools of artistic practice.'[13]

The Congress's final act was to establish itself as a permanent body with a national office in New York. In other localities, groups of five or more members could establish autonomous branches that would run their own activities in line with national policy. An executive committee of forty-seven (later increased to fifty-seven)

was set up along with various sub-committees headed mainly by leftists. Davis remained secretary, and Ward was appointed treasurer. The following year the veteran modernist Max Weber was voted in as national chairman. (Concrete evidence of the operation of a CP fraction in the Congress survives in the form of a memorandum calling 'all friends of the Party and of Progress' to an evening conference in October 1938.[14]) In November 1936 the Congress claimed 550 members and had branches in Cleveland, Saint Louis, New Orleans and Los Angeles, with one in formation in Chicago. By 1938 further branches had been set up in Baltimore, Salt Lake City and Portland, and membership exceeded 800. That year the Congress, in conjunction with the Artists' Union, also established a student group with the title of Young American Artists.[15]

For the remainder of the decade the American Artists' Congress functioned as something like the elite wing of the Artists' Union, taking up the same causes but using the prestige of some of its members to generate publicity and exert influence. Like that body it agitated for a permanent federal art programme, it supported the Society of Painters, Sculptors and Engravers in its campaign to get a museum rental fee for exhibiting artists, it fought against all censorship of artists on federal programmes and it worked vigorously to get a showing of contemporary American art at the New York World's Fair. In relation to international events, it repeatedly condemned Nazi repression in Germany and fascist aggression in Spain and China, and raised funds for the Spanish Republican cause. The Congress managed to put on a second national meeting in December 1937, to which Picasso sent an address on 'The Defense of Culture in Spain', and where a message from Thomas Mann was read by his niece. Although neither Mayor La Guardia nor House Representative John Coffee appeared to deliver their scheduled papers, Holger Cahill did talk on the 'Cultural Aspects of Government Support of the Arts'. The Congress also organised numerous lectures and symposia.[16]

The second national meeting was probably the Congress's high point. In his account, Herman Baron claimed that the mid-term elections of 1938 were a turning point in its history after which 'some timid souls began to be less active' and 'others began to stay away.'[17] Obviously, the Republican gains of that year would not have had any simple and direct effect on the Artists' Congress, but it is true that the federal arts projects, like the rest of the WPA, came under more conservative pressure thereafter. In August 1938 the House Committee on

Un-American Activities, under the chairmanship of the racist Texas Democrat Martin Dies, began to use allegations of Communist infiltration to smear the New Deal in general and the arts projects in particular. From the other side, the anti-Stalinist left was able to point to mounting evidence that the USSR was neither a true defender of democracy nor a model of cultural tolerance. In the spring of 1939 a group of anti-Stalinists and liberals formed the Committee for Cultural Freedom, which mainly became a vehicle for the anti-Communism of some of its leading members. Later that year another anti-Stalinist body with more left-wing aspirations was set up in the League for Cultural Freedom and Socialism. Both bodies directed their principal energies against the various front organisations.[18]

The Nazi–Soviet Non-Aggression pact of August 1939 caused considerable consternation and dismay in the CPUSA and lent weight to the case against Stalinism – a case compounded by the USSR's invasion of Poland and its aggressive war on Finland from November 1939 to March 1940. In accordance with the Party line the Artists' Congress took an ostensive stance of neutrality on the European war, and in February 1940 it organised two well attended symposia at the Museum of Modern Art directed against the 'rising wave of chauvinism', titled 'What is American Art?' and 'What is the American Tradition?'. However, divisions within the Congress came to a head over the executive board's refusal to issue a condemnation of fascist and Soviet aggression or contribute to the Finnish Relief Committee (headed by Herbert Hoover), and over Communist control of the board. In spring 1940 Meyer Schapiro and Ilya Bolotowsky formed a group to agitate on these issues, which succeeded in forcing a discussion of the Congress's stance on war and fascism at a large and rancorous membership meeting on 4 April. On this occasion Lynd Ward submitted a draft statement of Congress policy, and Schapiro spoke for the dissidents. Ward's report was then accepted by a majority of 'approximately 125 to 12'. According to a statement issued by the dissidents, this 'endorsed the Russian invasion of Finland and implicitly defended Hitler's position by assigning responsibility for the war to England and France.' Moreover, the Congress had shamefully reversed its position on boycotting fascist and Nazi exhibitions. On the following day Davis resigned, and on 15 and 17 April the New York papers carried announcements of the resignations of a range of the organisation's more prominent figures, including Biddle, Mumford, Ralph Pearson, Schapiro, Niles Spencer and William Zorach.[19] Although perhaps only thirty or forty members formally left, a great many more probably let their membership lapse, and the repercussions of this exodus were immediately felt in the poor quality of the annual membership exhibition in May.[20] The call for a congress of American artists held in New York in June 1941 could muster only 112 signatories, and it was held in conjunction with the Fourth Congress of the much reduced League of American Writers.

Yet decisive as these political developments undoubtedly were, it is important to note that the American Artists' Congress was in difficulties before them. Back in 1938 Lozowick (the executive secretary of the New York branch) was complaining that the organisation was 'so busy on so many fronts that there are not enough active members to attend to all the important work', and that summer the national office had to be closed for more than three months due to lack of funds and committed personnel. An attempt to raise funds by introducing a new category of Sustaining Members does not seem to have worked, and by May 1939 the financial situation was desperate. In 1939 there were also internal disagreements over the running of exhibitions, which were felt to have declined disastrously in quality. This all suggests that Congress suffered from the same tensions between professional artistic ambitions and the demands of political organising as did the John Reed Clubs.[21]

Exhibitions of the American Artists' Congress

According to Baron, the most active of the Congress's committees was the exhibition committee. Initially headed by Yasuo Kuniyoshi, in 1937 he was succeeded by the Communist Henry Glintenkamp. Baigell and Williams have listed twenty-two Congress exhibitions in New York alone, and even this is an underestimate. These included a sequence of four Annual Membership exhibitions (1937–41), four Annual Competitive exhibitions (1936–9) and a range of thematic and cause-oriented shows, such as *War and Fascism* (New School for Social Research, 15 April – 6 May 1936) and *To Aid Democracy in Spain* (ACA Galleries, 11–18 October 1936). The competitive exhibitions were for 'younger artists, whose names for the most part are unknown to the general public and who have never had one-man exhibitions,' and their ultimate reward was a free solo show at the ACA Gallery. They were well subscribed and widely reported, and their aim was probably to draw into the Congress's orbit artists who were excluded by the membership requirements.[22]

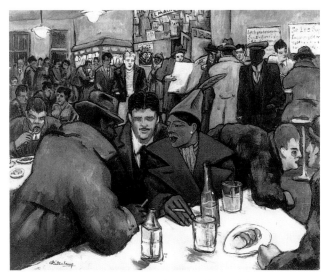

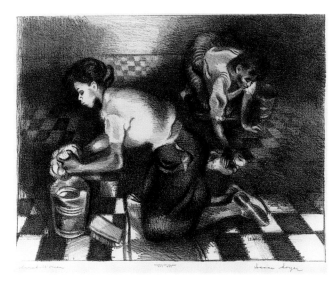

90 Hendrik Glintenkamp, *Cuban Workers Club*, 1937, oil on canvas, 26¼ × 32¼ in., Chrysler Museum, Norfolk, Va. Gift of Walter P. Chrysler Jr, 71.2248.

91 Isaac Soyer, *Scrub Women*, lithograph based on 1936 painting, 12 ⅛ × 15 ¾ in., Sheldon Memorial Art Gallery, University of Nebraska-Lincoln, US Govt WPA Allocation. 1943. WPA - 399.42.

The First Annual Membership exhibition in New York in April 1937 was matched by parallel events in seven other cities, while *An Exhibition in Defense of World Democracy, Dedicated to the Peoples of Spain and China* ... (15–30 December 1937) involved simultaneous shows in New York and six others. *America Today*, an exhibition of one hundred prints, was shown in thirty cities across the nation in 1936.[23] Concern with reaching a wider audience also led to displays outside the normal exhibition venues. Although the majority of the smaller shows were hung at the ACA Gallery, the Annual Membership exhibitions of the New York membership were shown successively in the Mezzanine Gallery of the International Building at Rockefeller Center, the picture galleries at Wanamaker's department store, 444 Madison Avenue (a forty-four-storey skyscraper built in 1931), and at 785 Fifth Avenue. All the membership shows were non-juried and were financed either by a small exhibition fee or a commission on sales. They thus fall into the pattern of artist-run independent exhibitions initiated in the early years of the century by the Henri circle. Baron later claimed that the uptown shows were for prestige and the downtown (that is, ACA) shows were for profit, and that with the exception of the first membership exhibition all the former ran at a loss.[24]

Since the exhibitions were intended to illustrate a common political stance among artists of different political allegiances and aesthetic commitments, it is hardly surprising that what impressed reviewers was their diversity. Whereas writers in the Communist press had tended to demand that the proletarian viewpoint be manifest in exhibits at the John Reed Club shows (while allowing for stylistic variation), now diversity became

a good in itself because it signified the spirit of the common cause. Thus Kainen remarked approvingly of the first Annual Membership exhibitions that 'every type of esthetic direction is represented', while Klein claimed that 'old battles over rival "isms" [give] way to a new stand, in which academicians, abstractionists, expressionists and realists join in a common front'. Such diversity seems to have been characteristic of all the exhibitions of this type.[25]

The New York Annual of 1937 comprised 291 paintings, graphics, photographs and sculptures by 261 artists. Like all the membership shows, it had an illustrated catalogue which enables us to form some picture of the range of work on show. It was the largest and probably most successful of all the Congress's New York shows, and I shall take it as exemplary. Several stalwarts of the John Reed Club exhibited, including Burck, Gellert, Gibson, Ishigaki and Lozowick. Glintenkamp's contribution, *Cuban Workers' Club* (fig. 90) – which represents inter-racial solidarity in front of a background of agitational material – exemplifies the continuance of the proletarian motif. But against this must be set the exhibits of established gallery artists such as Leon Kroll, Brook and Kuniyoshi whose usual work had no connections with social art in any form. Even Biddle showed an innocuous portrait of the artist Marguerite Zorach rather than any of his more critically charged works. Indeed, one reviewer in the mainstream press commented that instead of art 'belligerently social in temper', the show abounded 'with landscapes, still-lifes, portraits and abstractions'.[26] Proletarian naturalism was represented through paintings by Isaac (fig. 91), Moses and Raphael Soyer (although the latter

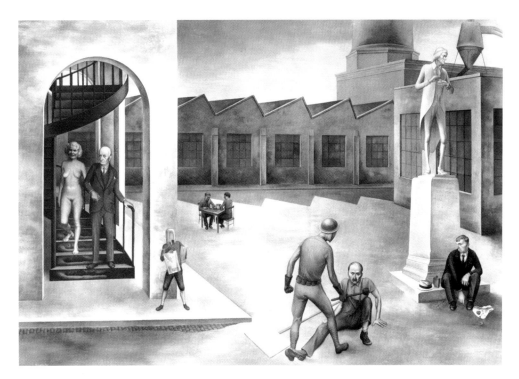

92 Henry Billings, *Arrest No. 2*, 1937, oil and tempera on cardboard, whereabouts unknown.

93 O. Louis Guglielmi, *American Dream*, 1935, oil on canvas, 21⅝ × 54⅛ in., whereabouts unknown.

showed an uncharacteristically militant canvas titled *Workers Armed*; private collection), and in the same category belongs Harriton's genre scene, *Lower Harlem*. References to the object of the organisation were present in works such as Refregier's Surrealistic panel *Fascism over Spain* and Ribak's *The Family in Flight*, while Henry Billings's *Arrest No. 2* (fig. 92), Guglielmi's canvas *American Dream* (fig. 93) and Ishigaki's *Ku Klux Klan* (Museum of Modern Art, Wakayama) indicated that fascism was a domestic problem too. But such works seem to have been completely overwhelmed by politically non-committal or more equivocal images.

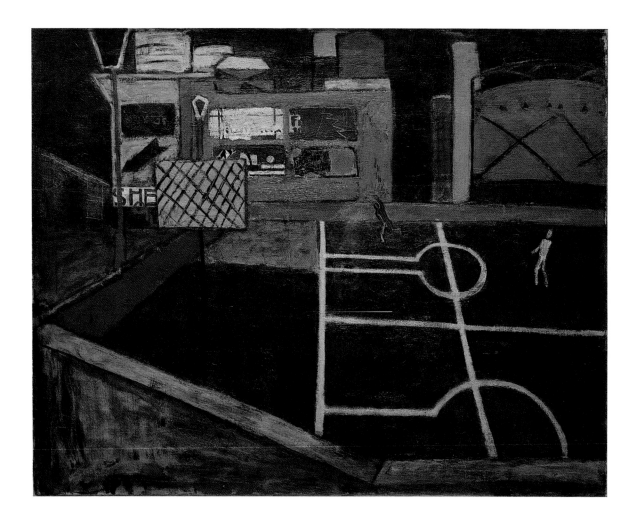

Among artists whose work was overtly engaged with modernism the Expressionists were a distinct presence, noted by all the left-wing critics. Solman's *City Playground* (fig. 94), Ben-Zion's *In the Barn*, Tschacbasov's *Penthouse* and Max Weber's *Oarsman* (Collection Maynard J. Weber) were among the works that seem to have particularly stood out from this category. Solman's almost oneiric image of two figures playing handball in a desolate-looking city lot dominated by a gasometer, Tschacbasov's cramped tenement family and Weber's bulky proletarian all seemed to exemplify the much anticipated attempt to address the contemporary social scene in a modernist idiom. But there was also a substantial cohort of abstractionists, including Bolotowsky, Byron Browne, Francis Criss, Davis, Werner Drewes, Graham, Irene Rice Pereira and Vaclav Vytlacil.[27] The work from this tendency that attracted most attention was Davis's *Red Cart* (fig. 95), partly perhaps because of its vibrant colour and partly because it was not really an abstract painting at all. It is in fact one of Davis's numerous Gloucester compositions, and had been painted about four years earlier.[28] Unlike some of his other works from this period such as *The Terminal* (1937; Hirshhorn Museum and Sculpture Garden), *Red Cart* makes no concessions to the idea of social art, and either Davis had nothing else on hand to show (he worked slowly and was much absorbed with organising at this time) or he chose the painting as a programmatic gesture to illustrate his belief that modernist form, conceived rightly, had a progressive import in and of itself.

The same contrast of aesthetics was evident in the forty-six sculptures on display, among which a mawkish carving of a girl and dog by William Zorach and a slick primitivising head by Jose de Creeft mingled with works in a range of idioms by left-wingers such as Cronbach, Glickman (fig. 96), Goodelman, Harkavy, Werner and Wolff, all of whom – with the exception of Glickman – had shown with the John Reed Club.

While reviewers in both the left-wing and mainstream press agreed that the first Annual Membership exhibition was impressive, it mainly illustrated the Congress's lack of aesthetic programme and a new-found spirit of tolerance or 'geniality' among competing artistic camps.[29] Other shows at least attempted a thematic

unity. *War and Fascism* consisted of 219 cartoons, drawings and prints by an international selection of artists, from historical figures such as Callot and Goya, down to the well-known twentieth-century artists Grosz, Masereel and Orozco, and also encompassed contemporary Americans like Burck, Dehn and Limbach. *An Exhibition in Defense of World Democracy*, which accompanied the second national conference in December 1937, was restricted to Congress members, with the exception of Picasso's etching series *The Dream and Lie of Franco* and a group of anti-fascist drawings by Madrid school children. Although abstractionists such as Bolotowsky, Browne, Drewes, Holty and Pereira exhibited, their contributions were entirely outweighed by artists working in more readily legible modes, and the titles of even their works in most instances (*Air-Raid*, *War-Torn City*, *Fascism*) indicate an attempt to amplify the programmatic effect.

By 1939 members of the New York Executive were complaining that the exhibitions were declining, even that the third membership exhibition was 'lousy'.[30] There are indications that not all contributors sent in

95 (*above*) Stuart Davis, *Red Cart*, 1932, oil on canvas, 32¼ × 50 in., 1946.15, Addison Gallery of American Art, Phillips Academy, Andover, Massachusetts, museum purchase. © Estate of Stuart Davis/ Licensed by VAGA, New York, N.Y.

96 (*left*) Maurice Glickman, *Asturian Miner and Family*, from *New Masses*, 11 May 1937, Tamiment Institute Library, New York University.

94 (*facing page*) Joseph Solman, *City Playground*, 1937, oil on canvas, 30 × 38 in., Collection of Paul Solman.

their best works to the annual shows, which were, after all, partly ritual displays of solidarity. For this reason, they could not supersede the various regular exhibitions of contemporary art put on by the museums in securing an artist's reputation. Neither could they substitute for the one-person show at the dealer's gallery in this regard.

Artists' Union Exhibitions and Other Initiatives

My main account of the Artists' Union will be resumed in the next chapter in relation to the federal art projects, which were its primary *raison d'être*. However, artist-run exhibitions were listed as part of 'The Purpose of the Organization' in an undated flier, and matched its general ethos. In Chicago, the Union managed to set up a permanent gallery, and the unions in Baltimore and Washington put on a joint exhibition in 1939.[31] In March 1934 the New York Union had inaugurated its move to new quarters with an exhibition, and in 1935 a whole succession of small shows of work in different media was put on there.[32] A group show by the membership held at the ACA Gallery in February 1936 appears to have been conceived as a continuation of the John Reed Club strategy, in that of the fifty or so exhibitors many had shown with the Club, and images of workers and anti-bourgeois satires dominated the display.[33] The first national exhibition of the Artists' Union was held at the Museum of Fine Arts in Springfield, Massachusetts, in 1938, and comprised 224 works from Union branches in eleven cities and states. However, this seems to have been a museum show rather than a cooperative effort. The average age of the exhibitors was twenty-seven, and although well established talents such as Cikovsky, Evergood, Gottlieb, Gross and Ribak were included, it was presented as 'an exposition of what the more radical new generation is doing.'[34]

The absence of regular membership shows in the years 1937–9 suggests that the better-known artists in the Union were concentrating on the Artists' Congress exhibitions or on the more select milieu of those arranged by An American Group.[35] The Union itself did not put on a national membership exhibition until 1940. Displayed in the Associated Press Building in Rockefeller Plaza and the ACA and Hudson D. Walker Galleries, this was a massive non-jury show, open to all members in good standing and comprising 344 works by 301 artists. It seems likely that the decision to put on such an exhibition was motivated both by the embattled state of the federal art projects and the need to demonstrate unity in the face of the divisions within the Democratic Front caused by Soviet foreign policy.[36]

One reason why the Artists' Union may not have been much concerned with arranging membership exhibitions in the later 1930s is because its leadership was attracted by more radical strategies of reaching a popular audience, strategies in line with the artists' identification with organised labour. At a convention of Artists' Unions from the eastern states held at the Hotel New Yorker in May 1936 much emphasis was placed on the public use of art, and Meyer Schapiro delivered a remarkable paper on the topic subsequently published in *Art Front*. While acknowledging that the federal arts projects were 'an immense step toward a public art and the security of the artist's profession', Schapiro also stressed their limitations and warned his audience that the 'temporary ease and opportunity for work' they offered should not cloak 'the harsh realities of class government'. Given that the administration would inevitably seek to provide 'conventional images of peace, justice, social harmony, [and] productive labour', of little interest to workers, artists must 'demand the extension of the program to reach a wider public' through 'collaboration with working class groups'.[37]

97 Elizabeth Olds, complete study for porcelain enamel mural, nd, crayon on cardboard, dimensions unknown, whereabouts unknown. From Museum of Modern Art, New York, *Subway Art* (1938).

98 Elizabeth Olds, *White Collar Boys*, 1936, lithograph, $11^{1}/_{8} \times 14^{13}/_{16}$ in., Smithsonian American Art Museum, Washington, D.C., Transfer from Smithsonian Institution, Archives of American Art.

In the aftermath of this conference, the union set up a Public Use of Art committee with around ten members, among whom were such committed leftists as Ida Abelman, Paul Block, Robert Cronbach and Joseph Solman. With what has been described as the 'guarded approval' of the FAP, trade unions were approached and asked what Project art-work they might wish to borrow and their preferred subject matter. The committee received specific suggestions from the International Ladies Garment Workers' Union (ILGWU), the Transport Workers' Union, the Ministers' Union and Labor Temple, the Union of Dining Car Employees and the Sign Writers' Union.[38] The contact with the Transport Workers' Union led to an ambitious plan to decorate New York subway stations with sculptures and murals in ceramic tiles, enamel panels, silicon ester and even sgraffito on black cement. In connection with this an exhibition of designs by thirty-three artists was shown at the Museum of Modern Art in February–March 1938 and drew an estimated 35,000 visitors, but the scheme eventually foundered due to opposition within the City Council and the cutback in WPA funding in 1939.[39]

Some of the art conceived in connection with the Public Use of Arts committee certainly signified a more critical and militant outlook than most public art of the FAP. Thus Elizabeth Olds conceived a design for a porcelain enamel mural (fig. 97) that incorporated elements of her 1936 caricature of middle-class subway riders, *White Collar Boys* (fig. 98), set against the heroic working-class type of her *Miner Joe* (see fig. 146), who is positioned next to implements of labour. On the right a group of workers and office girls stride purposefully towards the centre of the image. This contrast between an indecisive (and potentially fascistic) middle class and heroic labour is basic to Olds's imagery at this time.[40] It is not suprising that the City Council found such an imagery of social typology, with its modernist space and Orozco-like grotesques, unacceptable.

Ida Abelman's large lithograph *My Father Reminisces* (fig. 99) was illustrated in *Art Front* in May 1937 with an explanatory text that revealed that the print was produced under the FAP for trade union distribution. Effectively, Abelman took all the themes that had been suggested to the Committee by the ILGWU and compressed them within one image. An extraordinary com-

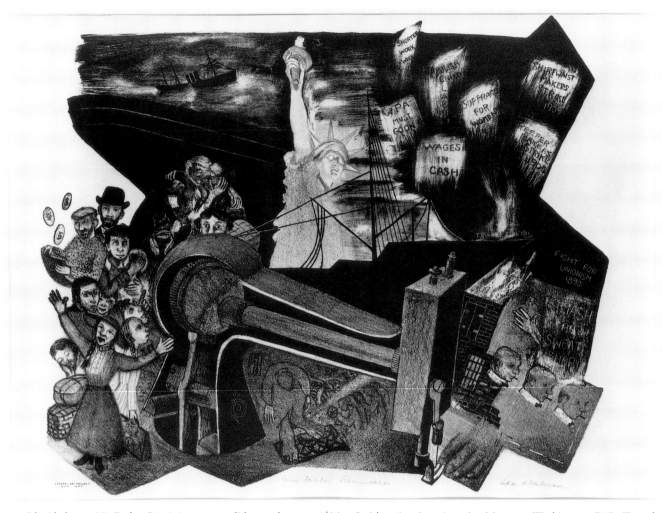

99 Ida Abelman, *My Father Reminisces*, 1937, lithograph, 15 × 18¹/₄ in., Smithsonian American Art Museum, Washington, D.C., Transfer from D.C. Public Library.

posite of immigrant life and labour struggles, it uses collage devices to describe a complex historical narrative stretching from left to right through the passage and arrival of immigrants, the exploitation of the sweatshops, the formation of the ILGWU, the Triangle Shirtwaist Fire and successful strike activity, which is set against the trio of the callous manufacturer, the jobber and the contractor. Liberty is reduced to a ghostly form silhouetted on deep blacks, and the sewing machine dominates all like a mill in which piece-workers are crushed. As will be evident by now, Abelman's fusion of Expressionist and Surrealist devices represents a widespread idiom of the period. How far it was successful with the union audiences at which it was aimed is not known, but in late 1938 the United American Printmakers within the recently renamed United American Artists launched a campaign to distribute such mass-produced prints through the union movement.[41]

The American Artists School

An announcement in *Art Front* of February 1936 declared that the John Reed Club School of Art had been dissolved at the end of January, and a group of 'nationally known artists' were organising an independent school that would take over its quarters and equipment. The new school, symptomatically renamed the American Artists School, opened in April on three floors of a 'modern loft building' at 131 West 14th Street. As well as studios and offices, there were a library, lecture room and large gallery.[42] In 1936 its total registration was more than five hundred students. However, the School experienced the familiar problems of such voluntary bodies in sporadic attendance at meetings and shortage of funds.[43] It was partly because of the latter problem that it put on a whole sequence of exhibitions and issued two portfolios of prints.

The stated aims of the School – set out in its 1936 brochure under the questions 'What Is America? What Is American Art? How Can We Achieve It?' – sought to distinguish the pedagogy it offered by characterising the training of other art schools, whether traditional or modern, as 'concentrated on technical efficiency'. By contrast, '[t]he American Artists School eschews this sterile approach and establishes as its fundamental premise that the student must be developed as an independent thinker at the same time he is trained to be a competent artist.' This was essentially the same argument that had been used to distinguish between revolutionary art and modernism, but couched in a new language of Americanism, with the faculty described as 'progressive' rather than 'revolutionary' or 'proletarian' artists. In a statement for the School published in *Art Front*, Evergood described the task of present-day art as 'to deal with our lives in a way that adds to them and still not be propaganda in the derogatory sense of the word as attacked by those who advocate an art devoid of thought and content.' In the pursuit of such an art, students would be given the opportunity 'to study the best of every form of art from the abstract to expressionism, to surrealism, to American genre, to experiments in painting revolving around American thought and content.'[44] This variety was reflected in the teaching staff, who in 1936–7 ranged from naturalists such as Harriton and Moses Soyer to the Social Surrealist Quirt and the modernists Criss and Schanker.

The School offered courses in a wide range of media, and there was also a criticism and discussion class. Students were promised the collaboration of 'psychologists, social commentators and outstandingly progressive artists, to give . . . [them] a living background for the aesthetic interpretation of America'. The intellectual range the School fostered is suggested by a 1938 lecture programme, which among regular artistic topics also advertised talks on contemporary dance (by Martha Graham), swing music, music and the people, stage design, housing, photomontage and American folk art.[45]

As Virginia Marquardt has observed, the School functioned as something like the 'educational "arm"' of the Artists' Congress, and although there was no official connection between the two bodies, many of the same figures were involved in both. The close connection between the School and Communist cultural movement is evinced by the extensive publicity for its activities in the pages of *New Masses* and the *Daily Worker*. Among these were many benefit shows put on by the faculty and students, usually selling works at very low prices.[46] In April 1937 what seems to have been a more ambitious thematic exhibition with the title of *The Social Scene* was put on. This comprised sixty-eight works by fifty-eight artists, and was accompanied by a symposium on 'New Forms and Content for American Art', at which Samuel Putnam and Charmion von Wiegand spoke, with Lozowick in the chair.[47] Like the two portfolios of prints the school issued in 1936, these exhibitions were both fund-raising devices and didactic displays. Doubtless they illustrated the pluralism of social art, at the same time as they showed the continuing kernel of proletarianism within it.[48]

An American Group, Inc.

An American Group, Inc. was set up by six artists in the summer of 1931 to address the problems of exhibition faced by 'younger, less well known artists', the founders being Stuart Edie, Robert Phillip, Frederic Knight, Anatol Shulkin, Jacob Getlar Smith and Chuzo Tamotzu. Initially they had their own gallery in a 1930 skyscraper, the Barbizon Plaza Hotel on Sixth Avenue and West 58th Street, but after three years of running exhibitions they handed over this side of their programme to a sequence of commercial galleries. From that point on they focussed primarily on annual membership exhibitions. New members of the group were elected every year, and by 1938 there were fifty-two in all. In fact, by then many of the members were relatively well-known figures. Like the American Artists' Congress, An American Group stood for an 'esthetic united front'.[49]

According to the 'Constitution and By-Laws' of 1941 An American Group was 'essentially cultural and non-political in character' but its domination by the left is unquestionable. Of the six founders, four were signatories of 'The Call' for an Artists' Congress and another had joined by the Congress's first annual membership exhibition. All the offices in 1939 were occupied by leftists, excepting the presidency which was held by Kuniyoshi, and the committees were similarly packed.[50] While non-leftists such as Cadmus and Bishop were members and showed in the annual exhibitions, they were entirely overwhelmed by stalwarts of the Communist cultural movement such as Criss, Dehn, Evergood, Goodelman, Gropper, Harkavy, Harriton, Lozowick, Olds, Quirt, Refregier, Ribak and the Soyers. One might wonder why these artists needed another exhibition body alongside the Artists' Congress or a welfare body beyond the Artists' Union, and I surmise that it was because the Congress was not sufficiently concerned with professional interests, and the Union was too focussed around the FAP. Both may also have been too politically inclusive in their membership.[51]

The annual membership shows of An American Group were certainly smaller than those of the Artists' Congress. Thus, the 1937 exhibition at the Montross Gallery consisted of only 39 works,[52] that of 1938 at Delphic Studios had 75 and that of 1939 at Associated American Artists' Gallery had 58. To judge from the exhibition catalogues, the works by modernists (represented by Davis and Criss) and Social Surrealists (Quirt) were entirely outnumbered by the social art, landscapes, portraits and still-lifes on show. However, while the membership shows of An American Group may have been more selective than those of the Artists' Congress and more uniformly naturalistic, they functioned mainly as manifestations of artists' new-found spirit of collectivism and 'progressive' Americanism.

Much more interesting are the two thematic exhibitions organised by the Group: the *Waterfont Art Show* it co-sponsored with the Marine Workers Committee, held at the New School for Social Research in February 1937; and *Roofs for Forty Million* shown at Rockefeller Center from 15 April to 1 May of the following year. The former was the sequel to a more modest benefit exhibition put on in late 1935 at the Italian Workers' Club on Bleeker Street.[53] According to a review in *New Masses*, the core of exhibitors was made up of artists who had 'trained in the tough three-mornings-a-week schedule of the waterfront units of the Communist Party', and who knew the longshoremen at first hand. The context of this involvement was provided by the Communists' strength in the maritime unions, and more particularly perhaps, by the numerous strikes the International Longshoremen's Association launched in 1936, directed mainly against the corrupt AFL leadership, which culminated in actions by the rank and file seamen and longshoremen in the autumn that shut down nearly all ports in the country for more than three months.[54]

The 1937 exhibition comprised 126 works by 107 artists, made up of oils, watercolours, and drawings, prints and photographs in relatively equal numbers, together with sculptures by Cronbach, Goodelman and Werner. In addition to the three last named, there was a solid presence of established leftists, such as Ault, Cikovsky, Davis, Dehn, Evergood, Gottlieb, Gropper, Guy, Harriton, Ishigaki, Lozowick, Morley, Olds and Ribak. Modernists such as Bolotowsky, Davis and Adolph Gottlieb were very much in a minority and, according to the *New Masses* reviewer, Davis's exhibit was at first unappreciated by the worker visitors.[55] To judge from their titles, a few of the pictures and prints were of strikes and labour, but these were apparently

swamped by 'pictures of lounging bums, absolutely beautiful marine blues, [and] chugging tug boats.' Evergood's *Strikers in the Snow* is likely to have been the painting *Warming Up* now in the Hirshhorn Museum, and he also contributed the powerful drawing *North River Jungle* in the same collection – both the fruit of an evening spent with unemployed men on a vacant lot in Greenwich Village in 1933.[56]

We can probably identify Alice Neel's *Marine Worker* with her impressive portrait of the Communist waterfront organiser Pat Whalen (fig. 100). Neel later described the sitter as 'an ordinary Irishman' but one driven by an absolute faith in Communist principles. In fact, Whalen was an archetypal working-class intellectual and activist, who led the seamen in the violent Baltimore dock strike of 1936 and subsequently became the first president of the Baltimore branch of the NMU after that union was established as a CIO affiliate in May of the following year. Although only just over five feet tall and weighing around 120 pounds, Whalen had a well-earned reputation for personal bravery and was an eloquent speaker in a working-class idiom that was liberally peppered with cuss words. Like Neel herself he was fiercely committed to the Party's struggle against racism, and like her he was an independent-thinking radical, who had problems with Party discipline. In the portrait Whalen's lack of tie and rough haircut serve to define him as a working man, and the protruding left ear gives him a homely appearance. Neel flags his beliefs through the copy of the *Daily Worker*, with its banner strike headline, but also signifies resolution through the clenched fists, furrowed brow and set visionary look of the eyes. This is one of the few individually credible images of a Communist as such from the period, and it is perhaps significant that reviews in the Communist press passed over it in silence, since Whalen looks almost like a saint consumed by the sufferings of the world – his fists substituting for hands in prayer and at the same time intimating the Communist salute and the will to struggle.[57] Such an image was perhaps out of step with the image of normalcy that the Party sought to project at this time, epitomised by numerous photographs of Earl Browder in suit and tie, often with a pipe in his mouth. At the same time, the Expressionist style may have seemed incongruous with the documentary claims implicit in the portrait genre.

In any case, given the preponderance of genre images and port views, the *Daily Worker's* claim that the *Waterfront Art Show* was 'the first important mass art exhibition in this country with the definite aim of supporting the rank and file of labor' must refer mainly to the symbolic display of solidarity, rather than to the art itself.[58]

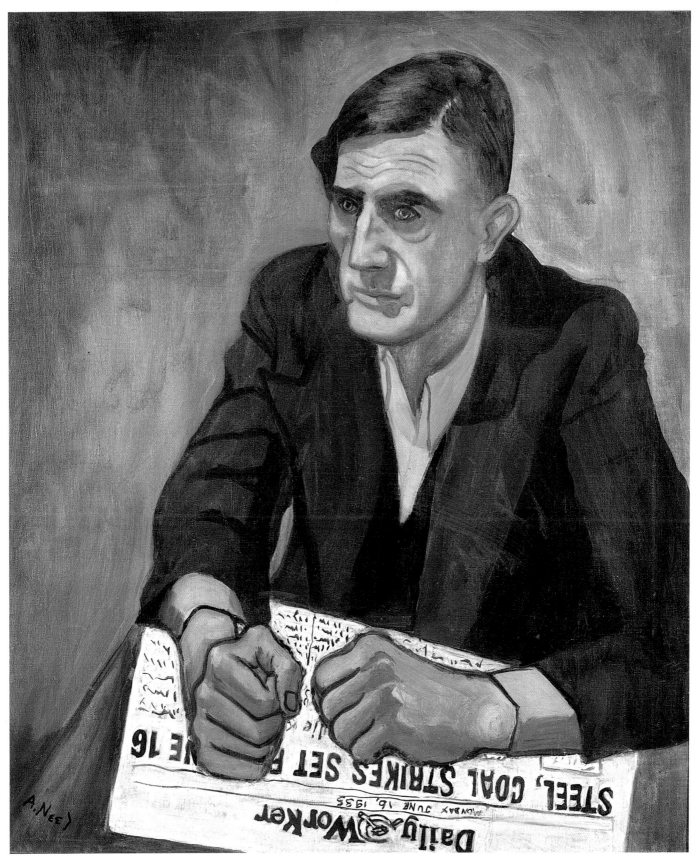

100 Alice Neel, *Pat Whalen*, 1935, oil on canvas, 27 × 23 in., Collection of Whitney Museum of American Art, New York, Gift of Dr Hartley Neel, 81.12. © Estate of Alice Neel. Courtesy of Robert Miller Gallery, New York.

Roofs for 40 Million was shown in the galleries of La Maison Française and consisted of nearly 200 works by more than 100 artists. The title is evocative of the 'One Third of a Nation' of Roosevelt's Second Inaugural Address, and of the Federal Theater production of that name, which was playing to packed audiences in New York at the time of the exhibition. Considering, too, that the city had some of the most appalling urban slums in the nation, the theme was also particularly apt.[59] In fact, the Wagner-Steagall Housing Act that the President signed into law in 1937 was inadequate to the problem, and although the CP supported the bill – as it supported the Social Security provisions of the New Deal – it also stressed its limitations. Correspondingly, *Roofs for 40 Million* was not simply an endorsement of the New Deal. The pictorial report of the exhibition in *New Masses* was accompanied by a critique of the 1937 Act and the Federal Housing Administration by the left-wing architect Sidney Hill, and that in the *Daily Worker* presented it as an indictment of 'the government'.[60]

The presentation of *Roofs for 40 Million* made it a more didactic display than the *Waterfront Art Show*, the artists' works being supplemented by a photographic section in a separate room, which illustrated both the horrors of slum housing and model dwellings built by both federal and municipal authorities. In her review, McCausland wanted works that would move the viewer to action rather than prompt contemplation of the 'morbid beauty' of decay, and while she found the exhibits generally did not fall into this trap, she still preferred the photographs to the paintings, drawings and prints. This points to a fundamental problem with the notion of art as documentary: as with that of art as a weapon, all the emphasis was on utility. One might argue, indeed, that there was an even more fundamental confusion of categories, in that while the latter (in the abstract at least) permitted formal flexibility, the former implicitly forced art into competition with a photographic mode which had all the authority of unmediated veracity, however illusory its foundations. This authority it simply could not match. Yet the thematic exhibition could hardly escape the documentary burden.[61]

The ACA Gallery

As I have noted, Herman Baron's ACA Gallery had played a major role in advancing proletarian art. In the later 1930s it provided the venue for a sequence of benefit and programmatic shows that were effectively manifestations of the Democratic Front. It also became the main forum for one-person and group shows of social art, for which its proprietor was a tireless publicist.

GROUP SHOWS

There were four main exhibitions of the first type: *Pink Slips Over Culture* (July 1937), *1938: Dedicated to the New Deal* (August–September 1938), *Exhibition for the Ben Leider Memorial Fund* (October 1938) and *We Like America* (November 1938).[62] In addition there were annual group exhibitions on 'social themes', such as *Paintings by 17 Artists on Social Themes* (January 1939).[63] The most important programmatic exhibition at the ACA in this period was *1938: Dedicated to the New Deal*, both because it emphatically marked the turn to support of the administration and also because it inadvertently revealed the ambiguities of the Democratic Front. Opening the 1938 season, it was a small show consisting of only twenty-one works, accompanied by an illustrated catalogue. The 'original idea' had been to have uniform mural panels, 5 × 3 feet, showing 'some phase of the New Deal and its effect in improving the conditions of the people.' In the catalogue Baron claimed the exhibitors had come together 'to give voice to the people's protest and desire for progressive action', and altogether the show demonstrated that artists had 'definitely aligned themselves with the forces grouped around the New Deal.'[64] Yet, in fact, reviewers in the mainstream press were struck by the mixed ideological message of the display. Thus the *New York Sun* observed that while the exhibition was supposed to demonstrate approval of the 'Great Experiment', 'to the one who approaches it from the outside it seems at most approval with reservations.' Referring to Weber's *The Forgotten Man* (which depicted a demonstrating worker with clenched fist), this reviewer suggested that several of the artists appeared to have been 'caught unawares', and 'simply sent what they chanced to have on hand'.[65] In actuality, Weber's picture had been painted in 1934, and both Biddle and Lozowick showed lithographs that were not done for the occasion. Biddle's *Death on the Plains* (fig. 101) hardly looks like a tribute to New Deal agricultural policy, while Sternberg's *Filibuster over the Senate* was a reworking of his 1935 *Southern Holiday* (see fig. 50), which could not really be read as a tribute to the administration either, since the president, while condemning lynching, had not endorsed the 1938 Anti-Lynching Bill.

Several of the canvases were essentially caricatures of reactionary forces. Gropper's *The Market* showed

101 George Biddle, *Death on the Plains*, 1936, lithograph, 10 × 13¹⁵/₁₆ in., Print Collection, Miriam and Ira D. Wallach Division of Art, Prints and Photographs, New York Public Library, Astor, Lenox and Tilden Foundations.

102 Elizabeth Olds, *The Middle Class*, 1936, lithograph, 10 × 14 in., Smithsonian American Art Museum, Washington, D.C., Transfer from Smithsonian Institution, Archives of American Art.

frantic capitalists responding to the Wall Street Crash by turning on the workers; Tschacbasov's *Roots of Decay* pilloried a whole cast of reactionary types including Coughlin, Ford and Hearst; and Gottlieb's *Strength through Joy* linked some of the same figures with Chamberlain, Hitler, Hirohito and Mussolini all dancing hand in hand in front of a war-torn landscape led by a skeleton.[66] Olds exhibited a painted variant of her 1936 lithograph *The Middle Class* (fig. 102), which represented them as an unstable group torn between the appeals of fascist demagoguery and an alliance with organised

labour. As the *Sun* observed, such images hardly seemed 'paeans in praise of the existing regime.'

If the aim of *1938: Dedicated to the New Deal* had been to reach beyond those already converted, then to judge by the critical response it failed. Further, as with *Roofs for 40 Million*, the exhibition seems to have defeated its own ends both aesthetically and politically. In relation to the former, the critical response revealed that form signified more strongly than political symbolism within the artistic field, and in relation to the latter it showed that the social critique advanced by the New Deal's would-be allies in the Communist movement was far to the left of any element within the administration.

ONE-PERSON EXHIBITIONS

Although the ACA was not the only gallery where social art could be seen in the later 1930s, its pre-eminence in this area was indisputable. Many of the most prominent artists we have encountered had one-person shows there, including Evergood, Gottlieb, Gropper, Harriton, Jones, Olds, Refregier, Ribak, Sternberg and Tschacbasov. Of these, Baron singled out Jones, Gropper and Evergood for special treatment in his history of the gallery, and more than any others they stood for social art and its problems. The responses to them thus merit separate consideration.

JOE JONES

Jones's early career and reactions to his first New York show were considered in Chapter Two. Baron claimed that this exhibition effectively won the battle for social art, leading to an immediate increase in the number of gallery visitors, and making Jones a success 'overnight'. By contrast, he described Jones's second exhibition, *Paintings of Wheat Fields*, as far less successful, a view that may be partly explained by the fact it was shown at the Maynard Walker Gallery in the art world enclave on 57th Street with only the cooperation of the ACA. The opening was reportedly a fancy affair, attended by Edward G. Robinson and Katherine Hepburn among others, and the fourteen exhibits were predominantly Midwestern landscapes, very different from the politically engaged canvases Jones had shown in 1935. Critics generally praised the authenticity of the works but also complained of their technical immaturity.[67]

The change in Jones's subject matter was partly occasioned by his employment by the Resettlement Administration to paint social conditions in the Midwest in the autumn of 1935, as a result of which he began to work as a documentarist. (Photographs he made at this time

103 Joe Jones, *Wheat Threshing Scene in St Charles County*, formerly Metropolitan Museum of Art, New York.

served as the basis for some of his later paintings.) In 1936 he was back living in Saint Louis, sharing a studio with the writer Jack Conroy, and in the following year he was awarded a Guggenheim fellowship 'to paint the life of the present day Middle-West.' His engagement with Midwestern themes was not accompanied by any diminution in his political commitments, which were reinforced by his spell at Commonwealth College, and he publicly endorsed the Communist presidential candidates in the 1936 elections.[68] His 1937 ACA exhibition was seen by the critics as marking a return to the form of his first exhibition, and in the catalogue Baron presented him again as a proletarian artist and realist: 'His realism stems from the old masters and is as fundamentally vital as theirs. He could not paint in any other style and be effective. He is a son of the people whose collective experience he is expressing.' Kainen, however, who had praised the 1936 exhibit, found in Jones's new works a laboured technique, which marked a falling off from the vitality of his earlier proletarianism.[69]

Marling has made much of the series of murals of Missouri agriculture that Jones made for a Saint Louis bar-room at the end of 1936 (Haggerty Museum of Art, Marquette University, Milwaukee), which suggest an essentially benign vision of the region. However, it is not clear that Jones took these very seriously,[70] and in New York the artist was best known for images of abandoned dustbowl farms, dispossessed farmers and impoverished children – images that suggested precisely those aspects of the Midwest with no place in Regionalist art. The painting *Wheat Threshing Scene in St. Charles County*

(fig. 103), which the Metropolitan Museum bought for $1,000 in 1937, was described as 'one of a series on the relationship of the worker to his job', and is emphatically a scene of modern collective labour unlike the owner-occupier homesteads of Wood's pictorial Iowa. (In 1935, Archibald MacLeish had found a political significance in the expression on the nearmost worker's face and the positioning of his left fist.[71]) While Jones told a newspaper reporter in 1938 that his 'active political life' was 'almost negligible', this was prefaced by the assertion that he was 'still a Communist'.[72]

Yet particularly after his move to New York in 1937, Jones was increasingly concerned with making a career as an artist. In a letter of that year he observed of his friends Arnold Blanch and Doris Lee that they were 'the only ones I have been able to find who had time for art – everyone else finds time only for political thought & activity, which should be a part of every artist but never his whole interest' (*sic*).[73] Jones certainly gave up revolutionary art after 1935, and his work of the ensuing years can be seen as a transition to the documentary mode of social art that McCausland recommended, and one that accorded with the ideal of a left-wing Regionalism advanced by the Popular Front magazine *Midwest*.[74] Gallery success was matched by a sequence of five commissions to decorate post offices from the Treasury Section of Fine Arts, which culminated in Jones's winning a prize in the Section's Forty-Eight States mural competition of 1940. In the same year, one of his paintings came second in a poll to determine the most popular picture at the New York World's Fair exhibition of contemporary art. However, the idea that Jones compromised his political ideals in the later 1930s is questionable, and against the Democratic Front Americanism of his post office murals should be set the images of workers and derelicts that filled his 1939 and 1940 shows at the ACA. Both exhibitions were favourably reviewed in the *Daily Worker*, and the catalogue to the latter quoted statements by the artist to the effect that his work was grounded in a progressive politics.[75] A further sign of his continuing commitment is the introduction he wrote for Gropper's 1940 exhibition at the ACA, which contained a sharp attack on the Regionalists, entirely in line with the CP's current anti-nationalist, anti-war stance.[76] In fact, Jones's turn from political art was not to come until 1942–3.

WILLIAM GROPPER

By 1940 Gropper was one of the Communist movement's most popular celebrities. In addition to his work as staff cartoonist for the *Morning Freiheit* and regular

contributions to other Communist publications, he was a well-known book illustrator and his cartoons had appeared widely in mainstream magazines and newspapers such as *Pearson's*, *The Nation*, *New Republic* and *New York Post*. Indeed, a caricature of Emperor Hirohito by him published in *Vanity Fair* in 1935 led to a minor diplomatic incident. Although he insisted that he was not a Party member, Gropper was an open Communist whose commitment to the Party's political positions was unequivocal, and much of his work for the movement was done gratis. It is indicative of Gropper's stature that in 1938 he was the subject of the ACA Gallery's first book.[77] His 1940 exhibition (which was attended by 10,000 people) was marked by a gala celebration to 'mark his twentieth year as a people's artist', and a dinner in his honour in 1944 was addressed by Carl Sandburg and Dorothy Parker among others, and commemorated in a large album of personal tributes.[78]

Gropper had been painting since at least 1921 and already had a reputation as a mural painter by the time of his first solo show. However, his three one-man exhibitions in 1936, coming in the same year as his first mural commission from the Treasury Section of Painting and Sculpture, marked his increasing ambition to be recognised as a painter. At this time he also bought a lithographic press and began to produce limited edition prints. Over the next few years Gropper achieved a significant reputation as a painter, large numbers of visitors crowded his exhibitions and major museums began to buy his work. In 1937 Lewis Mumford claimed that his 'dynamic feeling for form' was only matched by that of such established figures as Orozco, Benton and Marin among contemporary American artists. That August he was also the subject of a special feature in the *Magazine of Art*.[79]

Given Gropper's public status, the danger was that his work would be over-valued by Communist critics, and in 1940 *New Masses* acclaimed him 'the master of revolutionary painting in America'.[80] Yet in fact enthusiasm for his work was generally matched by recognition, more or less acute, of its limitations. In 1936 his showing of twenty-seven paintings and an unspecified number of drawings at the ACA Gallery was hailed by Harold Rosenberg in *Art Front* as a kind of coming of age of revolutionary art. Responding to the variety of Gropper's subjects Rosenberg claimed:

> It is no longer a question of crudely conceived 'left-wing' pictures of bread-lines, pickets, mounted police; everything of value in the art of painting is becoming the property of the revolutionary movement. It will

104 William Gropper, *The Last Cow*, 1937, oil on canvas, 24 × 34 in., private collection.

soon be possible to speak of a revolutionary landscape, of a revolutionary still-life.

Commitment to art as propaganda did not mean that every individual work had to 'contain in itself a complete argument leading toward a revolutionary conclusion', rather the value of Gropper's show lay in its cumulative effect. Although this demonstrated that the revolutionary painter was 'precisely the major discoverer of new pictorial possibilities as well as of new uses for old', Rosenberg acknowledged that Gropper's work might be criticised on two grounds: firstly, 'that he has discovered no new formal or technical approach to the problem of revolutionary painting', and secondly, that the very 'facility' and 'virtuosity' of his technique made his work seem 'lacking in profundity'. He sought to justify the artist on the first count by claiming that there was a necessary continuity in pictorial evolution, and on the second by pointing out that Gropper's urgent engagement with contemporary events and the press of his commitments left him no time to 'stop and grow heavy over a painting.'[81]

Other left-wing commentators also felt the need to defend the eclectic character of Gropper's style or excuse the superficiality of his technique. Thus while Stephen Alexander found that some paintings in his 1938 exhibition which came out of a trip through the West in the previous year (fig. 104) 'expressed profound tragedy with a stark simplicity that is deeply moving', he also complained that the display as a whole did not show 'as much of an advance' on its predecessors 'as we might wish for and reasonably expect'.[82] Many of Gropper's

105 William Gropper, *The Defenders*, 1937, oil on plywood, 21³/₈ × 39¹³/₁₆ in., Saint Louis Art Museum, Gift of Vincent Price.

paintings were imaginative fantasies on topical concerns such as the Spanish Civil War (fig. 105),[83] strikes and Southern racism, or even generalised Goyaesque images of violence and devastation that were little more than coloured cartoons. While Lozowick tried to defend the 'violence to natural appearance' and anti-naturalistic colour in Gropper's work as a kind of heightened realism, 'in a true sense objective', this was not how it signified to most critics of the left. Writing in 1941, Milton Brown claimed that Gropper was 'more and more the outstanding personality on the American art scene'. But it was the artist's lithographs that he praised unequivocally, and he criticised the figures in his paintings as often looking like studio portraiture and the 'still too many isolated areas of virtuosity in paint unrelated to the central content of his art.'[84] In fact the criticisms of Gropper's paintings by all these writers were acute, and the promise they discerned in them was never fulfilled.

Philip Evergood

According to Baron, Evergood was not 'cradled by left-wing groups' and his work passed unmentioned in the Communist press until 1937. However, he played an active role in the American Artists School, Artists' Union and Artists' Congress in the later 1930s, achieving prominence partly through his gifts as a public speaker, which made him sought after as a lecturer,

speechmaker and radio performer. (On occasion his appearance and English accent got him mistaken for Charles Laughton.) His statements about art were vivid and emotive, although for some tastes they seemed dangerously anti-intellectual.[85] These activities contributed to make Evergood figure as one of the leading social artists of the period, even if he was not entirely happy with the label.

Evergood had eight one-man exhibitions under his belt by the time of his 1938 show at ACA, and Baron had thus made a catch. In a catalogue note, he explained that Evergood, 'like many other artists, finds it necessary to distort the human form to intensify the contradictions or traits imposed upon the individual by the complexities of society.' However, while this device resembled that of a cartoonist, the artist avoided the 'pitfalls' that the cartoon form held for painters. Indeed, Evergood himself was careful to distance his work from cartooning, stressing in a statement of 1943 that his aim was 'to paint a good picture – a work of art', although one permeated by a 'sound ideology' arrived at through individual experience and conviction. In a later interview he said that he did not believe in 'leaflet' painting and social art had to strive for 'the greatest sensitivities and the greatest refinements' – a position that is distinctly different from that of exponents of proletarian art, who had not generally made much distinction between their art

106 Philip Evergood, *Street Corner*, 1936, oil on canvas, 30 × 55 in., private collection.

and the cartoon. Evergood saw himself as a modern, and part of his work's appeal for a critic such as McCausland was that it seemed to offer a sophisticated approach to formal problems coupled with a deep engagement with contemporary issues.[86]

The 1938 exhibition, which was put on 'with the co-operation of the Midtown Galleries', comprised twenty-two works, among which were several large paintings including *Music* (Chrysler Museum of Art, Norfolk, Virginia) and *Mine Disaster* (see fig. 45), as well as modestly scaled easel pictures such as *100th Psalm* (Terry Dintenfass Inc., New York) and *Horizons* (Hirshhorn Museum and Sculpture Garden). Thematically these works ranged from images related to current left causes such as lynching (*100th Psalm*) and the housing problem (*Horizons*), through the Spanish Civil War (*All in a Day's Work*, Syracuse University Art Collection), to a symbolic vision of male and female workers of different races making music together, originally painted for the Pierre Degeyter Club. The exhibition was fairly widely reviewed, most critics commenting on the ugliness and satirical aspect of the exhibits at the same time as they acknowledged their power.[87]

A second one-man show in 1940 had twenty-four exhibits, and was similarly varied. Again, although there were some large canvases that implied a mural conception, the majority were conceived within a genre format.

Indeed, Evergood's work can be understood partly as an attempt to update the traditional genres of painting so as to make them function in a modern context. This was an entirely self-conscious project grounded in the Popular Front model of art history. From this perspective, the art of the nineteenth century was an aberration because it had succumbed to the commodity form and lost the true 'functional beauty' of most earlier art. Realism was a universal characteristic of healthy art, and Evergood believed that it was the basis of the work of his idols Brueghel, El Greco, Rembrandt and Goya.[88] Among the moderns, he acknowledged his debt to the art of Degas, Lautrec and Cézanne, among others. Indeed, it was the use of devices drawn from Lautrec and the Expressionists that distinguished his art at a formal level from the urban realism of Marsh. Comparing Evergood's *Street Corner* (fig. 106), shown at the ACA in 1938, with Marsh's *Tenth Avenue at 27th Street* (see fig. 36), I note that not only are Evergood's figures foregrounded and particularised, they also have a kind of insistent vitality, signified through an emphasis on musculature and the signs of sexuality. Whereas Marsh's figures look dejected and emasculated, Evergood's multi-racial group seems alive and energetic. Of course, Marsh himself used a more academic drawing for a comparable end in his numerous images of Coney Island beach, but in them sexuality is an all pervasive principle of vulgar energy

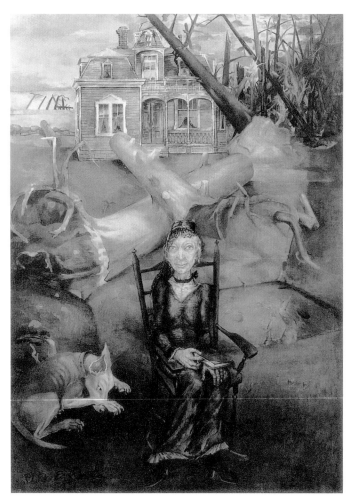

107 Philip Evergood, *My Forebears Were Pioneers*, 1940, oil on canvas, 50 × 36 in. (sight), Georgia Museum of Art, University of Georgia, University Purchase. GMOA 1974.3190.

contemporary political and social issues. That which was seen by critics to distinguish his work from revolutionary art, however, was the absence of direct political references and the element of humour.[91] Indeed, critics did not know what to make of paintings such as the artist's image of a slum child feeding birds from a tenement window, *Lily and the Sparrows* (1939; Whitney Museum of American Art), which Edward Alden Jewell described as 'strange serio-comic and surrealistic'. Similarly, *My Forebears Were Pioneers* (fig. 107), which depicts an old lady sitting in a rocking chair before a landscape devastated by hurricane, while understood as some kind of sardonic comment on bourgeois pretensions, was not generally interpreted as displaying 'the hearty contempt for social dry rot' that Jerome Klein found in it.[92]

The most troubling painting in the 1940 show for mainstream critics, and the one that has come particularly to symbolise Social Realism, was *American Tragedy* (fig. 108). Although the title evokes Dreiser (a Communist literary icon), in fact the work makes no reference to the narrative of Clyde Griffiths but depicts the Memorial Day Massacre at the South Chicago plant of Republic Steel on 30 May 1937. This episode was part of the offensive by Republic Steel to break the CIO-Steel Workers Organizing Committee, by force of arms if necessary. On a blazing hot day, more than two thousand strikers and their supporters gathered for a meeting a few blocks from the shut-down plant to protest against police restrictions on picketing. There were children present and the occasion had something of the atmosphere of a family picnic. 'Vendors were doing a good business in ice-cream bars and popsicles', according to the *New Masses* report. After the speeches an impromptu parade towards the factory across 'the vast stretch of prairie' was met by four platoons of Chicago police two blocks away from the gates. There a scuffle occurred, tear-gas grenades were hurled and the police began firing into the crowd at point-blank range. They continued to fire at the backs of those who fled and beat the wounded after they had fallen. They also refused first aid to the victims, two of whom bled to death in patrol wagons. In all, at least ten people died from their wounds. The incident was denounced by the Chicago police commissioner as a Communist provocation, a charge predictably echoed in the reactionary press. For the left, the massacre became a symbol of the ruthless abuse of legal authorities by corporate power.[93]

Evergood's picture partly derived from news photographs of the event, published to illustrate an eye witness account by the left-wing Chicago writer Meyer Levin, who later wrote a novel around his experiences.

within what are essentially modernised bacchanals. It says something of the rigidity of Marsh's imaginative categories that the men in his New York street scenes are generally bums and down and outs, while in his burlesque images they are lascivious grotesques. Evergood, by contrast, depicts self-possessed working men moving among what appear to be more middle-class types, as well as hustlers and a prostitute fixing her suspender.[89]

While Evergood regarded Marsh as 'a good friend' in the 1930s, he later characterised Marsh's 'bums' as projecting a kind of 'tragic hopelessness' which implied their condition was inevitable; his own bums, by contrast, were 'dangerous bums, discontented bums' who had '*not* accepted their lot.'[90] More generally, Marsh returned obsessively to certain themes that made up a kind of urban theatre of New York, whereas Evergood ranged widely seeking to make compelling symbols for

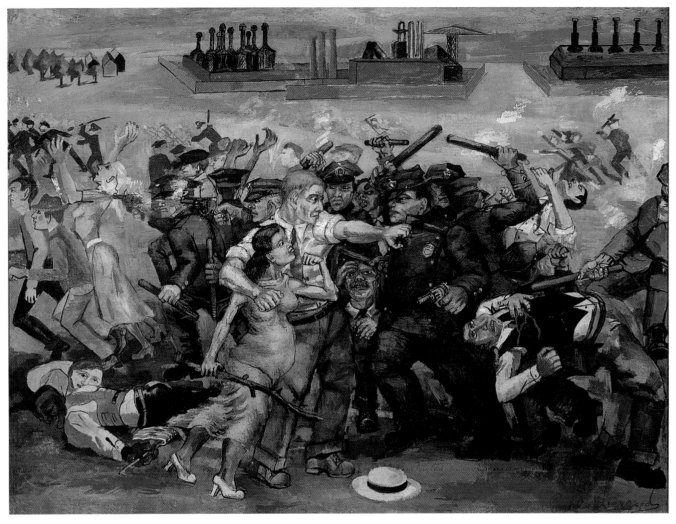

108 Philip Evergood, *American Tragedy*, 1937, oil on canvas, 29½ × 39½ in., private collection.

The artist himself linked the image with his own beating by the police during an Artists' Union occupation of WPA offices in December of the previous year.[94] However, what interests me here is not the genesis of *American Tragedy* so much as the critical responses to it, and what these tell us about the project of social art. Both leftists like McCausland and the liberal Emily Genauer regarded the painting as a major statement, and the former used it to exemplify the modernity of Evergood's 'plastic organization'. She defended the high horizon and schematic treatment of the upper part, and emphasised the way in which the blue police uniforms of the foreground figures performed a signifying function, and were formally balanced by the brilliant red of the steel mills above. By contrast, Edward Alden Jewell acknowledged the picture had 'much to recommend it in the way of painting', but found it 'cheap and unconvincing'

as 'social comment'. Even John Baur, writing in 1960, while praising the painting's formal qualities, complained of a theatrical aspect that brought it 'perilously close to the boundary between art and propaganda'. The fact that all history paintings have a theatrical quality and many a propaganda function does not seem to have occurred to him.[95] What I suspect disturbed both Jewell and Baur (although neither said so directly) was the pregant Latina woman, at whose distended belly the revolver of the foremost officer is pointing. Indeed, the policeman's aggression seems directed towards the woman as much as the man, who seeks to deflect him by grabbing his tunic. As with Grosz, all of Evergood's figures, good and evil, verge on the grotesque. And thus even when they are invested with the pathos of victims as they are here, it was hard for Communist critics to see them as proletarian ideal types.

It is worth noting, too, that the very characteristics that brought the picture into the realm of modern painting, and thus social art as opposed to revolutionary art, caused a little unease in the Communist press. While it was reproduced several times in the *Daily Worker*, the paper's main review of the show liked it less than Evergood's other exhibits, and found the 'industrial background, in bright vermilion . . . a little hard to take.'[96] It is difficult to see why the landscape of *American Tragedy* was more formally challenging than say *Lilly and the Sparrows*, which the same reviewer approved, and it may be that like Jewell and Baur, whatever the differences in their politics, he found the treatment of an actual historical event in an Expressionist mode too incongruous. From a different perspective, one can see the uncomfortable artifice and pathos of the drama as precisely the picture's strength.[97]

Taken together, these responses suggest that social art was a hybrid and unstable mode. It had to carry the imperative to be an art equal in formal achievement to both the great art of the past and the modern tradition. At the same time it had to suggest a political orientation without becoming overt revolutionary propaganda. Evergood himself felt the 'incompleteness of our endeavour' and its limitations from 'a formal and expressive point of view.'[98] Yet his work was well-suited to fulfill this role partly because of its knowing departures from standard naturalism and the elements of fantasy it contained. However, at times these features also rubbed against the basic functionalist imperative of Communist thinking on the arts.

Social Art at the Whitney Museum

As I showed in Chapter Three, *Art Front's* judgement on the Whitney's Second Biennial of Watercolours and Pastels in February–March 1936 was damning. However, the third Painting Biennial in November–December of the same year seemed to mark something of a turning point in terms of the representation of social art, instances of which included Gropper's *The Senate* (see fig. 88), Guglielmi's *Phoenix* (see fig. 26) and Tschacbasov's *Deportation* (see fig. 84), all of which had unmistakable political connotations. For Jerome Klein, it was the contrast between these works and those of artists 'who persist in painting social life without trying to clarify attitudes or meanings' that was crucial, among the latter being Cadmus,[99] French, Marsh and Miller. This position was logical, since while 'the abstractionists' (in the form of Davis, Gorky, Graham and Matulka)

were a presence in the display, they were as Klein put it 'a minor party', and the key concern of Marxian critique was necessarily to claim the superiority of Social Realism over other contending varieties.[100] The recognition that inclusion implied was reinforced by the museum's purchases from the show, among them being Jones's *Our American Farms*, a heavy-handed comment on the condition of the farmer in the Dust Bowl. The unemployed were represented by a marginal figure in Raphael Soyer's *Office Girls* and more centrally in *Home Relief Station* (see fig. 80) by Louis Ribak – an artist with a longstanding commitment to *New Masses* and the John Reed Club but also one who, like Soyer, had been a member of the Whitney Studio Club in the 1920s.[101]

The Social Realists were again strongly in evidence at the 1937 Painting Biennial, where a whole range of works relating to unemployment were on show including Evergood's *The Pink Dismissal Slip* (Herbert F. Johnson Museum, Cornell University), Harriton's *6th Ave Employment Agency*, Isaac Soyer's *Employment Agency* and Katherine Schmidt's *Mr Broe Waits his Turn* (University of Arizona Museum of Art, Tucson).[102] Gropper was represented by *The Last Cow* (see fig. 104), another Dust Bowl picture, and the young Jack Levine made his Whitney debut with *String Quartet* – which although not a 'social' subject demonstrated the arrival of a major new talent among the Expressionists and was bought by the Metropolitan Museum. The Whitney acquired Soyer's picture.[103]

Nor was the success of social art confined to paintings. The exhibitions of sculptures, drawings and prints were well stocked with contributions by left-wingers in both 1938 and 1939, when Dehn, Gottlieb, Harriton, Schreiber,[104] Shahn and Turnbull were among the exhibitors of watercolours. In 1936 the museum added Schreiber's drawing *Second Balcony* to its collection, and in 1938 Shahn's powerful gouache *Scott's Run, West Virginia*. Although in 1936 'social' themes were definitely a minority in the sculpture show, Harkavy's *American Miner's Family* (fig. 109) and Werner's carving *Lynching* (fig. 110) were singled out for special attention by Benson in the *Magazine of Art*.[105] Sculptors continued to use the Whitney for political statements throughout the decade, however isolated their contributions. Werner showed a bronze *The Boy David (A Tribute to the Abraham Lincoln Battalion)* in 1938, and the following year a work suggestively titled '*Let My People Go*'. In 1939 Goodelman was represented by *Cotton Picker* and Harkavy by *New England Farm Woman*. The exhibition, which ran from 24 January to 17 February,

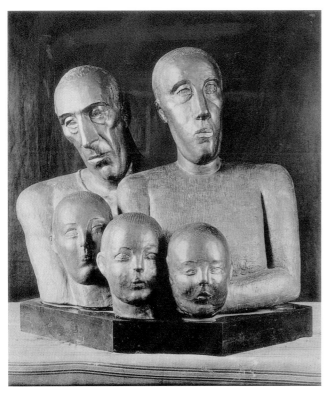

109 Minna R. Harkavy, *American Miner's Family*, 1931, bronze, 27 × 31³/₄ × 24 in., Museum of Modern Art, New York.

110 Nat Werner, *Lynching*, c. 1936, wood, 48 × 20 × 24 in., Howard University Gallery of Art, Washington, D.C.

took place in the month before the final collapse of the Spanish Republic, and the international portrait sculptor Jo Davidson pointedly exhibited a bronze of the Communist leader La Passionara. In 1940 he showed *France 1939*, while Goodelman showed the wood and iron *Kultur* and Werner a carving titled *Organizer*.[106]

It would be a mistake to think that the work of the social sculptors was technically regressive. (Davidson should not be numbered among them.) Indeed, when the modernist critic James Johnson Sweeney reviewed the 1939 exhibition he criticised sculptors such as Archipenko, Noguchi and Zorach for showing exhibits that did not advance from the experiments of twenty years previous, at the same time as he found Harkavy's sculpture 'very successfully incorporates the portrait elements without compromising itself plastically in their favour.' In fact the work he preferred to any at the Whitney was David Smith's steel *Suspended Figure*, concurrently on show in an exhibition of the United American Sculptors at the New School for Social Research. No less than Harkavy's exhibit, this should be considered as social sculpture.[107]

The problem with all the Whitney Museum's exhibitions in the later 1930s from the point of view of social art was that the very inclusiveness thst allowed it to be shown and even purchased also reduced it to just one item in the panorama of American painting. Even powerful anti-fascist pictures such as Philip Guston's *Bombardment* (shown in 1938; private collection) and Blume's *Eternal City* (shown in 1940; see fig. 86) suffered from this effect.[108] Moreover, the stylistic variety of social art weakened its cumulative impact when there was no common subject. Thus McCausland observed of the 1938 Painting Annual that while there was 'much competent and some excellent painting', 'the uncoordinated quality of the exhibition as a whole may be taken as ammunition by those who argue for "theme" exhibitions.'[109]

Such responses suggest both the limits of social art's penetration of museum culture and the inability of its exponents and defenders to define a distinctive and coherent aesthetic that would distinguish it within the usual exhibition array. The aesthetic pluralism associated with the Democratic Front might work well enough symbolically in the artist-run collective shows, but it left no traces in the museum display where the formal

kinship between paintings by Davis and those of Gorky, Graham or Browne (for example) was strikingly evident, while its author's political affiliations with the Social Realists were invisible. Moreover, museums themselves, with their plutocratic trustees, were suspect institutions, unaccountable to either artists or the public. To accept the conditions of the annual survey was to collude with the artist's servitude to bourgeois patronage, and it also reduced him or her to an individual competitor in the cultural marketplace.[110]

In survey exhibitions, the aesthetic of the easel painting and domestic sculpture prevailed. To show in them meant tacitly accepting a different aesthetic from that of New Deal public art (which had effectively superseded that of proletarianism), an aesthetic grounded in the individual apprehension of quality rather than in an ideological recognition that affirmed collective class experience and revolutionary will. For all the depth and sincerity of their political commitment, artists such as Evergood, Gwathmey and Toney – the stars of the Communist cultural movement in the postwar period – accepted this situation and key aspects of the aesthetic that went with it. In the absence of the New Deal art projects they had little choice, since galleries and museums were the only public spaces left to them.

Gropper wrote to Rockwell Kent in 1942 bemoaning the difficulties he found in selling his paintings to the 'rich bastards who are supposed to buy art', at the same time as insisting that he was still a 'People's artist'. To which Kent replied: 'The proper place for your pictures and mine, and everybody's, is not on gallery walls, but on bill boards and sides of buildings.'[111] This was effectively a plea for Gropper to concentrate his energies on cartoons and posters. However, the whole weight of the cultural value system militated against this tactic. To make an impression in the cultural field meant precisely to achieve recognition from galleries, patrons and museums. To balance this kind of success with more ephemeral work of the kind Kent recommended proved impossible for most artists, partly because increasingly the dominant value system excluded a fine artist from doing both. The artist who came closest to achieving this in the 1930s and 1940s was Ben Shahn, ironically not a Communist but a social democrat. While Shahn garnered considerable critical success in the short term, it was at the cost of his long-term reputation. But that was the result of later shifts in the cultural field that erected a nearly impermeable barrier between the political, popular and topical and the notion of quality – a development I shall have to consider later in my story.

7 Communist Artists and the New Deal (2): From the People's Front to the Democratic Front

The Federal Art Project and the Struggle over WPA

The history of the Federal Art Project is inseparable from that of the vast programme of which it was a part. The drawbacks of the WPA were its drawbacks too – the inadequacy of provision in relation to the total number of unemployed, the humiliation of the means test, continuing uncertainty about layoffs and low wages even during employment. Although Federal One became a particular focus of Congressional hostility, conservatives objected to the principles of the WPA as such, both with regard to work relief and the use of federal funds to redress unemployment. From the other side, the radicalisation and unionisation of project workers was not specific to the arts projects, and the activities of the Artists' Union (and its equivalents in the other arts programmes) need to be seen in relation to those of the Workers Alliance and other organisational initiatives among the WPA workforce. With the administration on the defensive in the face of the powerful conservative coalition of Southern Democrats and rural Republicans that emerged after the mid-term elections of 1938, the WPA as a whole was increasingly vulnerable as a key symbol of New Deal progressivism. Charges of Communist infiltration of the projects particularly targeted the Federal Theatre and Federal Writers' Projects, but they were not restricted to them. It is also important to remember that the principle of relief spending never achieved full popular legitimacy, and indeed according to opinion polls acceptance for it declined in the late 1930s – a phenomenon that probably owed something to the hostility of an overwhelmingly conservative press which accused the WPA, by and large falsely, of inefficiency and waste and, with somewhat more substance, of being a vehicle of political manipulation.[1]

From the beginning, opponents of the New Deal were concerned both that the WPA was a device for securing votes for Roosevelt and that it would somehow become permanent. Of course, permanency was never Roosevelt's intention. He saw the WPA strictly as a temporary relief measure and indeed wished to achieve a balanced budget. From early 1936, when the programme was at its peak, there was a constant threat of layoffs partly as a result of the president's inclination to economise but increasingly due to Congressional pressure. By the spring of that year funds from the 1935 ERA act were beginning to run out and Hopkins was forced to order layoffs. To add to this, anticipating an economic upturn, Roosevelt asked for a much smaller appropriation for the financial year 1936–7, which made further cuts inevitable and in the event contributed to a new recession. One effect of these cutbacks was increasing protests from the relief workers' organisations in the form of pickets and sit-down strikes, particularly in New York where unemployment was especially high. The famous '219' occupation of New York FAP offices on 1 December 1936 was only one instance in a much larger wave of actions against layoffs in all sections of the WPA. As the so-called 'Roosevelt depression' of 1937–8 deepened and the numbers on relief climbed, the president was persuaded to increase relief spending again, with the result that the WPA workforce in New York, which had fallen to 130,000 in September 1937, grew to 175,000 by the autumn of the following year. Audrey McMahon, the director of FAP in New York, recalled that such fluctuations produced 'a horrifying uncertainty as to the duration of ... employment' which was 'vastly detrimental' for morale. Further, workers had to undergo a fresh means test before each re-hiring which reinforced the idea that WPA was not a proper job but simply a glorified dole. Despite these difficulties, 1937–8 has been viewed as the halcyon days of Federal One, after which the real onslaught began.[2]

Congressional conservatives began to turn their attention to the arts projects in part as a result of two liberal initiatives to establish federal patronage on a permanent basis by setting up a government department for the

arts. The Coffee-Pepper Bill (HR8239), introduced in the House in January 1938, aroused considerable opposition from some art critics and professional groups, and never got beyond the committee stage. Its authors subsequently worked with Representative William I. Sirovich of New York to draw up another bill which was reported by the Committee on Patents, and debated on 15 June. Congressional reception of the Sirovich Bill was bawdy and derisory, and it was defeated by 195 votes to 35. Although the WPA administrators called before the committees maintained a posture of studied neutrality on the proposals, the federal arts projects inevitably received attention in newspaper reporting on the bills which was almost uniformly hostile. Federal One was damaged simply by association with this debacle.[3]

Worse was to follow. In July 1938, J. Parnell Thomas of the House Committee on Un-American Activities (HUAC) announced that the committee would conduct an investigation of the Federal Writers' and Theatre Projects, which served both as 'a branch of the communist organization' and as 'one more link in the vast and unparalleled New Deal propaganda machine.' The chair of HUAC, Martin Dies, described the WPA in 1940 as 'the greatest financial boon which ever came to the Communists in the United States.'[4] Beginning in August, the Committee began to call as witnesses WPA workers and former workers who claimed that the Workers Alliance virtually ran the projects, and that it in turn was Communist controlled. The Theatre Project in particular was denounced as a nest of Party members that produced blatantly communistic plays, and Edwin Banta, a former Communist employed as a supervisor, made similar claims about the Writers' Project. In December, the directors of the FTP and FWP, Hallie Flanagan and Henry Alsberg, both of whom had been accused of Communist sympathies in previous testimonies, appeared before the Committee to defend their programmes and refute specific charges. This was not what the Committee members wished to hear, and in their report of January 1939 they claimed that a 'rather large number' of employees on these projects were Communists or fellow-travellers, and that workers felt pressured into joining the Workers Alliance.[5]

In fact, the Workers Alliance had begun as a Socialist Party organisation for the unemployed, but in April 1936 it fused with the Communist Unemployed Councils, at the same time taking in many members of the Musteite National Unemployed Leagues. Its president remained David Lasser, a radical Socialist, but its secretary Herbert Benjamin was a Communist as were several other members of the executive board and perhaps the

majority. However, while Communists certainly played a major role in the Workers Alliance, its strength lay in its capacity to articulate the very real discontents and anxieties of WPA workers who by 1939 made up 75 per cent of its membership. Rather than directly attacking the administration, the organisation increasingly functioned as a pressure group to protest about assaults on relief provision from the Congressional right. As such it gave assistance to beleaguered WPA administrators, who recognised its position in some degree.[6]

Despite their manifest unfairness, the Dies Committee hearings did enormous harm to Federal One, partly because the frequently groundless charges were given massive publicity in the press. Although neither Cahill nor Nicolai Solokoff were called before HUAC, both the Art and Music Projects suffered from this besmirching of the other two. The conservative group in Congress was considerably strengthened by the November 1938 elections, and in the new session opposition to the WPA was mounted by both reactionary Democrats and Republicans in the House Subcommittee on Appropriations, the former led by Clifton Woodrum of Virginia and the latter by John Taber of New York. In March 1939 the House voted by a massive majority to authorise Woodrum's sub-committee to investigate the WPA. At the hearings that followed, witnesses (many of whom had already appeared before the Dies Committee) rehearsed the now familiar charges about the Workers Alliance's influence in the FTP and FWP. Federal One was also accused of waste and inefficiency, although the FAP and FMP largely escaped on this score.

The WPA was defended before the sub-committee by Colonel Francis Harrington, who had succeeded Harry Hopkins in December. Harrington did not have the same commitment to Federal One as his predecessor, and although he sought to defend the cultural projects he also acknowledged irregularities and promised a wholesale reorganisation. In the event, the ERA bill that Roosevelt signed into law in July clearly reflected conservative power in the House. Not only did it require a mandatory layoff of WPA workers after eighteen months (whether or not they had alternative employment) and put a ceiling on the cost of construction projects, it closed down the Federal Theatre Project and required that all projects, including Federal One, secure at least 25 per cent sponsorship. Moreover the appropriation Roosevelt had asked for was seriously inadequate, to the extent that in New York almost 45 per cent of WPA workers were discharged in the months following the act. The Theatre Project apart, Federal One in New York did survive, but only because Mayor La

Guardia agreed that the city would assume sponsorship costs.[7]

Unwilling to jeopardise the rest of WPA for a relatively small and wayward component, Harrington and Florence Kerr (who headed the Women's and Professional Division) decided to reorganise the arts projects from September 1939 by passing over far more control to WPA state administrators – for the most part construction experts with no competence or interest in artistic matters. This change, together with the new sponsorship requirement and the disruptive effects of the eighteen-month layoff rule, curtailed drastically the more creative aspects of the FAP. Colonel Brehon Somervell, the WPA administrator in New York, had run the larger programme in the city with great efficiency, but he was no friend of Federal One and had a personally antagonistic relationship with Audrey McMahon. In the aftermath of the 1939 ERA act he set a limit of 1,000 to the number of artists who could be on WPA rolls – at its height the New York FAP had employed 2,200. He was further empowered by an amendment to the 1940 ERA act that barred Communists and Nazi Bund members from WPA jobs, and required all personnel on the rolls to swear on oath that they belonged to neither organisation. Failure to swear would lead to instant dismissal, and false statements carried a heavy penalty. Somervell ordered an investigation of Board of Election records to identify registered Communists among his workforce, and also sought help from the FBI and the Dies Committee. This campaign proved relatively ineffectual, and of the 365 persons who had been fired by the end of 1940 most were reinstated by May 1941 as a result of protests from the unions and ACLU. Somervell also launched a campaign to purge anything that might be read as propaganda from FAP murals, which led to the destruction of three out of four innocuous canvases on the theme of flight that had been painted for the Administration Building of Floyd Bennett Airfield in Brooklyn by a self-confessed Communist, August Henkel.[8] However, by this time the Federal Art Project was on its last legs and in 1941 it was reorganised as a national defence programme, finally closing down with the remainder of WPA at the end of January 1943.

The CPUSA and the Federal Art Project

The Communist Party's position on the work relief programme was consonant with the positions it took on unemployment insurance, pensions, public housing and health provision. Continuation and expansion of work relief was part of its 1936 election platform, which demanded that the 'government continue and extend the WPA' in conjunction with a massive Federal Works Programme.[9] Protests against WPA cuts in late 1936 were extensively reported in the Daily Worker, and this coverage continued for most of 1937, slackening in intensity only towards the end of the year. Several editorials attacked Roosevelt over the cuts, and in November 1936 a substantial article warned workers on the art projects that in the aftermath of the election their future was uncertain, and they should campaign collectively for a permanent Department of Fine Arts.[10] From late 1936 onwards, New Masses, which had been so critical of the cultural projects in the past, now found they had 'done wonders to slake the cultural thirst of millions of Americans' and protested against moves to diminish them. The Daily Worker reported favourably on a number of Federal Theatre productions in the first half of 1937, and in June published an article affirming the achievements of the FAP.[11]

Although the Artists' Union drew its energies mainly from the grievances and anxieties of art project workers, it was also one arm of a larger Communist strategy in relation to the WPA. As such, it was a loyal exponent of Party policy. The Union backed the Communist-drafted Workers' Unemployment and Social Insurance Bill, introduced into Congress in February 1934. From PWAP onwards it argued that relief provision for artists was inadequate and it was campaigning for a Federal Arts Bill months before WPA was established.[12] In May 1936 the Union followed the CP line in calling on members to support the formation of a Farmer-Labor party,[13] and similarly it greeted the November election results as a victory over reaction. It was immediately forced to confront the threat of layoffs as money from the 1936 ERA act began to run out. Art Front denounced these as 'a betrayal of the mandate of the people given to President Roosevelt', and on 12 December artists joined in a picket by 5,000 relief workers of the WPA Central Office at 70 Columbus Avenue.[14]

From the beginning, the Union attacked Bruce's Section of Painting and Sculpture as inferior to the PWAP, both because it did not prioritise helping the destitute and was smaller in scope. By comparison with PWAP, the FAP was also a retrograde step since it paid a 'security wage' rather than the prevailing wage rate and involved a means test. Like the AFL unions, the Artists' Union opposed this undercutting of established pay norms and described the WPA as 'Roosevelt's starvation program for work relief', designed to reduce wages in private industry at a time when the cost of living was

rising. In fact its campaign to secure an AFL charter in mid-1935 occurred at a moment when actions by the New York Central Trades and Labor Council did wring some concessions out of the WPA – although these benefited only skilled workers with union membership. Yet the Union opposed proposals to cut back the WPA in the fiscal year 1936–7, and by 1937 had become a qualified supporter of the projects.[15]

At the same time as it fought cutbacks on a day to day basis and tried (unsuccessfully) to pressure the FAP administration into taking a stand for the permanency of the projects, the Union also emphasised that the 'fight to maintain and expand the Federal Art Project has never been considered by the Union merely as a problem of employment.' The experience of collective organisation had helped artists defeat 'the disease of Bohemianism' and thus the projects stood for a new kind of democratic and socially responsible aesthetic. Through the Public Use of Art committees unions had shown the administration how the scope of the projects could be expanded: 'Art has been brought down from the market places of the dealers and the museums. It is no longer necessary for the worker and the middle class American to take his hat in hand and make a pilgrimage to some shrine to see a work of art.' And this was only a beginning, for 'with the development of democracy in the sphere of wages and hours, with the inevitable political implications of this movement, the possibilities for the establishment of democracy *in the social sphere, including culture* will be realized.'[16]

Whereas *Art Front* had been generally dismissive about the products of PWAP, its reviews of exhibitions at the Federal Art Project Gallery in New York were sympathetic and that of *New Horizons in American Art*, a showcase exhibition of project art at the Museum of Modern Art in September 1936, was cautiously welcoming. McCausland found that 'the murals of the Federal Art Project, though not attaining the highest plastic quality, are vastly superior to the wooden and stereotyped creations of the Treasury Department Art Projects' – a superiority she attributed to the 'somewhat freer though still too restricted hand' allowed FAP workers.[17]

Concern about the influence of the Section (which was after all a source of far more substantial income for artists fortunate enough to secure commissions) prompted an extended critique by one Peter Vane, who argued that Bruce's team was 'a small clique, dominated by reactionary ideas and methods of procedure, which has brought into the workings of the Section a small and malodorous group of Museum Directors and others of

their ilk who have attempted to set up in their communities little dictatorships in art'. The Section's premises were essentially exclusive, and Bruce's rationale for the art programme as a kind of safety-valve for social discontents was 'reactionary and anti-democratic'. Moreover the Section had been given existence by the Secretary of the Treasury, an unelected official. By contrast the alternative of the FAP was 'a splendid one', and Cahill's catalogue essay for *New Horizons in American Art* was quoted approvingly. Vane emphasised that the WPA programme depended on funds voted by the elected representatives of the American people: 'the Project must go to the people for support *on the basis of performance.*' In fact, what from an ideal perspective seemed the projects' strength was precisely their undoing.[18] Assuming that the FAP was the basis for 'the complete development and maturation of art' in '*all sections of the nation*', the Union supported the Coffee Bill, the text of which was printed in the October 1937 *Art Front*. In spite of this, the magazine remained fiercely critical of the administration to the end, and the same issue accused even 'so-called liberals', such as Aubrey Williams, of working 'to intensify the effect of every reactionary aspect of the provisions of Congress for WPA on the Arts Projects'.[19]

In March–April 1938 the *Daily Worker* printed a series of six articles on the art projects in music, theatre, radio, literature and the visual arts, and from that point on it effectively subsumed them within the Democratic Front, extensively reporting their achievements.[20] In June the Party openly declared its support for the Sirovich Bill, which was also backed by the Labor Non-Partisan League (formed by the CIO leadership in 1936 to support Roosevelt), by some AFL unions and by the Minnesota Farmer-Labor Party. According to *The Communist*, the bill represented 'a program to establish the rights of creative workers to live and to produce their work with the assurance of reasonable remuneration based upon the social use of their work, to establish *people's sponsorship, enjoyment,* and *participation in the arts as a principle of our democracy.*' On such a basis the arts could 'flourish as the allies of the people and the enemy of reaction', and thus the bill '*should be made an issue in every election struggle.*'[21]

As the threat to the projects' very existence became evident in the debates around the 1939 ERA bill, *New Masses* published two articles by Joseph Starobin, the first exposing the Dies Committee and the second setting out the achievements of the projects.[22] At the same time, the *Daily Worker* printed articles lauding WPA art at the New York World's Fair, which had itself been turned

into a way station on the road to socialism: 'The World's Fair says – even [if] it does not know it – that poverty, unemployment, back-breaking work, disease and insecurity are needless burdens. The people feel it as they look at the "world of tomorrow".' Moreover, the mural art and public sculpture of the Fair showed America was 'Coming into its Own in the World of Art and Culture'.[23] The WPA building at the Fair was particularly praised, and the paper featured reports on murals by the *Sunday Worker* artist Louis Ferstadt and the leftists Guston and Refregier.[24] *New Masses*'s review of the Fair's massive exhibition of *American Art Today* (which was curated by Holger Cahill), and McCausland's long appraisal in *Parnassus*, were as positive as those of many mainstream art critics, despite the widely remarked dearth of 'social protest' art on show.[25]

In effect, after 1938 cultural criticism in the Party press accepted the project administrators' own evaluation of their achievements – that the 'Federal Art Project [had] made American artists and their work part of the life of the whole people for the first time.' The presence of WPA or former WPA artists in exhibitions was a subject for pointed comment, and by 1940 the *Daily Worker* was applauding new FAP mural commissions. In 1939, the position had shifted so much that even the Treasury Section's Forty-Eight States Post Office Murals Competition was given positive coverage – although the fact that Joe Jones was a prize-winner in this may have played some role in the evaluation.[26] All in all, considering the extent to which the cultural projects had come to stand for the 'most progressive facets' of the New Deal, and the zeal with which they were praised and defended in the Communist press, it is hardly surprising that conservative charges that they were a hotbed of Communist agitation would look credible. Correspondingly, after the Party changed tack with the Nazi–Soviet Pact and the outbreak of war, the diminution of the projects was seen as symptomatic of a conservative turn in the New Deal, for which Roosevelt was held responsible.[27]

The Ideology of the Federal Art Project

In addition to the CP's general stance on the WPA, there were solid reasons for Communists to view the Federal Art Project more favourably than the Treasury Section. These had to do with both the organisation of the project and with its ideological framing. In relation to the former, its orientation to relief rather than quality,

the greater freedom of expression it permitted artists, its commitment to art education and the extension of artistic knowledge through community art centres all made it seem preferable to the Section, which rested on a more traditional model of patronage relations and a far narrower notion of aesthetic culture. In relation to the latter, the key voice was that of Holger Cahill (1887–1960), whose background and formation were a world apart from that of Bruce and Watson. The child of impoverished Icelandic immigrants, Cahill was brought to North America around 1889, and spent most of his childhood in rural North Dakota. After a succession of labouring and low-level white collar jobs, he arrived in New York in 1913. There he moved in Greenwich Village circles, got to know members of *The Masses* group, acquired an interest in socialism and took courses on writing and journalism at New York University. One of his early friends was Mike Gold, but although Cahill initially shared Gold's enthusiasm for the Bolshevik Revolution, by 1921 he was a convert to a kind of modernist aestheticism – an outlook that matched his budding career as an art critic, publicist and curator. Cahill later indicated that his political orientation was towards American Populism and the Wobblies, but the fact remains that several of his friends of the early 1920s – Gropper, Stuart Davis, Malcolm Cowley and Orrick Johns – became active participants in the Communist cultural movement. I do not imply by this that Cahill was a closet fellow-traveller, merely that he was far closer to left-wing artistic and literary circles than those who ran the Section.

As Wendy Jeffers has pointed out, it was not by chance that Cahill landed the job of directing the Federal Art Project.[28] His work at the Newark Museum, a stint as acting director at the Museum of Modern Art in 1932–33 and his curating of the First Municipal Art Exhibit in New York (1934) had established his credentials as a propagandist and ideologue for modern American art. By 1935, Cahill had forged an historical rationale for federal patronage that was a fascinating amalgam of ideas culled from John Cotton Dana, John Dewey, Thorstein Veblen and modernist theory which matched perfectly the needs of the radical wing of the New Deal. Some of the guiding principles of his aesthetic were already there in his major essay on Max Weber of 1930, where he argued the familiar modernist point that nineteenth-century academicism had corrupted art by promoting the falsehood that its primary function was imitative and true imitation was necessarily naturalistic. Modern artists such as Weber had revitalised tradition by going back to a 'universal language'

of art, discernible in the Oriental and the primitive: 'The central problem of the painter is that of achieving ordered spatial relations within the rectangle of his canvas. This problem must be solved in terms of the medium. The set of ordered spatial relations achieved in terms of a medium must communicate something to a beholder.' But this 'something' was not like a scientific statement, a symbol referring to an object, for the pictures of 'any artist worthy the name, are intended to be looked at as objects in which the search of the beholder comes to rest.' True art worked by 'evocation'. And yet evocation had to be tied to a 'minimum of statement' for communication to work.[29]

In his brief spell at the Museum of Modern Art, Cahill put on a sequence of path-breaking exhibitions, for all of which he wrote substantive catalogue essays: *American Folk Art: The Art of the Common Man in America, 1750–1900* (1932), *American Painting and Sculpture, 1862–1932* (1932–3) and *American Sources of Modern Art* (1933). The first claimed that folk art grew out of 'the fertile plain of everday competence in the crafts', and was 'the expression of the common people, made by them for their use and enjoyment.' Unfortunately, such art had languished as a result of the spread of 'machine industry' after the Civil War, and by the end of the century the decline of the crafts caused it to die out. It had taken the 'pioneers of modern art' to discover its aesthetic quality. For Cahill, folk art had mirrored 'the sense and sentiment of a community'. In the second of his catalogues, Cahill was still more explicit in lamenting the effects of the rise of industrialism, and the concomitant 'dominance of classes with little interest in art and tradition of art patronage.' The alienation of the artist from community in the Gilded Age was deeply unhealthy, and led to the 'exploitation of personal peculiarities', to 'bohemianism'. Yet there was a dialectical twist here, in that the isolation of the artist also prompted forms of modernist experimentation with a 'powerful and vitalizing influence' on American art, which had produced a 'usable past', technically speaking.[30] Cahill believed that the 'period of experiments' was probably now over, and in a series of radio talks, published as a book in 1934, he argued that after twenty years in which they had been mainly preoccupied with the 'means' of art, American painters were now concerned anew with 'social and collective expression'. The 'world hegemony' of the School of Paris was over: 'American art is declaring a moratorium on its debts to Europe and turning to cultivate its own garden.' This 'contemporary emphasis upon human significance in art' found its 'strongest expres-sion' in a renewed interest in mural painting and art's decorative functions. The most important opportunity for mural painters had been provided by the 'various public art projects' for, whatever the quality of the art they produced, 'They show that the community is assuming a responsibility toward the artist. Through them there may be a possibility of healing the breach between the artist and the public.'[31] This historical schema, which had culminated in the PWAP in 1934, was applied and clarified in Cahill's catalogue essay for *New Horizons in American Art* (1936).

In a speech made at the eightieth birthday celebration for John Dewey in 1939, Cahill presented the WPA FAP as essentially an implementation of Dewey's ideas on art and education.[32] I am not sure how literally we should take this. Dewey's main contribution to aesthetics, *Art as Experience*, had been published in 1934, although he had been expounding its ideas earlier and many of them had a broader currency. (Cahill claimed to have first heard Dewey lecture at Columbia University around 1914.) I have found no reference to Dewey in Cahill's speeches of 1937–8, but many of their key themes certainly had a Deweyan resonance, such as the refusal of any sharp distinction between the fine arts and the arts of use, the insistence on the ordinariness of aesthetic experience, the emphasis on community and democratic participation and the stress on the cultural dimensions of democracy and the organic relationship between culture and social environment. These were coupled with a critique of plutocracy that stopped short of anti-capitalism. But then Communists supported New Deal democracy as a route to developing a socialist consciousness; they did not see it as socialist as such.[33]

References to Dewey were not calculated to appeal to Communist ideologues, to whom Pragmatism generally appeared 'the dominant American bourgeois philosophy', the failings of which were demonstrated by Dewey's involvement with the American Committee for the Defense of Leon Trotsky. Moreover, *Art as Experience* would have been made particularly suspect by the author's criticisms of proletarian art, which were linked to an assertion that 'art itself' could not 'be secure under modern conditions' without a revolutionary transformation in social relations of a type ill-defined but implicitly different from that proposed by the Communists.[34] However, such details aside, the rhetoric of cultural democracy and Americanism with which Cahill framed the WPA FAP meshed in well with the discourse of the Democratic Front. Statements such as 'Our experience with the Federal Art Program has inspired all of us with

the belief that art for all the people is possible and that government has a responsibility in making it possible' or that through the WPA artists had been 'given a vision of a genuine people's art functioning freely in relation to society' could be seen as pointing towards a Soviet-style culture, as this appeared in the CP fantasy of the USSR. Cahill's former friend, Mike Gold, claimed in 1940 that the 'WPA was "red" because it was democratic', and that from the perspective of the Congressmen who had destroyed the projects, democracy was 'a dangerous ideology that tried to burst the bonds of capitalism and express itself in the WPA program.' The terms in which Gold read this struggle were excessive, but his characterisation of the WPA's enemies and his perception of what the projects represented were essentially accurate.[35]

The Treasury Section of Fine Arts

After what has been said of the Artists' Union and Treasury Section so far, it might be assumed that relations between left-wing artists and Section administrators were fraught, and that the former found few opportunities for politically significant work within the programme. The first assumption would be unjustified, the latter can at least be argued over.

Ideology aside, the sheer scale and importance of Section patronage meant that artists of the left were obliged to establish some kind of *modus vivendi* with its personnel. Indeed, despite the fierce criticisms of the Section in *Art Front*, collective organisations of the left made several overtures to Bruce – all of which he rejected. From PWAP on, Bruce regarded the Artists' Union as irresponsible and unrealistic, but when the New York organisation asked him to speak at a symposium on 'Art and Government Responsibility' in May 1934, he responded cordially (and doubtless tactfully) enough.[36] In 1936, Biddle invited him to join the Artists' Congress, implicitly at the suggestion of Stuart Davis. While Bruce wisely declined, the superintendant of the Section, Edward Rowan, attended the Congress in 1938, although it is unlikely he was a member.[37]

A significant number of the dramatis personae of our story so far sought or achieved Section commissions, among them the painters Abelman, Arnautoff, Burck,[38] Cikovsky, Evergood, Gropper, Gwathmey, Jones, Refregier, Ribak, Siporin, Moses and Raphael Soyer, Sternberg and Zakheim; and the sculptors Ben-Shmuel, Cronbach, Glickman, Harkavy and Werner. Some of these certainly sought them out of financial exigency, but others may have been prompted to participate in Section

competitions in part because they recognised that the programme offered important spaces for public art. Indeed several leftists and Popular Fronters received commissions to decorate federal buildings in Washington itself, notably Cikovsky, Ernest Fiene and Gropper at the Department of Interior; Chaim Gross, Concetta Scaravaglione[39] and Rockwell Kent at the Post Office Department; Ben Shahn at the Department of Social Security; and Gross and Scaravaglione at the Federal Trade Commission. Moreover, the most important Section commission outside the capital, the Saint Louis Post Office, went to the Chicago radicals Edward Millman and Mitchell Siporin.

Of course, being awarded a commission hardly gave politically committed artists a free hand to paint or sculpt as they chose. While the Section claimed that its competition system was democratic and made much of the role of its regional committees and consultation with local communities, the Washington office overruled jury decisions it did not like and the actual production of all works was tightly supervised through a sequence of prescribed stages, tied in with the payment process.[40] Bruce's formalistic preferences partly set the Section's aesthetic agenda. In an early address to artists he observed: 'The artist's business is to help people to see and enjoy seeing and not think. . . . Art is getting too precious and ponderous.' In 1940 the Section's *Bulletin* printed a letter to Bruce from Henry Varnum Poor, in which Poor asserted that 'I think the basis of any great mural, as of all great painting, is a sense of the pictorial necessity, a visual freshness and reality, which speaks more clearly than anything. So a complicated or highly intellectual idea is a great drawback – something to surmount rather than a real help.' Not only did the Section publish this to guide contestants for the Social Security Building commission, but Poor explicitly stated that his ideas were close to Bruce's own. This formalism and insistence on the life-enhancing functions of the aesthetic went hand in hand with the Americanism of the project to justify the beneficent image of the nation that dominated in Section art. In a report to the president in 1939 Bruce observed of a selection of mural sketches that '[t]hey make me feel very comfortable about America', and of the thousands of competition entries the Section had received: 'There has been no sign of defeat or social unrest among any of them.'[41] Certainly the Section's administrators had sought to ensure this was the case. But if the representation of overt conflict was repressed, might not the clash of social interests manifest itself in more subtle forms? I shall consider this question under two heads, labour and history.

111 Joe Jones, mural, 1939, oil on canvas, 49 × 144 in., USPO, Seneca, Kansas.

LABOUR

The themes of Section art were broadly illustrative of the functions of the institutions they decorated, but in the case of the small post offices which made up the vast bulk of its commissions, subjects concerning the 'history and industries of the place' could substitute for the post.[42] It was in representing the 'industries of the place' and the functions of some departmental buildings in Washington that Section artists produced an extensive iconography of labour, although this also formed part of postal imagery. In his 'Public Use of Art' essay, Schapiro welcomed the art projects as a step in the right direction but warned:

> A regime that must hold the support of the people today, provides conventional images of peace, justice, social harmony, productive labor, the idylls of the farms and factories, while it proposes at the same time an unprecedented military and naval budget, leaves ten million unemployed and winks at the most brutal violations of civil liberties. In their seemingly neutral glorification of work, progress and national history, these public murals are instruments of a class.[43]

This contemporary judgement corresponds closely to that of the most sophisticated recent analysis, Barbara Melosh's *Engendering Culture* (1991), which argues that while the iconic status of male labour in Section art 'gave a new symbolic weight to working-class lives', the way it was used deflected 'the very challenge it raised' because subjects were 'seldom located . . . in any clear

social hierarchy and even less frequently suggested class conflict': 'Even as the image of the manly worker denied the authority of the contemporary middle class, it reaffirmed an enduring mythology of classlessness that limited and contained its critique of American society.'[44] The work of left-wing artists was effectively contained and muted by the Section's regime. This is a persuasive interpretation of Section iconography up to a point, but it seems to assume that the art spoke uniformly to different audiences, and arguably gives insufficient weight to the character of American working-class consciousness in the period.

Other scholars have sought to define the audience for Section art from the correspondence of post masters and newspaper clippings in its files, which are taken to manifest the response of 'communities' and 'citizens', or even 'popular taste'. Such materials are a valuable source, but they speak only for those who had a voice, and it should not be assumed that they represent the outlook and attitudes of all the complex groupings in the societies where Section art was sited.[45] Indeed, some left-wing artists specifically denied the representativeness of the post master and such citizens as he or she was likely to consult. It is also worth looking at the practice of specific Communists and fellow-travellers to see if there is room for a multi-accentual interpretation.

Among the Communist artists who worked for the programme, Joe Jones was one of the most successful in terms of the sheer number of commissions received: between 1937 and 1941 he painted five post office

154

112 William Gropper, *Construction of a Dam*, 1938–9, oil on canvas, centre panel 8 ft 11 in. × 14 ft 6 in., side panels 8 ft 11 in. × 7 ft 9 in., Department of Interior, Washington, D.C.

murals spread over Arkansas, Kansas and Missouri. All bar one of these are images of wheat harvesting. These seem a world apart from his 1935 murals at Commonwealth College, which were described by the *Daily Worker* as 'depicting the outstanding condition and major struggles of the Southern working people.'[46] Yet in fact Jones attributed his success in attracting Rowan's attention in 1935 to the Commonwealth College and Saint Louis Court House murals, together with the intercession of Elizabeth Green on his behalf. At the time Jones hoped the Mena commission would lead to 'other jobs at liberal colleges', and observed that he would 'like nothing better myself than to go around doing these murals'. But although he established friendly relations with Rowan, to begin with he was only offered work with the Treasury Relief Art Project – an offer he turned down both because the pay was less than he could earn from the Resettlement Administration, and because he felt that the WPA (which set the terms of employment under TRAP) was undercutting union wage rates. He was also wary of government patronage, observing in a letter to Green: 'Although Mr Rowan may sincerely want me to do an honest job, I know I will have to fight in order to accomplish anything decent . . . he will have to prove to me the sincerity of our government as a patron of the arts.'[47]

Jones's letters to Rowan (whom he sometimes addressed irreverently as 'Pop' or 'Pappy') suggest that it was mainly financial desperation that made him turn to the Section in 1937, and he may have used Section

commissions to fund his production of more politically pointed easel paintings.[48] It seems to have been Rowan who pushed him towards using the wheat theme in his murals, since for his first assignment at Magnolia, Arkansas, Jones suggested other subjects.[49] However, Jones did not see post office decorations just as jobs, and in preparing for the mural at Anthony, Kansas, he enthusiastically researched local conditions, living with wheat farmers and climbing over combine harvesters with a miniature camera. According to the post master, the installed mural was 'regarded very highly by a good many of our people here.'[50] Jones's mural for Seneca, Kansas (fig. 111), was also well received in the long run but, at the post master's request, he was obliged to remove the trade name Massey Harris inscribed on the harvester in the colour sketch and also to alter the vista to indicate smaller farms with mixed crops.

Defending his original conception for Seneca in a letter to Rowan, Jones acutely pointed out the problems raised by the Section's reliance on post masters and local newspapers as measures of public response: 'I hope you will first consider the fact that postmasters are never typical in their community, intellectually or spiritually. This goes for small town newspaper editors as well.' Replying to the criticism that he had not shown local crop culture accurately and that his harvester looked out of date, Jones emphasised that he was not trying to make 'a kind of agricultural survey' of a community but a 'vital work of art' which would have significance 'for the broadest mass of people' in the area. More specifi-

113 (*right*) Edgar Britton, *Work of the Petroleum Division of the Bureau of Mines* (east wall), 1939, fresco, 9 ft 3¹/₂ in. × 19 ft 7 in., Department of Interior, Washington, D.C.

114 (*facing page*) Edgar Britton, study for *Work of the Petroleum Division of the Bureau of Mines*, whereabouts unknown.

cally, 'I want the working people, the people producing useful things with their hands to enjoy this painting for the understanding and strength of which part of their lives are reflected.' In the event, the result apparently pleased everyone, including the artist himself. This seems to indicate precisely the multi-accentuality of such images, which could appeal to Rowan and the Section because of their pictorial qualities and progressive symbolism, to the post master and local press because of their presumed accuracy to locale and to the left-wing artist who desired an imagery of labour that would have meaning for a working-class audience. Whether they worked for the latter in the way Jones hoped, cannot be known.[51]

In Section art workers usually labour energetically and productively, and nowhere more so than in Gropper's *Construction of a Dam* for the Interior Department Building (fig. 112). This is a large and imposing painting at the south end of the main corridor, comprising two panels each nearly 9 × 8 feet flanking one of the same height but almost twice as wide. The correspondence between Rowan and Gropper was extremely cordial, and in February 1939 the former reported that E. K. Burlew, the First Assistant Secretary to the Treasury, had expressed 'great satisfaction and delight in your work'. In 1944 the Secretary of the Interior himself remarked on his satisfaction with the mural in a letter of birthday tribute to the artist, and Gropper had, in fact, responded to Ickes's 'instructions' that he 'particularize the building activities' represented in his initial sketches. In summer 1938 he made a research trip to the West, and according to Section publicity the

depicted structure was 'inspired by' the Grand Coulee Dam on the Columbia River and the Davis Dam on the Colorado River. (The side panels probably owe something to photographs of workers at the Bonneville Dam published in the *New York Times Magazine* in May 1937.) Section publicity described the artist's intention 'in essence' as 'to portray the drama of labor, the dignity of labor, and the strength of labor.'[52]

Many of the murals in the Department of Interior depict labour (including those of the leftists Edgar Britton,[53] Cikovsky and Fiene), but with its low viewpoint and straining purposive figures, *Construction of a Dam* offers by far the most heroic image. The figures in Britton's frescoes, *Work of the Petroleum Division of the Bureau of Mines* (fig. 113), are productive and self-possessed worker types, but they do not project the same urgency. My point, however, is not that Communist and fellow-travelling artists had some special affinity with energetic labour – Gropper's figures are no more energised than those in Marsh's *Assorting the Mail* for the Post Office Department Building in Washington or Charles Thwaites's *Cheese Making* for the post office at Plymouth, Wisconsin.[54] Rather I want to stress some of the contextual factors that current iconographical readings miss. Firstly, it should be noted that unlike sorting mail or making cheese, building dams was part of a highly controversial intervention in the economy by the federal government. Just as much as the Tennessee Valley Authority, the operation of the Grand Coulee and the Bonneville dams by the Bureau of Reclamation and the Bonneville Power Administration (both agencies of the Department of Interior) stood for public control

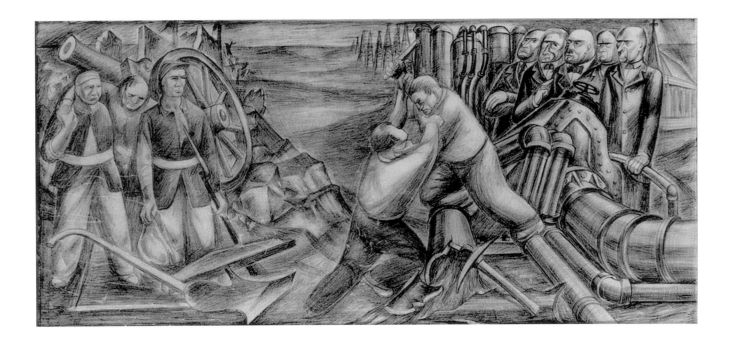

of power and state planning against private utilities and the vagaries of the market. At the time, the Columbia River was the largest single source of power in the United States, and the Grand Coulee the largest human-made structure in the world.[55] Thus Gropper's heroic design, however inadequate to the task, was both a tribute to the sheer gigantism of the project and to the way in which government enterprise provided employment, mobilised collective endeavour and worked in the public interest.

The Secretary was certainly not averse to murals that made this point, since when he rejected Britton's first sketches for the Bureau of Mines panels, one of his suggestions, as communicated by the Section was: 'If possible one of your designs might show a ruthless individualist sacrificing the people to his greed and in contrast to that the second panel might depict the Government helping or protecting these people and their rights'. In response Britton conceived two striking Orozcoesque designs, the first depicting the rise of monopoly in the oil industry in the period after the Civil War and the second (fig. 114) showing how international conflict over oil could lead to war: 'The conclusion in this panel deals with the problem of suggesting to the people of the United States that their social duty is to project their efforts and democratic ideology toward the protection of their interests in relation to the natural resources of their country.'[56]

Doubtless these designs went too far, and they were rejected in favour of a blander imagery of productive labour but, none the less, Ickes was concerned to develop an iconographic programme throughout his

new building that projected his interventionist view of the federal state. *Construction of a Dam* precisely exemplifies this. At the same time, his commitment to public power overlapped with the Communists' vision of the socialisation of production – for them it was a way station en route to that goal. (Indeed, for Communists, Gropper's generic dam may well have stood as something like an American Dnieperstroi.) Moreover, after the president himself, Ickes was probably the Party's favourite New Dealer because of his outspoken anti-racism and anti-fascism, and his public criticisms of the Dies Committee.[57]

It was entirely consistent that a progressive such as Ickes should find the modern social art of Gropper sympathetic and, in the context of the Democratic Front, equally consistent that a Communist artist such as Gropper should welcome the opportunity to decorate the building of one of the most interventionist branches of the New Deal administration dedicated to 'promoting the domestic welfare', and that the commission should be hailed in the *Daily Worker*.[58] In the huge pink granite building in Washington Gropper's mural belongs to federal authority, but this was not its only location. The full-scale sketch was exhibited at the ACA Gallery, and the initial sketches were reproduced in 1937 in the *Magazine of Art* alongside a range of his more critically charged works.[59] My point is that while the most celebrated Communist artist had contributed to a manifestation of federal authority, federal authority had also conferred a certain status on his work. Gropper's public identity cannot be simply filtered out of contemporary readings of *Construction of a Dam*.

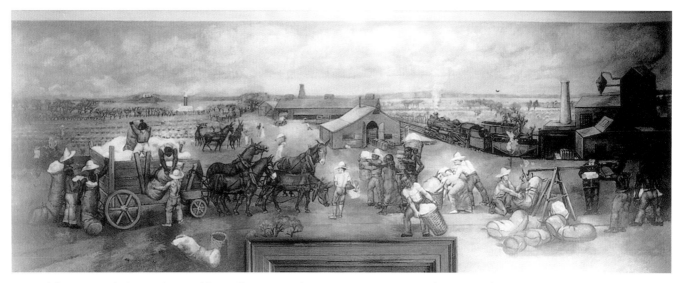

115 Philip Evergood, *Cotton from Field to Mill*, 1938–9, oil on canvas, approx. 4 × 12 ft, USPO, Jackson, Georgia.

116 Detail of fig. 115.

Melosh has argued that 'racial policy' functioned as a fault line dividing Communists from New Deal liberals, and that the limits of Ickes's anti-racism are demonstrated by his concern that the workers represented in the Interior Department Building should look 'truly American'. Yet Ickes was a longstanding supporter of the NAACP and had integrated the first government department in Washington. Further, Gropper did depict black and white workers labouring together, and Fiene's four panels on the Western Lands did represent 'descendants of many races or nationalities'.[60]

The region in which the theme of racialised labour became unavoidable was, of course, the South. In her study of Southern New Deal murals, Sue Bridwell Beckham suggests that while the Section and its artists were not always responsive to the demands of local white communities, the vast majority of murals articulated a model of gender and racial hierarchies acceptable to them through the symbolic typing of certain activities, and the omission of others. Thus, 'White men in the South always work, though often with their brains rather than their brawn; black men sometimes work, are sometimes incompetent; black women always work – and do so with dignity; white women never work and seldom do anything else.' Overwhelmingly, Southern whites wanted the region to be represented as progressive and prosperous.[61]

It was those murals that did not accord with these presumptions in some way that occasionally aroused dissent, and predictably these were the work of left-wingers. The key instance here is Evergood's mural for the post office at Jackson, Georgia: *Cotton from Field to Mill* (figs 115 and 116). Although relations between artist and Section were friendly, throughout the sketch and cartoon stages Rowan worried that Evergood's style would not be understood by 'the people of Jackson', and urged him to normalise his perspective and figure drawing and perhaps even to 'develop a landscape decoration' instead. Responding to the Section's criticisms, Evergood changed the design almost beyond recognition, and even added a colonial mansion in the background at Rowan's request. However, his real problems were with a post master who pronounced that a mural 'anything like' the cartoon would 'not be satisfactory' as it was 'not true to scenes in this section.' When the mural was installed the same official reported that 'Comments have been unfavorable and critical.'

Nothing was said about the iconography but, as Beckham has emphasised, the imagery of black and white men and women all labouring in the same way contradicted the symbolic order of Southern murals at their most sensitive point. Moreover, as a postal worker pointed out when I visited the mural, the range of colour phenotypes in the image indicates that sexual relations occur between black and white. There is, too, a symbol of the class oppressor of both races in the besuited white figure by the cotton scales. Evergood may have compromised on formal matters in some degree, but it was a political achievement to insert a mural of cooperative inter-racial labour into a federal building in the heart of a state where lynching was rife and whose governer, Eugene Talmadge, was an infamous white supremacist and one of the New Deal's fiercest opponents at state level.[62]

There is far more to be said on the representation of racial labour in New Deal murals by left-wing artists than can be included here. For the moment, the example of *Cotton from Field to Mill* must serve to illustrate that intimations of the left's critique of racism are to be found in Southern murals, although they were rarely as blatant as Evergood's.[63]

HISTORY

As Marlene Park and Gerald Markowitz have observed, the majority of Section murals that dealt with historical themes 'present a view of the past as peaceful, productive, and progressive' – a view that was intended to reassure the audience that the Depression was just a temporary detour from America's normal destiny that the New Deal would remedy. Of the few murals that offer a model of history based on conflict, the most important are those at the post offices in Decatur, Saint Louis and the San Francisco Rincon Annex.[64] All three were prestigious commissions, all were painted by leftists. Here I shall consider only the first two since the third was not executed until 1946–9, although it was commissioned in 1941. The iconography of the Rincon murals and the political struggles over them have to be understood in relation to the position of the Communist Party in the Cold War period, and for this reason they are discussed later.

Both the Decatur and Saint Louis commissions were the work of three Chicago-based artists who were recognised as being among the most distinguished of contemporary muralists by both the Section and WPA FAP, namely Edgar Britton (1901–82), Edward Millman (1907–64) and Mitchell Siporin (1910–76). Of

the three, Britton is the least clear-cut in terms of political convictions. He was a member of the Chicago Artists' Union and a lithograph by him on a Spanish Republican theme was illustrated in *New Masses* in 1938,[65] but he was not a signatory of the Call for the American Artists' Congress and, while it is almost inconceivable he was not a member, there are no indications that he played an active role. By contrast, Millman and Siporin signed the first Call to the Congress in 1935. Millman was on the executive board of the Chicago Artists' Union and Siporin had been an active member of the Chicago John Reed Club and was a contributor to *New Masses* as early as 1931.[66]

Indeed, Siporin, whose father was a union organiser, had produced one of the most complex and accom-

117 Mitchell Siporin, *Haymarket Series: The Stool Pigeons, Mr and Mrs William Seliger*, 1993–4, ink on cardboard, 21³/₈ × 14¹/₄ in., Collection of Whitney Museum of American Art, New York, Gift of an anonymous donor, 51.21.

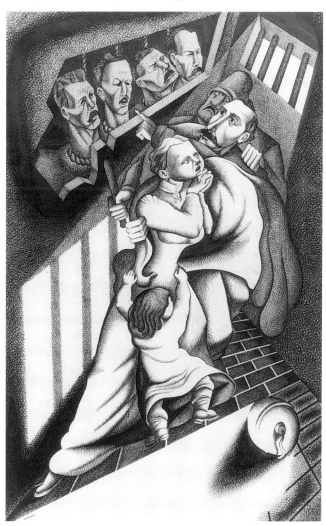

plished instances of proletarian art in his remarkable series of drawings on the theme of the Haymarket Martyrs of 1934–5 (fig. 117), through which he intended to capture 'the condensed essence of the class struggle in America.' He originally conceived a sequence of seventy drawings divided into two parts, the first dealing with the events around the Haymarket bombing, and the second continuing the story of class struggle up to the present. They were intended to form the basis of a book of lithographs, although only twenty-five were produced and the book was never realised. The project had come out of a concern with 'the depiction of American History in mural painting', and was an attempt to go beyond the problems posed by the single moment composition. But the drawings were also informed by a critical understanding of modern art. Describing the relationship between 'young revolutionary artists' like himself and modernism in 1935, Siporin observed: 'We are part of this movement, and still at war with it.' At the same time he characterised his 'principal problem' as that of 'injecting into my work a dynamism which would begin to approach the dynamism of the actuality with which I deal.' This presumably led to the Expressionist element in his style, which, as I have shown, displeased some Communist critics. It also meant that when it came to the mural, the key model was that of the Mexicans.[67] The Mexicans were equally important for Britton and Millman, and the latter had visited Mexico in 1934–5 and studied Rivera at work.[68]

By the time the competition for the Decatur Post Office murals was announced in 1936, both Britton and Millman had gained experience of decorative painting under the PWAP and FAP, and Siporin had been conceiving mural designs for some years.[69] Rather than adopting the theme of the post, the trio took advantage of the localism in Section thinking to develop motifs from the history of Illinois. This came at a time when the folklorist B. A. Botkin was arguing in the People's Front magazine *Midwest* that Marxists could not afford to ignore 'regional "acceptances and resistances" in relation to the class struggle', and must take into account 'the sense of a native tradition growing by folk accretions out of local cultures.' Precisely the same point of view was taken by Siporin (who was an editor of *Midwest*) in his essay 'Mural Art and the Midwestern Myth', written for a WPA anthology in 1936. Here he suggested that Midwestern muralists were seeking to achieve 'a new synthesis of form and content growing out of the artist's own milieu and the new social functions in our society.' Botkin's conception of canalising local traditions of radicalism is nicely matched in his

claim that 'Ours is the story of Labor and Progressivism, of Jane Addams and Mary McDowell, of Eugene Debs and Robert La Follette, Sr., of Vachel Lindsay and Theodore Dreiser, of Haymarket and Hull House.' This cultural pantheon is a People's Front in itself, where progressive social workers and La Follette rub shoulders with the Socialist Debs and the fellow-traveller Dreiser! Contrasting his conception with the Regionalism of Benton and Craven, Siporin claimed: 'There is no synthetic regionalism here, no collecting of obvious gadgetry, no jingoistic nationalism; but instead a human democratic art, deeply thoughtful and eloquent, an art of the lives and for the people.'[70] In fact, the fullest realisation of Siporin's vision came under the Section, not under the Federal Art Project.

The Federal Guide to Illinois describes Decatur as a typical prairie town[71] but, despite appearances, this was not the case. Situated at a major railroad junction, it was a small industrial city with a population of around 57,000 in 1938. It was the base for a thriving food processing industry, it had railroad workshops, a coalmine and factories making auto parts, tobacco products and garments. The diverse labour force that worked in these industries and in a host of skilled trades had some history of militancy, but in the 1930s Decatur remained a firmly AFL town. The major employers were still local companies and their proprietors were implacably opposed to industrial unionism. Incursions by the CIO were resisted (apparently with some 'open encouragement' from employers), and in 1937 the Decatur Trades and Labor Assembly suspended the three locals whose parent organisations had affiliated with the AFL's rival.[72]

However, one should not jump to conclusions about working-class consciousness from this. Macon County (where Decatur is situated) adjoins Christian County, the scene of a bloody and protracted struggle between the United Mine Workers (UMW) and the breakaway Progressive Miners of America (PMA) for much of the 1930s.[73] The city policed its unions with a heavy hand. In 1932, when Progressive Miners picketed UMW workers who had refused to strike, a crowd of 150–200 gathered outside the Macon County Coal Company were dispersed with shotguns, tear gas and axe handles.[74] Three years later, workers in Decatur's four garment factories struck in an attempt to achieve recognition for the ILGWU and better work conditions. The police sided more or less openly with the employers, and on several occasions officers and special deputies beat women picketers with clubs and fired tear gas at them at point blank range, before making multiple arrests. The strike lasted for thirteen months and was finally

called off without resolution. In the garment workers' strike, too, there were numerous incidents of intra-class violence.[75]

Decatur did well from the New Deal, and there were extensive public works projects in Macon County. In 1938, when federal relief and work relief spending in Illinois was around its peak, plans were approved for a $2 million sewer project in the town that was to be partly funded by the WPA, and for a new Macon County Building funded by the Public Works Administration.[76] Yet despite the fact that Roosevelt and the Democratic gubernatorial candidate had received landslide votes in the 1936 election, in the mid-term elections of 1938 the GOP won all except one of the Macon County offices, and voters gave majorities to all but two Republican candidates on the state ticket. Although the New Dealer Scott W. Lucas won a large majority in the Senate race in Illinois, he did not carry Macon County. 'Macon County repudiated the New Deal' announced the liberal *Decatur Herald*, which had recommended its readers to vote for the Democratic ticket for all except a few local offices.[77]

Without a detailed analysis of Decatur's social demography and of precinct voting patterns, it is impossible to know the role of Decatur's working class in this shift. But given the AFL's voluntarist tradition, there is no immediate contradiction between union membership and Republicanism, and a number of union members were active in the city's GOP. From the beginning, the AFL unions had problems with the New Deal public works and work relief schemes because programmes such as the Civil Works Administration and WPA usually undercut union wage rates. Moreover, in 1938 the AFL was complaining vociferously that the National Labor Relations Board was prejudiced against the AFL in union recognition battles. So in a strongly AFL town like Decatur there were quite a lot of reasons for unionised workers to vote against the New Deal – however lacking in larger class solidarity such action might appear.

Still, historians can be reasonably confident that one sector of the working class voted for the Democratic ticket in 1938, namely the WPA workforce of around 3,000. A significant number of Decatur's WPA workers were organised by the Workers Alliance, and on several occasions in 1938 they took action to protest against layoffs and to seek improvements in pay. This is one indicator of a Communist presence in the city.[78]

If Decatur's working class was divided by union affiliation and political allegiances, it was also divided by religion, race and ethnicity. There were, at the least, communities of African Americans, German Americans,

Greek Americans, Irish Americans and Italian Americans in the city. Some Polish names appear among lists of strikers arrested in 1935, and there was a small Jewish community. In the first thirty years of the century many African Americans had been drawn to Illinois, and the state's black population had increased from 1.8 per cent (85,078) of the whole to 4.3 per cent (328,972). However, Decatur's black population was small, being only about 3,400 at the end of the Second World War. Race relations in Illinois had been turbulent, and the Ku Klux Klan had been particularly successful downstate during its resurgence in the early 1920s. Part of its appeal was to fundamentalist elements among the Protestant working class, disoriented by the postwar crisis in the coal industry and culturally at odds with workers of southern and East European Catholic origins. In this period, Decatur had a mayor friendly to the Klan.[79] In what ways these various differences might help to explain, for instance, who joined the PMA and who the UMW, who joined the 1935–6 ILGWU strike and who scabbed, who voted Democrat and who Republican, at the moment there seems no way of knowing. But somehow, it should be assumed, this divided and complex population was the public to which artists of the Democratic Front (themselves members of a CIO union) wished to direct their work above all others.

The artists arrived in Decatur in mid-August 1938 and the murals were completed on 27 October. All the work was executed in the public eye and, from the outset, the progress of the panels was extensively covered in the Decatur press, which published several photographs of the different stages and reported interviews with the artists.[80] If only through the press, the themes depicted in the murals and the nature of fresco

118 Mitchell Siporin, *Pioneer Family*, from *The Fusion of Agriculture and Industry in Illinois*, 1938, fresco, 7 ft × 7 ft 6 in., USPO, Decatur, Illinois.

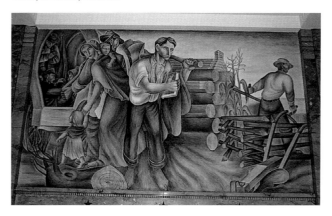

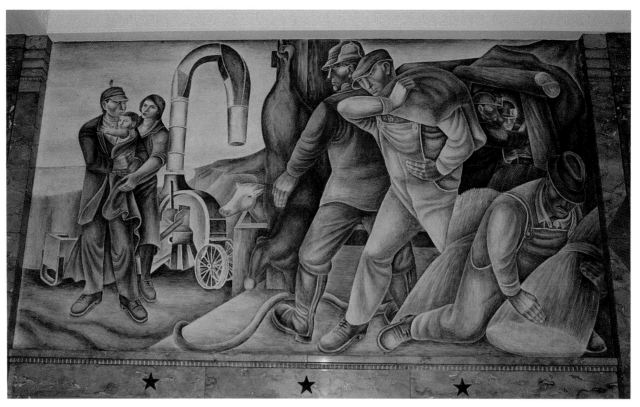

119 Mitchell Siporin, *Workers of Today*, from *The Fusion of Agriculture and Industry in Illinois*, 1938, fresco, 7 ft × 7 ft 6 in., USPO, Decatur, Illinois.

120 Mitchell Siporin, *The Exchange of the Products of Agriculture for the Products of Industry*, from *The Fusion of Agriculture and Industry in Illinois*, 1938, fresco, 7 ft × 7 ft 6 in., USPO, Decatur, Illinois.

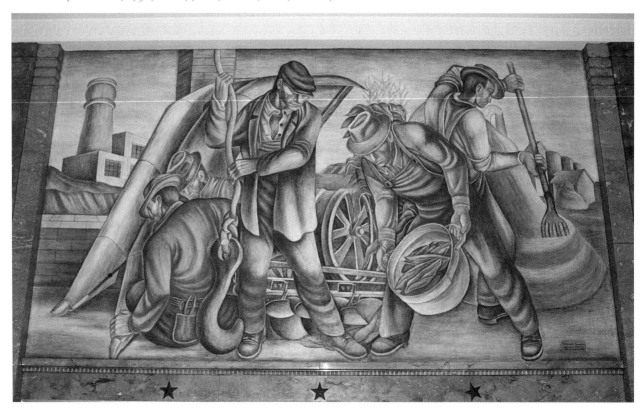

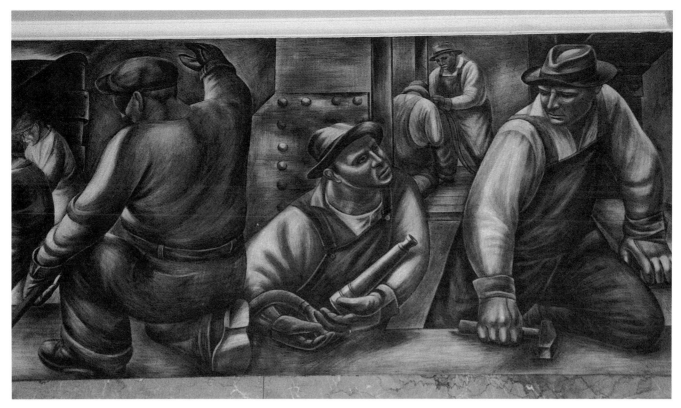

121　Edgar Britton, *Discovery, Use, and Conservation of Natural Resources* (north lobby, detail of south wall), 1938, fresco, 4 × 20 ft, USPO, Decatur, Illinois.

122　Edgar Britton, *Discovery, Use, and Conservation of Natural Resources* (north lobby, detail of south wall), 1938, fresco, 4 × 20 ft, USPO, Decatur, Illinois.

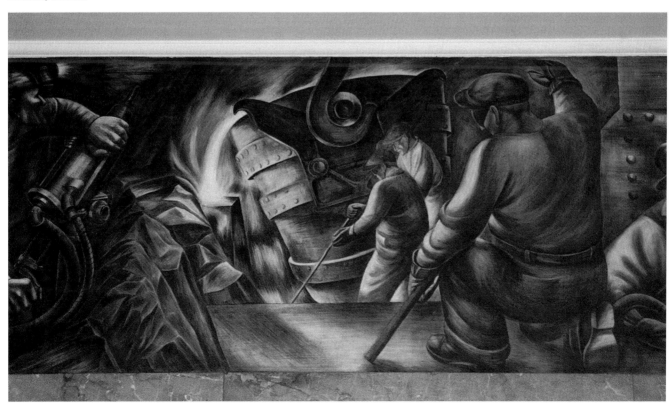

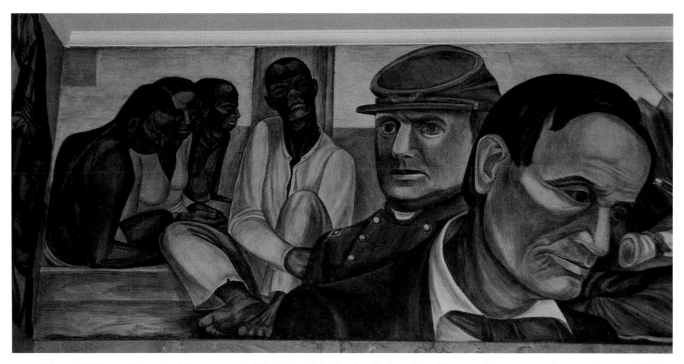

123 Edward Millman, *Growth of Democracy in Illinois* (south lobby, detail of south wall), 1938, fresco, 4 × 20 ft, USPO, Decatur, Illinois.

technique would have been well known. On the day before the murals were completed, the artists estimated that they had answered questions from 'at least 5,000 persons' during the course of their stay, and according to the press 'Hundreds of Decatur persons have paused each day to watch the artists at work.'[81] The artists themselves made much of the public nature of the fresco medium, and willingly stopped to explain things. But who were the people that made up their audience? Certainly it included members of Decatur High School art classes and pupils from grade schools, and on one occasion the artists talked on their work to members of Beta Sigma Phi, a businesswomen's sorority. Most tantalising of all, however, is the *Decatur Review*'s comment that the murals were popular with the 'rank and file of . . . postoffice visitors'.[82] One cannot conclude from this term that the murals had an especial appeal to working-class Decatur, but at least it suggests that their appeal was not limited to the middle class.

The Decatur Post Office was a large commission, comprising decorations to a main lobby nearly 124 feet long by more than 17 feet wide, and two attached north and south lobbies, each approximately 21 by 16 feet. All were painted in *buon fresco*. For the centre lobby – in fact the best spaces – Siporin executed three panels on the theme of 'The Fusion of Agriculture and Industry in Illinois' (figs 118–20), intended to show the 'essential character of the Prairie Midwest' through the representation of its specific economy and forms of labour. As

the artist put it in his own explanatory notes, 'The growth and expansion of Illinois farms have given rise to the growth and expansion of factories of Farm Machinery, of steel and flour mills, and of stock yards.' To emphasise historical continuities, Siporin wanted 'the railsplitter emerging from the pioneer family' in the first panel (a self-consciously Lincolnesque figure) to appear to be facing the workers with the contemporary cornblower in the second: 'The workers in Illinois Industry counterbalance their pioneer ancestors in the first panel.' In the third panel, the 'products of the toil of the farmer are exchanged for the machinery of the city workers.' The Communist Party might have temporarily abandoned its third-party ambitions, but the grounds for the alliance of the farmer and labour are still there. Significantly, farmers and workers exchange products here with no economic intermediary, in an ideal and essentially mutualist relationship.

In the north lobby, where the theme was 'Discovery, Use, and Conservation of Natural Resources', Britton had two panels 4 feet high by 20 feet long, on which he depicted respectively: early settlers and farming; and the building of the raiload, mining, steel works and skyscraper construction (figs 121 and 122) – all activities that could be seen to have a resonance with the occupations of Decatur's workforce. Here too workers labour cooperatively together with no sign of supervision. On four smaller curved panels on the east and west walls Britton painted portrait heads of Midwestern worthies:

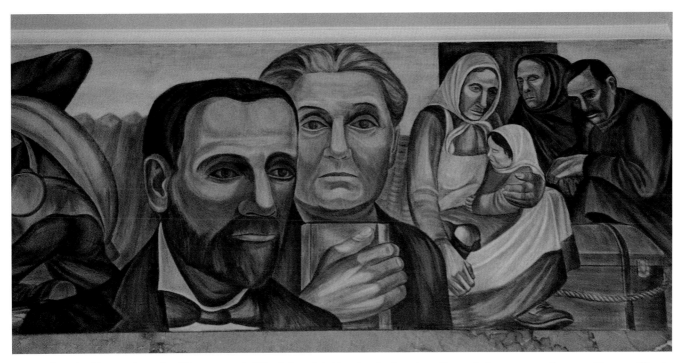

124 Edward Millman, *Growth of Democracy in Illinois* (south lobby, detail of south wall), 1938, fresco, 4 × 20 ft, USPO, Decatur, Illinois.

John Deere, Frances Parker, Carl Sandburg and Frank Lloyd Wright. Those of Parker, Sandburg and Wright were accompanied by appropriate quotes, of which that from Parker is the most politically resonant: 'Democracy founded upon the principle that each member of society contributes to the good of all.'[83]

In the south lobby, Millman represented the 'Growth of Democracy in Illinois' on panels of the same dimensions, depicting the history of the state from Indian times, through migration and settlement on the north wall, and from the Civil War through urban social work and contemporary democracy on the south. It was, in the artist's own words: 'an interpretation of those events most important in moulding our democratic destiny'. No one following the sequence could doubt that Illinois's history was one of 'dramatic struggle' (in the words of the *Decatur Herald*),[84] or that the heroes in this narrative were progressives such as the abolitionist martyr Elijah Lovejoy and Governor John P. Altgeld, whose pardons of the surviving Haymarket Martyrs in 1896 cost him his political career. The conflict over slavery in Illinois is central to the iconography of the south wall (figs 123 and 124), in which Lincoln is represented with his friend Governor Richard J. Oglesby, wearing the uniform of the Grand Army of the Republic. Although both had personal connections with Decatur, Lincoln was also a key figure in Communist political discourse under the Popular Front. Correspondingly, he is not represented simply as a son of Illinois but as the

instrument of African American Emancipation and thus as a revolutionary.[85] Similarly, Jane Addams, pictured next to Altgeld, represents not just another Chicago worthy but the entrance of immigrants into the workforce and into democracy. The sequence concludes with a panel representing a workman at the ballot box. Considering the nativist currents in Illinois in the 1920s, these figures can hardly stand as simple consensual symbols.

The three sequences are mutually supportive, but they do not really cohere into a single programme. However, it will be evident that labour's role in the building of the state is insisted on throughout. The only businessman represented is the agricultural machinery manufacturer Deere, and there is a marked presence of Democratic Front idols such as Lincoln, Sandburg[86] and Wright. All figures are equally endowed with a kind of symbolic *gravitas*, as if aware of their role in historical destiny. However pallid by comparison, the style was everywhere suggestive of the Mexican Mural Renaissance, more specifically of Orozco in the case of Millman's contributions, and of Rivera in those of Britton and Siporin.[87] The rather flattened bulky forms with clear outlines, and the uninflected facial expressions, spoke the language of revolutionary muralism, as this had been developed by 'Los Tres Grandes' in both Mexico and the United States. This stylistic quality unsettled Edward Rowan, who complained to all three artists of a pervasive 'serious mood', 'an unbroken lugubrious quality' and 'an unbroken somber mood' in their work. All were

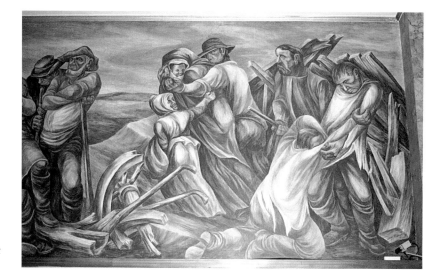

125 (*right*) Edward Millman, *Pre-Civil War Missouri* (detail of south wall) 8 ft 10 in. × 29 ft, 1940–42, fresco, USPO, Saint Louis, Missouri.

127 (*facing page*) Mitchell Siporin, *Labor* and *The Land* (east lobby), 1940–42, fresco, each 12 ft 8 in. × 4 ft 4 in., USPO, Saint Louis, Missouri.

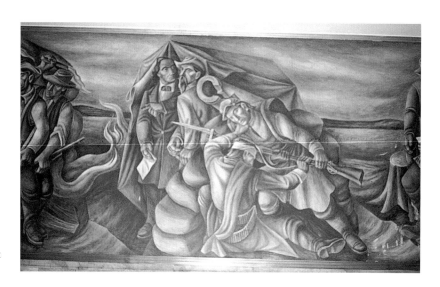

126 (*right*) Mitchell Siporin, *The Civil War* (detail of north wall), 1940–42, fresco, 8 ft 10 in. × 29 ft, USPO, Saint Louis, Missouri.

urged to avoid 'unnecessary distortions'. However, their designs were warmly supported by Daniel Catton Rich of the Chicago Art Institute, who chaired the local committee, and although the artists responded to Rowan's criticisms, they do not seem to have altered their overall conceptions much.[88]

It has become commonplace to argue that because such murals do not represent class conflict, their message was essentially affirmative of the status quo. This, I think, underestimates the extent to which working-class gains in the 1930s – especially the Wagner Act of 1935 – were a result of pressure from organised labour on the New Deal administration. Labour was hardly an uncontroversial topic in the early years of the CIO, and the majority of corporate America – as well as Decatur's major employers – was opposed to industrial unionism. In my view, the image of dignified labour at Decatur, like that in Rivera's *Detroit Industry*, offers an

image of potential workers' power. Moreover, in their representation of workers as cooperative and unified, the Decatur murals projected an ideal that was very different from the realities outside the building, where, despite the militancy of some of the city's workers, the unity of labour remained only an aspiration.

In their scheme for the St. Louis Post Office, Millman and Siporin deployed a similar approach to the regional history of Missouri. Covering a wall space of 2,913 feet, these frescoes were the largest mural commission awarded by the Section, and brought the pair $29,000 between them. The commission was extensively reported in the press, both nationally and locally, and the artists' opinions were recorded in numerous interviews.[89] As at Decatur, much was made of the artists' willingness to talk with kibitzers.[90]

For once the artists had a fine mural space in a lobby more than 211 feet long and 17 feet high. The competi-

tion announcement had suggested that the 'transportation of the mails from its earliest beginning to the present day' should be 'a subject of great interest involving much of the history of Saint Louis.' Millman and Siporin took up this theme, but reversed its order of significance. In the main lobby, nine panels, all 29 feet wide by nearly 9 feet high, depicted 'major events which shaped the history of Saint Louis', for which the artists conducted extensive researches at the Missouri Historical Society. References to the history of the mail appear only here and there. On the south wall, Millman painted five panels representing purchase of the territory and the arrival of settlers; the struggle for statehood; river traffic; fur traders; and episodes in pre-Civil War history such as the Dred Scott decision (fig. 125). Opposite, on the north wall, Siporin's four panels symbolised discovery and colonisation, the Lewis and Clark expedition and Daniel Boone; the destruction of the Civil War and

the achievements of Reconstruction and after (fig. 126). Because Millman took more panels in the main lobby, Siporin executed the four small panels in the east and west lobbies, which symbolise 'Unity', 'Democracy', 'Labor' and 'The Land' (fig. 127), and are linked with quotations from Walt Whitman, probably the key historical figure in American poetry for Communists.[91]

It will be evident that chronologically speaking Millman and Siporin's contributions in the main lobby are interspersed, and the narrative moves back and forth between north and south walls. There is greater unity of conception here than at Decatur, and Millman adopted the same kind of plastic motifs as Siporin, which are more effective than the mixture of portrait heads and smaller figure groupings he used in the earlier commission. The dark blue band of the river binds the panels together into a sombre and sometimes ominous sequence under a red sky. Facial expressions are sober

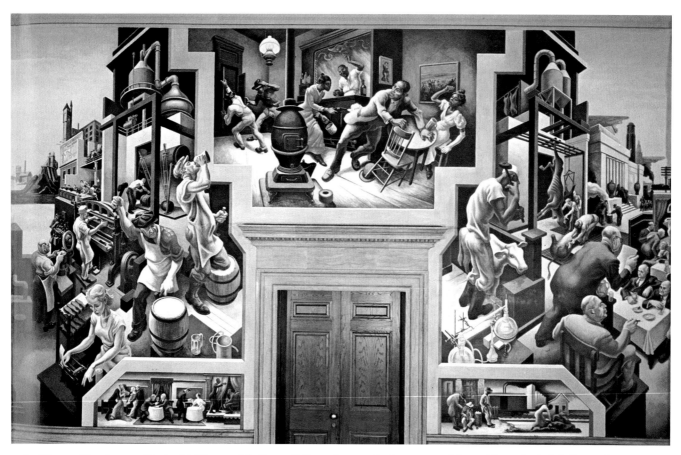

128 Thomas Hart Benton, *The Social History of the State of Missouri*, 1935–6, oil on canvas, Missouri State Capitol, Jefferson City, Missouri.
© T. H. Benton and R. P. Benton Testamentary Trust/Licensed by VAGA, New York, N.Y.

throughout, and the interlocked figure motifs suggest both collectivity and struggle. No one could doubt from this scheme that the state of Missouri had a bloody and destructive history of racial politics. Yet although the post master, W. Rufus Jackson, initially objected to some historical details such as the depiction of John Brown, he was won over,[92] and the Section seems to have been extremely pleased by the result. It is significant, however, that Rowan should write to the artists in the course of its execution to suggest that 'the over-serious expression of the figures be checked in the further work so that the "social conscious" quality is less insistent.'[93] To judge from the result, they responded only so far as was tactically necessary.

It seems unlikely that Millman and Siporin would not have felt the challenge of Benton's murals *The Social History of the State of Missouri* (fig. 128), given the overlap in theme and the left's continuing criticism of both the style and historical vision of Benton's work.[94] Seen in this light, the shallow spatial composition, simple groupings and sombre colouring in the Saint Louis Post

Office frescoes stand in marked contrast to the spatial convolutions, narrative detail and garish colouring of Benton's oil panels in the State Capitol Building in Jefferson City. 'The people' in Millman and Siporin's scheme carry the burden of historical destiny; in Benton's they are actors in diffuse and frequently picayune narratives that blend fact and fiction. For all their seriousness, the former bespeak a certain optimism about the political capacities of their subjects, the latter are pervaded by the same easy cynicism we find in Benton's autobiography.[95] By contrast, the pair openly avowed that their 'hero' was Orozco, 'the greatest mural painter of our time', and they visited Mexico together in 1939 to study his work in preparation for the Saint Louis commission.[96]

The completed murals were reviewed sympathetically in the liberal *St Louis Post-Dispatch*, which referred to their 'richness and meaning for the people of Saint Louis', and described them as being 'painted with a full feeling of destiny'.[97] However, Rowan's intuition that the combination of style and motifs would not please some elements in local society is confirmed by a number

of letters to the paper complaining about public art in the city, many of which focussed more on a singularly banal American Legion monument recently erected. One correspondent described the post office figures as 'agonized, unhappy and grotesque', but even more significant was the accusation that the murals had a 'foreign atmosphere' and were not 'AMERICAN'. There may even have been anti-Semitic undertones in the observation: 'I am sure that most of the founders of the City of St Louis did not come out of the Old Testament.'[98] This response seems to confirm the Section's view that the sectors of local communities with which they had to deal wished for an essentially benign vision of America. However, it also indicates that in the interests of quality Rowan and his colleagues were sometimes prepared to accommodate work by artists of the left that they knew was likely to be controversial at the same time as they sought to temper their style.

The problem with generalising interpretations of New Deal iconography is that they do not sufficiently take into account the specifics of particular works, either in relation to style and motif or in relation to location. (The attention given to the South in existing studies is a partial exception with regard to the latter.) Further, for all its insights, Melosh's study seems to expect too much from left-wing art in relation to its potential audience. It is a commonplace that despite massive unemployment and vast social dislocations, the situation in Depression America was not a revolutionary one. Specific studies of the culture of CIO workers suggest that for all their militancy, the outlook of even the most class-conscious sectors of the working class scarcely achieved the level of the social democratic.[99] In these circumstances, the representation of American workers as the backbone of democracy and the 'Resources of America' in federal buildings was not an insignificant achievement for the left. For all the limitations of Democratic Front analysis, it was acute enough in registering that before American workers could develop any more radical consciousness, they had to be brought to a common sense of their own dignity and potential as citizens. As such, some New Deal murals were arguably more politically valuable than the John Reed Club's collective exhibits at the Society of Independent Artists, or its small shows in a loft on Sixth Avenue. One testimony to this comes from Richard Nixon in 1949, who wrote in a letter to a California postal worker that 'some very objectionable art, of a subversive nature, has been allowed to go into Federal buildings in many parts of the country,' art that he hoped would be removed under a Republican administration.[100]

The WPA Federal Art Project

Relations between Popular Front collective organisations and the Federal Art Project were inevitably far closer than those they achieved with the Section, but also more intense, more turbulent. Cahill was regarded as sufficiently sympathetic to address the Second Artists' Congress in December 1937, and in 1939 the Congress put on a dinner in his honour at the Brevoort Hotel.[101] Reciprocally, the anthology *Art for the Millions*, which Cahill initiated as a report on the project in 1936, would have included a section on 'Artists' Organizations' with statements by representatives of the Artists' Union and Artists' Congress. The editor of this volume, Emanuel Benson, was a critic and prominent AAC activist.[102] In the 1957 interviews that make up his 'Reminiscences', Cahill emphasised the role of the Communist Party in orchestrating pickets and sit-down strikes, but also the anger and desperation of those involved. He and the regional offices were the immediate object of protest because activists assumed if they put pressure on them, they in turn would put pressure on the administration.[103] Regional directors varied in their degree of sympathy with the Union. In Illinois, relations between the Union and the director Increase Robinson were so bad that Cahill was forced to replace her.[104] By contrast, Audrey McMahon, who headed the New York project, declared approvingly in a 1936 article that the government had become 'in some measure, a permanent patron of the arts', and she later recalled that despite 'many bitter encounters' with Union and Congress representatives, 'I always felt that their basic purpose was similar to, if not identical with mine'. This seems to be confirmed by the fact that McMahon was herself a member of the Congress, from which she resigned in April 1940, claiming that she had not hitherto noticed political elements in the Preamble to its Constitution.[105]

Assessing the political import of WPA art works is much harder than assessing that of the Section. Not only was the programme much larger but its products were also far more varied and physically diffused. Moreover, the records of the FAP are both less comprehensive and less easy to use. Iconographical analysis of WPA public art is correspondingly less developed than that of the Section, although its general characteristics have been defined convincingly enough by Park and Markowitz.[106] That the cultural programmes were the subject of heated debates in the press I have already intimated. However, these debates tended to centre around the general principal of federal patronage as representing 'the standards and methods of relief symbolized by WPA'[107] rather than

around specific commissions or works. With WPA murals and public sculptures there are some measures of audience reaction in the form of press criticisms and the responses of sponsors. With the easel paintings, prints and small sculptures distributed to public buildings and offices, or eventually to museums, no such record exists, and the only register of responses lies in reviews of the numerous WPA exhibitions that were shown both at museums and at the FAP's own galleries and community art centres. Nominally, at least, WPA artists on the Easel and Graphic Art divisions in New York had no restriction as to subject beyond a ban on nudes and 'propaganda for a specific political or other kind of group', and the stipulation that 'pictures must be capable of being allocated to public buildings.'[108]

In assessing the politics of WPA art, I focus on New York and Illinois. This is partly for reasons of manageability, but also because of the central importance of the projects in these states and the scale of political activity around them.

MURALS

WPA public art was conceived for different types of institution from those in which the Section operated. Most commonly it decorated schools, hospitals, libraries, armouries, parks, public housing, borough halls, courthouses and prisons, but it was also placed in airports and radio stations among other places. Although it was commissioned by a federal agency, WPA art was thus not destined for federal buildings. Having said this, the institutions where it was displayed can be understood as branches of the state, and were characterised as 'authorized governmental agenc[ies]'. WPA projects generally required a 'sponsoring governmental agency', which was expected 'to contribute equipment, materials and services to the maximum amount possible', and after the 1937 ERA act this was a statutory obligation. Until the 1939 act Federal One did not have to meet this requirement, since the offical sponsor of Federal One was the WPA itself. FAP administrators were thus not tied to outside agencies responsible for non-labour costs, although they needed such agencies to reach the communal audience they desired. Project procedures did allow for the role of what were called 'Cooperating Sponsors', who might contribute money or services to its work, but such contributions were kept distinct from the formal transaction of allocation. The route by which WPA art works were installed in 'public agencies or institutions' was through long-term loans from the federal government. Nominally, at least, WPA art remains federal property.[109]

In an article of 1936 passing judgement on the WPA and Treasury projects, E. M. Benson claimed that 'after certain artists of outstanding talent and reputation have passed through the editorial mill of the Procurement Division what remains is something that can hardly be recognized as their work.' By contrast, the FAP was the first 'real attempt . . . to think in terms of a long-range cultural program that would meet the complex requirements of the world we live in.' For 'the most part', the Treasury had not produced a 'people's art'. By implication the WPA FAP would do so. Yet even the partisan Benson acknowledged significant work had been produced under the Section, work that 'has had a salutary and progressive influence in its own sphere.'[110] The FAP has commonly been presented as a model of freedom, in contrast to the Section's tight procedural controls, but supervision of murals and public sculptures was close, and in New York City they had to be approved by the Municipal Art Commission. Cooperating Sponsors could also demand changes, although they were not always acceded to.[111] At a 1939 meeting of the New York mural project, Evergood, then managing supervisor of the Easel Division in the city, gave an address in which he 'lauded the sympathetic understanding of the supervisors of the mural division and of the Subject and Approvals Committee toward the artists submitting work for mural assignment.' He appreciated that an artist might feel 'a resentment toward the committee due to constant recommendation for revision of his design', and he himself had 'formerly felt' it was taking away his ' "Freedom of Expression" '. However, after realising 'the tireless efforts' of the supervisors in gaining approval for submissions from the committee, the Sponsor and the Art Commission, he considered any resentment unwarranted.[112] Evergood's statement is a reminder of the constraints under which FAP public art was produced, but it also illustrates the way artists could move between being relief workers for the project and being supervisory personnel. By contrast, while artists were involved in Section procedures as competition jurors, they were deliberately excluded from the running of the programme. In fact, supervisors belonged to a different union from relief workers, although it too was a CIO affiliate.[113] It was the willingness of the FAP to appoint artists working in a wide range of styles as supervisory personnel that partly accounts for the stylistic diversity of the programme.

The leading question regarding public art under WPA is whether it allowed more space for 'Freedom of Expression' than the Section and, if so, whether this meant greater leeway for political radicalism,

manifested either iconographically or formally. To answer this it is useful to compare the murals by Britton, Millman and Siporin produced under both programmes. All three executed murals for high schools in Chicago and its neighbourhood, which, with one exception, matched well with established FAP iconography.

In the dining hall at Lane Technical High School, Britton painted six panels (all roughly 12 × 14 feet) and an overdoor with the title *Epochs in the History of Man*. Such grandiose themes were not uncommon in FAP school decorations, the best-known instance being James Michael Newell's *Evolution of Western Civilization* for Evander Childs High School in the Bronx.[114] The most important model for narratives of this type was Orozco's *The Epic of American Civilization* at Dartmouth College, although none of his American imitators matched its power. Neither Britton nor Newell ironised 'civilization' in the way Orozco did, and their formal motifs and colouring have nothing of his expressionism. Correspondingly, conflict plays no role in Britton's history and little in Newell's. Their history is also essentially Eurocentric. Britton's programme moves from the cave to the New Deal, passing only through the Egyptians, Greeks and Renaissance en route. In a text prepared to accompany the murals, Britton wrote of the last panel in the sequence (fig. 129):

> Our day shows the possibility of the individual standing serene against the product of collective effort of mind and united action. The fruit of his work now exists for the benefaction of Man – his use, his security. . . . Man has brought to this new world a sense of individual freedom through collective effort.

The balancing of individual against collective in this statement finds its counterpart in the image of the worker with wife and child set against a dam. The latter we may take as a synecdoche for 'united action', while worker and family (according to the artist, 'the greatest of human relationships'), isolated in an otherwise unpeopled landscape, are the basic unit of democracy. In this narrative, individual freedom is a product of 'collective effort'. If the familial politics here may count as what Gary Gerstle calls 'moral traditionalism', the progressivist message is not an affirmation of consumer capitalism. Progress here implicitly means, at the least, public control of power, and probably much more.[115]

The image of the worker as the end-product of education was again a common theme. Britton had painted nine panels representing different types of labour for the library at Highland Park High School in 1934 under

129 Edgar Britton, *Our Day*, from *Epochs in the History of Man*, 1936, fresco, 12 ft × 14 ft 4 in., Lane Technical High School, Chicago, Illinois.

the PWAP. Two years later he executed six frescoes on the theme of *Classroom Studies and their Application* in the entrance lobby of Bloom High School, a new Art Deco building in Chicago Heights. Whereas at Highland Park Britton's figures were all male and engaged primarily in manual activity, at Bloom manual workers are balanced by professionals such as architects, doctors and engineers. Women too are represented, but only in supporting roles. All these panels speak of the dignity of labour and cooperation, and the only hint of radicalism here is the red star on the glove of an engineering worker. The Bloom murals are essentially a catalogue of occupations, and the style has none of the dynamism of Britton's Decatur frescoes or their dark Orozcoesque accents.

Siporin's four panels on the Arts for the lobby auditorium at Lane Technical High School are more formally satisfying than these, but their iconography is no more challenging. At Lucy Flower Technical High School, however, Millman decorated a whole room covering 54 feet of wall with frescoes that were so disagreeable to the cooperating sponsor that they were painted over and have only recently been restored. The school is named after a nineteenth-century Chicago reformer who had fought to establish child welfare provision in Cook County and campaigned for vocational schools. Appropriately, Millman took as his theme *Women's Contribution to America's Progress* (fig. 130), illustrating this through images of 'Samaritans in the Field' (female Abolitionists), the 'Suffrage Movement', 'Child Labor and the Schools' and 'Women's Fight for

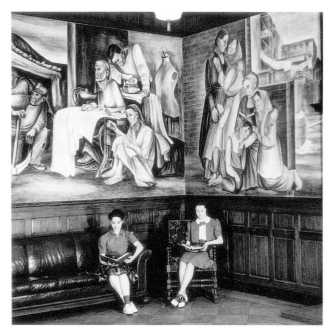

130 Photograph of students in front of Edward Millman's *Women's Contribution to America's Progress*, 1940, fresco, Lucy Flower Technical High School, Chicago, Illinois, Edward Millman Papers, Syracuse University Library.

Peace'. Among the figures represented were Harriet Tubman, Susan B. Anthony, Jane Addams, Clara Barton and – to bring the sequence up to date – Frances Perkins, Roosevelt's Secretary of Labour. Not only was the emphasis on women as political activists, but a recurrent theme was their role in redressing the social ills of racial injustice, poverty and male prejudice. And the style, while restrained by comparison with Orozco, was none the less clearly Mexican in inspiration. Colouring is sombre and facial expressions are uniformly serious. A year after they were finished, the school board had the murals covered up as 'drab and dreary'. This was also the fate of the 42-feet-long panel *The Blessings of Water* that Millman painted in the Bureau of Water in Chicago City Hall in 1937.[116]

The defacement of Millman's murals was the result of an orchestrated campaign against WPA art by the anti-New Deal *Chicago Tribune* in 1940, a campaign that particularly targeted him, Britton and Siporin. While the accusation that their work was 'un-American in theme and design' and displayed 'communistic influence' is the usual stuff of reactionary rhetoric, it does confirm that the tenebrous effects and Mexican style that so worried Rowan at Decatur had a leftish political resonance.[117] It was for this reason they were also adopted by the African American artist Charles White (1918–79), who worked

with Millman and Siporin in the FAP mural division, and studied in a fresco painting class they conducted.[118]

White grew up in the poverty-stricken section of Chicago's South Side in a cultural milieu that has been vividly evoked by Bill Mullen.[119] Apart from art classes at the South Side Settlement House, his formal training comprised a scholarship at the Chicago Art Institute in 1937 and a spell with Harry Sternberg at the Art Students League in 1942. Otherwise his artistic education came mainly through a self-help group formed by black Chicago artists, the Art Crafts Guild, and through informal contacts with artists of the Chicago left such as Aaron Bohrod, Todros Geller, Si Gordon and Morris Topchevsky. According to one account, he was a member of the John Reed Club,[120] and he was later active in the Artists' Union and American Artists' Congress. Equally important was his immersion in the circle that met at the studio of the African American choreographer Katherine Dunham and included the writers Nelson Algren, Willard Motley, Margaret Walker and Richard Wright, of whom the last-named impressed him most deeply. White also became a member of the Negro People's Theatre,[121] designing sets and acting in plays, and being coached by the radical playwright Theodore Ward, whose anti-capitalist play *Big White Fog* caused controversy when produced by the Chicago Federal Theatre Project. Given this formation, it is not surprising that White read 'Marx, Engels, and Lenin', and became a committed fellow-traveller, if not a Party member.

As a schoolboy White was outraged by the omission of African Americans from history teaching and mainstream historical writing, something he became aware of through his reading in the public libraries and, particularly, his early discovery of Alain Locke's seminal anthology *The New Negro*. As for so many radical African American artists and intellectuals of his generation, he saw one of the fundamental political tasks as to insert the story of African American oppression and struggles into the American historical narrative. Black Americans needed to be shown to themselves as active players in the nation's history, they needed their own heroes and heroines. As one of the twenty-one black artists taken on by the FAP in Chicago, White found an appropriate space to pursue this strategy in the FAP's South Side Community Art Center,[122] for the library of which he painted the mural *Five Great American Negroes* (fig. 131). Although the mural seems never to have been installed at the Art Center, it was shown at the Artists' and Models' Ball at Chicago's Savoy Ballroom in October 1939, and at the *Exhibition of the Art of the American Negro* held at the Library of Congress from

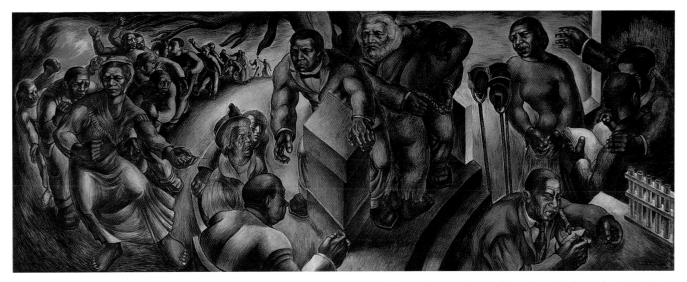

131 Charles White, *Five Great American Negroes*, 1939–40, oil on canvas, 5 ft × 12 ft 11 in., Howard University Gallery of Art, Washington, D.C.

December 1940 to January 1941, to commemorate the seventy-fifth anniversary of the Thirteenth Amendment. For this latter venue it was symptomatically retitled *Five Great Americans*.[123]

In line with the Democratic Front and FAP ideals of community engagement, White selected the figures on the basis of a survey conducted on his behalf by the *Chicago Defender*. The composition pivots on a podium, from which Booker T. Washington addresses a middle-class group. Just behind him Frederick Douglass (looking remarkably Marx-like) releases a slave from his bonds. This group is flanked by Sojourner Truth leading a line of fleeing slaves on the left[124] and, on the right, by symbols of more recent black achievement – Marian Anderson in concert and the agricultural chemist George Washington Carver at work in a laboratory. From behind Washington and Douglass there spread the ominous branches of a bare tree, overhanging the slave column. Although the picture does not have the formal sophistication of White's later work – he was only twenty-one when he painted it – it is undeniably forceful, and shows the artist already developing those bulky, slightly flattened forms that were intended to signify an authentic folk imagery of the Negro People.

However, if White had learnt the formal language of revolutionary mural painting from Millman and Siporin, he had departed from their example in terms of subject matter. For despite the Party's concern with promoting knowledge of black history and culture, African Americans appear on the walls at Decatur and Saint Louis only in relation to the Civil War and Abolitionist move-

ment, with the exception of a few waterfront workers in one of Millman's Saint Louis panels. There are no indications of African Americans' own role in the emancipation struggle and the war. White's work precisely remedied this lacuna.[125] Thus although his conception of mural iconography grew out of Democratic Front Regionalism, White transformed it in crucial ways, creating an imagery designed not to speak to the people of the Midwest but to a particular constituency within the American polity as a whole. I do not mean to imply that White intended his art only for an African American audience. As the *Chicago Sunday Bee* reported in 1940, he was not to be 'classed as a nationalist painter': 'He sees the problems of Negroes as differing from those of other workers in degree or intensity rather than in kind. He believes that all working class people have a common interest and that there is a common solution for their problems.'[126] In effect, White drew on the Communist conception of the National Question as defined by Stalin in treating African Americans as a subject nationality striving for freedom from national oppression within the United States. From within the Communist culture of the 1930s had come the conception of each 'people' producing an authentic national culture of its own, which was in some cases a weapon in national struggles for liberation from capitalism, as well as from racial and national oppression. White was thus able to produce an art designed to appeal specifically to African Americans, but one that would also, as he and other Communists saw it, contribute to the emancipation of oppressed peoples everywhere.[127]

132 Ben Shahn, *The First Amendment*, 1941, tempera, 8 ft 6 in. × 16 ft, USPO, Wood Haven, Queens, New York City. © Estate of Ben Shahn/Licensed by VAGA, New York, N.Y.

In relation to my main question, the case histories of the Chicago muralists suggest some kind of answer. From a left political perspective, Millman's achievement at Flower High School was significant, but his murals there are no more conspicuously radical than those in the post offices at Decatur and Saint Louis. On the other hand, it is hard to imagine that White's mural, with its overt imagery of racial struggle, could have been commissioned by the Section.[128] This should be compared with Ben Shahn's *First Amendment* (fig. 132) for the Wood Haven post office at Jamaica, New York, which is more experimental in formal terms, but perhaps has enough in the way of unequivocally American symbols (the liberty torch, Supreme Court building and New England church) to escape the charge of un-

Americanism. And, of course, Shahn's Americans are all white. We might conclude from this that for the most part the commissioning of public art under the Section was no more restrictive than under the FAP, but that just occasionally the latter permitted greater leeway.

This was certainly the case in relation to style, although only in New York did modernist artists of the left find opportunities to implement their aesthetic on a public scale. One reason for this was that the abstractionist Burgoyne Diller headed the FAP mural division there. Among these opportunities were the commissions for Radio Station WNYC, some buildings in the New York World's Fair, and the Williamsburg Housing Project in Brooklyn. I shall concentrate on the last.[129] The Williamsburg Project comprises twenty four-storey apartment buildings, erected under the auspices of the newly established New York City Housing Authority. Its chief architect, William Lescaze, was a member of the FAP Design Studio and an advisor to the programme. Swiss born, Lescaze trained in Europe, and his Philadelphia Saving Fund Society building of 1928–32 was one of the first major International Style buildings in the United States. His design for Williamsburg was also overtly modernist. Although the fenestration is tame by International Style standards, the flat-roofed blocks are arranged in a strikingly dynamic (and, as it turned out, environmentally impractical) way on the site. Even the colouring of the buildings was 'obstreperously striped' by the bands of concrete running through pinkish brick, and the complex layout was also said to have an 'aggressive formality'. One critic complained that the 'system'

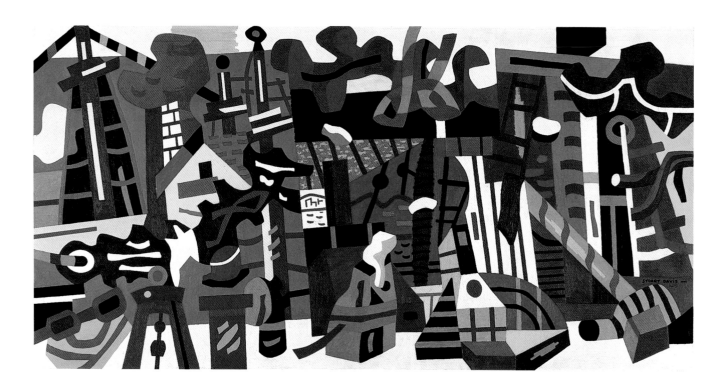

of the plan was hard to follow, and thus calculated only 'to bring pleasure to the esoteric few', making it unsuitable for a 'people's architecture'.[130] The modernist formalism of Lescaze's conception was to be stylistically complemented by the murals that decorated some of the public spaces within it.

In all twelve artists were involved, of whom seven can reasonably be characterised as leftists – Bolotowsky, Browne,[131] Criss, Davis, Greene, Matulka and Morley. The nature and intensity of their commitment to the left varied, of course, as did their individual relationships with the modernist tradition: Bolotowsky and Browne's compositions made no concessions to naturalistic reference, while Criss's *Sixth Avenue El* (National Museum of American Art, Washington, D.C.) is close to the Precisionist idiom and Davis's *Swing Landscape* (fig. 133) contains the residual outline shapes of a Gloucester harbour scene, which the artist may have thought appropriate in a mural for a port city. In an essay for *Art for the Millions*, written in 1936–7, Diller emphasised that the murals were intended to match the 'functional' character of the architecture, and stressed that their role was to provide 'relaxation and entertainment for the tenants': 'The more arbitrary color, possible when not determined by the description of objects, enables the artist to place an emphasis on its psychological potential to stimulate relaxation.'[132] Some of the artists involved would have claimed a great deal more for their contributions. However, I do not imply by this that they shared a common viewpoint, and the Williamsburg Project can be seen as a site at which different conceptions of pictorial modernism squared off, and particularly those of Davis and Greene (fig. 134).

As shown in Chapter Two, Greene was emphatic that the modern artist was necessarily a specialist, a *déclassé* individual, who could look for support only to 'a fearless intelligentsia'. The new middle class lacked a taste of its own, and did not have the resources to build collections on the traditional scale, while 'the class in power' sought to exploit and degrade 'new intellectual advances'. For Greene, as for Davis, modern art was materialist and realist, and corresponded to the general principle of progress. For him, too, while modernism had a progressive message, it could not be that of the political agitator. However, unlike Davis, Greene argued that modernist evolution had an internal logic that pointed towards abstraction, and correspondingly his model of the artist was significantly more elitist:

> Without denying that his ultimate aim is to touch the crowd, he sees the futility of addressing it in the language commonly used by the crowd. He must employ his own language, in this instance the language of form and color, in order to move, dominate and direct the crowd, which is his special way of being understood.

In his *Art Front* writings of 1936 Greene insistently associated modern art with revolution, but an essay he wrote for *Art for the Millions* specifically rejects 'orthodox Marxist' criticism, and implies that fascism and Communism are both forms of totalitarianism.[133]

134 (*left*) Balcomb Greene, *Untitled*, c. 1936, oil on canvas, 7 ft 7 1/2 in. × 11 ft 7 1/4 in., Williamsburg Housing Project, Brooklyn, New York. On loan to the Brooklyn Museum of Art from New York City Housing Authority.

133 (*facing page*) Stuart Davis, *Swing Landscape*, 1938, oil on canvas, 7 ft 2 3/4 in. × 14 ft 4 1/8 in., Indiana University Art Museum, Bloomington. © Estate of Stuart Davis/Licensed by VAGA, New York, N.Y.

Davis found the dominant forms of Marxist criticism equally unacceptable, but he was not prepared to separate art from politics as stringently as Greene, and he continued to believe in the Soviet ideal. His essay for *Art for the Millions*, while bearing the title 'Abstract Painting Today', emphasised that the term 'abstract' was misleading, if unavoidable in the context. Like Greene he argued that 'art values are social values, not by reflection of other social values, but by direct social participation.' Modern painting was, of itself, 'a direct progressive social force'. However, Davis's stress on the cognitive force of modernism was greater. Unlike 'domestic naturalism', the dominant trend in American painting of both left and right, which offered only passive reflections of reality, modernism affirmed 'the modern view that the world is real, that it is in constant motion, that it can be manipulated in the interest of man by knowledge of the real character of the objective relations'. Unlike the traditional perspective of naturalistic painting, modernist spatial systems were 'in harmony with, referable, and relative to the contemporary environment'. The progressive 'democratic' aspect of 'modern works' could easily be seen if they were 'contrasted with works of previous centuries, where the formal conception is hierarchically concentric with a center corresponding to monarchical authority and to a science of eternal categories.' Thus for Davis progressive values were directly inscribed in the forms of modernist painting, so that even 'the autonomy of parts' within them corresponded to 'the freedom of the individual under a democratic government.'[134] For Greene, abstract art seems to carry no such messages, and correspondingly his mural lacks both the vestigial naturalistic clues of *Swing Landscape* or its references to popular cultural forms. For Davis, as for other Democratic Fronters, Swing musically epitomised a democratic inter-racial culture, and the extraordinarily vibrant interplay of colours and forms in the work were intended to evoke the rhythms of hot jazz. From Davis's perspective, Greene's elitism and disdain for the Democratic Front would have connected with the position of the reformed *Partisan Review*, and he regarded him as a Trotskyist.[135]

Although the *Daily Worker* illustrated Davis's WNYC mural on two occasions,[136] it cannot be assumed from this that Davis's style had anything like the connotations he claimed for it. And in any case, his mural for Williamsburg was never installed. When it was shown at an exhibition of mural designs at New York's Federal Art Gallery in May 1938, it reportedly dominated the room, 'cancelling everything else within range'.[137] In so far as the surviving murals can be judged from their current condition, *Swing Landscape* would have dominated them too, both colouristically and compositionally. Greene's painting – which was intended to be 'impersonal' and executed with an air-gun – is pallid and formal by comparison.[138] If the murals of Bolotowsky, Browne and Greene were painted over (like Gorky's earlier Newark Airport murals),[139] there is no evidence that this was because some progressive political significance was read into them beyond their association with the WPA. Most commentators would have agreed with Jewell's assertion that '[a]bstract design...[is] not equipped to prod us into social consciousness, or agitate against war', well suited as it may have been formally to modern architectural environments.[140] With the defacement of Millman's work in Chicago there are certainly surer grounds. This is not to say that the style of FAP abstract murals had no political effects, but it probably stood mainly for WPA 'boondoggling' in the minds of conservative critics and little else. Having said this, there is evidence that some Williamsburg residents valued the art they received: the Tenants' Council sent a letter to Hopkins in May 1938 to protest against a proposed limitation on WPA costs that would mean the effective closing down of the Federal Art Project.[141]

EASEL PAINTINGS

While there had been earlier exhibitions of FAP work in New York, *New Horizons in American Art*, shown at the Museum of Modern Art in autumn 1936, was the first major display of the project's achievements. It was curated by Dorothy C. Miller, who had worked as research and editorial assistant to Cahill on earlier projects, and later became his second wife. The catalogue leads with murals, represented mainly by studies, cartoons, photographs and models. It was this aspect of the exhibition that received most critical attention, and pointed up clearly differences between the Federal Art Project and Section on the question of stylistic pluralism. For in addition to the relatively standard fresco forms of Britton's Bloom High School panels and Newell's *Evolution of Western Civilization*, the selection included Evergood's *Story of Richmond Hill*, Gorky's *Aviation: Evolution of Forms under Aerodynamic Limitations*, and colour studies for all the Williamsburg Housing Project murals. Far more than the Section's public showings, this demonstrated 'the complete eclipse of the old style mural in America' – that is, of generalising allegories in an academic style. Writing in *Parnassus*, Emily Genauer emphasised the predominance of American Scene – 'life and landscape outside the

135 Jolán Gross-Bettelheim, *In the Employment Office*, c. 1936, lithograph, 10⁷/₈ × 8¹/₂ in., © The Cleveland Museum of Art, Ohio Art Program, long term loan to the Cleveland Museum of Art, 4021.1942.

painter's door' – in the easel section, while the graphics showed both 'extraordinary versatility' and 'rich social content'.[142] E. M. Benson, in the *Magazine of Art*, stressed even more the latter aspect of the show:

> Here, at last, were no artists having to sit on aesthetic flagpoles to get into the public headlines, but serious craftsmen who had eaten the black bread of poverty and now, with the bulwark of the security the Government was offering them, were prepared to set down their feelings and thoughts in a direct and straightforward manner.[143]

However, to make this claim required a highly selective approach to the display. There were among the easel paintings a few grim genre scenes such as Guglielmi's *New York: Wedding in South Street* (Museum of Modern Art, New York), Vavak's watercolour *The Dispossessed* and two Expressionistic oils by the young Boston artist Jack Levine.[144] In the graphics section the 'social' element was probably stronger, with prints by

Jolán Gross-Bettelheim (fig. 135), Julius Bloch, Blanche Grambs (fig. 136), Refregier, Dorothy Rutka and Joseph Vogel.[145] Among the few sculptures there was even an impressive plaster *Homeless* (fig. 138), by Aaron Goodelman. But the catalogue and plates leave no doubt that such works were in a minority. In *Art Front*, McCausland observed the works on show appeared 'gayer and less socially critical than one might have expected in a world where an artist plies his brush and mallet at the price of possible blows from a cop's billy.' It would be a tragedy, she warned, if the work produced under the Project was to be merely ' "offical" art'. When Stuart Davis, as secretary of the AAC, wrote in to the *New York Times* to protest about adverse comments on the exhibition, it was on the grounds of the broader social and cultural benefits of the project, not because controversial works needed to be defended.[146]

New Horizons can be taken as showing what the Washington office wanted the FAP to look like, and at regional level artists may well have had more influence on exhibitions because of the close connections between supervisory personnel and project workers. In New York a Federal Art Gallery opened its first exhibition in late December 1935, at 7 East 38th Street in 'the heart of the shopping and garment manufacturing district'. A history of this 'Art Gallery for the People' emphasised that its exhibitions had 'offered a welcome respite from humdrum routine to office workers, business men and women, department store clerks, shoppers and a vast variety of garment workers from the nearby factories.' A sharp contrast is drawn between this audience and the 'roving band of gallery-habitues' (*sic*) that had dominated the gallery scene in the early 1930s:

> To many who spent their lunch hour in the Federal Art Gallery, the velvet lined splendor and sense of sanctity in some of the other galleries had been too forbidding; others had been unable to get past the chilling eye of attendants in those hushed high places, while still others had never been able to find time to look at paintings, sculpture or prints, or indeed to consider art in terms of their everyday experiences.

The role of the gallery was thus conceived as an educational one, and its exhibitions would 'offer taxpayers their best opportunity to see and discuss the results of the Federal art program.[147] Whether the gallery's audience was affected by its move to 225 West 57th Street in summer 1937 is not disclosed.

Between December 1935 and June 1939 New York's Federal Art Gallery put on forty exhibitions, many of which were showings of the work of the Art Teaching

Division (in fact the largest component of the FAP) and the Index of American Design. While these activities were not directly political, they were quite extensively reported in the *Daily Worker*, and so too was the Community Art Center in Harlem.[148] As this illustrates, consistent with their own efforts at workers' education, Communists embraced the principle of cultural democracy in the projects as well as the opportunities for producing agitational or politically symbolic work. However, it is on the latter I shall concentrate here, and specifically on the three annual shows of the Easel Division from 1937 to 1939 and on some of the graphics exhibitions.

The broader ambitions of the FAP are evident from the catalogue foreword to the 1937 exhibition, which argued that '[i]n the past the easel painter sat in his atelier and painted his pictures for eternity, as there was

no immediate market', but now the project was 'putting easel paintings where they will be seen and enjoyed . . . An isolationist attitude is, therefore, no longer possible for the artist. He must paint pictures which people will want to have in their schools, hospitals, courthouses, etc., and which they also will be able to enjoy.' Quite what this meant is not clear, since, as the foreword claimed, the fifty-seven exhibits represented 'the conflicting trends toward realism, surrealism, [and] abstractionism'.[149] No works are titled as abstractions, although some were shown in the 1938 and 1939 shows. The exhibitors included the veteran modernists Ben Benn and Joseph Stella, together with a large number of hitherto unknown artists. Eight of them had shown with the John Reed Club, but it is not evident that their work had a distinctively political character for the most part, and they probably merged in with the

136 Blanche Grambs, *Dock Scene, East River*, c. 1936, lithograph, 15⅞ × 22⅞ in., Collection of the Newark Museum, Newark, N.J., lent by the WPA, 1945.

138 *(above)* Aaron Goodelman, *Homeless*, plaster, whereabouts unknown.

137 *(left)* Abraham Harriton, *WPA Workers*, c. 1936, whereabouts unknown. This is characteristic of the genre works Harriton produced under WPA auspices.

139 O. Louis Guglielmi, *Sisters of Charity*, c. 1937, whereabouts unknown.

140 Irene Rice Pereira, *Composition*, c. 1938, oil, whereabouts unknown.

general run of sombre urban landscapes and genre scenes (fig. 137).[150] Guglielmi's *Sisters of Charity* (fig. 139) is an exception, however, in representing the Catholic church in a highly unfavourable light. Not only are the sisters juxtaposed with an image of a pig, as John Baker has pointed out, but the woman scrubbing her stoop, whose naked legs appear above her stocking tops, is inadvertently pointing her backside in their direction. The young woman standing to the right seems to regard them in a distinctly unfriendly way, and the Democratic Front magazine *Direction* read the sisters as money collecting. The anti-Catholic implications of the picture were sufficiently telling for a Mrs Sylvia Donnelly to write to the *New York Telegram* to complain. In pictures such as this Guglielmi eschewed Surrealist effects, which for him had associations of social decay, instead seeking to represent the tenement neighbourhoods of the Upper East Side in which he had grown up. In his essay for *Art for the Millions*, Guglielmi describes the private gallery as obsolete, and he seems to have kept more Surrealistic works such as *Persistent Sea* (formerly collection of

Nelson A. Rockefeller) and *Mental Geography* (private collection) for exhibition at the Downtown Gallery, where he had his first solo exhibition in 1938.[151]

The Easel Project's 1938 exhibition included oils and watercolours, and was both larger (ninety-six works) and more diverse. In addition to the urban landscapes and genre scenes of artists such as Harriton, Neel and Ribak, it included several works by The Ten,[152] an abstract composition by Irene Rice Pereira (fig. 140) and Quirt's *Obeisance to Poverty* (fig. 141). It may not have been just personal prediliction that caused Kainen to remark on the 'heavy representation by the moderns', who 'simply are doing the best work on the art projects'. Yet as he went on to explain, he put a 'wide interpretation on the term "modern"', meaning by it 'anything that presents a fresh viewpoint in the making of pictures, – something that is contemporary in tradition and feeling, not merely experimentation for its own sake.' Guglielmi's *Relief Blues* (fig. 142) was listed as one of 'the first rate things' on show and attracted the attention of several reviewers. The painting might seem to speak

141 (*right*) Walter Quirt, *Obeisance to Poverty*, c. 1938, oil on canvas, 24 × 32 in., San Francisco Museum of Modern Art, WPA Federal Arts Project Allocation to San Francisco Museum of Art.

143 (*facing page top*) Jules Halfant, *Dead End*, c. 1938, oil on canvas, 35 × 24 in., Smithsonian American Art Museum, Washington, D.C., Transfer from General Services Administration.

144 (*facing page bottom*) Abram Tromka, *Mining Village*, 1937, oil on canvas, whereabouts unknown.

142 (*below*) O. Louis Guglielmi, *Relief Blues*, c. 1938, tempera on fibreboard, 24 × 29¼ in., Smithsonian American Art Museum, Washington, D.C., Transfer from Museum of Modern Art.

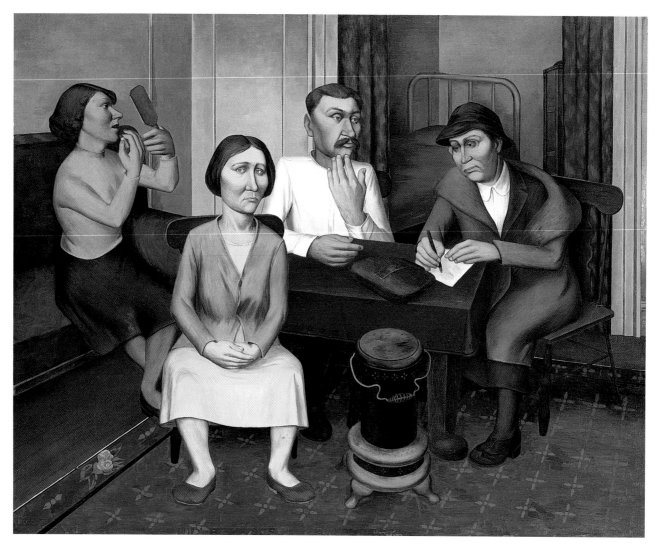

to Guglielmi's own experiences as a WPA worker and to that of the popular audience the gallery hoped to reach, for this is an image of a visit by a social worker who wears a pince-nez like a snooper's badge of office, and sits in her outdoor coat and hat itemising the family's paltry resources. The kerosene stove suggests an unheated building, and the carpet is torn through the flower leaf. This is an apartment in which the sleeping area of the young woman to the left is separated from the living room by only a curtain. Indeed, the picture seems partly a comment on generational differences, in the marked contrast between the daughter making up to go out and the stolid desexualised pose of her mother, whose red slippers somehow contribute to the sense of pathos. It is the parents here who seem to feel the humiliation of relief. The painting's intense colours and slightly precipitous spatial effect contribute to its claustrophobic feel.[153]

Otherwise, the works Kainen singled out for praise were mainly oils in an Expressionist vein by Milton Avery, Jules Halfant (fig. 143), Henry Kallem, Kopman, Rothko, Solman, Tromka (fig. 144) and Tschacbasov. This valorisation matches in some degree his affiliation with the so-called New York Group, eight young FAP artists among whom were Halfant, Kruckman, Neel, Louis Nisonoff, Herman Rose, Max Schnitzler and Joseph Vogel. The group showed together at the ACA Gallery at the end of the month, and were reportedly 'united by their identity with "the laboring people whose values are honest and who will last forever."'[154] We might see the works of Halfant and Tromka as seeking to do this not just through their industrial subject matter but also through their forthright style, which stood as an alternative both to the painterly grace of the proletarian naturalists and to the recherché formal effects of the abstractionists. In relation to the prominence of expressionistic art at the Federal Art Gallery, it may be relevant that the head of the exhibition division in New York was the critic and sometime art dealer Robert Ulrich Godsoe, who had helped to launch The Ten in 1935 and was committed to 'the modern expressive tradition'. At the 1938 exhibition he displayed a group of abstractions 'set into the wall so that the surface continuity is unbroken and the ornamental character of the paintings enhanced.'[155]

The 1939 showing of the easel division seems to have been similar in composition, with Social Surrealism represented by Guglielmi and Guy, and a sprinkling of Expressionists among the seventy-six works on show. The association between the gallery and the left was reinforced by a catalogue statement by Weber and a foreword signed by Evergood and his two assistants Murray Hantman and George Picken, both of whom had signed the 1936 Call for the Artists' Congress. The foreword claimed that the artists represented did not 'speak to the public' only as individuals but also 'as a working member of the community to fellow members of that community.' Indeed, the artist was liberated in that she or he was no longer working to please individual tastes: by 'working to please hundreds of thousands of people, the narrowness of individual prejudice is avoided or swept aside', and the artist's own outlook was broadened.[156]

The claims of the FAP to have liberated artists by giving them a collective public are almost impossible to assess, but at the least the numbers who visited the Federal Art Gallery do not seem very large. According to the Weekly Progress Reports from the New York Regional Office, 2,200 persons attended the 1938 Easel

and Watercolour exhibition, and 1,882 that of 1939. In 1938 1,793 attended the Sculpture Division show.[157] Further, there is no sociological breakdown of who these visitors were. However, the exhibitions at the Federal Art Gallery were by no means all of the Exhibition Division's activities, and in the summer and autumn of 1939, for instance, it scheduled eighteen displays of project work at 'labor unions and federal, state and municipal bureaus dealing with problems of the laboring class.'[158] Moreover, the claims of accountability were not entirely hot air, in that artists were answerable to some kind of audience through the process of allocation (however mediated this was), and the Division did respond to requests for specific subjects.[159]

While many of the paintings shown at the Federal Art Gallery are now lost, a general impression of them can be formed from those that do survive, from photographs in the WPA records and contemporary press reports. Altogether, this evidence suggests a predictable continuum between the FAP exhibitions and those of collective organisations of the period. Many artists of the left showed urban landscapes and genre in both. Within the iconographic framework provided by such motifs, artists sought to endow their work with greater critical force through adopting Expressionist and Surrealist devices. What was left out – at administration insistence – was anything overtly party political. Given the commitment of Communists to the larger cultural vision of the FAP and their substitution of a kind of progressive Americanism for revolutionary politics under the Democratic Front, this may not have seemed much of a sacrifice.

GRAPHICS

When Jacob Kainen reviewed an exhibition of prints and watercolours at the Federal Art Gallery, which had succeeded one of oils in February 1936, he claimed that the graphics were the most interesting.[160] And indeed, relations between formal and technical experimentation and social illustration were, arguably, resolved in more consistently effective ways within the print media.

The FAP Graphics Division in New York opened its first workshop in the WPA building at 6 East 39th Street in the same month, under the supervision of Gustave von Groschwitz. Of the five main FAP Graphic Workshops, that in New York was the largest, and probably the most important. Around 225 artists worked there at one time or another.

The Communist Russell Limbach was appointed as the Division's technical advisor, and many of those on its

payroll were leftists active in the Artists' Union, including Will Barnet, Stuart Davis, Harry Gottlieb, Kainen, Chet La More, Lozowick, Olds and Raphael Soyer. Although Kainen, in his retrospective essay on the Division, emphasised that there was no pressure on artists to work in a particular way, the production process certainly had mechanisms of control built in. Artists made an initial drawing for each print, which had to be approved by a supervisor, and first proofs were submitted to a supervisory committee before an edition could be printed. However, since the leftists involved seem to have embraced the Fine Art print ethos of the Graphics Division, this may not have proved too cramping, politically speaking.[161]

One would expect that demands for a 'people's art' could be addressed more convincingly in relation to the inherently multiple processes of printmaking than in relation to painting. Indeed, there was a more collective aspect to labour under the Graphics Division in that although image making was largely done in the artist's studio, printing was done in a workshop environment, and artists learned both from the printers and through lectures on technique. But for all the rhetoric about mass production that surrounded the Division's work, WPA prints remained primarily an individual product directed at a collective audience, with all the customary signs of individuality inscribed in their form. They did not become a collective product for a collective audience, but were still conceived as 'multiple originals', as Rockwell Kent reportedly described them.[162]

A good record of attitudes among left-wing printmakers exists in essays collected for the WPA FAP anthology *Art for the Millions*. The relationship between art and 'the people' is addressed particularly vividly in the essay 'Prints for Mass Production' by Elizabeth Olds (1896–1991), one of that remarkable generation of independent-minded women artists and writers who came to maturity in the 1920s and gravitated to the left. (Josephine Herbst, Agnes Smedley and Alice Neel also exemplify the type.) Born in Minneapolis, Olds studied at the Minneapolis Art Institute and Art Students League before travelling to Europe, where she stayed four years and received the first Guggenheim Fellowship awarded a woman for painting. Like so many others, Olds was radicalised by the Sacco and Vanzetti case. She was a signatory of the 1935 Call for the American Artists' Congress, and was also on the Board of the American Artists School and an active member of the Artists' Union.[163]

Consistent with her involvement with the Public Use of Art Committee, Olds called for the conception of

graphics suitable for printing with power presses. But this was a complex issue because it had to be achieved 'without loss of their basic significance or intent.' However, production was in itself only part of the problem. The other was the audience, in that most Americans were 'culturally illiterate', persons to whom 'the language of art is a closed book'. For Olds, the FAP provided the first mechanisms through which 'cultural literacy' might be extended, fulfilling a comparable function to the school system with regard to verbal literacy. In addition to the exhibition of prints in schools, libraries, hospitals and airports, she suggested they might be lent in the same way books were through libraries and housing projects. Graphic artists in turn had to address themselves to contemporary life, perhaps producing collective histories of technology and labour in print series accompanied by explanatory texts. In effect, the agitational conception of Communist prints of the Third Period was now reconceptualised as part of a state sponsored programme of cultural and social education. In her essay for the same volume, Mabel Dwight (1876–1955), a long-term socialist who specialised in satirical lithographs, advised that 'all the satirical work that has lived was fine art', and criticised 'Some of the young, class-conscious artists' for being 'too arrogantly vehement in their portrayals of vulgarity, ugliness, injustice, etc.' Dwight's view may partly reflect a generational divide, but it also chimes with the culture of the FAP.[164]

Above all else, it was the lithograph that embodied the WPA conception of the print to begin with, although the woodcut and later the silkscreen were seen as having comparable qualities. Correspondingly, etching lost its 'artificial prestige'.[165] By January 1938, Kainen was claiming in the *Daily Worker* that the Graphics Division had brought about a 'veritable renaissance' in American lithography.[166] Particularly significant, both for contemporaries and later commentators, were the Division's achievements in colour lithography, an aspect of the process that Limbach played a key role in developing. Ironically, while for him the Division's main achievement lay in making possible a clear distinction between lithography as a 'fine art' and its various commercial applications, his own prints are too banal as images to be of much interest for the most part.[167] However, other artists who worked for the division produced extraordinarily inventive prints across a range of media.

The two leftists whose work epitomised an experimental approach to technique combined with an essentially realist conception of motif were Olds and Gottlieb. From 1931 to 1935 Olds was living in the Midwest,

145 Elizabeth Olds, *Sheep-Skinners*, from the *Stockyard* Series, 1934, lithograph, 8⅝ × 12 in., Smithsonian American Art Museum, Washington, D.C., Transfer from Smithsonian Institution, Archives of American Art.

146 Elizabeth Olds, *Miner Joe*, c. 1938, lithograph, 17¾ × 13⁹⁄₁₆ in., Smithsonian American Art Museum, Washington, D.C., Transfer from D.C. Public Library.

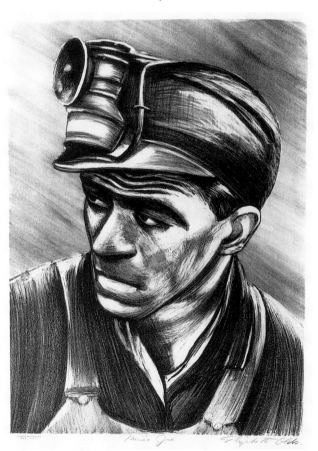

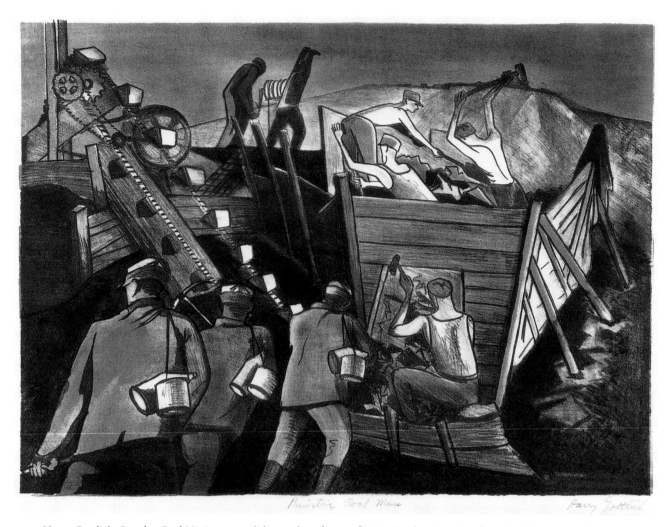

147 Harry Gottlieb, *Bootleg Coal Mining*, 1937, lithograph, 12$^{1}/_{16}$ × 16$^{9}/_{16}$ in., Smithsonian American Art Museum, Washington, D.C., Transfer from D.C. Public Library.

and under PWAP she produced a number of lithographs representing aspects of unemployment relief in Nebraska. After the project was phased out, she made 'hundreds of drawings' from a platform looking down on the 'killing floor' of Swift and Co.'s Southside Plant in Omaha, drawings that were the basis of an extraordinary series of ten prints of the stockyards.[168] One of these, *Sheep-Skinners* (fig. 145), was selected by the Weyhe Gallery in 1935 for showing in its exhibition *Fifty Best Prints of the Year*. The same documentary conception underlay a trip to the bootleg coal mines of north-eastern Pennsylvania in 1936, and a two-week sketching campaign to the Carnegie-Illinois steel works at Homestead in the following year – both excursions made in company with Gottlieb.[169] Twenty of Olds's drawings formed the basis of her solo exhibition at the ACA Gallery in 1937. Reviewing this, McCausland hailed the selection for its synoptic picture not only of technological processes but also of social relations, at

the same time as she read the artist's choice of motif and way of working as marking a new era in which women artists would not need to be restricted to feminine themes as Cassatt and Morisot had been.[170] Olds's views of steel works and the steel-making process are powerful illustrations, but as 'social art' her most compelling prints are her single figures of workers such as *I Make Steel* and *Miner Joe* (fig. 146). The effectiveness of the latter especially lies in the way that with characteristic economy of means Olds suggests both the immiseration of labour and intellectual energy: the averted look, focussed eyes and prominent ear signifying attention to a speaker, who in the context could only be inferred as a CIO organiser.

Gottlieb (1895–1992), who was born in Roumania and emigrated to the United States in 1907, like Olds studied at the Art Institute of Minneapolis and was one of that group of young radicals that also included Adolf Dehn and Wanda Gág. After serving in the navy in the

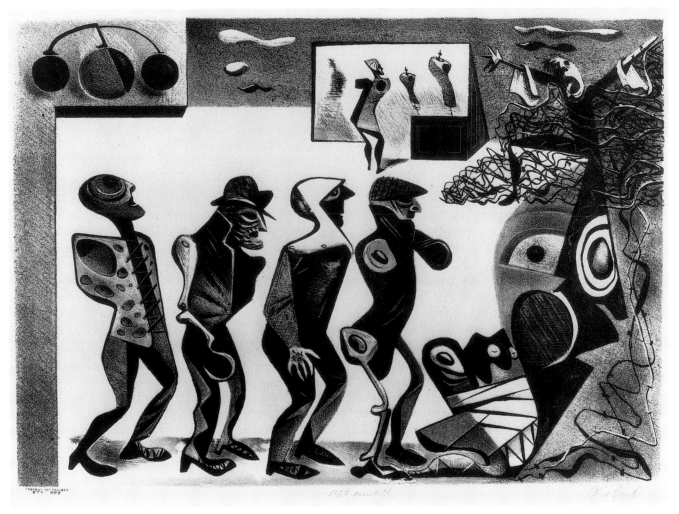

148 Phil Bard, *Aftermath*, 1938, lithograph, 11³/₄ × 16³/₄ in., Smithsonian American Art Museum, Washington, D.C., Transfer from D.C. Public Library.

First World War, he moved to New York and became involved with the Provincetown Playhouse, one of the focal institutions of Greenwich Village life. From 1923 to 1935 he lived in the bohemian artist's colony at Woodstock, New York. Radicalised by the Depression, Gottlieb helped set up the Woodstock Artists' Union, before returning to the city in 1935, where he became union president in 1936 and a tireless activist thereafter. Indeed, Gottlieb had become a staunch Communist and remained a stalwart of Party-sponsored organisations until his death.

Primarily a landscape painter, by the time Gottlieb had his first exhibition at the Whitney Studio Galleries in 1929 he had already settled on the kind of painterly naturalism that he practised throughout his career. A trip to Europe on a Guggenheim Fellowship in 1932 did not alter his essentially negative view of 'abstract . . . surrealist and non-objective' art. By 1940 he was arguing that 'social realism' was the appropriate art for 'working people', because it correlated with the outlook of those who have 'working knowledge of the structure of things and respect them'. Formalism was for the 'middle and upper classes.'[171]

It seems to have been Gottlieb's political convictions that made him turn to figure subjects and the graphic media in the later 1930s. Although he made his first lithographs in Paris in 1932, the FAP Graphics Division certainly gave a new direction to his printmaking, and a number of lithographs of bootleg mining made on the project were included in his 1937 exhibition at the ACA Gallery (fig. 147).[172] Despite his rather banal conception of realism, in the print media he like Olds adopted a simplified graphic style that would have been unthinkable but for the modern tradition. In both cases, this undoubtedly suggests an engagement with the example of Orozco, whose lithographs had made a considerable impact in the United States. Both artists experimented with colour lithography under the project's auspices,

but the appeal of that medium was supplanted for them by their involvement with the silkscreen process.

In fact, the Graphic Art Division not only provided a milieu that fostered technical experimentation but also, and correspondingly perhaps, was one in which many artists of the left adopted modernist stylistic devices. Thus Phil Bard, whom we encountered as a young Proletarian artist in Chapter Three, produced the extraordinary *Aftermath* (fig. 148), a kind of Surrealist development on Neue Sachlichkeit imagery of mutilated war veterans. At least, two other artists of great technical accomplishment worked in a similar stylistic and iconographic vein on the New York project, Boris Gorelick and Joseph Vogel. Gorelick's lithographs addressed themes such as sweated labour, child poverty, industrial accident and the bombing of civilian populations, all in the same idiom.[173] Joseph Vogel, who had been a regular exhibitor with the John Reed Club, made lithographs in which Picassoid proletarians move against lowering urban backgrounds, as well as a number of images that intimate war and were probably *Guernica*-influenced (fig. 149). The work of Bard and Vogel especially shows an absolute command of Cubist drawing techniques. As with Olds and Gottlieb, the ideal of a people's art did not exclude artistic ambition, in whatever stylistic mode it was formulated.

By around 1940, however, silkscreen had superseded lithography as a symbol for the democratisation of the arts, and in that year McCausland hailed it as: 'the popular graphic art of the twentieth century'.[174] An

149 Joseph Vogel, *Lament*, c. 1938, lithograph, 12 × 15⅜ in., Detroit Institute of Arts, Gift of the Works Progress Administration, Federal Art Project.

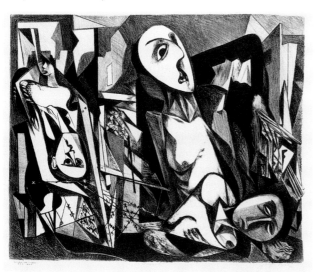

experimental silkscreen unit was set up in the New York Graphic Division in November 1938 at the instigation of the Artists' Union and Public Use of Art Committee. It was directed by Anthony Velonis, who had learned the process in his brother's sign-printing shop and hitherto worked for the Poster Division. Velonis was apparently the first to see the possibilities for turning this commercial medium into the basis for multiple fine art prints, which would be much easier and cheaper to produce than lithographs because they did not involve heavy stones or a press. Moreover silkscreen prints permitted extraordinary varieties of colour and texture, and each print could be individually various. Initially six artists worked in the unit, namely Ruth Chaney, Gottlieb, Morley, Lozowick, Olds and Warsager. In a text of 1940, Olds claimed the silkscreen as a distinctively American and democratic invention: 'Silk screen color prints fill an important need for the American people. Since Currier and Ives, there has been no comparable development of multiple original works of art in color.' However, the mass production of such prints 'for the home, office or public institution' needed 'a new exhibition and distribution program' to reach an appropriately large audience. For this reason, she and others formed the Silk Screen group in 1939, which organised numerous exhibitions over the next few years.[175]

The silkscreen print really came into prominence in 1940 with a trio of exhibitions on view concurrently at the ACA and Weyhe Galleries and the Springfeld Museum. The ACA exhibition was a one-man show of Gottlieb's prints, while that at Springfield was organised by Elizabeth McCausland working with Edward Landon and the Springfield Artists' Union.[176] Yet against inflated claims for the historical importance of silkscreen as the basis for a people's art, Velonis himself warned that the 'medium will not of itself bring about the "democracy of art" and should not be saddled with too heavy a burden at its inception.'[177] In the event, as soon as the FAP folded artists were confronted by the stark economic realities of printmaking. As Gottlieb later recalled:

> The bubble burst when we approached distributors in this field and found that the artist could not exist as an independent artist and craftsman. All they would offer us was workman's wages with the result that we were thrown back upon the limited editions concept regardless of the possibility of the medium.[178]

Of course artists were paid less than some 'workman's wages' on WPA, but it was perhaps one thing to accept this as a state employee in the 1930s, and another to accept it from a commercial print gallery in the postwar period.

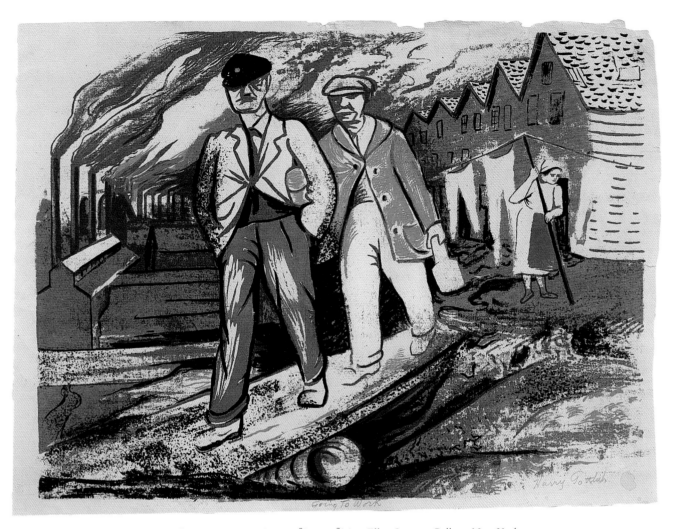

150 Harry Gottlieb, *Going to Work*, 1938, screen print, 14 ⁷/₈ × 19 ⁷/₈ in., Ellen Sragow Gallery, New York.

The 1940 exhibitions also revealed predictable divisions among the silkscreen artists as to what the formal possibilities of the medium actually were. The flat planes of colour it facilitated demanded a different approach to the kinds of image making in which Gottlieb and Olds specialised from that employed in their lithographs. Olds's silkscreens tend to be conceived as pictures, being rather muddy in colour and making no or little use of the white of the paper. Neither were the motifs she addressed in the medium politically significant in the way those she used for lithographs arguably were. In the screenprint she tended to stick to the comic. By contrast, it was not inappropriate that McCausland should single Gottlieb out for his 'substantial contribution to the fine arts use of silk screen', for not only were his prints more formally effective than Olds's, he also managed to adapt the medium more successfully to the kind of documen-

tation of proletarian life and struggle that he pursued in other media. In prints such as *Mine Disaster*, *Going to Work* (fig. 150) and *Rock Drillers* his summary drawing devices and use of texture acknowledge the nature of surface and technique at the same time as they serve as effective graphic notations for the narrative element. Neither was he inhibited by the non-naturalistic approach to colour the medium seemed to encourage. Other left-wing artists in the unit evidently felt that the characteristics of silkscreen lent themselves to a yet more flattened and modernist approach to form. For instance, at Springfield, Eugene Morley showed a suggestive but near abstract composition titled *Execution* (fig. 151). However, the relationship between form and political imperative hardly seems to be as satisfactorily resolved here as it is in some of Gottlieb's better prints.

151 Eugene Morley, *Execution*, screen print, whereabouts unknown. The signature is reversed in the photograph and probably on the original too.

It seems appropriate to end this chapter with the graphic art of WPA because both the art and the discourse around it illustrate so vividly the contradictions in the Communist ideal of popular art as these were played out in the FAP. Put simply, the category of fine art – in any of the forms current in the 1930s – was not demotic. Traditional craft skills and modernist innovations alike, almost any of the aesthetic qualities that artists valued had little meaning to proletarian audiences who were saturated in the more heady visual fare of films, illustrated magazines and billboards. As was widely recognised, even the most naturalistic imagery could not compete with these. Prints could indeed be produced cheaply in large quantities, but this did not solve the basic problem, to which the only solution was to educate the working class to make the kinds of aesthetic discrimination artists themselves cared about – to educate it to new criteria of value. Given that for Communists the proletariat was capable of a special kind of knowledge but needed to have its consciousness raised through Party activity before it would fully comprehend its own truth, this position was not as inconsistent as it might superficially seem. In the early 1930s revolutionary artists had believed that a great proletarian public would emerge almost spontaneously. The people's artists were more realistic about the outlook of their audience: the people needed to be inculcated with new values for their art to work. But they depended on there being a workable agency to conduct that process of inculcation. With the demise of the WPA, they lost the only agency in sight. No wonder many of them looked back on it with such an acute sense of loss. At a personal level, they were also thrown back on the market, no longer collective workers but individual artisans all in competition with one another.

Part III: From the Grand Alliance to Oblivion

8 Cultural Organising after 1939: The Artists League of America, Artists Equity and Other Initiatives

While its leadership never achieved an effective understanding of the New Deal, political and social developments of the late 1930s permitted the CPUSA to have an influence out of all proportion to the size of its actual following in both the trade union movement and in mainstream politics in some states. It also played a powerful role in shaping the culture of the period, although in ways that were sometimes indirect or covert. After the dog days of the Nazi–Soviet Pact, when the party had been once again marginalised and hounded, came the war in which it made its ultimate effort to merge with the mainstream of American politics by dissolving as a separate political party. But with the end of hostilities and the mounting antagonism between the former allies, the reformed Party's days were inevitably numbered.[1] This was not just the internal consequences of international events, but also an effect of the long-term conservative backlash against the New Deal. Despite the impressive strength and militancy demonstrated in the 1945–6 strike wave, organised labour proved incapable of holding its own against the corporate drive to reassert business supremacy and the conservative turn of the Democratic administration under Truman. Indeed, the CIO had essentially been on the defensive since the late 1930s, and the initiatives seized by the corporations in the war effort meant that they were able to dominate the conversion process. In this hostile environment, union leaderships became increasingly conservative and even less willing than before to tolerate Communist influence.[2] Further, the effectiveness of anti-Communist rhetoric had been demonstrated by Republican politicians and some right-wing Democrats in successive election campaigns before the onset of the Cold War. The CPUSA was no more capable of taking an independent or critical line in relation to the Soviet Union than any other of the world Communist parties at this stage, that of Yugoslavia excepted. In the face of mounting harassment and criminal proceedings, the Party's leaders could only appeal to constitutional freedoms that they had shown themselves quite willing to deny to others.[3] As federal, state and congressional bodies, together with various private groups, collaborated or competed with one another to eradicate domestic Communism, the space for the kind of manoeuvrings characteristic of the New Deal period was rapidly reduced. In this chapter I look at the various institutional initiatives through which artists loyal to the Party tried to rebuild the base for social art in the 1940s, and at the factors that defeated them.

A full account of all the organisations in which left-wing artists were active in this period would be wearying to the reader and require more space than is available to me. In what follows I sketch only the most significant of these initiatives. However, it is important to register that such artists were involved across a range of political and cultural organisations in a way we can hardly imagine today. Thus, by early 1939 artists had formed a committee within the American Labor Party (ALP) to put on fund-raising exhibitions, and the party in turn committed itself to defending artists' interests. Although it was dominated by CIO leaders and emphatically pro-labour, the ALP did not offer a socialist platform and basically worked to strengthen the Democratic vote in New York State. Socialists could join the ALP only as individuals, and Communists were formally excluded. Having said this, many Communists were active in the party and played a significant part in making it effective, and many familiar fellow-travellers and possible CP members figure among the artists and art critics who participated in ALP exhibitions and events.[4] The artists' commitment to the ALP seems to have been relatively long-term, but there were also more temporary organisations. Thus a grouping of prominent social liberals and Popular Fronters which came together in 1946 to aid workers' families in the great postwar strike wave had an artists' division which included fifty figures, nearly all of whom had been involved in the collective organisations of the previous

decade.[5] A somewhat different but overlapping list appears on the letterhead of the Art Committee of the National Council of American–Soviet Friendship.[6] Small benefit exhibitions for worthy causes were one of the main ways in which artists demonstrated their progressive commitments, but in this chapter I focus primarily on the organisations they formed and worked within that were more directly related to their interests as artists.

The Artists League of America

The American Artists' Congress did not evaporate with the public resignations that accompanied the Soviet invasion of Finland. Indeed, working in conjunction with the League of American Writers it managed to put on a Congress at the Hotel Commodore in New York in June 1941, which was accompanied by an exhibition of works by 101 artists, among whom were Evergood, Gropper, Lozowick, Reinhardt, Solman, Moses and Raphael Soyer, David Smith and Paul Strand. Ironically, a matter of days before Germany invaded the USSR, Lynd Ward asserted that the AAC remained 'steadfast in its devotion to peace for this country' as the best safeguard against fascism – a position that was very shortly reversed.[7] The Artists' Union (UAA) was also a sponsor of the 1941 Congress. However, with the winding down of the Federal Arts Projects, the union had lost most of its *raison d'être*: its membership was reduced and scattered, most of them were no longer in 'employment', and there was no basis for organising artists in private industry. As a result, in May 1942 the UAA disaffiliated from the United Office and Professional Workers of America-CIO, amid some acrimony.[8] By this time the UAA and American Artists' Congress were probably both reduced to a rump of CP members and fellow-travellers. Their membership was once again galvanised by US entry into the war, and a joint membership meeting was called for 7 May 1942, organised by Norman Barr, Harry Gottlieb, Joseph Le Boit and Lynd Ward, from which emerged the Artists League of America (ALA) as a fusion of the two.[9] Rockwell Kent, who had been president of the UAA, was elected president of the new body, although because of his residence in upper New York state and the variety of his other commitments, his role was essentially a formal one.

Those who were active in running the organisation varied over the course of its existence, but among the most prominent at one time or another seem to have been Barr, Gottlieb, Evergood, Daniel Koerner, Charles Keller, McCausland and Ward. Among the other familiar names who appear as functionaries or 'Members at Large' on its letterheads were Becker, Gross, Gwathmey, Hirsch, Lozowick, Olds, Refregier, Reinhardt, Solman and Moses Soyer. Some of these were veterans of the socialist and Communist movements such as Becker and Lozowick, but much of the energy seems to have come from younger artists like Barr, Koerner and Keller who had been drawn into the CP milieu during the Democratic Front. Altogether, the names that appear on letterheads and committee lists suggest that while the increasingly tarnished image of the USSR alienated well-known figures who had worked with the American Artists' Congress, a substantial number of established artists were still prepared to commit themselves to a body the avowed aim of which was to 'help build a vital people's art.'[10] Within the ALA there were also four smaller bodies: the Victory Workshop, to contribute to the war effort; the Silk Screen Group; Artist Associates, 'An Agency for the Promotion and Sale of Members' Work', which had a cooperative gallery at 138 West 15th Street; and the Young Artists' Group, a progressive art school and successor to the AAC's Young American Artists of the late 1930s.

A membership flier describes the aims of the League as follows:

> The ALA seeks to bring more art to more people through the widest possible extension of both private and governmental sponsorship of art. It believes in the dynamic cultural influence of art as a force for democracy. It encourages the fuller use of art in all spheres of life, and works for that measure of economic security for the artist that will permit the growth of a democratic people's art in America.[11]

Although this was the language of the Democratic Front, that alliance of progressive liberals, fellow-travellers and Communists could not be simply reconstituted after the debacle of the Nazi–Soviet Pact period. Indeed, in the aftermath of the war any association with Communists became an increasing liability to those liberals who wished to work with the post-Roosevelt Democratic Party. In 1944 Lynd Ward rejected a proposal that the ALA take a column in *New Masses* on the grounds that it would make impossible a 'wide growth in membership', but such caution perhaps reflected the needs of wartime anti-fascism, and in 1946 an ALA contingent marched on the New York May Day parade.[12] League members also made signs for trade union pickets and stood on picket lines themselves. As a body it actively sought to promote progressive legislation such

as the setting up of the Fair Employment Practices Commission and was involved in the Committee to Abolish the Un-American Committee. It also openly advocated peaceful co-existence with the USSR. Unsurprisingly, the ALA followed the CP line in 1946 in abandoning the Democrats and backing the American Labor Party in the Congressional elections in New York State, and in 1948 it endorsed Wallace. Thus the political complexion of the League was hardly a mystery.

In addition to its political allegiances, the openness of the ALA's membership (it had no membership prerequisites) probably discouraged some prominent artists from joining. It had no prestige to offer them, and they did not need its exhibitions or other services. Neither was it a truly national body in the way the American Artists' Congress had been.[13] Rockwell Kent characterised it in March 1945 as a 'movement of the "discontented masses" in art', and already sensed that as an organisation lacking any real political clout, it would eventually wither away.[14] However, while this may have been a realistic view of the ALA's prospects, it also reflected an unduly negative estimate of the calibre of some of the members and the extent of their activities. Kent's criteria of quality were very narrow and for him the bulk of the membership were too preoccupied with art exhibitions, and insufficiently concerned with doing graphic work for the labour movement and political organisations – in his view the true locus of a people's art.[15] However, although there was some communication between it and the Moscow League of Artists, no more than the American Artists' Congress did the ALA stand for a particular aesthetic line.

The League was run in the same way as its predecessors, limping along on the basis of members' dues ($4 per year) and fund-raising raffles and social events. In its early years it seems to have encountered difficulties because some members were away on active service, and also because its aims partially overlapped with those of the more ecumenical Artists for Victory organisation – a loose federation of professional artists' societies, many of them of longstanding.[16] The fact that the League was able to put out a professional-looking 'Armed Forces' issue of its magazine, ALA News, in March or April 1945 indicates that the executive was having some success, but it was hard to justify high dues for a body that did not really function as a trade union, and the ALA seems to have had problems generating enough income to run itself. In a letter of January 1947, the executive secretary Norman Barr informed Kent that the ALA had been on the verge of collapse in May 1946, but that a concerted effort to build up membership and collect

dues had put it back on a healthy footing. At that point, Barr estimated a paid-up membership of 276, with quite a substantial number who had been members but were behind with their dues. In 1946 the ALA managed to put out at least three numbers of ALA News, but this was more a news-sheet than a magazine and by 1948 the organisation was reduced to providing a mimeographed newsletter.[17] Although such well-known artists as Milton Avery, Evergood, Reinhardt, Sloan and Moses Soyer all participated in a fund-raising scheme for the ALA in that year, this could not save the League from dissolution in 1949. That there were further reasons for its demise will be shown later.

At its inception in 1943 the ALA had its own gallery at 13 Astor Place, but perhaps the space at 77 Fifth Avenue where it moved in early 1945 was all taken up by the ALA School, for there does not seem to have been one there until 1947, when classes were discontinued and the space remodelled as a gallery and clubroom. In 1948, the gallery put on five shows, none of which seems to have been a success, for only one painting was sold and the average number of visitors was between 150 and 200.[18] The ALA's main group exhibitions seem to have been very mixed displays. The first of these was held at the prestigious Wildenstein Gallery in March 1943 under the title 'This Is Our War', and featured such prominent artists as David Burliuk, Cikovsky, Evergood, Gropper, Kent, Léger, Lozowick, Marsh, Olds, Ribak and Moses and Raphael Soyer, with less established figures such as Hirsch and Keller. Wildenstein declined to show a second exhibition entitled The Bill Of Rights – A Document of Today, giving as his reason the misbehaviour of some persons at the crowded opening of the first, and the fact that he had received 'much criticism' for putting on a show of 'that character' at all.[19] A Second Annual Exhibition, held at the Peikin Galleries in April–May 1944, was a small display of only sixty-five works, from which most of the bigger names who had participated in 'This Is Our War' were absent.[20] I have been unable to locate a catalogue of the 1945 exhibition,[21] but that of 1946 was a much larger affair, held at the Riverside Museum on Riverside Drive. It included works by 132 artists, although a high proportion of them were unknowns and some of the most talented ALA members did not take part. In a review in the Daily Worker, Marion Summers took the exhibition as symptomatic of the way many leading progressive artists ignored the ALA: 'Many of them, and this includes many of the Left, are keeping their skirts clean. Is it that they are afraid it won't be good for business? Are they afraid that the company is not toney enough?' He blamed this

lack of solidarity on the boom in the art market, and complained that too many artists 'are concerned now only with maintaining the production of their particular commodity.'[22] Summers's explanation seems plausible enough and, as Rockwell Kent observed, the ALA was more important as a focus for the commitments and professional ambitions of lesser-known artists than as a forum for established talents to display their political allegiances.[23]

The Victory Workshop and the Graphic Workshop

One offshoot of the ALA that merits particular attention is the Victory Workshop, since more than any other aspect of the League's activities, it was this that implemented the policy of using members' talents to direct political effect. The workshop was set up in 1942 and had an impressive list of sponsors, including Francis Brennan, chief of the graphics division of the Office of War Information; Dr Alvin Johnson, director of the New School for Social Research in New York; and Howard Willard, president of the American Advertising Guild. Its executive secretary and leading organisational light was Charles Keller, a young artist (b. 1914) who had studied with Harry Sternberg and Will Barnet, and joined the Communist Party in 1940. The Victory Workshop initially had a studio at 47 East 12th Street, but was forced to move in the summer of 1943, eventually taking space at 182 Third Avenue. The single most important event in the Workshop's history was the exhibition *Art, A Weapon of Total War*, put on under its auspices at the New School for Social Research in March–April 1943. This was prepared for by a conference in January attended by 150–200 artists, and addressed by Francis Brennan and Barney Conal, the war service director of the CIO, among others. A series of six workshop evenings followed, each devoted to different fine or commercial art skills. The aim of the exhibition (and of the Victory Workshop generally) was to add a progressive political voice to the torrent of educational and propaganda material being put out by the federal government and many other voluntary, labour and business organisations. Suggestions for topics and media included the following: murals and panels for factory rest-rooms, cafeterias, union halls and workers' housing; prints for individual sales, exhibition and silkscreen murals; sculpture for floats, puppets and window and lobby displays; and various visual aids. In the event, trade unions, the Office of War Information

and other organisations sent in materials for the show, and it was accompanied by a conference of trade union educational directors.[24]

The 1943 exhibition may have gained the Victory Workshop useful contacts, but it was essentially a left-wing alternative to Artists for Victory, and could not compete with that body in terms of prestige and connections. In 1943, propaganda work for the labour movement – where the ambitions of the Workshop particularly lay – was partly taken over by the CIO Political Action Committee, which had its own art department. The Victory Workshop was still going in 1945,[25] but as the war drew to a close its *raison d'être* necessarily altered. Initially it metamorphosed into the Dreiser Workshop (combining for a while with writers and dramatists), before emerging as the Graphic Workshop under the direction of Jay Landau. In Charles Keller's words, this new grouping represented 'the eternal hope of a few die-hard artists to develop a workshop in NY along the lines of the *Taller [de] Grafica Popular* of Mexico.'[26] The Graphic Workshop operated from a space on East 14th Street where various printmaking facilities were available. The 'workshop' title signified both a cooperative model of artistic production and also the idea of art with a purpose. According to Keller, it was a group of artists motivated by 'social and political conscience', who wanted to develop an art for '*trade union audiences*' rather than those of '57th St.' To this end two types of work were envisaged: 'service work' and 'creative original projects which we prepare ourselves & attempt to market; folios of wood-cuts, calendars, books, etc.'[27] The first involved working with the arts and sciences division of Progressive Citizens of America, and producing posters and leaflets for the Wallace campaign. The main fruits of the second type of activity were two folios of print reproductions: *Yes, the People!* and *Negro USA*.[28] The former comprised reproductions of ten prints by seven artists, and appeared at the end of 1948. The series was stylistically diverse, ranging from the straightforward naturalism of Helen Maris's *Children* (which had no discernible 'social' theme) through the Orozcoesque forms of Charles White's two contributions, to Expressionistic woodcuts by Phyllis Skolnick, Irving Amen and Antonio Frasconi.[29] Kent's response crystallises some of the contradictions involved in trying to produce a popular art within the framework of the artist's print. When Keller told him about the print series in a letter of October 1947, Kent had warned in his reply that it could not 'serve two markets', and that if it was 'finally acceptable by labor it will not be found acceptable on 57th. Street.'

unable to rival.[30] The problem was that the Graphic Workshop artists were not prepared simply to repress their formal and expressive interests for the sake of straightforward communication as Kent advised. They expected their audience to make some effort to learn about art – in this respect their attitude echoes that of the WPA printmakers. However, the Workshop had only a brief time to build this audience, for in 1951 it was disbanded due to FBI harassment.[31]

The Arts, Sciences and Professions

One of the long-term problems of the ALA was that its aims overlapped with those of two other bodies, the Independent Citizens' Committee of the Arts, Sciences and Professions (ICCASP) and the Artists Equity Association (AEA). The first of these began life in 1944 as the Independent Voters Committee of the Arts and Sciences for Roosevelt (IVCASR), which was committed to securing the president's fourth term on the principle that his leadership was necessary to secure both victory and a progressive peace settlement. It was allied with the National Citizens' Political Action Committee (NCPAC), which had been initiated by the CIO's Political Action Committee, the brainchild of Sidney Hillman. The role of Communists in the organising work of the CIO-PAC was common knowledge and a highly controversial issue in the 1944 presidential election campaign, when it was frequently labelled a front by Roosevelt's opponents.[32] Communists probably played an even more important role in the ICCASP (which succeeded IVCASR in January 1945), although claims that it was set up by the Party should be treated with caution.[33] From its officers and the list of 'initiating sponsors' ICCASP appeared to be an organisation dominated by entertainers and Hollywood celebrities, and its ability to get the glitterati to endorse liberal political stances was the object of much pointed comment. Its chairman was the international portrait sculptor Jo Davidson and its treasurer the actor Frederic March. Other famous personalities who associated themselves with it included James Cagney, Eddie Cantor, Aaron Copland, Duke Ellington, Oscar Hammerstein, Walter Huston, Gene Kelly, Canada Lee, Edward G. Robinson, Frank Sinatra and Orson Welles. Albert Einstein and Thomas Mann also lent their names.[34]

Of course, this is not to say that Communists and fellow-travellers did not play an important role in ICCASP, but to see the organisation as only a front or its members as dupes of Party manipulation is to miss the

153 Antonio Frasconi, *Farmer with Hayloader*, 1948, from Workshop of Graphic Art, *Yes, the People!*, reproduction of woodcut. © Antonio Frasconi/Licensed by VAGA, New York, N.Y.

The result was, in his view, 'off the beam', and he was 'very critical of the manner and content of some of the prints', singling out especially Frasconi's *Farmer with Hayloader* (fig. 153). There is more at issue here than simply the conservatism of Kent's taste, for, as he observed in a letter of 1946, there was already a successful 'people's art' in the work of artists such as Norman Rockwell that 'socially conscious artists' were

nature of the 'social liberalism' of the 1930s and 1940s. That is, it seems more convincing to accept that there was a coherent liberal ideology in that period from within which it was possible to see the Soviet Union as embodying certain shared progressive values whatever the deformities of its political system. For liberals of this persuasion, both the increasingly aggressive foreign policy stance of the Truman administration and its domestic policies were alike a betrayal of the New Deal legacy, and to some they appeared incipiently fascistic.[35]

The motivating impulse behind the formation of IVCASR seems to have come from Davidson, who with twelve others sent out a letter to sympathetic artists, writers, musicians, actors and professionals in July 1944. According to IVCASR's published report, this attracted more than 1,500 members in less than six weeks, who put together an impressive programme of electioneering activities.[36] Davidson might be taken as the very type of the 'social liberal'. He had been to the USSR in 1924 when he made portrait busts of Soviet leaders, and he was an ardent supporter of the Spanish Republic, visiting the battle front in 1938. That he had socialist leanings and was sympathetic towards the USSR and the postwar 'People's Democracies' is obvious. However, there is also no doubt of Davidson's political independence and he was affronted when former friends cooled towards him after he visited Yugoslavia in 1949 and took the Yugoslav side against the Soviet Union.[37] When questioned about the role of Communists in ICCASP by *Time* magazine in 1946, Davidson and the organisation's national executive director, Hannah Dorner, replied that this had been greatly exaggerated and that 'Communists have no more to do with its course than fleas do with a dog's.' Privately, Davidson acknowledged that Communists might be 'an important factor in our thinking', but he bitterly resented the suggestion either that they were a liability or that they should be formally excluded, seeing the latter suggestion as a betrayal of liberal commitment to civil liberties.[38]

Roosevelt secured re-election in 1944 by the smallest margin of any of his four terms, and the campaign against him was marked by ominous red-baiting. It is thus no surprise that in the aftermath of the election a circular announcing the transformation of IVCASR into ICCASP should observe that: 'The immediate future presents a challenge that is as great if not greater than that presented by the election.' The new organisation was conceived as a permanent body with a paid professional staff, which would campaign for the extension of democracy, world-wide peace through the agency of the United Nations, and employment and 'a decent living

standard for all'. To achieve these ends it would issue publications, organise meetings and forums, produce radio programmes and take part in political campaigns. The main method was to be that of the 'Caravan' – meetings arranged with the cooperation of local organizations, for which ICCASP would provide a dramatic unit, a political speaker and assistance with publicity. Members were organised into sub-committees concerned with theatre, radio, literature, film, art, science and technology, music, education, medicine and journalism. In early 1946, ICCASP claimed a membership of 10,000 and by September of that year this had risen to 18,500. While it had chapters in a number of cities, predictably that in New York was the largest and fastest growing.[39]

ALA members participated in ICCASP from the beginning, and the executive board of the art division was packed with leftists, many of whom were also in the League.[40] Rockwell Kent had all along favoured the idea of 'a small group of artists of reputation' who would constitute themselves as a 'committee of action', and ICCASP's art division was far closer to this than the ALA. However, ICCASP was an organisation of liberals, whose leading figures were at best prepared to tolerate Communists as allies. While Kent recommended that ALA members should enter it in numbers, he also advised that they should 'avoid all efforts at control or to any action that might alienate the more conservative, but very important, people who now run it' (*sic*). Even by March 1945, one of Kent's correspondents reported that there was much talk of 'duplicity of purpose' between the two organisations, and this was certainly a view he shared. In 1948 he acknowledged as much in a letter to the ALA secretary, Daniel Koerner, and in the following year he resigned from the presidency. By this time the League was effectively defunct.[41]

The activities of the ICCASP art division included the production of a pamphlet explaining how artists could copyright their work, the drawing up of a draft bill with the music and theatre divisions to establish a Federal Bureau of Fine Arts, and work with CIO unions. The division also organised visual propaganda for the 1946 Congressional election campaign, in which ICCASP's campaign was to mobilise votes for progressive candidates as a counterweight to a Democratic administration that had now 'made a clean break with the traditions of the New Deal' and taken a position on labour and foreign policy 'indistinguishable from that of the Republican Party'.[42]

As things worked out, the hopes that Rockwell Kent (and many others) invested in ICCASP were misplaced,

for the kind of Democratic Front strategy the organisation represented became unworkable in the climate of the postwar period. The end of the war left both the NCPAC and ICCASP without any compelling slogan on which to base mass appeal, and the spirit of wartime anti-fascism, on which they had relied so much in the past, could not be galvanised against the unsavoury regimes of Spain or Argentina. Soviet policies in Poland and elsewhere in Eastern Europe offended significant sectors of the American electorate, and also conflicted with the Truman administration's determination to establish US hegemony. Thus by the time of the founding meeting of the United Nations in San Francisco in May 1945, ICCASP already found itself at odds with key aspects of administration policy.[43]

Further, the liberal camp itself was increasingly divided. In spring 1946, the CIO-PAC, NCPAC and ICCASP issued a call for a Conference of Progressives, which was held in Chicago in September. On this occasion, despite the stock Democratic Front character of many of the planks (which included a Federal Fine Arts Bill),[44] anti-Communist statements by Harold Ickes and the CIO president Philip Murray revealed just how tenuous the wartime alliances had become. The Union for Democratic Action (founded in 1941), which had always refused to work with Communists, did not participate in the Chicago conference and sought to discredit the occasion by showing that it was Communist-infiltrated. The disastrous showing of the Democratic Party in the mid-term elections of 1946 (despite some significant gains in the South) contributed to the backlash against cooperation with Communists, since many liberals blamed Democratic defeats on Communist suppport for the party. Shortly after, Harold Ickes and several other prominent figures resigned from the ICCASP because of perceived Communist domination of the organisation. At the end of 1946, the NCPAC and ICCASP merged to form Progressive Citizens of America (PCA), and a week later the Union for Democratic Action reformed as Americans for Democratic Action, which rejected any association with Communists. The split in liberal ranks had become a chasm.[45]

Having initially embraced Truman in 1945, ICCASP had increasingly found itself at odds with both his aggressive anti-Soviet foreign policy and his hostility to labour and accommodation of Southern racism at home, so that the reactionary forces against which the PCA directed its energies were increasingly forces within the United States itself, and especially within the Democratic Party. The PCA opposed the Truman Doctrine and the Marshall Plan, and from the outset identified itself

with Henry Wallace, whom Truman had fired as Secretary of State for Commerce in September 1946 because of disagreements over administration policy towards the USSR. Throughout 1947, Wallace spoke out against the military build-up and the imperialist policies of the administration, which he described as incipiently fascistic. His appeals for international cooperation together with his calls for a planned economy made him seem a credible focus for a third-party movement. On 16 December, the PCA executive formally endorsed the setting up of a New Party, and on the 29th Wallace announced he would run as its presidential candidate. However, whatever its criticisms of the administration, the leadership of the CIO was not prepared to back a third party, and in 1947–8 it was increasingly won over to Truman by the Marshall Plan and the president's veto of the Taft-Hartley Bill – despite the fact that this was utterly ineffectual. The new party was opposed by many prominent liberals, and Wallace's stance towards the USSR, together with the CP's endorsement of his campaign, enabled the CIO leadership and Truman Democrats to paint it as Communist-dominated. Although the Progressive Party attracted the support of prominent intellectuals such as Albert Einstein, Thomas Mann and Frank Lloyd Wright, Wallace suffered a crushing defeat in the presidential elections of November 1948, attracting little more than a million votes.[46]

With the formation of the PCA, the art division of the ICCASP transferred to the new body under the chairmanship of Robert Gwathmey.[47] In 1947 its most important activity seems to have been to protest against the scrapping of an international touring exhibition of works purchased by the State Department, *Advancing American Art*, as a result of Republicans in the House Appropriations Sub-Committee labelling the art it contained Communistic – a tactic that was part of a larger campaign to smear the Truman administration.[48] The art division called a protest meeting at the Capitol Hotel in New York in May 1947, which led to an artists' petition being sent to Truman and Secretary of State Marshall, and to a five-person artists' delegation visiting the State Department. A 5c pamphlet, *The State Department and Art*, was subsequently published, which quoted from the Sub-Committee hearings and the Congressional Record to identify who was actually behind the cancellation, and illustrate their reactionary attitudes in other matters too. The pamphlet described the episode as 'one of the clearest cases of fascist-like censorship upon an entire level of American culture', and linked it with earlier attacks on the New Deal art programmes.[49] In October, the whole question of cultural freedom and civil rights

was the theme of a national conference of the arts, sciences and professions of the PCA held at New York's Hotel Commodore. This included a panel on art chaired by John D. Morse, with J. LeRoy Davidson (the former State Department employee who had co-organized the *Advancing American Art* show), Lincoln Kirstein, Oliver Larkin and Jacob Lawrence as speakers.[50]

In mid-1948, as Progressive Citizens of America merged with what was still called the New Party, its arts, sciences and professions divisions again assumed independent identity as the National Council of the Arts, Sciences and Professions (NCASP). (Arts, Sciences and Professions had always been conceived as an independent pressure group rather than the appendage of a political party, and the membership was divided over the third-party campaign and the Wallace candidacy.) The NCASP launched its own monthly magazine, *Uncensored*, which as the title suggests was particularly concerned with the increasingly repressive atmosphere generated by the activities of the House Committee on Un-American Activities, the Justice Department and FBI, and the administration's Loyalty Oath Programme.[51] It also recorded the intimidation and violence directed against Progressive Party spokespersons and supporters. The honorary chairman of the NCASP was Jo Davidson, and the chairman Harlow Shapley. Vice-chairmen included familiar names from the left such as Max Weber, Lillian Hellman, John Howard Lawson and Paul Robeson; while 'Members-at-Large' grouped Evergood, Howard Fast, Langston Hughes and Albert Maltz with W. E. B. Du Bois, Albert Einstein and Thomas Mann. The key issue for the artists of the NCASP in the Progressive Party campaign was the insertion of a 'Cultural Plank' into the platform of the party at its convention in Philadelphia in July 1948, which was believed to cover the setting up of a Department of Fine Arts on a permanent basis to realise the promise of the WPA arts projects and initiate a national cultural programme.[52]

Sponsors of the Cultural Plank of the NCASP included not only the familiar roster of artists with longstanding Communist connections but also less expected figures such as Paul Cadmus, Katherine Dreier and Baroness Hillar Rebay, who had had no such affiliations. Many of the same names appeared in the committee of 'Artists for Wallace', a body launched in June 1948 with Max Weber as chairman and Robert Gwathmey as acting secretary.[53] What all this serves to illustrate is that in 1948 plenty of those who had been members of the Communist Party or who had cooperated with it to varying degrees of intensity in the 1930s and the war period could be counted on to rally to the political organisation

that seemed to represent the best hopes for a revival of New Deal politics. In the list of sponsors for the NCASP cultural programme there appeared, among others, Avery, Ben-Zion, Blume, Cikovsky, Dehn, Evergood, Gottlieb, Greenwood, Gross, Gwathmey, Hirsch, Kent, Levine, Millman, Olds, Pereira, Reinhardt, Reisman, Refregier, Siporin, the Soyer brothers, Strand, Ward, Weber and Zorach. For them, at least, the spirit of the Democratic Front lived on.[54]

The Waldorf Conference

The defeat of the Progressive Party campaign in 1948 did not bring to an end the NCASP. Its last major act was the organisation of the Cultural and Scientific Conference for World Peace, held in New York on 25–7 March 1949. The Waldorf Conference, as it became known, took place in the improbable venue of the Waldorf Astoria Hotel, and achieved a mythical status for Wallaceite progressives and anti-Stalinist liberals alike. For the former the refusal of the State Department to grant visas to some of the invited guests and the demonstrations outside the Conference confirmed the climate of intolerance that had been whipped up against progressive forces.[55] For the latter, the Conference itself showed the effectiveness of the international Communist propaganda machine. One of the key charges made against the Conference was that it was in essence a re-run of the Communist-sponsored World Conference of Intellectuals for Peace held at Wroclaw (formerly Breslau) in Poland in August 1948, at which the denunciations of Western culture by the Soviet novelist A. A. Fadeyev had outraged representatives from the bourgeois democracies.[56] In fact, the NCASP seems to have been planning a peace conference since May 1948 but, having said that, Jo Davidson was a US delegate at Wroclaw and was subsequently elected to the International Secretariat of the Congrès Mondial des Intellectuels pour la Paix.[57] The 'Prologue' to the published proceedings, *Speaking of Peace*, was written by an anonymous New York journalist, who claimed that while there were 'a half dozen outspoken Communists' among the conference's backers, the 'majority were clearly no sort of revolutionaries, but merely New Deal liberals or progressives'. This was only partly true, in that among the 532 film and theatre people, artists, writers, scientists and academics who sponsored the conference there were at least fifty who had regularly associated with the Communist Party in varying ways.[58] However, it is also clear that this group was numerically

overwhelmed by liberals and progressives with famous names, such as Aaron Copland, Albert Einstein, Erwin Panofsky and William Wyler.

It has been suggested that the aim of the organisers was 'to have famous people get together and praise Russia', but this was not the spirit of Wallaceite liberalism and is not born out by the proceedings.[59] Of the plenary speakers, several emphasised that the responsibility for international tensions lay on both sides, and both Shapley and Frederick Schuman (professor of political science at Williams College) referred to the restrictions on personal freedom in the Eastern *bloc*. One plenary speaker, the magazine editor Norman Cousins, even delivered a direct attack on the Conference and its organisers.[60] However, while anti-Stalinists such as Mary McCarthy and Dwight Macdonald were given opportunities to speak from the floor, the platform speakers were almost uniformly progressive liberals, Communists or fellow-travellers.[61] Thus the criticisms of American culture voiced by seasoned leftists such as John Howard Lawson, Clifford Odets and Philip Evergood were hardly balanced by Aaron Copland's argument that the unfriendly policies of the State Department towards Soviet musicians could not be redressed by Soviet attacks on Western culture and a closing of doors to Western influence, and set-piece statements on the virtues of Soviet culture by Fadeyev, Shostakovich and the film-maker Sergei Gerasimov were not really opened to discussion. Although the national executive committee of the NCASP told themselves that the Waldorf Conference had been a great success, it further contributed to the organisation's reputation as a Communist front and saddled it with crippling debts.[62]

Artists Equity Association

The new Democratic administration of 1949, while nominally committed to the principles of the New Deal, stood for a 'get tough' policy with the USSR abroad and anti-Communism at home. In the late 1940s, relations with the Soviet Union further deteriorated as a result of the Communist seizure of power in Czechoslovakia in early 1948, and the increasing success of the Chinese Communists against the Kuomintang, culminating in their final victory in 1949. The next year brought the Korean War. It was in this atmosphere that the so-called Foley Square trials of eleven members of the Party's national board under the Smith Act took place. This was only the most prominent of a wave of prosecutions and witch-hunts, in which labour and liberals, for the most part, cooperated. The Party responded to this concerted persecution and to its political ineffectiveness by engaging in its own internal witch-hunts, by a kind of 'turning inward'. Fear of FBI plants within the Party was so great that any who were inactive or showed signs of dissent were purged. Only those who had demonstrated unfailing loyalty to the leadership were deemed reliable – a principle that tended to reduce the majority of members once again to the foreign-born.[63] In 1951, the leadership, convinced that war was inevitable and the Party would shortly be declared illegal, ordered selected cadres to go underground. In these circumstances, the CP could no longer serve as the focus for a broad cultural movement in the way that it once had. The problems that the worsening climate created for the Party's artist activists can be registered through the early history of the Artists Equity Association (AEA).

Artists Equity was formally established in 1947 and was conceived as a purely professional organisation to assist artists in their relations with dealers and museums, taking Actors Equity as its model. Some of those involved in its creation were also members of the ALA, but the executive of that body was not entirely approving of what they conceived to be a new apolitical organisation, the economic functions of which overlapped with their own. By 1948, AEA had 1,300 members, and the following year it had 1,500 spread over thirty-eight states.[64] With Yasuo Kuniyoshi as its president and such respectable figures as John Taylor Arms, William Zorach, William Hayter and Eugene Speicher among its vice-presidents, it was able to attract precisely the kind of established artists the ALA could not. Something of the image AEA sought to project may be deduced from the fact that the first membership meeting in 1947 was held at the Museum of Modern Art, and was addressed by René d'Harnoncourt, Juliana Force and Francis Taylor among others. However, the composition of its leading officers and the prohibition on activities of a 'partisan aesthetic or political character'[65] does not tell the whole story. While the list of fifty-three founding members of the organisation included prominent artists such as Guy Pène du Bois, Henry McFee, Charles Sheeler and Franklin Watkins who had never associated with the left, around half had been signatories of the call for the American Artists' Congress in 1935 or had otherwise distinguished themselves as leftists. Moreover, while by no means an overwhelming presence, CP members and fellow-travellers such as Gottlieb, Hirsch, Siporin and Sternberg were to figure prominently in its executive committees. This is probably another instance of the Party being able to exert influence in non-Communist

organisations because of the willingness of those associated with it to undertake the mundane committee work which that with less firm commitments generally avoided.

Just how significant their influence was is difficult to evaluate, partly because so many artists were probably still attached to one or other of the competing forms of liberalism at this stage, but the political stances AEA took were certainly left of centre. At the first regular membership meeting in April 1947 resolutions were passed condemning the cancellation of the *Advancing American Art* exhibition, and calling for the setting up of state and federal art projects. In the following year, the honorary president Leon Kroll read a resolution to the annual meeting condemning the tactics of the House Committee on Un-American Activities as 'a threat to freedom of expression for workers in all the arts', and supporting the Stop the Censorship Committee. At the 1950 meeting, Jack Levine (a director) tabled a resolution calling for AEA publicly to oppose the infamous Mundt Bill, which became the basis of the McCarran Internal Security Act, although after much discussion the issue was referred to the directors.[66] None of these resolutions represented positions that Roosevelt liberals would have found difficult to endorse, but by the late 1940s liberals were increasingly being painted as Communist sympathisers by the Congressional right and their allies. On 25 March 1949, Representative George Dondero (R. Michigan) denounced AEA at length before the House, claiming that of its officers, directors and governors, sixty-nine had 'left-wing connections' and that most of its members were 'soldiers of the revolution – in smocks'(!). Dondero could indeed show that some of those he cited, such as Evergood, Gropper, Gwathmey and Weber, had longstanding links with Communistsponsored organisations and publications. However, some of his accusations about Communist influence in the art press were ludicrous, and he did not distinguish between membership in Popular Front bodies such as the American Artists' Congress (to which many liberals belonged) and genuine Communist commitments. One of the main 'subversive' organisations in which progressive liberals played a prominent role was the NCASF. As Dondero pointed out, leading AEA figures such as Jo Davidson, Leon Kroll, Paul Manship and Hudson Walker were all members. But the NCASF was only 'subversive' because it was on the attorney general's List of Subversive Organizations, against which there was no appeal.[67]

In the aftermath of Dondero's attack, Hudson Walker visited him in Washington in an attempt to explain that

AEA was concerned only with artists' 'economic problems', but met with a hostile reception: 'Mr Dondero replied that he was interested in doing away with any organization if it has even a few Communists.'[68] However, Dondero's attacks did not destroy AEA, and indeed in the early 1950s its New York chapter seemed to be going from strength to strength. In the early summer of 1951, it put on an exhibition of 550 works at the Whitney Museum and thereby raised $52,000 for a building fund.[69] A mortgage was taken out on a property at 13 East 67th Street, which was to become 'the first major [A]merican art center bought, created and manned solely by artists'. Exhibitions, forums, lectures and workshops were all planned.[70] Yet despite fundraising successes, tensions within the chapter led the national board to cancel the 1951 elections and suspend the chapter from further activities until new ones had been held. One issue of contention seems to have been practical problems in running the 67th Street building, another that the programme that those who had worked for it envisaged was in advance of what some of the membership wanted. The final straw was ardent canvasing for a particular slate in the 1953 elections. A statement put out by the national board of directors in June reveals that the chapter had become divided between the administration and a vocal 'opposition' which claimed the organisation was being run autocratically. About forty members resigned; there were legal threats and also some political name-calling.[71] Certainly, a number of Communist artists were active in the New York chapter, but whether the divisions between 'administration' and 'opposition' were on straightforward political lines is not clear. It is likely that members of the opposition objected to the Resolution against the Mundt Bill mentioned earlier, and also to the involvement of AEA with UNESCO, which was regarded by the Congressional Right as a 'subversive plot'. Also divisive was an open letter from the New York chapter to the Museum of Modern Art protesting about the museum's running of the competition for a monument to 'The Unknown Political Prisoner', which had occasioned a considerable furore. The board of directors disapproved of the tone of the letter, and also felt it had infringed on the prerogatives of the national organisation.[72]

In 1954 the AEA national organisation took over the New York chapter and its building, and New York members did not regain their status as an autonomous chapter until 1956.[73] The repercussions of all this are indicated by notes for a talk by Harry Gottlieb, probably from the mid-1950s, in which he observes that AEA had ceased to be a 'coalition' organisation and was now

'right led', with the result that progressives within it were subject to red-baiting. The new situation obliged Communist artists to 'work with anyone who agrees with us on a minimum program', and he urged them to do the 'normal things artists do' so that they should not appear to set themselves apart.[74] In effect, Communists were marginalised in the AEA in the same way as they were in the American trade union movement over the years 1948–50.[75]

The Defence of the Rincon Post Office Murals

Artists Equity did play a prominent role in the episode that perhaps more than any other came to symbolise the art world's resistance to McCarthyism, namely the campaign to defend Anton Refregier's murals in the Rincon Annex Post Office in San Francisco. But it did so only as one body within a much larger alliance that involved many liberals and prominent art-world professionals.

Refregier (1905–79) had won the $26,000 commission for the Rincon murals in 1941 in one of the largest of the Section's national competitions. Originally the scheme comprised twenty-seven panels (later increased to twenty-nine), to be painted in casein tempera. The war delayed realisation of the project, which was eventually executed over the years 1946–8. I mentioned earlier Refregier as a tireless activist in collective organisations of the 1930s, who had done extensive illustrational work for *New Masses*, union magazines and agitational pamphlets. But at the same time he was a cosmopolitan and successful artist. Russian-born, Refregier emigrated to the United States in 1920 and trained at the Rhode Island School of Design and later at Hans Hofmann's school in Munich. From the late 1920s he made a career as a set designer and decorative painter, working with modern architects and designers such as Henry Dreyfuss, Norman Bel Geddes and Percival Goodman, in this last role producing murals for hotels, liners, restaurants and private residences.[76] Under the New Deal, he had received commissions from both the WPA and Treasury Section.

In 1942 Refregier visited San Francisco to assess the building and do preliminary research. At the Society of California Pioneers, 'a group of ancient ladies' informed him that they regarded his work as an unjustifiable expenditure of taxpayers' money, and subsequently wrote to the Republican Senator Thomas Dewey to complain. It was a foretaste of what was to come. However, the controversy the murals eventually pro-

duced was very much a symptom of the Cold War climate, rather than just an effect of their intrinsic radicalism. Indeed, Refregier knew there were limits to what he could 'get away with' and acknowledged, for instance, that he could not properly represent the 'terrible exploitation' of Native Americans.[77] None the less, his whole conception was very much in the spirit of Democratic Front Americanism, and in the context of the later 1940s and early 1950s the conservative forces that might have attacked such a scheme in the previous decade were vastly more powerful.

Informed by what appears to have been a thorough grounding in Communist theory, together with a reading of the *WPA Guide to California*,[78] Refregier's *History of California* is a record of struggle and conflict, with labour omnipresent. Around the post office walls, anonymous workers build railroads, reconstruct the city after the Great Fire, raise the Golden Gate Bridge and labour in the wartime shipyards. But the city's population is also represented as divided over such issues as the Civil War, the immigration of Chinese labour and the Mooney-Billings case. When the murals were completed in 1948, *Masses & Mainstream* hailed them as 'a living record of the struggles of California's pioneers of yesterday and today': 'The frontier is the leitmotiv of the paintings; a frontier which shifts almost imperceptibly from man's struggles with a vast and encompassing nature to his pioneering battles within a social order which thwarts him more seriously than any natural limits.'[79]

From a conservative perspective, however, the murals' emphasis on conflict was inappropriate, even 'treasonous': they made '[e]arly Californians' look 'a goonish lot, spending much time beating Chinese and Mexicans'.[80] As Aline Louchheim noted in 1953, critics of the murals found them 'subversive' on two counts, either because of their 'general point of view' or because of 'specific details' – although often the two must have blended together.[81] Certainly, plenty of objections were raised about 'specific details' during the course of painting. The American Legion, Mexican Embassy, San Francisco Chamber of Commerce, Veterans of Foreign Wars and various other bodies all registered complaints with the Public Buildings Administration (amplified in the Hearst press), to which the artist was forced to respond by making numerous departures from his original conception. For instance, the relevant placards carried by workers in a panel showing *The Celebration of the Inauguration of the 8 Hour Day* were removed and it was ambiguously retitled *Torchlight Procession* (fig. 154). The Veterans of Foreign Wars forced

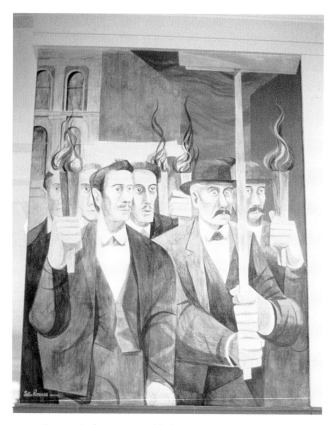

154 Anton Refregier, *Torchlight Procession*, 1946–8, casein tempera, Rincon Center, San Francisco.

the painting out of a veteran's cap from a section of the panel representing the 1934 Waterfront Strike, in which the Veterans' annual memorial to two of the strike's martyrs is depicted (fig. 155). Most symptomatic of all were criticisms levelled at the last three panels, *War and Peace* (fig. 156), from which a portrait of Roosevelt was excised. Not surprisingly, the inclusion of the hammer and sickle motif in flanking panels representing the wartime alliance against fascism and the first meeting of the United Nations prompted much hostile comment.[82]

From a Communist perspective, one of the most gratifying features of the struggle around the Rincon Annex murals in 1947–8 must have been the support Refregier received from organised labour via a specially constituted Artists and Labor Committee, support that focussed around the *Waterfront – 1934* panel. The National Union of Marine Cooks and Stewards, National Maritime Union and International Longshoremen's and Warehousemen's Union all protested over the threat of censorship, and Refregier addressed a meeting of 20,000 ILWU members under the auspices of Harry Bridges. In May, the San Francisco CIO Council organ-

ised a picket around the Post Office to defend the murals.[83] However, with its emphasis on the veteran status of the strike martyrs and its inclusion of the stars and stripes, *Waterfront – 1934* was entirely conceived within the limiting framework of the Democratic Front.[84] The fact that it was this feature that incensed the panel's critics rather than any overtly revolutionary message indicates how very much Communist politics was embroiled with defence of the New Deal legacy. Indeed, in 1948 the ILWU won a protracted strike with the shipowners precisely because of its ability to use the mechanisms established by the 1935 Wagner Act. Of course, the ILWU was Communist-controlled, and in 1950 it was expelled from the CIO.

With the final completion of the murals, however, Refregier's travails were far from over. In a 1949 letter to a postal worker at the Rincon Annex, who had written asking if anything could be done to remove the 'communist art' from the building, Congressman Richard Nixon observed that while it would be 'next to impossible to obtain the removal of such art' while Truman remained in office, under a different administration a Congressional committee might be set up to investigate the issue.[85] With the election of the Eisenhower administration in 1952, a new phase in the controversy over the Rincon murals began.

By November 1951, the General Services Administration of the Bureau of Public Buildings was reportedly considering whether or not to remove Refregier's panels,[86] and it was at this point that AEA mobilised a campaign in their support – despite the lukewarm attitude of some in its San Francisco chapter. The campaign was orchestrated by the national office and its executive director Hudson Walker, and numerous letters of support were collected from museum officials and collectors throughout the nation.[87] The most important figure in the drive to expunge the murals was Hubert B. Scudder, Republican Representative from a rural area north of San Francisco. It was Scudder who introduced the resolution against them before the Public Works Subcommittee of the House of Representatives on 1 May 1953, with backing from Representative Donald L. Jackson, another California Republican. Scudder reported the complaints of numerous local groups and Jackson read a seven-page typescript detailing Refregier's affiliations with subversive groups on the basis of evidence presented to the House Committee on Un-American Activities. The murals, Scudder claimed, distorted the history of the state and were 'Communist propaganda', which 'tended to promote racial hatred and class war'. Opposing, figures from the American

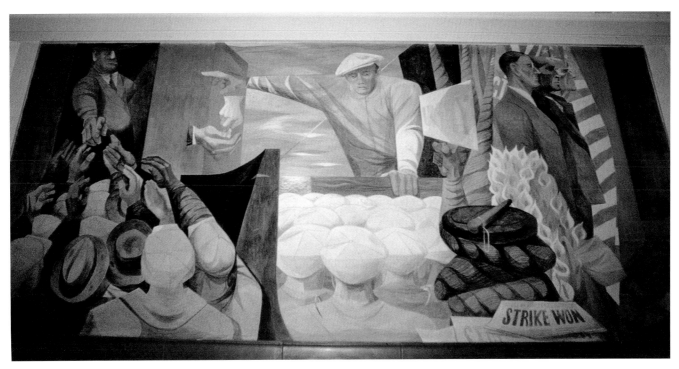

155 Anton Refregier, *Maritime and General Strike*, 1946–8, casein tempera, Rincon Center, San Francisco.

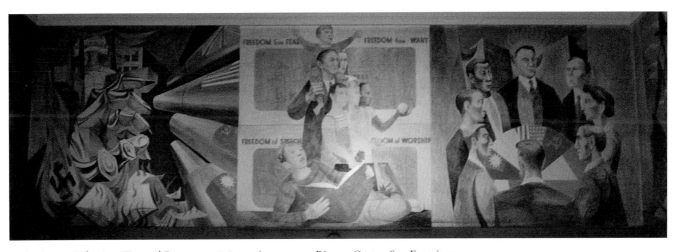

156 Anton Refregier, *War and Peace*, 1946–8, casein tempera, Rincon Center, San Francisco.

Section of the International Association of Art Critics protested against the threat to the murals, among them being Alfred Frankfurter and Thomas B. Hess of *Art News*, Robert Goldwater, Meyer Schapiro and James Johnson Sweeney. However, they were explicit that they did not defend either 'the style or the subject matter of the work', they opposed removal of the murals solely on the grounds of 'respect for art.' More important, probably, was the support of a group of San Francisco's 'leading names in finance, industry, and the arts', who in

spring 1953 formed the Citizens' Committee to Protect the Rincon Annex Murals, under the chairmanship of Ferdinand Smith, resident partner of Merrill, Lynch, Pierce, Fenner, and Beane. The Committee sent Thomas Carr Howe, director of the California Palace of the Legion of Honor, and Chauncey McKeever, 'a conservative San Francisco attorney', to represent them before the Subcommittee. Perhaps emboldened by the attitude of such socially respectable elements, two California Representatives, the pro-labour Democrat John Shelley,

and William S. Mailliard, a middle-of-the-road Republican, also warmly defended the murals against Scudder and Jackson.[88]

Refregier's murals survived the campaign against them, even though 1953 was perhaps the highpoint of McCarthyism. But they did so not because of actions mounted by the left or organised labour.[89] They survived because liberal Democrats and some moderate Republicans could see that their destruction 'would put us in the same position as Russia or Hitler's Germany' in relation to art, as Breyton Wilbur, president of the San Francisco Museum of Art and of Wilbur-Ellis Co., observed at a press conference of the Citizens' Committee. Thus their most important champions did not defend them even in relation to the heritage of the New Deal but in contemporary Cold War terms. Similarly, the grounds of Artists Equity's defence were both that the allegations were unjustified and that, generically, 'monumental works of art are important expressions of our living culture, and must not be subject to this type of attack.'[90]

And what of the murals themselves? In 1942 the respected critic Emily Genauer had praised Refregier's panels for the post office at Plainfield, New Jersey, because, unlike the work of many committed artists, they combined 'social consciousness' with 'taste and a flair for interior decoration'.[91] For all their iconographic daring (and enough of the artist's original scheme got onto the walls to justify this claim), the Rincon murals are decoratively effective but curiously vapid. While they clearly refer to the Mexican idiom, in Refregier's hands it has neither the dramatic chiaroscuro and disjunctive spatial effects of Orozco and Siqueiros, nor the individuation of the mass and sense of tumultuous energy that gives Rivera's work its power. Rather, the Rincon murals are an accomplished professional job by a capable modern painter.[92]

The ACA Gallery

As part of his campaign to defend the murals, in 1949 Refregier put on an exhibition of works related to San Francisco at the ACA Gallery.[93] Despite its move to East 57th Street in 1943, the ACA remained an important showcase for the left and a self-proclaimed 'people's art gallery'.[94] In March 1944 it launched *American Contemporary Art*, a small monthly magazine which ran until early 1946, carrying gallery news, regular criticism by Elizabeth McCausland and statements and criticism by such stalwarts as Evergood, Olds and Pereira. As we saw earlier, Baron had played a role in running *Art Front* but unlike that diverse and vital publication, *American Contemporary Art* was connected with no larger organisation and was essentially a forum for the social art faction for which ACA served as a focus. In 1945 the gallery expanded by taking over another floor of the building, and Baron certainly intended it to function as 'a vital center' where lectures would be given and from which publications would issue.[95] It continued to put on solo shows of regulars such as Evergood, Gottlieb, Gwathmey and Refregier, accompanied by catalogues with appropriately supportive statements by Baron or members of his circle. Baron's long and substantial correspondence with Evergood also suggests that he played a significant role as a confidant and sounding-board for some of his artists.[96] But inevitably ACA's position became increasingly beleaguered and marginal as the decade progressed.

In 1944, Baron was already warning against 'a trend towards individualism among artists', and in some later manuscript notes he wrote of the 1940s as the 'decade that plowed under idealism'. Art was 'devitalized' through the trend to 'non-objectivism', and although he did not deny such art the right to exist, he objected to the monopolistic status abstract art achieved in the 1950s.[97] This he blamed partly on McCarthyism, of which he had first-hand experience. On 17 May 1949, Representative Dondero, who had already described the ACA before the House as 'a definitely communistic place', devoted a whole statement to exposing the links between the gallery and other 'communistic' organisations such as the John Reed Club and American Artists' Congress. He referred to Baron repeatedly as 'Comrade Baron', and also claimed to show the 'Red record' of his associates such as Evergood, Gwathmey, Kopman and McCausland. In one particularly lurid passage he asserted: 'I believe it to be the hub, the gathering point of Marxists in art, whose subtle, nefarious un-American schemes receive their prime incitement [*sic*]. It should be shunned like a plague center of infection.' Dondero's remarks received significant coverage in the New York press, and in an interview with the *New York Sun* Baron explicitly denied his charges as 'just stupid', stating disingenuously that he did not know or care about the political affiliations of his artists. However, while he claimed to be 'interested only in artists', he refused to answer the question as to whether he had ever been a Communist Party member.[98] In July he produced a six-page statement, which asserted that to be attacked by Dondero was an honour, and accused him (correctly) of ignorance of art and anti-Semitism. Yet as Baron observed, 'one can die very heroically in a nightmare',

and it is clear that he was deeply disturbed by the climate of fear and in the 1950s articulated his feelings in an unpublished play about the Rosenberg case. None the less, the ACA remained the main showcase for 'pro-objective art' throughout the 1950s, and in 1958 it put on the first solo American exhibition of the Italian Communist Renato Guttuso. Baron died in January 1961, and although his wife Ella was committed to continuing the gallery, by the following year it appeared to Refregier to be 'sliding down hill' and he could see no way to reverse its course.[99]

Endings

The NCASP limped on into the early 1950s. It managed to retain some prominent liberals in its highest offices, including the literary scholar Robert Morss Lovett, and academics and scientists such as Erwin Panofsky, Linus Pauling, Harlow Shapley and Henry Pratt Fairchild. In 1951 it claimed to have 'functioning art galleries' in five cities and that its councils had put on 'dozens of concerts' and film programmes. That year, membership was said to have increased substantially, and three new councils were affiliated. Until at least 1953, it maintained chapters in six major cities outside New York, and claimed to have increased membership in that year too. The New York art division had a new gallery in 1951 and put on exhibitions, arranged competitions and held forums. By this time, most of those involved in the division seem to have been committed Communists or fellow-travellers, and there were close relations between it and the Graphic Workshop and Photo League.[100] Yet in a report on the New York Council circulated in March 1953, its condition was described as 'membership . . . small, base narrow, finances difficult'. The different divisions had become virtually autonomous and a large proportion of the policy-making board was inactive. By the middle of that year, several of the National Council posts were unfilled, and it was impossible to convene a quorate meeting. In 1954, no annual convention was held, and the national organisation seems to have been on the verge of collapse.[101]

All these dwindling efforts to combat McCarthyism through culture cannot disguise the increasing isolation of the Communist Party and its supporters (a phenomenon certainly compounded by FBI surveillance of left-wing artists). The renewed emphasis on Socialist Realism and the notion of art as a weapon in Communist critical discourse could only serve to reinforce this. In theoretical statements, Party spokespersons returned again and again to attack the monolithic conservatism of American popular culture, but faced with such massive obstacles to the development of a critical working-class consciousness, appeals to reorganise the Party's work in more rigorous accordance with Marxist-Leninist ideas look futile, if not self-defeating. Increasingly the Party's cultural workers were isolated within their own small clubs.[102] Yet if the Party could no longer create effective cultural organisations of its own, the belief in the value of political organising and the commitment to progressive causes was not eradicated among many of those who had associated with it. In 1961, a benefit exhibition for the Student Non-Violent Coordinating Committee (SNCC) was shown at the Society for Ethical Culture in New York. Prominent within the artists' committee for the SNCC which sponsored the show were Jacob Lawrence (chairman), Ad Reinhardt (vice-chairman), Harry Gottlieb, Robert Gwathmey and Harry Sternberg. The list of exhibitors and sponsors included some figures from the avant-garde art scene, such as Dore Ashton, Elaine de Kooning, Thomas B. Hess, Betty Parsons, Norman Lewis and Theodore Stamos; but these were entirely outweighed by the survivors from an earlier phase of Communist-led artistic and political activism.

9 Cultural Criticism between Hollywood and Zhdanovism

The reformation of the CPUSA in July 1945 under the leadership of Foster and Dennis had important implications for the Communist cultural movement at both theoretical and tactical levels.[1] The rejection of what was termed Revisionism, or Browderism, and the return to a Leninist vanguard position led to a revival of the slogans and stances of the Third Period. Yet while there were those such as Mike Gold who had never adapted to the relative pluralism of the Democratic Front, there were also many sincere and committed Party members who had either joined at that time or embraced the more expansive vision of progressive culture it promoted. These elements did not just adapt passively to the new line. There were other contradictory impulses at work too. After the confusions of Browder's ouster the Party needed to rebuild its membership and in 1946 it initiated a major recruiting campaign, which apparently had most success among the middle class.[2] That the Party's appeal to this sector partly depended on its cultural work was clear, and this reinforced awareness of the importance of *New Masses*.[3] Leninist vanguardism had to be measured in relation to the continuing need to forge cross-class alliances.

The Party's view that postwar capitalism was in a phase of crisis and desperate imperialist expansion had as its corollary an interpretation of contemporary culture as essentially decadent. This is well illustrated in the statements of V. J. Jerome, the chair of its cultural commission, who in a 1947 pamphlet, *Culture in a Changing World*, claimed that capitalism had come out of the war greatly weakened and more crisis-prone than ever. By contrast, 'advanced social ideas' had never before influenced the actions of so many millions. Consequently, American capital, in alliance with British imperialism, was set for conflict with the USSR and the new 'people's democracies', and artists and intellectuals must choose between the forces of reaction and the forces of progress in this world-historical drama. In evoking the putrescence of a decaying class, Jerome

ranged across philosophy attacking logical positivism and pragmatism (both covert forms of idealism), together with existentialism and the vogue for irrationalist philosophers such as Kierkegaard and Heidegger. These philosophical trends tied in with other phenomena: pessimism and the 'faith-cult' in literature, the 'Brute-Cult' in popular thrillers and contemporary cinema, Hollywood racism, the militarisation of science and the witch-hunt against progressive intellectuals. Contemporary artists and writers who lacked a 'clear vision of the course of history' were sinking into decadence, and 'To cover up or glamorize their failure to see and express the positive, they improvise crude philosophies of despair and cynicism.' With insignificant variations, this view was echoed again and again in the Party press. What is notable, of course, is that the conservative turn among artists and intellectuals was interpreted essentially as an effect of weakness and moral failure, rather than being subjected to a truly socio-historical analysis as ideology.[4]

The counterpart to this corruption of the intelligentsia was the fascistic character of American popular culture. In a report to the Fifteenth National Convention of the CPUSA in 1950, Jerome evoked the movie-going experience of the average worker and his family in terms reminiscent of Adorno and Horkheimer's diatribes. Wall Street deliberately promoted a culture of 'Anglo-Saxon racism', 'violence, sadism, and anti-humanism' as a cover for its drive for world domination. To counter this, Jerome argued that the Party needed to form cadres in the cultural field who would be 'forces of the people' 'with unbounded faith in the working class', cadres that would create 'novels and plays, poems, paintings, musical compositions, popular songs, and criticism, vibrant with the Party spirit, the very essence of Socialist realism.' Although there was some truth in Jerome's characterisations of American popular culture and the intellectual climate, they were overdrawn and the explanations he offered were crudely conspiratorial and func-

tionalist. Moreover, the vision of 'the inspiring Socialist culture of the Soviet Union' that he counterposed to the nightmare of a fascistic America was evoked in essentially Zhdanovite terms that had little resonance for such cultural cadres as the Party actually had. Many artists and intellectuals responded to it with both overt and covert resistance.[5]

However, it is also necessary to note the costs of Jerome's criticisms in another sense. In 1953 he was convicted under the Smith Act and eventually served two years in jail in 1955–7. His 1950 report was cited as evidence that he had conspired to advocate the overthrow of the US government by force.

The Maltz Affair

The key episode in defining differences over cultural strategy (and, by extension, aesthetic principles) in the postwar period was the so-called 'Maltz Affair' of 1946.[6] Albert Maltz was a talented writer, the author of two accomplished novels and also a Hollywood screenwriter. He joined the Party in the 1930s, and his Communist commitments later got him imprisoned as one of the Hollywood Ten. Maltz inadvertently became the focus of a major policy debate because of an article by him that appeared in *New Masses* in February 1946 under the title 'What Shall We Ask of Writers?' This seems to have been prompted by an earlier discussion article by the writer and critic Isidor Schneider, in which he noted the difficulties of adjudicating between the immediate demands of the labour movement and the requirements of literature *per se*, and lamented the abuse of slogans in the criticism of the 1930s and the vilification of writers such as Joyce and Eliot.[7]

Maltz, too, suggested that much left-wing writing had suffered from the shallow approach of critics who demanded of art an 'immediate political utility', while the slogan 'Art is a Weapon' had led to a vulgarisation of aesthetics. He stressed the need to distinguish between the value of works of art and the political stance of their authors, citing as instances the novels of J. T. Farrell and Richard Wright, both of whom had become anti-Communists. Although Schneider allied himself with Maltz and again criticised the 'emergency-mindedness and crude political determinism of the past' in the issue where 'What Shall We Ask of Writers?' appeared, it was Maltz who attracted a whole string of vehement rebuttals from the literary apparatchiks of the movement, which culminated in a series of six articles in the *Daily Worker* by Samuel Sillen, a critic and professor of

English at New York University.[8] The sum of all these critiques was that Maltz's arguments were 'anti-Marxist' in their attempt to make some space between art and politics; he slandered the achievements of the whole Left literary movement; he did not recognise the organic connection between progressive political ideas and literary achievement; and he was conciliatory to Trotskyism (in the person of Farrell). Sillen set out the logic of this critique clearly: 'The artists who ally themselves with the degenerating forces in our society, themselves degenerate *both* as "citizens" and as "artists", both in terms of "ideology" and of "art".' Art was necessarily a weapon in the Manichaean struggle between capital and the progressive forces of the proletariat, and all talk of 'pure art' was simply a delusion promoted by the ruling class. It was only because of the Party's errors under Browder's leadership that the slogan had been abandoned. Although the tone of this onslaught was intimidatory and personalised, it is important to note that some kind of a debate occurred, and *New Masses* and the *Daily Worker* both printed readers' correspondence which, while critical of Maltz's views, objected to the name-calling and 'sectarianism' of the responses of Gold and Sillen. They were forced to admit that they had received letters of complaint, and to defend their actions.[9]

Maltz had been unfortunate enough to provide the occasion through which the Party's cultural workers purged themselves of Browderism. This was ironic because he and Schneider were essentially responding to the call to rethink the errors of the past that followed Browder's fall. In part the assault on Maltz was a ritual of atonement, in part it was related to genuine differences of opinion between hard-liners like Gold and Sillen and those with more expansive views. Maltz's recantation, published simultaneously in *New Masses* and the *Daily Worker* in April 1946, advised those who had approved the original article that it was an example of revisionist thinking and that Browderism could not promote a healthy working-class culture.[10] Effectively the debate was closed by a statement on Party cultural policy by Foster later in the month, which rehearsed familiar Stalinist platitudes: art had been a servant of the ruling class throughout history, and consequently 'rising revolutionary social classes, instinctively realizing the importance of art as a social weapon, have always forged their own art and used it to challenge that of the existing ruling class.' A new 'people's culture' was being forged, and while this had not yet issued in a socialist art, it had produced art imbued with a democratic spirit. The task of Communist and 'other democratic artists' was to identify with the 'basic artistic strivings of the

masses'.[11] The transition to the new line (represented as the return to the true path) was symbolically celebrated by public symposia on the theme of 'Art as a Weapon' in Hollywood and New York.[12]

As I have shown in relation to earlier moments in the Party's history, the promulgation of a cultural policy was not the same as its enactment. The Party had to work with the writers and artists who were prepared to give it their allegiance, and many of these seem to have paid lip service to the new line while continuing to produce work that suggests a broader and more intelligent vision. George Charney recalled 'the hard uncompromising attitude toward liberalism and dissent, especially in the cultural periphery of the movement' at this time, but also observed 'an undercurrent of resentment and discontent' directed not so much against the Party itself as against its 'cultural bureaucrats and hatchet men.'[13] One instance of this was the cultural group that met at Annette Rubinstein's apartment on West 71st Street in the late 1940s and which included Charles Humboldt and Louis Harap. Both Rubinstein and Harap have referred to V. J. Jerome's ambitions to act the role of a kind of cultural commissar and described episodes in which they were reprimanded for wayward views. Significantly, all three left the Party in the following decade.[14]

What were the implications of the Maltz Affair and the revival of the weapon metaphor for art criticism? This question can be addressed most effectively through consideration of the three organs in which criticism appeared: the *Daily Worker*, *New Masses* and *Masses & Mainstream*.

Art Criticism in the *Daily Worker*

From March 1946 until May 1947, the *Daily Worker*'s main art critic was 'Marion Summers', reportedly the pseudonym of the art historian Milton Brown, whom I introduced in the context of the Marxist Critics Group. While in the context of the postwar period Summers's stance could only be overtly anti-revisionist,[15] what is striking is his insistent avowals that much of the significant art of the twentieth century had been modernist, and his repeated references to the formal contributions of early modernism: 'The art which these men have created, together with the science which has developed under capitalism, is the best that this class has produced, and to reject it is to reject the heritage of the past.'[16]

The term 'decadence' was used over freely in Marxist criticism of capitalist culture, Summers argued, and too often it was 'a cloak for ignorance and intellectual laziness'. Artists such as Brancusi, Klee, Lipchitz, Matisse, Mondrian and Picasso should be viewed similarly to research scientists, and they had revealed new possibilities of artistic form: 'out of the very conditions of a decadent society they created positive values. Isolation was the precondition for a vital bourgeois art in this period.'[17] However, for Summers this phase of healthy experimentation was now over, and the conditions of the epoch put new demands on artists. Thus while he praised the early Cubist works of Picasso and Braque as 'rational expressions of fundamental artistic ideas' that had fundamentally transformed 'concepts of beauty and of art', he was critical of the 'bitterness and cruelty' of Picasso's recent work as signifying 'a basic disregard for human values'.[18]

What gave urgency to Summers's judgements on modernism was his perception of the increasing dominance of abstract art in galleries and exhibitions, and the worry that such art was 'now in a position to dominate the entire field'.[19] In June 1946 he devoted a series of four articles to its critique. Summers was not an ignorant observer. He understood the variety of what went under the name of 'Abstract Art' and could see value in some of it, but now there was an 'offensive' to restrict all art to painting of this type and to 'enthrone' its theories as a 'universal aesthetic', despite the fact that many theories of abstraction were 'half-truths with limited validity' and others were 'sheer nonsense'. Summers ridiculed the argument that the two-dimensionality of the medium demanded abstraction, pointing out that *trompe l'oeil* and the denial of surface had not been the aim of naturalism. For all its 'fancy verbiage' and 'pretense', abstract art was now 'merely another docile expression of bourgeois culture'. The freedom to 'indulge in unrestricted personal expression' was a counterpart to the 'economic and social anarchy' of capitalism; it led to an art that was irresponsible and empty.[20]

Among contemporary abstract painters, Summers gave special attention to Reinhardt. This may have been because of Reinhardt's past association with the Party, but it would have been prompted in any case by the publication of the artist's art cartoons in New York's left-wing daily *PM*. Not only did these cartoons offer a rationale for abstraction, they also attacked (naturalistic) 'pictures' as 'a kind of opium of the people'. Additionally, the independent stance of *PM* and its criticisms of the Communist Party would have made Reinhardt an especially suitable target – although elsewhere Summers acknowledged that 'with all his

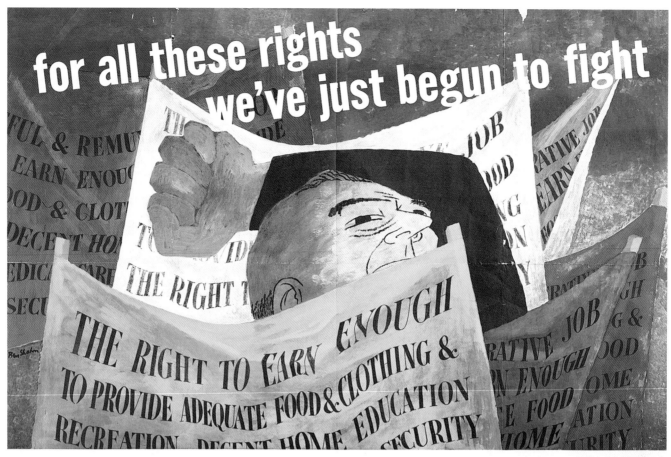

158 Ben Shahn, *For All These Rights We've Just Begun to Fight: Register/Vote*, 1946, offset lithograph, 28⅞ × 38¾ in., New Jersey State Museum, Trenton, Gift of Mr and Mrs Michael Lewis, Fla. 1969.156. © Estate of Ben Shahn/Licensed by VAGA, N.Y.

shortcomings, [he] is probably one of the better abstractionists at work in the US today.'[21]

Summers found contemporary geometrical abstraction of the Reinhardt type essentially evasive and a retreat from social problems, but he had even less time for the mythmaker wing of Abstract Expressionism and the pretentious discourse of irrationalism that framed its products. Reviewing a show of Adolf Gottlieb's pictographs at the Kootz Gallery in early 1947, Summers described the artist as one of those who turned away from the present to seek the primitive:

He turns up with child-like symbols which purport to offer us an insight into the primitive mind, but give us rather a glimpse of the mentality of the contemporary artist in search of something to say. All the fancy verbiage about 'universal underworld', 'cabalistic

writings', 'frightening mysteries', and 'ritualistic patterns', cannot hide the essential vapidity of this art.[22]

This was a repeated refrain in the criticism of the late 1940s: the turn to the irrational in contemporary culture was symptomatic of the desperate plight of postwar capitalism, despite all appearances to the contrary.

The nature of the realist art Summers wished to counterpose to the abstract trend was difficult to characterise because it was still only in the process of formation, but in a two-part article of July 1946 he sought to give the term some general definition. Drawing on the naturalist/realist distinction, which as I have shown was already familiar to artists and critics in the 1930s, he distinguished between realism as 'a purely stylistic term' meaning 'fidelity to natural appearances', and realism as a broader progressive attitude that was

recurrent throughout history and implied the search for 'the real, the truth about nature, man or society.' Because of the modernist break with the Renaissance tradition, realism was now 'almost purely an attitude', and Social Realists no longer felt tied to naturalistic techniques, but made use of 'symbolism, expressionism and even elements of abstract art.' Indeed, in its 'reflection of social reality' it could encompass 'many variations in style'. What also distinguished realist art was the artist's concern with communication.[23] Social art was 'unequivocal and outspoken propaganda for social progress'. To achieve this end, the social artist had to temper 'his' concern with freedom by awareness of the need to develop a 'common language', and this would require an effort on the part of the audience as well as the artist:

> We have not even begun to develop a set of artistic symbols to express our ideals. There is no body of folklore nor any coherent storehouse of common symbols upon which the social artist can draw. He is often forced to express himself in a purely personal symbolism. In some cases these symbols explain themselves, in others they remain obscure.

Summers acknowledged that painting was unable to represent social realities with the complexity of literature, but he appealed to the examples of Käthe Kollwitz and the Mexican muralists to illustrate what could be done. Art of such broad ambition could not flourish in the 'hot house atmosphere of 57th Street'. It needed a mass audience, not private patrons, and artists should thus look to the unions and workers' organisations to build direct contact with the proletariat.[24]

As will become evident in the next chapter, when it came down to particulars Summers was compelled to acknowledge the limitations of the work of many who were Party sympathisers in relation to his ideal. Ironically, the contemporary on whom he bestowed the highest praise as 'one of the few men who has successfully used the visual language of modern art to express social meaning' was Ben Shahn – not a Communist, but an independent left liberal. And what Summers admired the most was his posters for CIO-PAC (fig. 158) and the American Labor Party, which met both formal and utilitarian criteria.[25]

New Masses and Masses & Mainstream

The Maltz Affair led to some hardening of the Party line but it did not end debate or usher in a narrow Zhdanovism. Indeed, if anything it revitalised the Party's cultural criticism by forcing renewed reflection on principles. This is evident across the several cultural departments of New Masses, including the art reviews.

At the time of the Affair, the magazine's art editor and critic was Moses Soyer, who had held the post since 1943. Summarising the aims of his criticism in October 1945, he wrote: 'I did not try to be orginal or profound; I did not go deeply into the aesthetics and dialectics of art. I emulated the regular reviews that appear in our press, with the difference that, not being a professional critic, my column was more personal and freer from artistic clichés.' Elsewhere, he described the 'yardstick' of his admiration for an artist as 'his singleness of purpose'.[26] Soyer was thus unconcerned with trying to work through the implications of a Marxist viewpoint for contemporary art practice, and articulated no position on the problems of either social art or 'Art as a Weapon'. The statement quoted above may have been a defensive one, and it heralded the announccment that henceforth the New Masses art column would print critical contributions from a range of invited artists. In the event only three 'About Artists by Artists' appeared, and although they did provide an occasion for important statements by such figures as Elizabeth Catlett, Evergood and Reinhardt, they could not substitute for a theoretically informed art criticism – as a letter published in April 1946 pointed out.[27]

Soyer left New Masses as a result of the editorial shake-up in March and April of that year, but even before this the magazine had been the forum for two debates about modernism in which he played no significant role. The first of these was prompted by a long interview with Picasso published in March 1945, in which the artist discussed the relationship between his art and his recent commitment to the French Communist Party. This provoked a letter from Rockwell Kent, which described the examples of Picasso's recent work illustrated in the article as 'just plain silly' and without 'a single redeeming feature'.[28] According to an editorial statement in June, the Picasso interview and Kent's attack produced more 'discussion and controversy than any other article we have ever published.' In May the magazine published a 'Reader Symposium' that included a second letter from Kent defending his view, and the weekly 'Readers' Forum' also printed a substantial correspondence on the debate. It is striking that many of the letters printed – and certainly the longest and most articulate – were critical of Kent and asserted that art of high achievement necessarily demanded an effort on the part of the audience.[29]

The second of these debates raised the same issues, but was conducted in more overtly theoretical terms. Its opening shot was an article by one Charles Arnault of Los Angeles with the portentous title 'Painting and Dialectics', which appeared in August. This claimed that Marxist critics and historians of art had tended to be dominated by 'an approach carried over from literary criticism' that led them to underestimate form and over-estimate or distort 'the meaning and function of content.' Like some contributors to the earlier debate, Arnault argued the importance of 'plastic organization' in the visual arts, but sought to relate this directly to the principle of dialectical materialism. Pictorial com-position, Arnault claimed, involved an inherent contradiction because of the tension between the two-dimensionality of the picture plane and the three-dimensionality of what must be represented. To seek to suppress the material character of the picture surface in the search for illusion was to succumb to idealism: 'the two-dimensionality of the picture plane is a governing condition of painting'. The arrangement of pictorial ele-ments was governed by ' "laws" ' of composition which were themselves ultimately dialectical in character; moreover the 'endless mission' of painting was to 'seek perfection on ever higher levels of complexity of organi-zation.' While Arnault's article was welcomed as the beginnings of 'a more profound art criticism', and even as 'an antidote to the absurdities which have been filling your art columns', it was also attacked as 'an attempt to rationalize poor and talentless art by long, tedious, cumbersome and artificial reasoning'.[30] Together these debates suggest that not only were Communist cultural critics divided over what could count as a progressive artistic practice, but so was the broader constituency of Party members who took sufficient interest in such things to write to *New Masses*.

The role of a vanguard magazine was leadership, and one upshot of the Maltz Affair was the charge that *New Masses* had not been fulfilling its obligations properly in this regard. In March 1946 Isidor Schneider resigned as literary editor, and on 23 April a 'new and improved *New Masses*' appeared with a reconstituted editorial board. The new art editor was Charles Keller, and Ever-good, Gwathmey, Kent, Refregier, Turnbull and White joined the list of contributing editors. Under Keller's direction the magazine achieved something of its earlier visual impact and began to use illustrated covers again (fig. 159). By this time Gropper's work tended to be tired rehashings of his familiar symbols, but Kruckman's witty satires of upper-class attitudes compensated for this in some degree, while from early 1947 the abstract

painter Hananiah Harari contributed regular satirical collages under the title 'On Safari with Harari' (fig. 160). Frasconi, Hirsch and Levine were among the artists who provided occasional illustrations. In July 1947 financial difficulties forced the magazine to reduce from thirty-two to twenty-four pages, and there was a falling off in production standards after that point.

New Masses may have been beleaguered in the last few years of its life, but it was certainly not bereft of distinguished supporters or intellectual quality. To help meet its financial deficit, the magazine initiated annual art auctions in both New York and Los Angeles – in 1946 that in Southern California counted among its sponsors Charles Boyer, Gene Kelly, Artie Shaw, Ava Gardner, Ira Gershwin and John Garfield.[31] The Party had particularly cultivated African American musicians and actors such as Duke Ellington, Canada Lee and Fredi Washington, and a 'Musicians' Mobilization to Save *New Masses*' in 1947 put on a 'Duels in Jazz' concert at which Sidney Bechet, J. C. Higginbotham and Buster Bailey appeared among many distinguished jazzmen.[32] In part, the magazine maintained its vitality

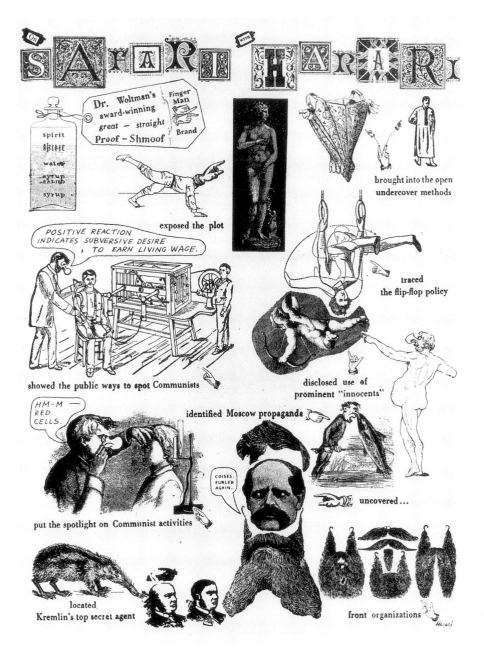

due to an influx of new talent in the form of returning servicemen. Among these were the activist and writer Lloyd Brown, Charles Humboldt and the critics Louis Harap and Sidney Finkelstein, who both published book-length exercises in Marxist aesthetics later in the decade. Schneider continued to write sensitive literary criticism and some theatre reviews, while occasional contributors included Herbert Aptheker, Philip Bonosky, Philip Foner, Barbara Giles and Tom McGrath. Short stories and poems appeared in every issue, and current affairs reporting was somewhat reduced.

The perceived need to redress the heresies of Browderism required a return to Marxist fundamentals, reflected in a number of articles on the philosophy of Engels.[33] This was hardly a productive direction, but the magazine did respond vigorously to the vogue for existentialism with a spate of reviews of Sartre's novels, plays and philosophical statements. While its judgement on the tendency of Sartre's thought was necessarily negative, a serious engagement with his work did take place, especially in articles and reviews by Harap.[34] Similarly, while *New Masses* took a highly critical line

on the fashion for writers such as Dostoyevsky and Kafka, this did not lead to simple blanket condemnations.[35] This engagement with contemporary culture extended to the middle-brow and popular: Humboldt published a three-part analysis of *Life* magazine, Lloyd Brown analysed the decline of radio and Vivien Howard provided a critique of women's magazines.[36] Within the American intellectual scene, the ex-Marxists of the *Partisan Review* circle attracted some of *New Masses'* fiercest criticisms. In a coruscating tirade of 1947, Humboldt attacked Philip Rahv as a peddlar of 'fashionable obscurantism' and Phillips as a '"disillusioned radical" by profession'.[37] What enraged Humboldt and other critics was not just the apostasy and anti-Communism of these writers, but their distrust of science and their disenchantment with the idea that humanity could order its own destiny through reason. They were also repelled by the mandarin intellectualism of *Partisan Review* and its assumption that art offered a kind of refuge from the exigencies of political choice. Commenting on Greenberg's 'Avant-Garde and Kitsch', Barbara Giles observed:

> Dividing all contemporary culture into *avant-garde* and *kitsch* (ersatz culture), Mr. Greenberg asserts that the latter dominates the Nazi and fascist worlds, the Soviet Union, and practically all the peoples of capitalist democracies. And what to do about it? There is only one solution, Mr. Greenberg declares – rather remote, perhaps, but no other will serve – international socialism. Meanwhile, as Mr. Rosenfeld's hero says: no struggling in the middle![38]

It was of course that 'middle' place between the demands of art and those of political effectiveness in which committed writers like Giles sought to work in the hope that they might connect with actual political forces.

It was not that the *New Masses* writers' analyses of bourgeois culture in the United States were wrong (although they were often unnuanced and crudely functionalist), it was rather that they were compromised by a naive model of progress and a conviction that human destiny was embodied in the Soviet Union. Their attacks on *Partisan Review*'s position hit the mark in many respects, but their assumption that the explanation for it lay simply in the intellectual vanity and misanthropy of its contributors disqualified them from producing a truly dialectical critique and often reduced them to invective. The reductive version of Marxism current in the Stalinist parties seemed to them a blinding light that showed the world in stark chiaroscuro with scarcely any halfway shades. However, while the fundamentals of their Marxism were philosophically crude in most cases, this did not prevent the *New Masses* writers from achieving sophisticated levels of cultural criticism at times.

In 1947 a group of writers in and around the Party launched a new literary quarterly under the title *Mainstream*. The idea was to produce a magazine of greater sophistication than *New Masses*, and *Mainstream* was well printed on good paper in contrast to the cheap pulp of the former. Samuel Sillen was its editor-in-chief, and the other editors were mainly Party faithfuls, but it also featured a whole range of talented writers, including Thomas Bell, Alexander Saxton and Dalton Trumbo.[39] Although the magazine was illustrated with drawings and prints by Evergood, Lawrence and Levine, it did not carry art criticism. By 1948 the party's membership and resources were both declining. One result of this was the folding of *Mainstream* and *New Masses* and the setting up of a new pocket-sized monthly magazine with the title *Masses & Mainstream*. The editor was again Sillen, with Aptheker, Brown and Humboldt as his advisory board, and Evergood, Gropper, Gwathmey and Solman among the contributing editors.

Probably as a result of Humboldt's influence, the *Masses & Mainstream* of 1948 had the appearance of a thoroughly modern magazine. The inaugural issue illustrated Picasso's etching *Bull-Headed Sphinx* on the cover (to accompany an appreciative article on the artist), and although few other cover images came near this in sophistication, the magazine maintained an arty look. Perhaps to economise on printing costs, from January 1949 onwards it was printed on cheaper paper, and most of its covers were framed around greyish black and white photographs of Communist heroes and workers. Although the format limited the character of the illustrations it could carry, *Masses & Mainstream* did reproduce drawings by Ben-Zion, Evergood, Lawrence, Levine, Neel, Refregier and Shahn among others, along with the predictable cartoons by Gropper and satiric collages by Harari.[40] One element within this graphic array was prints from the Mexican Taller de Grafica Popular and, in a kindred vein, there were also prints from the American Graphic Workshop, of which the most notable are those by Frasconi (fig. 161). As should be evident from the above, much of the illustrative material was formally modernist – a feature again probably attributable to Humboldt's involvement. However, in July 1949 Humboldt dropped off the advisory board and became a contributing editor.[41] While the range of illustrations continued to be quite wide until the end of that year, in 1950 it narrowed considerably and fewer were included. It seems more than coin-

161 Antonio Frasconi, *Foley Square*, reproduction of woodcut from *Masses & Mainstream*, December 1949. © Antonio Frasconi/Licensed by VAGA, N.Y.

cidental that in May 1949 the magazine had published a reader's letter complaining that especially the 'critical articles on art are over my head', while 'some of the drawings mean nothing to me': 'I like the attitude of the Soviet Union, that art is for the people and if it is vague or obscure or a mass of confusions it is of no value.'[42]

As noted, there was considerable continuity of personnel between *New Masses* and *Masses & Mainstream*, and it is hardly surprising that the same art critics wrote for both. After the 1946 shake-up, art criticism in *New Masses* acquired a heavier and more theoretical tone, and for the remainder of that year it consisted mainly of occasional pieces by the mysterious 'William Thor

Bürger', who was described only as 'an art historian'. This is entirely credible, given his knowing adoption of the pen name of the nineteenth-century French liberal critic Théophile Thoré. Unfortunately, no one I have spoken to who was connected with the magazine at the time has been able to reveal or recall his identity. Bürger subsequently contributed five reviews to *Masses & Mainstream*.

It is symptomatic of the rising status of abstract art in the postwar period (as well as of the challenge it posed to what was generally understood as Marxist aesthetics) that Bürger's first article was a review of the annual exhibition of the American Abstract Artists in 1946, which

included an historical sketch of the evolution of abstraction and a critique of its ideological framework. For Bürger, the exhibition raised two questions:

> First, why is it that a style which once produced masterpieces of great daring and originality is now capable only of endless, though charming, repetition? Second, why is it that abstract artists still speak of themselves as a struggling revolutionary movement, when they have had as diffused an influence as any previous style, and when half a dozen newer styles have come, created masterpieces, and spread their influence in turn?

Bürger's answer to the first question was that the vital phase of modernist art (which he identified with Cubism) was over by the mid-1920s, and that 'Like many another once progressive idea the abstract esthetic had been moved from its place in the vanguard of human progress.' In response to the second, he roundly denounced the pretension that such art was in any meaningful sense 'revolutionary', pointing out that the Nazis' hostility to modernism was a product of the particular German context, and not a consequence of fascism as such. While the 'class position of abstract artists in their own eyes is anti-bourgeois', this was premised only on a kind of bohemian individualism, and the ideology of the abstractionists, despite all their claims to practise a species of realism, was ultimately an idealism.[43]

By contrast, Bürger advanced social artists such as Evergood, Gwathmey, Levine, Siporin and David Smith as representing a stage beyond modernism but, like 'Marion Summers', Bürger stressed that conditions in the United States were unpropitious to the production of social art. He too found Ben Shahn 'still the most mature, consistent and satisfying of the American social painters', although he complained (not inappropriately) that a 'growing concern with paint quality, with indefinable mood, [and] with inferential symbolism' had led to a 'vagueness and sometimes even confusion' in his recent paintings.[44] For Bürger, the 1950 Whitney Annual, where works by de Kooning, Gottlieb, Pollock and Stamos were prominent, was a measure of the disaster that had befallen American art. He blamed this debacle partly on a 'closely knit monopoly of taste' within the Whitney and the Museum of Modern Art, and partly on artists themselves, instancing former social painters who had succumbed to 'this decadent bourgeois mode of thought', such as Guglielmi, Millman, Siporin and Prestipino. How had it happened, Bürger asked, that 'those American artists, who once comprised a thriving school of social art, have in many cases surrendered to the voluntary muteness of formalist painting?' His answer, predictably, was that despite their politically progressive opinions many had succumbed to the oppressive atmosphere of an 'imperialistic' and 'increasingly reactionary society': 'Given the choice between peace and war, socialism and capitalism, rule of the FBI and democracy, the artists have almost unanimously chosen "Art," in a kind of mass esthetic euthanasia.'[45] There is no doubt that Bürger had caught something of the current intellectual mood to judge from the statements of the Abstract Expressionists and others.[46] The problem was that the solution he offered was premissed on a social vision discredited by its association with Soviet tyranny, and, as he acknowledged, the economic and institutional base needed to support social art simply was not there.

As if to illustrate the divisions over modernism within the Party's cultural movement, when Bürger ceased to write criticism for *New Masses* in late 1946, he was succeeded by Joseph Solman, who contributed nine art reviews between December 1946 and November 1947, and also graduated to write for *Masses & Mainstream*. When Humboldt advised 'Marion Summers' in an exchange of 1946 that his pronouncements on abstraction could alienate abstract artists associated with the Party, he may well have had Solman in mind. Although Solman's work contained clearly recognisable naturalistic forms, its overt modernist techniques and lack of obvious social themes put it close to what Summers encompassed by 'abstraction'. Further, Solman had commented on this exchange in *New Masses*, arguing for an expanded conception of realism that could encompass modernist innovations: 'The concept of realism changes with the social demands and discoveries in each epoch. To reveal the fundamental reality of our day is the challenge facing the modern artist.' Solman denied that there was any 'framed formula' for a Marxist aesthetic, and while there was 'a direction and a belief', which implied that 'all creative work should move in the direction of the 'socially purposeful', the politically committed artist had a broad brief.[47]

For an artist with Solman's aesthetic predilections, it was crucial to distinguish between 'semi-abstract art' and 'non-objective art'. Thus his first review for *New Masses* argued, in contrast to Summers's erroneous view, that Cubist still-life painting had not implied 'eliminating the subject'. Rather, Cubism offered itself as a new means of expression. While Solman was highly critical of the 'pure design' of Mondrian and other non-objective painters as manifestations of various forms of

philosophical idealism, he was equally impatient with social painters who viewed 'all abstract art as outdated', for 'No vital painter today can ignore the tremendous contribution made by abstract painting in the last thirty years.' It will be evident that Solman had taken on the mantle of Stuart Davis as a defender of modernism within Marxist criticism, but he did not seek to achieve such a tight fit between the logic of artistic form and the progressive forces in history as Davis had in his formulations. This position meant that he accorded a positive value to the works of artists such as Carl Holty, Byron Browne and Balcomb Greene, which neither Summers or Bürger would have done.[48] In contrast with them, he also hailed Picasso's recent paintings as 'his greatest work' and thus as 'the greatest in our time', because of what he regarded as the expanded range of Picasso's subjects and a new expressive richness in his colour and paint textures.[49] This indicates that Solman placed less emphasis than Davis on form as the progressive aspect of modernism, and correspondingly more on expression. He was particularly concerned with the application of modernist techniques to the human figure, and wrote an admiring review of the Museum of Modern Art's 1947 Henry Moore exhibition: 'The grandeur and dignity implicit in his simple human figures lend them a large social aspect in the art of today. Whereas a cult of pessimism and an obsession with the fragmentary are so much in current evidence, Moore reveals the unified life, its fertility, its hope and its aspirations.' Of course, as things turned out, Moore's imagery of the human figure came to function as an official symbol of a bland humanistic idealism in ways Solman could probably not have envisaged, but in 1947 his work might reasonably seem an antidote to the debilitating pessimism of the avant-garde.[50]

Of all artists associated with the Communist movement, Solman was the best placed to pass judgement on Abstract Expressionism. Not only had he a sophisticated understanding of post-Cubist art, he also knew Gottlieb and Rothko from his involvement with The Ten and Harold Rosenberg from his *Art Front* days. In a comment on Rothko's work in 1947 he scathingly evoked the pretentious discourse of the 'mythmaker' wing of Abstract Expressionism. This was an art 'bent on resurrecting the ancient corpse of mythology':

The territory is clouded enough to allow for complete interchangeability of symbols or, more strictly speaking, it is made up of biomorphic shapes and hieroglyphs searching to attach themselves to symbols. The symbol, by this time half famished, begs for a title. It is at this point that the 'content' flowers out and we are treated to a thesaurus of oracles, rituals, portents and primitive mysteries.

However, such titles were redundant in Rothko's case, for his 'sophisticated decorative sense precludes all notions of primitive rigor or an aggravated psyche.'[51]

For Solman, Abstract Expressionism represented 'a flight from reality', 'a new mysticism', encouraged by commercial galleries and some of the major museums. Writing a year later in *Masses & Mainstream*, he divided the 'new cult' into those who drew on 'totemic, ritualistic symbols' (Gottlieb and Newman) and the ' "subjectivist school" which believes that the inner urge is the only valuable asset in art' (Pollock and Hofmann). Both groups shared common tenets '[i]n setting irrationality over reason, urge over concept, symbol over representation, and in making intuition the sole guiding principle of design'. However, even when he had disapproved of the tendency of Gottlieb's painting earlier in the decade he had still acknowledged a quality in his work.[52] For that of Pollock and Hofmann, Solman had nothing but contempt. Pollock's technique only signified 'an abortive expressionism since it never passes through the crucible of an idea or experience', while Hofmann's suggested ' "pure" emotion, no longer sullied by subject, motif, line, design or visual concept.' Solman contrasted the work of these artists with that of Klee, who had used his study of archaic and 'primitive' art to invent 'a cast of characters . . . who invest the older myths with a new life.' Referring to Motherwell and Rosenberg's statement on the extremity of the political situation in *Possibilities* he observed: 'Indeed, the works of men like Pollock, Hofmann and Rothko reveal inversely the dire impact of social forces and depict, in effect, an hysterical flight from reality, a wounded psyche seeking some vague retreat or revenge.' But to retreat into 'despair' was tantamount to a submission to those forces in society that wished to 'bind the artist and intellectual to obscurantism'.[53] The promotion of such art by museum curators and critics represented a specious cult of 'Individualism' counterposed to the bogey of 'Red collectivism'.[54]

That Solman's position was quite different from that of Summers's *Daily Worker* column is evident from subsequent reviews. It combined commitment to a post-Cubist approach to form with belief that any significant expression depended on naturalistic references that connected with common experience. To be meaningful aesthetically art had to be formally sophisticated and inventive. The application of these principles is exempli-

162 Ben-Zion, *Prophet Among the Ruins*, 1936, oil on canvas,
4 × 3 feet., Collection of Lillian Ben-Zion.

fied by a 1948 review of Ben-Zion's work (fig. 162), in which Solman praised his images of Jewish prophets as 'projections of the will and conscience of mankind', while claiming that his 'elemental' designs and original use of colour showed him as 'one of the few imposing figures in American art today'.[55] Clearly, Solman did not propose that committed artists should seek to produce a revolutionary art, and while he expressed sympathy with the efforts of those such as Anthony Toney (see fig. 194) and Hananiah Harari who sought to utilise experimental techniques for works with political themes, he found the results unsatisfactory for the most part, both formally and politically.[56] He praised Shahn for having made 'a most important contribution to a people's art' and acknowledged the formal brilliance of his work, but also criticised pictures by him in which 'an illustrative cunning mars the larger concept.'[57] However it was

Evergood who, for Solman, came closest to achieving a satisfying unity of form and social idea. Solman saw Evergood's work as a development of the Northern Renaissance tradition of moral satire and fantasy enlivened by modern Expressionist techniques. He acknowledged that this did not always come off, and was appropriately critical of some works in the artist's 1948 ACA show, but he also gave generous acknowledgement of the originality and wit of paintings such as *Dream Catch* (see fig. 164) and *Nude by the El* (Hirshhorn Museum and Sculpture Garden). What Solman could not abide was the 'corrupted realism' he saw in the works of artists such as Blume, Tchelitchew and the Albright brothers, who used a meretricious technique to deal in ideas of a 'coarse bourgeois venality'. Appropriately, his last review for *Masses & Mainstream* was a withering critique of this trend centring around the exhibition of Blume's ludicrously portentous painting *The Rock* (Chicago Art Institute) at the Durlacher Galleries.[58]

Bürger's review of the 1950 Whitney Annual was the last art criticism of any significance to appear in *Masses & Mainstream*. This was apparently not the result of an editorial decision, but rather because the worsening situation at the time of the Smith Act Trials made it increasingly hard to find contributors.[59] For the first time in more than two decades, there was no magazine in which Communist criticism of the visual arts appeared on a regular basis.

In the United States art critics who were in, or identified with, the Communist Party were forced to confront directly the most formally radical departures in the tradition of modernist painting in the 1940s. Given the political philosophy and associated aesthetic theory they subscribed to (in any of its variations), they could not but judge this art negatively. What I hope is clear is that many of their judgements concerning it were correct. Abstract Expressionism was an art advanced by entrepreneurial art dealers in conjunction with a few aggressive critics. For the most part, the critical discourse that framed it was either irrationalist or obscurantist (Gottlieb and Newman), or an arbitrary formalism presented apodeictically (Greenberg). It was an art premised partly on despair and a sense of political hopelessness (Motherwell and Rosenberg).[60] Communist critics also perceived that its existential and mystical posturings represented no challenge to the dominant order of values and indeed would prove ideologically congruent with it. Their criticisms should be seen not as some kind of failure of aesthetic perception, but rather as a principled refusal to accept that art would have

to be constrained within the narrow parameters of relevance that would be assigned it in postwar American society. That was a refusal to accept that the nearest thing the United States would have to a public art would be an art of extreme individualism promoted by commercial interests and so-called public museums which were actually the playthings of corporate interests. If there was a failure of perception, it was in not being able to comprehend that some Abstract Expressionism might have a kind of brilliance as a negative symbol of a particular cultural condition – which was, after all, why it could resonate so powerfully.[61] But this would have seemed thin justification to those who had committed themselves to the ideal of a participatory collective culture. I shall address the question of whether committed artists had anything better (or as good) to offer in the next chapter.

The End of Democratic Front Aesthetics and the Emergence of Zhdanovism

It is symptomatic of the level of scholarship on the Communist movement in the late 1940s that the received accounts cite the Maltz Affair as evidence of the degeneracy of Party culture,[62] but make no mention of the publication of two major books on Marxist aesthetics by International Publishers in 1947–9, that is to say, after it. Of course, to do so scholars such as Shannon, and Howe and Coser, would have had to acknowledge that Party members and followers were divided, and that debate did continue. Having said this, both the books were essentially the product of Democratic Front thinking on the arts and their appearance provided the occasion for the articulation of a new Zhdanovite stance.

Sidney Finkelstein's *Art and Society* was published in 1947, but written while he was working at Brooklyn Post Office in the 1930s and revised during and after his war service.[63] Finkelstein was primarily a musicologist, but he also had a wide knowledge of literature and a rather thinner grounding in the history of art. *Art and Society* was conceived for the non-specialist and, according to the preface, was intended to open discussion rather than constitute a definitive statement. However, necessarily Finkelstein assumed certain basic principles. For him, art was a species of 'communication', through forms the complexity and longevity of which ensured its address to all members of society. Throughout the book he emphasises the resources of folk and popular art – 'individual art' had emerged only during the Renaissance. There was, however, no funda-

mental conflict between the two, and the latter was constantly being enriched through contact with the 'popular' – a point illustrated through references to artists such as Brueghel, Shakespeare and Haydn. In sum, 'the aesthetic of popular art is the same as that of the greatest art.' This position is crucial to Finkelstein's argument that the nationalist art of the nineteenth century was not a new departure but rather a continuation of earlier trends. Conversely, he read an emergent national consciousness back onto medieval and Renaissance art. Of course, the underpinning for these ideas came out of the 'People's Culture' of the Democratic Front and Stalin's writings on the National Question. For Finkelstein, true nationalism is based on the language and mythologies of the common people, and he distinguishes between a healthy democratic nationalism and a competitive expansionist middle-class version that contributes to imperialism. In a passage peppered with quotations from Gorky and Stalin, Finkelstein praised the wisdom of the Soviet leaders who had understood 'the healthy, powerful and deeply progressive nature of the people's love of their land, of their language, history and cultural traditions.'[64]

Any Communist critic writing at this moment necessarily took realism as the central aesthetic category. For Finkelstein, the realism of art was to be judged according to its function in promoting the self-understanding of a 'people': realist forms were forms adequate to the expression of social relations. Like Lukács, Finkelstein saw realism as the principle of all truly great art, from which both Classicism and Romanticism were deviations. Romanticism was the result of an over-concern with individual emotion, while Classicism, in its more recent manifestations as Neo-Classicism, was the result of an over-concern with form. Broadly speaking, both were effects of the alienation of the artist from society under capitalism. But this position did not lead Finkelstein to deny a value to such art, for both Romantic and Neo-Classical art involved 'a partial grasp of reality'. He wrote sympathetically about the novels of Dostoyevsky, the poetry of Eliot and the music of Wagner and Schoenberg as instances of the former; and about the novels of Stein and Joyce and the music of Bartók as instances of the latter. While Finkelstein argued that art had been 'mortally hurt' by its growing isolation from common life, he did not censure modernism as such. Indeed, he claimed that 'Paul Cézanne, Pablo Picasso, James Joyce, Gertrude Stein, Bela Bartók, Igor Stravinsky, and Paul Hindemith are among the scientific minds of our era in art.' Joyce's *Ulysses* had wrought a profound transformation of English and Irish literature and stood 'at the

door of a new realism', while Schoenberg's twelve-tone system was 'one of the great intellectual and musico-logical achievements of the century's music.' Finkelstein thus embraced different tendencies in modern art, literature and music and tried to understand them in both their progressive and negative aspects. He emphasised the engagement of the best modernism with contemporary society, and also sought to register its diversity and national variations.[65]

In relation to the contemporary United States, Finkelstein's position was of necessity highly critical. As we have seen, for him great art required a common culture. While America offered unparalleled technological resources for the creation of such a culture, corporate domination of radio and cinema, and the consequent standardisation of cultural products had produced an environment inimical to artistic experimentalism. Further, the 'pseudo-universal audience' assumed by the media denied expression to African American, Italian American and Jewish cultures and led to a 'denationalized public art'. In assessing American culture, he looked back longingly to figures such as Dreiser and Ring Lardner, to Joplin, Gershwin and Bix Beiderbecke. The growth of media monopolies meant that artists would have to force their talents into channels that would dissipate and distort their 'creative power.' Finkelstein's remedy was a characteristically Democratic Front one. Producers and consumers should organise, and there needed to be government sponsorship of the arts at both federal and local level.[66]

Art and Society contains undoubted insights and some vivid passages of analysis, but Finkelstein's history is shaky to say the least, his central hypothesis about high art and popular culture is far too sweeping to be sustainable, and basic issues around the history of forms and audiences are not addressed. However, it was not just its scholarly and philosophical limitations that were to make it the target of attack, but also its generosity of vision. Initially the book was well received in the Party press,[67] and apparently occasioned much discussion. But this eventually turned to criticism, although it was not until 1950 that the criticisms took printed form. In that year *Art and Society* was attacked in a number of letters and articles in the *Daily Worker* and in a long article in *Political Affairs*, the substance of which was that Finkelstein's position rested on 'a gross theoretical error' and was non-Marxist. He had failed to register that art was always linked with class power, and his bland view of it as 'communication' had led him to formalism. Predictably, what most outraged his critics was his failure to register the intrinsic connection between form and

ideology, so that he wrote about writers such as Eliot and Joyce as if the formal qualities of their work could be separated from its political tendency. Louis Harap, in particular, drew attention to the book's conceptual ambiguities, its romantic tendency to associate high art forms with folk culture, and its failure to distinguish properly between folk art and working-class art. Finkelstein's reliance on the category of 'the people' did indeed lead him to an almost 'classless' approach, and in a letter of reply he acknowledged that he had been led astray by a desire to define 'some universal principle of "good art"'. He also suggested that his softness on 'extreme "modern" tendencies' arose from the fact that the book was conceived in the days of the WPA, when such art had a false 'air of social militancy'.[68]

Equally a product of the culture of the Democratic Front was Harap's own *Social Roots of the Arts*, which was drafted in the 1930s while its author was an assistant librarian at Harvard, and then rewritten after the war.[69] It seems surprising that International Publishers should publish two books on aesthetics in the space of two years, and according to Harap's recollection the reason was that his manuscript came to the attention of Foster, who liked it.[70] At the time of its appearance *Social Roots of the Arts* was truly a major work of synthesis. Harap made a sensitive reading of statements by Marx and Engels on culture which had recently appeared in an English-language anthology, as well as drawing on the corpus of aesthetic writings by Brown, Caudwell (to whose memory the book was dedicated), Lifshitz, Lukács, Mehring, Plekhanov and Siegmeister. Also impressive is Harap's familiarity with a whole range of bourgeois scholarship on art, literature and music, with the cultural sociology of Veblen and Simmel, and contemporary studies on fashion, radio and cinema audiences and mass publishing. Harap not only approached the task of setting out a Marxist aesthetic in a more systematic and scholarly fashion than Finkelstein but also used Marxist categories with a far more profound understanding. Thus, while Harap too discussed art as communication, he identified it as a 'mode of ideology' that not only 'objectifies the current state of consciousness' but functions to modify it. Harap was clear that art works could not be reduced to simple manifestations of class positions, at the same time as he insisted that they always function within systems of class power. Observing that form and content were dialectically interrelated and ultimately inseparable, he advised that Marxist critics generally had given insufficient attention to the history of forms, within which class struggles were also fought out.[71]

It says something of Harap's sophistication that he did not make the same kind of obeisances to the Stalinist position on national cultures as Finkelstein. While he too claimed that all great art was rooted in 'common consciousness', his whole handling of folk art and mass culture (to which he devoted separate chapters) was more nuanced and better informed. When he turned to modernism, Harap necessarily regretted the 'disproportionate' concern with form and technical experimentation in twentieth-century art, literature and music, at the same time as he acknowledged the role of the Russian Futurists in reinvigorating Russian poetry and praised Joyce's *Ulysses*. In the face of the bewildering variety of available forms in a society with no common tradition, he advised contemporary artists to make a careful adaptation of traditional forms to new ends, but also warned that 'there is no single tradition through which our age can best be expressed'.[72] Like Finkelstein, Harap saw great possibilities in the mass media. But if the technological resources for a great popular art were more developed in the United States than anywhere else, the dominance of commercial imperatives meant this could not appear without a transformation of social relations.

I do not mean to imply that *Social Roots of the Arts* is not in some respects a Stalinist book. Its final chapter, 'Art under Socialism', offers the Soviet Union as 'a powerful example of the first stages of the responsible functioning of the artist in relation to society, and the mutual interest of the people and the artist.'[73] But even this invocation of the Soviet example is relatively muted by comparison with the inflated claims made by Soviet ideologues and echoed in pronouncements in the American Communist press,[74] and when Sillen reviewed the book in *Masses & Mainstream* he particularly took exception to this passage, arguing that the Soviet audience was not 'growing into the cultural tradition of humanity' as Harap suggested, but constituted the most advanced protagonist of humanity's 'cultural tradition'. He also predictably attacked Harap's position on the value of modernism, pronouncing it 'eclectic'.[75] By comparison with Finkelstein, Harap got off lightly, and it is surprising that *Social Roots of the Arts* was scarcely mentioned in the Finkelstein debate, which came after its appearance.

What is striking about the furore over *Art and Society* is the breast-beating it occasioned. Sillen, as editor of *Masses & Mainstream*, and Jerome, as editor of *Political Affairs*, both felt it necessary to pronounce *mea culpa* for their failure to publish criticisms of the book when it appeared and to exercise sufficient vigilance in the

purging of Browderism.[76] This is probably indicative of that wrenching process of self-criticism with which the Party responded to the Smith Act prosecutions. But it is also symptomatic of the Soviet response to the crisis in Europe and the Marshall Plan, which had led to the establishment of the Cominform in late 1947, and the ending of Popular Front tactics by the European Communist parties. Significant in this regard are Sillen and Jerome's invocations of 'the brilliant cultural critiques of Andrei Zhdanov', and their appeal to the example of Soviet Socialist Realism as the model for a progressive art.[77] This was a new turn in the cultural discourse of the American party, linked with the circulation of articles by Zhdanov and others in translation. Zhdanov had been 'elected' head of the Leningrad Central Committee of the CPSU after the murder of Kirov in 1934, and was deeply involved in the subsequent purges. Among Stalin's close associates he played the role of theorist, and in 1946–7 made a series of speeches that prompted fresh purges in Soviet culture and ushered in a new conservative phase. Considering that Jewish theatre and Jewish officials were the main victims of this drive against 'cosmopolitanism', it is pathetically ironic that these pronouncements should have been hailed by Jewish Communists such as Sillen and Jerome, members of a Party that ardently supported the foundation of the state of Israel in 1948 (effectively embracing Zionism – although this was of course denied) and contemporaneously sponsored a School of Jewish Studies.[78]

However, while recent Soviet pronouncements undoubtedly provided the material from which the increasingly Manichaean view of culture was fashioned by the Party's critics, it is important to register that their position was also a response to the extremity of their situation. Further, there were those among the artists and writers associated with the Party who found the manifest anti-Westernism and crudely undialectical interpretations of bourgeois culture articulated in Soviet statements simply unacceptable. Finkelstein, though, was not among them. His 1954 book, *Realism in Art*, declared its 'primary purpose' as '[t]o help counter the present anti-human and undemocratic trend in American painting'. Unlike *Art and Society*, it is a book solely concerned with the visual arts. It is also a much inferior one. Finkelstein's strategy was to give an overview of the history of painting (with some references to sculpture) to show that realism was intrinsically linked to the truth and beauty of all great art, and that it was always the product of progressive social forces. By contrast with the insufficiently 'class conscious' *Art and Society*, he now frequently referred to art 'reflecting'

social contradictions and conflicts. Private patronage is simply 'the kiss of death' to art, and all great art is the product of the collective. While most artists in bourgeois society accept the world view of their patrons, a select few develop the critical perspective which is the basis of realism. Unlike *Art and Society*, *Realism in Art* is insistent on the inferiority of modernism, ritualistically comparing the Surrealists unfavourably with Bosch, the Expressionists unfavourably with El Greco and Manet unfavourably with Velázquez. Whereas the earlier book had acknowledged a realist aspect to many types of art, its successor was far more censorious in tone.[79]

The book's final chapter, 'Realism and Democratic Struggles in US Art', has a certain interest – not, however, because of its attack on Abstract Expressionism (which rests on an utterly misconceived attempt to associate the ideology of the movement with Dewey's *Art and Experience*), but rather because it epitomises the extreme antipathy to modernism that had become *de rigueur* among the Party's most authoritative cultural spokesmen. Thus the high point of twentieth-century American art for Finkelstein was the Ashcan School, because this came closest to a healthy and progressive realism. While acknowledging the political sympathies of progressive artists such as Gwathmey, Lawrence, Levine and Shahn, for him they had dallied too much with modernism: 'The limitations of a style based on the primacy of a decorative paint surface, or on subjective symbols and distortions, is that it is unable to do justice to the beauty or sensuous richness of human and natural life.' Significantly, his most extended comment was addressed to the work of Evergood, whose commitments he praised as those of 'a giant in . . . courage', but whose Expressionist devices he sharply criticised. For Finkelstein, the artist of the left who came nearest to an art that could 'speak to the common people' was Charles White.[80]

It is hard to imagine that the propagation of such narrow and crude views did not serve to alienate many artists who had displayed a loyalty to the Party in a period when the costs of Communist associations could be social ostracism, loss of employment and even imprisonment. Some evidence of this is provided by a mimeographed document circulated in the Party's New York artists' club in 1947,[81] which comprises a translation of an article from *Pravda* of 11 August, a commentary titled 'American Communist Artists Discuss the "Pravda" Article', and an unsigned and untitled rebuttal of the commentary by some higher-up. The *Pravda* article, 'Toward the Flowering of the Soviet Art', announced the decision to turn the All-Russian

Academy of Fine Arts into the Academy of Fine Art of the USSR and accompanied this with a statement about the functions of the new institution in building Soviet culture. What affronted the authors of the commentary was its incipient anti-Westernism, and its blanket assertions that the art of bourgeois societies was 'rotten', 'decadent' and 'formalistic'. To counter the example of Matisse and Picasso and others, the article held up that of 'a highly spiritualized Russian realistic art' deriving from Repin and Surikov.

As the authors of the commentary pointed out, the *Pravda* article displayed 'an oversimplified and non-Marxian concept of the relation between art and society'. Marx had specifically rejected the idea that ideology and culture mechanically reflected 'economic needs and processes'. Their rebuttal sought to distinguish between art that was produced in bourgeois society, and art that served bourgeois interests by rehearsing familiar arguments about the relative isolation of the artist under capitalism. However, while the modern artist was 'isolated from the main political currents of society' and could not produce an art that conveyed 'specific social messages', this did not mean 'his' work had no relation to social experience. The works of Cézanne, Van Gogh, Matisse and Picasso had contributed to 'the enlargement of human vision and feeling', and the study of non-Western art had led to the development of 'a new visual language with international and universal characteristics'. *Pravda*'s author had 'a static and limited approach to the question of realism'. While some bourgeois critics made 'absurd and extravagant claims' about modern art, it provided a rich resource for those who wished to use art as a weapon: 'in the ranks of progressive and communist artists throughout capitalist countries there are great numbers whose work in varying degrees is connected with the "formalist" tradition.'[82]

Like the Finkelstein of *Art and Society* (to which they referred), the authors of the rebuttal saw art generally as standing for values antithetical to capitalism, and could therefore envisage a broad alliance of artists working in different modes, all of whom were threatened by the current crisis. However, while this had been the vision of the Democratic Front, it was a position quite out of kilter with that of the Party's cultural leadership in the late 1940s. The critique of the artists' statement accused them of arrogance towards their Russian comrades and of ultimately falling into the camp of defenders of Western culture against the regimentation of 'eastern Communism'. Yet even this acknowledged that in looking to the Russian national heritage *Pravda* had

been 'diverted' from 'the more vital realist tradition of non-Russian painters of the 19th and 20th centuries', and failed to recognise 'the vital developments of social art in Mexico and the United States'. The author further implied that there was something to be learned from the work of Picasso and the School of Paris, and tried to qualify *Pravda*'s 'brash statement' that Soviet realist art was 'the most advanced in the world' by suggesting this did not mean 'the best in an esthetic sense', but only that which was 'at least ideologically, and in direction, the most advanced.' All the same, he expressed shock at the temerity of the artists in daring to question the Marxism of the CPSU. *Pravda* was correct in its critique of formalism which was premissed on the bourgeois myth of a classless art. It was not only art that directly propagated bourgeois ideals such as reactionary political cartoons and advertising that served the interests of the bourgeoisie as a class, it was also all art that did not directly ally itself with the proletarian movements.

For all the attempt to mitigate the stark crudity of the Soviet position,[83] the critique of the artists' statement could not disguise the fact that modernist techniques were now viewed as highly suspect, and Communist artists should not be indulging themselves in work with no direct political end. Charles Keller, whose studio on East 14th Street was a meeting place for one of the CP artists' clubs, has recalled that the statement was sent in to the *Daily Worker*, which refused to print it, and that the whole episode had the effect of further alienating abstract artists from the Party.[84]

The Crisis of 1956–1957 and its Aftermath

The debates of 1950 were not quite the end, however, and the pall of Zhdanovism lifted briefly in the last years of the decade. From 1950 to 1956, under the continuing editorship of Samuel Sillen, *Masses & Mainstream* was a sectarian Stalinist journal, with a limited number of regular writers. However, the crisis of the Party in 1956–7 fanned the residues of Communist culture into a brief spark of life before they died out for good.[85] In April 1956 Sillen stepped down as editor, to be replaced by Milton Howard, with Humboldt as managing editor. At the same time, the magazine's ongoing financial crisis forced a reduction in size from ninety-six to sixty-four pages,[86] and the editorial board was cut to two. In February 1958 Humboldt became sole editor, a position he held until July 1960. From September 1956 the magazine resumed the title of *Mainstream*.

In *Masses & Mainstream* as in other Party organs, the revelations of the xxth Congress of the Soviet Communist Party and the Soviet invasion of Hungary brought unprecedentedly frank exchanges and attempts at self-criticism. The open acknowledgment of anti-Semitism in the USSR was particularly troubling for Communist intellectuals, given the high proportion of Jews among them.[87] For a while, things were said about both the Soviet leadership and that of the CPUSA that Party members before could have voiced at most quietly and in private. Humboldt, one of the most intelligent and principled of the Party's intellectual lights, was able to use this climate to promote reviewing of a high calibre, despite the incredibly difficult circumstances in which he operated.[88] While he remained a member of the Party, Humboldt was highly critical of its leaders and of their outlook on culture. In a report of 1960, he referred to 'the well-known anti-cultural prejudice' within its ranks, and of 'an indifference, amounting to hostility on the part of many officials',[89] while of the record of its self-styled 'cultural leadership', he wrote privately: 'A crowd of intellectual pygmies wore the mantle of Marx, were wrong almost all the time, and still cannot see that the best thing that could happen would be if they announced that they believed at least half of them ought to be replaced by people willing to learn and closer to real life.'[90] At a more personal level, he had been deeply critical of the way Sillen had run *Masses & Mainstream*, and had a personally antagonistic relationship with Finkelstein, who, in turn, was rankled by his editorial interventions.[91]

For Humboldt the besetting weakness of Communist criticism to date had been that it was able to pronounce only pious generalities and usually fell flat when it came to the tasks of practical criticism. This position was grounded in a large perspective on art that explicitly rejected the familiar forms of Communist utilitarianism on cultural matters. In an important article of 1956, he wrote:

> To decree that art should make universal goals of such self-imposed limits as agitation and propaganda is to set the engineers of the soul to repairing the tracks of organization so that passengers may ride more smoothly – with the blinds down. Art is usually weakened when it adds the duty of solving problems explicitly to the task of presenting them suggestively.

While Humboldt likened art to science as a 'weapon' for progress, he also emphasised the differences between artistic and scientific knowledge, on the grounds that: 'There are no a priori rules for how the imagination shall conduct itself.'[92]

Yet at the same time as Humboldt wished to distance himself from the old-timers of the cultural movement and the discredited mantras of Stalinism, he was painfully aware of the isolation of *Mainstream*, and hamstrung by his inability to pay contributors.[93] The input of the few really gifted writers he could muster – Annette Rubinstein, Barbara Giles and Tom McGrath – was insufficient to fill the monthly issues, and because of the 'lack of competent people', Humboldt was forced to look abroad for material.[94] Hence under his editorship *Mainstream* published much work by British Communists, including some in the process of leaving the Party, among whom were Jack Beeching, John Berger, Christopher Hill and Arnold Kettle. From East Berlin, Edith Anderson also made a significant contribution.[95] Given the conditions under which the magazine was produced, it is impressive that Humboldt managed to print insightful and critical reviews of a wide range of contemporary literature by authors such as de Beauvoir, Ginzburg, Kerouac, Lessing and Salinger, as well as of major new sociological and cultural studies by the likes of Arnold Hauser, Irving Howe and C. Wright Mills.[96]

It was in this context that the last major exchange over the visual arts occurred, when a group of self-styled Californian 'progressive painters' published a collective critique of Finkelstein's *Realism in Art* that taxed its author with evaluating all art according to the standard of an 'ideal realism', in fact 'usually some variant of naturalism subjected to social interpretation.' Moreover, the tendency of his book was to move from general principles to the specific in a way that 'seems to us to violate the very materialist principle to which Finkelstein adheres', in that it took no account of the actual qualities of particular works or the historical circumstances of their production, and measured them by anachronistic criteria. Art was consistently graded by 'its scope to a one-to-one relationship with the historical moment' as Finkelstein saw it. The authors particularly attacked his judgements on twentieth-century art, according to which the work of the essentially naturalistic artists of the Ashcan School was superior to that of Expressionists such as Munch, whereas in fact the latter surpassed theirs in 'imaginative and formal power'.

Overall, his text exemplified the 'tactical approach that has plagued Left criticism for many years', and the authors called for its supersession 'by a strategic view of the complexity of human experience, desire and thought.' In the exchange that ensued, Finkelstein sought to position himself as one who was neither a 'formalist' nor a 'sociologist', but at the same time defended his view that the arts were in some degree progressive and interlinked with the larger growth of human knowledge – a position his opponents characterised as a kind of aesthetic Darwinism. The rejection of this principle by the Californian artists, Finkelstein claimed, left them with no criteria of realism. They, in turn, responded that Finkelstein sought to test art by norms of veracity that were inappropriate, because 'the truths involved in art are non-demonstrable, non-predictable.' At root, what was at issue was not only the question of art's specificity but also the claim that its truths were inherently subjective ones that could not be regimented by the immediate needs of the Communist Party or any other political agency. Truth in art, as more generally, was above Party. Although they did not say so, this was a lesson that the revelations of the xxth Congress had brought home to many who had long been dissatisfied with the operation of the left cultural movement.[97]

Those who emerged on top from the factional struggles of 1956–7, however, were precisely the same individuals who had always been fatally confused about the Party's relationship with truth. In 1959–60 Mike Newberry and Mike Gold attacked what they saw as the obscurantism and bohemianism of *Mainstream* in *The Worker*.[98] Although *Mainstream* defended itself vigorously, Humboldt was eventually forced to resign, and left the Party. With a new board, the magazine limped on until August 1963, but it was unable to attract the vital exchanges through which it had briefly achieved something like a truly Marxist quality in the late 1950s.[99] With a movement that had dropped from around 20,000 members to a mere 5,000 largely as a result of the crisis of faith among its own membership,[100] in all likelihood this hardly mattered. There was scarcely anyone left in the Party who could write effective Marxist criticism, and very few within it who would care if they did.

10 Social Art in the Cold War

This chapter has to be far more a narrative of individuals than my considerations of the earlier phases of social art for, as I have shown, the artistic organisations through which Communists operated from the early 1940s onwards simply could not provide the kind of collective displays their precursors had in the previous decade. Equally disorienting was the demise of the New Deal arts programmes, which had been so central to the definition of Communists' cultural vision under the Democratic Front. Congress's refusal to approve an appropriation of $100,000 to fund 'historical art records' of the war in 1943 underlined legislative hostility towards any further experiments in state patronage, and stood in marked contrast to the policy of the wartime state in Britain.[1] In the circumstances there was widespread concern with how artists would make a living in the postwar economy, and with the effects on art of a booming business culture, boosted by wartime production requirements and eager to adorn itself with the trappings of patriotism and public interest.[2]

Like the rest, Communist and fellow-travelling artists were forced to fall back on advertising work, dealers' exhibitions and the various museum shows. Yet the organised left had been such a force in the 1930s art scene that to begin with its members seemed capable of holding their own in these new conditions. Indeed, leftists were surprisingly successful with business patrons such as Pepsi-Cola, the *Encyclopedia Britannica* and La Tausca Pearls, who began to play a role in the art market in the 1940s.[3] However, the heyday of this phase of corporate patronage was relatively short-lived, and artists of the left remained largely dependent on private patrons with a taste for social art such as Joseph Hirshhorn, or on museum purchases. Their ability to attract either turned partly on their status in mainstream art criticism, and although in the long term the most authoritative critics were those associated with the new abstract painting, acceptance of this art was a gradual process, and its success did not prevent recognition of the value of more traditional practices except for its most doctrinaire defenders. (Greenberg is the exception, not the norm here.[4]) The key art magazines, *Art News* and the *Magazine of Art*, continued to print sympathetic appraisals of figures such as Evergood, Levine and Refregier into the 1950s. Given the decline of the Communists' own press and the increasing orientation of leftist artists to the gallery system and museums, the attitudes of such organs assumed a new importance in defining the public profile of social art.

Two general factors seem to bear particularly heavily on the character of such art after 1945, namely the impact of the war and the increasing marginalisation of the Communist Party in American political life. A significant number of Communist and fellow-travelling artists experienced military service and like other Communists in such circumstances were forced to confront the social world of ordinary Americans without the protective cocooning of Party culture. Some were also obliged to witness the horrors of fascism and war directly. Even for those who did not serve, endless reports of fresh barbarities, culminating in the use of atomic weapons against Japan, were an aspect of contemporary consciousness no politically aware artist could ignore, however difficult it might be to find forms adequate to address it. Reports of Nazi atrocities against the Jews were particularly traumatic for Jewish Communists, and contributed to a renewed sense of ethnicity that for many altered the 'delicate balance between ethnicity and universalism, and between *Yiddishkayt* and Marxism' that the Party's Jewish members had maintained in the 1920s and 1930s.[5]

The immediate aftermath of the war saw the greatest strike wave in American history, when 4.6 million workers walked off the job, and general strikes took place in a number of cities. But while Communists held influential positions in some unions, in few was there a strong left-wing rank and file. For all the labour movement's opposition to the Taft-Hartley Act of 1947, it gave anti-Communists within the CIO a weapon against Communist influentials, and the following year the Party compounded its isolation by opposing the main CIO leadership over the Marshall Plan and the Wallace Third Party campaign. Truman's victory and the humili-

ating defeat of the Progressive Party led to the isolation of the left in the CIO generally and formal expulsions of eleven left-led unions in 1949–50. Although the labour movement achieved an unprecedented standard of living for its members in ensuing years despite Taft-Hartley, it was at the cost of its larger social vision and union democracy. In these circumstances, Communist artists became largely divorced from the mainstream of organised labour. Their association with any mass political base – which had always been tenuous outside a few urban pockets – became increasingly a matter of fantasy. As a result, the symbolism of heroic labour became too removed from any palpable realites to be sustained, and the Party's artists by and large abandoned it.[6]

The effect of these developments on the character of social art was to make it more diffuse – in direct contradiction to the tendency of Party policy on the arts. The iconography of class struggle was in some degree replaced by symbolic imagery of the human condition, an imagery more specific and figurative than that offered by Abstract Expressionism, needless to say, but often allegorical and sometimes obscure.[7] Satire of the ruling class remained a key weapon for the left, but in the hands of its chief exponent, Jack Levine, it became the basis for Old Masterish oil paintings and fine prints rather than the medium of popular propaganda that committed artists of the 1930s had aspired to make it. While the Communist press called on them to relate to a collective audience, some artists responded to the perceived anti-humanism of abstract art by focussing on the genre of the individual portrait which assumed an enhanced resonance by contrast – as indeed did naturalistic imagery of the human figure more generally in face of the 'New Images of Man'[8] associated with modern art, which were for the most part primitivist and negative in their connotations. Given the Party's increasing focus on civil rights issues, it is hardly surprising that the African American painter Charles White should emerge as the most important Communist artist of the 1950s, at least at a symbolic level. The fact that White's work was the closest thing to Socialist Realism being produced in the US context (as well as being an art of genuine stature) must also have contributed to this. But despite the attempts to propagate an American Zhdanovism that I discussed in the previous chapter, the art of the left remained enormously diverse in stylistic terms, ranging from the tight naturalism of Honoré Sharrer[9] through to attempts to adapt modernist devices to politically charged motifs by Gwathmey and Toney. Before I examine these developments in more detail, it is necessary to consider who were the artists of the left in the postwar period, and what their relationship was with the movement of the previous decade.

Changing Personnel

By 1945 some of the main proletarian artists of the early 1930s had quit the Communist movement. Jacob Burck moved to Saint Louis in 1937 to work for the *Post-Dispatch* and in the following year joined the *Chicago Times*. A deportation hearing of the Immigration and Naturalization Service in 1953 took evidence that while the artist admitted having been a paid employee of the *Daily Worker* (though not a Party member), he had acted 'as a loyal and patriotic individual from 1938 to the present.'[10] Limbach, who had also done extensive cartooning for the Communist press, had certainly become a critic of Stalinism by the time of the Soviet invasion of Finland, and in 1945 he illustrated a laboured verse satire on socialism by the former Communist poet and critic Stanley Burnshaw.[11] By 1943, Joe Jones had self-confessedly lost faith in 'the political motive' that had driven his art hitherto, and in 1942 he left the ACA Gallery. Reviews of his 1945 exhibition noted a change of style in his work which, as a later critic put it, marked a shift from the 'homespun' to something more resembling Dufy or Segonzac.[12] In 1944, Ribak moved permanently to Taos where he established a school of art three years later, and began to paint abstract works.[13]

For doctrinaire modernists, there was perhaps even less reason for sticking with the movement as its moral and political credentials became increasingly tarnished. In notes of December 1939 Davis referred to 'the political provincialism of the Caucasian hill-billy Stalin', and next March he observed that Marxism was fallacious because 'it defines a human economy which excludes spiritual values.' While he continued to see modern art as a weapon against fascism in the early 1940s, he broke entirely with the collective groupings to which he had given so much energy during the previous decade.[14] In 1945 Ad Reinhardt was still lamenting Davis's 'political inactivity', but by the early 1950s he too had effectively withdrawn from the Communist movement – although he remained determinedly leftist in his political orientation.[15] For rather different reasons, Quirt had also never accepted the Social Realist aesthetic, and in the later 1930s his work became increasingly modernist in form. In the following decade he grew close to Davis and Romare Bearden, and in 1942 published a devastating critique of Social Realism, which, he

claimed, could not function as a vehicle for true artistic values. Quirt took a position at the Layton School of Art in Milwaukee in 1944, and thereafter supported himself teaching art at Midwestern universities.[16] Guglielmi's work after his discharge from the army in 1945 also suggests an engagement with Davis's example, and by the time of his solo exhibition in March 1948, his New York subject matter looked primarily an excuse for experiments in pictorial form. The haunting psychological tensions of his earlier work had disappeared, and with them its political edge.[17] Jacob Kainen moved to Washington, DC, in 1942 to take up a post in the Division of Graphic Arts at the US National Museum, and in the mid-1940s, learning he was under surveillance, severed his links with the New York left – although this did not save him from three security screenings between 1948 and 1954.[18] By 1950 his work was completely abstract in form, with no trace of the urban and political motifs that had preoccupied him in the 1930s.

Other veterans of the 1930s left did not leave the movement, but for various reasons played a less active role. Phil Bard's commitment to the Party was such that it sent him to Spain in 1936 to serve as political officer with the first International Brigade volunteers, although ill-health forced his early return.[19] Manuscript notes in Bard's papers show him to have been fully engaged in the debate over Zhdanovism in the late 1940s,[20] but in 1951 a heart operation left him paralysed down his right side, and while he continued to work as an artist, drawing with his left hand, he was an invalid thereafter. Lozowick moved to South Orange, New Jersey, in 1944 and seems to have largely withdrawn from the Communist cultural world in Manhattan.[21] Elements of his trademark iconography – industrial plant and electricity lines – continue to appear in his postwar prints, but from the mid-1950s he began to travel widely and his work thereafter was dominated by monuments and structures seen abroad, mixed with nature motifs. As late as 1950, Art News described Abraham Harriton as a 'veteran social realist' and he continued to show with the ACA Gallery, but from 1943 on he was increasingly preoccupied with technical problems, and particularly Old Master techniques of glazing and underpainting.[22] Olds, who also remained loyal to the ACA, worked as an illustrator reporter for magazines such as the New Republic and Fortune in the postwar years. However, her main interests shifted from the industrial workers of her 1930s prints to images of birds and children's books. Reviewers of her 1950 solo exhibition noted her abandonment of social motifs, and a new focus on more formal concerns.[23]

The work of some of those who remained in the movement, such as Gellert, Gropper and Reisman, showed no significant formal or intellectual development. However, that of others did – Neel, Solman and Raphael Soyer among them. Moreover, some of the younger figures who had gravitated to the party during the Popular Front continued to rethink the problem of social art in new ways. The most important of these were Gwathmey, Lawrence, Levine, Toney and White. In addition there were a few significant talents, such as Antonio Frasconi and Honoré Sharrer, who had no prior connection with the Party but were drawn to it in the last days of its cultural influence.

The New Symbolism

In April 1946, the Magazine of Art published an appraisal of the New York art scene by Milton Brown, which noted both the 'vogue' for abstraction and a new feeling among artists concerned 'with a more serious exploration of the social scene' that their means were inadequate. The 'most promising trend' he discerned among the latter was 'a social symbolism, which combines contemporary artistic concepts and a complex iconography.' Instances of this trend he found in the work of Evergood, Gwathmey, Shahn and Smith.[24]

The prominence accorded Evergood was not suprising. During the war he had consolidated his position as a favourite of the left through such topical works as the Boy from Stalingrad (1943), and twelve panels on the theme of American–Russian friendship painted for reproduction in a Russian War Relief calendar.[25] In 1944, his Wheels of Victory (Frederick R. Weisman Art Museum, University of Minnesota) won second prize in the 'Portrait of America' competition sponsored by Pepsi-Cola and Artists for Victory.[26] Two years later, the ACA Gallery put on a major retrospective of fifty-eight works, accompanied by a book-length catalogue with an interpretative essay by the art historian Oliver Larkin. The 1946 exhibition received no less than three reviews in the Communist press, and Mike Gold wrote an article in praise of it for the Daily Worker.[27]

Evergood's credentials as an activist were impeccable, but his was a complex and uneven art that challenged critics to find categories adequate to it. The artist's 1943 assertion that the highest objective was '[t]he prodigious feat of combining art, modernity, and humanity' acquired a new resonance in the postwar period with the supremacy of abstract art in various forms.[28] In many respects, his statements of the 1950s show him drawing

on key concepts in the current Communist repertoire, and especially in his repeated contra-distinction of humanism and formalism. From the same conceptual armoury came his insistence that he was not and never had been a naturalist or a 'photographic realist'. But on the other hand, his highly elastic conception of realism was emphatically not standard Stalinist issue. Realism was 'a state of consciousness of what's going on around one', and it was dependent on communication with an audience:

> Realism means being connected with this world, expressing emotions common to all Man. The extent to which an artist copies the forms of nature, *symbolizes* or *suggests* them, is a matter of temperament. The scope is vast and limitless for the realist – once he has mastered his technique – his is a free-flowing expression of life, sustained by contact with other people and the world around him . . .

Non-objective art, such as the work of Pollock, represented a '*retreat from life and reality*'. It 'was irrational' and non-'progressive', an academic elitist art that appealed primarily to the wealthy bourgeoisie. In some respects this model of realism resembles that of Lukács in its broad understanding of the cognitive dimensions of earlier art, but it is unlike his in its evaluation of modernism, since Evergood acknowledged the achievements of artists such as Beckmann, Chagall, Klee, Matisse, Rouault and Picasso – and was discernibly influenced by most of them.[29]

It was this broader concept of realism that enabled Evergood to justify the humorous and satirical elements in his work, which he consistently sought to validate through comparisons with Brueghel and Hogarth. To be popular, pictures needed to entertain, he is reported as saying. Modernism denominated 'Realism' and 'Satire' as 'bad taste' because they were 'useful', and contributed to 'social betterment'.[30] Similarly, and in line with a conventional trope of realist aesthetics, Evergood emphasised his concern with the 'affirmation of the ugly', with making 'art of what is not art'. Indeed, the complaint from a *Daily Worker* correspondent in 1944 that his images of the people were 'unnecessary and meaningless caricatures' prompted Evergood to make an extended self-justification. As some of his critics suggested, this ugliness was sometimes just a sign of aesthetic failure, but it was also the mark of a kind of deliberate anti-professionalism – as Fairfield Porter perceptively noted in 1952.[31]

There were also complaints that some of his symbols were so vague as to be near impenetrable. For Evergood

such devices were justified because there were aspects of life that could not be directly represented, its 'companion mysteries and intangibles'. As Larkin observed, his paintings could be understood partly as attempts to 'communicate emotions which lie far below the mind's surface':

> The strange confrontations, the paradoxes which result from this effort cannot be translated into words, and to indicate them is only to suggest undertones of dream, of fantasy, or pity and terror which trouble the mind yet somehow enrich, as the images of the Surrealists so seldom do, our sense of common humanity.

Despite his consistent populism, Evergood acknowledged that his art would not be understood by everyone: 'To create something original one must please himself first and last.'[32]

Looking back from 1964, Evergood observed that his work of the 1930s had dealt mainly with 'city life around 14th Street and Broadway.'[33] This perhaps makes it seem narrower in range than it was, but it had certainly centred on the social world of New York. Around the same time he told Donald Kuspit that in the 1940s his work had become more defensive, less realist, and this was largely in response to the growing interest in abstract art.[34] In 1958 he wrote of his 1930s paintings: 'I have a good many of the strong statements left but nobody wants them.'[35] If the 'multiplicity of meanings' Larkin found in Evergood's pictures of the 1940s was at the root of their mysterious and 'poetic' effect, it

163 Reproduction of *Dream Catch* in the window of Franklin Simon and Co., New York.

164 Philip Evergood, *Dream Catch*, 1946, oil on canvas, 30 × 20⅞ in., Hirshhorn Museum and Sculpture Garden, Smithsonian Institution, Washington, D.C., Gift of Joseph H. Hirshhorn, 1966.

could also suggest an indeterminacy that did not match his deeply felt political convictions. In contrast, some of his more explicitly symbolic works, such as his 1945 satire on militarism *The Quarantined Citadel* (private collection) and his attempts to represent the nuclear horror of the years following, as in *Renunciation* (private collection) and *The New Death* (Collection Charles Gwathmey), have too much the character of the 'leaflet' painting he rejected to be satisfying as works of art.

The ambiguity of his work and the incongruous situations created by the new business patronage are well exemplified by the small painting *Dream Catch* (fig. 164), which won second prize in a competition sponsored by the Heller-Deltah Company, manufacturers of La Tausca simulated pearls, in 1947. Ironically, the leftists Weber and Sharrer had won first and second prizes in the initial La Tausca Pearls competition in 1945–6 – a competition in which a woman with pearls had been the specified theme.[36] The 1946–7 competition had no such thematic limitation, and received a flood of entries from distinguished artists such as Guston, Lawrence, Levine and Kuniyoshi. A jury, which included Gwathmey, Weber and Raphael Soyer among others, awarded first prize to Abraham Rattner's Expressionistic *Christ and Two Soldiers*, with second prize going to *Dream Catch* and third to Byron Browne's *Circus Bandsman*.[37] By contrast with the showing of works from the 1945–6 competition at Portraits Inc. on Fifth Avenue, ninety-six entries from the second were exhibited in the less commercial ambience of the Riverside Museum. None the less, the relationship between any or all of the La Tausca pictures and the realm of advertising was vividly illustrated when a reproduction of *Dream Catch* was displayed in the window of Franklin Simon and Co. next to female mannequins wearing the latest 1946 fashions (fig. 163). Even so, the fact that Evergood placed a natural pearl prominently in his composition might be interpreted as an ironic comment on his patron.

Art News welcomed the picture as a move from 'indictment' to 'satire' and – not without justice – found it formally 'better coordinated' than Evergood's work had been for some time. It also pleased Joseph Solman, when he reviewed it for *Masses & Mainstream* two years later.[38] Evergood claimed the idea for the image came to him in a dream, and the painting as realised invokes the character of a dream at several levels. Formally, the departures from standard perspective and the scalding anti-naturalistic colour were well established devices for signifying oneiric experience. But the painting is also a dream in a thematic sense, in that the little

black boy floats effortlessly along with his huge fish, while the myriad white men enclosed in their scarlet fortress seem to angle fruitlessly. As such, the boy's dream is a classic image of displacement: aspirations blocked in reality are realised in the realm of fantasy.[39] What makes the work so poignant is partly that the dreams of this barefooted child are so modest. Given what might seem to be the picture's conscious Freudianism, it is perhaps worth noting that *New Masses* had printed an extensive debate on psycho-analysis in 1945–6, which despite its negative aspects contrasts markedly with the outright denunciations of Freudian psychology that appeared in the Party press at the beginning of the following decade.[40]

It would be reasonable to assume that the occasion for *Dream Catch* was provided in some sense by the wave of lynchings and other kinds of violence against African Americans in the postwar period. However, it is a sign of the shifts in Communist culture that in 1935 the artists of the John Reed Club had contributed to the contemporary campaign against lynching through a collective exhibition packed with works (many of them graphics) that depicted injustice and struggle under the slogan 'Pictures Can Fight!', while little more than ten years later one of the contributors to that earlier occasion (see fig. 52) was seeking to combat racial oppression through an image painted in the context of an advertising venture, the success of which depended primarily on the aesthetic status of the works it attracted.

The misrecognitions such works could prompt are illustrated by Henry McBride's review of Evergood's 1951 exhibition, in which he interpreted *Sunny Side of the Street* (fig. 165) as one of the artist's 'cheerful pictures', seemingly oblivious to the irony of the song that gives the picture its title, and to the tragedy of crowded slum streets where games are played among trash cans and the cycle of life is likely to be brief – as indicated by the ambulance in the middle distance (oblivious, too, to the political aspiration implicit in the inter-racial scene).[41] But if informed viewers could miss the rather obvious politics of such a work, what were they to make of the 'social content' of paintings such as *American Shrimp Girl* (fig. 166)? This is one of a number of pictures by the artist that centre on single images of women, and it was shown at his 1955 exhibition with two others, *Woman at Piano* (National Museum of American Art) and *Farmer's Daughter* (Collection Andrew Dintenfass). The first of these may be read as a satire on the trophy wife, the fastidiousness of the formal effects matching the doll-like face and languid elegance of the figure. By contrast, *Farmer's Daughter* is

an image of earthy abundance, in which an adolescent girl with a basket of fruit held under her breasts kneels in an orchard against a vista of apples and ladders. In this, as in *American Shrimp Girl*, with its numerous openings in lobster pots, shells and bones, and the blatant and suggestive juxtapositioning of the fish tail and the girl's crotch, the references to Freudian dream symbolism seem inescapable, and probably conscious. Seen from low down, the shrimp girl with her impassive look and bloated chalky thighs offers an overpowering image of adolescent sexuality. For all its faintly disturbing quality, the picture may be seen at one level as a riposte to the tubular legs of current screen idols such as Betty Grable and Marilyn Monroe, and to the image of the pin-up in general. By his own account, Evergood had some such satire on contemporary female stereotypes in mind with his women pictures of the 1950s[42] and, while hardly at the forefront of Communist political activity in the period, the 'subjugation of woman under capitalism, her dual exploitation as woman and as worker' and the critique of 'male supremacist ideology' remained recurrent themes in Party literature.[43] Obviously a great deal more could be said about these works than I have space for here, but I hope I have shown that there is a case for seeing them as being as rooted in Communist culture as Evergood's proletarian imagery of the 1930s had been.[44]

Reviewing the 1955 exhibition in the *New Yorker*, Robert Coates seems to have missed the satire of these pictures, beyond noting they had a certain 'circuslike air', but *Art News* came closer in its assertion of Evergood's seemingly indiscriminate absorption of such things as 'Advertisements, cosmetics, comic books, Tin Pan Alley, Mother, hair, pins, giant breasts, angry words, syrupy sentiments' and so on. *American Shrimp Girl* it characterised as 'The Great American Wide Open Dreck,' pointing to its 'debris-littered landscape' and 'bosomy girl with an expression of ecstatic insanity.' 'Ecstatic insanity' does not seem quite right, but 'Dreck' at least suggests the reviewer was discomfited by what he saw.[45]

In artistic terms, the 1950s brought Evergood considerable success, so much so that he found it difficult to paint enough to meet demand.[46] *Sunny Side of the Street* won a prize at the Corcoran Biennial in 1951, while four years later *American Shrimp Girl* came first in a competition sponsored by the Baltimore Museum of Art. In 1960 a large retrospective of his work was held at the Whitney Museum, which subsequently travelled to six other museums and was accompanied by a scholarly book by John I. H. Baur. This was probably the highpoint of Evergood's career, and the exhibition received a

165 Philip Evergood, *Sunny Side of the Street*, 1950, egg-oil varnish emulsion with marble and glass on canvas, 50 × 36¼ in., Corcoran Gallery of Art, Washington, D.C., Museum Purchase, Anna E. Clark fund, 1951.17.

long enthusiastic review in *Arts Magazine* by George Dennison, which remains the most acute appraisal of Evergood's later art. However, while Dennison grasped what Evergood was doing with the Social Realist aesthetic, to *Art News*'s reviewer it seemed he had simply given it up for Magic Realism.[47] This was to miss the point, for Evergood had abandoned neither his political nor his aesthetic commitments. In 1954 he spoke at an event honouring International Publishers on its thirtieth anniversary, and lent his support to the campaign for V. J. Jerome, convicted under the Smith Act in 1953. The year before his Whitney retrospective, he was both summoned before the House Committe on Un-American Activities and elected to the National Institute of Arts and Letters. He left the board of *Masses & Mainstream* when it was re-organised after the 1956 crisis, but this

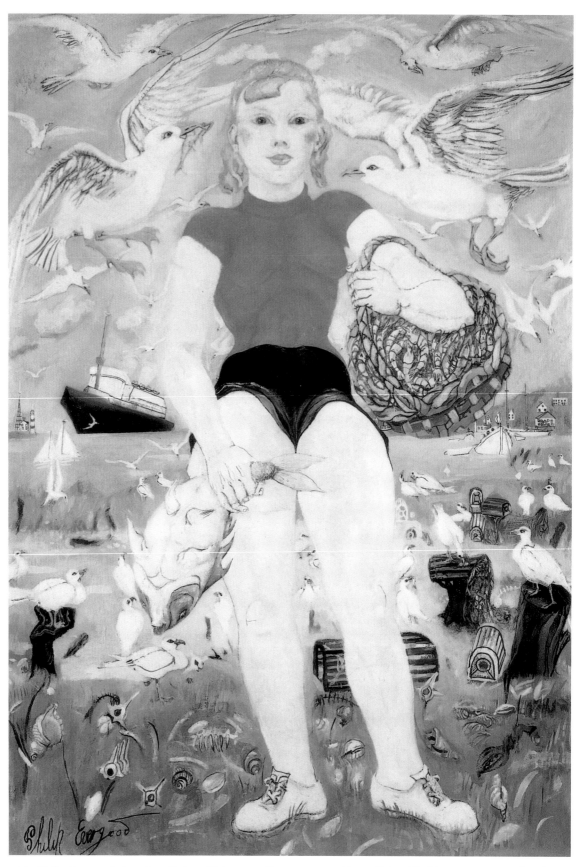

166 Philip Evergood, *American Shrimp Girl*, 1954, oil on canvas, 48¹/₄ × 32³/₈ in., Hirshhorn Museum and Sculpture Garden, Smithsonian Institution, Washington, D.C., Gift of the Joseph H. Hirshhorn Foundation, 1966.

does not seem to have signified any estrangement from the magazine, which printed a warm review of the Whitney retrospective[48] and continued to make occasional use of his drawings for illustrative purposes. In a 1964 interview with Donald Kuspit, Evergood maintained that while he still admired the USSR, he did not like the authoritarianism of Soviet society. Socialism remained a long-term ideal, but it was one that artist and proletarian should contribute equally to attaining.[49]

Siporin's route to his 'new symbolic style' (as *Art News* dubbed it in 1946) was different from Evergood's, and so were the reference points of his symbolism. Like Evergood, he had a reputation as a humourist and indeed had established his name as a caricaturist before he became widely known as a painter. Although his standing in the late 1930s depended primarily on his work as a muralist, he had produced an important series of gouaches on the Back of the Yards district of Chicago for the FAP easel division that were much liked by the administration and widely exhibited, and in 1939 the Museum of Modern Art bought one of his oils.[50] The works in the artist's first solo show, held in New York in 1940, surprised the critics by what was variously described as their 'romantic' or 'semi-surrealist' treatment of social themes and emphatic paint textures.[51] Significantly, the venue for this display was Edith Halpert's Downtown Gallery and not the ACA. Although not a fellow-traveller, Halpert was certainly a liberal in her political outlook. She was a warm supporter of the WPA and state support of the arts, and had a longstanding connection with social art.[52] Correspondingly, leftists were strongly represented in her stable, among them Crawford, Davis, Guglielmi, Lawrence, Levine and Shahn. But their work had a more modernist character than that of the ACA team generally, matching in this regard that of her less engaged clients such as Marin and O'Keeffe.

The mural aesthetic involved Siporin far more than Evergood (who never painted a fresco), and his works of the postwar period can be understood at one level as an attempt to cram the ambitions of his historical and social series of the 1930s into the framework of the single easel picture – as some contemporary critics recognised.[53] To begin with, the subject matter of his new work came directly out of his wartime service, most of which was spent with the Information and Historical Service of the Fifth Army. Siporin regarded his experiences of the campaigns in North Africa and Italy – where he witnessed the public display of Mussolini's corpse in Milan and the liberation of a concentration camp[54] – as marking a decisive turning point in his development. Although his wartime drawings are full of

compelling images of devastation, it was not warfare as such that gripped him so much as the spectacle of the North African and Italian peoples moving among the debris of their history: 'I discovered that the realities that most interested me in painting, the life that most stimulated my imagination, excited my emotions and creative impulses existed in panoramic proportions in both these places.' He used the Guggenheim Fellowships he received in 1945 and 1946 to produce a body of work that drew on what he had seen (see fig. 167), and in 1950, having won the Prix de Rome for Painting, he returned to Italy, travelling widely and steeping himself in the 'museums and monuments of Europe'.[55] The world of the Midwest, so central to the iconography of his prewar work, was completely discarded. At the same time, he became increasingly interested in the example of Italian fresco painting, adding Masaccio and Piero della Francesca to Orozco in his gallery of 'favourite artists'.[56]

In Siporin's own estimation, as well as that of others, his most important works of the immediate postwar period were *End of an Era* and *Endless Voyage* (fig. 168), both of 1946. The former is a complex canvas, 40 × 52 inches, packed with mannequin-like forms in a composition that suggests both the complex figure hierarchies of fifteenth-century Italian painters such as Benozzo Gozzoli and the spatial incongruities of modernist art. Although there is an implied causal connection between motifs in the upper part – the corpse of Mussolini to the left and various other references to his career[57] – and the funeral scene in the nearest plane, the picture works as much as a conglomeration of symbols as it does as a narrative. When *End of an Era* was exhibited at the Pennsylvania Academy in 1947, Dorothy Grafly singled it out in her *Art News* review as representative of a 'weird current of disillusion' prominent in the show. And on the basis of such works, another critic writing for the magazine later in the year associated Siporin with 'such social fantasists as Beckmann and Peter Blume'. The picture won first prize at the Chicago annual of local artists, but received several negative comments in the local press. Ivan Albright damned it as 'an incurably inane effort at painting', 'far more appropriate at the head of a May Day parade banner . . . than flaunting its hysteria on a Museum wall', capping this little piece of red-baiting with the anti-Semitic slur that the exhibits by Siporin and his mother were 'the only wailing wall' on show.[58] Whatever grounding this political and racist invective had in Albright's personal outlook or in art-world competition, it indicates that Siporin's work had not lost its association with social art because of his changes in style and motif.

167 (*right*) Mitchell Siporin, *Festa in Tuscany*, 1945, casein, 20 ¹/₂ × 26 ⁷/₈ in., collection of Cranbrook Art Museum, Gift of George Booth © Cranbrook Art Museum. Exhibited at the Downtown Gallery Siporin exhibition, October–November 1947.

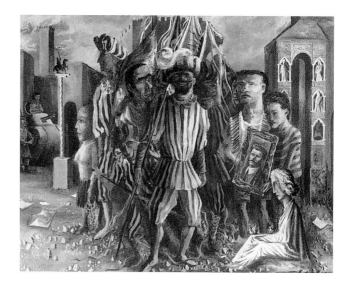

168 (*below*) Mitchell Siporin, *Endless Voyage*, 1946, oil on canvas, 34¹/₂ × 39³/₈ in., University of Iowa Museum of Art (1947.44), © The University of Iowa Museum of Art.

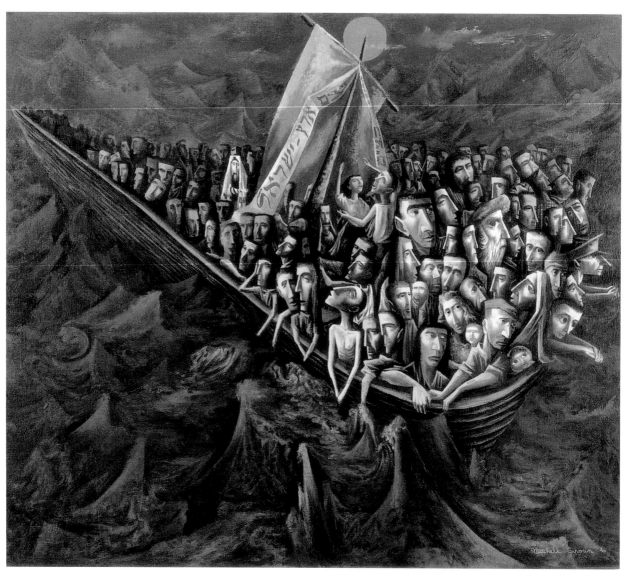

Like *Mountain Passage* (De Cordova Museum, Lincoln, Mass.) of the following year, *Endless Voyage* symbolises the plight of refugees, in this case Jewish 'Displaced Persons'. Siporin regarded it as one of his 'strongest social expressions'.[59] The picture is smaller than *End of an Era*, but it too is crammed with figures, all compressed into a teardrop-shaped vessel that seems too small to contain their bodies, perilously placed in a stormy sea under a glowering sky and bloody sun. The bow of their ark seems to point against the grain, and most faces are turned backwards to what they have left behind. Siporin said the sensation he wished to suggest came from the experience of a troop ship voyage back from Italy, but the contemporary reference point he is likely to have had in mind was the plight of illegal Jewish immigrants being turned away from Palestine, and the sail of the boat bears the words 'Land of Israel' in Hebrew.[60] The picture must have resonated even more powerfully after the debacle over the refugee ship *Exodus 1947*, which took place between July and September, and was used to great effect by Zionist propaganda to demonstrate the 'inhumanity' of the British administration and the alleged anti-Semitism of the Foreign Secretary, Ernest Bevin. Intercepted by the British navy off the Palestine coast, the *Exodus 1947* was taken to Haifa, where its passengers were transferred to three other ships. After they refused to accept asylum in France, they were sent to the British zone of Germany and forcibly disembarked. *Humanité*, the French Communist paper, dubbed the three ships 'a floating Auschwitz', and the plight of the refugees was a major theme in critiques of British imperialism in the American Communist press.[61] However, the archaicism of Siporin's boat and the Expressionist conception signified a more general comment. At least, this was certainly how *Fortune* read the picture when it featured it in December 1946 as 'one of the most striking efforts to come from an American artist since the formal war ended'. *Endless Voyage* was 'not a statement but a question – a question that echoes and re-echoes in the ear of all mankind: that is wordless, but thunders', namely the conundrum of 'humanity's destiny'. Siporin had phrased this question 'in terms of Judaism', but it spoke equally to the Gentiles.[62]

It was predictable that works that appealed to the middle-brow press as symbols of the human condition would seem to Communist critics insufficiently partisan, a masking of the real and precisely identifiable causes of contemporary suffering through obscure evocations of fate. The *Daily Worker*'s Marion Summers already discerned the 'remnants of the formalist tradition' in Siporin's *Verdict*, a relatively direct image of partisans gathered round the hanging bodies of Mussolini and his associates shown at the Downtown's *Six Artists Out of Uniform* exhibition in 1946. He disliked the 'confused and dreamlike quality' of the picture, and the representation of the partisans as 'a mob of distorted and inhuman puppets'. Later in the year, Summers compared *Endless Voyage* unfavourably with the work of Shahn (showing together with Siporin's at the Downtown's annual), complaining that his figures reduced persons to 'paper dolls', lacking in both 'individuality' and 'reality'. Siporin's symbolism was weaker than Shahn's because it was more removed from a 'particular condition'. Both, however, were afflicted by the 'pessimism which attacks so many sensitive people in our society', and which was 'a dominant note in bourgeois culture'. Perhaps too, unspoken, was an unease with what might be read – despite *Fortune* – as a picture of specifically ethnic protest.[63]

Pessimistic symbolism, in both abstract and figurative forms, was not just a vogue of the immediate postwar years. Indeed, by the time of the Whitney's 1949 annual, it had become such a besetting feature of contemporary American art as to prompt comment in a *Life* magazine editorial.[64] That such art matched the outlook of key players in the 'cultural apparatus' is evident from Thomas B. Hess's review, where he hailed the exhibition as the 'best one of its kind' in his memory.[65] Like other up-and-coming critics, Hess foregrounded the abstractionists – de Kooning, Pollock, Hofmann, Knaths, Motherwell and Greene in this instance – and wished that the 'one painting per painter' rule might be waived to permit the showing of more of their work at the expense of less worthy talents. However, he acknowledged the excellence of paintings by Beckmann and Shahn, '[t]wo of the most influential artists in America', and noted that their 'devices of allegory and social realism' were 'echoed in almost every room' in the show. One of the works that stood out in this vein was Alton Pickens's *Carnival* (fig. 169), a picture that despite its 'unpleasantness' commanded 'attention and respect'. Like other critics, Hess associated Pickens with such artists as Jared French, Henry Koerner and George Tooker. However, unlike theirs, Pickens's painting had a direct political significance, in that in the context of the late 1940s such a Goyaesque concatenation of symbols of superstition (the rightmost figure) and false witness (the leftmost figure and ape) could only refer to the antics of the House Committee on Un-American Activities, as *Life*'s description of it as 'a ghoulish parody on loud-mouthed frauds who pose as defenders of liberty' seems to imply.[66]

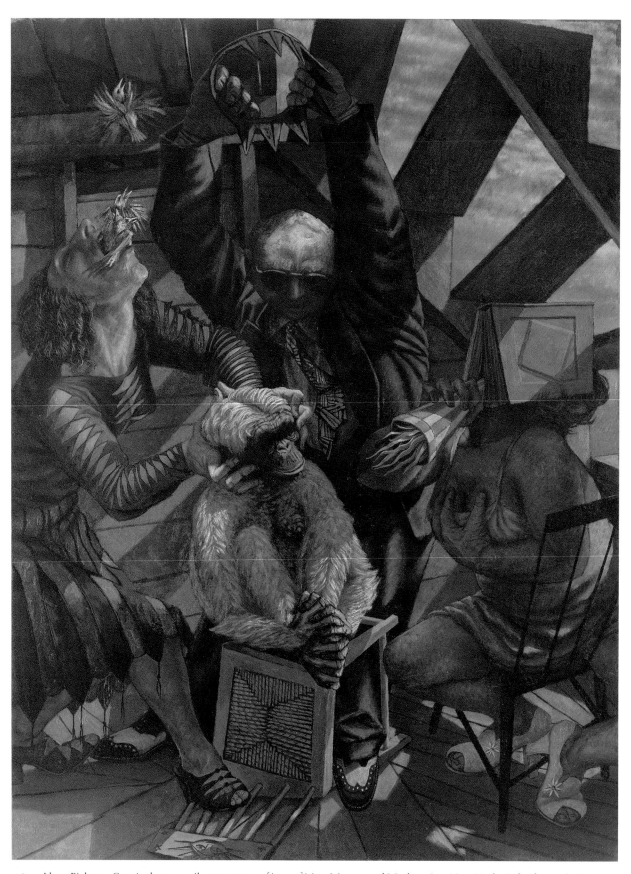

169 Alton Pickens, *Carnival*, 1949, oil on canvas, 54⁵/₈ × 40³/₈ in., Museum of Modern Art, New York, Gift of Lincoln Kirstein.

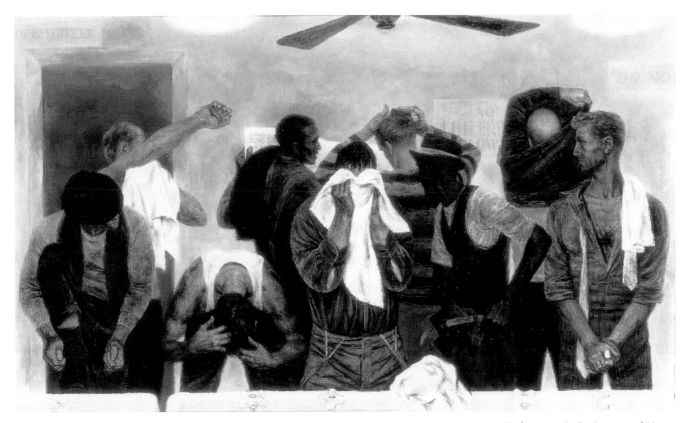

170 Joseph Hirsch, *Nine Men*, 1949, oil on linen, 38 × 64 in., Smithsonian American Art Museum, Washington, D.C., Bequest of Henry Ward Ranger through the National Academy of Design.

Pickens proudly asserted his associations with the labour movement, and described his art as an 'attempt to capture the warping of the truth and the fiction into one schismatic reality', to point out the differences between 'a nation's posturing of democracy' and 'its practices'. Yet despite this, his art was again too negative, too concerned with senseless 'phantasmagoria' to appeal to Communist sensibilities.[67] The paintings by him shown at the Museum of Modern Art's *Fourteen Americans* in 1946, such as *The Cardplayers* and *The Game of Pretend*, struck Marion Summers as pervaded by 'an overwhelming bitterness'. His figures – 'stunted and crippled, twisted into gnome-like caricatures performing grotesque rituals' – showed the artist's 'hatred of injustice', but his 'cynical distortion of people defeats his own purpose.' None the less, he distinguished between Pickens's art and that of Tooker, which he damned as simply 'degenerate', with no apparent concern for the historical resonances of that term.[68]

Clearly the artists of the left were not without talent or status in the late 1940s. Siporin's enigmatic image of alienation, *Dancers by the Clock*, was bought by the Whitney Museum, Pickens's *Carnival* was given to the

Museum of Modern Art by Lincoln Kirstein in 1951, and the year before Joseph Hirsch's *Nine Men* (fig. 170) – a work that came closer to the Social Realist paradigm in its dignified image of inter-racial fellowship among working men than almost any other of the decade – was awarded fourth prize in the Metropolitan Museum's much heralded national exhibition of American art.[69] But ironically, their art had more appeal generally to the critics of the mainstream art magazines than it did to those who wrote for the Communist press. It is a sign of how crippling the Manichean polarities of Communist political and cultural analysis were at this point that the Party's leading critics could make no significant distinction between a universalistic pessimism about the human condition associated with Abstract Expressionism – which they rightly perceived was grounded in irrationalist philosophies and mysticism – and the historically specific satires and imagery of contemporary tragedy that preoccupied left-wing artists such as Pickens and Siporin. And this despite the manifest differences in the artistic forms they deployed, with all that implied about different conceptions both of audience and the value of rational criticism. The Party's Polyan-

nish fantasies of the Soviet Union demanded an imagery that projected faith in the future in this moment of *The Twilight of World Capitalism*,[70] and which did so through an heroic or at least 'humanistic' picturing of 'Man'. The counterpart to this blindspot in the Communists' critical eye was, of course, the inability of popular magazines such as *Life* and the art press to make any such distinction either. But then they had no interest in doing so; the Communists arguably did.

Siporin went on to a distinguished academic career as Chair of the Department of Fine Arts at Brandeis University. By the middle of the decade references to contemporary culture in his work had become so oblique as to be virtually impalpable.[71] Pickens continued to produce thinly veiled satires on McCarthyism in the early 1950s, but thereafter his symbolism was increasingly hermetic, and in the 1960s he turned to sculpture. He was also unprolific. The solo exhibition he had at the ACA Gallery in 1956 was his first, and the year before he described himself as a 'Sunday painter' who lived by teaching.[72] Any association between either Siporin or Pickens and the Communist Party seems to have ended by 1950.

Socialist Humanism and the Portrait

For Communists and liberals alike, the key stakes in critical discourse on the arts in the 1950s – politically speaking – were represented by the term 'humanism'. Among the former, humanism was widely associated with a view of the human condition that was optimistic and progressivist, and that emphasised the individual's rational powers and capacity for collective effort in the pursuit of social betterment. For them, humanism was an attribute of the progressive forces in history. It was an outlook the bourgeoisie itself had developed in its phases as a rising and revolutionary class, but that it was unable to maintain in its current decadence and decline. Indeed, latterly its dominant outlook was characterised by 'ideas of chauvinism, of pessimism, of "eternal warfare" between the "individual and society", of the "unknowability of reality", of war as inherent in human nature, of man's mind as the eternal slave of mysterious subconscious forces.' This assumed outlook was correspondingly characterised as 'anti-human', and was manifested across the arts of Western societies in 'formalism' and what was perceived as an absence of human content.[73] In the visual arts specifically, it was revealed by the perceived dehumanisation of abstract art, or in distorted images of the figure that projected the individ-

ual as anguished and isolated, prone to irrational subconscious drives and primal emotions. The connection between contemporary avant-garde art and a pervasive ideological formation of this type was not in fact illusory, however reductive Communist explanations of it usually were. Indeed, we can recognise in it something broadly similar to the 'Modern Man Discourse' that Michael Leja has shown underpinned Abstract Expressionism.[74]

Before the Second World War, many liberals had shared something of the Communists' optimistic view of the human condition; it was partly because of this that cooperation between them around the New Deal had been possible. However, the bleaker tenor of Cold War liberalism matched with an utter scepticism towards the USSR and acceptance of bourgeois democracy as the best social model available, although some liberals hoped that democratic capitalist societies would gradually evolve towards some kind of more socialised economy. Historians of Abstract Expressionism have argued persuasively that this shift in the tenor of liberalism is crucial to understanding the positive critical reception of the movement, but they have not located this response in relation to the rearguard action of artists and critics around the Communist movement who continued to defend the paradigm of social art, and thus miss something of the negative thrust of such criticism and of the political issues at stake.[75]

Partisans of contemporary modernism responded in one of two ways to charges of anti-humanism, which seem to correlate with their respective institutional positions. Avant-garde critics and artists refused the idea that humanism, in the traditional sense, was any kind of relevant criterion. Thus Harold Rosenberg and Balcomb Greene defended the idea of 'pure art' and of specialisation in the pages of *Art News*. According to Rosenberg, the humanists' argument contra formalism was 'primarily . . . a *political* argument . . . It is designed to shark up a militant solidarity of Plain Men in behalf of an ideology seeking social power and to "integrate" the artist into a *polis* ruled by this ideology.' The 'separate nihilisms of the professions' were a necessary bulwark against totalitarianism, and the revolutionary party was just one group of professionals seeking to impose their extraneous demands on artists. Consequently, artists should not seek to make their work subservient to the demands of 'History' – however imperative these might seem, since the 'irreconcilability of art and ideological utility' had been demonstrated beyond question by the 'debacle' of American painting of the 1930s.[76] Similarly, Greene advocated the 'radical personalization of art' as

a kind of moral responsibility of the artist, and the only defence against what he called 'a rampant materialism and the blight of conformity'. The situation in which contemporary artists were working demanded a refusal of demands of 'communication' with any putative community.[77]

Institutional voices tended to reject the charge of dehumanisation as such by shifting the meaning of humanism so that it referred to something like a concern with the human condition in a more pessimistic sense, corresponding with Cold War liberalism. Thus, in one of the earliest synthetic statements on Abstract Expressionism, William Seitz, then 'critic in residence' at Princeton University, asserted:

Far from aiming at a programmatic abstraction of dehumanization, *human content* – interpreted in terms of a reality that is felt, rather than experienced visually or tactilely, is a central concern of American art today. Despite extreme difference, its common subject matter is the response of the individual and group self to existence in the modern world.

Moreover in charging the contemporary artist with undue 'preoccupation with formal means', critics missed the fact that 'the painters' and sculptors' empathic identification with materials, technical processes and structure is a symbolic function of the entire personality.'[78] The catalogue to a major exhibition with the title *New Images of Man*, shown at the Museum of Modern Art at the end of the decade, opened with a statement by the existentialist theologian Paul Tillich which interpreted the art on display as an attempt to assert the humanity of the artists in the face of both the 'dehumanizing structure of the totalitarian systems' and 'the dehumanizing consequences of technical mass civilization'. The exhibition's curator, Peter Selz, presented the international roster of twenty-three artists, who ranged from Appel, Bacon, Dubuffet and Giacometti to de Kooning and Pollock, as offering profoundly personal works in some sense set against the 'stereotypes and standardizations' that dominated contemporary life. They were painters and sculptors who, 'courageously aware of a time of dread, have found articulate expression for the "wounds of existence"'.[79] Thus partisans of contemporary modernism and its enemies on the left alike tried to claim title to greater human significance.

Although the debate was often inflected by Cold War rhetoric, that this was not simply a struggle between political right and political left was well understood at the time. As Rosenberg noted, those putting demands on art in the name of 'community' came from both sides of the spectrum. But beyond this, the letters columns in art magazines suggest that many artists and art-world professionals were alarmed by the hegemony of modernist abstraction, its authority in museums and the art press, and the corresponding devaluation of traditional skills and almost all variants of naturalism. The coming together of artists with diverse political inclinations that the situation brought about is clearly illustrated in the magazine *Reality*, subtitled '*A Journal of Artists' Opinions*', which appeared three times over the years 1953–5.

Reality was initiated by Raphael Soyer. To begin with it centred on a group that included Evergood, Hirsch, Hopper, Kroll, Poor, Shahn and Wilson, which had its first meeting in March 1950 at the Del Pezzo Restaurant in New York. An opening 'Statement' over forty-seven signatures asserted:

Today, mere textural novelty is being presented by a dominant group of museum officials, dealers, and publicity men as the unique manifestation of the artistic intuition. This arbitrary exploitation of a single phase of painting encourages a contempt for the taste and intelligence of the public . . . These theories are fixed in a ritual jargon equally incomprehensible to artist and layman.[80]

Such characterisation of the groups promoting abstract art suggests that, like the artists' organisations of the 1930s, *Reality* was partly an attempt by artists to assert their professional competence in the face of the authority represented by curators, collectors and critics.[81] Of the forty-seven, many had been or were leftists, but they also included Bishop, Burchfield and Hopper, who had no such political identifications.[82] Neither did they hold to any single aesthetic line. The editors explicitly denied that the title 'Realists' could serve as a 'rallying point' for the group,[83] and some of those involved practised in idioms that were essentially modernist, among them being Lawrence, Solman and Toney.

As their 'Statement' indicates, the *Reality* group also aimed to challenge the validating discourse on abstract art, and in issues 1 and 3, Maurice Grosser published articles pillorying the vagueness and pretentiousness of contemporary criticism through quotations taken mainly from *Art News*.[84] These charges did not pass unanswered. An editorial in *Art Digest* characterised the 'Statement' itself as the 'language of reaction', while in *Art News*, Frankfurter associated *Reality* with a Soviet-type critique of abstraction, but declined to attack it to avoid any association with 'the McCarthys or Donderos'.[85] It is likely that Rosenberg's withering

assault on 'Community Criticism' in the February 1956 *Art News* was also partly a response to the *Reality* group – or so his references to those with 'vested interests in certain obsolete techniques' and his concluding aspersions on Levine suggest.[86]

Inevitably, the group's institutional animus was directed primarily against the Museum of Modern Art, and the first issue printed a letter to the directors that discreetly blamed the museum for disseminating 'the fast-spreading doctrine that non-objectivism has achieved some sort of esthetic finality that precludes all other forms of expression', and called on it to arrange a more balanced programme. However, at two conferences between the editors and the directors the latter denied they were giving 'undue attention to non-objective art', a position they reiterated in a letter of reply in *Art Digest*. Here, d'Harnoncourt, Barr and Ritchie defended the Museum's record in showing and purchasing American 'realists' and 'expressionists', and asserted that they favoured no 'single point of view': 'We believe that diversity is a sign of freedom of expression inherent in any democratic society.' They in turn reminded the publishers of *Reality* 'that even as noble a word as humanism has recently become converted into a mask for several varieties of dogmatic intolerance.'[87]

Indeed, from the outset, *Reality*'s editors had identified their common perspective with 'humanism', and several statements about the term appeared in the magazine.[88] In response, *Art Digest*'s columnist Otis Gage sought to query the group's monopoly on the title, pointing out that 'humanism' was 'not a style of painting' but a rather vague 'philosophical concept' with no single artistic corollary. For him, what was 'offered as humanist art in the United States is sentimental and old-fashioned', 'illustrations of contemporary scenes' that were 'not necessarily expressions of modern reality.' By contrast, the 'American avant-garde is reaching out and has already produced a movement and certain individual works that promise a fruitful development.' This was the case because any art that would 'make a claim on our imagination' needed 'a value in the realm of form,' and since humanism was necessarily a 'changing concept' it demanded new forms.[89]

To this argument, Raphael Soyer replied directly in a symposium on the human figure published in November, precisely reversing Gage's evaluation:

> Certainly, the human figure – and by that I mean man and his life, his attributes, his habitat – human content in general, can be re-interpreted and have validity for our times, as it has been re-interpreted in each successive epoch throughout the ages. The human figure is

being painted today, at this moment, in forms adapted to our times, in many manners and styles, humbly, poignantly and meaningfully.[90]

Abstract Expressionism, by contrast, was 'meaningless', 'illogical' and 'unnatural'. In effect, the claims of both artist and critic were apodeictic ones that represented a clash of different values neither fully articulated. Although Soyer was famously described as a diminutive shy man who spoke in a 'husky whisper', even as 'gentle and elflike',[91] he was a vocal and pugnacious defender of realism in the postwar years. A profile of the artist, published in 1951 when he won first prize in the Corcoran Annual, reported that for him non-objective art was 'expressive of disillusionment, miasma and death.' In an impromptu address at the exhibition opening he called on his fellow artists to 'paint humanistically and intelligently, Man, and what Man touches, his aspirations, and whatever happens to him in this eternal struggle for a better life.'[92] It is this last phrase that gives away the political implications of Soyer's humanism, for such an expression had no part in that alternative model exemplified above by Seitz, Seltz and Otis, in which all the emphasis was on individual estrangement and isolation, and the forms of collective life appeared part of the problem rather than the route to a solution.

I want to be clear that I am not claiming Soyer's statements of the postwar period had any programmatic connection with criticisms of the 'anti-human' character of abstract art being advanced contemporaneously by critics in the Communist press, any more than his paintings of the 1930s had been attempts to embody the aesthetics of proletarianism and social art. The evolution of the Soyers' work out of the model of the Ashcan School and its kinship with Henri's aesthetic are clear enough. What I am claiming is that the positions were complementary, and given Soyer's continuing commitment to progressive political causes this is unlikely to have been coincidental.[93] In his 1972 monograph on Soyer, Lloyd Goodrich was at pains to emphasise that his art, even in the 1930s, was not 'political'. This is true in as far as Soyer consistently rejected the idea of art as propaganda, and he was quoted in 1941 as saying he thought it 'futile to paint social content pictures consciously'. But if his work was conceived without any propagandistic intent, it had always stood as an affirmation of class solidarity, a quality that prompted *Art Digest* to observe in 1938 that his images of dancers and models, just as much as his images of the unemployed such as the impressive *Transients* (1936; University of Texas at Austin), had a 'message for the downtrodden'. This pictorial solidarity with the common man and woman con-

tinued after the war, and he told the author of a 1948 profile: 'I paint what's nearest to me, the plain people I mingle with and understand.'[94] Correspondingly, he claimed to '*value the opinion of people* whose judgement is derived from daily experience above the opinions of esthetes, sophists and rationalizers ad absurdum.'[95]

If pictures of people had no single political meaning in the 1940s and 1950s, they continued to have distinctive connotations for those on the left, and this helps to explain the importance of the portrait genre in the work of painters such as Soyer, Solman and Neel, who maintained their political beliefs in these years. For all three – as for other artists I have looked at – the decline of the Communist-led left can be registered in terms of a more private iconography, in their case one focused on individual interactions and the studio. Neel largely abandoned the Social Realist motifs that had been one aspect of her 1930s output.[96] Solman painted fewer of the New York urban scenes with which he had made his reputation, and in his exhibitions of the late 1940s and 1950s appeared primarily as a painter of studio interiors and portraits. And Soyer, too, turned increasingly to portraits and studio themes, and when he depicted labour did so in interior scenes of seamstresses. In 1951 he was reported as saying that he now found the New York streets 'too choked, out of tune, brassy.' Although he contemplated painting the Union Square demonstration against the execution of the Rosenbergs on 19 June 1953, the picture was never realised.[97]

None of the three was interested in the portrait in the conventional sense of the term. Soyer painted a fair number of commissioned portraits when he was struggling to make a living at the start of his career, but never liked doing it. In 1984 he remarked that he always tried to 'penetrate people' and consequently: 'I have to know them intimately. I never paint a portait of a person I don't know well.'[98] The figures in his genre paintings were highly particularised, effectively portraits, and there are no clear lines dividing the portraits, nudes and single figures of women in his postwar art. Although his work became more broadly painted in these years, figures always appear to be distinct individuals.

As early as 1935, a reviewer had noted Soyer's attraction to 'New York office girls, of the thin, wiry, alert, efficient type who are the mainstay of our commerce', a 'type', moreover, that was not 'particularly enticing'. Such reviewers were somewhat discomfited by his presentation of proletarian women, who were treated with a kind of gravitas – endowed with a sense of interiority – not evident in the work of say Sloan.[99] This interest in

the theme of the modern woman was also manifest in some powerful portraits of women in the studio such as *Mina* (fig. 171) and *Girl in Black Jacket* (Metropolitan Museum of Art), both of 1932. Although the formal debt to Degas is as evident in these as it is in *In the City Park* (see fig. 56), with their tense poses and assured looks, these figures signify a kind of bohemian self-possession quite unlike anything we can find in Degas's imagery of working-class women. For instance, *Mina* can be usefully compared with Degas's portrait of the Italian art critic *Diego Martelli* (fig. 172)[100] in its asymmetrical composition and upturned perspective. Not only is a naturalistic portrait type developed to depict male artists and intellectuals recycled for a new kind of female subject, but also the sitter is given a kind of four-square frontality and bodily assertiveness that make her slender frame project a sense of individual determination and personal worth despite her anonymity.[101]

From his earliest experiments with modern city themes, Soyer had been concerned with suggesting the inner life of his subjects. In the 1930s there had usually been a social cause to the moods signified, which were generally the boredom and lassitude so characteristic of Depression experience: homeless men lounge despondently on park benches or sit hunched up in relief offices, young women wait in casting offices or backstage, railroad passengers await the announcement of their train. Moreover, as Ellen Wiley Todd has observed, the tired-looking single women Soyer depicted contemporaneously sitting on beds with magazines or just sleeping can stand as the after work counterparts of his smart shop and office girls moving confidently through the city.[102] Soyer himself said of his models that they were not professionals, but 'mostly young girls who are interested in dancing or writing or philosophy. Usually they are not very happy.'[103] In his paintings of the 1940s and 1950s this concern with inner life was maintained, but his figures seem to project a more generalised introspectiveness that is sometimes reminiscent of Corot's studio figures, as in the Carnegie Institute's *Pensive Girl* (1946–7). Even when there are markers of a specific locale, such as the brownstone façade of the Whitney Museum's *The Brown Sweater* (1952; fig. 173), the motifs often seem more tritely humanistic than Soyer's 1930s subjects, as in this instance where the conjunction between the adolescent girl and the family group behind intimates a kind of pre-maternal yearning.[104] This is not intended as a blanket judgement on Soyer's postwar work, but it is striking that many of his 1950s paintings not only lack the indicators of social groundedness characteristic of his earlier art, but also the signs that tell

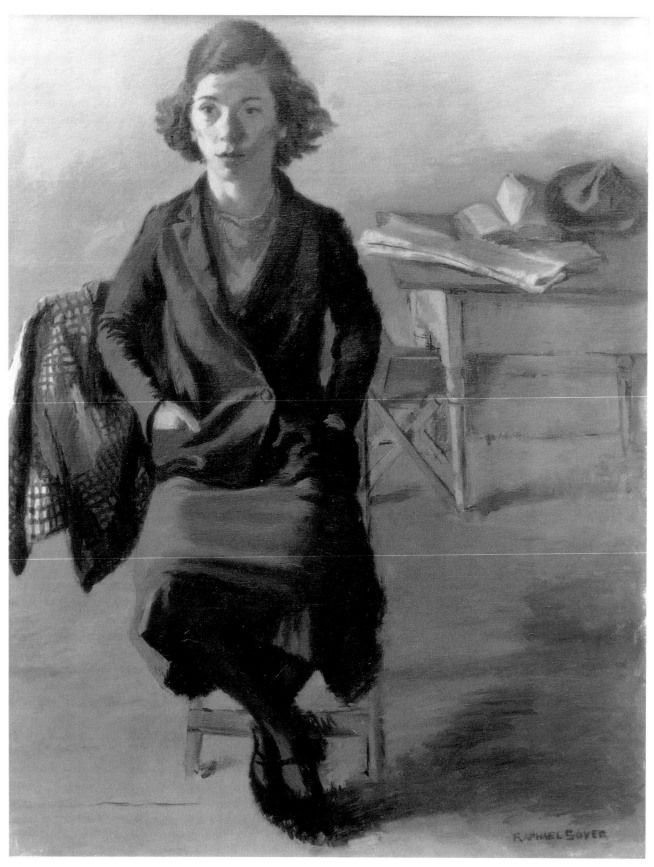

171 Raphael Soyer, *Mina*, 1932, oil on canvas, 36¼ × 27¼ in., Addison Museum of American Art, Andover, Massachusetts, 1934.4, museum purchase.

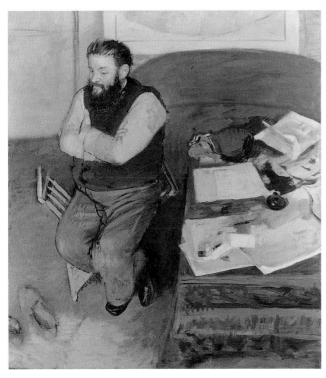

172 *(above)* Edgar Degas, *Diego Martelli*, 1879, oil on canvas, 43³/₈ × 39¹/₂ in., National Gallery of Scotland, Edinburgh.

173 *(right)* Raphael Soyer, *The Brown Sweater*, 1952, oil on canvas, 50 × 34 in., Collection of Whitney Museum of American Art, New York. Purchase, and gift of Gertrude Vanderbilt Whitney, by exchange, 53.53.

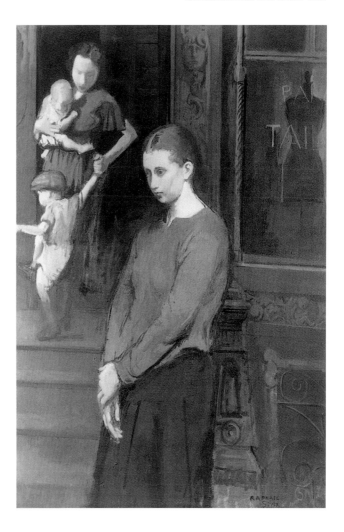

how mood and character can be understood as the product of identifiable social and historical circumstances. Sidney Tillim put the matter very well in an *Arts* review of 1961 when he wrote that Soyer's subject matter 'has evolved from another era's spirit of social solidarity to the *Weltschmerz* of Everyman'.[105]

At the same time, Soyer's approach to surface had become less naturalistic so that his roughly scumbled brushwork, summary denotations of form and apparently unfinished passages resemble late Degas more than that artist's work of the 1860s and 1870s, from which Soyer had taken so much in the past. However, his technique nearly always remained bluntly workmanlike – in the tradition of Eakins and the Ashcan School – and lacks the ingratiating quality of Impressionism.[106] Indeed, that these new formal devices were deployed within what remained an essentially realist aesthetic is particularly clear from Soyer's female nudes. Goodrich's claim that Soyer's approach to the female body was not

voyeuristic can scarcely stand,[107] given what feminist theoretical and historical work has since revealed about the power relations implicit in the artist/model relationship and encoded in traditional artistic forms. Although we can expect Soyer to have had some sense of women's oppression from his involvement with the Communist movement and his politically conscious wife, the Party did not offer any developed critique of the visual imagery of gender. While it is likely that some of the motivation behind Soyer's paintings of women shop workers in the 1930s may be traced to Communist culture, given CP attempts to organise this sector, and his images of dancers do represent them as workers,[108] some of the latter contain classically voyeuristic motifs of semi-dressed young women, as do more private works such as the Montclair Art Museum's *After the Bath* (1946), which shows a young woman with an exposed breast drying herself. In *My Friends* (Butler Institute of American Art, Youngstown, Ohio), a group

243

portrait set in the artist's studio from 1948, all the artists are men, while the women – who are probably included under the title – are only models.[109] However, as I have already indicated, in many of his genre scenes Soyer's female figures are particularised and empowered in ways that work against the standard tropes of objectification, and correspondingly he tends to depict men as weak and disempowered.

In Soyer's nudes of the 1950s, the signifiers of sexuality are often pictured in such a direct and matter of fact way that the figures seem presented without any intimation of eroticism, and on several occasions he painted models who were pregnant.[110] His women are usually depicted standing rather than in the reclining poses historically associated with seductive and postcoital situations that Neel tended to employ for her nudes. They pose as if in a life class, and in spaces that are clearly recognisable as the studio (fig. 174). Rarely do they look towards the spectator, but rather appear to stare past him or her, as if absorbed in their own interior life, their naked persons matter of factly presented as part of a job of work. Often, they seem to project that 'kind of moody emptiness' Soyer saw as characteristic of individuals alone in the city.[111] In Nude in the Studio, which was included in his 1960 ACA show, the subtleties of his new primary palette are evident, but this is Impressionist colour used for realist ends, since despite the extraordinarily economical brushwork, what is denoted is substance and form more than light. Moreover, there is no suggestion of an Impressionist equality within the visual realm here. The powerful figure of this seemingly confident young woman dominates the room, both colouristically and spatially. Perspective places her close to the viewer, and we see her as if from Soyer's viewpoint, looking up at her face from the height of one who is only 5 feet 2 inches tall. The fold-up bed behind is just a studio prop that mocks any notion of the erotic. None of this gainsays the fact that Soyer painted naked women repeatedly, while naked men formed no part of his repertoire. But, it might be argued, he did so partly out of particular feelings of respect and sympathy that had been nurtured by the culture of the left, and which permitted him to transcend the connotations of the genres in which he worked to some degree.

When these nudes are compared with the images of the figure shown almost contemporaneously in the New Images of Man exhibition, what is striking is not only the relative rationalism of Soyer's mode of picturemaking – the implicit assumption that the world is knowable through experience and science – but also the

concern to acknowledge the identity of other individuals through representation. In the works of the international moderns brought together at the Museum of Modern Art, the figure was insistently reduced to a primal type, and the only individuality that seems to matter is that of the artist, manifested in the intuitive approach to technique and signification. In Soyer's work intuition plays a part, but remains subordinate to perception and the established naturalistic codes that are understood as the basis of communication. The artist's individuality is thus balanced by a perceived need to register that of others. In Soyer's work ordinary people are consistently paid the tribute of having their individual selves dignified through induction into the realm of art.

It may seem a little odd to find Soyer in company with Solman in this section, given the former's staunch traditionalism and the latter's commitment to modernism. But not only were they linked by similar political convictions and the common intimist tendency of their art in the postwar period, they also came together in the editorial committee of Reality. Moreover in the late 1940s and the 1950s, Solman was a vocal critic of 'Avant-gardisme'[112] and increasingly spoke for a kind of classical modernism grounded in traditional skills, while Soyer's art was becoming more open to the influence of some kinds of Post-Impressionist technique.

In an article of 1951, Solman is reported as saying: 'Subject has always been very important to me . . . my city scenes were not just architectural studies, they were fragments of a real, living environment, in which signs, shop fronts and many other things were symbols of the human factor.'[113] His growing concern with more intimist themes seems to have come about partly as a result of his temporary removal from the New York scene in 1939, when he took up a WPA post at the Spokane Art Center in Washington State. From there, he wrote that he had begun 'to dream of an art without movement, an art regaining a simple organic quality'.[114] In the period after his return to the city, he started to paint more still lifes and the unpeopled studio interiors that became an important part of his output for over a decade – many of these depict the basement studio he rented in the Knickerbocker Village housing project from 1944 to 1952. His 1943 exhibition at the Bonestell Gallery, which marked the shift in his iconography, had rooms devoted respectively to portraits, interiors and still lifes. It was both a critical and financial success,[115] and several pictures were bought by Duncan Phillips, an important collector of Solman's work, who gave him a retrospective exhibition at the Phillips Memorial Gallery in 1949.

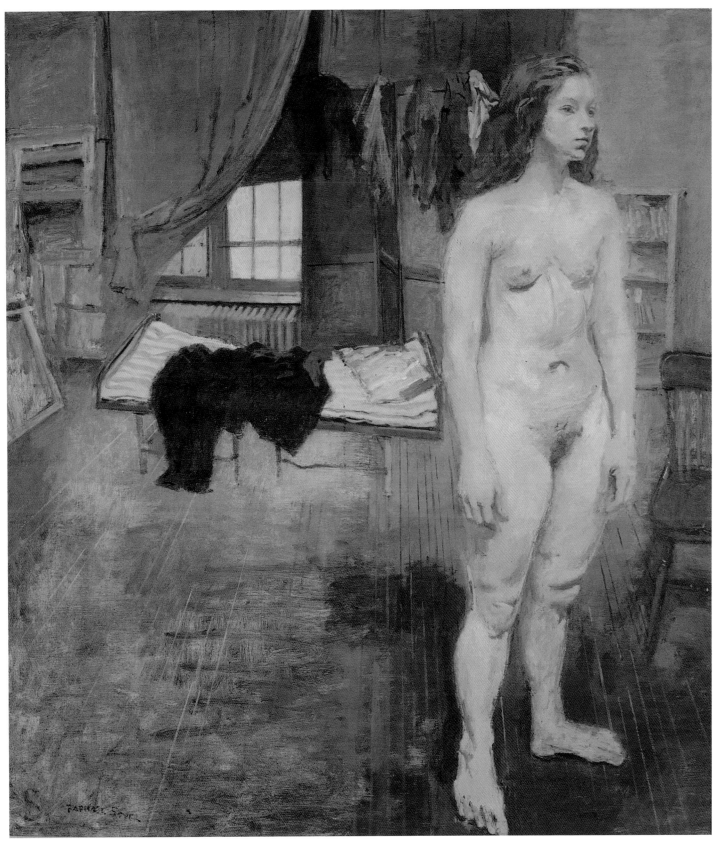

174 Raphael Soyer, *Nude in Studio*, oil on canvas, 3 ft 4 in. × 3 ft, Forum Gallery, New York.

175 Joseph Solman, *Studio Interior with Statue*, 1950, oil on canvas, 15³/₄ × 23⁵/₈ in., Hirshhorn Museum & Sculpture Garden, Smithsonian Institution, Washington, D.C.

Given Dondero's attacks on the ACA Gallery in 1949, it is hard not to see Solman's showing of 'Recent Paintings' there in the following year as some kind of gesture of solidarity, and in 1952 he joined the ACA stable.[116] Solman described his studio paintings as 'a kind of homage to the artist's own environment' (fig. 175), and at the time of his 1950 exhibition it was clear that they were more than simply formal experiments. In a contemporary review, Dorothy Seckler noted their variegated light effects and extraordinarily subtle colour nuances, which seemed to animate the lifeless objects so that they projected human emotions: 'Scattered along a window sill, these mute quintets of homely objects seem to have a life of their own: in the warm, diffused morning light their conversation is alive and expectant; in the late afternoon they communicate a quiet sense of waiting.' As Stuart Preston remarked, there was 'a note of strangeness in the absence of human figures when everything speaks of the human presence', which reminds one of Solman's earlier interest in de Chirico and the uncanny emptiness of many of his New York street scenes.[117] In more ideological terms, these pictures

can be seen as affirming Solman's conviction that nature should provide the basis for imagination, in the face of what he perceived as the vacuousness of abstract art.[118]

At the same time as painting the studio interiors, Solman was also working on portraits such as the stunning *Eddie* of 1950 (fig. 176), which depicts a parimutuel ticket clerk and tout at the New York racetracks, where Solman himself worked part-time. The figure's carefully groomed head, fastidiously poised atop the elongated column of his neck, and the controlled, somewhat vain expression – all reminiscent of Fred Astaire – seem to denote precisely the aspirations of an individual Solman remembers as a dandy and ballroom dancer,[119] at the same time as the loudly stylish clothes point to his occupation and actual class location. Solman had been interested in the portrait from the beginning of his career, and exhibited examples had attracted favourable attention from critics as early as 1943. But in a new departure, from 1950 onwards he focussed intensively on the genre, finding his sitters among friends and family, many identified only by their forename in exhibition catalogues. Like Soyer, a number of his subjects

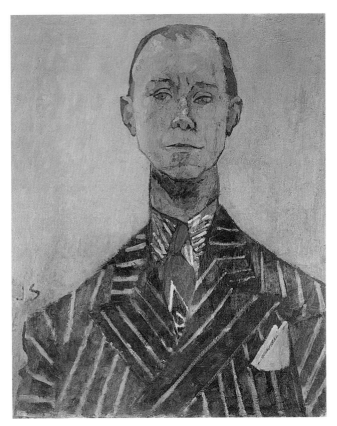

176 Joseph Solman, *Eddie*, 1950, oil on canvas, 16 × 20 in., private collection.

were fellow artists, including Byron and Rosalind Browne (Hirshhorn Museum & Sculpture Garden, Washington, DC, and Chatham College, Pittsburgh, respectively) and Soyer himself (private collection). Solman's 1954 show was like a programmatic demonstration of the continuing viability of the portrait medium, and may be compared with Soyer's insistent statements on the possibilities of figure painting in this regard. Four paintings were bought from it by Joseph Hirshhorn, and several others sold.[120] A second exhibition of portraits followed in the winter of 1957–8.

If Soyer's portraits seemed to affirm the value of traditional skills, Solman's showed that modernist pictorial discipline could be reconciled with an effective signification of the appearance and character of the sitter.[121] His indebtedness to the Expressionist tradition was unmistakeable, and the single colour background and angular drawing of *Eddie* clearly refer to devices developed by van Gogh, of whose work the Metropolitan Museum showed a major exhibition in the winter of 1949–50.[122] In this respect, his art resembles that of his friend Neel who, while she saw herself as a realist, was also a self-

conscious modern. However, there are key differences. Neel's sitters often seem animated, caught in some transitory expression; Solman's are impassive, so that almost the whole burden of denoting character is borne by the formal means, which have a kind of independent value. Commenting on this aspect of Solman's work in 1958, *Arts* magazine observed: 'As a result of such precision, deliberation, imposition, the generally grave beings in Solman's portraits have weight, not vivacity.'[123] By contrast, in Neel's the formal means are only deployed in as far as they are necessary to project an idea of character, and appear to have no function beyond that end. This corresponds with the primary impulse behind her 'pictures of people', which were to serve as a social and historical record of her times, a Balzacian *Comédie Humaine*.[124]

Of the three artists on whom this section is focussed, Neel was the one who remained most publicly involved with the Communist world. She contributed illustrations to *Masses & Mainstream* and to Communist books, attended the Writers and Critics group that met at Annette Rubinstein's apartment on the Upper West Side, and took classes with Howard Selsam, Jerome and Finkelstein at the Party's Jefferson School.[125] Her 1951 show at the Party-backed New Playwrights Theatre and 1954 exhibition at the ACA Gallery included portraits of well-known Communist figures, and the first of these also contained an agitational painting that supported one of the most publicised campaigns of the Civil Rights Congress, *Save Willie McGee* (Estate of Alice Neel).[126] In 1981, eighty-five of her works were shown at the Union of Artists of the USSR exhibition hall in Moscow, in a display she herself partly financed.[127]

Yet Neel acknowledged that she was 'never a good Communist',[128] and her continuing loyalty to the Party seems surprising at one level, given the consistent commitment to bohemianism that later drew her into the orbit of the Beats in the 1960s. In this regard, she is representative of that type of woman artist and intellectual who gravitated to the CP because – whatever its limitations – it offered the most sustained critique available of class, racial and sexual inequality, a type already encountered in Elizabeth Olds. Two impressive free verse poems and a short story from 1929 show Neel as having already developed a sharp awareness of women's oppression,[129] and she later claimed: 'I have always believed that women should resent and refuse to accept all the gratuitous insults that men impose upon them.'[130] Moreover, she was self-consciously an intellectual. 'I am an intellectual. I am sick of trash', she responded to an interviewer who asked her in 1979 if she could appre-

ciate bad art.[131] Not only was she extremely well-read – the same interviewer was given a list of favourite authors that included Auden, Proust and Joyce, along with more predictable figures such as Mann and Hemingway – but the classes she took at the Jefferson School covered philosophy as well as literature and art.[132] It is the breadth of her own literary and intellectual interests that helps explain the number of writers and critics she befriended and painted.

Solman wrote the foreword for her 1950 ACA exhibition catalogue but they drew on different elements in the modernist tradition. While the formal aspects of Neel's art should not be underestimated – the later work in particular shows an acute sensitivity to surface design[133] – her style had been premissed on what Art News aptly described as an 'intentional gaucherie' that signified personal authenticity above all else.[134] (Solman's 1930s work had something of the same character before he committed to a more calculating concept of expression around 1940.) Quite how Neel arrived at her personal variant of Expressionism is unclear, partly because she wished to present herself in later life as sui generis. 'I never followed any school. I never imitated any artist', she asserted in 1977.[135] But the ideas that the business of true art is to manifest individual experience as a kind of therapeutic catharsis and that to achieve this the artist must eschew all received conventions and principles of taste and work in a deliberately childlike manner, these were clichés that had a wide currency in the bohemian subculture in which Neel moved in the late 1920s and early 1930s – although few acted on them in such a sustained way. Whatever the particular modernist exemplars she encountered in her formative years, the two landscapes she showed at the international Exhibition of Living Art held in Philadelphia in 1933 must have looked entirely in keeping with a display that included works by Beckmann, Chagall, Klee, Pechstein and Rouault among the European contingent and Maurice Becker, Sara Berman and Benjamin Kopman among the Americans.[136] However, the autobiographical motifs in Neel's art became less central after 1933 when, by her own account, she started to produce 'revolutionary paintings' – a departure connected with the turn to Marxism among the writers and intellectuals of her acquaintance, and one that was confirmed by her involvement with the Artists' Union. In 1935 she became a Party member. Thereafter, although she remained committed to Expressionist techniques, she deployed them in conjunction with a documentary conception of art's functions that, as I noted in Part II, had far wider currency on the left and beyond. It was this particular

synthesis that brought her close to left-wing Expressionists such as those in The Ten and New York Group. Correspondingly, she later described Soutine as 'old-fashioned' because of his inability to 'see objective reality'.[137]

Perhaps it will seem a little bizarre to find Mike Gold praising Neel in the catalogue foreword for her 1951 exhibition at the New Playwrights Theatre as 'a pioneer of socialist-realism in American painting', and that this registers more the rigidity of the Party's own evaluative categories than of the nature of the works on show.[138] However, that Neel herself adopted a Zhdanovist-style discourse of affirmative humanism is suggested by Gold's account of statements by her in a contemporary notice in the Daily Worker: ' "I am against abstract and non-objective art," said Alice Neel to this reporter, "because such art shows a hatred of human beings . . . East Harlem is like a battlefield of humanism, and I am on the side of the people there, and they inspire my painting." '[139] Her statement for her Whitney Museum retrospective of 1974 offered a rudimentary critique of reification: 'Man in our present society cannot compete with the forces against which he is pitted, so he technologizes himself and denies his own humanity.'[140] Men's treatment of women she understood as an extension of the same process.[141]

Neel evidently saw her 'pictures of people' as pitted against this process of dehumanisation, and that was certainly how her exhibits of 1950–51 were presented in the Party press. The fact that so many of the paintings she showed in these years represented the working class of Spanish Harlem, where Neel lived from 1938 to 1962, must have added to their appeal at a time when the Party was particularly preoccupied with racial issues. Moreover, the predominantly Puerto Rican population of El Barrio was markedly radical in political orientation, supporting numerous left-wing clubs and organisations, not suprisingly considering the Party's fierce criticism of US imperialism in their homeland.[142] In 1951, the Daily Worker's Charles Corwin wrote of her 'portraits of friends and Puerto Rican neighbours': 'They are not portraits in the limited sense of the term but depictions of men and women . . . behind whose individual features and individual vitality lie the more generalized features and vitality of large sections of humanity.' However, while Neel's portraits of political activists such as Mike Gold (1951?; Estate of Alice Neel) and Edward Pinckney Greene (Collection Katherine H. Cole) or of the black actress and playwright Alice Childress (1950; Estate of Alice Neel) might carry conviction as positive images, Gold noted that '[s]ome of the melancholy of the region hangs over her work'

and Corwin detected 'an underlying sense of pessimism' running through all of it.[143] Indeed, pictures such as *TB in Harlem* (1940; Estate of Alice Neel) and *The Spanish Family* (1943; fig. 177) suggest a dignified endurance of poverty, rather than any struggle against it. Moreover, despite Neel's realist subject matter, it was rather hard to escape the connotations of her Expressionist devices as signifying personal anguish. The artist had, in fact, been hospitalised for attempted suicide after a nervous breakdown in 1930, and had endured years of poverty living on WPA and public assistance. In 1979 she described herself as a 'morbid person' who had wanted to commit suicide all her life.[144] Given her emphasis on artistic authenticity, the style of her art had to correspond to her own life as well as that of her subjects, so that whatever her embrace of 'humanism', this meant her work simply did not match the optimistic platitudes of Zhdanovism, either technically or symbolically.

As I have shown, the Party's cultural cadre were as divided on Zhdanovism as they had been on earlier versions of the Stalinist aesthetic. Strangely, however, Neel's personal loyalties lay more with the hardliners Gold and Philip Bonosky than with more expansive thinkers such as Humboldt. Indeed, in a debate in *Masses & Mainstream* over 'Lars Lawrence's' novel *Morning, Noon and Night* in 1955, she supported Bonosky, who had criticised the author's depiction of Communist organisers in a New Mexico mining town as too 'naturalistic', as over-psychological and unheroic, and argued that what was needed rather was images of 'people who are moved to act from the deepest love of other humans, from the profoundest knowledge of their mission in history.' In a letter to the magazine, Neel stressed 'the responsibility of the writer to reflect in the most advanced and humanistic way any part of the life of his day', and invoked actually existing 'heroes' such as the Smith Act prisoners and the Rosenbergs: 'A strong wind is blowing and meager is the heart who cannot see the heroes.'[145] For Neel, the Communist activists she painted were heroes. Indeed, she is likely to have seen such works as the pictorial equivalent of Communist biographies such as Bonosky's *Brother Bill McKie* – a book published in the same year that Neel painted its subject, and one its author described as 'a great opportunity to show everyone what a real Communist looked like' in the face of the demonisation of the Party in the mainstream media.[146] In this regard, the ordinariness of Neel's Communist portraits – which Pamela Allara has rightly stressed – may have been pointed.

We can understand Gold's support of Neel's work, I think, by seeing its direct and unglamorised mode of

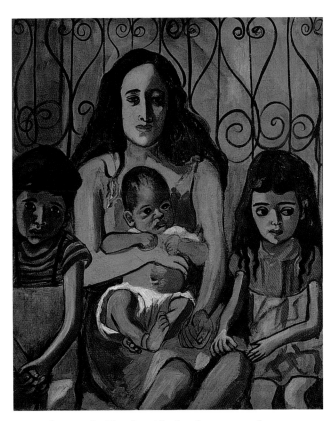

177 Alice Neel, *The Spanish Family*, 1943, oil on canvas, 34 × 28 in., © Estate of Alice Neel. Courtesy Robert Miller Gallery, New York.

portrayal, its seeming stylelessness, as corresponding with the straightforward setting down of truth he had envisaged as characterising proletarian art in the years around 1930. Her quotidian portrayals of Communists followed from the essentially naturalist premise of her procedures: her belief that once her sitters were at ease before the easel, they would adopt their most symptomatic and revealing attitudes: 'Before painting, when I talk to the person, they unconsciously assume their most characteristic pose, which in a way involves all their character and social standing – what the world has done to them and their retaliation.'[147] It is striking that the most impressive of these portraits, those of the labour journalist *Art Shields* (fig. 178) and of the union organiser *Bill McKie* (fig. 179), should look almost like homages to van Gogh. This is unlikely to have been coincidental, given the Metropolitan Museum's exhibition of 1949–50. The plain-coloured background and angular drawing of *Art Shields* parallels that of several of van Gogh's portraits of the Arles period, such as *L'Arlésienne* (1888), which was bequeathed to the museum in the same year as the former was painted. The way in which the sitter's outline interacts with the

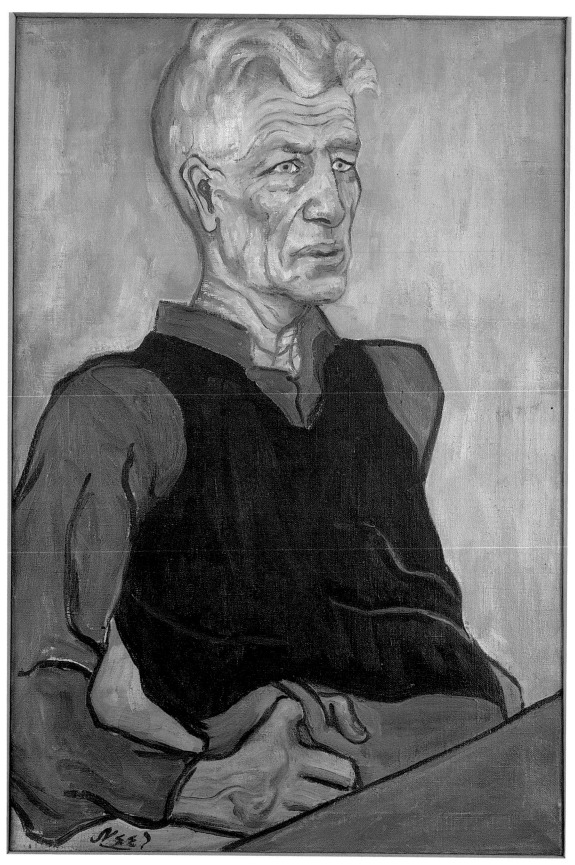

178 Alice Neel, *Art Shields*, 1951, oil on canvas, 32 × 22 in., © Estate of Alice Neel. Courtesy Robert Miller Gallery, New York.

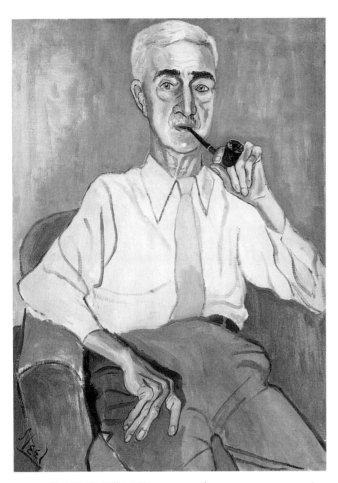

179 Alice Neel, *Bill McKie*, 1953, oil on canvas, 32 × 23 in., © Estate of Alice Neel. Courtesy Robert Miller Gallery, New York.

canvas edge – to compensate for the lack of naturalistic space – is also a characteristic van Gogh device, and one that Neel used in *Bill McKie* and many other works. Like van Gogh, she also jettisoned the inventory of lifestyle attributes characteristic of nineteenth-century naturalistic portraiture. And, like Soyer's, her sitters appear in the seemingly neutral space of the artist's studio, with no signs of their social selves but their choice of clothes and their physiognomies. In her view the face showed 'everything' about her sitters: 'Their inheritance, their class, their profession. Their feelings, their intellect. All that's happened to them.'[148]

At the height of American Zhdanovism, it was inevitable that the elements in van Gogh's art that seemed to point towards modernism would be viewed with a chilly eye in the Party press. On the other side, the catalogue to the Metropolitan Museum's exhibition suggested that the artist's 'continuing appeal may lie in his unique ability to suggest those tensions and dislocations

under which man lives today', and connected it with existentialism and the vogue for writers such as Dostoyevsky and Kafka – in other words connecting the artist to precisely those aspects of contemporary culture in which Communists found the symptoms of bourgeois decadence.[149] However, van Gogh had long been a Communist hero, and although an appraisal of the exhibition by W. T. Bürger criticised the Symbolist elements in his later work, it simultaneously stressed that the influence of Gauguin's Synthetism and a perceived orientation to the market did not submerge his 'humanitarianism', which was revealed in his 'persistent desire to be a "figure painter"': 'those figure studies he did – the postman Roulin... Roulin's son Armand, the "Berçeuse," the splendid old peasant in a straw hat... are as suffused with sympathy as with rich color.'[150] Further, if Neel looked outside the Communist press – as there is every reason to believe she would – she could have found a very different evaluation of van Gogh's art in Meyer Schapiro's 1950 monograph. Here, van Gogh is said to have abandoned only the genre and form of his early peasant paintings (which appealed more unequivocally to Communist sensibilities) in his later work, but developed the 'basic human program' they represented in a different style. Schapiro provided a particularly insightful account of the portraits of the Arles period, which emphasised both their non-commissioned character and natural poses. Van Gogh, he explained, had seen the portrait as 'the future of modern art', and produced 'the first democratic portraits', portraits that 'would have pleased Whitman especially.'[151] The similarities between van Gogh's programme as Schapiro described it and Neel's are as striking as the formal similarities identified above. Neel rarely used such non-naturalistic colour backgrounds as that of *Art Shields*,[152] perhaps because she understood that for van Gogh (and more generally) they signified a kind of spirituality alien to her own emphatically materialist approach. In the next decade, she established her distinctive manner of negotiating the demands of the picture surface through summary drawing of non-essentials in painted outlines and passages of raw canvas, devices that signified space and objects with only minimal concessions to conventional perspective.

At the point where this study ends, all three of the artists I have been considering still had some of their finest works ahead of them. This is particularly so with Neel, who achieved more consistent levels of professionalism without sacrificing the original qualities of her approach after her career took off in the early 1960s.[153] Despite the absence of a living Communist movement,

they remained artists of the left, and all were drawn to paint the Beats in the 1960s as the latest manifestation of resistance to American bourgeois mores. Inevitably, however, the enduring commitment to a 'humanist art' that endured as a relic of their earlier political allegiances put them increasingly at odds with their times and drew them into the orbit of the National Academy of Design.[154] As the controversies of the 1950s receded, the implications of their attachment to the figure were obscured, and they came to seem just upholders of traditional skills and outmoded aesthetics.[155]

Jack Levine's *comédie humaine*[156]

Another formidable exponent of the humanistic principle rooted in traditional skills, and one of Soyer's allies in *Reality*, is Jack Levine (b. 1915).[157] Although the culture of the Communist movement provides one frame for Levine's art, its underlying aesthetic derives from a subsidiary stream that fed into the artistic practices of the left, but which was always separate from the main current, namely Expressionism. Evergood, as I said earlier, also drew from this source but less deeply, and he also presented himself as a Communist artist in a way that Levine did not, or perhaps did only briefly. He was an activist in the Boston Artists and Writers Union but Levine did not have the same prominence in Popular Front organisations as Evergood, partly because of his age – he was fourteen years younger – and partly because he was still living outside New York. Having said this, the extent of Levine's political engagement should not be underestimated. He was certainly an active player in Artists Equity, and remained a stalwart defender of the WPA experiment and collective action by artists in the postwar years. In 1950 he was involved with a CP-sponsored body called Art Students for Peace, and in 1952 he was among a group of artists who protested against the prosecution of Jerome under the Smith Act.[158] He also stressed his sense of involvement with a broader community as necessary to his art.[159]

Levine spent the years 1942–5 in the military, serving for twenty months on Ascension Island and emerging as a technical sergeant. He hated the army and it hardened his sense of class resentment, feelings that issued in his 1946 painting *Welcome Home* (fig. 180), shown at the Downtown's *Six Out of Uniform* in May of that year. The same attitude informed some of the illustrations he provided for a three-part article on his wartime experiences by the composer Marc Blitzstein, which appeared

in *New Masses* in August and contained a withering description of the racism of the officer class.[160] Yet at the same time, Levine was making a highly successful career for himself through his social comment paintings. Widely seen as a prodigy in the 1930s, he had his first solo show at the Downtown Gallery in 1939. Halpert sold a number of his paintings during the war, and in 1943 an early canvas, *String Quartet*, received the second purchase prize of $3,000 in the Artists for Victory exhibition at the Metropolitan Museum, and was for a while one of the museum's most popular pictures. Solo exhibitions came in 1948, 1950, 1952 and 1953, and in 1955, when he was still only forty, the Whitney Museum gave him a twin retrospective with his fellow Bostonian and friend, Hyman Bloom.[161] In 1946 *Welcome Home* had been featured in *Time*, which labelled Levine 'Angry Artist', and said he made rich people look like 'withered apples seen through a mist of rage.' It also quoted his description of the picture's central figure as the kind of officer, a 'big slob', 'who is vice president of the Second National Bank and president of the Chamber of Commerce, only now he's been in the Army.' Later that year *Welcome Home* won second prize in the Carnegie Annual. In 1950 *Time* noted his large show at Boston's Mirsky Gallery, describing *Reception in Miami* (Hirshhorn Museum & Sculpture Garden, Washington, DC) as 'a soapbox snarl at the Duke and Duchess of Windsor', but otherwise approving the artist's energy and talent.[162] When Hilton Kramer referred to Levine's 'phenomenal success' in a venomous review of the 1955 retrospective, he was not far from the mark.[163]

Kramer attributed Levine's status partly to a sentimental interest in Jewishness among 'museum officials, art critics, and the rest of the officialdom of the art world', and also, by implication, to what he saw as the formal conservatism of his art. In Kramer's account, Levine's work is presented as fundamentally academic because of its reliance on traditional drawing structures, and its dependence on 'a constellation of technical devices culled from Rembrandt and other masters.' This corresponded with what he saw as the trite leftism of the artist's 'social realism', a hangover from the 1930s of no relevance because 'the satire no longer applies'. (One might surmise that Kramer was partly responding to Lloyd Goodrich's foreword to the exhibition catalogue, which presented Levine's 'uninhibited social criticism' as a necessary and welcome response to McCarthyism and the climate of conformity.[164]) Even putting to one side Kramer's dyspepsia over Levine's politics, his description of the formal aspects of his painting was one-sided and

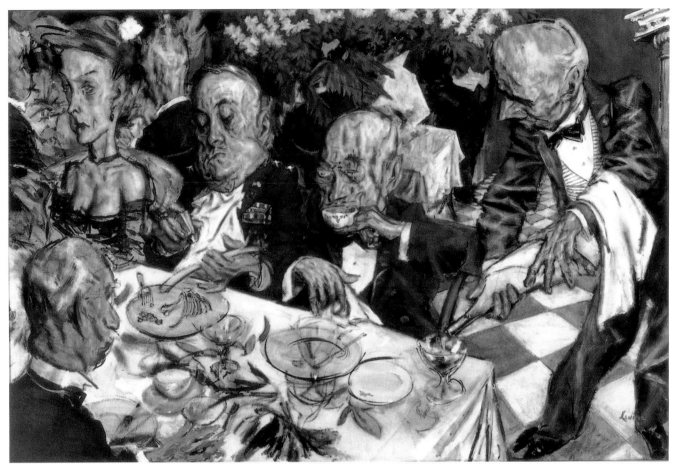

180 Jack Levine, *Welcome Home*, 1946, oil on canvas, 39 $^{15}/_{16}$ × 59 $^{15}/_{16}$ in., Brooklyn Museum of Art, John B. Woodward Memorial Fund, 46.124. © Jack Levine/Licensed by VAGA, New York, N.Y.

misleading. While Kramer's claims may have seemed to accord with the artist's outspoken attacks on avant-gardism and his repeated assertions of the value of traditional skills,[165] they ignored Levine's association with what another contemporary critic called the 'highly timely American style of Expressionism', which stood as one of the main alternatives to abstraction.[166] Although Levine did not like the Expressionist label, he has acknowledged the profound role such artists as Beckmann, Grosz, Kokoschka and Soutine played in his formation.[167] This was in any case obvious from the appearance of his work.[168] Neither were Levine's compositions, with their piled up figures and spatial elisions, entirely innocent of Cubism – as one would expect with an artist attentive to the examples of Beckmann and Grosz. Indeed, in the late 1940s Levine acknowledged he began to 'fool around' with Cubism, and although he associated his 1950–51 sojourn in Rome with a new understanding of the Old Masters, while there he painted his most overt experiment with Cubist devices in

Pawnshop.[169] As it turned out, this was a blind alley, but vestiges of Cubist space remain in his work for those with eyes to see, even in such a Rembrandtesque exercise as *Gangster Funeral* (1952–3; Whitney Museum of American Art).

Even supposing Kramer saw these traces of the modernist tradition, however, his narrowly aestheticist conception of modern painting excluded Levine's vision because of its 'literariness'. This does not, of course, mean that Levine's art was not modernist – it simply drew from artistic traditions that were extraneous to the pared down paradigm of modernism championed by critics such as Greenberg and Kramer in the Cold War, and disseminated more popularly by the Museum of Modern Art and its institutional allies. In fact, Levine had cut his aesthetic teeth on Joyce and Brecht, and has described Pabst's film of the *Dreigroschenoper* as 'a great motivating idea of art and politics', from which he learned 'more . . . than almost anything else.'[170] The *Dreigroschenoper* not only provided him with a fund of

motifs to which he returned repeatedly, it also suggested an atmosphere of corruption, a vision of the continuum from capital to political venality to organised crime that he sought to evoke in images of contemporary American society from the 1930s through to the 1970s. Like Brecht and Weill's musical collaborations, Levine's art shows a fascination with the tawdriness of mass culture, the power of which it acknowledges by the borrowing and transmutation of its motifs. In Levine's case these constitute mainly types from Hollywood gangster films, and images of celebrities from newspapers and television.[171] Those such as Kramer who have criticised Levine for making pastiches of the Old Masters do not seem to notice that the projection of middle and late twentieth-century realities through the techniques of the Baroque is done with a conscious irony that points up the ephemeral character of celebrity and the degraded charades of the so-called democratic process.[172]

At this point, I should also note that the *Dreigroschenoper* is the pre-Communist Brecht, and it is the kinship between Levine's art and the early Brechtian vision that not only explains the distaste of Kramer and other critics of the right, but also the uneasiness of some on the left with what seems an unremittingly negative conception of humanity. In his review of the 1955 retrospective for the CP's magazine *Jewish Life*, Finkelstein praised the artist's partisanship of the poor and oppressed in characteristically mawkish terms, at the same time as he regretted the one-sidedness of his art. Ironically, like Kramer he had problems with Levine's technique – not because it was conservative but because his style was intrusive. From the Zhdanovist perspective, Levine was a formalist![173]

To understand the nature of Levine's appeal in the 1940s and 1950s it is important to examine both the range of his work and how it was presented. Prior to his wartime service, Levine still saw himself as a painter who juxtaposed 'poor and rich in different pictures' – provoking the spectator actively to 'judge the merits of the case' – and he was as well known for his images of slums and working men at leisure as he was for that of 'crooked contractors, ward heelers, racketeers, minions of the law and the like.'[174] In the postwar years, while he produced some notable images of poverty, such as *The White Horse* (1946; University of Oklahoma Museum of Art, Norman) and *Apteka* (1947; whereabouts unknown), he was not able to arrive at a positive or sympathetic image of the poor. Evergood could continue to come up with an ideal image of the working class on occasion – however different from the muscular ciphers of Gellert or Kent – but Levine could not, or did

not wish to. Those who attended Levine's exhibitions in the 1950s found the social pictures mixed in with small paintings of Jewish kings and prophets and biblical and classical subjects reminiscent of Rubens or Titian. The former Levine had begun painting after his father's death in 1939 as 'a form of recreation'. Although he has stressed his 'complete rejection of religious mysticism', he has also stated his belief that 'a sort of humanism' is one component of Jewish culture, and one that has made an important contribution to the labour movement and to 'liberal and progressive thought'.[175]

Levine's paintings of the later 1930s had been grounded in his observations of Boston, and in their concern with everyday experiences they accorded with that WPA model of the democratic audience discussed in Chapter Seven. Reviewing the artist's 1948 Downtown show, Frankfurter observed: 'If he is painting social protest, it is social protest whose addressee is utterly undecipherable and whose message is utterly muddled.' Given the anti-Soviet stance of *Art News*, it was predictable that Frankfurter would object to Levine's satire on the Marshall Plan, *Improvization in a Greek Key*, and other instances of 'pamphleteering', but his first point picks up a genuine problem.[176] Seven years later Kramer likened Levine to Arthur Miller, and claimed that the success of his art came because, like Miller's theatre, what it said was not heresy 'but the most easily digestible cliché of the public imagination.'[177] Given the unpopularity of the political outlook manifested in many of his social pictures, this cannot be the case. Rather, it might be assumed that, like Miller, Levine spoke to a certain kind of metropolitan liberal constituency uneasy with the domestic and international costs of the Cold War, even if it had no more specific political commitments. Like Shahn's, his art stood for a humanism comprehensible to a broad middle-brow audience – but not to a popular one, not one constituted of a people politically conscious as such. It did intimate the possibility of a kind of democratic access, and in this respect it echoed the aspirations of the New Deal ideal of cultural democracy, but it did so in the absence of any institutions that might give those aspirations actual content, and it thus refused to acknowledge the conditions of its own possibility. It is not that Levine himself was unaware of these conditions, as his acerbic commentaries on art dealers and patrons, both verbal and pictorial, illustrate. However, in my view it is this lack of a sympathetic public for a political art that gives his art its tone of *ressentiment*, that quality which Nietzsche defined as the response of the oppressed 'to whom the only authentic way of reaction – that of deeds – is

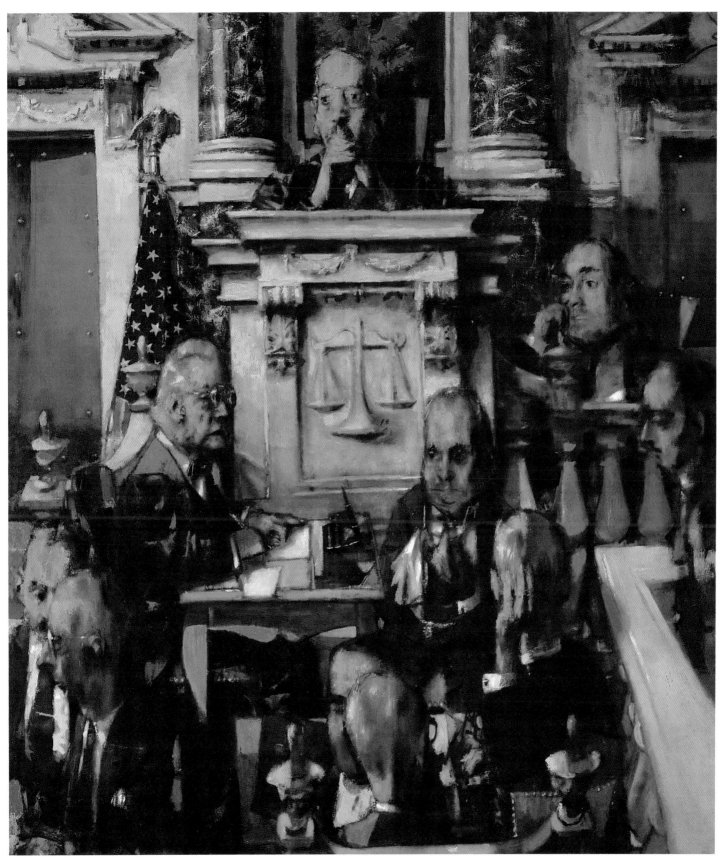

181 Jack Levine, *The Trial*, 1953–4, oil on canvas, 72 × 63 in., The Art Institute of Chicago, Gift of Mr and Mrs Edwin E. Hokin and Goodman Fund, 1954.438. © Jack Levine/Licensed by VAGA, New York, N.Y.

unavailable, and who preserve themselves from harm through the exercise of imaginary vengeance', and which Fredric Jameson has employed so fruitfully in literary analysis.[178] Without a public, there is only a contingent audience of gallery-goers.

Some of Levine's paintings from the 1940s and 1950s advertised political positions well to the left of liberalism. Pictures exhibited in 1948 and 1950, *Improvization in a Greek Key* and *Coronation of the King of Greece*, both alluded to the beginnings of American postwar imperialism, and a Communist *cause célèbre*. Further satires on the nation's hegemonic ambitions followed, such as *The Golden Anatomy Lesson* (1952; Munson-Williams-Proctor Institute, Utica, New York), in which Truman, wearing a wonderfully ludicrous gold helmet lifted from Rembrandt, divides up the globe aided and abetted by James V. Forrestal, Henry Wallace and a banker type against a background of Roman imperial architecture.[179] In 1956, he painted a Goyaesque canvas titled *The Turnkey* (Hirshhorn Museum and Sculpture Garden, Washington, DC), which represents America's Spanish ally through a pudgy general, bedecked with medals and absurd in his sash and cavalry boots, seated before the entrance to a gaol. However, Levine's largest and arguably his most sucessful canvases of the 1950s were grounded in American realities, and include *The Trial*, *Election Night*, *Medicine Show* and *Inauguration* (1956–8; Smithsonian American Art Museum, Washington, DC).

Like most of Levine's satires, *The Trial* (fig. 181) does not allude to any single event. It was intended – through its very lack of specifics – to suggest the character of the legal establishment in the United States of the early 1950s in a general sense. The picture was bought by the Chicago Art Institute from its *Sixty-First American Exhibition of Painting and Sculpture*, and shown in the 'Gallery of Art Interpretation' between mid-April and mid-September 1955, along with a group of preparatory drawings that Levine had donated. According to the account of the picture's genesis that the artist provided to accompany the exhibition, the courtroom was based on no particular courtroom, and the curious 'altar to justice' within which the judge is framed was his own invention. While the figure of the recorder was based on one of his Boston high school teachers, he did not disavow a likeness to John Foster Dulles. Other figures might derive from 'the press newsreeels, T-V, etc', but would not 'correspond to any news portrait or movie-still.' However, although he did not acknowledge it in his 1955 statement, in later interviews Levine identified the judge figure with Harold Medina, the notoriously

prejudiced judge in the 1949 Smith Act trial of Communist leaders, whom the image resembles in some degree.[180] Levine has associated the picture with McCarthyism in a general sense, but specifically attributes its 'emotional charge' to the 'horror' of the Rosenbergs' execution in June 1953. Although he intended the picture to put the court itself on trial, Levine says he was shaken by 'a heated argument with a social economist who argued that it was irresponsible to attack the courts when there were people in government who were bypassing, circumventing and destroying our legislative structure which, venal and biased though it may be, was the only safeguard we had.'[181] Yet as he put it elsewhere, 'our society is not divided between the evil and the virtuous, criminal and the law abiding, in quite the way it is divided between those who go to jail and those who do not.'[182] Levine did not lampoon the legal system – as he did the electoral process in *Election Night* (fig. 182) – but the picture's murky light, uncomfortable spatial effect and disjunct figure grouping make legal proceedings appear an arcane ritual in which men of power carry on their business with scant regard for the person in the dock, while the judge stares into space with a look that suggests indifference rather than impartiality. Moreover, in the complex geometry of the composition there is scarcely a single true vertical or horizontal, and even justice's scales are on the tilt. It is not a reassuring picture.

Levine's theme in all these works is the theatre of power. A propos of *Medicine Show* (fig. 183) he has said that 'I've always been trying to make a kind of indictment of mysticism, and people being fooled, people being gulled.'[183] It is this that partly gives the uncomfortable edge to his work, and explains why there is so little in the way of a positive imagery to the working class within it. As early as 1948, Frankfurter observed of another work on this theme that Levine 'treats the common herd of the street audience just as unkindly as he elsewhere handles capitalists, generals, and duchesses.'[184] I do not think this is so, with one notable exception which I shall discuss shortly. Like other social satirists, Levine uses physical grossness and the conspicuous display of wealth to signify the moral ugliness associated with exploitation and the abuse of power. You can see the point if you compare the cigarette girl on the left in *Election Night* with all the other figures. Despite the absurdity of her attire, her downturned mouth and impassive look give this figure – the only proletarian present – a certain dignity.[185] Similarly, the crowd in *Medicine Show* does not have the grossness of the barker himself.

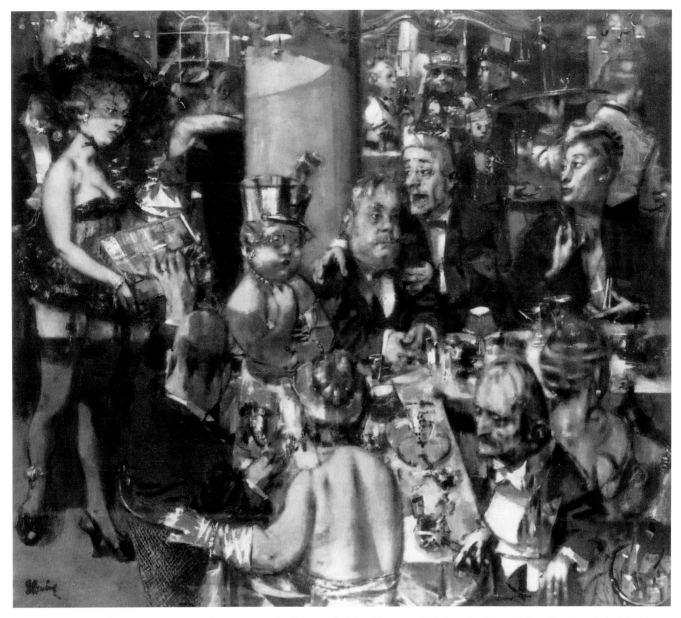

182 Jack Levine, *Election Night*, 1954, oil on canvas, 5 ft 3 $^1/_8$ in. × 6 ft $^1/_2$ in., Museum of Modern Art, New York, Gift of Joseph H. Hirshhorn. © Jack Levine/Licensed by VAGA, New York, N.Y.

From the late 1940s, American social critics of different political persuasions struggled to come to terms with the changing character of class relations and political power in an increasingly affluent but disturbingly conformist culture. Among phenomena that particularly taxed them were the impact of advertising and consumerism on the middle and working classes, and the effects of the media in political life. Landmarks of such writing include David Riesman's *The Lonely Crowd* (1950), C. Wright Mills's *White Collar* (1952) and *The Power Elite* (1956) and, at a more popular level, Vance Packard's *The Hidden Persuaders* (1957).[186] Although their mythology of proletarian virtue prevented them from any radical rethinking of the nature of the working class, the Communists too were concerned with these things. *Masses & Mainstream* printed some analysis of television and several intelligent critiques of advertising culture by Barbara Giles, who observed in 1952: 'Advertising *is* a cultural force in itself, a destructive one. It is, first, a pageant and drama of Things – a drama with competition, color, sound, and glittering techniques, which no one is wholly allowed to escape.'

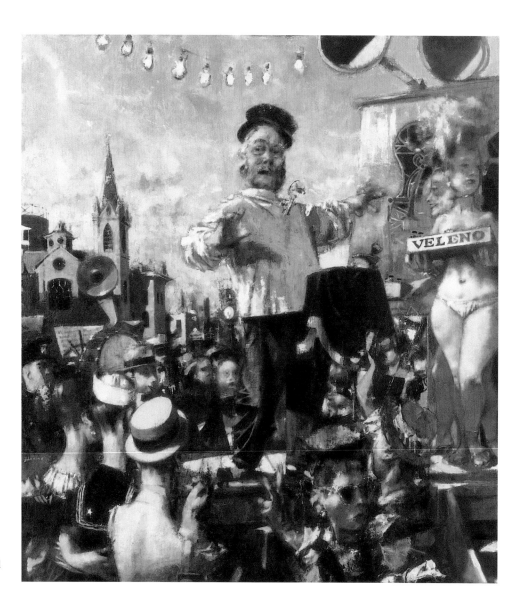

183 (*right*) Jack Levine,
Medicine Show, 1955–6, oil
on canvas, 6 ft × 5 ft 3 in.,
Metropolitan Museum of Art,
New York, Hugo Kastor Fund,
1956. (56.233). © Jack
Levine/Licensed by VAGA,
New York, N.Y.

184 (*facing page*) Jack Levine,
The Roaring Tropics, 1966–9, oil
on canvas, 6 ft × 6 ft 6 in., private
collection. © Jack Levine/Licensed
by VAGA, New York, N.Y.

Further, the culture of advertising had come to permeate politics, so that in the 1951 elections Eisenhower had been sold to the public 'like shaving-cream in a high-pressure TV-and-radio campaign'.[187] Levine's *Medicine Show* is also an address to these phenomena, and was tentatively titled *The Product Involved*. (In fact the product being peddled is poison, signified by the Italian word *veleno*.) Although the picture is a Brechtian street scene set against a background that the artist associates with South Boston around 1935, his underlying intention was to suggest 'all the elements of TV advertising and Madison Avenue'.[188] This does not make it a work rooted in a specifically Communist perspective, but it does suggest that it was prompted by concerns that were widespread in the left.

Levine sees the barker in *Medicine Show* as an ancestor figure of Madison Avenue, and has said that he probably could not paint well the paraphernalia of

modern advertising, such things as 'a TV set, an airplane, an automobile, a billboard.' None the less, in the 1960s some of his satires had a more insistent contemporaneity, perhaps most notably *The Roaring Tropics* (fig. 184), a picture that represents 'the newly-affluent American working class lolling around the swimming pools' in Puerto Rico. Here the garish patterns of bikinis and bathing suits stand out on the surface of the picture and break up the phantasmagoria of corpulent and sagging bodies, producing an effect of dazzling ephemerality that resembles the harsh colour patches of cheap advertisements and matches the tenor of the subject. The picture draws from the advertising cliché of the 'good life', at the same time as it turns it into something close to a *memento mori*. When *The Roaring Tropics* was exhibited at Levine's 1978 retrospective, it prompted the critic of the *New York Times* to observe that while it might be all very well in the 1930s to attack

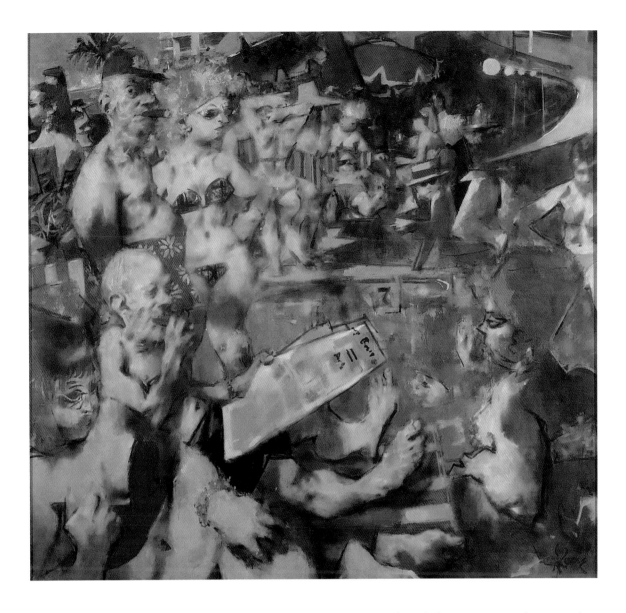

the wealthy and corrupt in pictures such as *The Feast of Pure Reason*, satire of American vacationers was 'not a very distinguished thing to do.' Levine compared unfavourably with Grosz, in that the former had 'put his life on the line when he published some of his more incisive images.'[189] The point, however, is not the relative physical courage of these artists, which is irrelevant to the stature of their art, but rather that whereas the *Times*'s critic presumably acknowledged some evils in Weimar society, he did not acknowledge them in his own – or at least did not see them as requiring images of such 'vindictive exactitude' to draw attention to them. In fact, like Grosz, Levine here produced a degraded image of the proletariat as a counterpart to his depiction of the corruptions of their rulers. But whereas Grosz's figures were degraded by poverty, Levine's are degraded by affluence. Levine's art is an art out of time, as his critics have said all along, but it is out of time not because its

technical devices are retardataire – they are often highly effective – but because it is a critical art in a society where there is no mass political agency with which the left-wing artist can ally him or herself.

By the late 1960s when the New Left was forming, Levine was in his fifties and felt profoundly alienated from contemporary culture. Like Evergood, he was publicly opposed to the Vietnam War, declining to attend the first White House Festival of the Arts in 1965 because of the Johnson administration's policy, and in 1971 was still sufficiently engaged to fund-raise actively for the Prisoners Solidarity Committee in the aftermath of the Attica Prison massacre.[190] However, by this point he was also disenchanted with the Soviet Union, partly because of revelations of Soviet anti-Semitism, and his politcal works were increasingly inflected by his sense of Jewish identity.[191] In any case, they fall outside the scope of this study.

African American People's Art:
Charles White and Jacob Lawrence

The particular forms of racialised oppression and exploitation inflicted on African Americans had been a central concern of the CPUSA since the Comintern instructed it to give special attention to the Negro Question in 1928. From the Party's perspective, African Americans needed to be encouraged and assisted in their struggles, and also brought to an understanding that these were interlinked with those of the proletariat and colonial peoples everywhere. Despite its commitment to production above all else, the Party continued to fight for civil rights and equal employment opportunities during the war years,[192] but after 1945 work with and on behalf of African Americans assumed even greater importance. This was partly an immediate and necessary response to the wave of racist violence that accompanied the war's ending, but it also arose from the realisation that Southern racism was central to the conservative turn of US politics in the 1940s, and that until African Americans were able to exercise the right to vote in the South and unions to organise freely there, progressive politics in the US could make little headway. The main institutional base for the Party's strategy against racism was the Civil Rights Congress (CRC), set up in 1946 through an amalgamation of three existing groups: International Labor Defense, the National Federation for Constitutional Liberties and the National Negro Congress. Although the CRC's agenda was not confined to African American rights – it also handled the legal representation of the Smith Act defendants – its work in this area was arguably its most important activity, mainly because of the controversial international campaigns it conducted on behalf of a whole string of African Americans subjected to racial injustice via the legal system, including Willie McGee, Rose Lee Ingram and the Trenton Six among others. Its leading figure, the African American lawyer William L. Patterson, was married to Louise Thompson, whom I introduced earlier as an activist and figure in Harlem cultural circles. Both were Communists. The CRC sought to mobilise the kind of broad alliances achieved by the organisations of the Popular Front and, particularly to begin with, the CRC enjoyed the backing of numerous celebrities. However, although it tried to work with the ACLU and NAACP, it was subjected to consistent red-baiting from both organisations. It also endured continuous harassment from the FBI, which finally caused it to dissolve itself in early 1956.[193]

That the CRC should be so targeted is hardly surprising when one considers the ways in which its campaign against domestic racism was interlinked with larger Cold War politics. The CP and the international Communist movement understood acutely that racial oppression in the United States seriously compromised the nation's standing with Third World countries, and indeed was not unconnected with certain racial assumptions in its foreign policy. On several occasions the CRC sought to bring human rights abuses in the US before the United Nations, a strategy that culminated in the presentation in Paris in 1951 of the petition *We Charge Genocide*, which accused the US government of officially sanctioning the genocidal treatment of African Americans. Published as a pamphlet, the petition had a massive circulation and was translated into several languages.[194]

The conventional picture of relations between the CP and African Americans in the postwar period has been inflected by the apostasy of the most celebrated of the black writers who had been associated with the Party. Ralph Ellison, Chester Himes and Richard Wright all produced vivid and unflattering portrayals of the Party's use of African Americans.[195] However, this should not obscure the fact that prominent black figures such as W. E. B. DuBois and Paul Robeson continued to be associated with it, and it also attracted some younger talents such as Alice Childress, Harold Cruse and Lorraine Hansberry. The later 1940s saw two black artists assume unprecedented prominence as avatars of social art in Charles White and Jacob Lawrence.[196] They were friends, mixed in the same circles in New York and were both involved in the Committee for the Negro in the Arts set up in 1949. Yet their art was vastly different. The significance of these differences was heightened by the Cold War and its repercussions within the Communist movement.

I considered White's formation as a mural painter within the Illinois Federal Art Project in Chapter Seven. Despite his youth, by the time the FAP ended he had established a considerable reputation. An oil mural by him, the *History of the Negro Press*, was hung outside the Associated Negro Press exhibition within the *American Negro Exposition* held in Chicago in 1940,[197] and over the next few years his work was shown in various exhibitions devoted to African American art, winning several prizes. In addition to his developing skills as a painter in oil and tempera and his finely worked drawings, he also made increasing use of lithography, a medium that he had studied at the Art Institute,

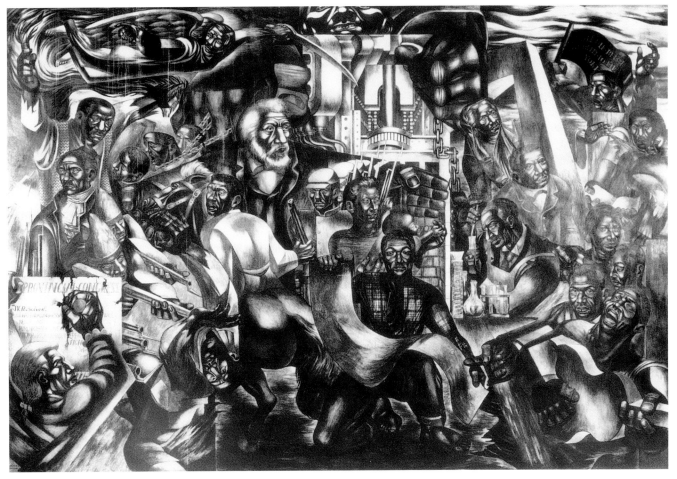

185 Charles White, *Contribution of the Negro to Democracy in America*, 1943, egg tempera *(fresco secco)*, 11 ft 9 in. × 17 ft 3 in., Hampton University Museum, Hampton, Virginia.

and one that suited his growing interest in working in black and white.[198]

In 1941 White married the gifted sculptor and printmaker Elizabeth Catlett,[199] and was awarded a Julius Rosenwald Fellowship. He had hoped to use the fellowship to study fresco technique in Mexico but, prevented from leaving the country by his draft board, he enrolled at the Art Students League and studied tempera painting with Harry Sternberg instead. White subsequently spent two years living in the South, which he later described as 'one of the deeply shaking and educative experiences' of his life.[200] During this period he devoted three months to researching 'the history of the American Negro, with particular emphasis on his role in helping to build a democratic America', at the same time making sketches and studies for a mural, the *Contribution of the Negro to Democracy in America* (fig. 185) for the Hampton Institute, Virginia. Like his earlier murals, this uses a

range of worthies, from Crispus Attucks (lower left) round through Nat Turner, Denmark Vesey and Frederick Douglass, to Marian Anderson, Paul Robeson and Leadbelly (lower right), to symbolise African Americans' own struggles in creating a more democratic environment for the modern black family, represented by the group in the centre, who look towards a planned future, signified by the blueprint held by the kneeling father.[201] As White made clear in his report and application for a fellowship renewal, he conceived his work as a contribution to the 'united front of all races of people' that was necessary to win the struggle against fascism: the 'forces in America that would oppress the Negro are not representative of America, but rather of the same element we are fighting in Europe and the far east'. Correspondingly, the fellowship renewal was for a series of works 'in the painting and graphic media', that would illustrate the role of African Americans in the war effort.[202]

186 Charles White, *This, My Brother*, 1942, oil on canvas, 24 × 36 in., Art Institute of Chicago, Pauline Palmer Purchase Prize Fund, 1999.224.

187 Charles White, *The Ingram Case*, from *Masses & Mainstream*, February 1950.

As Peter Clothier has observed, from the *History of the Negro Press* onwards White's interest in the objectives of Social Realism had been accompanied by a new concern with modernist formal devices.[203] While the forms in the Hampton Institute mural are heavily modelled, the piled up figures rely on *chiaroscuro* and overlap to give them a spatial presence, and there is no coherent recession. Even without the industrial press, so reminiscent of the kindred motif in the South Wall of Rivera's *Detroit Industry*, the influence of Rivera's example would be transparent, although the dynamic qualities of the image are more reminiscent of Siqueiros. In smaller works in tempera and crayon, such as those on war themes from around the same time (fig. 186), figure types are stylised in ways that demonstrate an engagement with Synthetic Cubism, and often appear silhouetted against generic landscape backgrounds that deny standard perspective.

In 1946, White made a year-long visit to Mexico, staying part of the time with Siqueiros, and studying with the artists of the Taller de Grafica Popular, whose work he admired enormously. 'Mexico was a milestone', he recalled four years later: 'I saw artists working to create an art about and for the people . . . It clarified the direction in which I wanted to move.'[204] On his return to the United States, he settled in the Sugar Hill area of Harlem where numerous artists and intellectuals lived, his circle of friends including Shirley Graham, Lorraine Hansberry, Langston Hughes, Jacob Lawrence and Paul Robeson. Despite chronic ill health due to the tuberculosis he had contracted during his military service, White was very much an activist artist in the late 1940s. As well as the predictable involvements with the American Labor Party and Arts, Sciences, and Professions, he provided cartoons and portraits for various pamphlets protesting about civil rights cases, and his powerful images of the Trenton Six and the Ingram Family (fig. 187) were widely reproduced to accompany articles in the Communist press.[205] As critics observed at the time, there was a monumentality to White's figural forms that was reminiscent of Rivera and Orozco's work,[206] but not only was he working in a context where he was unlikely to find mural commissions, ill health forced him to concentrate primarily on drawings and prints. Although he had participated in group exhibitions at the ACA Gallery from 1942 and had solo shows there in 1947, 1950, 1951 and 1953, White was disparaging of artists who concentrated solely on 'one-man shows, [and] gallery & museum representation'. Like many 1930s artists, he believed that the route to a working-class audience would come through the print media, and invested great

hopes in the Graphic Workshop, discussed in Chapter Eight.[207] One fruit of this concern with broadcast was a portfolio of six reproductions of White drawings published by *Masses & Mainstream* in 1953.[208] This folio was uniformly praised in the Communist press, and both the drawings and their reception are profoundly symptomatic of the impact of Zhdanovism on the artistic culture of the CPUSA. They thus demand attention here. First, however, I need to situate them in relation to White's development and reputation in the early 1950s.

In addition to the black historical figures who were an abiding concern to him throughout his career, White's early New York shows illustrated two other thematic preoccupations, namely images of African American music-making, usually in the form of single figures, and the courage and beauty of African American women – indeed, the 1951 exhibition was devoted to the latter theme.[209] The most politically focussed of these exhibitions seems to have been that of 1950, which opened on Lincoln's birthday and was timed to coincide with National Negro History Week. Among the exhibits were images of John Brown, Harriet Tubman, Gabriel Prosser, Frederick Douglass and the well-known drawings of the Ingram Case and Trenton Six. Yet at the same time as he 'applaud[ed] the correctness of his basic orientation', the *Daily Worker*'s Charles Corwin offered the artist 'certain suggestions', particularly warning him against repetitive stylistic mannerisms such as 'upturned eyes and furrowed brows' and gestures of animation that seemed unmotivated. While Corwin measured White's style by the example of Siqueiros (who certainly seems an influence on some of his work of the late 1940s), in fact over the next few years his art came to depend on naturalistic devices that brought it far closer to the Socialist Realism Siqueros himself rejected.[210]

According to Finkelstein's review of the 1953 ACA exhibition, this shift was at least partly brought about by 'his discussions with artists of the Soviet Union and the people's democracies, as well as with progressive artists of France and Italy.'[211] In 1951 White and his second wife, Frances Barrett, made an extended trip to Europe, where he was chairman of the American delegation to the World Youth Congress in East Berlin, and then went on to visit Czechoslovakia, Poland and the USSR.[212] However, although White was evidently deeply affected by this experience and came back declaring Soviet art to be without any qualification 'the greatest in the world', his own work had begun to change earlier, and was already being described as 'socialist realism' on the basis of his 1951 exhibition.[213] Doubtless his contact with Soviet art and artists confirmed this direction, and

in the aftermath of this tour White made statements that adopt the language of Zhdanovism, calling on those few artists who had not succumbed to the prevailing trends to 'distortion of truth, reality and the dehumanization of life', to take on 'the major task of placing the brush, the pen, the chisel, the photo at the disposal of the peace fighters': 'For them the question of realism must no longer remain a debatable question. We must shed the vestiges of formalism that still is evident in his work' (*sic*).[214] It is thus entirely apposite that White's work was exhibited and reported in several East European countries, especially in the German Democratic Republic, to the Arts Academy of which he was elected a corresponding member in 1961.[215]

Returning to the *Masses & Mainstream* portfolio, it can be seen that White continued to achieve effects of monumentality by cropping figures within frames that seemed too small to contain their bulk in drawings such as *Let's Walk Together* and *Harvest Talk* (fig. 188). As before, the status of his workers was signified as such through enlarged hands and generous musculature.[216] However, these six drawings also manifest White's new commitment to Socialist Realism in their greater naturalism and eschewal of the expressive devices of his earlier work. Symbolism is kept simple, as in the white dove being received into the hands of the girl in *Dawn of Life*, the mother's protective gesture over her child in *Ye Shall Inherit the Earth* or the hammer and sickle motif intimated by the conjunction of scythe, fist and stone in *Harvest Talk*. The shift is also evident in the way seraphic confident smiles have replaced anguished looks. As W. Z. Foster wrote: 'Socialist man and woman are happy beings.'[217] Numerous reviews in the Communist press show that this new style was seen as an advance on White's earlier work. Most importantly, it stood for both beauty and optimism – qualities that were deemed defining characteristics of the 'socialist humanism' that had become the key category of aesthetic approbation within Communist culture in the Zhdanovist phase.[218]

In the 1950s the qualities of such art were proclaimed again and again by what remained of the CP left as the answer to the perceived 'obscurity and anti-Humanism' of contemporary bourgeois culture.[219] However, in 1956 White himself largely withdrew from activism (although he remained under FBI surveillance), moving with his wife to California, where he had a distinguished teaching career. In the last two decades of his life his work acquired a new kind of appeal as a result of the Civil Rights Movement and the resurgence of black nationalism, and he became a kind of senior statesman of African American art.[220]

Like White, Jacob Lawrence (1917–2000) came into contact with the Communist cultural movement early in his career.[221] His mother brought her children to Harlem around 1930, and Lawrence first took art classes at a settlement house with the painter Charles H. Alston. He subsequently studied at the CAA-sponsored Harlem Art Workshop from 1932 to 1934 under Alston and Henry Bannarn, and then at a WPA Workshop housed in Alston's studio at 306 West 141st Street. Among the circle that gathered round the studio were such leftists as Aaron Douglas, Langston Hughes and Claude McKay.[222] Lawrence also frequented the studio of Augusta Savage, already encountered here as a member of The Vanguard. It was Savage who got Lawrence enrolled for his eighteen-month stint on the Harlem FAP easel division in 1938–9, an experience he regarded as profoundly educative. In 1937, through the offices of Harry Gottlieb,[223] Lawrence had won a two-year tuition scholarship at the American Artists School, and effectively he moved between the world of the School's premises on West 14th Street and that of the Harlem left. His work was first exhibited at a group show of the Harlem Artists Guild at the 115th Street branch of

the New York Public Library in April 1937, and for the second time at a Guild showing at the School the following month. Similarly, his first solo exhibition was held at the Harlem YMCA in February 1938, and the second at the School a year later.[224]

Again like White, Lawrence enjoyed a prodigious early success, but his impact in the mainstream art world and the press was greater and more enduring. From the outset, Lawrence established a distinctive signature style. Working in gouache or tempera on paper, or casein on hardboard panels, he used strongly coloured forms and mask-like faces contained within a radically simplified drawing that adhered firmly to the surface plane. While he was studying at the WPA Art Workshop, he had told Gwendolyn Bennett that he worried because 'no matter how much I try I just can't draw like the rest of the fellows'. Bennett, however, encouraged him to carry on in the way he was working.[225] Although terms such as 'primitive' and 'childlike simplicity' were toyed with by early reviewers seeking to characterise the small Harlem scenes for which Lawrence was first known (fig. 189), these were always superseded by acknowledgement of the sophistication of the artist's draughtsmanship and

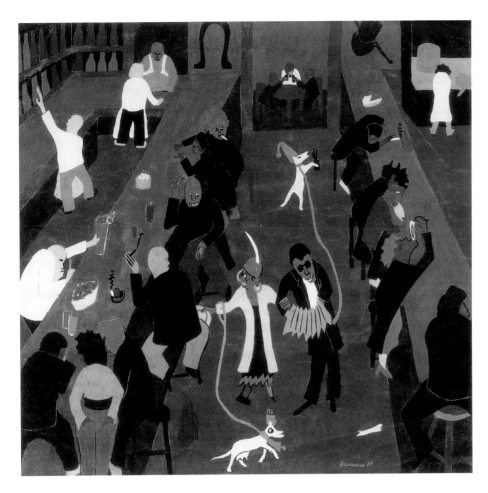

189 (*left*) Jacob Lawrence, *Bar'n Grill*, 1937, casein on paper, San Antonio Museum of Art, San Antonio, Texas. Purchased with funds provided by Mr and Mrs Hugh Halff, by exchange; Dr and Mrs Harmon Kelley; and Dr Leo Edwards. 95.58.

188 (*facing page*) Charles White, *Harvest Talk*, 1953, charcoal, pencil, and graphite, with stumping and erasing on ivory wood-pulp laminate body, 26 × 39 in., Art Institute of Chicago, Restricted gift of Mr and Mrs Robert S. Hartman (1991.126).

design. As reported by the *Daily Worker* in 1938, Lawrence comes over as precociously modernist in his viewpoint: 'The technique he uses – his attention to design through distortion and to symbolism – seems to him the best approach to the flat medium of painting, which he considers no more natural than a stage set. Into his flat surfaces he tries to put a paradoxical depth of significance.'[226]

Combined with this distinctive technique was a unique approach to narrative that was realised in series of small works of uniform size depicting the lives of various historical figures who had contributed to the struggle against African slavery. These were accompanied by terse captions, mainly of the artist's own invention, which, as contemporaries noted, functioned as a kind of free-verse libretto in relay with the images. The first of these, comprising forty-one paintings on the theme of Toussaint l'Ouverture (Armistad Research Center's Aaron Douglas Collection, New Orleans), was painted in 1937–8 and won second prize for watercolour at the 1940 *American Negro Exposition* in Chicago. It was followed by series around the lives of Frederick Douglass (1938–9; Hampton University),

Harriet Tubman (1939–40; Hampton University) and John Brown (1941; Detroit Institute of Arts). In this concern with the heroes and heroines of black history Lawrence again resembles White,[227] and the series can be understood as miniature mural sequences. Indeed, interviewed by McCausland in 1945, he referred to Orozco as the first 'well-known artist' he had taken note of, and associated him with his own mural type ambitions.[228]

In 1939 Lawrence began research for what became his most ambitious series to date, *The Migration of the Negro during World War I* (fig. 190). The first of three successive Rosenwald Fellowships allowed him to realise the sixty casein paintings, which are now divided equally between the Phillips Collection, Washington, DC, and the Museum of Modern Art in New York. Through the agency of Alain Locke, these were brought to the attention of Edith Halpert, who exhibited them at the Downtown Gallery in November 1941. This was the beginning of a long-running connection between Lawrence and the Downtown – as I have said before, a significantly different kind of gallery from the ACA where White showed[229] and one more sympathetic to an artist with Lawrence's formal interests. Simultaneously with

190 Jacob Lawrence, 'Race riots were numerous. White workers were hostile toward the migrants who had been hired to break strikes', panel 50 from the *Migration Series* (1940–41; text and title revised by the artist, 1993), tempera on gesso on composition board, 18 × 12 in., Museum of Modern Art, New York. Gift of Mrs David M. Levy.

the 1941 exhibition, twenty-six of the *Migration* series were showcased in a colour feature in *Fortune*. Lawrence had arrived, and the showing of his Harlem series in 1943 was widely reviewed and even reported in *Vogue*.[230] In 1942 he won the sixth prize of $500 in the Artists for Victory competition for *Pool Parlor* (Metropolitan Museum of Art, New York), and in 1944 he was given a solo show at the Museum of Modern Art.

This pattern of success needs to be understood in relation to the more widespread upsurge of interest in 'Negro Art' in the early 1940s, which was in part an effect of the opportunities provided to black artists, theatre workers and writers by the federal art programmes. The Downtown's important exhibition

American Negro Art: 19th and 20th Centuries of 1941–2, at which works by both Lawrence and White were shown, is only one of a number of such displays,[231] some of which I have already mentioned. But as Alain Locke's text accompanying *Fortune's* feature on the *Migration* series makes clear, African American culture was also newsworthy because of a new wave of migration and black resistance to discriminatory employment practices, culminating in A. Philip Randolph's 'March on Washington' movement and the 'Double V' campaign.[232] Moreover, as Locke noted: 'In every country in the world Hitler has used the American Negro as prime propaganda to convince people that US democracy is a mockery.'[233] The entry of the United States into the war and the continuing racial tensions in the defence industries kept black culture topical, and in 1943, when the *Migration* series was shown at the Portland Art Museum, a discussion forum was held in front of the paintings to try and defuse tense race relations in the Kaiser shipyards.[234]

Lawrence's wartime career epitomised the aspirations progressive liberals and Communists invested in the war effort as a route to advancing inter-racial democracy in the face of the rising tide of racism that the wartime migrations in the United States generated. Drafted into the US Coast Guard in 1943, Lawrence saw extensive service on troop ships. Fortunately, both his commanding officers had liberal views on race and recognised his talents. He served on the first integrated ship in the US Navy under Lieutenant Commander Carlton Skinner, who secured for him a public relations rating so that he could document service life, and subsequently he was combat artist on a troop ship under Captain J. S. Rosenthal.[235] When eight of his Coast Guard paintings (fig. 191) were shown at the Museum of Modern Art with the *Migration* series in 1944, the Museum's press release asserted that 'Coast Guardsman Lawrence paints facts, not propaganda', at the same time claiming:

> Yet almost imperceptibly his Coast Guard paintings suggest the gradual beginnings of a solution to the problem so movingly portrayed in the Migration series... [In them] both races face the same fundamental problem – the war. Colored and white men mingle in recreational sports on deck, eat together, work together... Death and injury play no favorites, and all Uncle Sam's nephews rate the same pay in their non-racial classifications.

To emphasise the point, at the reception preceding the opening, a song recital was performed by an inter-racial Coast Guard quartet. Reviewing the exhibition for the CP press, Elizabeth Catlett made essentially the same

191 Jacob Lawrence, *Painting the Bilges*, 1944, gouache on paper, 29 × 20 in., Hirshhorn Museum and Sculpture Garden, Smithsonian Institution, Washington, D.C., The Joseph H. Hirshhorn bequest, 1981.

192 Jacob Lawrence, *Rooftops (No.1, This is Harlem)* (1 of 30), 1942–3, gouache on paper, 15³/₈ × 22¹¹/₁₆ in., Hirshhorn Museum and Sculpture Garden, Smithsonian Institution, Washington, D.C., Gift of Joseph H. Hirshhorn, 1966.

argument as the Museum's press release, but in significantly different language: he 'began in the Coast Guard as a mess-man and has, through his own initiative, demonstrated that an artist can fight fascism with his paints. For his paintings are a powerful weapon against those who would divide us race against race.'[236]

Lawrence's success is likely to have been the result partly of his personal style as well as the specific qualities of his art. Whereas White's familiars described him as outspoken or even pugnacious, Lawrence was repeatedly characterised in the press as shy, modest and reticent.[237] In a profile of 1951, *Ebony* even suggested that he had 'shirked discussions that tended to become controversial' in interview. However, this should not lead one to underestimate his commitments, and five years earlier he was quoted as saying: 'I can only express the people and the class of which I am a part', at the same time as he rejected the idea of striving for 'a separate and distinct Negro art.'[238]

Both White and Lawrence showed in *A Tribute to the Negro People*, an exhibition mounted in Detroit by the National Negro Congress and *New Masses* in May–June 1946 to challenge the racist groupings active in the city.[239] However, while White produced a number of works addressed to the specific cases taken up by the CRC that functioned as illustrations in the Communist press, Lawrence did not. This is not to imply that he was quiescent, and he made notable illustrations for two articles on the South in the *New Republic*, and an important series of tempera paintings on postwar conditions in the Black Belt for *Fortune*.[240] But the *New Republic* was a liberal publication and *Fortune* not even that. Insofar as Lawrence's work features in the Communist press in the late 1940s, it was in the pages of *Mainstream* and *Masses & Mainstream* – that is to say in publications that were associated with the intellectual wing of the Party, indeed what for many members was its over-intellectual wing.[241]

In addition to his personal traits and iconographic choices, another key factor in explaining Lawrence's continuing success with liberal opinion and his diminishing standing in Communist critical discourse is the style of his art. From the outset, his work had been praised for its 'objective' quality – indeed, early reviews in the Communist press linked it to the documentary idiom.[242] The tenor of mainstream pronouncements is epitomised by *Vogue*'s description of the Harlem series of 1942–3 (fig. 192) as 'factual reports without bitterness or preaching.' While McCausland sought to argue that the series' impact was one of 'horror', this does not match the general reaction. More representative is the response of a reviewer who claimed: 'he envelops these lugubrious statements in such vivid color and presents them in such a decorative fashion that the spectator is more apt to be charmed than horrified.' In 1943 *Art News*, in an article significantly titled 'Lawrence: Quiet Spokesman', claimed that the 'propaganda' value of his work lay precisely in its 'purely visual truth', its lack of 'bitterness or overstatement.' Not surprisingly, the seeming coolness of Lawrence's art did not seem such a virtue to some critics on the left. In an otherwise positive appraisal, *New Masses*'s reviewer also emphasised the 'sociological foundations' of the Harlem series and praised their striking symbolism, but found that 'the abstract quality of the artist's style serves, unfortunately, to obscure the inherent human warmth.'[243]

These qualities did not apparently affect Lawrence's standing in the Communist movement as long as the Party's critics were still thinking within a Democratic Front framework. In January 1946, he was one of those honoured (along with Duke Ellington, Joe Louis and Frank Sinatra) at a *New Masses* awards dinner in New York.[244] The following year, Finkelstein invoked Lawrence's work to illustrate the healthy fusion of folk and national idioms in art that was yet universal in its appeal.[245] But I have already shown in the preceding chapter how Finkelstein's judgement on this matter changed in the 1950s under the impact of Zhdanovism, when he claimd that:

> whenever thin, decorative or subjective stylizations or distortions of drawing are applied to the human subject, whatever the intention, the subject inevitably looks one-sided, not really human as people know human beings to be, seemingly coming from a strange and alien world. An artist using this style cannot speak to the common people as one of them.

Correspondingly, the work of White, 'who broke increasingly from his early stylizations', displaced that of Lawrence in the pages of *Masses & Mainstream*.[246]

Modernist qualities had been central to Lawrence's art from the beginning and, while he criticised the abstract trend and anti-humanism in an address to Arts, Sciences, and Professions,[247] in the 1950s his work became more sophisticated and knowing in its use of modernist devices. In his own eyes Lawrence remained a Social Realist, and he associated himself with such artists as Gwathmey, Levine, Shahn, the Soyers and Davis. Although Davis seems an incongruous bedfellow with these others, for Lawrence Davis was a realist because he 'conveys the aspect of the city . . . better than anyone.' Realism was not to be confused with naturalism: 'Naturalism means fidelity to nature . . . Realism means getting beneath the surface of reality.'[248] While Communist critics continued to invoke this distinction, for many of them it could no longer license the kind of stylistic choices Lawrence made. This was their loss, for Lawrence went on to produce powerful works on historical and social themes throughout his career, as well as making highly effective graphics relating to immediate political issues.[249]

Modernism and Social Narrative

Lawrence's engagement with Cubism links him with two other artists who had closer long-term relationships with the Communist movement, Robert Gwathmey (1903–88) and Anthony Toney (b. 1913). Both were sometime Party members who suffered the attentions of the FBI. Gwathmey was involved with a sequence of Communist-sponsored organisations over many years: he was vice-president of the Philadelphia Artists' Union and a member of the Artists' Congress, played an important role in the Artists League of America, and was active in both Arts, Sciences, and Professions and Artists Equity.[250] Ten years his junior, Toney became politicised in the years 1934–7. Having completed a fine arts degree at Syracuse University in 1934, he returned to his home town of Gloversville, New York, where he taught classes to trade unionists and the unemployed, and became a Party member. In 1937 Toney travelled to Paris to study on a university fellowship, and the following year he went from there to fight in Spain, and was wounded in the face and neck while serving on the Ebro front. After resuming his artistic career, he was active in the same organisations as Gwathmey, and held several important offices in Artists Equity. Gwathmey was fired from the New School for Social Research art workshops in 1949 because of his Communist affiliations. Ironically, Toney was hired by the same School in 1953 and taught there for many years.[251]

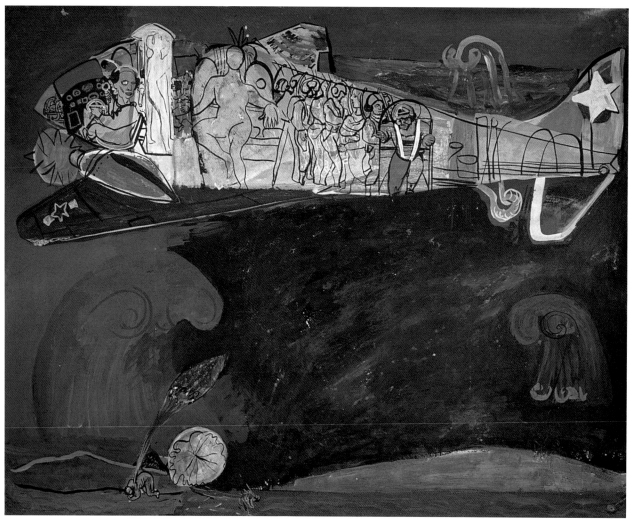

193 Anthony Toney, *Night Flying*, 1945–8, tempera, 22 × 28 in., whereabouts unknown.

Both Gwathmey and Toney were emphatic moderns, whose consistently advanced positions brought them up against the doctrinal rigidities of Party thinking on the arts in the Zhdanovite phase, without apparently causing them to alter their political allegiances. Unlike Lawrence, their approach to the problems of addressing complex historical and social realities in painting was not through the series but through the synoptic figure picture, although they differed markedly in technique and approach. Both had experimented with the mural in the New Deal period[252] when it seemed the 'natural' medium of a propagandistic public art. Like others, in the postwar years they were forced back into the realm of the easel painting where the principles of modernist form had far greater authority.

A sketch of Toney by his friend the sculptor Herzl Emmanuel dates his involvement with Cubism to the aftermath of his Paris trip. At the same time he began his 'love affair with New York city' of which he produced numerous pictures. (He moved to New York in 1939 after receiving threats from the Knights of Columbus in Gloversville.[253]) He himself wrote that '[i]t was not until the period 1939–42 that my direction assumed any distinctness.'[254] His first solo show at the Wakefield Gallery in 1941 prompted *Art Digest* to label him a 'modernist', but he was not a modernist in the aestheticist sense.[255] As I said before, the Social Realists generally emphasised that their art was grounded in individual experience, and this is as true of the modernists Lawrence and Neel as it is of more traditional painters such as Soyer. The key experiences for Toney's work of the 1940s were his role in the struggle against fascism in Spain and his three years of service as an aerial engineer with the Army Air Force in the Pacific. Toney flew 443 combat missions and was decorated with the Distinguished Flying Cross with Oak Leaf Clusters and the Air Medal with four Oak Leaf Clusters. He also continually sketched and made numerous portraits of his comrades.

194 Anthony Toney, *The Four Corners*, 1946, oil on canvas, 37³/₄ × 51³/₈ in., Collection of the Robert Hull Fleming Museum of Art, University of Vermont, Gift of Dr and Mrs Arthur Kahn, 1992.2.

The fruits of his wartime observations were evident in his solo exhibition at the Artists' Gallery in 1948, and in that shown next door at the ACA the following year. The press releases for both emphasised the holistic nature of the artist's vision. Some of the exhibits seem to have been based partly on direct experiences of working with c47 transport planes in New Guinea, while others, such as *Concentration Camp*, were apparently drawn from photographs.[256] The tempera of *Night Flying* (fig. 193) is characteristic of the way the machinery of war is humanised in these works by rendering surfaces transparent to reveal the persons inside – made to seem organic, while the oversized seated woman is perhaps an allegory intended to maternalise the aircraft as it delivers itself of the parachuting soldiers.[257] At the ACA exhibition of 1949 some of the titles – such as *Riverside Drive* and *Sherman Square* – anchored the works to New York, in other instances such as *Bridge*, the iconography clearly referred to familiar aspects of the city. But the images were generally composite and attempted to make larger statements about the condition of the world.

At the same time as the Artists' Gallery and ACA press releases gave details of his wartime service, they also drew attention to the distinctive formal and theoretical qualities of Toney's work. That of 1948 claimed:

Being essentially an abstract artist, Toney would make clear that this often misunderstood form of painting need imply no divorcement from life. According to his own definition: 'the term "abstract" involves taking from life elements, that thru' a process of analysis, invention and selection become a new reality, extending and enriching our consciousness of life.'

The ACA's statement noted that his paintings were rich in 'allegory and symbolism' within 'themes taken from everday life': 'His method is almost cine[ma]tic and he utilizes the elements of montage and surrealism to explore the most diverse and complex subject matter.'[258]

The examplary instance of this 'method' is the canvas *The Four Corners* (fig. 194) from the 1948 exhibition, a painting that had already been singled out by Joe Solman when it was shown at the ALA annual in 1946, and made the centrepiece of his review. Solman reported that the artist told him 'he was trying to render the terrifying apathy many GI's meet on their return home', and that although the painting depicted his native Gloversville, the city was 'faced with the same forbodings as any other corner on earth.'[259] The picture is certainly an extraordinary conjunction of symbols, and is also cacophonous in its visual effect. The archetypal 'Main Street' vista is packed with incongruous motifs that range from the concentration camp scene under the mauve awning on the mid-left, through the jitterbugging figures of two women, a GI talking to a Soviet soldier, a Japanese executioner, a bedecked military leader, a surrendering German, a little girl on a carousel under a lamppost, topped by a German helmet, from which a corpse hangs, and more. The naked figure reaching vainly for the all-seeing eye is positioned over an atom bomb cloud that marks the terminus to the perspective. On the upper right a man's face – which may represent the artist as returning GI – looks through bars. Solman aptly noted that the conglomeration of motifs suggested something like 'the stream of consciousness method in the novel'. Moreover, the picture is as stylistically diverse as it is iconographically complex. Passages of thin paint and summary drawing contrast with the lumpy impasto of areas such as the building façade on the right edge. In parts it seems as if Delaunay and Dufy are being mocked. As civilisation melts down, so does the art of painting.

When Solman returned to *The Four Corners* in his review of Toney's 1948 exhibition, he again praised it but warned that in other works 'the heap of images gets out of control and a multi-faceted confusion results.'[260] In fact, the wilful anti-aesthetic character of *The Four Corners* was probably difficult to sustain, and the painting *59th Street Bridge* (fig. 195), shown at the ACA Gallery in 1949, illustrates how in other works his ambitions were contained within more standard modernist structures. It also shows his attempt to use observed motifs from in and around New York as general symbols.[261] In a catalogue statement Toney described himself as an artist 'absorbed in modern experimental art traditions as well as the old Coptic, Byzantine and primitive streams', and reiterated that he regarded his work as 'abstract'. His aim was the 'integration of multiple levels of experience in a single structure object': 'A single space–time approach cannot give a sense of

20th century man, nor, for me, can the exploitation of only part of the painting means. The only limitation that an artist can recognize is that imposed by the organization and realization of his work.' Describing another painting on the bridge theme, he explained that he sought to utilise the 'dramatic contrasts of spatial relationships' that characterised the 'modern environment', and to suggest the interplay between it and human consciousness: 'In the bridge, the lamppost becomes a warrior structure with a spear capped by a symbol of the atomic bomb. My first child, Anita, becomes part of the base of another. Climbing the stairs are some millions of us . . . The bridge is a symbol of cooperation, of our strength and wisdom.'[262]

Toney hoped that in such works the interplay of 'contradictions' would amount to a 'plastic structure' that 'might be called Epic form'. (Probably he had in mind Brecht's Epic Theatre.) However, for all the interest Toney's work aroused, few seem to have been persuaded. Commenting on the artist's 1949 exhibition in the *Daily Worker*, Charles Corwin complained of the stylistic hybridity of his works, and observed that rather than achieving a synthesis of form and content, his approach 'tended to confuse and obscure the basic ideas'. Even Charles Keller, who wrote to the paper to defend Toney as 'one of the few artists who has successfully tackled the problem of expressing progressive ideas with modern painting forms and devices', none the less acknowledged 'weaknesses' that derived primarily from 'his tendency towards complex and subjective symbolism and his almost compulsive devotion to minute details.'[263]

At root of the problems in Toney's work seems to have been his continuing attraction to painting directly from life – at which he was extremely gifted. Although Toney did not renege on his commitment to a modern painting,[264] in the course of the 1950s the naturalistic elements in his style became more prominent and the powerful gaucherie of drawing and design that characterised his work of the previous decade diminished. At the same time his use of colour – which Solman had already suggested was inappropriate in its 'rich, spangled effects' to his 'dramatic or morbid themes'[265] – became more ingratiating. Lawrence Campbell wrote unflatteringly of the works in his 1955 show that they looked like 'a review of early American Cubism', which is to say that they had a Cubistic effect rather than showing any real understanding of Cubist principles: 'Toney may chew on his cityscapes and ruminate over them but they remain something seen through a glass that has fractured.' That Campbell should approve Toney's colour effects and

195 Anthony Toney, *59th Street Bridge*, c. 1949, whereabouts unknown.

liken them to Vuillard's only serves to indicate how much the artist had conceded to more conventional norms of taste.[266] Toney had a long and successful career as a teacher and remained an artist of considerable technical accomplishment, but the most challenging phase of his art was over by the mid-1950s.[267]

Gwathmey addressed the same problems as Toney, in that he wished to make synoptic depictions of social relations within a modernist idiom. However, in the long term he accepted the logic of Synthetic Cubism in a more consistent and rigorous way than Toney, and conceived his compositions without direct reference to observed experience. In 1946 he described himself as 'unalterably opposed' to naturalism, and defined realism as lying in 'the essence of the image'. Unlike Toney, he aimed for

'concise expression', and argued that 'the literary' could be avoided 'if your imagery is strong and inventive enough': 'Modern painting must, first off, have a simplified two-dimensional base and, second, a three-dimensional spatiality. These should be considered in direct color relations, with elimination of atmospheric effects created by chiaroscuro and impressionistic fuzziness.' Those he listed as providing 'points of reference' for a better understanding of his work included 'Picasso, most of all. Orozco. Matisse. Hartley's late work.'[268]

To arrive at this aesthetic, Gwathmey had effectively renounced much of the approach to art he had learnt in his years at the Pennsylvania Academy from 1926 to 1930, and in 1938 he destroyed nearly all his earlier work in a kind of symbolic purgation.[269] His painting

Chauffeur (Carnegie Museum of Art, Pittsburgh), a satirical image of a disdainful chauffeur holding out his mistress's lapdog, attracted some critical notice when it was shown at the third annual membership exhibition of the American Artists' Congress in February 1939. Although the picture is more Daumieresque in its use of facial expression than his later work, it already indicates his concern with avoiding naturalistic perspective and his distinctive sense of colour and surface pattern.[270] Later in the year, Gwathmey won first prize in the Congress's fourth annual competitive exhibition with *Land of Cotton*, which was probably the large gouache and watercolour of that title in the Art Institute of Chicago. As the *Daily Worker*'s reviewer noted, the composition of this is 'mural-like', and it offers a conspectus of Southern society not unlike Evergood's *Cotton from Field to Mill*.[271] (Evergood was one of the competition judges and became one of Gwathmey's closest friends.) Between the signs of the Old South on the left of the composition and of the New South on the right, immiserated workers, both black and white, endure grinding labour from their impoverished childhoods to equally impoverished old age. The picture was shown again at Gwathmey's solo debut at the ACA Gallery in 1941 with a number of other works on Southern themes that prompted the *Daily Worker*'s Oliver Mason to assert: 'I know of no other artist who has depicted life in the South with so much penetration'.[272]

Indeed, images of the South predominated in the exhibition and remained central to Gwathmey's work for the most productive part of his career. The artist himself gave a vivid account of how this came about in statements quoted by Elizabeth McCausland in a 1946 article. He stressed how his sharp awareness of the contrasts between South and North dated from his first visit to Baltimore in 1925, when he had begun his artistic training at the Maryland Institute of Design. It was in Baltimore that he first saw a black policeman and monuments to Yankee generals. The experience made him see his own region with new eyes, both physically and socially: 'When I got back home, I was shocked by the poverty . . . I was shocked at the red clay, at the *redness* of the clay. The green pine trees and red clay were everywhere. The Negro seemed to be everywhere, too, omnipresent. But he was a thing apart, so segregated.' The first time he met African Americans 'on an equal plane' was in the Philadelphia Artists' Union.[273] Like Toney, then, Gwathmey emphasised that his art was grounded in his own experiences. In 1944 he won a Rosenwald Fellowship in order 'to live on a tobacco farm' and encounter the nature of sharecroppers' labour first hand, and he spent the summer with his family on a farm in North Carolina. At the same time, his wife Rosalie (who also studied at the Pennsylvania Academy) had turned to photography and over several summers made pictures of sharecroppers that Gwathmey drew on in his work. In 1951 the artist even observed a Ku Klux Klan rally in the interests of authenticity.[274]

Yet while his personal experiences are crucial to understanding Gwathmey's preoccupation with Southern themes, this also needs to be seen in relation to Communist discourse on the South which in part determined his understanding of his observations and the particular iconography he devised for his work. The Southern images in his 1941 exhibition could stand, at one level, as an antidote to the racist mythologising of the South in *Gone With the Wind*, a film that was attacked repeatedly in the Communist press in 1939–40. Correspondingly, they match the Party's campaign against Poll Tax, Jim Crow and the KKK, and its relentless criticisms of reactionary Southern Democrats who allied themselves with right-wing Republicans to block the progressive policies of the New Deal in the aftermath of the 1938 elections.[275] Paradigmatic of Gwathmey's conception of the South at this time is the relatively large painting *From Out of the South* (fig. 196), which was seen as one of the most important works in his 1941 show. In this, the red soil of his native Virginia seems so exhausted by monoculture that it can support only a few straggly cotton plants and a little tobacco, the quintessential staples of the South. The racial order of the region is represented to the right by the plantation owner, with his family portrait and family graves, a figure who rests visually on the hand and gun of the obese chain-gang guard. These symbols of the Old South are balanced against the mean gas station and distant factory on the left. The poor whites gathered next to the pumps have a lot that is only relatively better than the black figures toiling behind them. But the composition implies that passing behind the façade of the gas station they can turn into the figure of the Klansman who menaces the sharecroppers working under the ominous lynching tree. The torn circus posters may well refer to the tawdry spectacle of Southern politics, while '666' was the brand name of a widely sold quack medicine,[276] as well as referring to the mark of 'the beast' described in the *Book of Revelation*, chapter 13, and hence perhaps to the modern apocalypse of social revolution. *From Out of the South* offers a pictorially interlocked formulation of a social order grounded in forms of class exploitation that are sustained by racism.

196 Robert Gwathmey, *From Out of the South*, c. 1941, oil on canvas, 39¹/₂ × 60 in., Smart Museum of Art, University of Chicago, Mary and Earl Ludgin Collection. © Estate of Robert Gwathmey/Licensed by VAGA, New York, N.Y.

Between 1941 and his retrospective exhibition of 1946, Gwathmey's work underwent a marked development that was widely commented on at the time. His colour range brightened, and in some works he used overlapping planes that indicated clearly his adoption of Synthetic Cubist devices, reminiscent of both Picasso and Tamayo. According to Paul Robeson (who wrote the catalogue essay) Gwathmey sought to draw on the culture of Africa,[277] while at the same time rejecting 'primitivism as it was used in the modern school to throw off civilization and to express disillusionment in the modern world.' The meanings of these modern devices lay partly in Gwathmey's resolute concern with avoiding anything that might smack of the 'picturesque', particularly in his depictions of African Americans: 'When any people can depict any other people as picturesque, it degenerates into romantic mockery. And this is true not only of the Negro, but of all oppressed groups – and also women.' The linear designs and sharp colour contrasts of his paintings thus had a critical anti-picturesque function, as Robeson saw: 'His color has an unusual harmony which is, in effect, the expression of a new social concept. The atmosphere of his painting is free of mysticism or superstition.' The 'architectural simplicity' of Gwathmey's art and its appearance of careful deliberation (Gwathmey was often described in the press as a slow worker) symbolically correlated with a precise perception of social relations. Modern pictorial means stood for a modern perception of the world, a perception from which reactionary myths about African Americans had been stripped away.[278]

In Aline Louchheim's review for *Art News*, Gwathmey was quoted as saying: 'Pure illustration and "literary painters" are on the lowest scale . . . I've instead tried to evolve a kind of symbolization in painting.'[279] Yet as Louchheim noted, '[o]ccasionally he falls into the literary pitfall,' and the artist himself acknowledged elsewhere that he was 'interested in telling a

story.'[280] Indeed, paintings such as *Ancestor Worship* (fig. 197), which develops the plantation owner motif in *From Out of the South* and juxtaposes it with two African American boys and one of mixed race, all barefoot, all with hoes,[281] depend, as Moses Soyer pointed out, on the collage principle, and have an uncanny quality not unlike some Surrealist art. Their flat empty spaces read like the space of the dream in the current system of pictorial denotation, and their symbols correspondingly project a dream-like atmosphere of foreboding.[282] As Charles Corwin observed in an acute review of Gwathmey's 1949 exhibition for the *Daily Worker*, such '"program" pictures' depended on 'socially agreed on symbols' that had to be 'invented fresh', and it was 'not easy at once to achieve clarity and force and to avoid banality.' *Ancestor Worship* and *Poll Tax County* (Hirshhorn Museum and Sculpture Garden, Washington, DC; shown in the 1949 exhibition) maintain a precarious balance between the formal requirements of modernist painting and graphic satire.[283] However, the other strand in Gwathmey's art of the 1940s, which Corwin described as 'the heroized figure of the agricultural laborer of the South', courted the danger of becoming simply over-decorative.[284] In a work such as *Singing and Mending* (fig. 198) it is arguably the way that Gwathmey's drawing and composition define

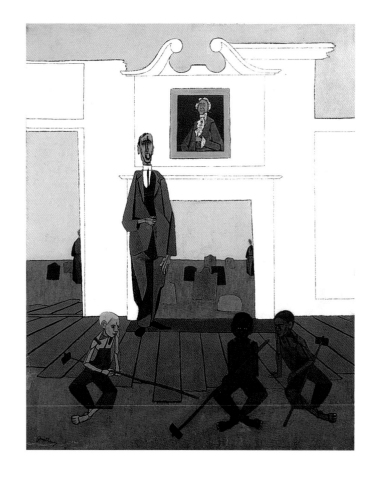

197 (*above right*)
Robert Gwathmey,
Ancestor Worship, 1945,
oil on canvas, 38½ × 31 in.,
Collection of Charles
Gwathmey. © Estate of
Robert Gwathmey/Licensed
by VAGA, New York, N.Y.

198 (*right*) Robert
Gwathmey, *Singing and
Mending*, 1945, oil on
canvas, 30 × 36¼ in.,
Hirshhorn Museum
and Sculpture Garden,
Smithsonian Institution,
Washington, D.C., Gift of
Joseph H. Hirshhorn,
1966. © Estate of Robert
Gwathmey/Licensed by
VAGA, New York, N.Y.

199 (*facing page*) Robert
Gwathmey, *Late Twentieth
Century*, 1974, oil on
canvas, 45 × 30 in. © Estate
of Robert Gwathmey/
Licensed by VAGA, New
York, N.Y.

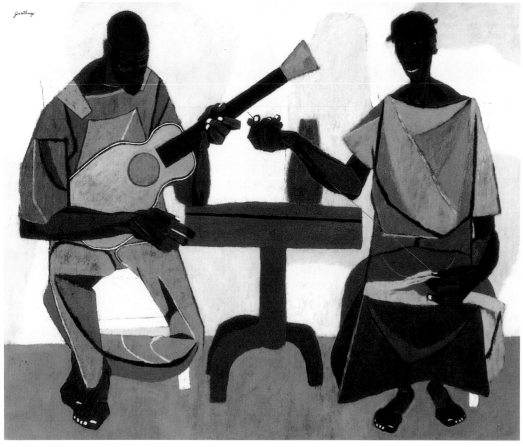

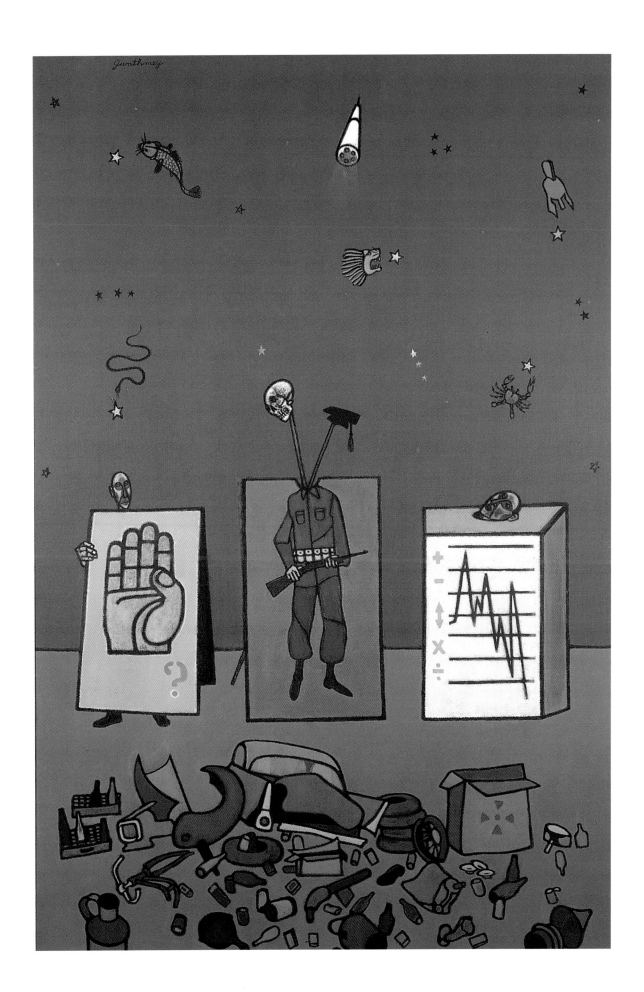

social relationships with a logic that is both epistemological and formal that enables the work to escape such criticism. 'Work is never done . . . after working all day in the fields, there's still mending to be done' was the artist's own lapidary comment on the picture.[285] Everything in the drawing of the man suggests weariness, from the bowed head and lined brow to the arm resting on the table, the long arc running from his ear to his right elbow and the limp curve of his left leg. The woman, however, must carry on – although her muscular development implies she is as familiar with field work as he is. The way in which her right hand seems to lend support to her partner's guitar is matched by the upright shapes that define her skirt and upper body, and her foursquare feet. Woman is fully man's equal here, not surprisingly considering the emphasis Communists placed both on African American women as 'the most oppressed stratum of the whole population', and their role as 'the real active forces – the organizers and workers – in all the institutions and organizations of the Negro people.'[286]

While the Communist Party of the postwar years endlessly exhorted white Communists to empathise with African Americans and aid them in their struggles, the representation of blacks was no simple matter for white artists who might easily lay themselves open to the charge of 'white chauvinism'. Moses Soyer's review of Gwathmey's 1946 show seems to imply that he had been criticised for producing caricatures of 'the Negro', but if this was the case it was only a minor strain in the response to his work within the movement. More striking is the fact that the Party's most prominent black luminary endorsed the exhibition, and that in the same year Gwathmey's work appeared alongside that of Lawrence and White (both of whom were his friends) in an issue of *American Contemporary Art* devoted to 'the problems of the Negro as an Artist'. Indeed, the lead essay in the magazine, a lecture by the Communist playwright and screenwriter Arnaud d'Usseau, stressed the difficulties of the 'Negro artist' understanding white people, equally with those faced by the 'white artist' understanding 'the Negro people'.[287] In Gwathmey's art, although the greater burden of oppression falls on the black workers of the South, it also falls on poor whites. The gazebo-like structure in *Poll Tax County* that contains the representatives of the oppressors rests on the backs of both.

As Michael Kammen has pointed out, Gwathmey's images of Southern agriculture in *Hoeing* (1943; Carnegie Museum of Art, Pittsburgh),[288] *Sowing* (1949;

Whitney Museum of American Art) and related works invite comparison with the peasant paintings of Millet,[289] and despite Gwathmey's aversion to the picturesque, some of his images suggest a comparable fascination with archaic forms of labour. He himself noted that the figure in his *Cotton Picker* (1950; Fine Arts Museums of San Francisco) 'is outmoded by the great flat planted areas of Texas and California that lend themselves to the mechanical harvester.'[290] None the less, Communist analysis of the South continued to emphasise the extent of the 'plantation system' in the main cotton and tobacco states, and the connection between this and the racist regime of the region:

> Here slavery of the Negro people survives in a different but in certain ways no less barbarous form than before the Civil War, and inevitably the Southern white masses are also degraded by the oppression of their Negro neighbours. Impoverished homes, eroded land, intense racial oppression, these are the bitter fruits of the monopoly-nourished plantation system . . .[291]

The factory system of the South is represented in Gwathmey's work only by the distant buildings that appear in such paintings as *From Out of the South* and *The Farmer Wanted a Boy* (Art Institute of Chicago),[292] and industrial labour does not figure. It is thus not surprising that Robeson's essay for Gwathmey's 1946 exhibition catalogue made no reference to the CIO's postwar organising drive in the South, 'Operation Dixie', which was taking place contemporaneously.[293]

Gwathmey's work continued in the same iconographic and stylistic vein throughout the 1950s, but it was eight years between the 1949 exhibition and his next solo show, and this attracted far less attention than his earlier ones.[294] Although charges of formalism were inevitably laid against Gwathmey's work in the Zhdanovist phase, he neither shifted his aesthetic or wavered in his political commitment.[295] In the 1960s and 1970s, Gwathmey broadened his themes, with mixed success, but he remained capable of producing works that combined biting political symbolism with his characteristic formal sophistication, such as *Custodian* (1963; Collection of Philip J. and Suzanne Schiller) and *Space* (1964; private collection). With the passage of time his commitment to the painter's craft came to look increasingly retardataire, and with the collapse of the Communist movement in the United States he struggled to find a coherent political iconography (fig. 199).[296] However, as I have shown, these were problems for artists of the old left generally.

Epilogue

In this book I have tried to give a materialist history of the Communist movement in the United States as it bore on the visual arts, and to analyse the works and thinking of Communist artists and fellow-travellers from the perspective of critical Marxism at the millennium. There is an apparent paradox here, in that many of the artists I have been concerned with saw themselves either as Marxists or as allied with a movement that embodied Marxism. If their programmes failed and their ambitions were unrealisable in important ways, as I have suggested throughout, how does this bear on the status of Marxism as a hermeneutic system now? An obvious answer to this question, and one which has been well rehearsed over the years by the anti-Stalinist left, is that the Marxism of the official Communist parties was vitiated – failed to reach the standard of scientificity – because of their adulation of the Soviet state and unwavering aceptance of its theoretical leadership. They thus produced a grossly distorted Marxism at best. There is an evident truth to this in as much as misconceptions about the nature of the USSR meant that there were fundamental cognitive errors at the heart of official Marxism, from which further errors flowed at all levels, analytical, strategic and ethical. Given that Communists were unable to recognise that exploitative relations continued within Soviet society, they were correspondingly unable to perceive that the version of Marxism that issued from it functioned as an ideology in the most negative sense.

This does not mean that no creative Marxist work was done within the orbit of the official Communist movement, but it does mean that it had to be done against the grain for the most part after the onset of Stalinism. However, for anyone on the left it is hard not to grant Communists certain fundamental insights into the nature of capitalism, and into class, racial and sexual oppression, sadly inadequate as their analyses of these phenomena often were. In relation to the object of my inquiry, whatever the flaws in Communists' understanding of the capitalist economy or the relationship between class forces and the political process, their greatest failing was in their conceptions of consciousness and culture in the broad sense. For how else are we to explain their inability to build a truly mass party, or their utterly unrealistic expectations about American working-class behaviour in many instances? Indeed, part of what I have been tracing in this book is the chequered pattern of attempts to achieve an understanding of social consciousness and of cultural practice adequate to the realities of American life, attempts that were partly responses to the exigencies of Soviet policy and partly authentic attempts to address concrete lived experiences. This is why the experiments of the Popular Front have remained crucial, since that was the moment of most creative thinking in this area, as Michael Denning has so vividly shown.

Although American Communists could be acute about art's ideological and status functions, they generally had little sense of the contradictions of the category as such. For them, art tended to remain a good, which was sometimes perverted and misused, but that in essence was affirmative. Similarly, despite some creative thinking about the popular, the tensions between the demands of audience effect and the demands of aesthetic quality were not rigorously addressed. In the prewar years, at least, the pattern of their thinking on the visual arts was not dissimilar to that in other artistic fields. The cultural movement of the Third Period was dominated by an essentially collectivist and utilitarian aesthetic based on a reductive conception of class audience which presumed that the revolutionary proletariat would organically bring forth its own culture through organisational forms initiated by the vanguard party. With the transition to the People's and Democratic Fronts, there followed a gradual shift (never accepted by some artists and critics) to a more expansive conception of social art, an art less directly instrumental and geared to a popular audience conceived in broader class terms. Although the Party would provide some of the institutional framings for this art, it would do so discreetly, and would rely more on structures created by what it saw as its progressive allies within the bourgeois state and

established trade unions. In the postwar period, with the contraction of Party organisations, a sharp drop in Communist influence in the labour unions and the ending of the New Deal arts programmes, artists were forced to rely more on dealers and established art institutions. Not surprisingly, in these circumstances a more individualistic notion of artistic practice prevailed, and correspondingly also a more nebulous notion of audience. Art contributed to social progress, but for the leading artists associated with the movement only in a somewhat imprecise humanistic sense. At the same time, the conservative turn in Soviet policy as a result of the Cold War made the Soviet example even less useful as a reference point for cultural producers in the United States, and led to both the most heavy-handed attempts to discipline cultural work by would-be Party apparatchiks and the most direct criticisms of the Stalinist model to appear within the American movement.

The Communist Party may never have been much more than a small sect within the American political scene, but it had offered real institutional structures and forms of collectivity that provided the basis for a distinctive cultural vision, and it was able to connect at some points with working-class consciousness in the labour movement and the civil rights struggles of African Americans. Once those structures and forms of collectivity were destroyed or collapsed, cultural producers who had grounded their world-view in them were forced to confront the differences between the CP's ideal of an inter-racial, inter-ethnic revolutionary proletariat always just about to shake off its chains, and the actuality of an American working class overwhelmingly indifferent and increasingly hostile to that which they wished to offer. Put another way, without a vital counter-hegemonic culture with some prospect of a mass base, there were no real possibilities for a vital Communist art. To adapt terms from Raymond Williams, cultural producers who had seen themselves as the vanguard of an emergent class formation challenging the dominant culture, found themselves the exponents of a residual subculture on the skids.[1] Symptomatic of this situation is Charles Humboldt's observation in a letter to John Berger of 1958: 'many artists here are haunted with a feeling of utter powerlessness, of its not mattering one god damn whether they ever put a brush to canvas again or not.'[2]

Yet, as I showed in the last chapter, despite the seemingly inexorable decline of the American Communist movement in the Cold War, a significant number of artists attached to it continued to have successful careers into the 1950s and 1960s. At the same time, almost all of them expressed feelings of increasing isolation and estrangement from the dominant culture, and many made acerbic comments on contemporary artistic trends.[3] This is not just a question of political isolation or of an ageing generation's inability to cope with the new. Their perception that the most experimental and loudly touted art of the period was no longer art as they understood it was fundamentally correct. The signifier art no longer attached to the same signified in terms of either practice or concepts. Although, as I have stressed throughout, some American Communists were more receptive to modernism than standard assessments of the movement have usually acknowledged, none had been receptive to avant-garde strategies as such. (In this regard, the very limited take-up of the photomontage technique among them is significant.[4]) Whereas they might register Dada as an extreme form of cultural protest appropriate to the mood of crisis in Europe around the end of the First World War, they could see no value in neo-avant-garde activities detached from any realistic political agenda, or forms of practice that seemed to nullify all craft skills, modernist or naturalist. For all the artists we have been considering, the category of art remained sacrosanct. While Walter Quirt had long since broken with the proponents of social art (although he continued to maintain a concern with art's social responsibilities), he could have spoken for any of them when he wrote in 1968: 'the changing art world has played me and my generation a dirty trick by making our kind of art obsolete. There is practically no market for it. My generation is the last of the traditional painters and sculptors'.[5] If this statement exaggerated the market decline for traditional practices, it registers accurately enough the decline in their perceived relevance (and correspondingly status) among critics and cultural managers. The diehards of social art perceived correctly that the new trends were, consciously or unconsciously, a symptom of the conditions of late capitalism in the United States (although 'late capitalism' was not part of their vocabulary), but they did not see in this any reason to value them. To the veterans of the Communist left, art stood for an Enlightenment notion of the subject and for authenticity; it offered a mode of knowledge that potentially contributed to rational collective action for human betterment. They were correspondingly hostile to cultural developments that threw such beliefs into question, and which in the 1970s began to be referred to as Postmodernism. We may see this as yet another indication that their artistic aspirations were unrealisable. The nightmare of our age is that this may be true of socialist aspirations generally.

Yet even if that were to be the case, it would be no less necessary to strive for them.

And this returns me to the issue of value, which was mooted in the Introduction. Very few of the artists covered in this study have an assured place in the dominant narrative of modern painting, really only Stuart Davis and Ad Reinhardt. Some of the artists considered in the last chapter – such as Evergood, Gwathmey, Lawrence, Levine, Neel and Soyer – do make it onto the walls of American museums, but only here and there, and they do not apparently merit the same kind of showing as any number of 'blue chip' artists associated with the sucession of postwar movements: Abstract Expressionism, Post-Painterly Abstraction, Pop Art, Minimalism and so on. Significantly, the last substantive studies of American art to give them equal coverage alongside Abstract Expressionism were published in the 1950s.[6] Of course, Americanist art historians do accord their work some attention, but these artists tend to be associated with the cultural formation of the 1930s, and American art pre-1940 is a low-prestige specialism in relation to which the normal criteria of quality do not apply.[7] It is symptomatic that of the six listed above only two have been the subject of sustained studies of the kind that are standard for postwar movement artists – I shall return to these exceptions shortly. There are a number of reasons for this neglect, some of which Communist artists and critics recognised acutely enough, as I showed in Chapter Nine. But leaving aside the complex issue of the ideological congruence between the postwar movements and hegemonic interests, there is an obvious sense in which the dominant ethos of the artistic field (museums, art history, the art market) in both the United States and Western Europe is modernist, in that it consistently valorises the new – this is both a market and an ideological imperative, the two being interlocked. (I do not intend this observation, in itself, as a value judgement.) An inevitable consequence of this is that the concept of progress that governs the field consistently privileges innovation. Even as self-consciously conservative a critic as Greenberg, with no tolerance for the genuinely avant-garde in Peter Bürger's sense of the term, is concerned only with that which 'keeps culture moving'.[8] The modernist ethos has no time for those who do not embrace the imperative for formal change. It was frustration with this law that made even such a 'savvy' modern as Levine proclaim himself a traditionalist. However, as I hope I have shown, Levine's problem was not with modernism as such but with the arid and narrow version of modernist theory codified after the Second World War, and its absolutist pretensions – a

version which through an absurd pseudo-Hegelian logic claimed that the historical destiny of the aesthetic was concentrated in the hands of a tiny number of artists (almost invariably of European descent) in one or two cities in the United States, who alone were capable of art of universal significance. It was a theory that confused aesthetic innovation with notions of scientific progress, although its standard of achievement was far narrower than that of the natural sciences which – whatever the ideological and political forces that operate on them – at least formally disavow geographical and cultural exclusivity. Of course, this is symptomatic of how much more closely the aesthetic is tied to the ideological than the natural sciences – as one would expect considering their respective relationships with the real bases of social power.[9]

It is significant that the two artists of the six who have received most sustained attention are a woman and an African American, namely Neel and Lawrence. Significant in that they have unquestionably benefited from the challenges to the modernist story that have been mounted by feminists and the black consciousness movement since the 1970s. As a result, both have been the subject of major museum shows and substantial scholarly monographs. While the attention given to these artists is all to the good, the narratives within which their work have been framed are primarily feminist narratives of women artists and narratives devoted to the recovery of African American art, respectively. As such, they have come to stand effectively for political and cultural values associated with particular identity perspectives, although, in the case of both, these are interlinked with entirely justifiable claims as to the formal sophistication of their work that tie them to more widely acknowledged criteria of competence. The questions that hang awaiting an answer are: how do these claims affect the status of works sanctioned by the hitherto hegemonic modernist model, and what do these claims mean for those who do not or cannot lay claim to the identities concerned, beyond requiring 'recognition'?

Underlying these is that perennial conundrum of aesthetics: are there common standards in matters aesthetic that have some degree of validity beyond cultural difference?[10] Part of the appeal of high modernist theory (and one of the reasons that it has proved so durable) is that it appeared to offer relatively clear criteria of value of unimpeachable universality. This is doubtless why so much of the ambitious criticism since the 1960s when the postwar modernist project finally foundered has taken it as a paradigm that had to be

built on rather than jettisoned. Such criticism has generally assumed that high modernist theory worked well enough until the 1960s, and essentially it continues to build on the same narrative as that theory took as its underpinning. None the less, it has been obliged to tweak the old tale a little here and there to encompass the contemporary art it seeks to valorise, and particularly by giving a new centrality to those very avant-garde practices that Greenberg and others could see no value in. This tendency is epitomised by the journal *October*. The implication of this – and my point here – is that value and historical narrative are intrinsically connected. One of the key objectives of feminist historians and historians of African American art has been to provide counter-narratives that, implicitly or explicitly, will sustain claims for their values. Unlike modernist theory, they assume, as I do, that aesthetic judgements are always impure and cannot be either effectively or usefully detached from other aspects of the subject's experience and world-view. Whereas modernist theory assumed that aesthetic apprehension should take place in some state of detachment in which the sensitive observer responds in a heightened way to the phenomenal presence of the art-work (but presumably prepared by a sophisticated understanding of the necessary evolution of artistic

form hitherto), feminists, Marxists and others assume an interested observer.[11]

One of the notable features of our period is the fashion for perspectivism (the rejection of traditional epistemological concerns) in the humanities and to some degree in the social sciences, a position that has proved particularly appealing to many partisans of identity politics. It will be evident, I hope, that the position that underpins this volume is not of this kind. I assume – along with some of those who have sought to advance the knowledge and understanding of women's art and African American art – that an historical narrative that omits consideration of significant bodies of work for blatantly ideological reasons is not just partial but is in important ways inadequate to the explanation of its object.[12] In this regard I assume the classic Marxist position represented by the title of O. K. Werckmeister's important essay, 'From a Better History to a Better Politics.'[13] Similarly, from a better history to better judgement. My point is not that aesthetic criteria can be finally decided – knowledge only provides the grounds for judgements in this area, it cannot in itself deliver them – but that with a better history we can at least have more grounded and fruitful dialogues about such matters. The ultimate aim of this book has been to contribute to that end.

Notes

List of Abbreviations

AAAJ	*Archives of American Art Journal*
AD	*Art Digest*
AF	*Art Front*
AN	*Art News*
AAC	American Artists' Congress
AEA	Artists Equity Association
AFL	American Federation of Labor
ALP	American Labor Party
ALA	Artists League of America
CA	*Creative Art*
CAA	College Art Association
CIO	Congress of Industrial Organizations
CP	Communist Party
CRC	Civil Rights Congress
DH	*Decatur Herald*
DR	*Decatur Review*
DSHR	*Decatur Sunday Herald & Review*
DW	*Daily Worker*
F	*Fortune*
FAP	Federal Art Project
ICCASP	Independent Citizens Committee of Arts, Sciences, and Professions
IL	*International Literature*
IURW	International Union of Revolutionary Writers
IVCASR	Independent Voters Committee of the Arts and Sciences for Roosevelt
JRC	John Reed Club
LWR	*Literature of World Revolution*
M	*Mainstream*
MA	*Magazine of Art*
M&M	*Masses & Mainstream*
MM	*Modern Monthly*
MQ	*Modern Quarterly*
NAACP	National Association for the Advancement of Colored People
NCASP	National Council of Arts, Sciences, and Professions
NCPAC	National Citizens Political Action Committee
NM	*New Masses*
NYHT	*New York Herald-Tribune*
NYP	*New York Post*
NYS	*New York Sun*
NYT	*New York Times*
NYWT	*New York World-Telegram*
NY	*New Yorker*
P	*Parnassus*
PA	*Political Affairs*
PCA	Progressive Citizens of America
PR	*Partisan Review*
PW	*People's World*
PWAP	Public Works of Art Project
RAPP	Russian Association of Proletarian Writers
SSUR	*Springfield Sunday Union and Republican*
SLPD	*Saint Louis Post-Dispatch*
SW	*Sunday Worker*
UAA	United American Artists
WPA	Works Progress Administration

Introduction

1 Among the most important are: Daniel Aaron, *Writers on the Left: Episodes in American Literary Communism* (1961; New York: Columbia University Press, 1992); Eric Homberger, *American Writers and Radical Politics, 1900–1939* (Basingstoke & London: Macmillan, 1986); Charlotte Nekola and Paula Rabinowitz (eds), *Writing Red: An Anthology of American Women Writers, 1939–1940* (New York: Feminist Press, 1987); James Murphy, *The Proletarian Moment: The Controversy over Leftism in Literature* (Urbana & Chicago: University of Illinois Press, 1991); Barbara Foley, *Radical Representations: Politics and Form in U.S. Proletarian Fiction, 1929–1941* (Durham, N.C.: Duke University Press, 1993).

2 The main literature comprises: David Shapiro (ed.), *Social Realism: Art as a Weapon* (New York: Ungar, 1973), and Boston University & Bread and Roses, *Social Concern and Urban Realism: American Painting of the 1930s* (catalogue by Patricia Hills *et al*; Boston University & Bread and Roses, 1983). Also relevant are two major catalogues to exhibitions by the Neue Gesellschaft für bildende Kunst: *Amerika: Traum und Depression 1920/1940* (ed. Eckhart Gillen and Yvonne Leonard; West Berlin, 1980) and *Das andere Amerika: Geschichte, Kunst und Kultur der amerikanische Arbeiterbewegung* (ed. Philip S. Foner and Reinhard Schultz; West Berlin: Elefanten Press, 1983). Cécile Whiting's interpretation of the art of the Third Period and the Popular Front in her *Antifascism in American Art* (New Haven & London: Yale University Press, 1989) is erroneous in important respects – see Andrew Hemingway, 'Fictional Unities: "Antifascism" and "Antifascist Art" in 30s America', *Oxford Art Journal* 14, no. 1 (1991): 107–17. The most important institutional study is Gerald Monroe,

'The Artists Union of New York', DEd. thesis, New York University, 1971. Monroe published a series of articles based on his thesis in the 1970s, which are listed in the bibliography.

3 Key texts include: Serge Guilbaut, *How New York Stole the Idea of Modern Art: Abstract Expressionism, Freedom, and the Cold War* (tr. A. Goldhammer; University of Chicago Press, 1983); Michael Leja, *Reframing Abstract Expressionism: Subjectivity and Painting in the 1940s* (New Haven & London: Yale University Press, 1993); Nancy Jachec, *The Philosophy and Politics of Abstract Expressionism* (Cambridge University Press, 2000). For a useful compilation of shorter pieces, see Francis Frascina (ed.), *Pollock and After: The Critical Debate* (London: Harper & Row, 1985).

4 This seems to me notably the case in recent essays on Abstract Expressionism by T. J. Clark, so often seen as the avatar of Marxist art history: see his *Farewell to an Idea: Episodes from a History of Modernism* (New Haven & London: Yale University Press, 1999), chs 6–7.

5 Walter Benjamin, 'Eduard Fuchs, Collector and Historian', in *One-Way Street and Other Writings* (London & New York: Verso, 1985), 349–86.

6 As Meyer Schapiro observed at the time, 'the deliberate, individual criticism and evaluation of social facts' was a 'recently acquired function' of the artist. See 'A Note on the Nature of Abstract Art', *Marxist Quarterly* 1, no. 2 (April/June 1937): 11.

7 My interpretation of Stalinism draws on the work of Sheila Fitzpatrick and Moshe Lewin, among others. See also Robert C. Tucker (ed.), *Stalinism: Essays in Historical Interpretation* (New York & London: Norton, 1977).

8 The literature on American Communism is now very large, and the topic has become a booming research area for both historians and literary scholars. A succinct account of traditional and revisionist viewpoints (with a bibliography up to that time) is given in Fraser M. Ottanelli, *The Communist Party of the United States: From the Depression to World War II* (New Brunswick, N.J., & London: Rutgers University Press, 1991), 1–5. For a recent and uneven compilation of revisionist scholarship, see Michael E. Brown *et al.* (ed.), *New Studies in the Politics and Culture of US Communism* (New York: Monthly Review Press, 1993). For the traditionalist response, see Theodore Draper, 'The Life of the Party', in *New York Review of Books*, 13 January 1994.

9 See especially Robin D. G. Kelley, *Hammer and Hoe: Alabama Communists During the Great Depression* (Durham, N.C.: University of North Carolina Press, 1990).

10 Harvey Klehr, John Earl Haynes and Fridrikh Igorevich Firsov, *The Secret World of American Communism* (New Haven & London: Yale University Press, 1995), and Harvey Klehr, John Earl Haynes and Kyril M. Anderson, *The Soviet World of American Communism* (New Haven & London: Yale University Press, 1998). In relation to these publications of 'sensational' documents from Soviet archives, everything depends on the interpretation. See the review by Maurice Isserman, 'Notes from Underground', *The Nation* (12 June 1995): 846–56 and, generally, Ellen Schrecker and Maurice Isserman, 'The Right's Cold War Revision', *The Nation* (24–31 July 2000): 22–4; Victor Navasky, 'Cold War Ghosts: The Case of the Missing Red Menace', *The Nation* (16 July 2001): 36–43.

11 Neither do I address the work of American artists in Mexico, for which see the important work of James Oles: 'Walls to Paint On: American Muralists in Mexico, 1933–1936', PhD thesis, Yale University, 1995.

12 As this volume was going to press, I learned of Patricia Phagan's 'William Gropper and *Freiheit*: A Study of his Political Cartoons, 1924–1935', PhD thesis, City University of New York, 2000. Unfortunately, this information came too late for me to consult it.

13 On this area, see Melissa Dabakis, *Visualizing Labor in American Sculpture: Monuments, Manliness, and the Work Ethic, 1880–1935* (Cambridge University Press, 1999), ch. 7.

1 *New Masses*

1 Theodore Draper, *American Communism and Soviet Russia: The Formative Period* (1960; New York: Vintage Books, 1986), ch. 1; Harvey Klehr, *The Heyday of American Communism* (New York: Basic Books, 1984), ch. 1.

2 Klehr, *Heyday of American Communism*, chs 2–3. See also Ottanelli, *Communist Party of the United States*, ch. 2.

3 League of Professional Groups for Foster and Ford, *Culture and the Crisis: An Open Letter to the Writers, Artists, Teachers, Physicians, Engineers, Scientists and other Professional Workers of America* (New York 1932), 20–23, 28, 30.

4 Klehr, *Heyday of American Communism*, 80–84.

5 On the organisational structure, see Draper, *American Communism and Soviet Russia*, ch. 7. On the humdrum nature of club and branch life, see Dorothy Healey and Maurice Isserman, *Dorothy Healey Remembers: A Life in the American Communist Party* (New York & Oxford: Oxford University Press, 1990), ch. 6. Vivian Gornick, *The Romance of American Communism* (New York: Basic Books, 1977), ch. 3.

6 Maxwell Bodenheim to Joseph Freeman, 2 June 1937 (Freeman Papers, CU).

7 On fronts, see Draper, *American Communism and Soviet Russia*, 171–85. For 'fellow-travellers', see David Caute, *The Fellow-Travellers: Intellectual Friends of Communism* (2nd ed., New Haven & London: Yale University Press, 1988), 1–14.

8 'report: fraction meeting hardys office friday: nov. 4, 1932' (*sic*) (Freeman Papers, HI, 16:1).

9 Karl Marx and Friedrich Engels, *On Literature and Art* (ed. Stefan Morawski and Lee Baxandall; New York: International General, 1973). For the historical variety of Marxist aesthetics, see Maynard Solomon (ed.), *Marxism and Art: Essays Classic and Contemporary* (Brighton: Harvester Press, 1979).

10 For Hathaway, see Klehr, *Heyday of American Communism*, 26–7; Klehr *et al.*, *Soviet World of American Communism*, 43–4, 47–8 and passim.

11 Clarence Hathaway, 'A Letter from the Editor to the Readers of the "*Daily Worker*"', *DW*, 22 July 1933; 'Letters from Readers on the 6 Page "Daily"', 2 August 1933; C. A. Hathaway, 'Editor Again Asks Readers' Co-operation in Efforts to Improve and Build "DAILY"', 14 August 1933.

12 On *The Masses*, see Leslie Fishbein, *Rebels in Bohemia: The Radicals of the Masses, 1911–1917* (Chapel Hill: University of North Carolina Press, 1982); Rebecca Zurrier, *Art for The Masses: A Radical Magazine and its Graphics, 1911–1917* (New Haven: Yale University Art Gallery, 1985). On *The Liberator*, see Aaron, *Writers on the Left*, chs 3–4, and for the Garland Fund, see p. 100. The *Workers Monthly* – into which *The Liberator* fused, along with the *Labor Herald* and *Soviet Russia Pictorial*, in 1924 – had boldly designed colour covers and carried cartoons, poems and some cultural reporting.

For *New Masses* in this period, see David Peck, '"The Tradition of American Revolutionary Literature": The Monthly *New Masses*, 1926–1933', *Science and Society* 42, no. 2 (winter 1978–9): 385–409.

13 Of these, Gropper alone had not worked for *The Masses*. For biographical outlines, see Zurrier, *Art for The Masses*, 163–8. For the artists of *The Liberator*, see Virginia Hagelstein Marquardt, 'Art on the Political Front in America: From *The Liberator* to *Art Front*', *Art Journal* 52, no. 1 (spring 1993): 72–81.

14 A point made in a letter by Ann Weedon, 'Correspondence', *NM* 16, no. 9 (27 August 1935): 22. For the role of women generally, see Robert Shaffer, 'Women and the Communist Party, USA, 1930–1940', *Socialist Review* no. 9 (May–June 1979): 73–118. And for women writers, see Nekola and Rabinowitz, *Writing Red*.

15 Joseph Freeman, *An American Testament: A Narrative of Rebels and Romantics* (New York: Farrar & Rinehart, 1936), 379; Freeman, 'Ivory Towers – White and Red', *NM* 12, no. 11 (11 September 1934): 22; 'report: fraction meeting hardys office friday: nov. 4, 1932' (Freeman Papers, HI 16:1). For a fascinating outsider's view of the *New Masses* circle at this time, see the autobiography of Freeman's first wife: Ione Robinson, *A Wall to Paint On* (New York: Dutton, 1946), 118–57.

16 'Memorandum for Committee for New Magazine', 'Prospectus for Dynamo', 'Prospectus for the New World' (Freeman Papers, HI 176:9, 177:1). Perhaps not coincidentally, *Smoke and Steel* is the title of a collection of Carl Sandburg's poems published in 1921.

17 For analysis of *New Masses* from an art-historical perspective, see Virginia Hagelstein Marquardt: 'Louis Lozowick: Development from Machine Aesthetic to Social Realism, 1922–1936', PhD thesis, University of Maryland, 1983, ch. 3; '*New Masses* and John Reed Club Artists, 1926–1936: Evolution of Ideology, Subject Matter, and Style', *Journal of Decorative and Propaganda Arts* no. 12 (spring 1989): 56–75.

18 Ludwig Renn, 'Greetings from Revolutionary Writers of Germany', *NM* 6, no. 5 (October 1930): 23.

19 Sixty-one artists contributed to a benefit sale for *New Masses* at the time of its transition to a weekly: see

Catalogue of the Art Exhibition and Sale for the Benefit of New Masses, 14–24 December 1933, Allied Arts Galleries (Evergood Papers, AAA 429:1022–3).

20 See Zurrier's excellent analysis of the technical aspects of the magazine, in *Art for The Masses*, 103–27. For Ellis, see Walt Carmon, 'Ellis: A "Red" US Artist at Work in USSR', *DW*, 24 June 1933; Celia Kraft and Oakley Johnson, 'Fred Ellis: Artist of the Proletariat', *DW*, 4 August 1936; Art Shields, 'Fred Ellis, 54 Today', *DW*, 15 October 1938.

21 Davis's cartoons appeared in *NM* 1, no. 1 (May 1926): 6, 19; *NM* 1, no. 2 (June 1926) front cover; *NM* 1, no. 3 (July 1926) back cover.

22 National Collection of Fine Arts and Whitney Museum of American Art, *Jan Matulka, 1890–1972* (Washington, D.C.: Smithsonian Institution Press, 1980).

23 For the first see *Excavation*, *NM* 2, no. 4 (February 1927): 6. The directly political is exemplified by *Election Day – Call Your Tune*, *NM* 2, no. 1 (November 1926): 6.

24 For Dehn, see the essays by Richard A. Cox and Clinton Adams in Jocelyn P. Lumsdaine and Thomas O'Sullivan, *The Prints of Adolf Dehn: A Catalogue Raisonné* (Saint Paul: Minnesota Historical Society Press, 1987). Cox represents Dehn as 'a cautious radical' (8), but rather underestimates his commitments in the 1920s and 1930s. For Grosz in *New Masses*, see Julian Gumperz, 'George Grosz – Up Out of Dada', *NM* 2, no. 6 (April 1927): 17–18. For Dehn's views, see also Carl Zigrosser, *The Artist in America: Twenty-Four Close-Ups of Contemporary Printmakers* (New York: Knopf, 1942), 14–23.

25 E.g., Ezra Pound, 'Workshop Orchestration' (on Ballet Mécanique), *NM* 2, no. 5 (March 1927): 21; Ezra Pound, 'The Damn Fool Bureaukrats', *NM* 4, no. 1 (June 1928): 15; Allen Tate, 'Our Will-to-Death', *NM* 2, no. 3 (January 1927): 29.

26 Michael Gold, 'America Needs a Critic', *NM* 1, no. 6 (October 1926): 7. For Gold's inevitable turnaround, see 'Trotsky's Pride', *NM* 6, no. 1 (June 1930): 4–5. On attitudes to Trotsky in the *New Masses* circle at this time, see Freeman, *An American Testament*, 345–8. See also Leon Trotsky, letter to *NM* 2, no. 1 (November 1926): 24.

27 These debates inevitably centred on how far jazz could remain an authentic manifestation of the national identity of African Americans at the same time as it was commercially exploited: see e.g. Michael Gold, 'What a World', *DW*, 20 September 1933; Charles Edward Smith, 'Class Content of Jazz Music', *DW*, 21 October 1933.

28 Freeman, *An American Testament*, 381–6; 633–5.

29 Duncan Hallas, *The Comintern* (London: Bookmarks, 1985), 126–31; Klehr, *Heyday of American Communism*, 11–17. For Gold's reminiscences of this phase, see Michael Gold, '*The Masses* Tradition', *M&M* 4, no. 8 (August 1951): 45–55.

30 Biography from: Michael Folsom (ed.), *Mike Gold: A Literary Anthology* (New York: International Publishers, 1972); and Folsom, 'The Education of Michael Gold', in David Madden (ed.), *Proletarian Writers of the Thirties* (Carbondale & Edwardsville: Southern Illinois University Press, 1979), 222–51. On Gold's years as a journalist, see also 'The

Reminiscences of Holger Cahill' (1957) (Columbia Oral History Collection, Columbia University, New York), 54, 61–2, 89, 95–9.

31 Michael Gold, 'Towards Proletarian Art', in Folsom (ed.), *Mike Gold: A Literary Anthology*, 66.

32 James F. Murphy, *The Proletarian Moment: The Controversy over Leftism in Literature* (Urbana & Chicago: University of Illinois Press, 1991), 21–5. See also Brandon Taylor, *Art and Literature under the Bolsheviks* (2 vols; London & Concord, Mass.: Pluto Press, 1991, 1992), vol. 1, 75–85. Gold's concept of proletarian art certainly has affinities with that set out by Lunacharsky in 'Proletarian Culture', *Survey Graphic* 2, no. 6 (March 1923): 691–3. My thanks to Andrew Lee for this reference.

33 Eden and Cedar Paul, *Proletcult (Proletarian Culture)* (New York: Thomas Seltzer, 1921), 140, 103–4. The Pauls' earlier book, *Creative Revolution: A Study of Communist Ergatocracy*, was published by the same publisher the year before. The implicit reference to Bergson in the title is made explicit in the text. For revolution as poetic act, see 212. Eric Homberger was the first to note the relevance of the Pauls' *Proletcult* for the *Liberator* circle, but seems to have been unaware of the US edition. See his *American Writers and Radical Politics*, 120.

34 Freeman, *An American Testament*, 384.

35 Joseph Freeman, Joshua Kunitz and Louis Lozowick, *Voices of October: Art and Literature in Soviet Russia* (New York: Vanguard Press, 1930), 34–41. The 'Resolution on Literature Adopted by the Political Bureau of the Communist Party' (CPSU) of 1 July 1924, which was explicit on this matter, is printed in this volume, 59–65.

36 Folsom, *Mike Gold: A Literary Anthology*, 136–7. Cf. 'Toward an American Revolutionary Culture', *NM* 7, no. 2 (July 1931): 12. Leon Trotsky, *Literature and Revolution* (tr. Rose Strunsky; New York: International Publishers, 1925), ch. 6.

37 For the significance of RAPP, see Sheila Fitzpatrick, 'Cultural Revolution as Class War' in Fitzpatrick (ed.), *Cultural Revolution in Russia, 1928–1931* (Bloomington: Indiana University Press, 1984), 8–40. See also Taylor, *Art and Literature under the Bolsheviks*, vol. 1, 143–58; and Lawrence Schwartz, *Marxism and Culture: The CPUSA and Aesthetics in the 1930s* (Port Washington: Kenikat Press, 1980).

38 J. Q. Neets [Joshua Kunitz], 'Let Us Master Our Art!', *NM* 6, no. 2 (July 1930): 23. See Murphy, *The Proletarian Moment* for more on this criticism.

39 Freeman emphasises this heritage in his introduction to Granville Hicks *et al.* (ed.), *Proletarian Literature in the United States* (London: Lawrence and Wishart, nd), 24–5. For useful anthologies, see Joyce Kornbluh (ed.), *Rebel Voices: An IWW Anthology* (Ann Arbor: University of Michigan, 1964); William L. O'Neill (ed.), *Echoes of Revolt: The Masses 1911–1917* (Chicago: Quadrangle, 1966).

40 Gold, 'Towards Proletarian Art', 64.

41 Michael Gold, 'Go Left Young Writers!', *NM* 4, no. 8 (January 1929): 3–4; repr. in Folsom (ed.), *Mike Gold: A Literary Anthology*, 186–9; 'Proletarian Literature', *NM* 6, no. 4 (September 1930): 4–5; 'Notes of the Month', *NM* 5, no. 8 (January 1930): 7. For Gold's vision of collective art at this time, see also Michael Gold, *120 Million* (New York: International Publishers, 1929).

42 'Brisbane, We Are Still Here!', *NM* 4, no. 3 (August 1928): 2; *NM* 5, no. 1 (June 1929): 2.

43 See Foley, *Radical Representations*, ch. 3; and Douglas Wixson, *Worker-Writer in America: Jack Conroy and the Tradition of Midwestern Literary Radicalism, 1898–1990* (Urbana & Chicago: University of Illinois Press, 1994).

44 Michael Gold, 'Readers' Forum', *NM* 25, no. 2 (5 October 1937): 21; 'Loud Speaker and Other Essays', *NM* 2, no. 5 (March 1927): 6; 'Notes on Art, Life, Crap-Shooting, etc.', *NM* 5, no. 4 (September 1929): 10–12; 'American Jungle Notes', *NM* 5, no. 7 (December 1929): 8–10.

45 Joseph Freeman, 'Greenwich Village Types', *NM* 8, no. 9 (May 1933): 18–20.

46 Robert C. Tucker, 'Stalinism as Revolution from Above', in Tucker (ed.), *Stalinism: Essays in Historical Interpretation* (New York & London: Norton, 1977): 77–108.

47 E.g., Sol Funaroff, 'Dnieprostroy', *NM* 8, no. 4 (November 1932): 20. Michael Gold, 'Notes from Kharkov', *NM* 6, no. 10 (March 1931): 4–6.

48 See e.g., J. Q. Neets [Joshua Kunitz]: 'From Our Critic in Moscow', *NM* 6, no. 5 (September 1930): 23; 'A Letter from Soviet Russia', *NM* 6, no. 6 (November 1930): 14.

49 Louis Lozowick, *William Gropper* (London & Toronto: Associated University Press, 1983). For Gropper's reactions, see 'Gropper, Proletarian Artist, Returns Here', *DW*, 19 November 1928.

50 Louis Lozowick, *Survivor from a Dead Age: The Memoirs of Louis Lozowick* (ed. Virginia Hagelstein Marquardt; Washington & London: Smithsonian Institution Press, 1997); Janet Flint, *The Prints of Louis Lozowick: A Catalogue Raisonné* (New York: Hudson Hills Press, 1982). See e.g., Joshua Kunitz, 'New Women in Old Asia', *NM* 13, no. 2 (2 October 1934), which reproduces Flint cat. nos 87, 89, 101, 109. See also Joshua Kunitz, *Dawn Over Samarkand: The Rebirth of Central Asia* (New York: International Publishers, 1936).

51 Michael Gold, 'Faster, America, Faster!', *NM* 2, no. 1 (November 1926): 7–8; repr. in Folsom (ed.), *Mike Gold: A Literary Anthology*, 140–47.

52 Michael Gold, 'Notes of the Month', *NM* 5, no. 8 (January 1930): 6. Cf. Herman Spector, 'Fantasy: 1929', *NM* 4, no. 9 (February 1929): 16.

53 *NM* 6, no. 4 (September 1930): 5; *NM* 6, no. 6 (November 1930): 4. Flint, *Prints of Louis Lozowick*, nos 51 and 46. Cf. William Siegel, 'New York', *NM* 1, no. 4 (August 1926): 9.

54 Marquardt, 'Louis Lozowick', ch. 5. Marquardt argues that Lozowick particularly approved the Soviet grouping OST (Society of Easel Painters) and that the OST artists Deineka and Pimenov had some formal influence on his work (121). On OST and its fate, see Taylor, *Art and Literature under the Bolsheviks*, vol. 2, 8–20, 123–43.

55 A. Elistratova, 'New Masses', *IL*, no. 2 (1932): 111.

56 For Kharkov, see Homberger, *American Writers and Radical Politics*, 132–9; and Murphy, *The Proletarian Moment*, 36–9, 69–81. Josephine Herbst gives a fascinating personal account in *The Starched Blue Sky of Spain and Other Memoirs* (New York: Harper, 1992), 113–27. The resolutions and proceedings were published in 'Second International Conference of Revolutionary Writers: Reports, Resolutions, Debates', *LWR*, Special Number, 1931.

57 Walt Carmon, managing editor of *New Masses* in 1929–32, was an editorial assistant to *International Literature* in 1932–5. See Carmon's correspondence from Moscow, Freeman Papers, HI 16: 16–19; Carmon, 'Three Years of It', *NM* 21, no. 9 (24 November 1936): 13.

58 'The Charkov Conference of Revolutionary Writers', *NM* 6, no. 9 (February 1931): 6–8.

59 Gold, 'Notes from Kharkov', 5; and also the letter from A. B. Magil, 'Correspondence', *NM* 10, no. 3 (16 January 1934): 25. On this issue, see Murphy, *The Proletarian Moment*, 75–81.

60 'Resolution on the Work of New Masses for 1931', *NM* 8, no. 3 (September 1932): 20–21. See also Bruno Jasienski, Secretary of the IURW, to *New Masses*, 27 June 1932 (copy in Lozowick Papers, unfilmed, AAA).

61 Joseph Freeman to Alexander Trachtenberg, 10 August 1933 (copy; Freeman Papers, HI 39:1).

62 For Freeman's biography; see *An American Testament*, and Aaron, *Writers on the Left*, 68–72, 80–84, 130–38, 365–75.

63 'report: fraction meeting hardys office friday: nov. 4, 1932'; Joseph Freeman to Earl Browder, 9 November 1932 (copy); Joseph Freeman to Earl Browder, 5 August 1937 (marked '*not* sent'; Freeman Papers, HI 16:1). For Calverton, see Leonard Wilcox, *V. F. Calverton: Radical in the American Grain* (Philadelphia: Temple University Press, 1992).

64 'Memorandum Concerning the Reorganization of the Literary and Professional Sections of the Movement'; untitled 'memo' on 'the NM–JRC situation' (inscribed 1931 but datable to 1932 on internal evidence; Freeman Papers, HI 172:8, 177:1).

65 Granville Hicks, 'Memorandum on the New Masses and the Partisan Review', 2 January 1934; Joseph Freeman to Philip Rahv, 11 July 1934 (copy; Freeman Papers, HI 33:1).

66 Joseph North, 'The New Masses – A Weapon Against War and Fascism', *DW*, 20 April 1935; 'A Year of the Weekly *New Masses*,' *NM* 14, no. 10 (1 January 1935): 9–10; Earl Browder, *Communism in the United States* (New York: International Publishers, 1935), 314.

67 Browder, *Communism in the United States*, 313.

68 On the culture of Jewish Communism, see Paul Buhle, 'Jews and American Communism: The Cultural Question', *Radical History Review* no. 23 (spring 1980): 8–33. For ethnicity and the Communist movement, see Paul C. Mishler, *Raising Reds: The Young Pioneers, Radical Summer Camps, and Communist Political Culture in the United States* (New York: Columbia University Press, 1999).

69 Michael Gold, 'A Letter to Workers' Art Groups', *NM* 5, no. 4 (September 1929): 16.

70 'Workers' Art', *NM* 5, no. 6 (November 1929): 20–21; Hugo Gellert, 'The Role of the Communist Artist', 6 (Gellert Papers, AAA, unfilmed, Box 3); 'Constitution of the John Reed Club', mimeo, undated (Refregier Papers, unfilmed, AAA, Box 1). An unheaded memo probably relating to the formation of the club is in the Lozowick Papers, AAA 1334:417. The role of the fraction is discussed in the 'memo' on 'the NM–JRC situation' (Freeman Papers, HI 177:1). The most useful account is Homberger, 'Proletarian Literature and the John Reed Clubs', in *American Writers and Radical Politics*, 119–40.

71 Michael Gold, 'A New Program for Writers', *NM* 5, no. 8 (January 1930): 21; 'Red Art Night Dec. 28 for Mine Strike Relief', *DW*, 19 December 1929; Harry Alan Potamkin, 'The John Reed Club', *NM* 6, no. 2 (July 1930): 20.

72 Malcolm Cowley, *The Dream of the Golden Mountains: Remembering the 1930s* (New York: Viking Press, 1980), 135, 140; William Phillips, *A Partisan View: Five Decades of the Literary Life* (New York: Stein & Day, 1983), 36; Raphael Soyer, *Self-Revealment: A Memoir* (New York: Random House, 1969), 70–79. On the social constituency of the club, see also Phillips, 'What Happened in the '30s', *Commentary* 34 (September 1962): 204–12. Bernarda Bryson, conversation with the author, 27 November 1996; Minutes of the 'Bureau of the John Reed Club' in Lozowick Papers, AAA, unfilmed.

73 Under the auspices of VOKS (the USSR Society for Cultural Relations with Foreign Countries) an exhibition of graphics by JRC artists was shown at the Museum of Western Art in Moscow in 1932, from which the Museum purchased several works, as did the Scientific Research Institute for the Organization of Invalid Labour. The following year, on the invitation of the International Bureau of Proletarian Revolutionary Artists, JRC members participated in an international exhibition to honour the fifteenth anniversary of the Red Army, and in 1935 they organised a collection of works of art to be sent to the museum in the 'autonomous' Jewish territory of Birobidzhan in the far east of the USSR. See Boris Ternovetz, 'John Reed Club Art in Moscow', *NM* 8, no. 8 (April 1933): 25; correspondence and documents relating to these exhibitions in Lozowick Papers, AAA, unfilmed, JRC file; 'John Reed Clubs Will Present Art Works to Biro-Bidjan Museum', *DW*, 4 September 1934; 'Letters in Brief', *NM* 17, no. 7 (12 November 1935): 21; Jacob Kainen, 'Art for Biro Bidjan', *DW*, 16 March 1936. See also Andrew Weinstein, 'From International Socialism to Jewish Nationalism: The John Reed Club Gift to Birobidzhan', in Matthew Baigell and Milly Heyd (ed.), *Complex Identities: Jewish Consciousness and Modern Art* (New Brunswick, N.J., & London: Rutgers University Press, 2001), 142–61. My thanks to Diana Linden for this reference.

74 'The Charkov Conference of Revolutionary Writers', *NM* 6, no. 9 (February 1931): 7.

75 Michael Gold, 'Toward an American Revolutionary Culture', and 'The Workers Cultural Federation', *NM* 7, no. 2 (July 1931): 12–13; 'Art is a Weapon! Program of the Workers Cultural Federation', *NM* 7, no. 3 (August 1931): 11–13.

76 Klehr, *The Heyday of American Communism*, 73–4. As Klehr has noted, the WCF had reorganised and probably accepted a more modest role by April 1932 – *NM* 7, no. 10

(April 1932): 28. Oakley Johnson, 'The John Reed Club Convention', *NM* 7, no. 13 (July 1932): 15: mimeo, 'General Program of Activities for John Reed Clubs Adopted at the National Convention, Chicago, May 29–30, 1932' – 'Additional Remarks by the Chairman' (Lozowick Papers, AAA, unfilmed, JRC file) .

77 'Memo' on 'the NM–JRC situation', Freeman Papers, HI 177:1.

78 To judge from a letter from Ella Winter of the Carmel JRC to Joseph Freeman, 3 June 1932, quoted in Homberger, *American Writers and Radical Politics*, 228–9, n. 36.

79 'The Palm Group of Chicago', *NM* 6, no. 8 (January 1931): 22; 'Chicago John Reed Club', *NM* 7, no. 3 (August 1931): 21; 'Workers' Art': *NM* 6, no. 12 (May 1931): 23; *NM* 7, no. 5 (October 1931): 28; *NM* 7, no. 9 (February 1932): 29. Sheet headed '*JRC Data*' (Lozowick Papers, AAA, unfilmed, JRC file). For a description of the Chicago club, see Richard Wright, *American Hunger* (New York: Harper & Row, 1977), ch. 4.

80 Oakley Johnson, 'The John Reed Club Convention', and 'John Reed Club Resolution Against War', *NM* 7, no. 13 (July 1932): 14; 'Draft Manifesto of John Reed Clubs', *NM* 7, no. 12 (June 1932): 3–4. Both Johnson's report and the 'Draft Manifesto' are reprinted in David Shapiro (ed.), *Social Realism*, 42–53. Several women stenographers made records of the conference, copies of which are in the Freeman Papers, HI 177:8, 177:9.

81 Mimeo, 'General Program of Activities for John Reed Clubs Adopted at the National Convention, Chicago, May 29–30, 1932' (Lozowick Papers, AAA, unfilmed, JRC file).

82 Johnson, 'The John Reed Club Convention', 15; Conrad Komorowski, 'John Reed Clubs Shape Program in Conferences', *DW*, 12 August 1933; 'The Midwest John Reed Conference', *Left Front* 1, no. 2 (September–October 1933): 11; 'Memorandum Concerning the Reorganization of the Literary and Professional Sections of the Movement' (Freeman Papers, HI 172:8). The plan for the national organisation is set out in a four-page typed document headed 'Constitutional Plan for the Organization of the John Reed Clubs of the United States, Adopted at the National Conference in Chicago May 29–30, 1932' (Freeman Papers, HI 172:8).

83 Joseph Freeman to Alexander Trachtenberg, 7 August 1933 and 10 August 1933 (Freeman Papers, HI 39:1).

84 Mimeo letter from the National Executive Board, 15 February 1934 (copy, Lozowick Papers, AAA, unfilmed). *JRC Bulletin* 1, no. 1 (April 1934): 1. The members were Kunitz, Freeman, Bard, William Siegel and Alan Calmer. See also Calmer's reports in the *Daily Worker*, 'What's Doing in the John Reed Clubs of the U.S.', 18 April 1934, 25 May 1934, 28 June 1934, 26 July 1934.

85 Alan Calmer to Joseph Freeman: 27 April 1934; nd (in response to Freeman to Calmer, 10 September 1934); 4 September 1934; Joseph Freeman to Alan Calmer, 10 September 1934 (copy). Freeman Papers, HI 172:9. Kunitz's claim of thirty clubs was probably just wishful thinking – see 'A Note to Max Eastman', *NM* 11, no. 6 (8 May 1934): 24–5.

86 Orrick Johns, 'The John Reed Clubs Meet', *NM* 13, no. 5 (30 October 1934): 25–6.

87 'Call for an American Writers' Congress', *NM* 14, no. 4 (22 January 1935): 20; 'The League of American Writers', *NM* 15, no. 6 (7 May 1935): 7; 'American Artists' Congress', *NM* 17, no. 1 (1 October 1935): 33. Minutes of the Buro of the John Reed Club, 17 December 1934; mimeograph *JRC Bulletin*, January 1935 (Lozowick Papers, AAA, unfilmed). Aaron discusses the resentments generated by the dissolution of the clubs in *Writers on the Left*, 282.

88 The Ferrer School, where Henri and Bellows had taught, was named after the Spanish anarchist martyr Francisco Ferrer. See Paul Avrich, *The Modern School Movement: Anarchism and Education in the United States* (Princeton University Press, 1980). The Educational Alliance was set up in 1889 by wealthy Jews of German extraction to Americanise East European Jewish immigrants. See Irving Howe, '"Americanizing" the Greenhorns', in Jewish Museum, New York, *Painting a Place in America: Jewish Artists in New York, 1900–1945* (New York, 1991). 'A Proletarian School', *AD* 4, no. 9 (1 February 1930): 26.

89 'John Reed Club Art School', *NM* 8, no. 6 (January 1933): 31; Stephen Alexander, 'A Different Art School', *NM* 14, no. 8 (19 February 1935): 26; 'John Reed Club Art School in New York Begins Spring Term', *DW*, 11 February 1933; 'John Reed Club Art School Begins Its Third Year Today', *DW*, 23 October 1933; 'JRC Art School to Open Fifth Season', *DW*, 26 September 1934; 'Revolutionary Art School', *AF* 1, no. 3 (February 1935): 2. 'Facts about the John Reed Club School of Art' and 'Recommendations for the School', dated 15 July 1935. Refregier Papers (AAA, unfilmed, Box 1, Box 2) and minutes of School Board meetings in the Lozowick Papers (AAA, unfilmed). The faculty in 1934–5 were Bard, Burck, Gellert, Gropper, Limbach, Quirt, Siegel, Guy and Refregier. For the instructors, see 'Between Ourselves', *NM* 14, no. 5 (29 January 1935): 30.

90 Max Eastman, *Artists in Uniform: A Study of Literature and Bureaucratism* (New York: Knopf, 1934), 9.

2 Defining Revolutionary Art

1 Michael Gold, 'The Ninth Year', *NM* 2, no. 1 (November 1929): 5.

2 Freeman, Kunitz and Lozowick, *Voices of October*, 58.

3 Ibid., 277–8. On AKHRR, see Taylor, *Art and Literature under the Bolsheviks*, vol. 2, 21–30, 53–68, 123–43.

4 *Voices of October* was not published by the Party's own International Publishers but by the Vanguard Press, and received lukewarm reviews in the CP press. See Jessica Smith, 'Soviet Art and Literature', *NM* 6, no. 2 (July 1930): 18; Avram Landy, 'A New Survey of Art in the Soviet Union', *DW*, 14 June 1930.

5 Taylor, *Art and Literature under the Bolsheviks*, vol. 2, 180–88; Katerina Clark, 'Utopian Anthropology as a Context for Stalinist Literature', in Tucker (ed.), *Stalinism*, 184–5.

6 Eastman, *Artists in Uniform*, 39–40.

7 Max Eastman, 'Artists in Uniform', *MM* 7, no. 7 (August 1933): 397–404; Joshua Kunitz, 'Choose Your Uniform', *NM* 8, no. 12 (August 1933): 14–15; 'Max Eastman's Hot

Unnecessary Tears', *NM* 9, no. 1 (September 1933): 13–15. Handbill in Lozowick Papers (AAA, unfilmed) for lecture series on 'Art under the Proletarian Dictatorship'.

8 Moissaye J. Olgin, 'A Pageant of Soviet Literature', *NM* 13, no. 3 (16 October 1934): 16–20; 'One Literature of Many Tongues', *NM* 13, no. 4 (23 October 1934): 16–19. Reports also appeared in the *Daily Worker* of 24 and 27 September 1934.

9 Robert Gessner, 'A Task for the Writers' Congress', *NM* 15, no. 1 (2 April 1935): 39, 41. Later in 1935, parts of the proceedings of the Writers' Congress were published as *Problems of Soviet Literature* (New York: International Publishers).

10 Cited by Murphy, *The Proletarian Moment*, 128–9.

11 Rufus Mathewson, 'The First Writers' Congress: A Second Look', in Max Hayward and Leopold Labedz, *Literature and Revolution in Soviet Russia, 1917–62* (London, New York & Toronto: Oxford University Press, 1963), 62–73.

12 His first contribution was 'Broad-Minded Medici', *NM* 10, no. 12 (20 March 1934): 15. He wrote most of the art notices for the numbers between 27 November 1934 and 3 December 1935, and was on the committee for the 'Art Issue' of 1 October 1935. Alexander may have been one of those lesser artists who gained a certain prominence in the John Reed Clubs, and was then marginalised by their closure and the shift to the People's Front. He exhibited at the Club's *Revolutionary Front–1934* exhibition and at the *Exhibition of Graphic Art by Members of the John Reed Club* at the New School for Social Research in 1935.

13 See e.g. the series of articles by Theodor Shmit (Director of the Institute for the History of the Arts in Leningrad) in the College Art Association magazine *Parnassus*: 'The Study of Art in the USSR (1917–1928)', *P* 1, no. 1 (January 1929): 7–10; 'The Development of Painting in Russia', *P* 1, no. 5 (May 1929): 32–8; 'Roads to Art in the U.S.S.R.', *P* 2, no. 8 (December 1930): 8–12. See also Clara Mason, 'Pictures and Peasants', *P* 5, no. 7 (December 1933): 24–5.

14 Grand Central Palace, New York, *Exhibition of Contemporary Art of Soviet Russia: Paintings, Graphics, Sculpture* (foreword by Christian Brinton; introduction by P. Novitsky; February 1929). 'Work of Revolutionary Artists Will Be Shown at Sessions of Russian Exposition', *DW*, 25 February 1929; 'Over 150,000 Workers Attend USSR Art Exhibition', *DW*, 11 March 1929; 'Soviet Art in New York', *NM* 4, no. 9 (February 1929): 5.

15 Christian Brinton, 'Realism in Soviet Art', in American Russian Institute, *The Art of Soviet Russia* (foreword by Fiske Kimball; 1936).

16 Louis Lozowick, 'Aspects of Soviet Art', *NM* 14, no. 5 (29 January 1935): 16–19. *Fortune* published a well illustrated and surprisingly sympathetic review, which interpreted the 1932 April Decree as marking a liberalisation of Soviet culture, and stressed the similarities of Soviet and American art, comparing Deineka, Katzman and others to Benton, Karfiol, Marsh and Wood. See 'State Art', *F* 11, no. 3 (March 1935): 62–7.

17 Russell Limbach, review of Studio Publications, *Art in the USSR, NM* 17, no. 9 (26 November 1935): 25.

18 I address this issue more fully in my article 'American Communists View Mexican Muralism: Critical and Artistic Responses', *Crónicas*, nos 8–9 (March 2001 – February 2002): 13–43.

19 On this, see James Oles *et al.*, *South of the Border: Mexico in the American Imagination, 1914–1947* (Washington, D.C., & London: Smithsonian Institution Press, 1993). Among those involved with the Communist movement were Maurice Becker, Henry Glintenkamp, Grace and Marion Greenwood and Mitchell Siporin.

20 John Dos Passos, 'Paint the Revolution!', *NM* 2, no. 5 (March 1927): 15.

21 Porter Myron Chaffee, 'Diego Rivera (Mexican Revolutionary Artist)', *NM* 5, no. 3 (August 1929): 16.

22 'The Charkov Conference of Revolutionary Writers', *NM* 6, no. 9 (February 1931): 6.

23 On Lovestone's passage through the Communist Party, see Draper, *American Communism and Soviet Russia*. On the New Workers School murals, see Diego Rivera, *Portrait of America* (text by Bertram Wolfe; New York: Codivici, Friede, 1934); Laurance P. Hurlburt, *The Mexican Muralists in the United States* (Albuquerque: University of New Mexico Press, 1989), 175–93.

24 Diego Rivera: 'The Revolutionary Spirit in Modern Art', *MQ* 6 no. 3 (autumn 1932): 51–7 (I suspect this is the text of Rivera's lecture to the John Reed Club); 'What is Art For?', *MM* 7, no. 5 (June 1933): 275–8; 'The Position of the Artist in Russia Today', *Arts Weekly* 1, no. 1 (11 March 1932): 6–7. Rivera became art director of the *MM* in 1934.

25 'Diego Rivera and the John Reed Club', *NM* 7, no. 9 (February 1932): 31; Walter Gutman, 'News and Gossip', *CA* 10, no. 2 (February 1932): 159. There is evidence that the JRC members objected to this heavy-handed intervention by Party figures – see 'memo' on the 'NM–JRC situation' (Freeman Papers, HI 177:1).

26 Robert Evans, 'Painting and Politics: The Case of Diego Rivera', *NM* 7, no. 9 (February 1932): 22–5.

27 'A Shameless Fraud', *Workers Age* 2, no. 15 (15 June 1933) Rivera Supplement, np. See also Bertram D. Wolfe, *Diego Rivera: His Life and Times* (New York & London: Knopf, 1939), 302–6. For Freeman's notes and correspondence on this episode, see Freeman Papers, HI 69:8, 69:34, 180:3, 180:4. Freeman reportedly presided at the meeting that expelled Rivera and his belief that changes in the conception of the mural reflected Rivera's betrayal of the Revolution went back to 1929. Tensions between him and the artist had been intensified by the fact that his wife to be was not only Rivera's assistant but also posed for him naked. See Robinson, *A Wall to Paint On*, 110–16, 197–201.

28 Meyer Schapiro, 'The Patrons of Revolutionary Art', *Marxist Quarterly* 1, no. 3 (October–December 1937): 462–6; Wolfe, *Diego Rivera: His Life and Times*.

29 'Support for Rivera Protest is Urged by John Reed Club', *DW*, 16 May 1933; 'Workers, Artists Protest Ban on Lenin Mural Today', *DW*, 17 May 1933.

30 Charmion von Wiegand, 'David Alfaro Siqueiros', *NM* 11, no. 5 (1 May 1934): 16–21. On Siqueiros in the United States, see Hurlburt, *Mexican Muralists in the United States*, ch. 3.

31 David Alfaro Siqueiros, 'Rivera's Counter-Revolutionary Road', *NM* 11, no. 9 (29 May 1934): 16–19.

32 Von Wiegand, 'David Alfaro Siqueiros', 16.

33 Cf. the amusing account of the confrontation between Rivera and Siqueiros in Mexico City in August 1935 by Emanuel Eisenberg: 'Battle of the Century', *NM* 17, no. 11 (10 December 1935): 18–20. While reiterating the usual complaints against Rivera, this was far from uncritical of Siqueiros. The most enthusiastic response to Siqueiros's 1934 exhibition came from Mike Gold, who also offered a surprisingly judicious assessment of Rivera and Orozco – 'Change the World!', *DW*, 7 April 1934.

34 'Orozco is "modern" because direct technique, high color, primary forms best express his intense emotion.' – 'Current Art Activities', *P* 2, no. 2 (February 1930): 6. Sheldon Cheney insistently contrasts Orozco's modernism with Benton's non-modernist approach to the mural in *Expressionism in Art* (New York: Liveright, 1934), 186–9, 296–8. The John Reed Club artists James Guy and Walter Quirt drove periodically to Dartmouth to watch Orozco at work in 1932–4. See University Gallery, University of Minnesota, *Walter Quirt: A Retrospective* (catalogue by Mary Towley Swanson; Minneapolis, 1980), 19, 28.

35 Anita Brenner, 'Orozco', *NM* 8, no. 7 (February 1933): 22–3; Charmion von Wiegand, 'Our Greatest Mural Art', *NM* 15, no. 1 (2 April 1935): 34; Stephen Alexander, 'Orozco's Lithographs', *NM* 17, no. 8 (19 November 1935): 29; Charmion von Wiegand, 'Portrait of an Artist', *NM* 23 no. 6 (27 April 1937): 24–6.

The relative evaluations of Orozco and Siqueiros were reversed at the end of the decade when Orozco's work was perceived to be in decline, while that of Siqueiros was still developing. See Ray King, 'Fine Exhibit of Siqueiros Paintings', *DW*, 24 January 1940; Walt Anderson, 'The Vital Art of Mexico', *DW*, 23 May 1940.

36 It seems to have originated in an article on the tasks of the Communist press by the former *Masses* cartoonist Robert Minor: 'Art as a Weapon in the Class Struggle', *DW*, 22 September 1925. Another early example is: Michael Gold, 'Art is a Weapon', in Fred Ellis *et al.*, *Red Cartoons from the Daily Worker, the Workers' Monthly and the Liberator* (Chicago: Daily Worker, 1926).

37 Murphy, *Proletarian Moment*, ch. 5; Michael Gold, '3 Schools of US Writing', *NM* 4, no. 4 (September 1928): 14.

38 Pauline Zutringer, 'Machine Art is Bourgeois', *NM* 4, no. 9 (February 1929): 31. Vern Jessup, 'And Now the Artists . . .' in 'Letters from Readers', *NM* 6, no. 5 (October 1930): 22; Louis Lozowick, 'What Should Revolutionary Artists Do Now?', *NM* 6, no. 7 (December 1930): 21. For an earlier and more positive appraisal of Lozowick, see Genevieve Taggard, 'The Ruskinian Boys See Red', *NM* 3, no. 3 (July 1927): 18.

39 'Resolution on the Work of New Masses for 1931', *NM* 8, no. 3 (September 1932): 20–21. 'Resolution on the Work of New Masses for 1931', attached to letter from Bruno Jasienski, Secretary to the IURW, 27 June 1932 (Lozowick Papers, AAA, unfilmed). See also Elistratova, 'New Masses', 110.

40 Marquardt, 'Louis Lozowick', 128–30; Louis Lozowick, 'Art in the Service of the Proletariat', *LWR* no. 4 (1931): 126–7. Cf. Lozowick's review of International Labor Defense, *Tom Mooney, A Story in Pictures*, *NM* 8, no. 12 (August 1933): 31.

41 Stephen Alexander, 'Revolutionary Front – 1934', *NM* 13, no. 9 (November 1934): 28–9; and 'White Haired Boy of the Crisis', *NM* 15, no. 6 (7 May 1935): 28. For Americanism, see e.g. Virgil Barker, 'The Search for Americanism', *MA* 27, no. 2 (February 1934): 51–2. On the antecedents of this position, see Andrew Hemingway, 'To "Personalize the Rainpipe": The Critical Mythology of Edward Hopper', *Prospects* 17 (1992): 379–404.

42 Alexander: 'Revolutionary Front – 1934', 28: 'Quintanilla's Etchings', *NM* 13, no. 10 (4 December 1934): 28; 'Salvador Dalí, or Life Is a Nightmare', *NM* 13, no. 5 (11 December 1934): 28.

43 Stephen Alexander, 'Jacob Burck's America', *NM* 14, no. 10 (5 March 1935): 25–6; 'Recent Magazines', and '"TOM" BENTON', *NM* 15, no. 4 (23 April 1935): 25, 28; 'Mural Painting in America', *NM* 14, no. 9 (26 February 1935): 28. Benton enunciated a specifically racialist model of American regional art, and directly criticised the work of Gellert and Lozowick. See his lecture to the John Reed Club, printed as 'Art and Nationalism', *MM* 8, no. 4 (May 1934): 232–6. For Benton's murals at the Chicago Century of Progress International Exposition, see Erika Doss, 'New Deal Politics and Regionalist Art: Thomas Hart Benton's *A Social History of the State of Indiana*', *Prospects* 17 (1992): 353–78.

44 Alexander, 'White Haired Boy of the Crisis', 28; Ferargil Galleries, *Catalogue of the First New York Exhibition of Paintings and Drawings by Grant Wood* (New York, 1935). E.g., Forbes Watson, 'The Phenomenal Professor Wood', *MA* 28, no. 5 (May 1935): 285–9; Constance Rourke, 'American Art: A Possible Future', *MA* 28, no. 7 (July 1935): 397.

45 Jacob Burck, *Hunger and Revolt: Cartoons by Burck* (New York: Daily Worker, 1935), 247; Walt Carmon, 'Jacob Burck: American Political Cartoonist', *IL* no. 3 (1935): 82–3; 'Soviet Snapshots by Jacob Burck', *SW*, 8 November 1936; 'Jacob Burck Returns Home', *DW*, 1 April 1937. See also Lowell B. Kowie, 'A Man of Mischief and Imagination', *Chicago Sun-Times Magazine*, February 1980; Lloyd Green, 'Cartoonist Burck Dies After Blaze', *Chicago Sun-Times*, 12 May 1982. I am grateful to the Chicago Historical Society for providing me with information on Burck from its files.

46 *Death of a Communist* illustrated as *Demonstration against Hunger* in *DW*, 9 July 1932; see also Hugo Gellert, 'The Independents' Show', *NM* 7, no. 11 (May 1932): 29; *The New Deal*, illustrated in *NM* 17, no. 1 (1 October 1935): 25; Jacob Kainen, 'Revolutionary Art at the John Reed Club', *AF* 1, no. 2 (January 1935): 6. Jacob Burck, 'For Proletarian Art', *American Mercury* 34, no. 135 (March 1935): 336. Burck describes his painting methods in a letter to Edward Rowan, 21 February 1941 (NARA, RG121:133, Bradley, Ill.).

47 Hurlburt, *Mexican Muralists in the United States*, 123–7; 'In the New York Galleries', *P* 6, no. 1 (January 1932): 10.

For Burck on Rivera, see 'A Portrait of Diego Rivera', *DW*, 19 May 1934.

48 Ironically, the Kaufmann Store was decorated by the leftist Boardman Robinson. See Lloyd Goodrich, 'Mural Paintings by Boardman Robinson', *The Arts* 16, no. 6 (February 1930): 391–3. Museum of Modern Art, New York, *Murals by American Painters and Photographers* (New York, 1932); Dorothy Grafly, 'Murals at the Museum of Modern Art', *MA* 25, no. 2 (August 1932): 93–102; Hugo Gellert, 'We Capture the Walls!', *NM* 7, no. 12 (June 1932): 29. Ben Shahn's *The Passion of Sacco and Vanzetti* (Whitney Museum of American Art) was also nearly excluded, and several other artists showed images critical of American society.

In March 1932, Gellert, Lozowick, Gropper and Refregier collaborated in *An Exhibit of Projects for Murals* at the Decora Gallery on East 52nd Street (catalogue, Refregier Papers, AAA, unfilmed, Box 17). This suggests that some of Lozowick's designs of this time, such as *Construction*, were partly conceived as murals.

49 Stephen Alexander, 'Murals by Burck and Laning', *NM* 14, no. 4 (22 January 1935): 26; 'Burck Mural on Exhibit', *DW*, 14 January 1935; Louis Lozowick, 'Magnificent Murals by Burck Depict Soviet Achievements', *DW*, 18 January 1935; 'Burck Exhibits in Soviet Union', *SW*, 28 June 1936. For reproductions of the murals, see 'Five American Murals on the Soviet Union – by Jacob Burck', *IL* no. 3 (1935): 84–8. It may have been partly to install his murals that Burck travelled to Moscow, where he spent part of 1935–6 working for the *Komsomolskaya Pravda*.

50 Jacob Burck, 'For Proletarian Art', 334–6; 'Benton Sees Red', *AF* 1, no. 4 (April 1935): 5, 8. 'Second Issue of Partisan Review Appears April 1', *DW*, 31 March 1934; Georg Lukács, 'Propaganda or Partisanship?', *PR* 1, no. 2 (April–May 1934): 43; tr. as '"Tendency" or Partisanship?', in Georg Lukács, *Essays on Realism* (ed. Rodney Livingstone; Cambridge, Mass.: MIT Press, 1981), 33–44. In fact the translation of 'tendenz' as 'propaganda' is misleading.

51 Biographical details from: John Selby, 'Joe Jones, Artist, Began as a House Painter', *Washington Star*, 11 September 1938; Karal Ann Marling, 'Workers, Capitalists, and Booze: The Story of the 905 Murals', in Haggerty Art Museum, Marquette University, *Joe Jones & J. B. Turnbull: Visions of the Midwest in the 1930s* (Milwaukee, 1987), 7–25. (Marling's work on Jones is enormously useful but she trivialises his politics.) My thanks to Jennifer Crets of the Saint Louis Art Museum for sending me materials from the Joe Jones artist file.

52 'Joe Jones Tries to "Knock Holes in Walls"', *AD* 7, no. 10 (15 February 1933): 9. Jones's letters from New York in February–March 1934 record a period of intensive study in galleries and museums.

53 Marquis W. Childs, 'Three St Louis Artists', *MA* 28, no. 8 (August 1935): 486. Robert Hanna to Elizabeth Green, 27 February 1935 (Dr John Green Papers, Missouri Historical Society – all MHS papers hereafter in this collection. I am very grateful to Dinah Young and other staff of the Missouri Historical Society for their assistance.)

54 'Housepainter', *Time* (3 June 1935): 33; 'Provincetown Makes Artist a Communist', undated clipping from *St Louis Post-Dispatch* (MHS); Childs, 'Three St Louis Artists', 486. Jones felt he had been mistreated by the Joe Jones Club. For that and the houseboat, see his undated letters to Elizabeth Green of September 1933 (MHS). For Jones and Midwestern Communism, see also Wixson, *Worker-Writer in America*, 368–72 and passim.

55 Joe Jones to Elizabeth Green, 23 November 1934 (MHS).

56 According to several reports the Unemployed Art Class was initiated by the Saint Louis John Reed Club. If so, Green seems to have been unaware of this – see her account of the project in Green to Harriette F. Ryan, 22 February 1935 (draft; MHS).

57 Bill Gebert, 'The St. Louis Strike and the Chicago Needles Trades Strike', *The Communist* 12, no. 8 (August 1933): 800–06.

58 Orrick Johns, 'St. Louis Artists Win', *NM* 10, no. 10 (6 March 1934): 28; 'American Unemployed Art', *IL* no. 2 (1934): 95–7; Joe Jones *et al.*, 'Four Cases of Mural Censorship', *Midwest – A Review* 1, no. 1 (November 1936): 17–20; and the following from the *St Louis Post-Dispatch*: 'Joe Jones Stirs Up Art Row at Old Courthouse' (undated clipping, MHS); 'Social Unrest Mural in Old Court-House', 16 February 1934; 'City to Oust Artist from Old Courthouse', 13 December 1934; 'Joe Jones Not Going to Move Willingly', 14 December 1934; 'Unemployed Artists Protest on Lockout', 16 December 1934.

59 Stephen Alexander, 'Joe Jones', *NM* 15, no. 9 (28 May 1935): 30. Cf. Jacob Kainen, 'Joe Jones, Vital Revolutionary Artist', *DW*, 24 May 1935.

60 Joe Jones to Elizabeth Green, 25 February 1935, 26 February 1935, 4 March 1935, 7 March 1935, 10 August 1935 (MHS). Lewis Mumford, 'The Art Galleries', *NY* (1 June 1935): 73–4; Archibald MacLeish, 'US Art 1935', *F* 12, no. 6 (December 1935): 69.

61 Joe Jones to Elizabeth Green, 16 February 1935 (MHS).

62 The most incisive critique of Benton's work from the period is Meyer Schapiro's 'Populist Realism', *PR* 4, no. 2 (January 1938): 53–7. For a persuasive analysis of Benton's politics and social vision, see Erika Doss, *Benton, Pollock, and the Politics of Modernism: From Regionalism to Abstract Expressionism* (University of Chicago Press, 1991).

63 Alexander, 'Joe Jones'.

64 On this bill, see Klehr, *Heyday of American Communism*, 283–6.

65 Margaret Cowl explicitly contrasts the role of Soviet tractors with that of the tractor in *Grapes of Wrath* in 'The Monster Breathes Profits', *SW*, 11 February 1940.

66 ACA Gallery, New York, *Joe Jones* (19 May – 1 June 1935). The mural version is illustrated in *NYT*, 26 May 1935.

67 'Provincetown Makes Artist a Communist'; Childs, 'Three St Louis Artists'. For Jones and the Saint Louis Waterfront at this time, see Orrick Johns, *Time of Our Lives: The Story of My Father and Myself* (New York: Stackpole, 1937), 338–9.

68 Al Lehman, 'Brilliant Murals by Joe Jones Decorate Labor College Walls', *DW*, 31 August 1935. For Commonwealth College, see Wixson, *Worker-Writer in America*, 407–9.

69 Thomas S. Willison, 'Revolutionary Art Today', *NM* 17, no. 1 (1 October 1935): 17.

70 Weinstock later changed his name to Charles Humboldt. To avoid confusion I use that under which he died throughout.

71 Gerald M. Monroe, 'Art Front', *AAAJ* 13, no. 3 (1973): 16–17; 'Notes on Editorial Board Meeting of Art Front, Jan 22, 1936' (Stuart Davis Papers Relating to *Art Front*, AAA, unfilmed). For *Art Front*, see also Francine Tyler, 'Artists Respond to the Great Depression and the Threat of Fascism: The New York Artists' Union and its Magazine *Art Front* (1934–1937)', PhD thesis, New York University, 1991, ch. 4.

72 The best study of Davis remains the Brooklyn Museum's *Stuart Davis: Art and Art Theory* (catalogue by John R. Lane; New York, 1978). But see also Diane Kelder (ed.), *Stuart Davis* (New York: Praeger, 1971); Metropolitan Museum of Art, New York, *Stuart Davis: American Painter* (New York, 1991); and Patricia Hills, *Stuart Davis* (New York: Abrams, 1996). The bulk of Davis's papers are deposited at the Houghton Library, Harvard University. All references are to these unless otherwise stated.

73 Typescript headed 'Order of Art Creation Oct. 1, 1935'. However, Davis's view of Dewey's aesthetic was unfavourable: 'All speculative and primarily "god-worship."' ('Jan. 20, 1937'; Stuart Davis Papers).

74 A. L. Chanin, *Joseph Solman* (New York: Crown, 1966); Theodore F. Wolff *et al.*, *Joseph Solman* (New York: Da Capo, 1995); author's interviews with Joseph Solman, 13 December 1991, 12 March 1993, 13 November 1996; Artist's File, Hirshhorn Museum & Sculpture Garden, Washington, D.C.

75 'For a Farmer-Labor Party', *AF* 2, no. 6 (May 1936): 6.

76 Margaret Duroc, 'Rivera's Monopoly', Parts 1 and 2, *AF* 1, no. 7 (November 1935); 2, no. 1 (December 1935); 'Art, US Scene', *Time* 24, no. 26 (24 December 1934): 24–7; Stuart Davis, 'The New York American Scene in Art', *AF* 1, no. 3 (February 1935): 6; 'A Letter from Curry', *AF* 1, no. 4 (April 1935): 2; [Benton], 'On the American Scene', ibid., 4, 8; Jacob Burck, 'Benton Sees Red', ibid., 5, 8. See also the letters by Benton and Jacob Kainen in 'Correspondence', *AF* 1, no. 5 (May 1936): 7; and Lincoln Kirstein's fine critique of Grant Wood: 'An Iowa Memling', *AF* 1, no. 6 (July 1935): 6, 8.

77 'Miró's Dog Barks While McBride Bites', *AD* 4, no. 6 (mid-December 1929): 5.

78 Rutgers University Art Gallery, *Surrealism and American Art, 1931–1947* (New Brunswick, N.J., 1977); Ilene Susan Fort, 'American Social Surrealism', *AAAJ* 22, no. 3 (1982): 8–20.

79 Stephen Alexander, 'Salvador Dalí, or Life Is a Nightmare', *NM* 13, no. 11 (11 December 1934): 28.

80 John Graham, 'Eight Modes of Painting', *AF* 1, no. 2 (January 1935): 6–7. For Graham's bizarre amalgam of Marxism and modernist theory, see Marcia Epstein Allentuck, *John Graham's 'System and Dialectics of Art'* (Baltimore & London: Johns Hopkins University Press, 1971).

81 Monroe, 'Art Front', 15; Stuart Davis, 'Paintings by Salvador Dalí', *AF* 1, no. 2 (January 1935): 7. See also Clarence Weinstock [Charles Humboldt], 'A Letter on Salvador Dalí', *AF* 1, no. 3 (February 1935): 7–8.

82 Margaret Wright Mather, 'Columbia Fires Two', *NM* 11, no. 11 (12 June 1934): 9–10.

83 Jerome Klein, 'Dada for Propaganda', *AF* 1, no. 3 (February 1935): 7–8.

84 Margaret Duroc, 'Critique from the Left', *AF* 2, no. 2 (January 1936): 7. By contrast, see Jacob Kainen, 'The Capitalist Crisis in Art', *DW*, 3 December 1935, which praised the contributions of both Guglielmi and Quirt. Duroc's article is preceded by a sensitive and nuanced assessment of de Chirico by Solman: 'Chirico – Father of Surrealism' (6–7). For Guglielmi, see Rutgers University Art Gallery, *O. Louis Guglielmi: A Retrospective Exhibition* (New Brunswick, N.J., 1980).

85 Grace Clements, 'New Content – New Form', *AF* 2, no. 4 (March 1936): 8–9; Joseph Solman, 'The Post-Surrealists of California', *AF* 2, no. 6 (June 1936): 12 (review of Brooklyn Museum, *Oil Paintings and Water Colors by California Artists*). For the Post-Surrealists, see Susan Ehrlich (ed.), *Pacific Dreams: Currents of Surrealism and Fantasy in California Art, 1934–1957* (Los Angeles: UCLA, 1995), 17–22; for Clements, see 94–5. Clements was on the executive committee of the Hollywood John Reed Club, and leader of its 'art unit' (Grace Clements to Louis Lozowick, 26 July 1932, Lozowick Papers, AAA, unfilmed). She was subsequently secretary of the Los Angeles branch of the American Artists' Congress.

86 See the useful essay by Mary Towley Swanson, in University of Minnesota, *Walter Quirt*; *DW*, 28 March 1933; 'In This Issue', *NM* 7, no. 5 (October 1931): 31. Two designs for murals for workers' clubs are illustrated in 'American Revolutionary Paintings by Walter Quirt', *IL* no. 4 (1934): 66–8.

87 C. W. [Charles Humboldt], 'Quirt', *AF* 2, no. 5 (April 1936): 13. Jacob Kainen, 'Revolutionary Surrealism', *DW*, 26 February 1936. A copy of the exhibition catalogue is in the Jacob Kainen Papers, AAA 2149:1016–17. Cf. Charmion von Wiegand: 'Quirt's unified, logical synthesis compressed into exquisite miniature painting is the antipodes of the irrational, intuitional, nightmare dreams of Surrealism.' – 'Walter Quirt', *NM* 18, no. 12 (24 March 1936): 25.

88 Annette T. Rubinstein, 'For Charles Humboldt', *National Guardian*, 30 January 1964; and 'Charles Humboldt 1910–1964' (typescript, Humboldt Papers, YU, Box 9, folder 292). Jacob Kainen to Garnett McCoy, 15 April 1992; I am grateful to Garnett McCoy for showing me this letter.

89 Stuart Davis, 'Introduction', in Whitney Museum of American Art, *Abstract Painting in America* (New York, 1935), np; repr. in Kelder (ed.), *Stuart Davis*, 112–14.

90 Clarence Weinstock [Charles Humboldt], 'Contradictions in Abstraction', *AF* 1, no. 4 (April 1935): 7.

91 Stuart Davis, 'A Medium of 2 Dimensions', *AF* 1, no. 5 (May 1935): 6; repr. in Kelder (ed.), *Stuart Davis*, 114–16.

92 Léger was in the news because of his 1935 exhibition at the Museum of Modern Art, and a lecture he had given there with the provocative title 'The New Realism', which appeared in translation in the December *Art*

Front. Fernand Léger, 'The New Realism', *AF* 1, no. 8 (December 1935): 10–11. A second Léger lecture, 'The New Realism Goes On', appeared in *AF* 3, no. 1 (February 1937): 7–8.

93 Balcomb Greene, 'The Functions of Léger', *AF* 2, no. 2 (January 1936): 8–9. Clarence Weinstock [Charles Humboldt], 'Freedom in Painting', *AF* 2, no. 2 (January 1936): 9–10. For Greene, see John R. Lane and Susan C. Larsen (ed.), *Abstract Painting and Sculpture in America 1927–1944* (Pittsburgh: Museum of Art, Carnegie Institute, 1983), 161–3.

3 Revolutionary Art on Display

1 'Workers' Art': *NM* 5, no. 7 (December 1929): 21; *NM* 6, no. 11 (April 1931): 22; *NM* 6, no. 12 (May 1931): 23. There is evidence of a later exhibition at the German Workers' Club at 1536 Third Avenue in an advertisement, *DW*, 25 April 1933.

2 'The John Reed Club', *NM* 6, no. 3 (July 1930): 20; 'Current Exhibits', *NM* 7, no. 9 (February 1932): 31. These are certainly not all that took place: see e.g. Jacob Kainen, 'Class Struggle at JRC Exhibit in New York', *DW*, 11 June 1934; 'Proletarian Sculpture Show', *DW* 13 April 1935; Abraham Harriton, 'Interesting Art Exhibition by John Reed Club Members', *DW*, 15 March 1935.

3 Sources: Obituaries of Baron in *NYHT*, 28 January 1961, *NYT*, 28 January 1961; Elizabeth McCausland, 'Herman Baron' (typescript, ACA Gallery Papers, AAA D304: 561–5); Herman Baron, 'Unpublished History of the ACA Gallery' (D304: 566–681); Hugh J. Riddell, 'A Unique Gallery of Social Art', *DW*, 18 October 1939.

4 Harry Sternberg, telephone conversation with the author, 3 December 1996; Bernarda Bryson, conversation with the author, 27 November 1996.

5 ACA Gallery, *Twenty John Reed Club Artists on Proletarian and Revolutionary Themes*, 7–25 November 1932 (scrapbook in Refregier Papers, AAA, unfilmed, Box 17). For Biel, Oley and Spivak, see NYC WPA Artists Inc., *New York City WPA Art* (New York, 1977), 96, 68, 83. For Hernandez, see *NM* 7, no. 1 (June 1931): 23.

6 Anton Refregier, interview with Mary Towley Swanson, 1978, in University of Minnesota, *Walter Quirt*, 17.

7 Biographical details from Zurrier, *Art for The Masses*, 165; Mary Ryan Gallery, *Hugo Gellert*, 1–3; Michael Gold, 'Salute to Hugo Gellert', *M&M* 8, no. 1 (January 1955): 27–31; Gellert, 'The Role of the Communist Artist', MS notes (Gellert Papers, AAA, unfilmed, Box 3).

8 'From a Labor Mural by Hugo Gellert'.

9 O. Frank, 'A Classic in Pictures', *NM* 10, no. 9 (27 February 1934): 27–8; Earl Browder, 'Notes on a Review', *NM* 11, no. 1 (3 April 1934): 35; O. Frank, 'Reviewing a Review of a Review', *NM* 11, no. 4 (24 April 1934): 21–2. Robert Minor also defended Gellert – 'Karl Marx on the Lithographer's Stone', *DW*, 24 March 1934. Cf. Milton Howard's more critical 'Hugo Gellert Gives Us Marx's "Capital" in Picture Series', *DW*, 3 March 1934. Two more

picture books followed: *Comrade Gulliver* (1935) and *Aesop Said So* (1936).

10 The murals for the Schenley Corporation are reproduced in Ernest Brace, 'William Gropper', *MA* 30, no. 8 (August 1937): 469. An instance of Gropper's pamphlet work from 1933–4 is Harrison George, *A Noon-Hour Talk on the Communist Party* (New York: CPUSA, nd).

11 For another example, see 'Another Kid', *NM* 5, no. 3 (August 1929): 9. Such images were also the basis for separate lithographs, sold as prints: see advertisement in *NM* 13, no. 5 (30 October 1934): 7.

12 'In This Issue', *NM* 6, no. 7 (December 1930): 22; Walt Carmon, review of *No Jobs Today*, *NM* 7, no. 3 (August 1931): 17. Phil Bard, *No Jobs Today: A Story of a Young Worker in Pictures* (introduction by Robert Minor; New York: Young Communist League, nd); *It Happens Every Day: A Story in Pictures* (introduction by Lloyd Brown; New York: Youth Publishers, nd; 1933–4). There are copies of both in the Tamiment Institute Library. 'Workers Art', *NM* 7, no. 6 (November 1931): 28, includes a photograph of the monument; 'John Reed Clubs', *PR* 1, no. 2 (April–May 1934): 62; 'Bard Murals to Have First Showing Tonight at Workers Center', *DW*, 9 March 1934; William Siegel, 'Phil Bard Murals in the New York Workers Center', *DW*, 22 March 1934. For reproductions of the murals, see Walt Carmon, 'Phil Bard: American Artist', *IL* no. 5 (1934): 80–83.

13 Lozowick's exhibits were probably the lithographs *Hooverville* and *In the Park – No Job* (Flint, *The Prints of Louis Lozowick*, nos 98 and 30). On Refregier's copy of the catalogue, *Coal Pockets* (Flint, no. 20?) has been deleted and *Hooverville* substituted. Limbach's *Three Cops* is likely to be the lithograph *Faith, Hope and Charity* illustrated in *NM* 7, no. 4 (September 1931): 8.

14 Baron, 'Unpublished History of the ACA Gallery', 7, 11. Thomas Linn, 'A Scolding Show', quoted, 10. Ishigaki's painting *On the Bench* was probably *Unemployed*, in Museum of Modern Art, Wakayama, *Japan in America: Eitaro Ishigaki and Other Japanese Artists in the Pre-World War II United States* (1997), 106.

15 J. B. [Jacob Burck?], 'Leading US Artists to Exhibit Work at the John Reed Club', *DW*, 21 January 1933; 'John Reed Club Art Exhibit Opens Tonight at 450 Sixth Avenue', *DW*, 26 January 1933; 'Art Exhibition at the John Reed Club', *DW*, 3 February 1933. John Reed Club, *Exhibition: Sculpture, Painting, Drawing: The Social Viewpoint in Art*, 26 January – 16 February 1933 (copy in scrapbook in the Refregier Papers, AAA, unfilmed, Box 17).

16 Burck's No. 30, *The Chinese Red Army*, was probably related to the mural sequence mentioned by Alexander in 'Murals by Burck and Laning'. Flint, *Prints of Louis Lozowick*, nos 93, 101, 91, 104 and 94. For Coleman and Higgins, see Milton W. Brown, *American Painting from the Armory Show to the Depression* (Princeton University Press, 1955), 170–72, 28–30.

17 John Kwait [Meyer Schapiro], 'John Reed Club Art Exhibition', *NM* 8, no. 7 (February 1933): 23. Benton's contributions were: 14. *Broncho Busters* (sic), 15. *Cotton*

Pickers, 16. *Crap Shooters*, 17. *The Wreck*. Benton's *The Arts of Life in America* murals are now in the New Britain Museum of American Art.

18 Miller's contributions were: 115. *In the Fourteenth Street*, 116. *In the Whitney Museum*, 117. *The Sand Pit*, and 118. *The Serpent*. The *Fourteenth Street* by Miller illustrated in Brown, *American Painting from the Armory Show to the Depression* (182), certainly makes an explicit social contrast between shoppers and street vendor. This was repainted c. 1940 and retitled *Sidewalk Merchant* (University of Texas at Austin, Archer M. Huntington Gallery): see Ellen Wiley Todd, *The 'New Woman' Revised: Painting and Gender Politics on Fourteenth Street* (Berkeley: University of California Press, 1993), 340–41, n. 46.

19 For Bishop's outlook, see Todd, *The 'New Woman' Revised*, 121, 294–6; and James M. Dennis and Kathleen M. Daniels, 'A Modern American Purgatory: Isabel Bishop's *Dante and Virgil in Union Square*, 1932', in Sordoni Art Gallery, Wilkes University, *Between Heaven and Hell: Union Square in the 1930s* (Wilkes-Barre, Penn., 1996), 4–20.

20 Marilyn Cohen, *Reginald Marsh's New York: Paintings, Drawings, Prints and Photographs* (New York: Whitney Museum & Dover Publications, 1983); Todd, *The 'New Woman' Revised*, ch. 5; Lloyd Goodrich, 'Introduction', in Norman Sasowsky, *The Prints of Reginald Marsh* (New York: Clarkson Potter, 1976), 11; 'Rebel Arts', *AD* 6, no. 16 (15 May 1932): 32. Marsh's desk calendars of 1931 record him attending a five-week course at the Workers School, and in July 1933 he made a brief trip to the USSR (Marsh Papers, AAA NRM2).

21 For *Tenth Avenue*, see Sasowsky, *The Prints of Reginald Marsh*, no. 128; for *Locomotives*, see nos 29, 85 and 87.

22 For Laning and Miller, see Wichita Art Museum, *Edward Laning, American Realist 1906–1981: A Retrospectve Exhibition* (Wichita, Kan., 1982), 6. For Laning and Marsh, see Laning, 'East Side West Side', in University of Ariz. Museum of Art, *East Side West Side All Around the Town: A Retrospective Exhibition of Paintings, Watercolors, and Drawings by Reginald Marsh* (Tucson, Arizona, 1969), 85–98. For Laning on the JRC, see Edward Laning, 'The New Deal Mural Projects', in Francis V. O'Connor (ed.), *The New Deal Art Projects: An Anthology of Memoirs* (Washington, D.C.: Smithsonian Institution Press, 1972), 81–2. Stanley I. Grand has related the composition to a newspaper photograph of the event in the *New York Times*, in Sordoni Art Gallery, *Between Heaven and Hell*, 36, 40 n. 92.

23 For the studio, see Tyler, 'Artists Respond to the Great Depression and the Threat of Fascism', 43.

24 Harry Sternberg, telephone conversation with the author, 3 December 1996.

25 George D. Bianco, *The Prints of Philip Reisman: A Catalogue Raisonné* (New York: Bedford Press, 1992). My guess is that the works Reisman showed were the following: 137. *Builders* (no. 10 or 11); 138. *6th Ave "L"* (no. 45 or 57); 139. *Soda Fountain* (no. 52); 140. *Sunday Morning* (no. 55); and 141. *Veterans* (no. 59). See also Andrew Hemingway, *Philip Reisman's Etchings: Printmaking and Politics in New York, 1926–1933* (London: College Art Col-lections, University College London, 1996); and Martin H. Bush, *Philip Reisman: People Are His Passion* (Wichita, Kan.: Edwin A. Ulrich Museum of Art, Wichita State University, 1986). More problematically, Kainen claimed that his subjects 'torn out of the lives of the working class are saturated with revolutionary implications' – 'Art', *DW*, 18 April 1936.

For comparable Lower East Side subjects by Sternberg, see Edwin A. Ulrich Museum of Art, *Harry Sternberg: A Catalog Raisonné of his Graphic Work* (Wichita, Kan: Wichita State University, 1975), cat. nos 2 and 27.

26 I am assuming that the prints Sternberg showed were cat. nos 60, 89, 71 and 55 in ibid. For Sternberg, see also Zigrosser, *The Artist in America*, 62–9.

27 See esp. Gertrude Benson, 'Art and Social Theories', *CA* 12, no. 3 (March 1933): 216–19. It seems very probable that the works illustrated in 'Nine American Arists in an Exhibit of the New York John Reed Club' (*IL* no. 1 [January 1935]: 49–54, 108, 110) are from this display. For Wolff, see Francis M. Naumann and Paul Avrich, 'Adolf Wolff: "Poet, Sculptor and Revolutionist, but Mostly Revolutionist"', *Art Bulletin* 68, no. 3 (September 1985): 486–500. Wolff's *Canton Commune* (no. 193) and Paul Meltsner's *The Strikers* (no. 114) are illustrated in *AD* 7, no. 11 (1 March 1933): 32.

28 Quirt also showed: 129. *Elections – U.S.A.* and 131. *Unity*. A photograph of the latter (a long composition on Southern oppression and inter-racial proletarian unity) is in the Quirt Papers, AAA, 572: 539.

29 For Cikovsky, see R. F. [Rosamund Frost], 'Naturalized Russo-Fauve', *AN* 45, no. 1 (March 1946): 47; 'Artist's Biography' form, filled out by Cikovsky, Hirshhorn Museum & Sculpture Garden Archives, Washington, D.C. Hoffman's *In Dixieland* is presumably the work illustrated in *IL* no. 1 (January 1935): 52, as *Chain Gang*. He also showed 83. *Coal Miner's Shack*, and 86. *War*. For his career, sce Margaret Sullivan, *Irwin D. Hoffman* (New York: Associated American Artists, 1936).

30 Anita Brenner, 'Revolution in Art', *The Nation* 136, no. 3531 (8 March 1933): 268. Brenner (1905–74) was an independent leftist and member of the *Menorah Journal* group, who shortly moved close to Trotskyism. Her review, Benson's 'Art and Social Theories' and Schapiro's review and exchange with Burck are all reprinted in Shapiro (ed.), *Social Realism*, 66–80. I am guessing that Davis's contribution was a version of *Adit* or *Industry*. See Amon Carter Museum, *Stuart Davis: Graphic Work and Related Paintings with a Catalogue Raisonné of the Prints* (Fort Worth, Tex., 1986), 28–9. Benson's description fits the Boston painting best. For Brenner, see Susan Noyes Platt, *Art and Politics in the 1930s: Modernism, Marxism, Americanism: A History of Cultural Activism in the Depression Years* (New York: Midmarch Arts Press, 1999), ch. 8.

31 See Marsh, 'What I See In Laning's Art', *CA* 12, no. 3 (March 1933): 187–8.

32 Benson, 'Art and Social Theories', 218.

33 Kwait, 'John Reed Club Art Exhibition'; Jacob Burck, 'Sectarianism in Art' and John Kwait [Meyer Schapiro],

'Reply to Burck', *NM* 8, no. 8 (April 1933): 26–7; 'American Artists Take Up Eager Roles in "Social Revolution"', *AD* 7, no. 11 (1 March 1933): 32.

34 Unattributed scrapbook clipping in the Refregier Papers (AAA, unfilmed, Box 17), probably from the *Daily Worker*. This claims that more than 3,000 people had visited the exhibition, more than half of them working class.

35 '120 Works Shown at Art Exhibition of John Reed Club', *DW* 13 December 1933; Louis Lozowick, 'John Reed Club Show', *NM* 10, no. 1 (2 January 1934): 27. Draughts of the call for the exhibition are in the Quirt Papers, AAA 571: 364–6. A copy of the catalogue is in the Evergood Papers, AAA 429: 1025–6.

36 Bernarda Bryson, 'Portray Hunger, Fascism, War At John Reed Club Art Exhibit', *DW*, 23 December 1933. Laning recalled being impressed by Bukharin's *Dialectical Materialism*, but claimed Marxism had not affected the 'form and content' of his work. See Laning, 'The New Deal Mural Projects', 81–2. Although Laning remained committed to a kind of social art, after 1935 his works suggest a generalised moral critique of US society rather than a specifically socialist one.

37 George Biddle, 'An Art Renascence Under Federal Patronage', *Scribner's Magazine* 95 (June 1934): 428–31. For Biddle's politics, see also his *An American Artist's Story* (Boston: Little, Brown & Co., 1939), 306–16.

38 Presumably *In Memoriam: Sacco and Vanzetti*: see Martha Pennigar, *The Graphic Work of George Biddle, with Catalogue Raisonné* (Washington, D.C.: Corcoran Gallery of Art, 1979), no. 102.

39 This is confirmed by the fact that *Starvation* was illustrated in the *New Masses* 'Revolutionary Art' issue of 1 October 1935 (27), and by the description in Bryson's review. I am grateful to Michael Biddle for showing me the painting. For *Tom Mooney*, see Pennigar, *Graphic Work of George Biddle*, no. 110.

40 To judge from Bryson's description, this was the fresco panel Laning exhibited at the Art Students League in 1935: see Alexander, 'Murals by Laning and Burck'. A drawing on this theme, now known as *The Haves and the Have Nots*, is in a private collection: see Wichita Art Museum, *American Art of the Great Depression: Two Sides of the Coin* (Wichita, Kan., 1985), fig. 43.

41 Orozco's exhibit was almost certainly the lithograph of a lynching illustrated in *New Masses* 10, no. 10 (6 March 1934): 17, as *American Landscape*. Bryson's review illustrates Fogel's *The Land of Plenty*.

42 *Mine Disaster* can be identified with *Miners* (no. 27) from ACA Gallery, *20 Years Evergood* (New York, 1946), 99.

43 The main biographical source for Evergood is Kendall Taylor, *Philip Evergood: Never Separate from the Heart* (London & Toronto: Associated University Presses, 1987); but see also John I. H. Baur, *Philip Evergood* (New York: Whitney Museum of American Art, 1960). Pierre Degeyter was the Lille woodcarver who wrote the music for Eugene Pottier's *L'Internationale*. Evergood's mural is now in the Chrysler Museum, Norfolk, Virginia. *NYHT* as quoted in 'Philip Evergood', *Current Biography – 1944* (1945): 191–3.

44 Philip Evergood to Alfred H. Barr, 12 December 1933 (NARA, New York Office, RG121:110).

45 Elistratova, 'New Masses', 111.

46 Edward Alden Jewell, 'Propaganda Art', *AD* 8, no. 7 (1 January 1934): 14, repr. from the *New York Times*. Six months after it had closed, the exhibition was attacked from an ultra-left position in *New Masses*, but this time the magazine published no response. See Mark Graubard, 'The Artist and the Revolutionary Movement', *NM* 12, no. 5 (31 July 1934): 24.

47 Alfred Durus to Hugo Gellert, 3 October 1935 (Gellert Papers, AAA, unfilmed, Box 1, file 'Letters 1935–1939').

48 Museum of Modern Art, Wakayama, *Japan in America*; Ayako Ishigaki, *The Painter of Love who Crossed the Sea: The Life of Eitaro Ishigaki* (Tokyo: Ochanomizushobou, 1988). See also Tokyo Metropolitan Teien Art Museum, *Japanese and Japanese American Painters in the United States: A Half Century of Hope and Suffering* (1995). For the world of Japanese American Communism, see Karl G. Yoneda, *Ganbatte: Sixty-Year Struggle of a Kibei Worker* (Los Angeles: Asian American Studies Center, UCLA, 1983). I am grateful to Yuji Ichioka and Janis Conner for advice on researching Japanese American artists, and to Makiko Yamanashi for tracking down the relevant publications and providing translations.

49 Allen Weinstein, *Perjury: The Hiss-Chambers Case* (New York: Knopf, 1978), 128–30, 309; 'A Voice from Japan', *NM* 7, no. 10 (April 1932): 28–9; 'Noda Dies in Tokyo', *AD* 13, no. 10 (15 February 1939): 28. Kumamoto Prefectural Museum of Art, *Hideo Benjamin Noda & Chuzo Tamotzu* (1992).

50 A copy of the ACA catalogue is in Meyer Schapiro's papers, Noda file. Noguchi and Kuniyoshi were among the other exhibitors. Baron, 'Unpublished History of the ACA Gallery', 28.

51 See 'Six American Paintings by Lydia Gibson', *IL* no. 4 (April 1935): 48–52.

52 Bryson came from an academic family and had studied at Ohio University, Ohio State University, Western Reserve University and Cleveland School of Art. She was introduced to the CP by Alfred H. Sinks and Russell Limbach. Interview with the author, 27 November 1996; Bernarda Bryson to the author, 10 June 1997.

53 Information about Sara Berman Beach provided by her daughter Rose Shain. On the Battle of Wilmington, see Klehr, *Heyday of American Communism*, 66. Four of Berman's drawings of the march were shown in *The Social Viewpoint in Art*, and some were illustrated in *NM* 8, no. 6 (January 1933): 8. See also 'John Reed Club Exhibit Opens Tonight At 450 Sixth Avenue', *DW*, 26 January 1933.

54 Alexander, 'Revolutionary Front – 1934', 28; Jacob Kainen, 'John Reed Club Art Show Displays Class Theme as Main Note', *DW*, 16 November 1934; Jacob Kainen, 'Revolutionary Art at the John Reed Club', *AF*, 1, no. 2 (January 1935): 6; Minutes of JRC Buro meetings of 12 October 1934 and 17 December 1934 (Lozowick Papers, AAA, unfilmed). A copy of the catalogue is in the Refregier Papers, AAA, unfilmed, Box 1a. This was the only JRC exhibition in which

Alice Neel showed, as did Charles Pollock and 'Jackson Sande' – perhaps Jackson Pollock.

55 Klehr, *Heyday of American Communism*, ch. 17; Mark Naison, *Communists in Harlem During the Depression* (New York: Grove Press, 1985), chs 3–5. 'A Call for a United Anti-Lynch Exhibition', *NM* 14, no. 9 (26 February 1935): 21. For the origins of the NAACP show, see Marlene Park's important article: 'Lynching and Antilynching: Art and Politics in the 1930s', *Prospects* 18 (1993): 325–7.

56 See Sherwood Anderson, 'This Lynching', in Arthur U. Newton Galleries, *An Art Commentary of Lynching* (New York, 1935), which specifically attributes lynching to the lack of self-respect among 'Poor Whites' produced by the psychological degradation of labour in the South.

57 Naison, *Communists in Harlem During the Depression*, 88; Patricia Sullivan, *Days of Hope: Race and Democracy in the New Deal Era* (Chapel Hill & London: University of North Carolina Press, 1996), 87–9.

58 The NAACP show was originally scheduled for the Jacques Seligmann Galleries but was cancelled there due to 'an outburst of opposition': see 'Mysterious Protests Bar "Lynching Show"', *AD* 9, no. 10 (15 February 1935): 14. According to the *Amsterdam News* (not an impartial source) the opposition came from the John Reed Club: Park, 'Lynching and AntiLynching', 327–8, but cf. 330.

59 Stephen Alexander, 'Art', *NM* 14, no. 12 (19 March 1935): 29. For *Stevedore*, by Paul Peters and George Sklar, see Michael Gold, 'Stevedore', *NM* 11, no. 5 (8 May 1934): 28–9.

60 Although Cowley referred to 'a few Negroes' among those he saw in the JRC club rooms, none seems to have played a significant role in the Artists Group in New York. By contrast, Richard Wright was secretary of the Chicago club, and another black writer, Eugene Gordon, was secretary of that in Boston.

61 Jacob Kainen praised both works in 'Anti-Lynching Exhibition', *DW*, 14 March 1935.

62 For Goodelman, Gross and Harkavy, see Jewish Museum, *Painting a Place in America*, 59, 171–2, 174–7.

63 Margaret Duroc, 'Critique from the Left'; Kainen, 'The Capitalist Crisis in Art'; Jerome Klein, 'The Critic Takes a Look Around the Galleries', *NYP*, 30 November 1935.

64 'Workers' Art', *NM* 5, no. 11 (April 1930): 20; 'No Cash in Modernism, Independents Turn to Conservative Art', *AD* 5, no. 12 (15 March 1931): 5–6; 'The Independents' Show', *NM* 7, no. 11 (May 1932): 29; Andre Schwob, 'The Academy of the Left Exhibits', *CA* 12, no. 5 (May 1933): 376. Soyer, *Self-Revealment*, 73. Virginia Marquardt has identified *Washington Market* with Gropper's *Peddling the Same Old Junk* in *NM* 6, no. 10 (March 1931): 10, in '*New Masses* and John Reed Club Artists, 1926–1936', 70, n. 41. *Oppression of American Imperialism* is related to the Gropper cartoon in *NM* 8, no. 8 (April 1933): 16–17. The fifth collective exhibit, *The Class Struggle*, was mainly the work of Hideo Noda: see Philip Sterling, 'Class Struggle depicted by John Reed Club Artists at "Independent Exhibit"', *DW*, 26 April 1934. A sixth, 'China's Red Army', is illustrated in Louis Lozowick, 'The Independent Art Show', *DW*, 19 April 1935.

65 For which see Avis Berman, *Rebels on Eighth Street: Juliana Force and the Whitney Museum of American Art* (New York: Atheneum, 1990); Patricia Hills and Roberta K. Tarbell, *The Figurative Tradition and the Whitney Museum* (New York: Whitney Museum of American Art, 1980).

66 'Soyer, Isaac; Soyer, Moses; Soyer, Raphael', *Current Biography – 1941* (1941): 809–13; Moses Soyer, 'Three Brothers', *MA* 32, no. 4 (1939): 201–9, 254.

67 'Exhibitions in New York', *The Arts* 15, no. 5 (May 1929): 334; Walter Gutman, 'Raphael Soyer', *CA* 6, no. 4 (April 1930): 258–60; 'Around the Galleries', *CA* 10, no. 4 (April 1932): 305; Walter Gutman, Jerome Klein and Raphael Soyer, *Raphael Soyer: Paintings and Drawings* (New York: Shorewood Publishing, 1961), 30; Todd, *The 'New Woman' Revised*, 66–70.

68 Jacob Kainen, 'Brook and his Tradition', *AF* 2, no. 3 (February 1936): 6–7. Kainen lumps Soyer with Cikovsky and Ribak as practitioners of 'studio realism'.

69 Abraham Harriton, 'Interesting Art Exhibition by John Reed Club Members', *DW*, 15 March 1935.

70 Soyer, *Self-Revealment*, 72. For the exceptions, see Todd, *The 'New Woman' Revised*, 127–8, 268–70. Interestingly, by the mid-1940s Soyer felt that he had become too involved with naturalism in such works: Raphael Soyer, *Raphael Soyer* (New York: American Artists Group, 1946), np. Soyer visited the USSR in 1935.

71 Forbes Watson, 'Gallery Explorations', *P* 4, no. 7 (December 1932): 1. For a description of the museum, see Berman, *Rebels on Eighth Street*, 289–90.

72 For Ben Kopman, see Jewish Museum, *Painting a Place in America*, 179. Kopman showed in *The Social Viewpoint in Art* (no. 92) and *Hunger Fascism War* (nos 52 and 53).

73 Probably catalogue nos 21 and 23 in Hirshhorn Museum & Sculpture Garden, *Raphael Soyer: Sixty-Five Years of Printmaking* (Washington, D.C.: Smithsonian Institution Press, 1982).

74 Burck's print was probably that showing concurrently at *Hunger Fascism War*.

75 A copy of the Downtown catalogue is in the files of National Museum of American Art, Washington, D.C. Given the proximity in date, this seems a more likely contender than the painting *No Jobs* Cikovsky exhibited in a Downtown group show later in the year: see E. M. Benson, 'Exhibition Reviews', *MA* 28, no. 12 (December 1935): 751–2.

76 Illustrated in *NM* 14, no. 4 (22 January 1935): 25. Only a fragment of this seems to survive; see Wichita Art Museum, *Edward Laning*, fig. 10.

77 Harriton (1893–1986), had shown at *Revolutionary Front – 1934*, *Struggle for Negro Rights* and a non-juried show of March 1935, which he also reviewed in the *DW*, 15 March 1935. For information on him, see Harriton Artist's File, Hirshhorn Museum & Sculpture Garden, and Abraham Harriton Papers, SU.

78 Jerome Klein, 'Twenty-One Gun Salute', *AF* 1, no. 5 (May 1935): 6. See also Stephen Alexander, 'Art', *NM* 15, no. 4 (23 April 1935): 26. Cf. Alexander, 'Raphael Soyer and Arnold Blanch', *NM* 14, no. 11 (12 March 1935): 28.

79 The description of Soyer's ACA exhibit as depicting 'East River lounging "lumpen"' suggests it may have been his 1932 canvas *Water Street*, or the lithograph after it: see Hirshhorn Museum, *Raphael Soyer: Sixty-five Years of Printmaking*, no. 25.

80 Paula Rabinowitz, *Labor and Desire: Women's Revolutionary Fiction in Depression America* (Chapel Hill: University of North Carolina Press, 1991), 36–7. On proletarian fictional autobiography and its problems, see Foley, *Radical Representations*, ch. 8.

81 Cf. Lukács's critique of Ernst Ottwald's novel *Denn sie wissen, was sie tun*, from *Linkskurve* 4, nos 7–8 (1932), in Lukács, *Essays on Realism*, 45–75.

82 Reginald Marsh uses a comparable motif of unemployed men around the base of Henry Kirke Brown's Washington monument in his lithography *Union Square* (1933, Sasowsky 27), although in this the statue is viewed from the other direction. There was also apparently a painting of the composition titled *Washington Takes Union Square*, location now unknown. See also Sordoni Art Gallery, *Between Heaven and Hell*, 26–8.

83 In his report to the Extraordinary Party Conference of 7 July 1933, Browder insisted that the men in flop houses were not 'lumpen-proletarians' but true workers among whom new cadre could be found – *Communism in the United States*, 146.

84 Feodor Gladkov, *Cement* (New York: International Publishers, 1929).

85 There are also striking parallels with the imagery of short stories and poems in contemporary Communist magazines, e.g., Alfred Hayes, 'In a Coffee Pot', *PR* 1, no. 1 (February–March 1934): 13–14.

86 Joseph Solman, 'Tour through the Whitney', *AF* 2, no. 5 (April 1936): 14.

4 Communist Artists and the New Deal (1)

1 On the Communists and the Bonus March, see Klehr, *Heyday of American Communism*, 60–63.

2 Lizabeth Cohen, *Making a New Deal: Industrial Workers in Chicago, 1919–1939* (Cambridge University Press, 1990), ch. 6.

3 Klehr, *Heyday of American Communism*, ch. 3; Ottanelli, *Communist Party of the United States*, 28–36; Browder, *Communism in the United States*, 121–4.

4 The policy assumed the AFL unions were incapable of reform, and the Party should work to set up alternative 'red unions' rather than 'boring from within'. On this phase, see Bert Cochran, *Labor and Communism: The Conflict that Shaped American Unions* (Princeton University Press, 1979), 43–90; Klehr, *Heyday of American Communism*, ch. 2.

5 David Milton, *The Politics of U.S. Labor: From the Great Depression to the New Deal* (New York & London: Monthly Review Press, 1982), ch. 2. For the role of the Communist Party, see Cochran, *Labor and Communism*, ch. 4; Klehr, *Heyday of American Communism*, ch. 7.

6 Melvyn Dubofsky, *The State and Labor in Modern America* (Chapel Hill & London: University of North Carolina Press, 1994), ch. 5; Anthony J. Badger, *The New Deal: The Depression Years, 1933–1940* (Basingstoke & London: Macmillan, 1989), 126–9.

7 For an acute analysis of debates on the New Deal state, see G. William Domhoff, *The Power Elite and the State: How Policy is Made in America* (New York: Aldine de Gruyter, 1990), chs 1–4. The position taken here is similar to that advanced by Michael Goldfield in 'Worker Insurgency, Radical Organization, and New Deal Labor Legislation', *American Political Science Review* 83, no. 4 (December 1989): 1257–82.

8 In what follows I draw heavily on Ottanelli's analysis of the party's changing position on Roosevelt and the New Deal in *Communist Party of the United States*, 66–80 and ch. 4. For a rather different view, see Anders Stephanson, 'The CPUSA Conception of the Rooseveltian State, 1933–1939', *Radical History Review* 29 (fall 1980): 161–76.

9 Browder, *Communism in the United States*, 114–15.

10 For his speech to the plenum of the CI, see Browder, *Communism in the United States*, 177–87.

11 Browder, *Communism in the United States*, 247.

12 Earl Browder, *The People's Front* (New York: International Publishers, 1938), 24, 36, 102, 129ff. Yet cf. 'Roosevelt and his Party', *NM* 24, no. 10 (31 August 1937): 14.

13 William F. McDonald, *Federal Relief Administration and the Arts* (Columbus: Ohio State University Press, 1969); Richard D. McKinzie, *The New Deal for Artists* (Princeton University Press, 1973); Marlene Park and Gerald E. Markowitz, *New Deal for Art: The Government Art Projects of the 1930s with Examples from New York City and State* (Hamilton: Gallery Association of New York State, 1977); Belisario R. Contreras, *Tradition and Innovation in New Deal Art* (London & Toronto: Associated University Presses, 1983); Marlene Park and Gerald E. Markowitz, *Democratic Vistas: Post Offices and Public Art in the New Deal* (Philadelphia: Temple University Press, 1984).

14 For FERA, see Badger, *The New Deal*, 191–6; McDonald, *Federal Relief Administration and the Arts*, ch. 3.

15 McDonald, *Federal Relief Administration and the Arts*, ch. 2; Park and Markowitz, *New Deal for Art*, 3.

16 Badger, *The New Deal*, 197–200; McDonald, *Federal Relief Administration of the Arts*, ch. 4, 63–8. For figures, see Public Works of Art Project, *Report of the Assistant Secretary of the Treasury to Federal Emergency Relief Administrator, December 8, 1933–June 30, 1934* (Washington, D.C.: United States Government Printing Office, 1934), 5, 7.

17 McKinzie, *New Deal for Artists*, chs 3–4. For figures, see 66–7, 54.

18 Ibid., 38–42.

19 For this opposition, see ibid., ch. 9.

20 Badger, *The New Deal*, 200–15; McKinzie, *New Deal for Artists*, chs 5–7; McDonald, *Federal Relief Administration and the Arts*, chs 8, 18–19; Park and Markowitz, *New Deal for Art*, 6.

21 Jane de Hart Matthews, 'Arts and the People: The New Deal Quest for a Cultural Democracy', *Journal of American History* 62, no. 2 (September 1975): 316–39; Park and Markowitz, *New Deal for Art*, ch. 2. The most valuable contribution in this area is the anthologies edited by Francis V. O'Connor, *The New Deal Art Projects*, and *Art for the Millions* (Greenwich, Conn.: New York Graphic Society, 1973).

22 Jonathan Harris, *Federal Art and National Culture: The Politics of Identity in New Deal America* (Cambridge & New York: Cambridge University Press, 1996). See my review: 'Middlebrow: For and Against', *Oxford Art Journal* 22, no. 1 (spring 1999): 166–76.

23 On this, see Klehr, *Heyday of American Communism*, 279–303. Francine Tyler has argued in 'Artists Respond to the Great Depression and the Threat of Fascism' that 'leftist artists' organizations', particularly the Artists' Union, played a key role in persuading the administration to set up the FAP. I think this takes the achievements of the union too much on the evaluation of its own activists, but her argument merits serious attention and the relationship between the union and the administration needs more detailed study. I suspect that whatever pressures artists' groups put on the administration need to be seen more in relation to those that came from actors' and writers' groups than hitherto. For the latter, see Jerre Mangione, *The Dream and the Deal: The Federal Writers Project, 1935–1943* (Boston & Toronto: Little, Brown, & Co., 1972), 34.

24 See Steven Fraser's brilliant study *Labor Will Rule: Sydney Hillman and the Rise of American Labor* (New York & Toronto: Free Press, 1991).

25 For Biddle's own acount, see *An American Artist's Story*, 268–70. Biddle's Diary in the Library of Congress also contains relevant material: see AAA 3621. In general, see T. A. Krueger and W. Gidden, 'The New Deal Intellectual Elite: A Collective Portrait', in Frederic Cople Jaher (ed.), *The Rich, the Well Born and the Powerful* (Urbana: University of Illinois Press, 1973), 338–78.

26 The main source on Bruce's career is his scrapbooks, and other materials in his papers, esp. AAA D91:263–504. See also Italo Tavolato, *Edward Bruce* (Rome: Valori Plastici, 1926); 'Portrait of a Contented Man', *Fortune* 3, no. 5 (May 1931): 73–5.

27 Correspondence with Reinhardt Galleries, 1929–31, Bruce Papers, AAA D88:1012–37. 'Portrait of a Contented Man', 75.

28 Edward Bruce, 'What I Am Trying To Do', and Leo Stein, 'Edward Bruce', *CA* 2, no. 5 (November 1928): xlv–xlix, 1; Tavolato, *Edward Bruce*, 6–7; Edwina Spencer, 'Edward Bruce', *CA* 12, no. 2 (February 1933): 96–107; 'Lawyer Quits Business for career as Artist', *Oakland Post Enquirer*, 14 February 1931; 'Artist Urges Country to Back Artisans as Aid to Unemployment', unattributed clipping, Bruce Papers, AAA D91:414.

29 For his somewhat equivocal attitude, see Bruce to Leo Stein, 7 September 1934 (copy), AAA D89:339–40. Cf. Bruce to Harold Mack, 17 May 1933 (copy) and 11 October (copy), D87: 812, 813–14.

30 Douglas Naylor, '"International" Jury Gives Its Views on Other Things', unattributed clipping, AAA D91:671.

31 *Extension of Remarks of Hon. Elbert D. Thomas of Utah in the Senate of the United States, Monday, April 29, 1940* (Radio Program over NBC Network, 25 April 1940): 3–4. AAA D89:769–74.

32 Bruce to Lincoln Schaub, 18 May 1940 (copy), AAA D88: 1813–14; Bruce to Olin Dows, 7 March 1939 (copy), D86:50; Bruce to Inslee Hopper, 13 February 1940 (copy), D86:1522. The mural was paid for by subscriptions raised by a committee of which Bruce was chair.

33 See Dewey's radio address on the Section's work, in *Extension of Remarks of Hon. Elbert D. Thomas of Utah*, 5–6. For Bruce's negative response to Dewey's *Art as Experience*, see e.g. Bruce to Jackson E. Reynolds, 7 September 1935 (copy), AAA D88:1079.

34 Bruce to Harold Mack, 15 January 1939 (copy), AAA D87:848–50. On the Smithsonian Gallery proposal, see McKinzie, *New Deal for Artists*, 43–7. Bruce to Eleanor Roosevelt, 15 March 1941 (copy), D90:639. Cf. 'Mellon Gallery Likened to "Mausoleum"', *Washington Post*, 28 January 1941.

35 'Treasury Department Order', 16 October 1934 (copy), AAA D89:1–2. Joseph Alsop and Robert Kintner, 'The Capital Parade', *Washington Evening Star*, 12 December 1938.

36 'Fellow Artists' (14pp typescript, 1935?), AAA D89:57–64.

37 Forbes Watson, 'The All American Nineteen', *The Arts* 16, no. 5 (January 1930): 310; 'The Winning Lists', 16, no. 8 (April 1930): 519; 'Charles Sheeler', 3, no. 5 (May 1923): 337. For more on the Americanism of *The Arts*, see Hemingway, 'The Critical Mythology of Edward Hopper', 380–84.

38 George Biddle, 'Mural Painting in America', *MA* 27, no. 7 (July 1934): 361–71; 'The Artist Serves his Community', *MA* 27, no. 9 (September 1934, Supplement): 31–2; Edward Bruce, 'Implications of the Public Works of Art Project', *MA* 27, no. 3 (March 1934): 113–15; Forbes Watson, 'The Public Works of Art Project: Federal Republican or Democratic?', *MA* 27, no. 1 (January 1934): 6–9; 'A Steady Job', *MA* 27, no. 4 (April 1934): 168–72; 'The Public Works of Art Project: A New Deal for the Artists', *MA* 27, no. 9 (September 1934, Supplement): 29–30; 'The Innocent Bystander', *MA* 27, no. 11 (November 1934): 601–6. See also Forbes Watson, 'The USA Challenges Artists', *P* 6, no. 1 (January 1934): 1–2. Watson was an associate editor of both the *Magazine of Art* and *Parnassus*.

39 Dorothy Grafly, 'The Whitney Museum of American Art', *MA*, 24, no. 2 (February 1932): 100. The new openness to 'modern' painting was also signalled by the editorial 'Good-Bye Modernism?', *MA* 26, no. 6 (June 1933): 275.

40 George J. Cox, 'Modern Art and this Matter of Taste', *MA* 25, no. 2 (August 1932): 81–2; Philippa Gerry Whiting, 'Rockefeller Center Debut', *MA* 26, no. 2 (February 1933): 84–5; 'Millions for Laborers, Not One Cent for Artists', *MA* 26, no. 12 (December 1933): 521–2.

41 Forbes Watson, 'Henri Matisse', *The Arts* 11, no. 1 (January 1927): 33–8.

42 Watson, 'A Steady Job', 68–9. Cf. Bruce: 'The very method of payment is democratic' – 'Implications of the Public Works of Art Project', 115.

43 Watson, 'The Public Works of Art Project: A New Deal for Artists', 29–30.

44 Watson, 'The USA Challenges Artists', 2; Watson, 'The Public Works of Art Project', 8. Cf. Watson, 'The Innocent Bystander', 602; Bruce, 'Implications of the Public Works of Art Project', 114–15.

45 Biddle, 'Mural Painting in America', 362–71; Biddle, 'The Artist Serves his Community', 31–2.

46 Bruce, 'Implications of the Public Works of Art Project', 114–15; Watson, 'The Public Works of Art Project'.

47 Ralph Miliband, *The State in Capitalist Society* (London: Weidenfeld & Nicolson, 1969), ch. 5.

48 Watson, 'The Innocent Bystander', 601.

49 For a contemporary statement, see Virgil Barker, 'The Search for Americanism', *MA* 37, no. 2 (February 1934): 51–2.

50 Frederick Jochem, 'Prints at Chicago', *MA* 27, no. 8 (August 1934): 429. Anon., 'The Americana School', ibid.: 409–10. For further liberal critiques of Craven, see E. M. Benson's review of his *Modern Art* in the same issue: 446, 449; A. Philip McMahon, 'New Books on Art', *P* 6, no. 5 (October 1934): 26.

51 Alan Dawley, *Struggles for Justice: Social Responsibility and the Liberal State* (Cambridge, Mass., & London: Belknap Press, 1991), 359–70; Richard H. Pells, *Radical Visions and American Dreams: Culture and Social Thought in the Depression Years* (Middletown, Conn.: Wesleyan University Press, 1984): 78–86.

52 Cf. Perry Anderson, 'The Antinomies of Antonio Gramsci', *New Left Review* no. 100 (November 1976/January 1977): 25–7.

53 Editorial, *NM* 10, no. 1 (2 January 1934): 4.

54 Gerald Monroe, 'The Artists' Union of New York'; 'Artists as Militant Trade Union Workers During the Great Depression', *AAAJ* 17, no. 1 (1974): 7–10; 'Artists on the Barricades: The Militant Artists' Union Treats with the New Deal', *AAAJ* 18, no. 3 (1978): 20–23; 'The '30s: Art, Ideology and the WPA', *Art in America* 63 (November–December 1975): 64–7. See also Tyler, 'Artists Respond to the Great Depression and the Threat of Fascism'.

55 Monroe, 'The Artists Union of New York', 135. For the art programme of the Emergency Work Bureau in New York (initiated by the College Art Association), see Audrey McMahon, 'May the Artist Live?', *P* 5, no. 5 (October 1933): 1–4.

56 'The Artist's Struggle for Relief (Statement by the Unemployed Artist Group' (*sic*), *Art Forum* 1, no. 1 (January 1934): 5. The statement is signed by Max Spivak, from the group's headquarters at 416 East 18th Street. A statement of the 'Artist Group of the Emergency Work Bureau', dated 24 September 1933, already calls for state patronage of mural painting and other art projects.

57 'The Artist's Struggle for Relief', 6; 'For a Permanent Federal Art Project', *AF* 1, no. 1 (November 1934): 4.

58 Interview with Bernarda Bryson, 27 November 1996; McKinzie, *New Deal for Artists*, 13–16; Berman, *Rebels on Eighth Street*, 342–3, 349–51, 356–7.

59 Monroe, 'The '30s: Art, Ideology and the WPA', 66.

60 'Artists Join the Artists Union' (handbill), AAA D343:442; 'In Answer to the Art News', *AF* 1, no. 1 (November 1934): 5; Oakley Johnson, 'At Madison Square', *NM* 11, no. 7 (15 May 1934): 21.

61 Monroe, 'The Artists Union of New York', 135, 141–3, 148–9. Author's interview with Bernarda Bryson, 27 November 1996.

62 McDonald, *Federal Relief Administration and the Arts*, 351–3. The union accused the CAA of trying to break down its organisation on the programme: see 'Pink Slips and College Art', *AF* 1, no. 4 (April 1935): 2; 'The Union', *AF* 1, no. 5 (May 1935): 2; 'Why Artists Picket', *AF* 1, no. 6 (July 1935): 3.

63 Harold Rosenberg, 'Artists Increase their Understanding of Public Buildings', *AF* 1, no. 7 (November 1935): 3.

64 Gerald Monroe, 'Art Front', *AAAJ* 13, no. 3 (1973): 13. A lot of this information comes from four files relating to the Artists Committee of Action in the Hugo Gellert Papers, AAA, unfilmed, Box 2.

65 Edward M. Freed, 'Artists on the Picket Line', *NM* 17, no. 13 (24 December 1935): 21.

66 Stuart Davis, 'The Artist Today: The Standpoint of the Artists' Union', *MA* 28, no. 6 (August 1935): 476–8, 506.

67 'Morals in Murals', and Stuart Davis, 'We Reject – The Art Commission', *AF* 1, no. 6 (July 1935): 3–4.

68 'What Now Mr Bruce?', *AF* 1, no. 2 (January 1935): 2; 'Competitions Without Pay', *AF* 1, no. 5 (May 1935): 3.

69 Forbes Watson, 'The Chance in a Thousand', *MA* 28, no. 8 (August 1935): 470–75, 506–8.

70 Stuart Davis, 'Some Chance!', *AF* 1, no. 7 (November 1935): 4. Reprinted in Kelder (ed.), *Stuart Davis*, 154–8.

71 Forbes Watson, 'The Innocent Bystander', *MA* 28, no. 3 (March 1935): 173–4; 'The Purpose of the Pittsburgh International', *MA* 28, no. 11 (November 1935): 644; 'Watson vs. Artists', *AF* 1, no. 8 (December 1935): 2.

72 Helen A. Harrison, 'John Reed Club Artists and the New Deal: Radical Responses to Roosevelt's "Peaceful Revolution"', *Prospects* 5 (1980): 247.

73 At least 26 left-wing artists who exhibited with the John Reed Club worked for PWAP in New York. There are affirmative letters to Bruce from Adolf Dehn (AAA DC5:811), Harry Gottlieb (DC5:1099–1100), and Evergood (DC7:445). For complaints about incompetence and prejudice, see Helen Lundberg to Bruce (DC5:976–7) and Joe Jones to Forbes Watson (DC6:122–5). Among those who produced unsatisfactory work were Bernarda Bryson, Irwin D. Hoffman, and Alice Neel. Pele deLappe lied about her economic status and was fired. See files on these in NARA RG121, entry 117.

74 Quoted in 'Sloan-Zorach Relief Defended as US Policy', *NYHT*, 19 March 1934. Biddle claimed that Communist artists sought to 'sabotage' the project – 'An Art Renascence Under Federal Patronage', 430.

75 See Kenneth Rexroth to Bruce, 25 March 1934, and 'Proposals of the Artists Section of the Writers and Artists Union of San Francisco' (AAA DC6:877–82); 'Resolution' of the same, addressed to Hon. Franklin D. Roosevelt, 15 April

1934 (DC7:496–7); and protest from New York Artists' Union (signed Bernarda Bryson) and accompanying correspondence (DC7:502–5).

76 Meltsner's letters to Bruce and Roosevelt are so obsequious it is hard to believe he was a Communist (AAA DC6:605–10, 664–7).

77 The 'Central Office Correspondence with Artists, 1933–34' is held at the NARA (Record Group 121), and is available on microfilm (AAA DC5–7). All Regional Records were destroyed except for those relating to Region 2, 'New York State and Metropolitan Districts of Connecticut and New Jersey'. The Receipt Cards for Region 2 are held at the NARA in Washington, D.C. (RG121, entry 113) and the Correspondence with Artists at the NARA Office in New York (RG121, entry 117).

78 Public Works of Art Project, *Report*, 1–2.

79 Information from correspondence and receipt cards (RG121, entries 117, 113). Glintenkamp's correspondence files contains proofs of all three prints. For biographical information on Pandolfini, see Downtown Gallery, *10th Anniversary Exhibition* catalogue (1936). *Composition* is not listed in the General Services Administration, *WPA Artwork in Non-Federal Depositories* (Washington, D.C., 1996), and the negative of it listed in the NARA's catalogue is missing. The photograph is reproduced in Contreras, *Tradition and Innovation in New Deal Art*, 77.

80 Philip Reisman to Knight, 8 March 1934, and related correspondence in RG121, entry 117.

81 In his paper at the 1936 American Artists' Congress, Douglas claimed that the identity of the 'Negro artist' was an inherently proletarian one, for he 'is essentially a product of the masses and can never take a position above or beyond their level.' Aaron Douglas, 'The Negro in American Culture', in American Artists' Congress, *Artists Against War and Fascism: Papers of the First American Artists' Congress* (1936; ed. Matthew Baigell and Julia Williams; New Brunswick, N.J.: Rutgers University Press, 1986), 83.

82 Cf. Douglas, 'The Negro in American Culture', 78–9.

83 Amy Helene Kirschke, *Aaron Douglas: Art, Race, and the Harlem Renaissance* (Jackson: University Press of Mississippi, 1995): 121–4. T. R. Poston, 'Murals and Marx: Aaron Douglas Moves to the Left with PWA Decoration', *New York Amsterdam News*, 24 November 1934; Douglas file in NARA, RG121, entry 117. Douglas himself claimed that 'only in revolutionary art' was 'the Negro sincerely represented', but even there 'the portrayal is too frequently automatic, perfunctory and arbitrary' – 'The Negro in American Culture', 84.

84 For coverage in the national press, see Nadia Lavrova, 'Forty-Six Artists, One Palette', *Christian Science Monitor*, weekly magazine section, 1 August 1934; Evelyn Seeley, 'A Frescoed Tower Clangs Shut Amid Gasps, *Literary Digest* 118, no. 8 (25 August 1934), 24, 31.

85 Anthony Lee, *Painting on the Left: Diego Rivera, Radical Politics, and San Francisco's Public Murals* (Berkeley: University of California Press, 1999), ch. 5. For the tower's history and a full description of the scheme, see Masha

Zakheim Jewett, *Coit Tower, San Francisco: Its History and Art* (San Francisco: Volcano Press, 1983).

86 Lee, *Painting on the Left*, 95–103. For Zakheim, see the typescript biography in the Zakheim Papers, AAA 3988: 585–668. For Arnautoff, see the abundant materials in the Arnautoff Papers, AAA 3429–30.

87 Lee, *Painting on the Left*, 102–3, 131–4. Lee does not mention Rexroth's role in the San Francisco John Reed Club or the fact that his wife, Andrée Dutcher, was 'an ardent party member'; Kenneth Rexroth, *An Autobiographical Novel* (New York: New Directions, 1991), p.vii; cf. 418–19. According to Rexroth's report to the 1932 JRC Convention, the club began in late 1929 as the Hammer and Sickle Club, changing its name to the John Reed Club in January 1932. His report is an extended lament about the failure of the New York club to provide national leadership, and a call for a 'strong national organization'. From this it appears that Rexroth was a more orthodox Communist at the time than Lee implies. (Minutes of the Chicago JRC Convention, Freeman Papers, HI 172:8.) Lee also describes Triest as an 'anarchist', but as executive secretary of the San Francisco JRC in 1932 he is likely to have been a CP member.

88 Cf. Lee, *Painting on the Left*, 130–36.

89 Milton, *Politics of U.S. Labor*, 40–52.

90 For Bruce's personal response, see his correspondence with Harold Mack (AAA, DC87:823–35).

91 'Art Commission Head Replies to Coit Tower Artists Committee', *San Francisco Chronicle*, 4 July 1934. For the Committee's response, see Seeley, 'A Frescoed Tower Clangs Shut Amid Gasps', 24.

92 '"Propaganda" in Art Shown', unidentified clipping (Clifford Wight Papers, SU, Box 2); Junius Cravens, 'Artists Fight to Prevent Changes in Coit Tower Frescoes', *San Francisco News*, 7 July 1934; Glen Wessels, 'The Art World: Painted Propaganda', *San Francisco Argonaut*, 13 July 1934; 'Amusing Artists', *San Francisco Examiner*, 9 July 1934.

93 Parker Hall, Edith A. Hamlin and Gordon Langdon to Bruce and Robert, 11 August 1934 (AAA DC7:474–6). Many of the sixteen reportedly belonged to the Artists and Writers' Union before the episode. The executive secretary to the Union, Charles Coppock, accused Langdon of 'Fascist tendencies': see Coppock, 'Coit Tower Fracas', *San Francisco News*, 11 August 1934.

94 Seeley, 'A Frescoed Tower Clangs Shut Amid Gasps', 31.

95 Howard, too, was a JRC member. See Ruth Westphal and Janet B. Dominik, *American Scene Painting: California, 1930s and 1940s* (Irvine, Calif.: Westphal, 1991), 182–7.

96 Cravens, 'Artists Fight to Prevent Changes in Coit Tower Frescoes'.

97 'Statement in Defense of Coit Tower' (Wight Papers, Box 2, SU); Lee, *Painting on the Left*, 148–9.

98 Edward Bruce to Harold Mack, 27 July 1934 (copy; AAA D87: 835). See also Harold Mack to Edward Bruce, 16 July 1934 (D87:825–6).

99 Joe Jones, 'Repression of Art in America', in American Artists' Congress, *Artists Against War and Fascism* 76; Correspondence, *NM* 12, no. 3 (17 July 1934): 23–4.

100 Helen Buchalter, 'Social Views vs. Art – and PWAP Exhibit Excels', *Washington News*, 28 April 1934.

101 Emily Genauer, 'Cost of Art Project Held Fully Justified', *NYWT*, 28 April 1934; Helen Appleton Read, 'A Challenge is Met', *Brooklyn Eagle*, 29 April 1934; 'Doors Open on a Stale Tradition', *Journal of Electrical Workers & Operators* 33, no. 6 (June 1934): 235–7, 276. 'Independent Artists', *Washington Post*, 27 March 1934, also emphasised authentic Americanism and independence from European examples: 'They are often as brutal as the life they depict, but they are also as independent as the land which gave them birth.'

102 'Roosevelt Selects 32 CWA Paintings for White House', *New York American*, 24 April 1934; 'Public Buildings May Get New Deal Art; Roosevelt Favors Murals Instead of Scrolls', *NYT*, 26 April 1934. Despite the president's comment on the absence of defeatism, the *Washington Star* described Bloch's work as 'a portrait of a boy with a sulky mouth and a look of defeat in his eyes' – Grace Hendrick Eustis, 'PWAP Paintings Selected for White House', 24 April 1934.

Julius Thiengen Bloch (1888–1966) was a Philadelphia artist, who specialised in images of black and white working-class types in the 1930s; see O'Connor (ed.), *Art for the Millions*, 115–16, 270.

103 Indeed, Bruce's assistant Ed Rowan was particularly enthusiastic about Isaac Soyer's *Art Beauty Shoppe* (Smithsonian American Art Museum). See Rowan to Soyer, 10 May 1934 (copy), AAA DC6:1038.

104 For Limbach, see William H. Robinson and David Steinberg (ed.), *Transformations in Cleveland Art, 1796–1946: Community and Diversity in Early Modern America* (Cleveland, Ohio: Cleveland Museum of Art, 1996): 233. Elizabeth Seaton has argued that the eagle's head in the print is intended as a negative comment on the NRA. I think it was probably a touch of ironic humour – the emblem of the federal state is positioned under the workers' buttocks. See Elizabeth Gaede Seaton, 'Federal Prints and Democratic Culture: The Graphic Arts Division of the Works Progress Administration Federal Art Project, 1935–1943', PhD thesis, Northwestern University, 2000.

105 There is a photograph of this in Evergood's Papers (AAA 430:195).

106 Jones had made the sketches for the mural on PWAP time ('Social Unrest Mural in Old Court-House', *SLPD*, 16 February 1934), and it is hard to see what else the catalogue entry 'Old Court House' by his name in the mural section could refer to.

107 'PWAP Display of Art Opened by First Lady', *Washington Star*, 25 April 1934; Edward Alden Jewell, 'Public Works Art Shown at Capital', *NYT*, 24 April 1934. Bruce was working to raise funds for the casting of the sculpture in May 1934; see Bruce to Glickman, 10 May 1934 (copy; AAA DC5:1020). Initially the sculpture went to the Department of Labor. It was installed in the Department of Interior in 1940.

108 On Glickman and the sculpture, see David W. Look and Carol L. Perrault, *The Interior Building and its Architecture* (Washington, D.C.: US Department of Interior, National Park Service, Preservation Assistance Division, 1986), 116–18. For Glickman in *New Masses*, see 23, no. 8 (11 May 1937):

24; 27, no. 4 (19 April 1938): 22; 29, no. 5 (25 October 1938): 27. He also taught at the American Artists School.

109 Work records in Glickman file, NARA, RG121, entry 117.

110 Seymour Waldman, 'Roosevelt Likes Paintings That Gloss Over Crisis', *DW*, 27 April 1934. Bloch's print may have been the same work shown at the First Annual Exhibition of the Philadelphia John Reed Club: see 'Social Trend in Art', *Left Review* 1, no. 3 (1934): 31.

5 Cultural Criticism from the People's Front to the Democratic Front

1 Georgi Dimitroff [Dimitrov], *The United Front: The Struggle Against Fascism and War* (London: Lawrence & Wishart, 1938), 109–10, 87–91.

2 Dimitroff, *The United Front*, 41–3. The CPUSA printed half a million copies of Dimitrov's report for sale as a 5c. pamphlet.

3 Julian Jackson, *The Popular Front in France: Defending Democracy, 1934–38* (Cambridge University Press, 1988), ch. 1; Geoff Roberts, 'Collective Security and the Origins of the People's Front', in Jim Fyrth (ed.), *Britain, Fascism and the Popular Front* (London: Lawrence & Wishart, 1985), 74–88.

4 Browder, *The People's Front*, 160–63; Ottanelli, *Communist Party of the United States*, 112–13.

5 'The Communist Convention', *NM* 27, no. 10 (31 May 1938): 11.

6 For the critique of *Gone With the Wind*, see Elizabeth Lawson, 'Lynch Law and Pulitzer', *DW*, 13 May 1937; and the sequence of articles by James Dugan in *NM* 34, no. 2 (2 January 1940): 28–30; 34, no. 5 (23 January 1940): 28–30; 34, no. 6 (30 January 1940): 28–9.

7 Browder was playing on this idea before the Seventh Congress of the Comintern. In June 1935 he claimed that 'The revolutionary tradition is the heart of Americanism', and that 'Communism is the Americanism of the twentieth century': see 'What is Communism?', *NM* 15, no. 12 (25 June 1935): 13. For his auto-critique, see 'Concerning American Revolutionary Traditions', *The Communist* 17, no. 12 (December 1938): 1079–85. See also Klehr, Haynes and Anderson, *Soviet World of American Communism*, 36–40.

8 Granville Hicks, *I Like America* (New York: Modern Age Books, 1938).

9 Ottanelli, *Communist Party of the United States*, 122–32. See also Klehr, *Heyday of American Communism*, chs 12, 19.

10 Ottanelli, *Communist Party of the United States*, 85–7; 133–4. See also Stephanson, 'The CPUSA Conception of the Rooseveltian State, 1933–1939', 167–73.

11 'What We Can Do', *NM* 29, no. 4 (18 October 1938): 7.

12 Healey and Isserman, *Dorothy Healey Remembers*, 58.

13 On responses to these events, see Judy Kutulas, *The Long War: The Intellectual People's Front and Anti-Stalinism, 1930–1940* (Durham, N.C., and London: Duke University Press, 1995): chs 3–7.

14 'Are You a Victim of Spectatorism?', *NM* 8, no. 12 (August 1933): 2.

15 Crockett Johnson to Rockwell Kent, 19 September [1936] (Rockwell Kent Papers, AAA, unfilmed, Box 43, 'New Masses #1'). By contrast, at the end of 1935, *New Masses* had advertised itself as 'America's only revolutionary weekly'.

16 For Rico, see Howard Rushmore, 'Vivid Portraits in Wood', *DW*, 23 November 1937.

17 For Heliker, see Whitney Museum of American Art, *John Heliker* (New York, 1968); Kraushaar Galleries, *John Heliker: A Celebration of Fifty Years* (New York, 1995). Occasional drawings by him appeared in *NM* as late as 1942.

18 Michael Corris, 'The Difficult Freedom of Ad Reinhardt', in John Roberts (ed.), *Art Has No History!: The Making and Unmaking of Modern Art* (London & New York: Verso, 1994), 63–110.

19 Maynard Dixon, 'Cartoonists, Attention', *NM* 23, no. 3 (6 April 1937): 21; Abe Ajay, 'From Artist Ajay', *NM* 23, no. 4 (13 April 1937): 19. Dixon painted a series of paintings on the San Francisco waterfront strike in 1934, on which see Donald J. Hagerty, *Desert Dreams: The Art and Life of Maynard Dixon* (Layton, Utah: Gibbs-Smith, 1993), 199, 203, 208, 210. For the theory of caricature, see also Herman J. Wechsler, 'Birnbaum's Caricatures on View at FAR Gallery', *DW*, 12 May 1939.

20 Joseph Freeman to Michael Gold, 8 August 1936 (copy); *MEMO ON NEW MASSES*, inscribed '7/26/37'; 'EDITORIAL CONFERENCE, August 11, 1937' (Freeman Papers, HI 24:23; 177:1). Earl Browder, 'Not Victory Alone', *NM* 21, no. 12 (15 December 1936): 10.

21 'Between Ourselves', *NM* 28, no. 3 (12 July 1938): 2; '20,000 New Readers', *NM* 28, no. 5 (26 July 1938): 3; 'Between Ourselves', *NM* 32, no. 8 (15 August 1939): 2. An advertisement in the issue of 28 July 1936 claimed a circulation of 25,000.

22 Ralph Bates, 'Forging Catalonian Unity', *NM* 22, no. 5 (26 January 1937): 18–22; James Hawthorne, 'Spain's Government Girds for War', *NM* 23, no. 13 (22 June 1937): 7–8; 'Trotsky's Agents in Spain', *NM* 24, no. 3 (13 July 1937): 13–15: Editorial, *NM* 23, no. 12 (15 June 1937): 8–9.

23 'The Trotsky Cesspool', *NM* 20, no. 1 (1 September 1936): 4; Joshua Kunitz: 'The Moscow Trials', *NM* 21, no. 4 (20 October 1936): 3–5; 'Getting in Deeper', 20, no. 6 (3 November 1936): 13; 'Guilty as Charged', 26, no. 4 (18 January 1938): 8–9. For a collective statement supporting the trials, see 'Moscow Trials', *NM* 27, no. 6 (3 May 1938): 19.

24 Trotsky's brilliant indictment *The Revolution Betrayed: What is the Soviet Union and Where is it Going?* was published in a translation by Max Eastman in 1937. Ironically, it was denounced by Theodore Draper in *NM* 23, no. 13 (23 March 1937): 21.

25 Michael Gold, 'Notes on the Cultural Front', *NM* 25, no. 11 (7 December 1937): 2. On the *Partisan Review* group's break with the CP, see Terry Cooney, *Rise of the New York Intellectuals*: Partisan Review *and its Circle, 1934–45* (Madison & London: University of Wisconsin Press, 1986), 112–17.

26 Samuel Sillen, 'The People, Yes', *NM* 31, no. 11 (6 June 1939): 22; Joshua Kunitz, 'The Soviets' Greatest Achievement', *NM* 25, no. 7 (9 November 1937): 3–5. On 'the essential hopefulness of Communism', see also Granville Hicks, 'Review and Comment', *NM* 25, no. 1 (28 September 1937): 22–3.

27 Advertisement, *NM* 19, no. 7 (12 May 1936): 2; Joshua Kunitz, 'The Shostakovitch "Affair" ', *NM* 19, no. 11 (9 June 1936): 15–18; 'Stairway That Leads Nowhere', *NM* 19, no. 6 (5 May 1936): 21. For earlier panegyrics on 'Shostakovitch's Brilliant Opera', see *DW*, 9 February 1935, 18 February 1935, 26 February 1935. Roy A. Medvedev, *Let History Judge: The Origins and Consequences of Stalinism* (New York: Knopf, 1971), 230–34.

28 Louis Lozowick, 'The Artist in the USSR', *NM* 20, no. 5 (28 July 1936): 18–20.

29 'Hitler and Picasso', *NM* 24, no. 8 (17 August 1937): 11; 'Cocteau and Picasso', *NM* 24, no. 9 (24 August 1937): 11; Jay Peterson, 'Picasso as a Spaniard', *NM* 25, no. 13 (21 December 1937): 7. Cf. Peter C. Rhodes, 'Modern Goya', *SW*, 22 August 1937.

30 Isidor Schneider, 'Shrines of Unreason', *NM* 22, no. 1 (29 December 1936): 22–3; James Agee, 'Art for What's Sake', *NM* 21, no. 12 (15 December 1936): 48–9; Jack Lindsay, 'Freud's Error', *NM* 21, no. 13 (22 December 1936): 17–18; letter from Philip Sharnoff, 'Readers' Forum', *NM* 24, no. 6 (3 August 1937): 22.

31 Clarence Weinstock [Charles Humboldt], 'Ivory Tower or Hole in the Ground', *NM* 27, no. 9 (24 May 1938): 20.

32 Von Wiegand to Joseph Freeman, 21 March 1931; von Wiegand to Joseph Freeman, 14 September 1933; von Wiegand to Joseph Freeman, 17 October 1933 (Freeman Papers, HI, 39–23); Charmion von Wiegand Artist's File, SAAM. There are five files of von Wiegand's correspondence in the Freeman Papers at Stanford. See also Susan C. Larsen, 'Charmion von Wiegand: Walking on a Road with Milestones', *Arts Magazine* 60, no. 3 (November 1985): 29–31; Platt, *Art and Politics in the 1930s*, ch. 7.

33 Cf. Andrei Zhdanov, 'Soviet Literature – The Richest in Ideas, the Most Advanced Literature', in Maxim Gorky *et al.*, *Soviet Writers' Congress, 1934* (London: Lawrence & Wishart, 1977), 20; originally published as H. G. Scott (ed.), *Problems of Soviet Literature* (New York: International Publishers, 1935).

34 Charmion von Wiegand: 'Chirico and Picasso', *NM* 22, no. 3 (12 January 1937): 6–7; 'Fine Arts', *NM* 24, no. 3 (13 July 1937): 26–8.

35 Charmion von Wiegand: 'Fine Arts', *NM* 24, no. 3 (13 July 1937): 28; 'The Fine Arts' (Bauhaus and WPA Design Laboratory), *NM* 24, no. 2 (6 July 1937): 28–9; 'Fine Arts' (Spanish Republican posters), *NM* 23, no. 13 (22 June 1937): 29.

36 Charmion von Wiegand, 'Sights and Sounds', *NM* 23, no. 7 (4 May 1937): 35.

37 Charmion von Wiegand, 'The Fine Arts' (The Ten), *NM* 23, no. 9 (18 May 1937): 32–3.

38 Charmion von Wiegand: 'The Fine Arts', *NM* 23, no. 5 (20 April 1937): 37–8; 'The Fine Arts', *NM* 23, no. 12 (15 June 1937): 29–30. The Turnbull painting illustrated here, *Farm Woman*, was almost certainly the painting praised in an anonymous review in the *Daily Worker*: 'Art', *DW*, 10 June 1937. Turnbull deserves more attention than I can give him here. A substantial collection of his papers is in the archive of the Woodstock Artists Association, Woodstock, N.Y.

39 Charmion von Wiegand to Joseph Freeman, 11 July 1937 (Freeman Papers, HI 39:23).

40 See Aaron, *Writers on the Left*, 368–71.

41 'The Palace of the Soviets rather spoils my stomach for Russia. It's disgusting to spend the people's money for such a thing' – Charmion von Wiegand to Joseph Freeman, 10 August 1933 (Freeman Papers, HI 39:23). For her view of the FAP, see von Wiegand to Joseph Freeman, 11 July 1937. This presumably refers to Gorky's *Evolution of Forms under Aerodynamic Limitations* for Newark Airport, models of which were shown at the Museum of Modern Art's *New Horizons in American Art* exhibition in 1936.

42 Elizabeth McCausland to Marian Rubin, 27 May 1944, copy; Elizabeth McCausland resumé (McCausland Papers, AAA, unfilmed, Box 35); [Garnett McCoy], 'Elizabeth McCausland, Critic and Idealist', *AAAJ* 2, no. 2 (1966): 16–20; Platt, *Art and Politics in the 1930s*, ch. 5. From December 1937 to May 1940, McCausland also wrote the New York gallery notes and several substantive articles for *Parnassus*.

43 Elizabeth McCausland, 'Sights and Sounds', *NM* 23, no. 2 (6 April 1937): 27; 'The Fine Arts', *NM* 25, no. 10 (30 November 1937): 27. For more interesting judgements on documentary photography, see Lozowick's review of Berenice Abbott's *Changing New York*, *NM* 31, no. 6 (2 May 1939): 25–6; and David Wolff, 'The Photograph as Art and Document' (on Walker Evans's *American Photographs*), *NM* 29, no. 2 (4 October 1938): 31.

44 Elizabeth Noble [McCausland], 'Four Art Exhibitions', *NM* 30, no. 6 (31 January 1939): 28–9. Cf. 'Housing Exhibition and Harriton's Art', *NM* 27, no. 4 (19 April 1938): 26–7.

45 Elizabeth Noble [McCausland]: 'Art', *NM* 28, no. 11 (6 September 1938): 3; American Artists' Congress Exhibition', *NM* 26, no. 2 (4 January 1938): 29; 'Artists' Congress' Second Show', *NM* 27, no. 8 (17 May 1938): 27; The Berkshire Museum, *The World Today: Pictured in Oils, Water Color, Gouaches, Drawings and Prints by New York Artists* (Pittsfield, Mass., 1939), 11.

46 Milton Howard, 'Review and Comment', *NM* 20, no. 12 (15 September 1936): 22.

47 Published with 'French Drama and Painting of the Eighteenth Century' as *Art and Society: A Marxist Analysis* (New York: Critics Group, 1937).

48 Milton Howard, 'Review and Comment', *NM* 20, no. 12 (15 September 1936): 22–4; 'Smirnov's Shakespeare', *NM* 20, no. 13 (22 September 1936): 19; Morris U. Schappes, 'Defending Smirnov', *NM* 21, no. 1 (29 September 1936): 19; 'Milton Howard Replies', *NM* 21, no. 2 (6 October 1936): 21.
 Cf. the adverse commentaries on Mark Rosenthal's 'Relative vs. Absolute Criteria in Art', *Dialectics* no. 8

(1938): 15–24, by Charles Humboldt and Louis Harap: 'The Function of Art', and 'Criteria in Art as Relatively Absolute', *Dialectics* no. 9 (1939): 24–8.

49 Milton W. Brown, 'The Marxist Approach to Art', *Dialectics* no. 2 (1937): 23–31. According to Margaret Duroc, the article was written after the pamphlet – 'Revolutionary Artists', *NM* 29, no. 4 (18 October 1938): 26–7. See also William Gerdts, 'A Tribute: Milton Brown (1911–1998)', *American Art* 12, no. 2 (summer 1998): 74–7.

50 The thesis was submitted at New York University in 1935. Brown had wished to acknowledge Schapiro's help, but was told by the Critics Group not to. (Conversation with the author, 25 July 1990.)

51 Brown, 'The Marxist Approach to Art', 25, 8–9, 30; Milton W. Brown, *Painting of the French Revolution* (New York: Marxist Critics Group, 1938), 70, 93. Cf. Herbert Lawrence, 'Social Importance of Art in "Painting of the French Revolution"', *DW*, 14 July 1938.

52 Charles Humboldt to John Berger, 24 November 1959 (copy; Humboldt Papers, YU); Francis Klingender, 'Form and Content in Art', *AF* 3, nos 3–4 (May 1937): 17–18; A. L. Lloyd, 'Modern Art and Modern Society', *AF* 3, no. 7 (October 1937): 16–19. Betty Rea (ed.), *5 on Revolutionary Art* (1936).

53 Salvador Dalí, 'I Defy Aragon', and Clarence Weinstock [Charles Humboldt], 'The Man in the Balloon', *AF* 3, no. 2 (March 1937): 7–10; Samuel Putnam, 'Marxism and Surrealism', *AF* 3, no. 2 (March 1937): 10–12.

54 Lucy Embick, 'The Expressionist Current in New York's Avant-Garde, 1935–1940: The Paintings of "The Ten"', *Rutgers Art Review* 5 (spring 1984): 56–69; Isabelle Dervaux, 'The Ten', *AAAJ* 31, no. 2 (1991): 14–20. For Solman's first-hand account, see 'The Easel Division of the WPA Federal Art Project', in O'Connor (ed.), *New Deal Art Projects*, 115–30.

55 'Between Ourselves', *NM* 25, no. 8 (16 November 1937): 2. Another member, Karl Knaths, was also said to be concerned with social art – see E. M. Benson, 'Karl Knaths', *MA* 29, no. 6 (June 1936): 370–72. Earl Kerkam, who exhibited with the group in autumn 1939, was a staff artist for the *Sunday Worker*.

56 Herbert Lawrence, '"The Ten"', *AF* 2, no. 3 (February 1936): 12.

57 Charmion von Wiegand, *AF* 2, no. 10 (November 1936): 10–13; Lukács, 'Expressionism: Its Significance and Decline' in *Essays on Realism*, 76–113 (originally published in *Internationale Literatur* no. 1, 1934). For Vavak, see Boston University Art Gallery & Bread and Roses, *Social Concern and Urban Realism*, 90–91.

58 'National John Reed Conference', *PR* 1, no. 5 (November/ December 1934): 60–61; Alfred Durus to Hugo Gellert, 3 October 1935 (Gellert Papers, AAA, unfilmed). See also Avis Berman, 'Images from a Life', in National Museum of American Art, *Jacob Kainen* (Washington, D.C.: Smithsonian Institution, 1993), 9–20; Jacob Kainen, 'Memories of Arshile Gorky', *Arts Magazine* 50, no. 7 (March 1976): 96–8.

59 Ben-Zion Weinman painted under his forename only. See Jewish Museum, *Painting a Place in America*, 161, and National Jewish Museum, *Ben-Zion: In Search of Oneself* (catalogue by Tabita Shalem and Ori Z. Soltes; Washington, D.C., 1997). His output of the 1930s included both Biblical and political themes, such as the 'abstraction' with collage from the *Daily Worker* he showed at an Artists' Union exhibition in 1934 – see Alexander, 'Without Benefit of Ritz', *NM* 13, no. 13 (25 December 1934): 27. A photograph of *Lynching* (now lost) is reproduced in Dervaux, 'The Ten', 16. I am grateful to Lillian Ben-Zion for her hospitality and for discussing her late husband's work with me.

60 Jacob Kainen, 'Our Expressionists', *AF* 3, no. 1 (February 1937): 14–15.

61 Wolff *et al.*, *Joseph Solman*, plates 38, 39, 42.

62 Solman, 'Chirico – Father of Surrealism'.

63 Joseph Solman to Jacob Kainen, 26 February 1939 (Jacob Kainen Papers, AAA, 565:171–2). Cf. Kainen on 'American Abstract Artists', *AF* 3, nos 3–4 (May 1937): 25–6. For an extremely negative view of the American Abstract Artists, see O. Frank, 'New Forces in American Art', *NM* 28, no. 3 (12 July 1938): 24.

64 Elizabeth Noble [McCausland], 'Social Intentions and Good Paintings', *NM* 26, no. 6 (1 February 1938): 30–31. Kainen had already appraised Tschacbasov in 'Painter of Savage Irony', *DW*, 20 January 1937. Jacob Kainen, 'Communist Party Branch Gets Noted Hunger Mural', *DW*, 14 May 1936.

65 Jewish Museum, *Painting a Place in America*, 197–8; letters from Tschacbasov, 'Editor's Letters', *AN* 44, no. 3 (15–31 March 1945): 4; *AN* 44, no. 6 (1–14 May 1945): 4; letter from Louis Schanker *et al.*, *AN* 44, no. 4 (1–14 April 1945): 4. According to Solman, his 'brashness and opportunism' alienated the others and he was frozen out – O'Connor (ed.), *New Deal Art Projects*, 125.

66 '"Art Front" Temporarily Silent', *MA* 31, no. 2 (February 1938): 119.

67 Monroe, 'Art Front', 19.

68 'The Newspaper for the Entire Family', *DW*, 12 December 1935. Wendy Z. Goldman, *Women, the State and Revolution: Soviet Family Policy and Social Life, 1917–1936* (Cambridge University Press, 1993). On Americanism, see Gary Gerstle, *Working-Class Americanism: The Politics of Labor in a Textile City, 1914–1960* (Cambridge University Press, 1991), 5–15.

69 Kainen was invited to write for the paper by Sender Garlin – Jacob Kainen, interview with the author, 8 October 1993.

70 Jacob Kainen, 'Abstract Art Exhibit Barely Comprehensible', *DW*, 25 February 1938.

71 Jacob Kainen, 'Development of a True Artist', *DW*, 9 July 1937.

72 Kainen, 'Abstract Art Exhibit Barely Comprehensible'. Kainen was emphatic that modern sculpture, even more than painting, required an engagement with the plastic qualities of the medium. See 'Proletarian Sculpture Show', *DW*, 13 April 1935. For the AAA, see George McNeil, 'American Abstractionists Venerable at Twenty', *AN* 55, no. 3 (May 1956): 34–5, 64–6; Lane and Larsen, *Abstract Painting and Sculpture in America 1927–1944*, 15–44. For

Smith and the CP, see Paula Wisotzki, 'Strategic Shifts: David Smith's China Medal Commission', *Oxford Art Journal* 17, no. 2 (1994): 63–77.

73 Jacob Kainen, 'Joe Jones' One-Man Exhibition', *DW*, 27 January 1936.

74 Jacob Kainen, 'Accomplished Craftsman and Younger Painter on View', *DW*, 5 March 1938; 'Gropper's Paintings', *DW*, 13 February 1936.

75 Jacob Kainen, 'Max Weber, Dean of American Modernists, on Exhibition', *DW*, 6 November 1937; 'The Ten', *DW*, 6 May 1937; 'Monster Shows of Picasso and Rouault Top Art Week' (on Ben-Zion; cf. on Jennings Tofel in this review), *DW*, 13 November 1937; 'Exhibition of New Paintings by "The Ten" Lacks Social Themes', *DW*, 21 May 1938; 'Friends of Jewish Culture Hold Fine Arts Exhibit', *DW*, 4 March 1938.

76 Jacob Kainen, 'The Capitalist Crisis in Art', *DW*, 3 December 1935; 'Revolutionary Surrealism', *DW*, 26 February 1936; 'Anti-Fascist Painting on Display by Guggenheim Winner', *DW*, 2 December 1937.

77 E.g., Jacob Kainen, '"Departure" Proves an Exciting and Revolutionary Painting' (on Max Beckmann), *DW*, 15 January 1938.

78 For these developments, see Maurice Isserman, *Which Side Were You On? The American Communist Party During the Second World War* (Middletown, Conn.: Wesleyan University Press, 1982), chs 3–5.

79 E.g., Oliver F. Mason: 'Leading Artists Open Exhibitions This Week', *DW*, 24 October 1939; 'Honor Work of Eakins After Artist is Dead', *DW*, 7 November 1939. 'Artists Give Hoover "Relief" Cold Shoulder', *DW*, 23 January 1940; 'Cuss Words Take Place of Criticism in Art Magazine', *DW*, 6 February 1940.

80 'ACA Exhibit Hits Hearst Art Slanders', *DW*, 25 September 1939 (there is a copy of the catalogue in the Toney Papers, SU, Box 2, 'Memorabilia II'); Oliver F. Mason, 'Critics Walk Tight Rope on Picasso Show', *DW*, 21 November 1939; Ray King, 'The Incredible Picasso', *DW*, 2 December 1939.

81 Ray King: 'New Evergood Works Unique in US Art', *SW*, 31 March 1940; 'Barbaric Splendor in Tschacbasov Paintings', *DW*, 26 April 1940; 'Solman's Exhibit Puts Him In Front Ranks of Artists', *SW*, 3 November 1940. S. N., 'Direct Vigorous Approach In Jacob Kainen's Paintings', *DW*, 1 November 1940.

82 Ray King, '"New York Realists" Depict Social Theme', *DW*, 29 December 1939.

83 Frank, 'New Forces in American Art', 23. See also Margaret Lieberson, 'Two Art Exhibits', *NM* 31, no. 7 (9 May 1939): 31.

84 Stuart Davis, 'Jan. 27, 1937' (Davis Papers, HU).

85 Stuart Davis to George Biddle, 1 July 1940 (Biddle Papers, AAA P17:536); 'Jan. 10, 1938' (Davis Papers, HU).

6 Social Art on Display

1 Gerald M. Monroe, 'The American Artists Congress and the Invasion of Finland', *AAAJ* 15, no. 1 (1975): 14; Matthew

Baigell and Julia Williams, 'The American Artists' Congress: Its Context and History', in American Artists' Congress, *Artists Against War and Fascism*, 5–7; Garnett McCoy, 'The Rise and Fall of the American Artists' Congress', *Prospects* 15 (1990): 286.

2 Ottanelli, *Communist Party of the United States*, ch. 3.

3 Baron, 'Unpublished History of the ACA Gallery', 71–4; Baigell and Williams, 'The American Artists' Congress', 8–10.

4 Cf. the complaint of sectarianism among the organisers, in 'Bill' [Gropper] to unidentified correspondent [Louis Lozowick?], nd (Lozowick Papers, AAA 1333:87).

5 For a sampling of core support, see also the exhibitors in the ACA Gallery's fund-raiser *Exhibition, American Artists Congress* (New York, 10–23 November 1935; AAA D343:89–91).

6 American Artists' Congress, *Artists Against War and Fascism*, 53. Ault joined the CP in 1935 and Billings was involved in a succession of front organisations into the 1940s. See Louise Ault, 'George Ault: A Biography' (MS), 27 (Artist's File, Smithsonian American Art Museum). A profile of Billings from 1946 describes him somewhat euphemistically as 'a militant liberal' – R. F. [Rosamund Frost], 'Billings: Machines & Life', *AN* 44, no. 20 (February 1946): 88. Both came from affluent backgrounds.

7 'American Artists' Congress', *NM* 17, no. 1 (1 October 1935): 33 (107 signatories). Cf. 'A Call to Arms: The Artists' Congress', *MA* 28, no. 12 (December 1935): 752. The call also circulated as a handbill with 110 signatories. Significantly the 'Call' omitted two paragraphs from an earlier version drafted by Lozowick (Lozowick Papers, AAA 1333:88), which appealed to artists to align themselves with the militant working class as the only 'bulwark against Fascism', and to recognise that their interests lay with the Soviet Union where '[a]ll creative workers' were 'free from the deadening threat of economic insecurity and all art trends are encouraged.' (The latter claim was clearly contradicted by reports in the Communist press.)

In the event, the AAC's main contacts were with the London-based Artists International Association, and the Mexican League of Revolutionary Artists and Writers. For the former, see Museum of Modern Art, Oxford, *AIA: The Story of the Artists International Association 1933–1953* (catalogue by Lynda Morris and Robert Radford; Oxford, 1983), 16, 55. For the latter, see the reports of Orozco and Siqueiros, in American Artists' Congress, *Artists Against War and Fascism*, 203–6, 208–12.

8 American Artists' Congress, *Artists Against War and Fascism*, 85–6, 162–4, 92–7. (Gorman's paper was not in fact read – see 94n.) For Broun and Gorman, see Klehr, *Heyday of American Communism*, 235, 226–7, 452 n. 10. For Biddle's very positive view of the Congress, see George Biddle to Edward Bruce, nd (AAA D82:953–5).

9 'Report of the American Artists' Congress, to the Membership, by the editorial committee. March 15, 1936' (Lozowick Papers, AAA, unfilmed); Joseph Freeman, 'The Battle for Art', *NM* 18, no. 9 (25 February 1936): 8; Stuart Davis to Rockwell Kent, 29 January 1936 (Kent Papers, AAA, unfilmed, Box 1).

10 The papers were edited by a committeee of five chaired by Klein. Of these, Klein, Duroc and Lozowick were Communists or fellow-travellers, while the other two, E. M. Benson and Ralph Pearson, were probably independent socialists.

11 American Artists' Congress, *Artists Against War and Fascism*, 78–84, 103–20. For Schapiro, see Andrew Hemingway, 'Meyer Schapiro and Marxism in the 1930s', *Oxford Art Journal* 17, no. 1 (1994): 13–29.

12 Papers by Max Weber, Gilbert Wilson, John Groth, Harry Sternberg and Ralph M. Pearson – American Artists' Congress, *Artists Against War and Fascism*, 121–47.

13 'The Policy of the American Artists' Congress, Inc.' (Rockwell Kent Papers, AAA, unfilmed, Box 1, file 2).

14 Circular letter from Philip Reisman, Fraction Secretary, 20 October 1938 (Lozowick Papers, AAA 1333:1029).

15 'Report of the American Artists' Congress, to the Membership, by the Editorial Committee. March 15, 1936'; American Artists' Congress, Inc., 'Report to Membership, November 1, 1936' (Lozowick Papers, AAA, unfilmed); 'News from the Branches', *American Artist* 2, no. 1 (spring 1938): 4–6. For the programme of the YAA, see AAA 429:1294.

16 One of the main records of the Congress is its quarterly news bulletin *American Artist* (AAA RD343:93–100 and 4466:1273–86). For a fuller account of Congress activities, see Baigell and Williams, in American Artists' Congress, *Artists Against War and Fascism*, 24–8. Picasso's message is printed as 'Picasso and Spain', *AF* 3, no. 7 (October 1937): 11. For materials relating to the 1937 Congress, see Lozowick Papers, AAA 1335:680–720.

17 Baron, 'Unpublished History of the ACA Gallery', 88.

18 Kutulas, *Long War*, ch. 6.

19 '17 Members Bolt Artists' Congress', *NYT*, 17 April 1940; 'Red Issue Splits Artists' Congress', *NYT*, 15 April 1940; 'Artists' Group Split by Row on War and Russia', *NYHT*, 15 April 1940; Oliver F. Mason, 'Disruption Will Fail in Artists' Congress', *DW*, 16 April 1940. For the executive board's response, see H. Glintenkamp, 'A Statement Clarifying the Policy of the American Artists' Congress', undated press release (AAA 141:1192); and unheaded mimeo of 27 April 1940 (Rockwell Kent Papers, AAA, unfilmed, Box 1, AAC file).

20 'Artists Congress Holds "Golden Gloves" Show', unattributed clipping and clipping from *Direction* 3, no. 5 (May 1940) (AAA 429:1408). Cf. Robert Coates, 'The Art Galleries', *New Yorker*, 18 February 1939, 64–5.

21 Louis Lozowick to Ryan Lugins, 8 May 1938 (copy); Arthur Emptage to Branch Secretaries, 23 May 1938; 'To the Chairmen or Secretary of each Branch of the AAC', 1 October 1938; Ralph M. Pearson to Louis Lozowick, postcard, nd, and 2 June 1939 (Lozowick Papers, AAA 1333:1006, 1011, 1022–3, 1069–70). There is an extensive record of discussion around the problems of the AAC in the Minutes of the New York executive board meetings of 9 March 1939 (AAA 1335:751–7). For the financial crisis, see Minutes of the Membership Meeting of the New York Branch, 15 May 1939; and Minutes of the New York Executive Board, 25 May 1939 (AAA 1335:763–6).

22 American Artists' Congress, *Artists Against War and Fascism*, 277–8; Charmion von Wiegand, 'The Fine Arts', *NM* 24, no. 1 (29 June 1937): 29–30.

23 Alexander R. Stavenitz, *America Today: A Nationwide Exhibition of Contemporary American Graphic Art* (nd); American Artists' Congress, *America Today: A Book of 100 Prints* (New York: Equinox Co-operative Press, 1936); O. Frank, 'America in Art', *NM* 22, no. 9 (23 February 1937): 24–5.

24 Baron, 'Unpublished History of the ACA Gallery', 85. For the planning and budgeting of the third membership show, see minutes of New York Branch Executive Board Meeting, 22 December 1938 (Lozowick Papers, AAA 1335:743–5).

25 Jacob Kainen, 'Liberty-Loving Artists in Momentous Exhibition', *DW*, 24 April 1937; Jerome Klein, 'Artist Congress Members Exhibit "For Democracy"', *NYP*, 17 April 1937. Cf. Elizabeth McCausland: 'Artists Congress's Third Annual Show', *SSUR*, 12 February 1939; 'Fourth Annual Show by Artists' Congress', *SSUR*, 14 April 1940.

26 Emily Genauer, 'Artists' Show', *NYWT*, 17 April 1937.

27 For Bolotowsky, Browne, Drewes and Vytlacil, see Lane and Larsen (ed.), *Abstract Painting and Sculpture in America*, 51–5, 56–8, 74–5, 231–2.

28 Metropolitan Museum of Art, *Stuart Davis: American Painter*, 224–5.

29 The term 'geniality' is Genauer's. For another fairly favourable review from a mainstream critic, see Edward Alden Jewell, 'American Artists Congress', *NYT*, 25 April 1937.

30 Minutes of Executive Board Meeting, 9 March 1939 (Lozowick Papers, AAA 1335:755).

31 'Artists Join the Artists Union' (Harry Gottlieb Papers, AAA D343:442); 'Why An Artists Union' (D343:446–9); 'Baltimore and Washington Artists' Unions', *Washington Star*, 5 February 1939.

32 'Artists Union in Opening of New Quarters Exhibit', *DW*, 24 March 1934; 'Between Ourselves', *NM* 14, no. 10 (5 March 1935): 30; Stephen Alexander, 'Art', *NM* 15, no. 1 (2 April 1935); Stephen Alexander, 'Current Art', *NM* 16, no. 5 (30 July 1935): 27; 'Current Art', *NM* (12 November 1935): 30; Jacob Kainen, 'PWA Artists' Exhibit Is Best Answer to Hearst's Hobohemian Slander', *DW*, 3 October 1935.

33 E. M. Benson, 'The Artists' Union Hits a New High', *MA* 29, no. 2 (February 1936): 113–14. See also Charles Humboldt, 'The Union Show', *AF* 2, no. 3 (February 1936): 9; Jacob Kainen, 'Artists' Union Group Show', *DW*, 2 January 1936. Cf. the exhibition held in the rooms of the *Daily Worker* chorus, reported in 'del', 'A Significant Art Show', *DW*, 12 December 1934.

34 Springfield Museum of Fine Arts, *Artists' Union National Exhibition*, 4–30 October 1938 (my thanks to the Springfield Museums for supplying me with a copy of this). Five works from the show are illustrated in 'Living Art in a Museum', *NM* 29, no. 4 (18 October 1938): 16.

35 Membership exhibitions held in 1940 and 1941 were essentially youth shows. ACA Gallery and Hudson Walker Gallery, 2 *Gallery Exhibit: A Jury Selected Exhibition of Paintings, Sculptures, and Prints by Members of United American Artists* (27 May – 15 June, 1940); ACA Gallery, *United American Artists Membership Exhibition* (16–29 November 1941) (Anthony Toney Papers, SU, Box 2).

36 'Meritorious Work in Show by Local 60', *AN* 38, no. 36 (8 June 1940): 12; Ray King, 'United American Artists on Show', *DW*, 3 June 1940; Elizabeth McCausland, 'Militant Group on Parade, Union Artists Show in Three Galleries', *SSUR*, 26 May 1940. Five works from the exhibition are illustrated in *NM* 35, no. 11 (4 June 1940): 29.

37 'The Artists Again', *NM* 19, no. 7 (12 May 1936): 4; Russell T. Limbach, 'Artists' Union Convention', *NM* 19, no. 8 (19 May 1936): 28; Meyer Schapiro, 'Public Use of Art', *AF* 2, no. 10 (November 1936): 4–6.

38 Helen Harrison, 'Subway Art and the Public Use of Arts Committee', *AAAJ* 21, no. 2 (1981): 4; Clarence Weinstock [Charles Humboldt], 'Public Art in Practice', *AF* 2, no. 11 (December 1936): 8–10; Robert Godsoe, 'A Project for the People', *AF* 3, nos 3–4 (May 1937): 10–11. Suggestions were also promised by the Cafeteria Workers', Pharmacists', Amalgamated Clothing Workers', Musicians', and Marine Firemen and Oilworkers' Unions. See 'Report of the Public Use of Art Committee (Harry Gottlieb Papers, AAA D343: 1243). See also 'A Written Request from the Pullman Porters Union' (1127) and 'Suggestions for Art Subjects for Pullman Porters' (1010).

39 Louise Mitchell, 'Art to Go Underground in New York', *DW*, 10 February 1038; 'Transport Union Approves Art for New York Subway Stations', *DW*, 10 April 1938.

40 Elizabeth Olds, 'Explaining Subway Art', *NYT*, 20 January 1938.

41 Ida Abelman, 'My Father Reminisces', *AF* 3, nos 3–4 (April–May 1937): 11; Marcia Minor, 'Artistic Prints by Machinery', *DW*, 1 December 1938. Cf. 'Two and United Artists Join in Mass Art Movement', *DW*, 13 July 1939. Minna Bromberg, Ida Abelman's granddaughter, has confirmed to me that Abelman was a CP member.

42 *AF* 2, no. 3 (February 1936): 11; *AF* 2, no. 5 (April 1936): 16; Ruth Allen, 'New School of Art', *DW*, 14 February 1936. See also Virginia Hagelstein Marquardt, 'The American Artists School: Radical Heritage and Social Content Art', *AAAJ* 26, no. 4 (1986): 17–23.

43 Circular letter on paper of American Artists School, signed Walter Quirt, 9 December 1936 (Anton Refregier Papers, AAA, unfilmed, Box 8).

44 *American Artists School, September 21, 1936 – June 12, 1937* (AAA 429:1128–31); Philip Evergood, 'Building a New Art School', *AF* 3, no. 3 (April 1937): 21.

45 *American Artists School, September 21, 1936 – June 12, 1937*; 'Through Social Research', *MA* 29, no. 10 (October 1936): 758, 763.

46 E.g., 'Sights and Sounds', *NM* 21, no. 13 (22 December 1936): 29; 'Sights and Sounds', *NM* 25, no. 11 (7 December 1937): 27; 'American Artists School Gallery', *NM* 27, no. 1 (29 March 1938): 31; 'Between Ourselves', *NM* 29, no. 4 (18 October 1938): 2; Ray King, 'American Artists School Faculty Puts on Group Show', *DW*, 14 September 1939.

47 'Between Ourselves', *NM* 23, no. 2 (6 April 1937): 2; Jacob Kainen, 'The Social Scene', *DW*, 7 April 1937.

48 For the portfolios, see Marquardt, 'The American Artists School', 19.

49 Ernest Brace, 'An American Group, Inc.', *MA* 31, no. 5 (May 1938): 271–5; 'Ninth Anniversary Exhibit by American Artist Group' (*sic*), *DW*, 18 September 1939; 'Sixty Artists Exhibit Work in Anniversary', *DW*, 9 September 1940; Oliver F. Mason, '10 Exhibits Open New Art Season', *DW*, 17 September 1940.

50 'Constitution and By-Laws of An American Group, Inc., November 1941', An American Group, Inc., 'Report of Activities, December 6th 1939' (mimeo; Lozowick Papers, AAA, unfilmed, file 'Organizations #1').

51 There was certainly concern about the overlap between the Group and the AAC. See Minutes of New York Branch Executive Board Meeting, 22 December 1938 (AAA 1335:743–5).

52 Kainen remarked that several of the exhibits had been shown before, 'some of them quite often', in 'The American Group Annual', *DW*, 26 April 1937.

53 'Waterfront Art', *DW*, 6 December 1935; Jacob Kainen, 'Waterfront Art Show', *DW*, 19 December 1935; Leonard Sparks, 'Waterfront Art Show', *NM* 22, no. 8 (16 February 1937): 17. Cf. 'Longshoremen are Critics at Waterfront Art Exhibit', *DW*, 16 February 1937.

54 Louis Adamic, *My America, 1928–1938* (New York & London: Harper, 1938), 373–7. The CP was more successful among seamen than among longshoremen in New York, although there were nuclei in some docks. See Max Steinberg, 'Problems of Party Growth in the New York District', *The Communist* 15, no. 7 (July 1936): 648–9.

55 Sparks, 'Waterfront Art Show'. Sparks refers to Davis's '*Coffee Pot*', but he was probably talking about an exhibit at the 1935 show, since Davis showed a watercolour titled *Waterfront Demonstration* in 1937.

56 Taylor, *Philip Evergood*, 87–9. *North River Jungle* is not listed in the catalogue, but Evergood noted on his own copy that it was included (AAA 429:1158).

57 Patricia Hills, *Alice Neel* (New York: Abrams, 1983), 63–4; Pamela Allara, *Pictures of People: Alice Neel's American Portrait Gallery* (Hanover, N.H., & London: Brandeis University Press, 1998), 83–5. For Whalen, see Vernon L. Pedersen, *The Communist Party in Maryland, 1919–57* (Urbana & Chicago: University of Illinois Press, 2001), 94, 96–101, 119, 121; and the vivid recollection in I. Duke Avnet, 'Pat Whalen', *Phylon* 12, no. 3 (September 1951), 249–54. Whalen was killed in the Pacific in June 1942. A Liberty Ship was named after him. The presence of newsprint under the painted *Daily Worker* raises the possibility the picture was originally exhibited with a collage element.

58 'Marine Art', *DW*, 28 February 1937. The Marine Workers' Committee divided the proceeds with the artists.

59 Federal Writers' Project, *New York Panorama: A Companion to the WPA Guide to New York City* (1938; New York: Pantheon Books, 1984), ch. 22.

60 Sidney Hill, 'Homes for the One-Third', *NM* 27, no. 5 (26 April 1938): 19–20; Lydia Paul, 'Roofs for Forty Millions – An Exhibition on Housing', *DW*, 16 April 1938. Hill received a prize in the Palace of the Soviets Competition in 1932 and was in the USSR in 1934. He published several articles in *New Masses* and International Publishers also issued a pamphlet by him on *Housing Under Capitalism*. See also: 'The Housing Question – 1937', *The Communist* 16, no. 6 (June 1937): 555–68.

61 Elizabeth Noble [McCausland], 'Housing Exhibit and Harriton's Art', *NM* 27, no. 4 (19 April 1938): 26. See also 'Roofs for 40 Million', *NM* 27, no. 5 (26 April 1938): 17–18; 'Roofs for Forty Million', *DW*, 19 April 1938.

62 See e.g. Charmion von Wiegand, 'The Fine Arts', *NM* 24, no. 5 (27 July 1937): 29–30; Elizabeth Noble [McCausland], ' "We Like America" ', *NM* 29, no. 9 (22 November 1938): 27.

63 The 1939 exhibition is described as the seventh such annual in reviews by Jerome Klein (*NYP*, 14 January 1939) and Henry McBride (*NYS*, 21 January 1939). It consisted of only twenty-seven works. See the catalogue in the Evergood Papers, AAA 429:1310.

64 ACA Gallery, *1938: Dedicated to the New Deal*, 15 August – 11 September 1938; Jacob Kainen, 'ACA Show on New Deal', *DW*, 5 September 1938.

65 M. U., 'Artists Toying with New Deal', *NYS*, 20 August 1938.

66 Gottlieb's work had again been produced earlier – see Charles Edward Smith, *The Bookplate* 1, no. 1 (November 1938) (Evergood Papers, AAA 429:1273).

67 Baron, 'Unpublished History of the ACA Gallery', 34–6; E. M. Benson, 'Two Proletarian Artists: Joe Jones and Gropper', *MA* 29, no. 3 (March 1936): 188–9; 'Joe Jones Paints Wheat', *NYT*, 26 January 1936.

68 'Joe Jones–Guggenheim Fellow', *SLPD*, 30 March 1937; Jacob Kainen, 'Murals of Joe Jones', *DW*, 2 February 1936; 'Writers and Artists Aid Browder, Ford', *DW*, 2 September 1936.

69 Carlyle Burrows, 'Notes and Comment on Events in Art', *NYHT*, 31 October, 1937; Emily Genauer, 'Joe Jones Takes Rank with the Masters', *NYHT*, nd, 1937 (Green Papers, MHS, Box 4); ACA Gallery, *Paintings by Joe Jones*, (New York, 24 October – 13 November 1937); Jacob Kainen, 'Joe Jones on Show at ACA Galleries', *DW*, 3 November 1937.

70 Jones's friend Turnbull, who also produced murals for the '9-0-5' liquor store chain, included a hammer and sickle in one of his – pointed out by Frank Peters, ' "9-0-5 Murals" Find a Second Beertown Home', *SLPD*, 15 February 1987.

71 MacLeish, 'US Art 1935', 69.

72 'Metropolitan Buys Joe Jones Painting', *SLPD*, 10 May 1937; John Selby, 'Joe Jones, Artist, Began as a House Painter'. For an instance of Jones's continuing engagement, see his exchange with Benton: 'To Thomas Benton', *NM* 28, no. 3 (12 July 1938): 22; 'Two Artists', *NM* 28, no. 6 (2 August 1938): 21.

73 Joe Jones to Elizabeth Green, 18 March 1938 (Green Papers, MHS, Box 4).

74 See e.g. B. A. Botkin, 'Regionalism: Cult or Culture?', *Midwest – A Review* 1, no. 1 (November 1936): 4, 32. For

Botkin, see Michael Denning, *The Cultural Front: The Laboring of American Culture in the Twentieth Century* (London and New York: Verso, 1996), 132–4; and Mangione, *The Dream and the Deal*, 263, 265, 269–73, 275–8.

75 ACA Gallery, *Recent Paintings: Joe Jones* (New York, 12 November – 2 December, 1939); ACA Gallery, *Joe Jones* (New York, 10–30 November, 1940). For reviews, see Ray King, 'Mr Jones Goes to Town', *DW*, 17 November 1939; Oliver F. Mason, '20 New Canvases by Joe Jones at ACA', *DW*, 15 November 1940; Ray King, 'New Joe Jones Exhibition a Challenge to Status Quo', *DW*, 20 November 1940.

76 ACA Gallery, *Gropper 1940* (New York, 1940), repr. in Shapiro, *Social Realism*, 206–9. For Jones's closeness to Gropper at this time, see J[ames] D[ugan], 'Gropper's Harvest', *NM* 34, no. 11 (5 March 1940): 30.

77 ACA Galleries, *Gropper* (New York, 1938).

78 Oliver F. Mason, '10,000 Visit Gropper Exhibit', *DW*, 5 March 1940; 'To Bill Gropper from his Friends, December 4, 1944' (Gropper Papers, SU).

79 August L. Freundlich, *William Gropper: Retrospective* (Los Angeles: Ward Ritchie Press in conjunction with Joe and Emily Lowe Art Gallery, University of Miami, 1968) refers to an exhibition at the Dinghy Gallery and two at the ACA in this year (16–17). Lewis Mumford, 'Satirist into Painter', *NY* (27 March 1937): 41–3; Ernest Brace, 'William Gropper', *MA* 30, no. 8 (August 1937): 467–71.

80 Dugan, 'Gropper's Harvest'.

81 Harold Rosenberg, 'The Wit of William Gropper', *AF* 2, no. 3 (March 1936): 7–8.

82 Stephen Alexander, 'The Art of William Gropper', *NM* 26, no. 13 (22 March 1938): 22. Cf. E. M. Benson, 'Two Proletarian Artists: Joe Jones and Gropper', 189; Jacob Kainen, 'The Magic of William Gropper', *DW*, 15 March 1937.

83 *The Defenders* was bought by Vincent Price from the 1937 exhibition.

84 Lozowick in ACA Gallery, *Paintings by William Gropper* (New York, 7–21 March 1937); Milton Brown, 'William Gropper', *P* 13, no. 4 (April 1941): 156. Cf. Ray King, 'Gropper Exhibit is a "Must" for Everyone', *DW*, 23 February 1940.

85 ACA Gallery, *20 Years Evergood* (New York, 1946). This major catalogue contains a useful chronology, together with lists of writings, talks and broadcasts, and reviews. His friend McCausland complained about his 'anti-intellectualism' in a letter to Oliver Larkin, 8 February 1944 (copy; McCausland Papers, AAA, unfilmed).

86 Philip Evergood, 'Sure I'm a Social Painter', *MA* 36, no. 7 (November 1943): 258–9; Beth McHenry, 'Evergood's Chosen Audience: The American Working Class', *DW*, 3 May 1946; Elizabeth McCausland, 'The Plastic Organization of Philip Evergood', *P* 11, no. 3 (March 1939): 19–21.

87 E.g., 'Current in Other Galleries', *NYS*, 26 February 1938; 'Art and Artists of Today', *Time* 31, no. 10 (7 March 1938): 39. Cf. Jacob Kainen, 'Philip Evergood Holds One-Man Show at ACA', *DW*, 2 March 1938.

88 Philip Evergood, 'Social Art Today: II', *American Contemporary Art* 1, no. 10 (December 1944): 4–8.

89 The importance Evergood attached to this work is suggested by the fact he showed it at the Carnegie International in 1938 and again at the Saint Louis Annual in 1939.

90 'There is a Difference in Bums' (AAA D304:315), quoted in Taylor, *Philip Evergood*, 91. See also Evergood to Herman Baron, 26 July 1954 (D304:91).

91 E.g., Edward Alden Jewell, 'Philip Evergood Shows Paintings', *NYT*, 27 March 1940; Melville Upton, 'Wide Variety in Half a Score of Art Exhibitions', *NYS*, 30 March 1940.

92 Jerome Klein, 'Evergood's Stand', *NYP*, 30 March 1940. Both paintings were based on observed experience – see Baur, *Philip Evergood*, 56–7, 77–8.

93 George Robbins, 'Chicago's Memorial Day Massacre', *NM* 23, no. 12 (15 June 1937): 11–12; Milton, *The Politics of U.S. Labor*, 108; Patricia Hills, 'Evergood's American Tragedy: The Poetics of Ugliness, the Politics of Anger', *Arts* 54 (February 1980): 138–42.

94 Taylor, *Philip Evergood*, 172, 174; Meyer Levin, *Citizens* (New York: Viking Press, 1940); Morris Neuwirth, '219', *AF* 2, no. 12 (January 1937): 4. A photograph with a fallen African American figure which provided one of Evergood's motifs was reproduced in the *Daily Worker* on both 1 and 19 June 1937.

95 Emily Genauer, 'Evergood Works Among New Displays', *NYWT*, 30 March 1940; Elizabeth McCausland, 'Picturing the People: Philip Evergood Shows his Recent Paintings', *SSUR*, 24 March 1940; Elizabeth McCausland, 'Exhibitions in New York', *P* 12, no. 4 (April 1940): 34, 36–7; Jewell, 'Philip Evergood Shows Paintings'; Baur, *Philip Evergood*, 52, 54.

96 Oliver F. Mason, 'Evergood Exhibit at the ACA Gallery', *DW* 26 March 1940; Roy King, 'New Evergood Works Unique in U.S. Art', *DW*, 31 March 1940.

97 Evergood himself emphasised this aspect – see Taylor, *Philip Evergood*, 172. The event was also the subject of a painting by Harriton, *Memorial Day, Chicago 1937*, shown at the ACA Gallery's *Paintings by 17 Artists on Social Themes* in January 1939 (no. 10); there is a photograph of it in a scrapbook in the Harriton Papers, Box 1 (SU).

98 Evergood, 'Social Art Today: II', 7.

99 Cadmus showed *Venus and Adonis* (Forbes Magazine Collection, New York) in which Adonis, a bronzed youth in trunks, is restrained by a corpulent suburbanite as he leaves to play tennis. Cadmus's moral satire centred on a critique of social mores grounded in a generalised revulsion from lust, rather than a model of political propaganda. See Cadmus's 1937 'Credo', in Whitney Museum of American Art, *Paul Cadmus: The Sailor Trilogy* (New York, 1996), np. Cadmus's art was so widely unpopular that it posed no challenge to Social Realism, and was generally ignored by the left.

100 Jerome Klein, 'Art Comment', *NYP*, 14 November 1936. A change was also noted by F. A. Whiting, Jr, 'Two Versions of American Art, Chicago and Manhattan', *MA* 29, no. 12 (December 1936): 819.

101 For Ribak, see Jewish Museum, *Painting a Place in America*, 187–8. Ribak made his first contribution to *New Masses* in

July 1926, and was a contributing editor from 1930 to 1933.

102 For the last work, see Boston Museum & Bread and Roses, *Social Concern and Urban Realism*, 79.

103 Kainen praised the show as reflecting a 'new policy' of including new talents, but the works he singled out were Davis's *Composition* and Tschacbasov's *Clinic*: 'Whitney Museum Opens Doors to Varied Artists', *DW*, 20 November 1937.

104 For Schreiber, see 'Panorama of America', *NM* 33, no. 11 (5 December 1939): 17.

105 E. M. Benson, 'The Whitney Sweepstakes', *MA* 29, no. 3 (March 1936): 188. Both were also praised in 'Whitney Museum Exhibition', *DW*, 8 February 1936.

106 For Davidson and the Spanish Republic, see Jo Davidson, *Between Sittings: An Informal Autobiography of Jo Davidson* (New York: Dial Press, 1951), 307–16. The leftists Gross, Glickman and Ahron Ben-Shmuel also showed in these years, but it is not clear that their exhibits had any clear political references.

107 James Johnson Sweeney, 'Exhibitions in New York', *P* 11, no. 2 (February 1939): 19–22; 'United Sculptors', *NM* 30, no. 3 (10 January 1939): 19.

108 See Boston Museum & Bread and Roses, *Social Concern and Urban Realism*, 54–5; Isidor Schneider, 'A Notable Anti-Fascist Painting', *IL* no. 1 (January 1938): 99–102; Fort, 'American Social Surrealism', 15–16.

109 Elizabeth Noble [McCausland], 'Progressive Sculptors', *NM* 29, no. 8 (15 November 1938): 31.

110 For the critique of museums, see esp. James Swanson, 'J. P. Morgan, Art Racketeer', *NM* 18, no. 6 (4 February 1936): 19–20; Jacob Kainen, 'Mellon Chisels into Art Control', *DW*, 8 March 1937; Clarence Weinstock [Charles Humboldt], 'The Frick Formula', *AF* 2, no. 3 (February 1936): 10–11; and Stuart Davis, in O'Connor (ed.), *Art for the Millions*, 122n. However, the Whitney was seen as a liberal institution, and its support of artists on the rental issue earned it respect.

111 William Gropper to Rockwell Kent, 30 April 1942; Rockwell Kent to William Gropper, 2 May 1942 (copy; Kent Papers, AAA, unfilmed, Box 24).

7 Communist Artists and the New Deal (2)

1 Barbara Blumberg, *The New Deal and the Unemployed: The View from New York City* (Cranbury, N.J., & London: Associated University Presses, 1979), 221–8, 300.

2 Blumberg, *New Deal and the Unemployed*, 86–94, 101–8; McKinzie, *New Deal for Artists*, 96–102; McMahon in O'Connor (ed.), *New Deal Arts Project*, 57. Jacob Kainen describes the process of re-hiring in his memoir of the Graphic Arts Division, ibid., 164.

3 McKinzie, *New Deal for Artists*, 151–5.

4 Thomas quoted in Blumberg, *New Deal and the Unemployed*, 228; Dies quoted in Eric Bentley (ed.), *Thirty Years of Treason: Excerpts from the Hearings of the House Committee on Un-American Activities, 1938–1968* (New York: Viking Press, 1971), 3.

5 Blumberg, *New Deal and the Unemployed*, 228–31; McKinzie, *New Deal for Artists*, 155–8, Mangione, *The Dream and the Deal*, ch. 8. Flanagan's testimony is reprinted in Bentley (ed.), *Thirty Years of Treason*, 6–47. For earlier accusations of this type, see Ralph M. Easley of the National Civic Federation to President Franklin Roosevelt, 16 July 1937 (AAA DC89:721–6). For a deeply hostile retrospect of the Workers Alliance from the Cleveland FAP director, see Clarence Holbrook Carter, 'I Paint as I Please', *MA* 38, no. 2 (February 1945): 47.

6 Klehr, *Heyday of American Communism*, 297–304; Blumberg, *New Deal and the Unemployed*, 88–95.

7 Blumberg, *New Deal and the Unemployed*, 231–43; McKinzie, *New Deal for Artists*, 158–62.

8 Blumberg, *New Deal and the Unemployed*, 260–64; McKinzie, *New Deal for Artists*, 163–6; Gerald M. Monroe, 'Mural Burning by the New York City WPA', *AAAJ* 16, no. 3 (1976): 8–11. The threat to Henkel's mural made the front page of the *Daily Worker* (9 July 1940), and the UAA's campaign against Somervell's 'Hitler Technique' was reported extensively in the paper between early July and early September. See also 'Vandals on WPA', *NM* 36, no. 5 (23 July 1940): 17. Somervell's obsession with Communists on the projects went back at least to early 1937: see Memorandum from Lawrence Morris to Ellen Woodward, 4 March 1937 (AAA DC89:422–3).

9 'Election Campaign Outline for 1936', *The Communist* 15, no. 9 (September 1936): 822. For the CP campaign for unemployment insurance, see Klehr, *Heyday of American Communism*, 283–9.

10 Charles E. Dexter, 'The Federal Arts Projects Face an Uncertain Future', *DW*, 18 November 1936; 'Roosevelt's WPA Double Cross', *DW*, 27 January 1937; Harrison George, 'No American Shall Starve', *SW*, 2 May 1937.

11 'Not by Bread Alone', *NM* 22, no. 1 (29 December 1936): 20; Theodore Draper, 'Roosevelt and the WPA', *NM* 21, no. 13 (22 December 1936): 14–16; 'The Pink Blight', *NM* 24, no. 2 (6 July 1937): 8; 'Art, The WPA Record', *DW*, 15 June 1937.

12 'Social Insurance and the Artist', *AF* 1, no. 2 (January 1935): 3; 'For a Permanent Art Project', *AF* 1, no. 1 (November 1934): 3; 'Artists' Union Federal Art Bill', *AF* 1, no. 2 (January 1935): 2.

13 'The 40,000 Lay-off Threat', *AF* 2, no. 5 (April 1936): 3–4; 'For a Farmer-Labor Party', *AF* 2, no. 6 (May 1936): 6.

14 Blumberg, *New Deal and the Unemployed*, 101–5; Boris Gorelick, 'The Artist Begins to Fight', *AF* 2, no. 12 (January 1937): 5–6.

15 'The Union Applies for an AFL Charter', *AF* 1, no. 6 (July 1935): 2; 'For a Permanent Art Project', *AF* 2, no. 3 (February 1936): 3; see also 'July 1st 1936', in the same issue (3–4). Blumberg, *New Deal and the Unemployed*, 53–7.

16 'The Artists' Unions: Builders of a Democratic Culture', *AF* 3, nos 3–4 (May 1937): 3.

17 'The Public Use of Art', and JS [Joseph Solman?], 'Exhibitions', *AF* 2, no. 4 (March 1936): 14–15; Elizabeth

Noble [McCausland]: 'New Horizons', *AF* 2, no. 9 (September/October 1936): 7–9; 'Official Art', *AF* 2, no. 10 (November 1936): 8–10.

18 Peter Vane, 'Big Words by Bigwigs', *AF* 3, nos 3–4 (May 1937): 7, 26.

19 'Answer to Washington' and 'The Federal Arts Bill', *AF* 3, no. 7 (October 1937): 3–5, 5–9. For Williams (Hopkins's deputy) and the left, see Klehr, *Heyday of American Communism*, 301–2.

20 The articles appeared in the *Daily Worker* on 18 March 1938 (FMP); 22 March 1938 (FTP); 23 March 1938 (Radio Division of FTP); 24 March 1938 (FWP); 25 March (FAP); 28 March 1938 (Coffee-Pepper Bill). Cf. Adam Lapin, 'WPA: A Record of Achievement', *DW*, 15 May 1938.

21 C. S. Marin, 'The Campaign for the Federal Arts Bill', *The Communist* 18, no. 6 (June 1938): 562–3, 570. Cf. 'Culture for America', *DW*, 13 June 1938.

22 Joseph Starobin, 'Barbarians on Capitol Hill', *NM* 31, no. 7 (9 May 1939): 10–11; 'The United States Arts Projects', *NM* 31, no. 8 (16 May 1939): 12–14. Cf. 'Stop the Wreckers', *NM* 31, no. 11 (6 June 1939): 21.

23 'The World's Fair – It's Really Grand', *DW*, 2 May 1939; 'America Comes into its Own in the World of Art, Culture', *DW*, 30 April 1939.

24 George Morris, 'WPA Exhibit at Fair', *DW*, 4 June 1939; Marcia Minor, 'A Progressive Muralist at the Fair' (Ferstadt), *DW*, 24 November 1938; Lawrence Emery, 'Man in Control' (Ferstadt), *DW* 14 July 1939; 'WPA Art Project Murals Win Prizes at Fair Competition' (Guston and Refregier), *DW*, 13 August 1939.

25 M. R. Linden, 'Art at the Fair', *NM* 31, no. 12 (13 June 1939): 30–31; Elizabeth McCausland, 'Living American Art', *P* 11, no. 5 (May 1939): 16–25. Cf. Donald Baer, 'For the New York World's Fair Contemporary Art Exhibition', *P* 11, no. 3 (March 1939): 14–18. For more critical views, see James Johnson Sweeney, 'Thoughts Before the World's Fair', *P* 11, no. 3 (March 1939): 3, 6–7; Howard Devree, 'Art and Democracy', *MA* 32, no. 5 (May 1939): 262–70.

26 Sam Wiseman, 'Workers Alliance Leader Praises Artist Tromka', *DW*, 4 February 1940; 'Many Project Artists in Whitney Show', *DW*, 22 January 1940. E.g., 'Six Art Project Murals Get Official Approval', *DW*, 15 March 1940; Oliver F. Mason, 'Joe Jones is Winner in Mural Competition', *DW*, 31 October 1939.

27 E.g., Oliver F. Mason, 'The Week's Highlights in the World of Art', *DW*, 1 October 1940.

28 Wendy Jeffers, 'Holger Cahill and American Art', *AAAJ* 31, no. 4 (1991): 2–5; 'Reminiscences of Holger Cahill', 90, 407–8. In 1935 a right-wing publication described Cahill as 'a former adherent of the IWW' and 'a familiar figure in Communist high-brow circles'. See 'Hopkins Selects Communists as WPA Directors', *The Awakener*, 1 September 1935 (AAA 1108: 1128–9).

29 Holger Cahill, *Max Weber* (New York: Downtown Gallery, 1930), 12, 31, 36–7. Cf. John Dewey, *Art as Experience* (1934; New York: Perigree, 1980), 15–16. Cahill became a defender of Abstract Expressionism in the later 1940s. See Holger Cahill: 'In Our Time', *MA* 39, no. 7 (November

1946): 308; and 'Forty Years After: An Anniversary for the AFA', *MA* 42, no. 5 (May 1949): 178, 189.

30 Museum of Modern Art, New York, *American Folk Art: The Art of the Common Man in America, 1750–1900* (New York, 1932), 6–8, 26–7; *American Painting and Sculpture, 1862–1932* (New York, 1932), 11–12, 22.

31 Holger Cahill and A. H. Barr (ed.), *Art in America in Modern Times* (New York: Reynal & Hitchcock, 1934), 43–4, 47–8.

32 Holger Cahill, 'American Resources in the Arts', in O'Connor (ed.), *Art for the Millions*, 33–44.

33 See esp. 'Federal Art Project, Holger Cahill – Director'; 'Mr. Cahill's Lectures before the Metropolitan Museum of Art, New York City, March 28, 1937' (NARA, RG69:1022); 'Works Progress Administration, The Federal Art Project' [early 1938] (AAA, 1105:994–1006).

34 Dewey, *Art as Experience*, 190, 298–9, 329n, 344. The book would have been made doubly suspect by Dewey's prefatory acknowledgement of the Marxist renegades Sidney Hook and Meyer Schapiro (vii–viii). For the CP view of Dewey, see Frank Meyer, 'Reactionary Philosophy of Dewey and his School', *DW*, 16 October 1939; Philip Carter, 'Pitfalls of Pragmatic Logic', *The Communist* 18, no. 2 (February 1939): 163–9.

35 Holger Cahill, 'July 1937' (AAA, 1105:1218–19); Michael Gold, *The Hollow Men* (New York: International Publishers, 1941), 56–7.

36 Jacob Kainen to Edward Bruce, 22 April 1934; Bruce to Kainen, 4 May 1934 (copy; AAA DC6:219–20). Cf. Bruce to the secretary, The Artists' Union, 28 March 1934 (copy; DC7:502); Bruce to Harold Mack, 11 March 1938 (copy; D87:846).

37 George Biddle to Bruce, undated [March] 1936; Bruce to Biddle, 18 March 1936 (copy; AAA D82:950, 949); Philip Evergood to Edward Rowan, 6 January 1938 (NARA RG121:133, under USPO, Jackson, Ga.).

38 Burck joined the *Saint Louis Post-Dispatch* on a temporary basis in August 1937, and the following year moved to the *Chicago Sun-Times* – 'Between Ourselves', *NM* 24, no. 8 (17 August 1937): 2. In 1938 he was given a mural commission for the post office at Bradley, Illinois. There is extensive correspondence between Burck and the Section over this stretching from 1938 to 1942 (NARA RG121:133), but Burck never realised the *Industrial Life of Bradley*, in part because of ill-health.

39 For Gross and Scaravaglione, see Jewish Museum, *Painting a Place in America*, 174–5, 189–90. Both signed the 1936 Call for the American Artists' Congress and were sometime faculty at the American Artists School. Gross was also active in YKUF. However, neither were really 'Social' sculptors.

40 See McKinzie, *New Deal for Artists*, 53–6; 'Detailed Report of Section of Painting and Sculpture with Procedure for Competitions', Section of Painting and Sculpture *Bulletin* no. 8 (January/February 1936): 14–18. There is a complete run of the Section *Bulletin* in the Bruce Papers (AAA D91:790–1003). The Section's control of commissions is abundantly documented in 'Case Files Concerning Embellishment of Public Buildings' (NARA RG121:133).

41 'Report of the Section of Painting and Sculpture', January 16 1935 (AAA D89:64); Section of Fine Arts *Bulletin* no. 21 (March 1940): 4; Bruce quoted in *Speech of Hon. Elbert D. Thomas of Utah in the Senate of the United States, May 8, 1939* (Washington, D.C.: Government Printing Office, 1939), 3. Cf. McKinzie, *New Deal for Artists*, 57–8.

42 Section of Fine Arts *Bulletin* no. 2 (April 1935): 10. For analyses of Section iconography, see Karal Ann Marling, *Wall-to-Wall America: A Cultural History of Post Office Murals in the Great Depression* (Minneapolis: University of Minnesota Press, 1982); Park and Markowitz, *Democratic Vistas*; Sue Bridwell Beckham, *Depression Post Office Murals and Southern Culture: A Gentle Reconstruction* (Baton Rouge & London: Louisiana State University Press, 1989); Barbara Melosh, *Engendering Culture: Manhood and Womanhood in New Deal Public Art and Theater* (Washington, D.C., & London: Smithsonian Institution Press, 1991). Melosh's book contains the most complete inventory of Section murals and sculptures (233–63).

43 Schapiro, 'Public Use of Art', 6.

44 Melosh, *Engendering Culture*, 97; cf. 230. The sketch for Victor Arnautoff's *Richmond – Industrial City*, for the post office at Richmond, California, depicts 'collective bargaining', but this was changed in the finished version, although workers with union buttons remain. See Victor Arnautoff to Edward Rowan, 4 April 1940 (RG121:133, Richmond, Cal.). For a thorough study of the mural (now lost) and its setting, see Jennifer Golden, 'Victor Arnautoff's *Richmond – Industrial City*: The Negotiation between Radical Politics and Federal Patronage during the New Deal', MA dissertation, University College London, 2001.

45 For an instance where a subaltern group protested about their representation in Section art, see the African American responses to Gustaf Dalstrom's mural for the post office at Saint Joseph, Missouri – discussed in Beckham, *Depression Post Office Murals*, 204–14.

46 Lehman, 'Brilliant Murals by Joe Jones'. The murals were painted on pressed wood board, and were intended to be portable. They are illustrated in *IL* no. 12 (1935): 56–7. Their fate is unknown, but see Marling, 'Workers, Capitalists, and Booze', 45 n. 65.

47 Joe Jones to Elizabeth Green 4 August 1935, 27 August 1935, 28 August 1935, 12 September 1935 (Green Papers, MHS).

48 'the jobs you have already given me have been the only stable thing in my last 5 years of existence.' Jones to Rowan, 'May 26' (RG121:126, 'Correspondence with Artists, 1939–42').

49 Jones to Rowan, 30 July 1937 (RG121:133, Magnolia, Ark.).

50 Jones to Rowan, nd (stamped 15 May 1939), and 23 June 1939; Post Master, Anthony, Kansas, to Federal Works Administration, 15 September 1939 (RG121:133, Anthony, Kan.). 'Joe Jones Completes His Seventh Mural', *SLPD*, 26 July 1939.

51 W. S. Kauffman to Jones, 18 November 1939; W. S. Kauffman to Public Building Administration, 6 February 1940; Jones to Rowan, 4 December 1939; Rowan to Jones, 11 December 1939; 'Postal Mural Here; It's Nice' (unidentified clipping) (RG121:133, Seneca, Kan.). Cf. Marling, *Wall-to-Wall America*, 122–4, 167; Melosh, *Engendering Culture*, 116–17; Park and Markowitz, *Democratic Vistas*, 49, 158.

52 Edward Rowan to William Gropper, 23 February 1939, 23 November 1938, 20 July 1937, 20 September 1938 (copies) (RG121:133, Department of Interior Building); Harold Ickes to Gropper, 28 November 1944, in the album 'To Bill Gropper from his Friends, December 4, 1944' (Gropper Papers, SU). Look and Perrault, *The Interior Building and its Architecture*, 129–30; 'Power Giant of the Far West: Mighty Bonneville Dam', *NYT Magazine*, 16 May 1937 (clipping in Gropper Papers, SU). Three of the sketches are illustrated in *MA* 30, no. 8 (August 1937): cover, 514.

53 My identification of Britton's politics is tentative, as will be apparent later. For his biography, see Look and Perrault, *The Interior Building*, 146–8. His papers are held in the library of the University of Illinois, Chicago. My thanks to Carmen Niekrasz for this information. Unfortunately I was not able to consult these materials before this volume went to press.

54 Illustrated in Park and Markowitz, *Democratic Vistas*, 140; and Marling, *Wall-to-Wall America*, 173.

55 John Gunther, *Inside USA* (New York & London: Harper & Bros, 1947), 118–33. For the Communist view of the Tennessee Valley Authority under the Democratic Front, see Ernest Moorer, 'TVA – Light and Power That Unites the South', *SW*, 5 June 1938.

56 Rowan to Britton, 21 July 1937 (copy); Britton to Rowan, 29 March 1938; Rowan to Britton, 14 April 1938 (RG121:133, Department of Interior Building). As head of the Oil Administration, Ickes had good reason to see corporate interests in this way. See Jeanne Nienaber Clarke, *Roosevelt's Warrior: Harold L. Ickes and the New Deal* (Baltimore & London: Johns Hopkins University Press, 1996), 101–7.

57 E.g., 'America's Duty to the Negro People', *SW*, 23 October 1938; 'Ickes to Assail Dies Committee', *SW*, 1 January 1939; 'Ickes Raps Critics', *DW*, 3 February 1939.

58 'Department of the Interior', Section *Bulletin* no. 12 (February 1937): 6; 'Gropper Gets a Contract from Department of Interior', *DW*, 14 November 1938. Other notable symbols of state interventionism in Washington include Ben Shahn's murals in the Social Security Building, and Simeon Shimin's *Contemporary Justice and the Child* at the Department of Justice. Shahn's must be one of the most successful of all New Deal murals, but his social democratic politics place him outside my purview here.

59 Brace, 'William Gropper', 514 and cover illustration.

60 Melosh, *Engendering Culture*, 89–91; Clark, *Roosevelt's Warrior*, 44–5. Patricia Sullivan has said of Ickes that '[a]mong FDR's major appointments, [he] was exceptional in his willingness to act unequivocally in behalf of racial fairness and inclusion.' See her *Days of Hope*, 54 and, generally, 53–5.

61 Beckham, *Depression Post Office Murals*, 164, 192.

62 Rowan to Evergood, 18 February 1938, 10 August 1939 (copies); Evergood to Rowan, 12 July 1940; Victor H. Carmichael to Evergood, 5 October 1939; Carmichael to Federal Works Administration, 28 October 1940 RG121:133, Jackson, Ga.). Beckham, *Depression Post Office Murals*, 141. For Talmadge, see Gunther, *Inside USA*, 767–70, 777–80. My thanks to Walter Widemond for the observation.

63 Instances I have in mind include Victor Arnautoff's mural for the post office at Linden, Texas, and Robert Gwathmey's for that at Eutaw, Alabama. See also Park and Markowitz, *Democratic Vistas*, 85–93; Melosh, *Engendering Culture*, 67–76.

64 Park and Markowitz, *Democratic Vistas*, ch. 3.

65 *NM* 28, no. 4 (19 July 1938): 16.

66 Siporin was nearly expelled from the Club in 1934 for reasons unknown: see Joseph Freeman to Alexander Trachtenberg, 14 June 1934 and 18 June 1934 (copies); Alexander Trachtenberg to Joseph Freeman, 16 June 1934 (Freeman Papers, HI, 39:1).

67 'Plans for Work'; draft letter from Siporin to Sheldon Cheney [1935]; 'Sketches for Haymarket Series' (Siporin Papers, AAA 2011:17; 2011:88–99; 2012:142–277); Cheney, *Expressionism in Art*, 360; Rose Art Museum, Brandeis University, *Mitchell Siporin: A Retrospective* (Waltham, Mass., 1976).

68 Typescript obituary notice in Edward Millman Papers, SU, Box 1.

69 Siporin painted three tempera panels, *Jane Addams*, *Lincoln and Altgeld* and the *Prairie Poets*, under the FAP. See Fritzi Weisenborn, 'Siporin Paints Social Scene', *Chicago Sunday Times*, 17 September 1939; and, for photographs, AAA ND/68:499–503. A series of photographs of Orozcoesque mural studies in Siporin's papers can be tentatively dated to 1933 on the basis of the business stamp on one of them (AAA 1328:141, 150–52). Millman established himself as a muralist through restaurant decorations at the Chicago World's Fair of 1933. For photographs of these, see Millman Papers, SU, Box 5.

70 Botkin, 'Regionalism: Cult or Culture?'; Siporin, 'Mural Art and the Midwestern Myth', in O'Connor (ed.), *Art for the Millions*, 64–7; 'Thoughts Out Loud' (Siporin Papers; AAA 2012:94–5). Cf. Granville Hicks, *The Great Tradition: An Interpretation of American Literature Since the Civil War* (New York: International Publishers, 1935), 277–83; Carl Carmer, 'Stranglers of the Thunder', *NM* 27, no. 3 (12 April 1938): 79–81.

71 Federal Writers Project, *Illinois: A Description and Historical Guide* (Chicago: McClurg, 1939), 303–8; Janet Snow-Godfrey and Milton Derber, 'Decatur', in Milton Derber, *Labor in Illinois: The Affluent Years, 1945–80* (Urbana & Chicago: University of Illinois Press, 1989), 309–22. Most of the following account is based on the Decatur press. My thanks to Bob Sampson for his advice and encouragement.

72 'CIO Unions Are Ousted by Local Assembly', *DR*, 11 June 1937.

73 Carl D. Oblinger, *Divided Kingdom: Work, Community, and the Mining Wars in the Central Illinois Coal Fields During the Great Depression* (Springfield: Illinois State Historical Society, 1991).

74 'Two Shot, Nab 40 in Miners' Clash with Police Here', *DH*, 4 November 1932.

75 E.g., 'Officers Raid Strike Picket Lines; Jail 48', *DR*, 22 February 1935; 'Tear Gas Routs Girl Strikers; Eleven Jailed', *DR*, 11 March 1935. For the background to the strike, see James S. Patton, 'Marginal Prices Balk Cotton Dress Unions, Employers', *DSHR*, 24 February 1935.

76 'Five Millions Spent by WPA in County Jobs', *DSHR*, 30 October 1938; 'Decatur Says Yes', *DR*, 3 September 1938; 'Local Firm Gets Courthouse Job', *DR*, 29 October 1938.

77 'Macon Turns Down New Deal Plea', *DH*, 10 November 1938. Cf. 'Republicans Win County Offices', *DH*, 9 November 1938; 'GOP Wins County, Demos Sweep State', *DR*, 9 November 1938.

78 E.g., 'WPA Group Asks Better Conditions', *DH*, 8 August 1938; 'Seeks $175 WPA Wage', *DH*, 12 August 1938; 'Relief Project Aid Demanded by WPA Crew', *DR*, 3 October 1938. In 1932, the CP staged a May Day rally in Decatur, and the Illinois party held its state convention there. Apart from a jobless parade in 1934, no more public May Day events were organised, but an Unemployed Council and Workers Center were established in the city.

79 Donald F. Tingley, *The Structuring of a State: The History of Illinois, 1899 to 1928* (Urbana: University of Illinois Press, 1980), ch. 10; David M. Chalmers, *Hooded Americanism: The First Century of the Ku Klux Klan, 1865–1965* (New York: Doubleday, 1965), ch. 25.

80 E.g., 'Artists Start Murals Monday in Post Office', *DSHR*, 14 August 1938; 'Post Office Murals Here to be Largest in State', *DH*, 17 August 1938.

81 'Finish Murals Tomorrow', *DR*, 26 October 1938; 'Complete Postoffice Murals Soon', *DH*, 24 October 1938.

82 'Murals Take Form on Postoffice Walls, *DR*, 20 September 1938.

83 Typescript descriptions by Siporin, Britton and Millman (RG121:133, Decatur, Ill.).

84 'Murals Take Form', *DH*, 10 September 1938.

85 Cf. Earl Browder, 'Lincoln and the Communists', in *The People's Front*, 187–96. This is the text of an address Browder delivered in nearby Springfield on Lincoln's birthday in February 1936.

86 For a contemporary Communist perspective on Sandburg, see Hicks, *The Great Tradition*, 241–2.

87 See Millman on Orozco in 'Symbolism in Wall Painting' (typescript for *Art for the Millions*, Millman Papers, SU, Box 6); and Siporin on the same, in Siporin to Edith Halpert, 27 May 1941 (draft; AAA 2011:344–5).

88 Rowan to Britton, 14 June 1937, 9 December 1937; Rowan to Millman, 15 July 1938; Rowan to Siporin, 12 June 1937; Daniel Catton Rich to Rowan, 19 June 1937. Rowan visited Decatur to inspect the murals in November. See 'Art Chiefs Laud Murals at Postoffice', *DH*, 14 November 1938.

89 'Art', *Time* 34, no. 14 (2 October 1939): 46; 'Missouri: New Murals Show its History', *Life* 13, no. 15 (12 October 1942): 70–76, 78, 80. The *SLPD* published a picture feature on the murals in its Sunday 'Pictures' magazine of 5

April 1942. The commission was also hailed in the *Daily Worker*: see 'Progressive Artists Win Competition', *DW*, 23 September 1939.

90 E.g., 'Unroll the Scroll of Saint Louis History', *St Louis Star-Times*, 25 February 1942.

91 Four-page typescript description of iconography; Siporin to Rowan, 10 April 1940 (RG121:133, Saint Louis Post Office). For the CP view of Whitman, see Hicks, *The Great Tradition*, 20–31; Sam Roberts, 'On Walt Whitman', *DW*, 25 May 1938; 'Walt Whitman's 119th Anniversary', *DW*, 31 May 1938.

92 W. Rufus Jackson to Bruce, 6 October 1939; Jackson to Rowan, 18 June 1942; Millman and Siporin to Rowan, 13 February 1940. Effectively Millman and Siporin converted the Section to their conception, and used it rather skilfully to mediate with the post master.

93 Rowan to Siporin and Millman, 14 November 1941 (Siporin Papers, AAA 2011:366).

94 In one interview Siporin joked that he was planning a take-off of Benton's infamous *Susannah and the Elders*, which would show 'two old spinsters taking a peek at Benton, naked as a jaybird in the old swimmin' hole', while in another, Millman intimated his low opinion of Grant Wood's work. See 'Start Work Postoffice Murals', unidentified clipping, 22 September 1941 (AAA ND/68:272); Reed Hynds, '2 Talented Artists to Do St. Louis P.O. Murals', *St. Louis Star-Times*, 29 September 1941.

95 For Benton's *Social History of the State of Missouri*, see Doss, *Benton, Pollock, and the Politics of Modernism*, 126–38.

96 Hynds, '2 Talented Artists to Do St Louis P.O. Murals'.

97 Quoted in Downtown Gallery, *Paintings, Cartoons, Photographs of the Saint Louis Post Office Murals by Mitchell Siporin and Edward Millman* (New York, 1942). Cf. the sympathetic and informative article by Otto Fuerbringer, 'Top-Flight Painting Team', *SLPD*, 21 February 1940.

98 Clippings from the *SLPD*, July 1942, in the Siporin Papers (AAA 2012:1132, 1135, 1141). Both artists were Jewish.

99 Cohen, *Making a New Deal*; Gerstle, *Working-Class Americanism*.

100 Printed in 'Let's Throw Red Art Out of Federal Buildings', *The Argonaut*, 14 November 1952.

101 Cahill's paper was titled 'Cultural Aspects of Government Support of Art'; Circular letter of invitation to Cahill dinner, 16 May 1939 (Lozowick Papers, AAA 1333:1063).

102 O'Connor (ed.), *Art for the Millions*, 13–14 and Part 4.

103 Cahill, 'Reminiscences', 418–22, 457–8.

104 George J. Mavigliano and Richard A. Lawson, *The Federal Art Project in Illinois, 1935–1943* (Carbondale & Edwardsville: Southern Illinois University Press, 1990), 30–45. See also the extensive correspondence in NARA RG69:1023, Box 19.

105 Audrey McMahon, 'A General View of the WPA Federal Art Project in New York City and State', in O'Connor (ed.), *New Deal Art Projects*, 66; Audrey McMahon to American Artists' Congress, 16 April 1940 (copy; NARA RG69:1031, Box 63); Audrey McMahon, 'The Trend of the Government in Art', *P* 8, no. 1 (January 1936): 3–6. Lincoln Rothschild,

director of the Index of American Design in New York and an AAC activist, recalled McMahon as being friendly with Union leaders. See his 'Artists' Organizations of the Depression Decade', in O'Connor (ed.), *New Deal Art Projects*, 206.

106 Park and Markowitz, *New Deal for Art*, 44–72. See also Harris, *Federal Art and National Culture*.

107 'Editorials', *The Nation* 148, no. 22 (27 May 1939): 602–3.

108 'Committee Sees Administration on Public Use of Art', *Art Project Reporter* (September 1936): 3 (AAA D343:503–6).

109 McDonald, *Federal Relief Administration and the Arts*, 264–78.

110 Emanuel M. Benson, 'Art on Parole', *MA* 29, no. 11 (November 1936): 700, 703–5.

111 McMahon, 'A General View of the WPA Federal Art Project', 59. For an instance of interference that backfired, see Greta Berman, 'The Walls of Harlem', *Arts Magazine* 52, no. 2 (October 1977): 122–6.

112 Works Progress Administration, Federal Art Project, *General Bulletin No. 2*, 15 May 1939 (Gellert Papers, AAA, unfilmed).

113 On this, see Rothschild, 'Artists' Organizations of the Depression Decade', 206–7.

114 James Michael Newell, 'The Evolution of Western Civilization', in O'Connor (ed.), *Art for the Millions*, 60–63. I have found no evidence as to Newell's political outlook.

115 Works Progress Administration Federal Art Project, *Epochs in the History of Man: Frescoes by Edgar Britton in the Lane Technical High School* (nd); Edgar Britton, 'The Cafeteria Murals', *The Lane Tech Prep* (December 1936): 15 (AAA 1107:636); Gerstle, *Working-Class Americanism*, 12.

116 Gary Wisby, 'Long-hidden Historic Mural Blossoms Forth at Flower High', *Chicago Sun-Times*, 19 May 1997. *The Blessings of Water* murals have also been restored.

117 Seymour Korman, 'Critics Assert WPA Art is Ugly and Subversive', 'Alien Influence, Bad Art Seen in WPA Paintings', '4 WPA Canvases Found Unworthy the Name of Art', in *Chicago Tribune*, 19, 20, 21 December 1940.

118 Autobiographical notes by White made in connection with his application for a Guggenheim Foundation Fellowship, White Papers, AAA 3191:1190; Benjamin Horowitz, *Images of Dignity: The Drawings of Charles White* (Los Angeles: Ward Ritchie Press, 1967), 14–15. For White generally, see also Studio Museum in Harlem, *Images of Dignity: A Retrospective of the Works of Charles White* (New York, 1982); and the special commemorative issue of *Freedomways* 20, no. 2 (1980). White describes his formation in 'Path of a Negro Artist', *M&M* 8, no. 4 (April 1955): 33–44.

119 Bill V. Mullen, *Popular Fronts: Chicago and African-American Cultural Politics, 1935–46* (Urbana: University of Illinois, 1999).

120 Margaret Burroughs, '"He will always be a Chicago artist to me"', *Freedomways* 20, no. 2 (1980): 153. White was only seventeen when the club was closed in late 1935/early 1936. Topchevsky was secretary to the Chicago American Artists' Congress. See Larry Forhman, 'Portrait of an Artist: Morris Topchevsky (1899–1947)', *NM* 64, no. 4 (22 July 1947): 9–10.

121 Fanny Buford, 'Acting in Anti-War Play Wins Applause', unidentified clipping (AAA 3194:1244); Horowitz, *Images of Dignity*, 14.

122 White autobiographical notes, AAA 3191:1190; 'Chi Negro Artist Immortalizes Own Folk', *Pittsburgh Courier*, nd, AAA 3195:23. On the history of the Center, see Mullen, *Popular Fronts*, ch. 3.

123 Barnwell, 'Sojourner Truth or Harriet Tubman?: Charles White's Depiction of an American Heroine', in Andrea D. Barnwell *et al.*, *The Walter O. Evans Collection of African American Art* (Seattle: University of Washington Press, 1999), 57, 65 n. 13. See also 'The Barnett-Aden Gallery', *Newspic* (September 1945): 20. It has been suggested that the mural was subsequently installed at the George Cleveland Hall Branch of the Chicago Public Library, but the work White associates with the Library in his Autobiographical Notes (AAA 3191:1191) had the theme of 'tactics use[d] to fight for the abolition of slavery', and is presumably that illustrated in Horowitz, *Images of Dignity*, 31. This mural, which seems unfortunately to be lost, looks a stronger and potentially more controversial painting.

124 Andrea Barnwell has pointed out that Truth is shown playing an historical role actually performed by Harriet Tubman, and argues that the figure should be seen as a composite of the two. See her 'Sojourner Truth or Harriet Tubman?', 54–66.

125 'I do know that I want to paint murals of Negro history. That subject has been sadly neglected.' White, quoted in Willard F. Motley, 'Negro Art in Chicago', *Opportunity* 18, no. 1 (January 1940): 22.

126 Robert A. Davis, 'The Art Notebook', *Chicago Sunday Bee*, 6 October 1940.

127 Joseph Stalin, 'Marxism and the National Question', in *Marxism and the National Question: A Collection of Articles and Speeches* (San Francisco: Proletarian Publishers, 1975), 36; Francis Franklin, 'The Cultural Heritage of the Negro People', *The Communist* 18, no. 6 (June 1939): 563–71.

128 However, when realised, such murals were not necessarily safe. Eitaro Ishigaki's two murals for the Harlem courthouse, *Human Rights in the United States* and *Emancipation of Negro Slaves*, were removed in 1938, both because the artist was technically Japanese and because his images of Washington and Lincoln were deemed unacceptable by the Municipal Art Commission. See Louise Mitchell, 'The Fight for Negro Liberation', *DW*, 5 April 1938; Museum of Modern Art, Wakayama, *Japan in America*, 47–9, 108, 117.

129 For a general account, see Greta Berman, 'Abstractions for Public Spaces, 1935–1943', *Arts Magazine* 56, no. 10 (June 1982): 81–6; Brooklyn Museum, *The Williamsburg Murals: A Rediscovery* (nd); Olin Dows, 'Art for Housing Tenants', *MA* 31, no. 11 (November 1938): 616–23, 662.

130 Talbot Faulkner Hamlin, 'New York Housing', *Pencil Points* 19, no. 5 (May 1938): 286–92; Robert A. M. Stern, Gregory Gilmartin, Thomas Mellins *et al.*, *New York 1930: Architecture and Urbanism Between the Two World Wars* (New York: Rizzoli, 1994), 495, 497–8.

131 In 1940 Browne joined the faculty of the American Artists' School – *DW*, 12 January 1940.

132 Burgoyne Diller, 'Abstract Murals', in O'Connor (ed.), *Art for the Millions*, 69. The artists' belief that their work complemented the 'true modern utilitarian style' of the project is confirmed by Hananiah Harari's report, 'Who Killed the Home Planning Project?', *AF* 3, no. 8 (November 1937): 13–15.

133 Greene, 'The Functions of Léger; Abstract Art at the Modern Museum', *AF* 2, no. 5 (April 1936): 5–8; 'Society and the Modern Artist', in O'Connor (ed.), *Art for the Millions*, 263–5. Greene's position on the artist and the crowd is strikingly akin to that of Gleizes and Metzinger's 'Du Cubisme'. See Robert L. Herbert (ed.), *Modern Artists on Art* (Englewood Cliffs, N.J.: Prentice-Hall, 1964), 18.

134 Davis, 'Abstract Painting Today', in O'Connor (ed.), *Art for the Millions*, 121–7. The Democratic Front positioning of the text is even more evident in the earlier version printed by O'Connor (122n), with its attacks on cultural institutions and reference to 'tory reaction'. For *Swing Landscape*, see Metropolitan Museum of Art, *Stuart Davis*, 235–9. The painting was to have been installed with the panels by Paul Kelpe.

135 In notes dated 9 March 1938, Davis specifically criticises Greene for accepting a narrow audience for his art and refusing to work for a People's Art through a United Front (Davis Papers, HU). It is difficult to tell whether for him the substance of Greene's 'Trotskyism' amounted to more than denying 'the leadership of the Communist Party in the political field'. For the Democratic Front and Swing, see Denning, *Cultural Front*, chs 8–9. Davis had a swing band play at the opening of his 1943 exhibition at the Downtown Gallery, so that 'guests would see how the irregular geometrical shapes and piebald colors of his compositions . . . echo the rhythms and tempo of swing music' – Emily Genauer, 'Two Americans Give Solo Shows', *NYWT*, 6 February 1943.

136 'Symbols of the Radio', *SW*, 17 December 1939; Eric Munx, ' "Uncensored" Radio – A Myth', *DW*, 4 January 1940. On the WNYC mural, see Metropolitan Museum of Art, *Stuart Davis*, 239–40.

137 Edward Alden Jewell, 'Commentary on Murals', *NYT*, 29 May 1938.

138 Elaine de Kooning, 'Greene Paints a Picture', *AN* 53, no. 3 (May 1954): 48.

139 Newark Museum, *Murals Without Walls: Arshile Gorky's Aviation Murals Rediscovered* (catalogue by Ruth Bowman; Newark, N.J., 1978).

140 Jewell, 'Commentary on Murals'.

141 Tenants' Council of Williamsburg Houses to Harry Hopkins, 20 May 1938 (AAA DC90:1080).

142 Emily Genauer, 'New Horizons in American Art', *P* 8, no. 5 (October 1936): 5–7. Cf. 'Meet Uncle Sam, World's Greatest Collector of a Nation's Art', *AD* 11, no. 1 (1 October 1936): 5.

143 Benson, 'Art on Parole', 770.

144 For the context of the Massachusetts project, see Edith A. Tonelli, 'The Avant-Garde in Boston: The Experiment of the

WPA Federal Art Project', *AAAJ* 20, no. 1 (1980): 18–24. For *New York: Wedding in South Street*, see Louis Guglielmi, 'After the Locusts', in O'Connor (ed.), *Art for the Millions*, 113–14.

145 For Gross-Bettelheim, see Robinson and Steinberg (eds), *Transformations in Cleveland Art*, 142, 187, 230; for Rutka, see ibid., 140, 190–91, 235. For Grambs, see James Wechsler, 'The Great Depression and the Prints of Blanche Grambs', *Print Quarterly* 13, no. 4 (1996): 376–96. Both Grambs and Gross-Bettelheim were CP members.

146 Noble, 'New Horizons'; Davis quoted in 'Opinion Under Postage', *NYT*, 27 September 1936. Davis's letter was in response to Jewell's review, 'Extending Our Horizons', *NYT*, 20 September 1936.

147 'An Art Gallery for the People', in WPA FAP, *40 Exhibitions at New York's Federal Art Gallery: A Preview of the Art of the Future* (1939), 1–3 (Cahill Papers, AAA 1107:585–629). The opening of the new gallery and its decor are described in Jacob Kainen, 'Federal Art Gallery', *DW*, 16 October 1937.

148 E.g., 'Art Holiday Exhibit of Best of Children's Work', *DW*, 20 December 1938; 'WPA Art Exhibit Shows Rare Talents of East Side Kids', *SW*, 28 May 1939; Marcia Minor, 'Harlem's Community Art Center', *DW*, 1 August 1938, 2 August 1938. A listing of FAP exhibits in the city of 1939 is remarkably extensive: 'Variety of Art Shows Offered by Project', *DW*, 5 October 1939. For the Harlem CAC, see Tyler, 'Artists Respond to the Great Depression and the Threat of Fascism', ch. 5.

149 WPA FAP Federal Art Gallery, *Exhibition of Oil Paintings* (New York, 23 February – 23 March 1937) (Harriton Papers, SU, Box 2).

150 Former JRC exhibitors included Mark Baum, Remo Farrugio, Guglielmi, Guy, Harriton, Daniel Koerner, Kopman and Ribak. Harriton's *Astoria Shipbuilding* (19) may be related to the *Astoria Landscape* of which there is a photograph in a 1936 scrapbook in the Harriton Papers (SU).

151 *Direction*, April 1938. The letter is printed in Rutgers University Art Gallery, *O. Louis Guglielmi*, 16; Guglielmi, 'After the Locusts', 114–15. Strangely, the *Daily Worker's* review did not approve of *Sisters of Charity*, describing it as 'vicious in a crude and unimaginative manner' – [Jacob Kainen?], 'WPA Artists Exhibit Work', *DW*, 9 March 1937.

152 In addition to Gottlieb and Rothko, the future Abstract Expressionists were represented by de Kooning and Pollock. A copy of the catalogue is in the Harriton Papers, SU, Box 1. Photographs of a number of works from the exhibition are in the WPA Photo Archive, AAA 1162–74.

153 Jacob Kainen, 'Art Project Presents Work by WPA Easel and Water Color Painters', *DW*, 5 May 1938; unidentified clippings in Guglielmi's scrapbook (AAA N69-119:239). Cf. 'Uncle Sam's Xmas Gift by a WPA Investigator', *SW*, 20 December 1936.

154 Lydia Paul, '"Eight" Exhibit Stimulating', *DW*, 28 May 1938.

155 Dervaux, 'The Ten', 14; Robert Godsoe, 'A Project for the People', *AF* 3, nos 3–4 (April–May 1937): 10–11; M. D., 'The Easel Division of the WPA in its Last Seasonal Show', *AN* 36, no. 32 (7 May 1938): 17.

156 A copy of the catalogue is in NARA RG69: 1031, Box 65.

157 AAA DC90:188–99; DC91:404–14, 415–27, 429–41; DC89:1241–9, 1350–67, DC90:8–17.

158 Audrey McMahon to Paul Edwards, 31 May 1939 (Weekly Letter), AAA DC91:771.

159 There is some record of institutional allocations in the Weekly Progress Reports. For perceived relations between WPA commissions and receiving institutions, see *The WPA Federal Art Project: A Summary of Activities and Accomplishments* (mimeo, New York, 1938) (AAA DC89:217–41).

160 Jacob Kainen, 'Art Project Exhibits Work', *DW*, 5 March 1936.

161 Seaton, 'Federal Prints and Democratic Culture', 6, 80–100; Jacob Kainen, 'The Graphic Arts Division of the WPA Federal Art Project', in O'Connor (ed.), *New Deal Art Projects*, 155–75.

162 Hyman Warsager, 'Graphic Techniques in Progress', in O'Connor (ed.), *Art for the Millions*, 139. Cf. American Artists' Congress, *America Today: A Book of 100 Prints*, 5–10.

163 'Chronology' and Biographical Statement (1973), Elizabeth Olds Papers, AAA 2976:5–11, 12–14; Paul Andrews, 'Interviewing Elizabeth Olds: An Artist and Organizer', *DW*, 23 December 1941.

164 Elizabeth Olds, 'Prints for Mass Production', and Mabel Dwight, 'Satire in Art', in O'Connor (ed.), *Art for the Millions*, 142–4, 151–4. For a longer version of Olds's text, see AAA 2976:200–06. Cf. Harry Gottlieb: 'The taste of the majority of the people, in particular those in the low income groups is on the 5 & 10 store level, where they can buy, at a cost, commensurate with their income, a vulgarized form of upper class culture. This is not their fault. The limited art, available to the people, is an expression of their economic and social condition and not an expression of their cultural aspirations.' (*sic*) From fragment of a handwritten text on the artist and society, c. 1940, Gottlieb Papers, AAA 3889:799–814.

For Dwight, see Susan Barnes Robinson and John Pirog, *Mabel Dwight: A Catalogue Raisonné of the Lithographs* (Washington, D.C.: Smithsonian Institution Press, 1997). Ill-health and deafness meant Dwight was little involved with the workshop.

165 Lynd Ward, 'Printmakers of Tomorrow', *P* 11, no. 3 (March 1939): 8–12.

166 Jacob Kainen, 'Federal Art Project Achieves Renaissance in Lithography', *DW*, 27 January 1938. Cf. Joseph Leboit and Hyman Warsager, 'The Graphic Project: Revival of Print Making', *AF* 3, no. 8 (November 1937): 11.

167 Russell T. Limbach, 'Lithography: Stepchild of the Arts', in O'Connor (ed.), *Art for the Millions*, 145–7. There is an extensive collection of Limbach's colour prints at the Davison Art Center, Wesleyan University, Middletown, Conn.

168 'Packing Plant Art is Shown', *Omaha World Herald*, nd (1935), AAA 2976:251.

169 Olds and Gottlieb both showed lithographs of bootleg mining in the American Artists' Congress *America Today* exhibition. Gottlieb recalls the mining trip in Stephen Neil

Greengard, 'Ten Crucial Years: A Panel Discussion by Six WPA Artists', *Journal of Decorative and Propaganda Arts* 1 (spring 1986): 54–6. See also Art Shields, 'He Painted Miners', *People's World Magazine*, 30 March 1974. Contemporaneously, Harry Sternberg used a Guggenheim Fellowship to make a series of prints of coal mining and steel production in Pennsylvania. See Edwin A. Ulrich Museum of Art, *Harry Sternberg*, nos 133–51, 158; and Wechsler, 'The Great Depression and the Prints of Blanche Grambs', 386–8.

170 ACA Gallery, *Steel: Drawings by Elizabeth Olds* (New York: 1937); Elizabeth McCausland, 'Steel Mill Drawings by Elizabeth Olds', *SSUR*, 5 December 1937 (AAA 2976:249).

171 'Autobiographical Sketch', Gottlieb Papers AAA D343: 507–30; Forbes Watson, 'Harry Gottlieb', *The Arts* 15, no. 2 (February 1929): 99–102. For Gottlieb on realism, see AAA 3889:803, 1090–95.

172 ACA Gallery, *Paintings by Harry Gottlieb* (New York: 1937), AAA 3890:210–11.

173 *Sweat Shop, Case No . . . , Mine Disaster, Bombing*. Examples of each are in the Newark Museum WPA print collection.

174 Elizabeth McCausland, 'Silk Screen Color Prints', *P* 12, no. 3 (March 1940): 35.

175 Anthony Velonis, 'A Graphic Medium Grows Up', in O'Connor (ed.), *Art for the Millions*, 154–6; Elizabeth Olds, 'The Silk Screen Group', typescript in Olds Papers, AAA 2976:193–8. See also Reba and Dave Williams, 'The Early History of the Screenprint', *Print Quarterly* 3, no. 4 (December 1986): 286–321.

176 'WPA Project Developed Silk Screen Art', *DW*, 7 March 1940; Oliver F. Mason, 'Exhibit of Silk Screen Color Prints at ACA', *DW*, 5 March 1940; McCausland, 'Silk Screen Color Prints'; 'Silk Screen Art at Springfield Museum', *SSUR*, 10 March 1940.

177 Velonis, quoted in 'Silk Screen', *NM* 35, no. 1 (26 March 1940): 30.

178 Autobiographical Notes, undated, Gottlieb Papers (AAA 3889:1052).

8 Cultural Organising after 1939

1 Isserman, *Which Side Were You On?* For the postwar period generally, see Joseph R. Starobin's acute and moving study *American Communism in Crisis, 1943–1957* (Cambridge, Mass.: Harvard University Press, 1972).

2 On these issues, see George Lipsitz, *Rainbow at Midnight: Labor and Culture in the 1940s* (Urbana & Chicago: University of Illinois Press, 1994); Dubofsky, *State and Labor in Modern America*, 137–208; Nelson Lichtenstein, 'From Corporatism to Collective Bargaining: Organized Labor and the Eclipse of Social Democracy in the Postwar Era', in Steve Fraser and Gary Gerstle (eds), *The Rise and Fall of the New Deal Order, 1930–1980* (New York & Toronto: Free Press, 1991).

3 Notably in relation to the indictment and prosecution of Minneapolis members of the Trotskyist Socialist Workers Party under the Smith Act in 1941, on which see Isserman, *Which Side Were You On?*, 123–4.

4 On the ALP, see Kenneth Waltzer, 'The Party and the Polling Place: American Communism and an American Labor Party in the 1930s', *Radical History Review* 23 (spring 1980): 104–29; Gerald Myer, 'American Labor Party', in Mari Jo Buhle, Paul Buhle and Dan Georgakas, *Encyclopedia of the American Left* (Urbana & Chicago: University of Illinois Press, 1992), 24–5. For the ALP Artists Committee, see Elizabeth McCausland to Marian Rubin, 27 May 1944 (copy), and documents relating to the ALP in Box 35, McCausland Papers, unfilmed.

5 The New York Citizens Emergency Committee to Aid Strikers' Families was transparently a creation of pro-labour elements in the ICCASP. For a listing of the artists' division, see letterhead of Frank Kingdon to Anton Refregier, 11 February 1946 (Refregier Papers, AAA, Box 1a, 'Correspondence c.1950').

6 For American-Soviet Friendship, see Buhle *et al.* (eds), *Encyclopedia of the American Left*, 29–32.

7 Copy of Call for the Congress, 'In Defense of Culture' (Gottlieb Papers, AAA D343: 64–6); American Artists' Congress, *In Defense of Culture* (New York, 1941), 11.

8 On the background to this, see Norman Barr to Rockwell Kent, 19 January 1942 (Daniel Koerner Papers, AAA 1337: 801–2). For the disaffiliation, see the correspondence between Lewis Merrill (President of the UOPWA) and Barr and Kent also in this collection (AAA 1337:803–24). For Merrill as a fellow-traveller, see Gary M. Fink (ed.), *Biographical Dictionary of American Labor* (Westport, Conn., & London: Greenwood Press, 1984), 403–4.

9 *Joint Bulletin of the American Artists' Congress and the United American Artists*', May 1942 (Gottlieb Papers, AAA D343: 22–5); draught of letter from Harry Gottlieb to [Richard] Carline (AAA 3889:332); Charles Humboldt, 'What the Artists Want', *NM* 43, no. 11 (16 June 1942): 26–7.

10 Mimeographed flier, 'Your Program for 1944' (Kent Papers, AAA, Box 4).

11 Flier in Charles Keller Papers (AAA).

12 Lynd Ward to Rockwell Kent, 10 December 1944; cf. Kent to Suzanne Noble, 19 December 1944 (copy); Kent to Ward, 7 May 1946 (copy; Kent Papers, AAA, Box 4).

13 It did have friendly relations with similar groups in Cleveland and Chicago. See Rockwell Kent to Leon G. Miller of Artists for Action, Cleveland, 19 November 1946 (copy); correspondence from Harold Hayden to Kent, 1946, on paper of ALA Chicago (Kent Papers, AAA, Box 4).

14 Rockwell Kent to Alvena Seckar, 15 March 1945 (copy). A month earlier, Kent wrote to the ALA executive secretary Suzanne Noble regretting that 'we have so few artists of established reputations in our membership' – Kent to Noble, 10 February 1945 (copy). By contrast, leading figures on the executive such as Lynd Ward and Norman Barr wanted to create a '*mass*, broad, rank & file included, progressive, anti-fascist art organization' – Barr to Kent, 24 January 1947 (Kent Papers, AAA, Box 4).

15 Rockwell Kent to Harold Hayden, 30 November 1946 (copy); Kent to Leon G. Miller, 19 November 1946 (copy; Kent Papers, AAA, Box 4).

16 As Ward noted in a letter to Kent of 10 December 1944 (Kent Papers, AAA, Box 4). Artists for Victory (of which ALA was a member body) came out of a grouping called Artists Societies for National Defense, formed in late 1941. Although Gellert was one of three vice-presidents, according to him the organisation was dominated by the National Academy of Design and the Architectural League. The ALA resigned from the body in early 1945 because conservative architects blocked 'every effort of artists to project a progressive war program'. See Hugo Gellert to V. Bazykin, 30 July 1943 (copy); typescript draught of letter attacking William Gropper's acceptance of the vice-presidency of Artists for Victory, 4 April 1945; draught of 'An Open Letter to the President of Artists for Victory', nd (Gellert Papers, AAA, Box 2); Minutes of ALA Executive Meeting, 21 February 1945 (Ward Papers, AAA 4466:196); Ellen G. Landau, *Artists for Victory* (Washington, D.C.: Library of Congress, 1983).

17 For copies, see Ward Papers, AAA 4466:281–3, 320–30; 141:1249.

18 Norman Barr to Rockwell Kent, 24 January 1947 and 9 June 1947 (Kent Papers, AAA, Box 4); 'ALA Gallery', *ALA Newsletter* (1948) (AAA 4466:281). The catalogue to an ALA exhibition in the Ward Papers (AAA 141:1243) includes works by Harari, Hirsch, Levine and Reinhardt, with some by less well-known figures.

19 '"This Is Our War"', *ALA News* no. 2 (1943); Robert Gwathmey to Rockwell Kent, 5 November 1943; Kent to Gwathmey, 10 November 1943 (copy) (Kent Papers, AAA, Box 4).

20 Catalogue in Keller Papers (AAA).

21 See Moses Soyer, 'In the World of Art', *NM* 55 no. 13 (26 June 1945): 29; 'The Passing Shows', *AN* (15–31 May 1945): 6.

22 Marion Summers, 'Art Today: Roll Call of Honor', *DW*, 8 December 1946.

23 Cf. Philip Evergood to Anton and Lila Refregier, 13 January 1946 [actually 1947]: 'I think its weakness lies in the fact that 30% of its membership are not professional artists' (Refregier Papers, AAA).

24 'Preparatory Material for the Exhibition Art a Weapon for Total War', 5pp statement (Victory Workshop File, Tamiment Institute Library, NYU); 'Art, a Weapon for Total War', *ALA News* no. 2 (1943) (Kent Papers, AAA, Box 4).

25 For a list of Victory Workshop members, see 'Greetings', *ALA News* no. 1, 1945 (Kent Papers, AAA, Box 4).

26 Charles Keller to Rockwell Kent, 22 October 1947 (Kent Papers, AAA, Box 4). An exhibition of work by the Taller de Grafica Popular was shown at the Tribune Subway Gallery in 1949 – see Charles Corwin, 'An Exciting Exhibition of Mexican People's Art', *DW*, 30 September 1949.

27 *Gazette: Bulletin of the Workshop of Graphic Art* no. 1 (May–June 1948); 'A New Step in American Art', undated mimeographed statement (Tamiment Institute Library, NYU); Charles Keller to Rockwell Kent, 22 October 1947 (Kent Papers, AAA, Box 4).

28 It also produced a series of eight woodcuts titled *Jimcrow – A Government Policy*, published by the Civil Rights Con-gress. Four are illustrated in *M&M* 3, no. 7 (July 1950). See also Angelica Kaufman, 'The Graphic Workshop and its First Portfolio', *DW*, 20 December 1948; 'A Centuries-Old Form Aids Negro People's Fight', *DW*, 22 February 1950.

29 Frasconi, one of the most gifted graphic artists associated with the Communist movement in the postwar years, was born in Buenos Aires and spent most of his life in Uruguay before emigrating to the United States in 1945. See *NM* 59, no. 5 (30 April 1946): 25; Antonio Frasconi, *Frasconi: Against the Grain* (New York: Macmillan, 1974).

30 Rockwell Kent to Charles Keller, 30 October 1947 (copy); Kent to Leon G. Miller, 19 November 1946 (copy; Kent Papers, AAA, Box 4); Kent to Keller, 26 January 1949 (Keller Papers, AAA).

31 Charles Keller, interview with the author, 23 June 1992.

32 Fraser, *Labor Will Rule*, 517–26; Isserman, *Which Side Were You On?*, 208–13.

33 See e.g. William L. O'Neill, *A Better World: The Great Schism: Stalinism and the American Intellectuals* (New York: Simon & Schuster, 1982), 144; David A. Shannon, *The Decline of American Communism: A History of the Communist Party of the United States since 1945* (London: Stevens & Sons, 1960), 390 n. 25. Having said this, a sense of the CP presence within ICCASP is given by the fact that members were urged to join a special cultural division on the 1946 May Day parade – see 'Fall In!', *NM* 59, no. 5 (30 April 1946): 7.

34 On the formation of the ICCASP, see 'International Cultural Cooperation on Way', *The Independent* 2, no. 1 (27 April 1945).

35 I take the term 'social liberalism' and this interpretation from Norman D. Markowitz's important study *The Rise and Fall of the People's Century: Henry A. Wallace and American Liberalism 1941–1948* (New York & London: Free Press, 1973). For the 1930s, see Frank A. Warren, *Liberals and Communism: The 'Red Decade' Revisited* (Bloomington: Indiana University Press, 1966).

36 Independent Voters Committee of Arts and Sciences for Roosevelt, *Report of Election Campaign Activities of IVCASR* (nd, 1944); circular letter from Jo Davidson to Miss Estelle Sternberg, 3 August 1944 (Gellert Papers, AAA, Box 4, 'Printed Material 1944–45'; Box 1, 'Letters 1944–45'). Tallulah Bankhead, Ethel Barrymore, Van Wyck Brooks, Thomas Hart Benton and Robert Flaherty were among the initiating sponsors. Amongst IVCASR's activities were a production 'Broadway for Roosevelt' and a 'Tribute to Roosevelt' art exhibition.

37 Davidson, *Between Sittings*; 'Jo Davidson', *Current Biography – 1945* (1946): 134–8. Jo Davidson to 'Louis' (copy), 10 November 1949; Florence Davidson to Thierry Trilling (copy), 3 November 1949; Davidson to Hannah [Dorner?], 26 December 1949 (Davidson Papers, Library of Congress, Box 7).

The Harvard astronomer Harlow Shapley, who played a considerable role in both the ICCASP and its successor, the NCASP, was also an outspoken supporter of American–Soviet friendship but, like Davidson, Shapley voiced occasional criticisms of the USSR, and particularly of its treatment of

scientists. See 'Dr. Shapley Attacks Political Pressure on Soviet Astronomy', 2pp press release of 15 August 1949, in Harlow Shapley Papers (HU 4773.80), file 'Political – Rankin et al., Mostly 1947'.

38 'Sculptor Jo Davidson, Amateur Politician', *Time* 48, no. 11 (9 September 1946): 9. Davidson's portrait appeared on the cover together with a satirical cartoon, which set the tone for *Time's* report. Davidson is quoted as saying of the founders of IVCASR: 'We were mostly virgins in things political.' Davidson to Babette Deutsch (copy), 28 July 1945; Davidson to Morris Llewellyn Cooke (draught), nd (Davidson Papers, Library of Congress, Box 8).

In the aftermath of the 1946 mid-term elections, Cooke outraged Davidson by proposing that all ICCASP employees whose past might make them look like fellow-travellers be fired. See Cooke to Davidson, 21 November 1946; 26 November 1946; 27 December; 7 February 1947; 5 March 1947; and Circular letter to the Philadelphia Chapter of ICCASP, 24 December 1946 (Davidson Papers, Library of Congress, Box 5).

39 *The Independent* 2, no. 1 (27 April 1945); ICCASP, '. . . *but when the ballots are cast, your responsibilities do not cease . . .*' (late 1944); *By-Laws of Independent Citizens' Committee of the Arts, Sciences and Professions, Inc.* (Kent Papers, AAA, Box 27); Editorial, *The Independent* (13 February 1946). A good idea of the range and nature of ICCASP is given by the newsletter *January 1945 – June 1946: The History of the First Eighteen Months of the Independent Citizens' Committee of the Arts, Sciences and Professions* (Shapley Papers, HU, Box 10e, 'Newspaper Clippings').

40 The ALA advertised the National Wartime Conference of the Professions, the Arts, the White Collar Fields in its newsletter in 1943, and printed the call for ICCASP in 1945. See *ALA News* no. 3 (1943); *ALA News* no. 1 (1945). The Art Division executive included, among others, Weber, Evergood, Gág, Gellert, Gross, Gwathmey, Oliver Larkin and McCausland.

In its initial form as IVCASR, ICCASP already involved Communist and fellow-travelling artists. An ICVASR pamphlet from late 1944, *The President's Speech, Illustrated by Nineteen Artists*, printed the text of an address by Roosevelt to the Teamsters' Union, accompanied with drawings by Becker, Dehn, Ellis, Gropper, Johnson, Markow, Refregier, Reisman, Schreiber, Sternberg and Ward.

41 Rockwell Kent to Suzanne Noble, 10 February 1945 (copy); Kent to Lynd Ward, 2 March 1945 (copy); Alvena Seckar to Kent, 12 March 1945; Daniel Koerner to Kent, 21 August 1948; Kent to Koerner, 23 August 1948 (copy); Kent to Norman Barr, 6 May 1949 (copy; Kent Papers, AAA, Box 4).

42 ICCASP, *A Program for American Artists* (nd; Gellert Papers, AAA, Box 4, 'Printed Material, 1944–45'); *The Independent* (13 February 1946); *The Independent* 2, no. 5 (15 June 1946).

43 E.g., Allan Chase, 'Spain: Incubator of World War III', *The Independent* (October 1945): 4; Ray Josephs, 'The Argentine See-Saw', *The Independent* (June 1945): 4–5; 'Yalta Calling Frisco! An Editorial', *The Independent* (June 1945): 3. On US hegemonic ambitions, see Melvyn P. Leffler, *A Preponderance of Power: National Security, the Truman Administration, and the Cold War* (Stanford University Press, 1992).

44 ICCASP, *Report of Congress of Progressives . . . 1946* (nd, 1946), 8.

45 On these developments, see Alonzo P. Hamby, *Beyond the New Deal: Harry S. Truman and American Liberalism* (New York & London: Columbia University Press, 1973), ch. 6; Markowitz, *Rise and Fall of the People's Century*, ch. 6; Norman Markowitz, 'A View from the Left: From the Popular Front to Cold War Liberalism', in Robert Griffith and Athan Theoharis (eds), *The Specter: Original Essays on the Cold War and the Origins of McCarthyism* (New York: New Viewpoints, 1974), 90–115; and Sullivan, *Days of Hope*, ch. 8. In May 1947 PCA had only 17,000 paid-up members, but a reduction in dues led to a large influx which by mid-September had raised this figure to more than 47,000 – 'Minutes of Meeting of Board of Directors of PCA, 4 October 1947' (Shapley Papers, HU, Box 10c, 'Progressive Citizens of America – Unsorted').

46 The CP supported the third-party movement as the 'first stage of a far-reaching political realignment', but was critical of some aspects of Wallace's position on the USSR and the economy. See William Z. Forster, 'Organized Labor and the Marshall Plan', *PA* 27, no. 2 (February 1948): 107–9; Max Weiss, 'Henry Wallace's "Toward World Peace"', *PA* 27, no. 5 (May 1948): 400–11.

The relationship between the CP and the new party is best discussed in Markowitz, *Rise and Fall of the People's Century*, 253–6, 268–71, 284–9. See also Starobin, *American Communism in Crisis, 1943–57*, 173–94; and Curtis D. MacDougall, *Gideon's Army* (3 vols, New York: Marzani & Munsell, 1965).

47 For some account of the PCA art division, see Frances K. Pohl, *Ben Shahn: New Deal Artist in a Cold War Climate 1947–1954* (Austin: University of Texas Press, 1989), 34–7.

48 See Montgomery Museum of Fine Arts, *Advancing American Art: Politics and Aesthetics in the State Department Exhibition, 1946–8* (Montgomery, Ala., 1984).

49 Art Division of New York State PCA, *The State Department and Art, Report of the Artists' Delegation to Washington* (nd; Tamiment Institute Library).

50 Programmes of the Conference and the Art Panel, in Harlow Shapley Papers, HU, Box 10c, 'Progressive Citizens of America – Unsorted'. For the Call to the conference, and list of sponsors, see McCausland Papers, AAA D374:420–21.

51 'ASP Defined', *Uncensored* no. 1 (July 1948): 6. *Uncensored* was published by the New York State Council of the ASP.

52 *A Platform for Artists: The Federal Fine Arts Program of the New York State Art Division, National Council of the Arts, Sciences and Professions* (pamphlet, 1948). Kent seems to have been active in achieving this, and spoke before the Platforms Committee of the party at Philadelphia. See 'Proposal for New Party Cultural Plank' (Kent Papers, AAA, Box 13, 'Culture 1948–9'). In the event the New Party adopted planks calling for a Department of Education, Arts and

Sciences, and a Department of Culture. The place of the Department of Fine Arts within the two was left unclear.

53 'Artists for Wallace', Circular Letter, undated; Lynd Ward to Louis Lozowick, 21 June 1948 (Lozowick Papers, unfilmed, AAA). Cf. 'Form Writers' Wallace Group', *DW*, 21 September 1948.

54 Cf. the list of sponsors in the advertisement for 'Arts, Sciences, and Professions for May Day', *DW*, 30 April 1948.

55 See e.g. 'Thousands Parade, Pray, Jeer At Park Ave.'s Little Kremlin', *Daily News*, 26 March 1949. There was extensive coverage of the Conference in the *Daily Worker*, see editions of 28 March 1949, 29 March 1949, 30 March 1949, and *SW*, 10 April 1949. David Caute, *The Great Fear: The Communist Purge Under Truman and Eisenhower* (New York: Simon & Schuster, 1978), 251–4.

56 Stanley Mitchell, 'The Wroclaw Conference', unpublished paper delivered at the 'Cold War Culture' conference, University College London, October 1994.

57 Davidson to Paul [Nelson], 24 February 1948; Louis Aragon to Davidson, 19 January 1949 (Davidson Papers, Library of Congress, Box 7); 'Poland at Home and Abroad', *Poland Today* 3, no. 10 (October 1948): 13–16. By contrast, Harlow Shapley refused to be co-opted to the Wroclaw continuing committee. See Shapley to Dorothy Canfield Fisher, 15 March 1949 (copy; Shapley Papers, HU, Box 10c, 'Peace Conference').

58 Daniel S. Gillmor (ed.), *Speaking of Peace* (New York: National Council of Arts, Sciences and Professions, 1949), 1. Artists among the latter included Abott, Burliuk, Cikovsky, Dehn, Evergood, Gottlieb, Gropper, Gross, Gwathmey, Hirsch, Johnson, Kent, Levine, Olds, Pereira, Refregier, Reinhardt, Siporin, Raphael Soyer, Strand, Weber and Ben-Zion.

59 O'Neill, *A Better World*, 164.

60 Harlow Shapley, 'A Sick Civilization'; Frederick L. Schuman, 'American–Soviet Relations'; T. O. Thackrey, 'America's "Cold War" Foreign Policy'; and Norman Cousins, 'A Dissenting Opinion', in Gillmor (ed.), *Speaking of Peace*, 5–6, 7, 9, 20–23. I. F. Stone attacked the restrictions on press freedom in the Eastern *bloc* in the panel on Mass Communications (105–6), and Norman Mailer went even further in that on Writing and Publishing, criticising the United States and USSR as both 'moving radically towards state capitalism' (83). For the Communist Party, the Conference was far too even-handed; see Howard Fast, 'Cultural Forces Rally Against the Warmakers', *PA* 28, no. 5 (May 1949): 29–38. Even the National Executive Committee of NCASP passed a motion (seconded by Paul Strand) to condemn NATO because the Conference Resolutions had not done so: 'Minutes of the National Executive Committee Meeting of NCASP', 6 April 1949 (Shapley Papers, HU, Box 10c, 'NCASP').

61 For the debate on 'Intellectual Freedom in the Soviet Union', see Gillmor (ed.), *Speaking of Peace*, 85–8. Shapley had hoped to have 'the other side' represented in the panels: see Shapley to Maxine Wood, Conference Director, 6 January 1949 (copy; Shapley Papers, HU, Box 10b, 'Maxine Wood').

62 E.g., Ralph M. Pearson, 'A Modern Viewpoint', *AD* 23, no. 14 (15 April 1949): 21, 31. On the financial crisis of NCASP, see Clark Foreman to Harlow Shapley, 14 September 1949, which mentions debts of more than $25,000 (Shapley Papers, HUG, Box 10b, 'Clark Foreman').

63 Starobin, *American Communism in Crisis*, ch. 8; Michael Bellknap, *Cold War Political Justice: The Smith Act, the Communist Party, and American Civil Liberties* (Westport, Conn. & London: Greenwood Press, 1977), ch. 7. Bellknap says the Party still had a membership of 54,174 at the end of 1949, but that this had dropped to 24,796 by early 1953 (190). See also Healey and Isserman, *Dorothy Healey Remembers*, 125–32.

64 Norman Barr to Rockwell Kent, 24 January 1947 (misdated 1945; Kent Papers, AAA, Box 4, ALA file). Describing the setting up of the AEA in a letter to Anton Refregier of 13 January 1947, Evergood wrote that 'some of the people who have been meeting' were Gottlieb, Gwathmey, Hirsch, Frank Kleinholz, Kroll, Kuniyoshi, Sidney Laufman, Levine, Peppino Mangravite, Katherine Schmidt and himself (Refregier Papers, AAA, Box 17). See also Hudson D. Walker, 'Artists Equity', *MA* 40, no. 5 (May 1947): 188; *AEA Newsletter* 1, no. 4 (June 1948): 1; *AEA Newsletter* 2, no. 3 (June 1949): 1.

65 Article X of the Constitution of the Chicago AEA (AAA D343:338). Cf. AEA circular letter from Leon Kroll and Yasuo Kuniyoshi [nd, 1949]: 'We all know that nothing political is permitted to enter our organization. That prohibition is the cornerstone of our organization' (Toney Papers, SU, Box 1, Undated Correspondence).

66 *AEA Newsletter* (May 1947): 1–2; *AEA Newsletter* 1, no. 4 (June 1948): 2; 'Resolution proposed by Jack Levine, Director, at the Annual Meeting held in New York City on Friday, April 28' (1950; Gottlieb Papers, AAA, D343:298). Cf. anonymous to Hudson Walker (Walker Papers, AAA, D355:1246).

67 *Congressional Record* 95, part 3 (1949): 3233–5. On the travails of the NCASF, see Caute, *The Great Fear*, 175–6. Presumably as a result of Dondero's speech, AEA was listed in a 'Guide to Subversive Organizations and Publications' prepared by the House Committee on Un-American Activities in 1951, which was taken as authoritative by the FBI: see FBI file of Charles White.

68 Minutes of AEA Board of Directors, 6 April 1949 (AAA D343:323).

69 *Exhibition of Paintings and Sculpture by Members of the New York Chapter of Artists Equity Association for the Building Fund*, Whitney Museum, 28 May – 10 June 1951; Mara Leff, MS 'History of the NY Chapter of AEA, 1949–59'; information from files of AEA, 498 Broome Street, New York. I am grateful to Mara Leff for showing me the AEA files and discussing these developments with me.

70 *NY Artists Equity Workshop, 1952–3*, pamphlet in AEA files.

71 Confidential Circular from Lincoln Rothschild, executive director of AEA, to Membership, New York Chapter, 1 June 1953 (AEA files).

72 John S. Wood, Chairman of HUAC, quoted in Caute, *The Great Fear*, 43. On the right's campaign against the UN, see

ibid., ch. 16. Cooperation with UNESCO had been AEA policy from the beginning: see *AEA Newsletter* (May 1947): 3. Cf. Mary Turley Robinson to Hudson Walker, 27 January 1952 (AAA D355:1220). The open letter and the Museum's response are printed in 'Letters', *AD* 27, no. 11 (1 March 1953): 4, 19. See also 'Minutes – Board of Directors Meeting – March 16, 1953' (D355:1233–4). For the furore around the competition, see Sidney Geist, 'Monumental Contest: US Entries', *AD* 27, no. 9 (1 February 1953): 9; 'Editorial: Unfair! Unfair!', *AD* 27, no. 10 (15 February 1953): 5, and 'Letters' in *AD* 27, no. 11 (1 March 1953): 4, 19; *AD* 27, no. 12 (15 March 1953): 5–6; AD 27, no. 13 (1 April 1953): 4. For the competition, see Robert Burstow, 'The Limits of Modernist Art as a "Weapon of the Cold War": Reassessing the Unknown Patron of the Monument to the Unknown Political Prisoner', *Oxford Art Journal* 20, no. 1 (1997): 68–80; and 'Modern Public Sculpture in "New Britain", 1945–1953', PhD thesis, University of Leeds, 2000.

73 'Artists Equity Decides', *AN* 53, no. 3 (May 1954): 66. The 67th Street building was sold in that year. Differences between the New York AEA and the national organisation finally led to a split between them in 1965. Information from Leff, 'History of the NY Chapter of AEA'.

74 'Equity' – manuscript notes in the Harry Gottlieb Papers, probably for an address to a CP artists' club (AAA 3889: 885–98). They are datable through their reference to the Eisenhower administration.

75 On which, see Cochran, *Labor and Communism*, chs 10–12.

76 For autobiographical statements in the Refregier Papers, see 'Getting Along' (AAA, Box 11); typed chronology of 1968 (Box 4a); Anton Refregier to Miss Hasten, 22 January 1938, copy (Box 2); 'Record of Mural Jobs', 30 March 1938 (Box 2). See also Gray Brechin, 'Politics and Modernism: The Trial of the Rincon Murals', in Paul J. Karlstrom (ed.), *On the Edge of America: California Modernist Art, 1900–1950* (Berkeley: University of California Press, 1996), 68–93.

77 Refregier statement in ACA Gallery Papers, AAA D304: 1099–1106.

78 I assume the grounding in Communist theory from the sheer volume of Party literature in Refregier's papers. The artist made six visits to the USSR between 1959 and 1974, including one year-long stay in 1973, and remained an apparently uncritical supporter of the Soviet state. See Anton Refregier, *Sketches of the Soviet Union* (Moscow: Progress Publishers, 1978)

79 George Hitchcock, 'The Un-American Murals', *M&M* 1, no. 8 (October 1948): 35.

80 'Class Art', *Fortnight* (30 March 1953): 15.

81 Aline B. Louchheim, 'The Case of a Criticized Mural', *NYT*, 10 May 1953.

82 'American Art in the Deep-Freeze Period', *National Guardian*, 19 September 1949; Lee, *Painting on the Left*, 217–20.

83 'CIO Pickets Will Demand Hearing on Censorship of Rincon Murals', *Labor Herald* 11, no. 47 (20 April 1948); AAA D304:1104–5; Refregier, 'Up Against the Wall', 26–7. See also 'Unions Protest Attempt to Bar Refregier Mural', *DW*,

16 April 1948; 'Union Defends Refregier Murals', *DW*, 14 April 1953.

84 I cannot see this motif as representing the Americanism of the city's Industrial Assocation as Lee does – *Painting on the Left*, 220. While he is correct in saying that the strike was not 'won' as Refregier's panel proclaims, it did lead to long-term gains for waterfront workers.

85 'Let's Throw Red Art Out of Federal Buildings', *The Argonaut*, 14 November 1952.

86 Arthur Caylor's column, *San Francisco News*, 5 November 1951.

87 'Equity Spearheads Defense of Murals at Congressional Sub-Committee Hearing', *AEA National Newsletter*, 6 July 1953. On the reluctance of the local AEA head, see Emmy Lou [Packard] to Anton Refregier, 23 November [1951] (Refregier Papers, AAA, Box 25, Box 4a).

88 'Resolution to Remove Rincon Annex Murals', *Congressional Record* 99, part 2 (1953): 1643; *Congressional Record* 99, part 10 (1953): A2015–6, A2041–2; Aline B. Louchheim, 'Art in Post Office on Coast Debated', *NYT*, 2 May 1953; Louchheim, 'The Case of a Criticized Mural'; 'Leading Citizens Here Join to Defend Refregier Murals', *San Francisco Chronicle*, 30 April 1953; Matthew Josephson, 'The Vandals Are Here: Art is Not for Burning . . .', *The Nation* 177, no. 13 (26 September 1953): 244–8; Richard W. Reinhardt, 'Art Survives an Explosion at the Post Office', *The Progressive* 19, no. 1 (January 1955): 25–7.

 Significantly, *Art News* had published a sympathetic appraisal of the murals in 1949: Amy Robinson, 'Refregier Paints a Mural', *AN* 48, no. 6 (October 1949): 33–4, 55–6; see also 'Editorial: The New Iconoclasts', *AN* 52, no. 4 (June–August 1953): 17.

89 Emmy Lou Packard warned Refregier that the NCASP should not be involved, as they would 'immediately alienate all other groups' – Packard to Refregier, 23 November [1951].

90 Circular Letter from Henry Billings, AEA President, 20 February 1952 (Refregier Papers, AAA, Box 25).

91 Emily Genauer, 'Refregier's Murals Charming', *NYWT*, 8 August 1942.

92 For the subsequent fate of the Rincon Post Office, now part of the multi-use Rincon Center, see Douglas Frantz, *From the Ground Up: The Business of Building in the Age of Money* (New York: Henry Holt, 1991).

93 ACA Gallery, *Anton Refregier: San Francisco* (New York, 1949). Refregier had earlier ACA shows in 1942 and 1945.

94 Richard Graham, 'ACA's Progress: A Gallery on the Move', *AN* 42, no. 10 (1–14 October 1943): 17, 31; Moses Soyer, 'In the World of Art', *NM* 57, no. 4 (23 October 1945): 29.

95 Circular letter from Herman Baron, 2 July 1945 (AAA 3887:388); statement on back cover of *American Contemporary Art* 3, no. 1 (winter 1946).

96 See also Philip Evergood to Anton Refregier, 'Thursday 6' (May 1951?), in which Evergood lays out ideas he and Baron propose for a talk by Refregier (Refregier Papers, AAA, Box 10, 'Correspondence').

97 Herman Baron, 'Diagnosis: Artistic Myopia', *American Contemporary Art* 1, no. 3 (May 1944): 9; pencil notes by Baron from the 1950s (AAA D304:903–18). (In the same

notes Baron observes that the 'germ of regression bit Russia' under Stalin, although he does not date this degeneration precisely.) Draught for the text of ACA, *31 American Contemporary Artists* (1959; AAA D304:882–3). Cf. Herman Baron, 'ACA – A Thriving Art Gallery with a Deep Social Purpose', *SW*, 21 October 1945.

98 *Congressional Record* 95, part 5 (1949): 6372–5; 'Art Gallery Called "Red" Congressman Dondero Says ACA Veils Propaganda', *NYS*, 18 May 1949.

99 Herman Baron, 'American Art Under Attack', typescript (AAA D304:846–52); Herman Baron, 'The ACA Gallery: Impressions and Recollections', in ACA Gallery, *31 American Contemporary Artists* (1959), np (D304:981–1019); Anton Refregier to 'Phil'[ip Evergood], 16 January 1962 (copy; Refregier Papers, AAA, Box 7, 'Correspondence'). There are several versions of Baron's Rosenberg play in the ACA papers (e.g., D304:808–32).

100 'A Year-End Report to National Board Members, December 31 1951'; J. J. Joseph to Harlow Shapley, January 1953 – mimeo report (Shapley Papers, HU, Box 10a, 'NCASP'). Art Division of NCASP, *Artists Bulletin* no. 1 (February 1951); Minutes of ASP Art Division Executive Meeting, 6 September 1951; flier for ASP Graphic Arts Competition and Exhibition (1951; Gellert Papers, AAA, Box 4, 'Printed Material Undated'; Box 5, 'Printed Material 1951').

101 'A Critical Appraisal of the New York Council of ASP, submitted for discussion, March 1953', by Irving Adler, National Director (Shapley Papers, HU, Box 10a, 'NCASP'); mimeo letter from Henry Pratt Fairchild (Chairman) to Anton Refregier, 16 August 1954 (Refregier Papers, AAA, Box 13, 'Correspondence – Mainly 1950s'). Fairchild refers to a debt of about $10,000.

102 One of these was the Art Young Club, set up in 1945. A draught constitution of this (dated 8 December 1945) is in the Gellert Papers (AAA, Box 4, 'Printed Material 1944–45'). Charles Keller has estimated that in the late 1940s there were about 100 CP artists in New York, divided into three clubs and the Photo League. Charles Keller, interview with the author, 23 June 1992.

9 Cultural Criticism between Hollywood and Zhdanovism

1 On this development, see Starobin, *American Communism in Crisis*, ch. 4; and Isserman, *Which Side Were You On?*, ch. 10.

2 George Charney, *A Long Journey* (Chicago: Quadrangle Books, 1968), 154, 157; John Williamson, 'Improve and Build our Communist Press – the Next Step in Party Building', *PA* 25, no. 9 (September 1946): 810–26.

3 Joseph North and A. B. Magil, 'The Struggle for the Urban Middle Class', *PA* 26, no. 7 (July 1947): 527–30; letter from William Z. Foster in 'Mail Call', *NM* 59, no. 6 (7 May 1946): 19. An editorial in *New Masses* in 1945 noted that many of the letters received by the magazine asked for 'more cultural material' – 'Between Ourselves', *NM* 56, no. 2 (18 September 1945): 2.

4 V. J. Jerome, *Culture in a Changing World: A Marxist Approach* (New York: New Century Publications, 1947). On Jerome, see Bernard K. Johnpoll and Harvey Klehr, *Biographical Dictionary of the American Left* (New York, Westport & London: Greenwood Press, 1986), 224–5. For literary representations of the moral turpitude of intellectuals, see Dalton Trumbo, 'Confessional', *Mainstream* 1, no. 1 (winter 1947): 16–22; Alvah Bessie, *The Un-Americans* (London: John Calder, 1957).

5 V. J. Jerome, 'Let Us Grasp the Weapon of Culture', *PA* 30, no. 2 (February 1951): 195–6, 214–15. Subsequently published as a pamphlet *Grasp the Weapon of Culture!* (New York: New Century, 1951), George Charney recalled that the title became 'a source of satiric and bawdy comedy' – *A Long Journey*, 184.

6 For accounts of this episode, see Starobin, *American Communism in Crisis*, 136–8; Aaron, *Writers on the Left*, 386–9.

7 Isidor Schneider, 'Probing Writers' Problems', *NM* 57, no. 4 (23 October 1945): 22–5. Cf. Schneider, 'Henry James: Mandarin?', *NM* 57, no. 12 (18 December 1945): 23–4; 'Henry James & Other Matters', *NM* 58, no. 3 (15 January 1946): 22.

8 Albert Maltz, 'What Shall We Ask of Writers?', *NM* 58, no. 7 (12 February 1946): 19–22; Isidor Schneider, 'Background to Error', *NM* 58, no. 7 (12 February 1946): 25; Samuel Sillen, 'Which Way Left Wing Literature', *DW*, 11, 12, 13, 14, 15, 16 February 1946. Most of the numerous contributions to the debate are listed in Lee Baxandall, *Marxism and Aesthetics: A Selective Annotated Bibliography* (New York: Humanities Press, 1973), 174–6.

9 Samuel Sillen, 'The Main Issue for the Literary Left', *DW*, 24 February 1946; 'Art as a Weapon', *DW*, 13 February 1946.

10 Albert Maltz, 'Moving Forward', *NM* 59, no. 2 (9 April 1946): 8–10, 21–2; *DW*, 7, 8 April 1946. For Maltz's retrospective view, see Albert Maltz to Charles Humboldt, 11 April 1956 (Humboldt Papers, YU, Box 1).

11 William Z. Foster, 'Elements of a People's Cultural Policy', *NM* 59, no. 4 (23 April 1946): 6–9. For Foster's own youthful renunciation of the aesthetic, see his 'Apprenticeship to Art', *DW*, 29 March 1939.

12 'Noted Writers at Hollywood Forum', *DW*, 15 April 1946; '3,500 at Symposium on Art is a Weapon', *DW*, 19 April 1946. The artists Elizabeth Catlett, William Gropper and Charles Keller spoke in New York – 'Just a Minute', *NM* 59, no. 5 (30 April 1946): 2.

13 Charney, *A Long Journey*, 183–4.

14 Annette Rubinstein interview with the author, 26 August 1992; Louis Harap interview with the author, 2 December 1993.

15 Marion Summers, 'On the Function of Criticism', *DW*, 28 April 1946.

16 Marion Summers, 'A Disturbing Vagueness in New Weber Show', *DW*, 17 March 1946; 'Social Art Must Breathe the Air of the Common Man', *DW*, 7 April 1946.

17 Marion Summers, 'The Question of Decadence in Art', *DW*, 9 June 1946.

18 Marion Summers, 'A Glimpse of Early Cubism', *DW*, 10 November 1946; 'Kootz Exhibits Ten New Works by Picasso', *DW*, 9 February 1947.

19 Marion Summers, 'Little Fenced-in Visions of Unreality', *DW*, 13 March 1946; 'Luxury Goods for Sensuous Enjoyment', *DW*, 23 June 1946.

20 Marion Summers, 'Abstract Art: Highway or Dead End?', *DW*, 12 June 1946; 'The Tyranny of Purity in Art', *DW*, 16 June 1946; 'Abstract Art is a Denial of Social Content', *DW*, 20 June 1946; 'Luxury Goods for Sensuous Enjoyment', *DW*, 23 June 1946.

21 Marion Summers, 'Lessons in Utter Confusion', *DW*, 19 May 1946; 'Two Abstractionists and a Painter of Decay', *DW*, 1 November 1946. On *PM*, see Paul Milkman, *PM: A New Deal in Journalism* (New Brunswick, N.J.: Rutgers University Press, 1997). On Reinhardt's trajectory, see Michael Corris, 'The Difficult Freedom of Ad Reinhardt'.

22 Marion Summers, 'A Quick Tour of the Galleries', *DW*, 23 January 1947.

23 Marion Summers, 'Realism, Handmaiden of Progress', *DW*, 14 July 1946; 'Behind the Anti-Realist Attitude', *DW*, 21 July 1946.

24 Marion Summers, 'Three Problems of the Social Artist', *DW*, 7 April 1946, 14 April 1946, 21 April 1946; 'One Man's Reaction to Nature', *DW*, 6 March 1946.

25 Marion Summers, 'Pessimism is Not Enough', *DW*, 3 October 1946; 'PAC Posters – Propaganda and Art', *DW*, 17 November 1946. On Shahn's career in this period, see Pohl, *Ben Shahn*.

26 Moses Soyer, 'In the World of Art', *NM* 57, no. 4 (23 October 1945): 28; *NM* 55, no. 13 (26 June 1945): 30.

27 'About Artists by Artists', *NM* 57, no. 9 (27 November 1945): 14–17; *NM* 58, no. 1 (1 January 1946): 26–8; *NM* 58, no. 8 (19 February 1946): 27–30. B. G., 'Wanted: Art Criticism', *NM* 58, no. 13 (2 April 1946): 20.

28 Jerome Seckler, 'Picasso Explains', *NM* 54, no. 11 (13 March 1945): 4–7; Rockwell Kent, 'That Ivory Tower', *NM* 55, no. 1 (3 April 1945): 17.

29 'Between Ourselves', *NM* 55, no. 10 (5 June 1945): 2. 'Readers' Forum': *NM* 55, no. 2 (10 April 1945): 17; *NM* 55, no. 3 (17 April 1945): 17; 'Understanding Picasso', *NM* 55, no. 7 (15 May 1945): 26–8.

30 Charles Arnault, 'Painting and Dialectics', *NM* 56, no. 7 (14 August 1945): 28–30; Herb Kruckman, 'Cézanne, Picasso et al.', *NM* 56, no. 9 (28 August 1945): 21–2; Michael Carver, 'Platitudes and Criticism', *NM* 56, no. 11 (11 September 1945): 22; Morris Kellerman, 'Arnault and Art', *NM* 57, no. 3 (16 October 1945): 21–2.

31 'Just a Minute', *NM* 60, no. 8 (20 August 1946): 2.

32 Back cover advertisement, *NM* 62, no. 1 (1 April 1947).

33 E.g., Howard Selsam, 'Frederick Engels: Philosopher', *NM* 61, no. 2 (8 October 1946): 9–13.

34 See e.g. Louis Harap, 'Sartre and Existentialism', parts 1 and 2, *NM* 62, no. 1 (31 December 1946): 8–11; *NM* 62, no. 2 (7 January 1947): 21–2; and also the review of *The Reprieve* by José Yglesias, 'Condemned to Freedom', *NM* 65, no. 12 (16 December 1947): 19–20.

35 E.g., Sidney Finkelstein on Kafka's *Metamorphosis*, in 'On Bourgeois Bondage', *NM* 62, no. 3 (14 January 1947): 22–3.

36 Lloyd Brown, 'Soap Gets in your Ears', *NM* 64, no. 5 (29 July 1947): 6–8; Charles Humboldt, 'Sweet Mystery of Life',

parts 1–3, *NM* 65, nos 6–8; (4 November 1947): 7–9; (11 November 1947): 14–16; (18 November 1947): 11–14; Vivien Howard, 'Housewives are Simply Wonderful', *NM* 65, no. 13 (23 December 1947): 9–11.

37 Charles Humboldt, 'To the Mad Hatters', *NM* 62, no. 11 (11 March 1947): 13–17.

38 Barbara Giles, 'Bleak House' (review of William Phillips and Philip Rahv, eds, *The Partisan Review Reader*), *NM*, 61, no. 5 (29 October 1946): 23–4. 'Mr. Rosenfeld's hero' refers to a character in a short story by Isaac Rosenfeld also reprinted in the volume.

39 *Mainstream* offers vivid testimony to the sense of crisis among Communist intellectuals at this time: see 'The Crisis in American Letters', *M* 1, no. 1 (winter 1947): 5–9; Samuel Sillen, 'The Iron Heel', *M* 1, no. 2 (spring 1947): 133–7.

40 Despite the fact that Shahn had long since distanced himself from the CP, no less than nine images by him appeared over the years 1948–9.

41 Lloyd Brown has recalled that Humboldt had the job of going round artists' studios to solicit drawings for the magazine. (Telephone conversation with the author, 4 July 1992.) From 1948 to 1952, Humboldt worked as an editor for Citadel Press, of which Philip S. Foner was co-owner (Weinstock Resumé, Humboldt Papers, YU, Box 9, folder 298).

42 'D.A.', of Wabash, Indiana, 'Meaning of Art', *M&M* 2, no. 5 (May 1949): 96.

43 William Thor Bürger, ' "New Realism" or Old Hat?', *NM* 59, no. 4 (23 April 1946): 25–9.

44 William Thor Bürger, 'New Season', *M&M* 2, no. 2 (December 1949): 84–7. Cf. Charles Corwin, 'Ben Shahn's Rewarding Exhibit at Downtown Gallery', *DW*, 4 November 1949. For Shahn's work of this period, see Jewish Museum, *Common Man, Mythic Vision: The Paintings of Ben Shahn* (Susan Chevlowe, ed.; New York & Princeton, N.J.: Jewish Museum and Princeton University Press, 1998).

45 William Thor Bürger, 'The Whitney Disaster', *M&M* 3, no. 3 (March 1950): 89–92.

46 On which, see Nancy Jachec, ' "The Space Between Art and Political Action": Abstract Expressionism and Ethical Choice in Postwar America 1945–50', *Oxford Art Journal* 14, no. 2 (1991): 18–29.

47 Charles Humboldt, 'Disagrees with Review of Ralston Crawford Show', *DW*, 17 December 1946; 'The Question of Abstract Art', *DW*, 14 January 1947; Joseph Solman, 'Art', *NM* 62, no. 7 (4 February 1947): 30.

48 Joseph Solman, 'A Look at Abstract Art', *NM* 61, no. 10 (3 December 1946): 25–6; 'Art' (for Balcomb Greene), *NM* 63, no. 2 (8 April 1947): 30–31.

49 Joseph Solman: 'Art', *NM* 62, no. 8 (18 February 1947): 29–31; 'Apples and Guns', *NM* 62, no. 10 (4 March 1947): 25–6.

50 Joseph Solman, 'Henry Moore', *NM* 62, no. 5 (28 January 1947): 28–9.

51 Joseph Solman, 'Art', *NM* 63, no. 1 (1 April 1947): 30–31. This comment was probably prompted by Rothko's one-man show at the Betty Parsons Gallery.

52 Referring to a recent group show, Solman wrote in 1943: 'Gottlieb had the best pictures – like coptic cloth abstrac-

tions with a few symbolic overtones. A strange phase in his work – not a healthy direction but nevertheless good painting in some instances.' Joseph Solman to Jacob Kainen, September 1943 (Kainen Papers, AAA 565:194).

53 Joseph Solman, 'Totem and Tattoo', *M&M* 1, no. 1 (March 1948): 86–8. Cf. 'Crisis at the Whitney', *NM* 62, no. 1 (31 December 1946): 30. For a splenetic account of Solman's rounds of the galleries before writing this, see Joseph Solman to Jacob Kainen, 4 March 1947 (Kainen Papers, AAA 565:200.) Robert Motherwell and Harold Rosenberg, 'The Question of What Will Emerge is Left Open', *Possibilities: An Occasional Review* 1 (winter 1947/8): 1.

54 Joseph Solman, 'Life's Mad-Hatters', *M&M* 1, no. 10 (December 1948): 83–4. A later critique by Sidney Finkelstein particularly stressed the role of the New York museums in promoting the new art: see 'Abstract Art Today: Doodles, Dollars and Death', *M&M* 5, no. 2 (September 1952): 22–31.

55 Joseph Solman, 'Three American Painters', *M&M* 1, no. 5 (July 1948): 87–8. Cf. 'Art', *NM* 63, no. 2 (8 April 1947): 30–31.

56 Joseph Solman, 'Painters with Ideas', *M&M* 1, no. 2 (April 1948): 85–8. For Harari, see Montclair Art Museum, *Hananiah Harari: A Personal Synthesis* (catalogue by Gail Stavitsky; Montclair, N.J., 1997).

57 Joseph Solman, 'The Art of Ben Shahn', *NM* 65, no. 6 (4 November 1947): 22–3.

58 Joseph Solman, 'Rock Candy', *M&M* 2, no. 3 (March 1949): 89–91. Solman's position here is similar to that taken by the anti-Stalinist G. L. K. Morris, writing on Blume's *Eternal City* a decade earlier: see 'To Peter Blume', *PR* 4, no. 4 (March 1938): 40–41.

59 This was confirmed by Lloyd Brown, telephone conversation with the author, 5 July 1992.

60 An insightful reading of the political resonance of Rosenberg's 'The American Action Painters' (1952) is given by Fred Orton, in 'Action, Revolution, Painting', *Oxford Art Journal* 14, no. 2 (1991): 3–17.

61 Michael Leja presents the movement in something like these terms, though without any real political reference points, in *Reframing Abstract Expressionism*.

62 Howe and Coser, *American Communist Party*, 316–18; Shannon, *Decline of American Communism*, 56–8.

63 For Finkelstein, see Solomon, *Marxism and Art*, 274–6; Ben Field, 'A Man Born to Teach . . .', *SW*, 29 February 1948.

64 Sidney Finkelstein, *Art and Society* (New York: International Publishers, 1947), 13, 35, 44, 54, 260, 60–61, 229. Cf. Sidney Finkelstein, 'National and Universal Art', *M* 1, no. 3 (summer 1947): 345–61.

65 Finkelstein, *Art and Society*, 104–14, 177, 169, 189, 209, 161.

66 Ibid., ch. 10. Cf. Sidney Finkelstein, 'For More Attention to Culture', *SW*, 11 July 1948.

67 E.g., Field, 'A Man Born to Teach . . .'; Charles Humboldt, 'The Best Kind of Critic', *NM* 65, no. 9 (25 November 1947): 17–18.

68 Barnard Rubin, 'Serious Errors in Finkelstein's Art and Society', *DW*, 15 May 1950; 'Final Group of Letters on "Art and Society"', *DW*, 15 June 1950; Sidney Finkelstein, 'Finkelstein Replies to Criticism of His Book', *DW*, 18 May 1950.

69 Biographical information from author's interview with Louis Harap, 2 December 1993, and Louis Harap (ed.), *A Ten Year Harvest: Third Decennial Reader; A Selection of Short Stories, Poems and Essays from Jewish Currents, 1966–1976* (New York: Jewish Currents, 1977). Harap received his doctorate from Harvard in 1932 and joined the CP in 1937, resigning twenty years later, partly over revelations of Soviet anti-Semitism. He was managing editor of the Party magazine *Jewish Life* from 1948 to 1957, and subsequently an editor of the independent socialist magazine *Jewish Currents*. On the Communist Party at Harvard, see Bentley (ed.), *Thirty Years of Treason*, 575–624; Ellen W. Schrecker, *No Ivory Tower: McCarthyism and the Universities* (New York & Oxford: Oxford University Press, 1986), 194–205.

70 Foster certainly endorsed it: see 'Praise for Harap's New Book "Social Roots of the Arts"', *DW*, 18 November 1949.

71 Louis Harap, *Social Roots of the Arts* (New York: International Publishers, 1949), 21 (cf. 40), 52–3 and chs 4 and 5.

72 Ibid., 22, 108, 74–9.

73 Ibid., 181. Harap has told me that Foster insisted on his adding the chapters on 'Art under Fascism' and 'Art under Socialism', which he now regards as the weakest part of the book. (Interview with the author, 2 December 1993.)

74 See e.g. Sidney Finkelstein, 'Soviet Culture: A Reply to Slander', *M&M* 3, no. 1 (January 1950): 51–62.

75 Samuel Sillen, 'Marxism and Art', *M&M* 3, no. 1 (January 1950): 85–9.

76 Samuel Sillen, 'Art in the Struggle Today', *DW*, 20 June 1950; V. J. Jerome, 'On Finkelstein's "Art and Society"', *DW*, 7 and 8 August 1950.

77 This is also a marked feature of Harry Martel and Marvin Reiss, 'Art and Class', *PA* 29, no. 8 (September 1950): 79–96. 'Martel' and 'Reiss' are almost certainly pseudonyms.

78 Medvedev, *Let History Judge*, 483–4; Aleksandr Kamenski, 'Art in the Twilight of Totalitarianism', in Matthew Cullerne Brown and Brandon Taylor (eds), *Art of the Soviets: Painting, Sculpture and Architecture in a One-Party State* (Manchester & New York: Manchester University Press, 1993), 154–60; Andrei Zhdanov, *Essays on Literature, Philosophy and Music* (New York: International Publishers, 1950). An abridged version of Zhdanov's speech against the literary journals *Zvezda* and *Leningrad* was published in *PA* 25, no. 12 (December 1946): 112–31. See also 'Zhdanov Dies – Hero of Leningrad', *DW*, 1 September 1948.

The CPUSA made strenuous efforts to rebut charges of Soviet anti-Semitism, and in 1949 the Party's magazine *Jewish Life* published a pamphlet by the *Morning Freiheit* editor Moses Miller, titled *Soviet Anti-Semitism: The Big Lie*. Correspondingly, it stressed the continuing presence of anti-Semitism in the United States – e.g., David Carpenter, 'Shocking Record of US Anti-Semitism', *DW*, 27 April 1949. For the Party stance on Israel, see e.g. the editorial 'The Jewish State Will Live', *DW*, 14 May 1948.

79 Sidney Finkelstein, *Realism in Art* (New York: International Publishers, 1954), 9, 29, 41, 74, 102–3, 72, 95–6, 134–6, 143–51.

80 Ibid., 161–2, 171–3. Indeed, Finkelstein evidently preferred Burchfield and Hopper to the progressive artists on stylistic grounds (170–71). Cf. Rockwell Kent's review 'To Work, Artists!', *M&M* 7, no. 12 (December 1954): 38–41.

81 Copy in the Tamiment Institute Library, New York University, Workshop of Graphic Art file. I am grateful to Charles Keller for first drawing my attention to this episode and discussing it with me. Keller believes that those who wrote the response were Herzl Emmanuel, Daniel Koerner and Anthony Toney (interview with the author, 23 June 1992). My guess is that the rebuttal was by Jerome.

82 One of the striking aspects of the response is the range of Marxist authorities invoked, from Lenin, Lifshitz, Lunacharsky and Plekhanov, to Frederick Antal, Christopher Caudwell and Ralph Fox.

83 Further evidence of awareness of Soviet views is provided by a reprint of VOKS (All-Union Association for Foreign Cultural Relations) Bulletin no. 52, comprising an article of 1947 by Vladimir Kemenov titled 'Aspects of Two Cultures', which was distributed by the art section of the CP Cultural Division in New York (Gellert Papers, AAA, Box 4, 'Printed Material 1946–49'). This is a dismal document and anyone reading it could not doubt that contemporary Soviet criticism found no redeeming features whatsoever in the work of Picasso after his Blue Period. His art was described as 'morbid' and 'revolting', 'an aesthetic apologetics for capitalism'. Invoking a seemingly random list of modernists and Surrealists including Peter Blume along with Miró, Klee, Moore and Lipchitz, Kemenov suggested that future generations would seek to analyse their work with the aid of the psychiatrist rather than the art expert. The 'victory of the socialist revolution in the USSR' had 'reassigned the places of different countries on the ladder of general human progress' he bluntly declared. Excerpts from Kemenov's text are reprinted in Herschel B. Chipp (ed.), *Theories of Modern Art: A Source Book by Artists and Critics* (Berkeley: University of California Press, 1968), 490–96.

84 Interview with the author, 23 June 1992.

85 On this phase of the Party's history, see Maurice Isserman, *If I Had a Hammer . . . : The Death of the Old Left and the Birth of the New Left* (New York: Basic Books, 1987), ch. 1.

86 The annual deficit was said to be $7,500 in 1956 and $10,000 in 1957. In 1959, it had a circulation of 3,100 ('Report on Mainstream', 30, Humboldt Papers, YU, Box 4, file 163).

87 E.g., Charney, *A Long Journey*, 276–8.

88 On Humboldt's gifts as an editor, see the tribute by Annette Rubinstein, 'Charles Humboldt 1910–1964' (Humboldt Papers, YU, Box 9, file 292).

89 'Report on Mainstream', 30.

90 Charles Humboldt to John H. Lawson, 28 October 1956 (copy; Humboldt Papers, YU, Box 2, file 78).

91 On Sillen, see Charles Humboldt to Lloyd Brown, 5 August 1952 (copy; Humboldt Papers, YU, Box 1). Finkelstein, in turn, acknowledged his intense dislike for *Mainstream*

under Humboldt's direction, and accused him of trying to drive him out of the magazine. See Sidney Finkelstein to Charles Humboldt, 18 July 1957 and 13 July 1958 (Humboldt Papers, YU, Box 2, file 59).

92 Charles Humboldt, 'The Salt of Freedom', *M* 9, no. 9 (October 1956): 21. Cf. Humboldt, 'Second Thoughts on Politics and Culture', 9, no. 4 (May 1956): 8–15. For the implications of this for Humboldt's evaluation of the visual arts, see his review of Alma Reed's *Orozco*: 'Artist in Conflict', *M* 9, no. 5 (June 1956): 53–6. Humboldt spent part of 1952–3 in Mexico, working on a book on the iconography of Mexican mural painting. Manuscript material relating to this project is in the Humboldt Papers, YU, Box 7, file 261.

93 Charles Humboldt to William Blake, 8 October 1959 (copy, Humboldt papers, YU, Box 1); 'Report on Mainstream', 21. Payment was a year's subscription.

94 Charles Humboldt to John Berger, 19 December 1958 (copy, Humboldt papers, YU, Box 1).

95 See especially Anderson's feminist story 'The Socks' (*M* 11, no. 10 (October 1958): 18–24), and the ensuing exchanges, 'Letters', 11, no. 11 (November 1958): 63–4; 'Letters', 11, no. 12 (December 1958): 58–60.

96 E.g., Thomas McGrath, 'Search for Kicks' (On Kerouac's *On the Road*), *M* 11, no. 2 (February 1958): 53–6; Helen Davis, 'Rebel with Cause' (On de Beauvoir's *Memoirs of a Dutiful Daughter*), *M* 12, no. 9 (September 1959): 56–8; Louis Harap, 'Art in Society' (on Hauser's *The Philosophy of Art History*) *M* 12, no. 7 (July 1959): 49–53.

97 'Painters and the Left', *M* 10, no. 8 (August 1957): 1–7; Sidney Finkelstein, 'The Artist and his World', 10, no. 9 (September 1957): 37–46; 'Letters', 10, no. 10 (October 1957): 62–4. I have not been able to identify the artists concerned. Humboldt directly guided the artists in formulating both the original statement and the response, revealing in the process his low opinion of their adversary. See Charles Humboldt to 'Mac', 1 March 1957, 31 July 1957 (copies; Humboldt Papers, YU, Box 3, file 123).

98 Michael Gold, 'Change the World', *The Worker*, 16 August 1959, 6 December 1959; Mike Newberry, 'The Arts', and Annette Rubinstein in 'Letters', *The Worker*, 3 January 1960. For the response, see John Condell, 'Hands Off the Imagination!', *M* 12, no. 10 (October 1959): 49–51; Charles Humboldt, 'No Hard Feelings', 13, no. 2 (February 1960): 45–7.

99 Despite some worthy features, *Mainstream's* successor, *American Dialog* (1964–1972), never achieved it either.

100 Isserman, *If I Had a Hammer*, 31–2.

10 Social Art in the Cold War

1 Peppino Mangravite, 'Congress Vetoes Culture', and John Rothenstein, 'Arts for the People: The Story of England's CEMA', *MA* 36, no. 7 (November 1943): 264–6. Cf. Louis Harap, 'A People's Art in England', *NM* 57, no. 2 (9 October 1945): 23.

2 Elizabeth McCausland, 'Why Can't America Afford Art?', *MA* 39, no. 1 (January 1946): 18–21; Elizabeth McCausland

(ed.), *Work for Artists: What? Where? How?* (New York: American Artists Group, 1947).

3　On this development, see Rosamund Frost, 'It Pays to Advertise', *AN* 42, no. 9 (August–September 1943): 11–25; Elizabeth McCausland, 'Pepsi-Cola and Patronage', *American Contemporary Art* 1, no. 10 (October 1944): 6–8; and, in general, Michele H. Bogart, *Artists, Advertising, and the Borders of Art* (Chicago & London: University of Chicago Press, 1995), 256–92.

4　Cf. the self-serving arrogance of Greenberg's assertion, 'The naturalistic art of our time is irredeemable, as it requires only taste to discover' (92), with the views of Barr, Baur, Goodrich and Soby in 'A Symposium: The State of American Art', *MA* 42, no. 3 (March 1949): 82–102.

5　I borrow the phrase from Mishler, *Raising Reds*, 81.

6　For hopes for a new union patronage in the postwar period, see Walter Abell, 'Art and Labor', *MA* 39, no. 6 (October 1946): 231–9; 254–63; Lewis Merrill, 'Labor and a People's Art', *NM* 57, no. 11 (11 December 1945): 14.

7　This was well understood at the time. See e.g. Charles Corwin's critique of the 1948 Whitney Annual: 'The Whitney Museum Annual Exhibit', *DW*, 3 December 1948; and the responses: 'Herman Baron and Critic on Social Art', *DW*, 17 December 1948; 'Philip Evergood on Progressive Art Today', *DW*, 5 January 1949. See also Charles Corwin, 'Easel Painting, Subjectivism and Realism in American Art', *DW*, 27 December 1948, and 'The Art Galleries', *DW*, 18 February 1949.

8　This was the title of a 1959 exhibition at the Museum of Modern Art, curated by Peter Selz, which surveyed the human figure in modern art of the 1950s.

9　For Sharrer, see Museum of Modern Art, New York, *Fourteen Americans* (1946), 62–5; Dorothy Seckler, 'Honoré Sharrer Paints a Picture', *AN* 50, no. 2 (April 1951): 40–43, 66–7.

10　'Deport Hearing for Sun-Times Artist Near End', *Chicago Tribune*, 31 December 1952; 'Plan Appeal of Decision on Burck', *Chicago Sun-Times*, 9 July 1953 (clippings, Jacob Burck file, Chicago Historical Society). The last contribution by Burck to the *Daily Worker* I have discovered is 'Max Weber – Reborn Artist', *SW*, 30 May 1937.

11　A caricature of Stalin as the burglar of Finland is in the Limbach collection at the Davison Art Center, Wesleyan University (1985.1.27). Stanley Burnshaw, *The Revolt of the Cats in Paradise* (privately printed, 1945).

12　Harry Salpeter, 'The New Mister Joe Jones', *Esquire* (June 1945): 82, 188; 'Our Box Score of the Critics', *AN* 44, no. 1 (15–28 February 1945): 28; Aline Louchheim, 'Spotlight on Joe Jones', *AN* 46, no. 9 (November 1947): 34. Jones's experiences in the army seem to have confirmed his new outlook, see Joe Jones to Elizabeth Green, 11 April 1945 (MHS).

13　Jewish Museum, *Painting a Place in America*, 187–8.

14　Notes of 24 December 1939 and 11 March 1940 (Stuart Davis Papers, HU); Stuart Davis, 'The American Artist Now', *Now* 1, no. 1 (August 1941): 7–11.

15　Ad Reinhardt, 'About Artists by Artists', *NM* 57, no. 9 (27 November 1945): 14; Corris, 'The Difficult Freedom of Ad Reinhardt', 81–3. Yet as late as 1950 Reinhardt took part in an ALA symposium, 'Recent Soviet Criticism': see 'Forum on Art', *SW*, 12 March 1950.

16　Romare Bearden to Walter Quirt, nd, refers to the latter's rejection of Social Realism 'back in the social realist days' (AAA 570: 613–14). Walter Quirt, 'Social Content versus Art in Painting', *The Pinacoteca* (winter 1942) (AAA 570: 938–9). For Quirt's later career, see University Gallery, University of Minnesota, *Walter Quirt*, 21–6, 39–51.

17　Judith Kaye Reed, 'Presenting Guglielmi in Solo Exhibition', *AD* 22, no. 11 (1 March 1948): 16. In 1947, Guglielmi defended Davis's art in a letter to *Life*: see 'Letters to the Editors', *Life* 22, no. 13 (31 March 1947): 9. For Guglielmi's later work, see Rutgers University Art Gallery, *O. Louis Guglielmi*, 36–67.

18　National Museum of American Art, *Jacob Kainen*, 21–2, 31–2.

19　Peter N. Carroll, *The Odyssey of the Abraham Lincoln Brigade: Americans in the Spanish Civil War* (Stanford University Press, 1994), 67–8, 96.

20　'The Question Marks of Social Art' (nd, but c. 1950 on the basis of internal evidence), Bard Papers, AAA N/70–8: 542–60.

21　Lozowick wrote for *New Masses* as late as mid-1946, but did not contribute to *Mainstream* or *Masses & Mainstream*.

22　Alfred M. Frankfurter, 'Reviews and Previews', *AN* 49, no. 3 (May 1950): 48; Harry Salpeter, 'Harriton, Ex Picassoid', *Esquire* (January 1946): 98–9, 211–12. Cf. Abraham Harriton, 'This is a Brief Credo' (typescript; Harriton Papers, SU).

23　Howard Devree, 'Midseason Survey', *NYT*, 1 January 1950; Robert M. Coates, 'The Art Galleries', *New Yorker* (14 January 1950): 53–4; Charles Corwin, 'The Art Galleries', *DW*, 16 January 1950.

24　Milton Brown, 'After Three Years', *MA* 39, no. 4 (April 1946): 138, 166. On Smith, cf. Stanley Meltzoff, 'David Smith and Social Surrealism', *MA* 39, no. 3 (March 1946): 98–101. Brown might also have mentioned the enigmatic symbolic subjects of Philip Guston, whose haunting *If This be Not I* (Washington University Art Gallery, Saint Louis) was exhibited at the 1945 Whitney Annual.

25　For *Boy from Stalingrad*, see Evergood, 'Sure, I'm a Social Painter', 259. For the American–Russian friendship series (bought by Emil J. Arnold), see Moses Soyer, 'In the World of Art', *NM* 53, no. 11 (12 December 1944): 26–7; 'The Passing Shows', *AN* 53, no. 15 (15–30 November 1944): 23.

26　'12 Americans Hit the Spot!', *AN* 43, no. 10 (August 1944): 14.

27　William Thor Bürger, 'Evergood: Pioneering a New Art', *NM* 59, no. 8 (21 May 1946): 7–9; Marion Summers, 'Art Today', *DW*, 2 May 1946; Beth McHenry, 'Evergood's Chosen Audience: The American Working Class', *DW*, 3 May 1946; Michael Gold, 'The Search for Truth in the Paintings of Philip Evergood', *DW*, 21 July 1946.

28　Evergood, 'Sure, I'm a Social Painter', 259. Evergood thought the 1947 Whitney Annual 'looked almost like the museum of Non objective painting'. Philip Evergood to

Anton and Lila Refregier, 13 January 1946 (actually 1947; Refregier Papers, AAA).

29 Philip Evergood, 'Friends of Alexander Trachtenberg', 17 December 1954 (AAA D304:94–7); 'The Humanist Approach to Art' (MS from c. 1956; D304:1026–38); 'Humanism in Art' (MS; D304:1043–56); untitled manuscript from 1958 (AAA 429:807–19).

30 Evergood, 'Sure, I'm a Social Painter', 257; Stuart Preston, 'Variety in Approaches – Klee – Evergood', NYT, 17 April 1955.

31 Fairfield Porter, 'Evergood Paints a Picture', AN 50, no. 2 (January 1952): 55; Evergood, 'The Humanist Approach to Art', 13; ' "For and Agin": Should Art Prettify Heroes?', DW, 2 November 1944.

32 Oliver Larkin, 'The Humanist Realism of Philip Evergood', in ACA Gallery, 20 Years Evergood (New York: 1946), 17, 21–2; Evergood quoted in ACA Gallery, Philip Evergood (New York: 1955). In this connection, see also Evergood's letter rejecting Moses Soyer's designation of his work as 'Social Surrealism' in 'Reader's Forum', NM 54, no. 7 (13 February 1945): 22.

33 Philip Evergood, 'Bridgewater Library Talk', MS, October 1964 (AAA 429:833).

34 Donald Kuspit, 'Philip Evergood's Social Realism', MA thesis, Pennsylvania State University, 1964, 47.

35 Philip Evergood to Alice Jerome, 24 January 1958 (Jerome Papers, YU).

36 'La Tausca Opening', AN 44, no. 8 (1–14 January 1946): 34; Rosamund Frost, 'Women, Pearls, and Paint', AN 44, no. 9 (15–31 January 1946): 19.

37 Advertisement, AN 45, no. 11 (January 1947): 51; 'Pictures Before Pearls in La Tausca's New Contest', AN 45, no. 12 (February 1947) 32, 55–6.

38 Joseph Solman, 'Philip Evergood', M&M 1, no. 4 (June 1948): 92.

39 Cf. Evergood's statement, quoted by Kendall Taylor in Philip Evergood: Selections from the Hirshhorn Museum and Sculpture Garden (Washington, D.C.: Smithsonian Institution Press, 1978), np (8).

40 The debate began with Joseph Wortis, 'The Psychoanalytic Tradition', NM 57, no. 1 (2 October 1945): 10–13, and ended with J. B. Furst, 'What Psychoanalysis Can Do', NM 58, no. 4 (22 January 1946): 14–18.

41 Henry McBride, 'Reviews and Previews', AN 50, no. 2 (April 1951): 49. For Evergood on the picture, see Kuspit, 'Philip Evergood's Social Realism', 18.

42 Other pictures that need to be considered in this connection include The Hidden Apple (1946), Woman of Iowa (1958), Cool Doll in a Pool (1959; collection Philip and Suzanne Schiller, Chicago), and Dixie and Bess Expectant (a photograph of this work is in the Evergood Papers, AAA 430:270).

43 Irene Epstein, 'Women in the USSR', M&M 4, no. 5 (May 1951): 92; Margrit Reiner, 'The Fictional American Woman', M&M 6, no. 6 (June 1952): 1–10; Barbara Giles, 'Brand-Name Culture', M&M 5, no. 12 (December 1952): 45. For an outstanding critique and commentary from some years earlier, see Joy Davidman, 'Women: Hollywood Version', NM 44, no. 2 (14 July 1942): 28–31; Charles

Humboldt, 'Caricature by Hollywood', NM 44, no. 4 (28 July 1942): 29–30.

44 For Evergood on American Shrimp Girl, see Taylor, Philip Evergood: Selections from the Hirshhorn Museum, 7. In 1952, Joseph North praised the novel A Lantern for Jeremy by Evergood's friend V. J. Jerome as 'a passionate indictment of those who would degrade women to sub-citizenship in life.' See North, 'Book Review', PA 31, no. 6 (June 1952): 63.

45 Robert M. Coates, 'The Art Galleries', New Yorker, 25 April 1955, 85; L[awrence] C[ampbell], 'Reviews and Previews', AN 54, no. 3 (May 1955): 46.

46 Philip Evergood to Alice Jerome, 24 January 1958 (Jerome Papers, YU). Cf. Philip Evergood to Herman and Ella Baron, 29 December 1957: 'to hell with this crank turning' (AAA D304:163).

47 George Dennison, 'Month in Review', Arts Magazine 34, no. 8 (May 1960): 50–53; HC, 'Evergood', AN 59, no. 3 (May 1960): 40, 63.

48 Alice Dunham, 'The Courage of Philip Evergood', M 13, no. 6 (June 1960): 56–60. For Evergood's response, see Philip Evergood to Charles Humboldt, 8 June 1960 (Humboldt Papers, YU, Box 2).

49 Kuspit, 'Philip Evergood's Social Realism', 79, 104.

50 On the success of this series, see Holger Cahill to Mitchell Siporin, 20 April 1937; Mitchell Siporin to Edith Halpert, May 1937 (AAA 2011:146, 155–7).

51 Jerome Klein, 'Trying Times Spur Romantic Art Trend', NYP, 6 January 1940; Carlyle Burrows, 'Notes and Comment on Events in Art', NYHT, 7 January 1940; Robert Coates, 'The Art Galleries', New Yorker (13 January 1940): 53.

52 November 1944 found Halpert working for the CIO-PAC, in 1947 she spoke attacking the State Department's cancellation of Advancing American Art at a PCA event and in 1952 she was rooting for Adlai Stevenson. She was unphased when the FBI called to make inquiries about Siporin in 1943 (Edith Halpert to Mitchell Siporin, 3 November 1944; 28 October 1952; 23 June 1943 – AAA 2011:608, 835, 552. 'Talk given by EGH at the meeting held at the Hotel Capital on May 3rd . . .', AAA 1883:445–9). For Halpert's career, see 'Edith Halpert', Current Biography – 1955 (1955): 35–7; and Diane Tepfer, 'Edith Gregor Halpert: Impresario of Jacob Lawrence's Migration Series', in Elizabeth Hutton Turner (ed.), Jacob Lawrence: The Migration Series (Washington, D.C.: Rappahannock Press in association with the Phillips Collection, 1993), 129–39.

53 E.g., H[oward] D[evree], 'Two Modern Americans', NYT, 26 October 1947.

54 See Siporin's war photographs, AAA 2061:51–4, 480–530.

55 Mitchell Siporin to Charles Alan, July 1954, copy; Mitchell Siporin to Henry Allen Moe, 26 October 1946, copy (AAA 2011:893, 672); typescript headed 'Statement of Accomplishment Since 1946' (AAA 1332:279).

56 Edgar Stillman Jr, 'Mitchell Siporin, NY Artist, Heads Painting at School Here', Berkshire Evening Eagle, 25 June 1948; Michell Siporin to American Academy in Rome, 4 February 1950, copy (AAA 2011:768–9).

57 The motif of Mussolini's hanging body is based on photographs in Siporin's scrapbook (AAA 2061:51, 53).

58 Dorothy Grafly, 'Pennsylvania Academy', *AN* 45, no. 12 (February 1947): 31; 'Five Star Shows', *AN* 46, no. 8 (October 1947): 27, 58; Ivan Le Lorraine Albright, 'Chicago Art Exhibition Shakes Provincialism', *Herald-American*, 4 June 1947.

59 Mitchell Siporin to Deborah Calkins, 7 January 1955 (copy; AAA 2011:907).

60 A supposition reinforced by the fact that Siporin had numerous relatives in Palestine. See Mitchell Siporin to Meyer Levin, 3 August 1961 (copy; AAA 1332:176–7).

61 Mitchell Siporin to Mae Huntington, 11 April 1951, copy; Mitchell Siporin to Dorothy Adlow, 23 January 1952, copy (AAA 2011:785, 808–9). For the *Exodus 1947*, see Michael J. Cohen, *Palestine and the Great Powers, 1945–1948* (Princeton University Press, 1982), 250–59. For the CP's response, see Joseph North, 'Dachau Goes to Sea', *NM* 64, no. 7 (12 August 1947): 3; and, on Palestine generally, Charles Abrams, 'Palestine: A Solution', *NM* 63, no. 10 (3 June 1947): 20–22. In the US, pro-Zionist sentiment was fuelled by Ruth Gruber's reports and photographs, which were the basis for her book *Destination Palestine: The Story of the Haganah Ship Exodus 1947* (New York: Current Books, 1948).

62 *Fortune* 34, no. 6 (December 1946): 170–71. Cf. Alonzo Lansford, 'Mitchell Siporin Continues to Advance', *AD* 22, no. 3 (1 November 1947): 19.

63 For a photograph of *Verdict*, see AAA 1328:360–61. Marion Summers, 'Art Today', *DW*, 15 May 1946; 'Art Today', *DW*, 3 October 1946. The *Daily Worker* had found a tendency to 'unnecessary complexity' in Siporin's pre-war work: see Ray King, 'Mitchell Siporin Exhibits at the Downtown Gallery', *DW*, 10 January 1940.

64 'The Image of Man', *Life* 28, no. 4 (23 January 1950): 24.

65 C. Wright Mills, 'The Cultural Apparatus', in *Power, Politics, and People: The Collected Essays of C. Wright Mills* (ed. Irving Louis Horowitz) (London: Oxford University Press, 1967): 405–22; Thomas B. Hess, '8 Excellent, 20 Good, 133 Others', *AN* 48, no. 9 (January 1950): 34–5, 57–8. Cf. Corwin, 'Easel Painting, Subjectivism and Realism in American Art'.

66 '19 Young Americans', *Life* 28, no. 12 (20 March 1950): 88. One of the very few studies to address this aspect of 1940s painting is Rutgers University Art Gallery, *Realism and Realities: The Other Side of American Painting, 1940–1960* (New Brunswick, N.J.: 1982), 62–110.

67 Alton Pickens, 'There Are No Artists in Hiroshima', *MA* 40, no. 6 (October 1947): 236–8. *New Masses* published a statement by Pickens and reproduced three of his sketches in 1946: 'About Artists by Artists', *NM* 58, no. 1 (1 January 1946): 27; *NM* 58, no. 6 (5 Feburary 1946): 4–5.

68 Marion Summers, 'Art Today', *DW*, 22 September 1946. (Cf. Charles Corwin's judgement on this type of painting in 'Stephen Greene's Macabre Paintings', *DW*, 11 March 1949.) By contrast, for *Art News*'s reviewer Pickens was the 'star of the whole show' – Aline B. Louchheim, 'The Favoured Few Open the Museum's Season', *AN* 45, no. 7 (September 1946): 17, 52.

69 Alfred M. Frankfurter, 'Open House at the Met', *AN* 49, no. 8 (December 1950): 30–31, 67. For the avant-garde's objections to this exhibition, see Alfred M. Frankfurter, 'Vernissage', *AN* 49, no. 4 (June–August 1950): 15. For Hirsch, see Georgia Museum of Art, *Joseph Hirsch* (Athens: University of Georgia, 1970).

70 The title of a key pamphlet by William Z. Foster of 1949.

71 In 1954, Siporin's dealer, Charles Alan, complained that his work had become 'increasingly abstract and obscure', and two years later he terminated their business relationship. Charles Alan to Mitchell Siporin, 7 June 1954 and 3 April 1956 (AAA 2011:885–6, 943). This does not indicate any decline in the saleability of Siporin's work. See Mitchell Siporin to Thomas M. Messer 12 August 1958 (copy; AAA 2011:1038–9).

72 Vassar College Art Gallery, *Alton Pickens: Paintings, Prints, Sculpture* (Poughkeepsie, N.Y., 1977). Pickens's correspondence with Herman Baron from the late 1950s suggests he felt overworked and isolated: see AAA D304: 368–78.

73 Finkelstein, 'Soviet Culture: A Reply to Slander', 55; Samuel Sillen, 'The "Human Obstacle" in Art', *M&M* 3, no. 3 (March 1950): 54–7. Cf. Roger Garaudy: 'The invasion of decay into art has a precise meaning: the class which had made culture into a kind of noble privilege has entered into a decadence beyond repair.' From Garaudy, *Literature of the Graveyard: Jean-Paul Sartre, François Mauriac, André Malraux, Arthur Koestler* (New York: International Publishers, 1948), 61.

74 See Leja, *Reframing Abstract Expressionism*, 49–76, 203–49.

75 Serge Guilbaut has argued that the model of liberalism articulated in Arthur Schlesinger, Jr.'s *The Vital Center* is particularly relevant to understanding the reception of Abstract Expressionism; see Guilbaut, *How New York Stole the Idea of Modern Art*, 189–92, 200–03. For an important corrective to Guilbaut's intepretation of Schlesinger's position, see Jachec, *The Philosophy and Politics of Abstract Expressionism*, 3–4, 59–61, 126–9; and for Schlesinger's political trajectory, see Michael Wreszin, 'Arthur Schlesinger, Jr., Scholar-Activist in Cold-War America', *Salmagundi* 63–4 (spring–summer 1984): 255–85.

76 Harold Rosenberg: 'Community Critics vs Modern Painting', *AN* 54, no. 10 (February 1956): 33, 59; 'Everyman a Professional', *AN* 55, no. 7 (November 1956): 66. Both essays were reprinted in slightly modified form in Rosenberg, *The Tradition of the New* (New York: Horizon Press, 1959).

77 Balcomb Greene, 'This Painter Examines the Social Contract', *AN* 55, no. 2 (April 1956): 30–31, 92–3. Cf. Balcomb Greene, 'The Cooperative Arts and Inspirational Art', *MA* 42, no. 7 (November 1949): 267–9.

78 William Seitz, 'Spirit, Time and "Abstract Expressionism"', *MA* 46, no. 2 (Feburary 1953): 86. Meyer Schapiro's 1960 address to the American Academy and Institute of Arts and Letters 'On the Humanity of Abstract Painting' is of the same ilk. See Schapiro, *Modern Art, 19th and 20th Centuries: Selected Papers* (New York: Braziller, 1978): 227–32.

79 Museum of Modern Art, New York, *New Images of Man* (New York, 1959) 9, 11. The quotation is from Nietzsche.

80 Soyer, *Self-Revealment*, 79–84; 'Statement' and Henry Varnum Poor, 'How This Group Began', *Reality* 1, no. 1 (spring 1953): 1, 6. For minutes of meetings and other materials relating to *Reality*, see Raphael Soyer Papers, AAA 867, and Raphael Soyer Papers (Cornell University).

81 See esp. Joseph Solman, 'Jehovah Juries', *Reality* 3 (summer 1955): 5.

82 The opening editorial committee comprised Bishop, Alexander Dobkin, Hopper, Levine, Poor, Solman, Soyer and Wilson.

83 'Editorial: The Response to Reality', *Reality* 2 (spring 1954): 2.

84 Maurice Grosser, 'Speaking in Strange Tongues', *Reality* 1, no. 1 (spring 1953): 7; 'Revolt of the Critics', no. 3 (summer 1953): 1, 7–8.

85 'Editorial: The Language of Reaction: "Reality" ', *AD* 27, no. 17 (June 1953): 5; 'Editorial: The New Iconoclasts', *AN* 52, no. 4 (June–August 1953): 17. The charge is repeated in 'Editorial: Social Notes From All Over Totalitaria', 53, no. 3 (May 1954): 17. For correspondence around *Reality*, see 'Letters', *AD* 27, no. 18 (July 1953): 3–4; 27, no. 19 (August 1953): 3–4. *Reality* was praised in the Communist press: see Sidney Finkelstein, 'NY Art Magazine Gets Down to Earth', *PW*, 28 September 1953; Van Ludwig, 'Around the Galleries', *PW*, 3 March 1954.

86 Rosenberg, 'Community Critics vs. Modern Painting', 59–60. See also Joseph Jeffers Dodge, 'A Reaction to "Action Painters" ', *Reality* no. 2 (spring 1954): 10.

87 'Letter to Museum of Modern Art', *Reality* 1, no. 1 (spring 1953): 2; 'An Open Letter to REALITY', *AD* 27, no. 15 (1 May 1953): 3–4.

88 Notably Honoré Sharrer, 'Humanism in Art', and Jack Levine, 'Man Is the Center', in *Reality* 1, no. 1 (spring 1953): 4, 5–6. For Sharrer's position, see also Honoré Sharrer to Raphael Soyer, 26 April 1953; and Perez Zagorin (husband of Honoré Sharrer) to John Berger, 25 April 1953 (copy), Soyer Papers (Cornell University, folder 2).

89 Otis Gage, 'The Reflective Eye', *AD* 20, no. 20 (15 September 1953): 6.

90 'Symposium: The Human Figure', *AD* 28, no. 4 (15 November 1953): 12.

91 Harry Salpeter, 'Raphael Soyer: East Side Degas', *Esquire* 9 (May 1938): 59; Ernest W. Watson, 'The Paintings of Raphael Soyer', *American Artist* 12, no. 6 (June 1948): 29.

92 PB, 'A Soyer Profile', *AD* 25, no. 14 (15 April 1951): 8, 28.

93 Soyer made a second trip to the USSR in 1963, and his work was the subject of a monograph by a Soviet art historian. See Raphael Soyer, *Homage to Thomas Eakins, Etc.* (ed. Rebecca L. Soyer; South Brunswick, N.J., & London: Thomas Yoseloff, 1966), 74–86; Andrei Chegodayev, *Raphael Soyer* (Moscow, 1970).

94 Lloyd Goodrich, *Raphael Soyer* (New York: Abrams, 1972), 68, 70; 'Soyer, Isaac; Soyer, Moses; Soyer, Raphael', 812; 'Raphael Soyer, Realist, Captures That "Haunted Look of the Unemployed" ', *AD* 12, no. 12 (15 March 1938): 12; Watson, 'Paintings of Raphael Soyer', 64.

95 Statement in Associated American Artists Galleries, New York, *Raphael Soyer* (30 March – 18 April 1953).

96 For exceptions, see Allara, *Pictures of People*, 102–4.

97 PB, 'A Soyer Profile', 8; Patricia Hills, 'The Artist Previews "Raphael Soyer's New York: People and Places" ', in Cooper Union, *Raphael Soyer's New York: People & Places* (New York, 1984), np. At the end of the decade, Soyer returned to New York street scenes, but with a quite different iconography from that of his 1930s work. On this aspect of his career, see Goodrich, *Raphael Soyer*, ch. 4; and Abram Lerner, *Soyer Since 1960* (Washington, D.C.: Smithsonian Insitution, 1982).

98 Hills, 'The Artist Previews'.

99 'New York Criticism', *AD* 9, no. 11 (1 March 1935): 18. For a fine discussion of Soyer's treatment of this theme, see Todd, *The 'New Woman' Revised*, ch. 6.

100 Bought by the National Gallery of Scotland in 1932.

101 Cf. Goodrich on Soyer and Degas in *Raphael Soyer*, 19–20.

102 Todd, *The 'New Woman' Revised*, 258.

103 'Art', *Time* 51, no. 12 (22 March 1948): 59–60.

104 Of a kindred work from the same year, *City Children* (private collection), Soyer wrote: 'This is the kind of painting I do from time to time which leaves me uneasy because it is open to accusations of sentimentality.' See Soyer, *Homage to Thomas Eakins*, 130. Already in 1948 Robert Coates regretted what he saw as the increasing blandness of Soyer's subjects. See 'The Art Galleries', *NY* 24, no. 3 (13 March 1948): 62.

105 Sidney Tillim, 'Month in Review', *Arts* 35, no. 4 (January 1961): 47.

106 'One does not find in his work a preoccupation with painting for its own sake nor "pretty passages".' – Moses Soyer, 'In the World of Art', *NM* 55, no. 13 (26 June 1945): 30.

107 Goodrich, *Raphael Soyer*, 19.

108 Moses Soyer's wife, Ida, was a dancer with the revolutionary dance troupe of Helen Tamiris.

109 In a later programmatic group portrait, *Homage to Thomas Eakins* (1964–5; Hirshhorn Museum & Sculpture Garden, Washington, D.C.) the only woman present is Soyer's daughter Mary, who brings in drinks for the imaginary gathering of artists.

110 E.g., *Nude* (1952, Whitney Museum of American Art).

111 'Art', *Time* 76, no. 24 (12 December 1960): 78.

112 E.g., 'Statements by Four Artists', *Reality* 1, no. 1 (spring 1953): 8.

113 Dorothy Seckler, 'Joseph Solman Paints a Picture', *AN* 50, no. 4 (June–August 1951): 42

114 Joseph Solman to Jacob Kainen, 26 February 1939 (AAA 565:171).

115 It was mentioned in reviews in three of the New York dailies (*NYT*, 31 May 1943; *NYHT*, 31 May 1943; *NYWT*, 30 May 1943), and received a brief favourable notice in *AN* 42, no. 8 (June–July 1943): 41.

116 In an interview with the author, 13 November 1996, Solman remembered the decision as primarily a financial one.

117 D[orothy] S[eckler], 'Joseph Solman', *AN* 49, no. 7 (November 1950): 48; Stuart Preston, 'Diverse Moderns',

NYT, 26 November 1950. On the studio interiors, see also Chanin, *Joseph Solman*, 10–11.

118 Joseph Solman, 'Notes on Art Education', *Reality* no. 2 (spring 1954): 5.

119 Interview with the author, 13 November 1996.

120 Chanin, *Joseph Solman*, 13–14.

121 L[awrence] C[ampbell], 'Joseph Solman', *AN* 53, no. 8 (December 1954): 52.

122 Metropolitan Museum of Art, New York, *Van Gogh Paintings and Drawings: A Special Loan Exhibition* (New York, 1949).

123 'In the Galleries', *Arts* 32, no. 4 (January 1958): 54.

124 Neel rejected the idea of painting 'for hire' and disliked being called a portrait painter. See 'Alice Neel', in Cindy Nemser, *Art Talk: Conversations with 12 Women Artists* (New York: Scribner, 1975), 130; Allara, *Pictures of People*, 16–17. In a letter to the cp's *Daily World* of 2 February 1971, Neel praised a review of her work by Philip Bonosky 'because it included the sociologic and historic aspects of my art which are so important.' Cf. Bonosky, 'Social Comment of Alice Neel', *Daily World*, 30 October 1970.

125 Allara, *Pictures of People*, 94–101; Hills, *Alice Neel*, 86–7, 92. Neel's work was illustrated in *M&M*: 2, no. 5 (May 1949): 70; 2, no. 12 (December 1949): 68; 3, no. 4 (April 1950): 31; 4, no. 1 (January 1951): 87; *M* 11, no. 6 (June 1958): 40–45; 14, no. 2 (February 1961): 44; 14, no. 8 (August 1961), cover. In 1953 Neel gave an illustrated lecture on her work at the Jefferson School: see 'Films, Lectures, Music', *DW*, 27 March 1953.

126 Allara dates the painting to both 1958 and 1952, but it was in fact exhibited in 1951. It thus does not postdate the demise of the CRC in 1956 as she assumes. See *Portraits of People*, 103–4.

127 Allara, *Pictures of People*, 124–5; Hills, *Alice Neel*, 177, 179. See also D[avid] G[ordon], 'Alice Neel, Humanist Artist, for More Cultural Exchange', *Daily World*, 31 May 1973.

128 Hills, *Alice Neel*, 60. None the less, the FBI maintained a file on her, and she was interviewed by two agents in 1955.

129 Printed in ibid., 24–5, 28–9.

130 Doctoral Address to Moore College of Art, printed in ibid., 132, 134. She also claimed: 'I was always class-conscious' – see 'Alice Neel', in Eleanor Munro, *Originals: American Women Artists* (New York: Simon & Schuster, 1979), 128.

131 'Alice Neel', *Night* 2, no. 3 (April 1979). Bizarrely, this interview appears next to a photo feature on Studio 54.

132 Her library includes Howard Selsam's *What is Philosophy?* and *Socialism and Ethics*, and philosophical works by Engels and Lenin. Selsam was director of the Jefferson School, which was forced to close under government pressure in 1956.

133 For Neel on the importance of the frame and '[d]ividing up the canvas,' see Hills, *Alice Neel*, 181, 183–4.

134 'The Passing Shows', *AN* 43, no. 3 (15–31 March 1944): 19.

135 Munro, *Originals*, 128.

136 Mellon Galleries, Philadelphia, *Living Art: American, French, German, Italian, Mexican, and Russian Artists* (16 March – 4 April 1933). The exhibition was organised by J. B. Neumann. Allara discusses the relationship with Expressionism and Neel's tendency to cover her tracks in *Pictures of People*, 48–9, 272 n. 10. Neel recalled seeing Matisse's work when she was at art school, but said it did not satisfy her (Hills, *Alice Neel*, 15–16). None the less, *Futility of Effort* (1930; private collection) clearly suggests his influence.

137 Hills, *Alice Neel*, 49, 53, 59–60, 184. Her long-term relationship with the Communist photographer and film-maker Sam Brody, which lasted from 1940 until the mid-1960s, is also relevant in this regard: see Allara, *Portraits of People*, 105–7. On the importance of the thirties experience to Neel, see Susan Rosenberg, 'People as Evidence', in Philadelphia Museum of Art, *Alice Neel* (Philadelphia, 2000), 33–51.

138 New Playwrights Theatre, *Paintings by Alice Neel* (New York, 23 April – 23 May 1951), printed in Hills, *Alice Neel*, 89–90. The exhibition was in part a retrospective, and included twenty-four works, among which were Social Realist paintings from the 1930s, such as *Demonstration* (1935; Estate of Alice Neel) and *Uneeda Biscuit Strike* (1936; private collection).

139 Mike Gold, 'Alice Neel Paints Scenes and Portraits from Life in Harlem', *DW*, 27 December 1950. Cf. her negative judgements from the 1970s on Giacometti and Beckett, in 'Bloomsburg State College Lecture, March 21, 1972', typescript, AAA 4964:544; Hills, *Alice Neel*, 134;

140 Whitney Museum of American Art, *Alice Neel* (New York, 1974), np.

141 See her comment on Athol Fugard's *Boesman and Lena*, in Hills, *Alice Neel*, 134.

142 The area was the main stronghold of the American Labor Party, and in 1948 Wallace won in all of its eight election districts. See Gerald Meyer, 'Puerto Ricans', in Buhle *et al.* (eds), *Encyclopedia of the American Left*, 614–17; Jesus Colón, *A Puerto Rican in New York, and Other Sketches* (New York: Mainstream, 1961); Allara, *Pictures of People*, ch. 6.

143 New Playwrights Theatre, *Paintings by Alice Neel*; Charles Corwin, 'Deep Humanity, Sincerity Marks Paintings of Talented Alice Neel', *DW*, 15 January 1951.

144 'Alice Neel', *Night*. Cf. the extended account of her 'hypersensitivity' in Munro, *Originals*, 120–30.

145 Lars Lawrence [Phillip Stevenson], *Morning, Noon and Night* (New York: G. P. Putnam, 1954); Philip Bonosky, 'Mining Town', *M&M* 7, no. 12 (December 1954): 51–5; Albert Maltz and Philip Bonosky, 'Two Opinions on a Novel', *M&M* 8, no. 5 (May 1955): 62–4 'More on "Morning, Noon and Night"', *M&M* 8, no. 7 (July 1955): 58–64 (Neel's letter is 62–3). Allara, I think, misreads this exchange, in *Pictures of People*, 96–7.

146 Philip Bonosky, *Brother Bill McKie: Building the Union at Ford* (New York: International Publishers, 1953); Philip Bonosky, 'How I Came to Write Brother Bill McKie', *SW*, 29 March 1953.

147 Allara, *Pictures of People*, 108–13; Hills, *Alice Neel*, 141. For several accounts of Neel's interchanges with her sub-

148 Munro, *Originals*, 130.

149 Daniel Catton Rich, 'Van Gogh', in Metropolitan Museum of Art, *Van Gogh Paintings and Drawings*, 10.

150 W. T. Bürger, 'Van Gogh: Two Paths of an Artist', *M&M* 3, no. 1 (January 1950): 46–9.

151 Meyer Schapiro, *Vincent Van Gogh* (New York: Abrams, 1950), 16–19. Neel painted Schapiro's portrait from memory in 1947 (private collection), presumably because direct contact with a notorious 'Trotskyist' would have been unthinkable. There is obviously a case for seeing the influence of van Gogh in earlier portraits such as *Max White* (1935; Smithsonian American Art Museum) and *Pat Whalen* (fig. 96).

152 For Shields, see Art Shields, *My Shaping-Up Years: The Early Years of Labor's Great Reporter* (New York: International Publishers, 1983).

153 Hubert Crehan's article 'Introducing the Portraits of Alice Neel', *AN* 61, no. 6 (October 1962): 44–7, 68, marked something of a turning point in terms of critical attention.

154 Soyer was elected Academician in 1951 and Solman in 1967. Neel was not elected but received prizes at the 1971 and 1983 NAD exhibitions. She became increasingly friendly with Raphael Soyer from the late 1960s, and painted her portrait of Raphael and Moses (Whitney Museum of American Art) in 1973.

155 Neel benefited from the revival of interest in realism in the 1970s and from the feminist movement. However, she detested the New Realist painting of the period, so alien in its premises to her own: see Hill, *Alice Neel*, 90.

156 'I want to paint the *comédie humaine* – as it is today.' Levine quoted in Elizabeth McCausland, 'The Caustic Art of Jack Levine', '47 *The Magazine of the Year* 1, no. 7 (September 1947): 57.

157 For Soyer on Levine, see *Homage to Thomas Eakins*, 137–40. Key sources for Levine include Henry Freedman, 'Jack Levine: Painter and Protester', PhD thesis, Johns Hopkins University, Baltimore, 1975; Jewish Museum, *Jack Levine: Retrospective Exhibition: Paintings, Drawings, Graphics* (New York, 1978); Jack Levine, *Jack Levine* (ed. Stephen Robert Frankel; New York: Rizzoli, 1989).

158 'Artists Aid "Art Students for Peace"', 1950, unidentified clipping, Levine Papers, AAA, 'Message to Mexico', *M&M* 5, no. 5 (May 1952): 27. The painter Ruth Gikow, whom Levine married in 1946, also had a longstanding connection with the left.

159 Jack Levine, 'Form and Content', *College Art Journal* 9, no. 1 (autumn 1941): 58; 'LEVINE Jack, *The Turnkey*', in University of Illinois, *Contemporary American Painting and Sculpture* (Urbana, 1957), 221.

160 Marc Blitzstein, 'A Musician's War Diary', *NM* 60, no. 7 (13 August 1946): 3–6; 60, no. 8 (20 August 1946): 6–9; 60, no. 9 (27 August 1946): 10–12. For other Levine illustrations see: *NM* 59, no. 10 (4 June 1946): 18; 60, no. 14 (1 October 1946): 13; 61, no. 3 (15 October 1946): 23–6; 'From the Sketchbook of Jack Levine', *M* 1, no. 2 (spring 1947): 213; *M&M* 1, no. 5 (July 1948): 86; 1, no. 10 (December 1948): 10.

161 The Levine exhibition was actually a travelling show that started in the Boston Institute of Contemporary Arts in 1952.

162 'Angry Artist', *Time* 47, no. 20 (20 May 1946): 64. For Levine on *Welcome Home*, see Emily Genauer, 'Welcome Home Gets Reception at Denver Show', *NYWT*, 24 August 1948; 'City Boy', *Time* 55, no. 5 (30 January 1950): 51.

163 Hilton Kramer, 'Bloom and Levine: The Hazards of Modern Painting', *Commentary* 19, no. 6 (June 1955): 583–7. Almost equally negative was *Art News*'s review: Manny Farber, 'Jack Levine', *AN* 54, no. 1 (March 1955): 33, 67.

164 Institute of Contemporary Art, Boston, *Jack Levine* (Boston, 1955), 2. For Goodrich's outspoken position contra McCarthyism, see also his contribution to 'Symposium: Freedom and Art', *AD* 29, no. 11 (1 March 1954): 10, 26.

165 E.g., Jack Levine, 'Statement', in University Gallery, University of Minnesota, *40 American Painters, 1940–1950* np; Emily Genauer, 'Art and Artists: Modern Museum Forum', *NYHT*, 27 April 1952.

166 A. M. Frankfurter, 'Spotlight on: Levine', *AN* 47, no. 3 (May 1948): 54. On this tendency generally, see Piri Halasz, 'Figuration in the '40s: The Other Expressionism', *Art in America* 70, no. 11 (December 1982): 111–19, 145, 147.

167 Levine, *Jack Levine*, 20, 31–2. For Levine's criticisms of Expressionism, see McCausland, 'The Caustic Art of Jack Levine', 58; Institute of Contemporary Art, Boston, *Jack Levine*, 5–7. But cf. Jack Levine, 'Homage to Vincent', *AN* 47, no. 8 (December 1948): 26, 59.

168 E.g., 'Old Masters and New Ones in This Weeks Exhibit', *DW*, 13 May 1948.

169 Jewish Museum, *Jack Levine*, 17; Levine, *Jack Levine*, 51–2; Emily Genauer, 'Prominent Painter, in from Europe, Says Art Needs the Human Image', *NYHT*, 23 September 1951. The picture's whereabouts are unknown.

170 Levine, *Jack Levine*, 20; Ernesto J. Ruiz de La Mata, 'Jack Levine', *San Juan Star Magazine*, 4 February 1968. Significantly, perhaps, Levine's friend Marc Blitzstein overtly acknowledged the influence of Brecht and Weill in his proletarian operas *The Cradle Will Rock* (1936) and *No for an Answer* (1941). For Blitzstein, see Denning, *The Cultural Front*, 285–95.

171 'Pages of *Life Magazine* and old newspaper photographs' adorned the walls of his studio, according to Frederick S. Wight's essay in Institute of Contemporary Arts, Boston, *Jack Levine*, 4. For Levine and the movies, see Freedman, 'Jack Levine: Painter and Protester', ch. 7.

172 This aspect of Levine's art is addressed well in Frank Getlein, *Jack Levine* (New York: Abrams, 1966).

173 Sidney Finkelstein, 'The Painting of Jack Levine', *Jewish Life* 9, no. 7 (May 1955): 27. A further irony is that the following year Harold Rosenberg also attacked Levine for formalism – although with a different agenda, of course. See Rosenberg, 'Community Critics vs. Modern Painting'.

174 Museum of Modern Art, *Americans 1942: 18 Artists from 9 States* (New York, 1942), 86–7.

175 Levine, *Jack Levine*, 54, 44, 93.

176 Frankfurter, 'Spotlight on: Levine', 54. I am not implying that *Art News* was illiberal – it most certainly was not.

Frankfurter protested against the cancellation of the Advancing American Art exhibition and backed Artists Equity, pilloried Dondero and vehemently rejected Communist accusations that the magazine was an instrument of the State Department. He also refused attempts by the Museum of Modern Art and ICA Boston to equate avant-garde art with democratic values. Frankfurter's conception of the modern was expansive, and unlike Kramer he acknowledged Levine's talents. See A. M. Frankfurter, 'Vernissage', *AN* 46, no. 3 (May 1947): 13; 'Vernissage', 48, no. 4 (June–August 1949): 15; 'Vernissage', 48, no. 5 (September 1949): 13; 'Boston Adventure and the New York Look', 47, no. 9 (January 1949): 60. Cf. 'Vernissage', 49, no. 2 (April 1950): 15. None the less, it is symptomatic of Cold War liberalism that in 1954 Frankfurter named US artists whose work was shown in an international art exhibition in Warsaw and accused them of 'implicitly endorsing the totalitarian persecution of all art except Soviet-sanctioned social realism'. Some of the artists concerned (including Lozowick) wrote to protest that their works had been shown without consultation. See 'Editorial', *AN* 53, no. 3 (May 1954): 17; 'Editor's Letters', *AN* 53, no. 5 (September 1954): 6.

177 Kramer, 'Bloom and Levine: The Hazards of Modern Painting', 585.

178 Nietzsche, quoted in Fredric Jameson, *The Political Unconscious: Narrative as a Socially Symbolic Act* (Ithaca: Cornell University Press, 1981), 201.

179 In 1988, Levine said he did not know why he had included Wallace. One may guess it was because in 1950 Wallace had broken with the Progressive Party over the Korean War and been denounced by the Communists as a traitor. See Starobin, *American Communism in Crisis*, 185.

180 Medina was analysed repeatedly in the Communist press. See e.g. Howard Fast, 'The Judge – A Portrait', *DW*, 1 February 1949; Theodore Ward, 'The Affable Judge of Trial of US Democracy', *DW*, 7 February 1949.

181 Marilyn Robb Trier, 'Summer Events: Chicago', *AN* 54, no. 4 (June–August 1955): 74; 'Notes on "The Trial" by Jack Levine', March 1955, typescript, Chicago Art Insitute; Levine, *Jack Levine*, 63–4.

182 Circular letter from Jack Levine, 11 November 1971, on behalf of the Prisoners Solidarity Committee (Levine Artist's File, Hirshhorn Museum and Sculpture Garden, Washington, D.C.).

183 Levine, *Jack Levine*, 70.

184 Frankfurter, 'Spotlight on: Levine', 54. The picture was *Magic for the Millions* (1948; Seattle Art Gallery).

185 A feature also noted by Freedman, 'Jack Levine: Painter and Protester', 59.

186 Some of this literature was reviewed in the Communist press. See e.g., Herbert Aptheker's reviews of *The Lonely Crowd* and *The Power Elite*: 'The Cadillac Credo', *M&M* 8, no. 1 (January 1955): 3–14; 'Power in America', *M&M* 9, no. 8 (September 1956): 1–16.

187 Giles, 'Brand-Name Culture', 47–9. Re Packard, see also Giles's 'The Grey Flannel Mouth', *M&M* 11, no. 6 (June 1958): 10–20.

188 Levine, *Jack Levine*, 70; Selden Rodman, *Conversations with Artists* (New York: Devin-Adair, 1957), 195–6.

189 Jewish Museum, *Jack Levine*, 23–4; Freedman, 'Jack Levine: Painter and Protester', 78, 118; John S. Russell, 'A Retrospective Show of Radical Art of Jack Levine', *NYT*, 11 November 1978.

190 Freedman, 'Jack Levine: Painter and Protester', 72; circular letter from Jack Levine, 11 November 1971. The Prisoners Solidarity Committee was set up by Youth Against War and Fascism, itself an offshoot of the Workers World Party.

191 Levine, *Jack Levine*, 110.

192 Isserman, *Which Side Were You On?*, 117–19, 141–3, 169.

193 The main source for the CRC is Gerald Horne's deeply partisan *Communist Front? The Civil Rights Congress, 1946–1956* (London & Toronto: Associated University Press, 1988). For an insider's account, see Jessica Mitford, *A Fine Old Conflict* (New York: Vintage, 1978), chs 5, 6 and 8.

194 Part of *We Charge Genocide* is printed in Albert Fried, *Communism in America: A History in Documents* (New York: Columbia University Press, 1997), 378–83.

195 Mullen has questioned these portrayals in relation to Chicago in *Popular Fronts*, ch. 1.

196 Other prominent African American artists associated with the Communist movement at this time included Elizabeth Catlett, Ernest Crichlow and Marion Perkins. On the last of these, see Daniel Schulman, 'Marion Perkins: A Chicago Sculptor Rediscovered', *Art Institute of Chicago Museum Studies* 24, no. 2 (1999): 220–43.

197 Mullen, *Popular Fronts*, 75–80; Studio Museum, *Images of Dignity*, 15; 'Shows History of Negro Press', *Chicago Sunday Bee*, 27 July 1940. The mural was illustrated in *MA* 33, no. 8 (August 1940): 478.

198 E.g., Tanner Art Gallery & American Negro Exhibition, *Exhibition of the Art of the American Negro* (Chicago, 1940); Library of Congress, *Exhibition of the Art of the American Negro* (Washington, D.C. 1940–41); Davis, 'The Art Notebook'.

199 Bill Chase, 'Meet Mr., Mrs. Charles White', unidentified clipping, 5 September 1942 (AAA 3195:55).

200 White, 'Path of a Negro Artist', 39.

201 'Negro Mural', *MA* 42, no. 9 (August/September 1943): 37; Art Council, 'Art Today', *DW*, 28 August 1943.

202 'Report of Year's Progress and Plan of Work for a Renewal of Julius Rosenwald Fellowship', typescript, AAA 3193: 320–24. The connection between African American struggles and the struggle against fascism is also made in Herbert Aptheker's pamphlet *Negro Slave Revolts in the United States, 1520–1860* (New York: International Publishers, 1939), a text with which White is likely to have been familiar.

203 Studio Museum, *Images of Dignity*, 16.

204 Walter Christmas, 'Artist Seeks Life of Man on Street', *Daily Compass*, 10 February 1950. Cf. White, 'Path of a Negro Artist', 40.

205 E.g., Harry Raymond, *Dixie Comes to New York: Story of the Freeport GI Slayings* (New York, 1946), cover cartoon; Civil Rights Congress, *We Demand Freedom!: Two*

Addresses by William L. Patterson (New York, nd), cover portrait; Elwood M. Dean, 'The Story of the Trenton Six', *SW*, 11 September 1949; 'The Ingrams Jailed America's Shame', *SW*, 9 October 1949; 'The Charge is Genocide', *Freedom* 2, no. 1 (February 1952), portrait of Paul Robeson.

206 'Reviews and Previews', *AN* 46, no. 8 (October 1947): 51.

207 Charles White to Charles Keller, 14 January 1949 (Keller Papers); Christmas, 'Artist Seeks Life of Man on Street'.

208 *The Art of Charles White: A Folio of Six Drawings* (New York: Masses & Mainstream, 1953).

209 Catlett had been awarded a Rosenwald Fellowship in 1945 to make a series of works 'on the role of the Negro woman in the fight for democratic rights in the history of America'. Instead of a statement, the 1951 catalogue printed a poem by Eve Merriam titled 'To My Negro Sisters'. See also John Hudson Jones, 'Negro Women – Vanguard Fighters', *The Worker*, 12 February 1950, which is illustrated by White's *Harriet Tubman*.

210 Charles Corwin, 'Art Galleries', *DW*, 20 February 1950. William Thor Bürger had been sharply critical of White's style in 'Delacroix and the "Social Realists"', *NM* 59, no. 13 (25 June 1946): 30–31.

211 Sidney Finkelstein, 'Charles White's Humanist Art', *M&M* 6, no. 2 (February 1953): 45.

212 For White's European trip, see 'Young America Asks: Can We Be Friends With USSR Youth?', *New Challenge* 1, no. 4 (December 1951): 5; Charles White, 'Until the Day I Die, My Life is Dedicated to My People', *Freedom* 2, no. 7 (July 1952): 7. The Whites' travel diaries are in the White Papers, AAA 3099:25–157. White found the party's visit to Stalin's birthplace especially moving: see 3099:45.

213 John Pittman, 'Charles White's Exciting "Negro Woman" Show at ACA Gallery', and Charles Corwin, 'White's Exhibit is Valuable Object Lesson to Progressive Artists, Public', *DW*, 26 February 1951; David Platt, 'Charles White Finds USSR Creating Finest Art', *DW*, 13 December 1951, and 'Soviet Art Reflects Life of a Heroic Society, Says White', *DW*, 14 December 1951; Charles White, 'Eyewitness Report on Soviet Art by an Outstanding Negro Artist', *DW*, 23 November 1952.

214 '"A Negro Artist Speaks"', typescript of talk, AAA 3190: 484–8.

215 Academy of Arts: GDR, '"The Impact of his Art Crosses the Borders of North America"', *Freedomways* 20, no. 2 (1980): 184–6. A study of White by Finkelstein was published in the GDR: *Charles White: ein Künstler Amerikas* (Dresden: VEB, Verlag der Kunst, 1956).

216 For the significance of hands in White's work, see Howard Fast, 'A Note on the Graphic Art of Charles White', *DW*, 9 February 1950.

217 William Z. Foster, *Twilight of World Capitalism* (New York: International Publishers, 1949), 152.

218 See the following reviews: Philip Evergood, 'Charles White: Beauty and Strength', *M&M* 6, no. 8 (August 1953): 36–9; Hugo Gellert, 'Charles White, People's Artist', *Jewish Life* 7, no. 10 (August 1953): 8–9; Al Richmond, 'Charles White, A Great Artist Celebrates the Cause of Man', unidentified clipping; Jane Hamilton, 'Art That Speaks the Truth', unidentified clipping, AAA 3192:732–3.

219 See e.g., Lorraine Hansberry's Foreword to White's 1961 ACA show, repr. in *Freedomways* 20, no. 2 (1980): 197–9.

220 By 1963, White was saying he had been over-involved with 'organizations' in New York: see Hoyt W. Fuller, 'Charles White: Artist', *Negro Digest* 12, no. 9 (July 1963): 42–3. For White's later career, see Studio Museum, *Images of Dignity*, 23–38.

221 For Lawrence, see *Current Biography* 26, no. 7 (July 1965): 18–20; Ellen Harkins Wheat, *Jacob Lawrence: American Painter* (Seattle & London: University of Washington Press, 1986); Peter T. Nesbett and Michelle DuBois, *Jacob Lawrence: Paintings, Drawings and Murals (1935–1999): A Catalogue Raisonné*, and (eds), *Over the Line: The Art and Life of Jacob Lawrence* (Seattle & London: University of Washington Press in association with the Jacob Lawrence Catalogue Raisonné Project, 2000). Other sources drawn on here include the Lawrence Papers (SU), and the Lawrence scrapbooks in the Downtown Gallery Papers, AAA ND/65, ND/66.

222 For Lawrence on McKay, see Wheat, *Jacob Lawrence*, 59. Lawrence provided six illustrations for Hughes's volume of poems, *One-Way Ticket* (New York: Knopf, 1948).

223 Elizabeth McCausland, 'Jacob Lawrence', *MA* 38, no. 7 (November 1945): 252. Cf. Harry Gottlieb to Jacob Lawrence, 4 October 1937 (Lawrence Papers, Box 1).

224 See Wheat, *Jacob Lawrence*, 42–3.

225 Gwendolyn Bennett, 'Jacob Lawrence', *M* 1, no. 1 (winter 1947), between 96 and 97. In 1945, Lawrence was quoted as saying: '"You see, when I first began painting I discovered my style medium and I've studied to develop it."' – Marjorie E. Greene, 'Jacob Lawrence', *Opportunity* 23, no. 1 (winter 1945): 27.

226 Marcia Minor, 'Satire Theme of his Paintings', *DW*, 17 August 1938. Of those who taught Lawrence at the American Artists School, Eugene Morley is most likely to have encouraged him in a modernist direction.

227 See esp. the statement quoted by Wheat, *Jacob Lawrence*, 39–40.

228 McCausland, 'Jacob Lawrence', 254. Cf. Lawrence quoted in 1957: 'If I could get mural commissions . . . I'd certainly take them.' Rodman, *Conversations with Artists*, 205.

229 See Turner (ed.), *Jacob Lawrence: The Migration Series*. Lawrence did show in the ACA exhibition *Social Art Today* in 1947.

230 Alain Locke, '". . . And the Migrants Kept Coming"', *Fortune* 24, no. 5 (November 1941): 102–9; 'Artist in Harlem', *Vogue* 102 (15 September 1943): 94–5.

231 See also Baltimore Museum of Art, *Contemporary Negro Art* (3–19 February 1939); Albany Institute of History and Art, *The Negro Artist Comes of Age: A National Survey of Contemporary American Artists* (3 January – 11 February 1945).

232 On these developments, see Sullivan, *Days of Hope*, ch. 5.

233 Locke, '". . . And the Migrants Kept Coming"', 102, 108.

234 'Jacob Lawrence', *Museum of Modern Art Bulletin* 12, no. 2 (November 1944): 11.

235 See Wheat, *Jacob Lawrence*, 69–71.

236 Museum of Modern Art, New York, press release: 'Paintings by Leading Negro Artist Shown at Museum of Modern Art' [1944]; Elizabeth Catlett, 'Artist with a Message', *People's Voice*, 21 October 1944.

237 E.g., Sam Leavitt, 'Jacob Lawrence, Nationally Known Negro Artist is at USCG Training Station', *St. Augustine Record*, 15 December 1943.

238 'Jacob Lawrence', *Ebony* 6, no. 4 (April 1951): 78; Irwin Silber, 'Meet Jacob Lawrence', *Tan Town Stories* (March 1946): 18. Cf. 'I paint the things I know about and the things I have experienced . . . So I paint about the American Negro working class.' Jacob Lawrence, 'My Opinion About Painting', *ALA News* 2 (1946).

239 Elizabeth Catlett, ' "A Tribute to the Negro People" ', *American Contemporary Art* 3, no. 1 (winter 1946): 17. See also *NM* 59, no. 4 (23 April 1946): 21; 59, no. 8 (21 May 1946): 27; 59, no. 9 (28 May 1946): 15.

240 Henry Wallace, 'Violence and Hope in the South', *NR* 117, no. 23 (8 December 1947): 15; Richard Watts, Jr., 'A Liberal View of the South', *NR* 118, no. 3 (19 January 1948): 26–7; Walker Evans, 'In the Heart of the Black Belt', *Fortune* 37, no. 2 (August 1948): 88–9.

241 Bennett, 'Jacob Lawrence'; 'A Hot Summer's Night' (drawing), *M&M* 1, no. 8 (October 1948): 54; 'They Broke Chains' (four drawings), *M&M* 2, no. 2 (February 1949): 18–21.

242 Minor, 'Satire Theme of his Paintings'; Art Council, 'Art Today', *DW*, 29 May 1943.

243 'Artist in Harlem'; Elizabeth McCausland, 'Pictures of Harlem by Jacob Lawrence', *SSUR*, 16 May 1943; 'Attractions in the Galleries', *NYS*, 14 May 1943; Aline B. Louchheim, 'Lawrence: Quiet Spokesman', *AN* 43, no. 13 (15–31 October 1944): 15; Mayer Symason, 'Canvas and Film', *NM* 47, no. 10 (8 June 1943): 29–30.

244 'Recognition: "New Masses" Honors Outstanding Artists', *NM* 58, no. 7 (12 February 1946): 16–17.

245 Sidney Finkelstein, 'National Art and Universal Art', *M* 1, no. 3 (summer 1947): 347–8. The 1947 War series was also favourably received in the CP press: see 'The Art Galleries', *DW*, 12 December 1947.

246 Finkelstein, *Realism in Art*, 172.

247 Untitled typescript beginning 'Friends and members of The Arts, Sciences, and Professions', Lawrence Papers, SU, Box 2.

248 Rodman, *Conversations with Artists*, 206. Lawrence was seemingly dismissive of Abstract Expressionism in his conversation with Rodman, but somewhat more positive in an interview of 1963: see Louise Elliott Rago, 'A Welcome from Jacob Lawrence', *School Arts* (February 1963): 32.

249 E.g., his later works in connection with the Civil Rights Movement. See Patricia Hills, 'Jacob Lawrence's Protest Paintings During the Protest Years of the 1960s', in Nesbett and Du Bois (eds), *Over the Line*, 175–91.

250 Gwathmey came from a working-class family and he largely supported himself through a succession of jobs during his artistic training. See 'Robert Gwathmey', *Current Biography – 1943* (1943): 261–3; Elizabeth McCausland, 'Robert Gwathmey', *MA* 39, no. 4 (April 1946): 149–52; Judd Tully, 'Robert Gwathmey', *American Artist* 49, no. 515 (June 1985): 47–50, 88, 90–92; Michael Kammen, *Robert Gwathmey: The Life and Art of a Passionate Observer* (Chapel Hill & London: University of North Carolina Press, 1999).

251 Author's interview with Anthony Toney, 20 July 1992; Anthony Toney to Anna W. Olmstead, 23 October 1955 (copy; Toney Papers, SU, Box 1). See also 'Verbal Self-Portrait: An Interview with Anthony Toney', *PA* 64, no. 9 (September 1985): 12–18.

252 For Gwathmey's fine mural for the Eutaw, Alabama, post office, see Charles K. Piehl, 'The Eutaw Mural and the Southern Art of Robert Gathmey', *Alabama Review* 45, no. 2 (April 1992): 103–31. In 1936–7 Toney painted a mural of 'Kneestakers' (leatherworkers) for the Gloversville High School study hall, and six panels on literary themes for the New Junior High Library. See Park and Markowitz, *New Deal for Art*, 136.

253 ACA Gallery, *The Art of Anthony Toney* (commentary by Herzl Emmanuel; New York, 1964); interview with the author, 20 July 1992.

254 Toney to Olmstead, 23 October 1955.

255 'Anthony Toney, Modernist', *AD* 15, no. 15 (1 May 1941): 21. Among the exhibits was a still-life inscribed 'à Cézanne'. Toney studied Cézanne as a student at Syracuse University – interview with the author, 20 July 1992.

256 Emmanuel records that in the postwar period Toney had photographs of Nazi death camps tacked to his studio wall: see ACA Gallery, *The Art of Anthony Toney* (1964). Unlike Emmanuel, Toney was not Jewish but the child of Christian Arab parents. There is a colour slide of *Concentration Camp* in the Toney Papers.

257 I am assuming that *Night Flying* may be no. 8, *Night Scene* in the 1948 exhibition.

258 Artists' Gallery, New York, *Anthony Toney* (13 March – 2 April 1948); ACA Gallery, *Paintings, Anthony Toney* (26 September – 15 October 1949). Press releases for same, Toney Papers, SU, Box 4, Box 3. Cf. Anthony Toney, 'Abstraction', *Reality* 3 (summer 1955): 7.

259 Joseph Solman, 'Art', *NM* 61, no. 12 (17 December 1946): 30. Marion Summers made no mention of the picture in his *Daily Worker* review of the exhibition (8 December 1946). A drawing for the work is illustrated in ACA Gallery, *The Art of Anthony Toney* (1964).

260 Joseph Solman, 'Painters with Ideas', *M&M* 1, no. 2 (April 1948): 86. Solman reviewed Toney's exhibition with that of his friend Harari, with whom he had studied at Syracuse, and whose work – as Solman noted – was engaged with similar problems.

261 Cf. Toney on the 'twofold direction' of his work, in Anthony Toney to Roland McKinney, 6 June 1948 (copy; Toney Papers, SU, Box 1).

262 University of Illinois, *Contemporary American Painting* (Urbana, 1951), 219–20. The painting in question, *Bridge*, was in the Norton Gallery and School of Art, West Palm Beach, but has been deaccessioned. Cf. on *Monument* in University of Illinois, *Exhibition of Contem-*

porary American Painting (Urbana, 1952), 236. Cf. statement on application for a John Simon Guggenheim Foundation grant in 1952 (?): 'The work I do is experimental, aimed toward extending the language of painting, rather than limiting or purifying it' (Toney Papers, su, Box 3).

263 Charles Corwin, 'Anthony Toney's Exhibit at ACA Gallery', *DW*, 7 October 1949; 'Correspondence on Review of Toney's Paintings', *DW*, 17 November 1949. Cf. William Thor Bürger: 'New Season', *M&M* 2, no. 2 (December 1949): 85–6; 'The Whitney Disaster', *M&M* 3, no. 3 (March 1950): 92.

264 See his defence of difficult and experimental art in 'Freedom by Trial and Error', *American Dialog* 3, no. 2 (summer 1965): 11–12.

265 Solman, 'Painters with Ideas', 86.

266 L[awrence] C[ampbell], 'Reviews and Previews', *AN* 54, no. 6 (October 1955): 53.

267 He received an MA from Columbia University Teachers College in 1952, and an EdD in 1955. His 1966 student handbook is in part a defence of his own work, and discreetly makes an expanded conception of realism equivalent to dialectical materialism. See Anthony Toney, *Creative Painting and Drawing* (introduction by Rudolph Arnheim; New York: Dover, 1966), 8, 10.

268 McCausland, 'Robert Gwathmey', 150–51.

269 In 1946 he was reported as having been '[s]ick of Impressionism and of the styles he absorbed during four years at the Penn Academy'. See A[line] B. L[ouchheim], 'Gwathmey Adds Scale to Pattern', *AN* 44, no. 9 (15–31 January 1946): 20.

270 ' "Art in a Skyscraper" ', *NYP*, 11 February 1939; 'Artists Congress Opens Members' Exhibition', *NYHT*, 6 February 1939; Julia R. Myers, '*Chauffeur*', in Diana Strazdes *et al.*, *American Paintings and Sculpture to 1945 in the Carnegie Museum of Art* (Pittsburgh: Carnegie Museum of Art, 1992), 217–18. I think Myers misreads the picture in seeing it as a satire partly at the chauffeur's expense – his expression signifies disdain and resentment at his situation rather than a sense of superiority shared with his employer.

271 See Ray King, 'Artist Congress Exhibit at ACA', *DW*, 22 July 1939. King praised Gwathmey for having 'cut loose from his earlier dependance on Franklin Watkins', who had taught him at the Pennsylvania Academy. Paul Robeson also mentions the influence of Watkins in 'Paul Robeson Evaluates An Important American Artist', *DW*, 4 February 1946.

272 Oliver F. Mason, 'Gropper Heads Roster of Year's Best Artists', *DW*, 1 January 1941. The exhibition was widely reviewed, e.g. Melville Upton, 'Groups and Individuals', *NYS*, 4 January 1941; J[eanette] L[owe], 'Satirical Flair in a Show by R. Gwathmey', *AN* 39, no. 14 (4 January 1941): 12; 'Gwathmey's Reward: A Successful Debut', *AD* 15, no. 8 (15 January 1941): 22.

273 'The Artists' Union was . . . one of the greatest forces for the promotion of Negro-white art unity in the history of our country.' – Elizabeth Catlett, 'The Negro Artist in America', *American Contemporary Art* (April 1944): 5.

274 McCausland, 'Robert Gwathmey', 149–50; Kammen, *Robert Gwathmey*, 37–8, 79–83; Robert Gwathmey to Herman Baron, 9 July 1946 and 21 August 1951 (AAA

D304:328–31, 332–3). Cf. Gwathmey's statement on authenticity and truth in: University of Illinois, Urbana, *Contemporary American Painting and Sculpture* (Urbana, 1953), 186.

275 E.g., William Pickens, 'Poll Tax: Denial of Democracy', *NM* 33, no. 1 (26 September 1939): 16–17; Adam Lapin, 'The Klan Rides to the Polls', *NM* 35, no. 3 (9 April 1940): 18–19.

276 For '666', see Kammen, *Robert Gwathmey*, 5–6, 76–7. The connection between the circus posters and the tag 'bread and circuses' is made explicit in the title of a 1945 painting (Museum of Fine Arts, Springfield, Mass.) that includes the same motif. The posters plastered on shacks in Gwathmey's paintings also signify poverty.

277 Cf. Moses Soyer: 'He has been profoundly influenced by Negro art, especially the masks' – 'Robert Gwathmey', *NM* 58, no. 8 (19 February 1946): 27.

278 Paul Robeson, 'Paul Robeson Evaluates an Important American Artist' (text of Robeson's catalogue essay), *DW*, 4 February 1946; McCausland, 'Robert Gwathmey', 150. Cf. Gwathmey's reference to his 'disgust for the picturesque' in University of Illinois, *Contemporary American Painting and Sculpture* (1953), 186.

279 L[ouchheim], 'Gwathmey Adds Scale to Pattern'.

280 A propos of *Cotton Picker* (Fine Arts Museum of San Francisco), in University of Illinois, *Contemporary American Painting* (Urbana, 1951), 184.

281 On the symbolism of this, see Gwathmey quoted in McCausland, 'Robert Gwathmey', 151.

282 Soyer, 'Robert Gwathmey'. Contemporaneously, Stanley Meltzoff associated Gwathmey with Social Surrealism in 'David Smith and Social Surrealism', *MA* 39, no. 3 (March 1946): 98.

283 Charles Corwin, 'Robert Gwathmey's Important Exhibit at ACA Gallery', *DW*, 22 April 1949. *Poll Tax County* also featured prominently in the ACA Gallery's *Social Art Today* exhibition of 1947: see Joseph Solman, 'Art', *NM* 62, no. 11 (11 March 1947): 30. Despite Gwathmey's graphic gifts and his long-term editorial links with *New Masses* (he joined the board in April 1946) and *Masses & Mainstream*, his only contribution to the Communist press as an artist seems to be a single cartoon in *New Masses* 59, no. 3 (16 April 1946): 5.

284 In this regard, it is worth noting that some works in the 1946 exhibition were shown simultaneously in the form of ceramic reproductions by Francis Serber.

285 McCausland, 'Robert Gwathmey', 149.

286 'An End to the Neglect of the Problems of the Negro Woman!', *PA* 28, no. 6 (June 1949): 52, 57.

287 Arnaud d'Usseau, 'The Negro as an Artist', *American Contemporary Art* (winter 1946): 6–7. The magazine illustrates *Singing and Mending* and *Bread and Circuses*.

288 Strazdes *et al.*, *American Paintings and Sculpture . . . in the Carnegie Museum*, 218–19.

289 Kammen, *Robert Gwathmey*, 62–5, 69–73.

290 University of Illinois, *Contemporary American Painting* (Urbana 1951), 184.

291 Lem Harris, 'Toward a Democratic Land Program for the South', *PA* 28, no. 3 (March 1949): 87.

292 This is one of Gwathmey's relatively few pictures focussing on the immiseration of Southern whites, and it formed the basis for the silkscreen *Rural Home Front* of 1943. The irony of the image depends on the fact that the poorest sectors of the population must sacrifice their children in war for a state that so neglects them.

293 The racial politics of 'Operation Dixie' were compromised, to say the least: see Sullivan, *Days of Hope*, 208–10.

294 See reviews of his 1957 ACA exhibition: 'Art Exhibition Notes', *NYHT*, 5 October 1957; P[arker] T[yler] in 'Reviews and Previews', *AN* 56 no. 6 (October 1957): 19.

295 Corwin, 'Robert Gwathmey's Important Exhibit at ACA Gallery'; Finkelstein, *Realism in Art*, 171. In 1964, Gwathmey was a sponsor of *American Dialog*, the forlorn successor to *Mainstream*.

296 Although a notable talker, Gwathmey did not publish any significant statements. However, for his position in the late 1950s, see the typescript 'art for art's sake?', Gwathmey Papers (AAA D245:1060–62). See also the 4pp typescript in Soyer Papers (Cornell University, folder 5).

Epilogue

1 Raymond Williams, *Marxism and Literature* (Oxford University Press, 1977), II.8.

2 Charles Humboldt to John Berger, 9 June 1958, copy (Humboldt Papers, YU, Box 1).

3 E.g., Philip Evergood, 'Art Is Not a Popsicle', *American Dialog* 1, no. 2 (October–November 1964): 15–17; Hills, *Alice Neel*, 134; Kammen, *Robert Gwathmey*, 138–40.

4 Gellert's accomplished photomontage *What's It All About?* in *New Masses* 4, no. 2 (July 1928): 16, does not seem to have led to an enduring interest in the medium. In the face of the relentless tendency of museum culture and art-historical discourse to sidestep the radical challenge to the aesthetic posed by Dada, Surrealism and Constructivism at their best, and line them up with the modernist movements in a bland aestheticist category of modern art, Peter Bürger's modernism/avant-garde distinction remains useful – even if one does not accept all the conclusions he draws from it: see Peter Bürger, *The Theory of the Avant-Garde* (1980, tr. Michael Shaw; Manchester & Minneapolis: Manchester University Press & University of Minnesota Press, 1984).

5 Walter Quirt to Leila Purcell, 13 February 1968 (AAA 570:95).

6 In 1957 five prominent figures in the American museum world, headed by John I. H. Baur (then curator of the Whitney Museum) collaborated on a lavish volume titled *New Art in America*. To read this now is a forceful reminder of how different the prevailing sense of value then was. 'In spite of the recent popularity of abstraction', they wrote, 'it is apparent that the last fifteen years has produced in America, a greater diversity of styles, subjects and attitudes than any comparable period of the past.' They were emphatically affirmative of the continuing value of American Scene painting, Expressionism and 'social protest' painting, and claimed that some of their practitioners had produced their finest works in recent years. See John I. H. Baur (ed.), *New Art in America* (New York & Greenwich, Conn.: New York Graphic Society in cooperation with Frederick A. Praeger, 1957). The other contributors were Lloyd Goodrich, Dorothy C. Miller, James Thrall Soby and Frederick S. Wight.

7 I have addressed this issue in my unpublished paper, 'How the Tale of Taste Wags the Dog of History: American Art pre-1945 and the Problem of Art History's Object', given at the Association of Historians of American Art panel at the annual College Art Association conference in Los Angeles, 1999.

8 Clement Greenberg, 'Avant-Garde and Kitsch' (1939), in Clement Greenberg, *The Collected Essays and Criticism, Volume 2: Perceptions and Judgements, 1939–44* (ed. John O'Brian; Chicago & London: University of Chicago Press, 1986), 8, 10.

9 Let me be clear: I do not mean that the natural sciences are immune from ideological imperatives or that 'science' does not perform ideological functions. My point is rather that there are certain standards of method and argument within their domain that are far more rigorous than those that apply in the domain of taste, where, when reasoned argument is exhausted, intuition is always in some respects unanswerable, and the exposition of truth claims has a more performative than constatative basis.

10 This is anything but a recent question, but one that goes back to some of the earliest texts that mark the emergence of aesthetics as a distinct philosophical discipline, such as Hume's essay 'Of the Standard of Taste'. It is not surprising, given the acute awareness of the major Enlightenment thinkers of the problems posed for the universalising pretensions of their systems by increasing knowledge of developed cultures outside Europe, which was one fruit of European imperialism. See David Hume, 'Of the Standard of Taste', in *Essays: Moral, Political, and Literary* (Eugene F. Miller, ed.; Indianapolis: Liberty Classics, 1985), 226–49. The contradictions of Hume's essay are brilliantly analysed in Barbara Herrnstein Smith, *Contingencies of Value: Alternative Perspectives for Critical Theory* (Cambridge, Mass.: Harvard University Press, 1988), ch. 4.

11 For a wonderfully nuanced consideration of the status of the aesthetic in relation to 'other situations', see Williams, *Marxism and Literature*, III.2.

12 Obviously I do not accept the view associated particularly with Hayden White that the narrative structures of history vitiate its standing as a social science. The larger claims of White's well-known study *Metahistory: The Historical Imagination in Nineteenth-century Europe* (Baltimore: Johns Hopkins University Press, 1974) are compromised by his naive positivistic conception of the natural sciences and his failure to address twentieth-century historical practices. On White, see also Gregor McLennan, *Marxism and the Methodologies of History* (London: Verso, 1981), 83–7; Alex Callinicos, *Theories and Narratives: Reflections on the Philosophy of History* (Oxford: Polity Press, 1995), 49–53, 69–75 and *passim*.

13 O. K. Werckmeister, 'From a Better History to a Better Politics', *Art Bulletin* 77, no. 3 (September 1995): 387–91.

Select Bibliography

Primary Sources

NB: This listing does not include periodical articles or exhibition catalogues.

American Artists' Congress, *America Today: A Book of 100 Prints* (New York: Equinox Co-operative Press, 1936)

—, *Artists against War and Fascism: Papers of the First American Artists Congress* (1936; ed. Matthew Baigell and Julia Williams; New Brunswick, N.J.: Rutgers University Press, 1986)

Biddle, George, *An American Artist's Story* (Boston: Little, Brown & Co., 1939)

Browder, Earl, *Communism in the United States* (New York: International Publishers, 1935)

—, *The People's Front* (New York: International Publishers, 1938)

Brown, Milton W., *Painting of the French Revolution* (New York: Marxist Critics Group, 1938)

Burck, Jacob, *Hunger and Revolt: Cartoons by Burck* (New York: Daily Worker, 1935)

Cahill, Holger, *Max Weber* (New York: Downtown Gallery, 1930)

—, and Barr, Alfred H. (eds), *Art in America in Modern Times* (New York: Reynal & Hitchcock, 1934)

Charney, George, *A Long Journey* (Chicago: Quadrangle Books, 1968)

Cheney, Sheldon, *Expressionism in Art* (New York: Liveright, 1934)

Cowley, Malcolm, *The Dream of the Golden Mountains: Remembering the 1930s* (New York: Viking Press, 1980)

Davidson, Jo, *Between Sittings: An Informal Autobiography of Jo Davidson* (New York: Dial Press, 1951)

Dewey, John, *Art as Experience* (1934; New York: Perigree, 1980)

Dimitroff [Dimitrov], Georgi, *The United Front: The Struggle Against Fascism and War* (London: Lawrence & Wishart, 1938)

Eastman, Max, *Artists in Uniform: A Study of Literature and Bureaucratism* (New York: Knopf, 1934)

Ellis, Fred, *et al.*, *Red Cartoons from the Daily Worker, the Workers' Monthly and the Liberator* (Chicago: Daily Worker, 1926)

Federal Writers Project, *Illinois: A Description and Historical Guide* (Chicago: McClurg, 1939)

Finkelstein, Sidney, *Art and Society* (New York: International Publishers, 1947)

—, *Realism in Art* (New York: International Publishers, 1954)

Folsom, Michael (ed.), *Mike Gold: A Literary Anthology* (New York: International Publishers, 1972)

Foster, William Z., *Twilight of World Capitalism* (New York: International Publishers, 1949)

Freeman, Joseph, *An American Testament: A Narrative of Rebels and Romantics* (New York: Farrar & Rinehart, 1936)

—, Kunitz, Joshua, and Lozowick, Louis, *Voices of October: Art and Literature in Soviet Russia* (New York: Vanguard Press, 1930)

Gellert, Hugo, *Karl Marx' 'Capital' in Lithographs* (New York: Ray Long & Richard R. Smith, 1934)

Gillmor, Daniel S (ed.), *Speaking of Peace* (New York: National Council of Arts, Sciences and Professions, 1949)

Gladkov, Feodor, *Cement* (1925; New York: International Publishers, 1929)

Gold, Michael, *120 Million* (New York: International Publishers, 1929)

Gorky, Maxim, *et al.*, *Soviet Writers' Congress, 1934* (London: Lawrence & Wishart, 1977)

Harap, Louis, *Social Roots of the Arts* (New York: International Publishers, 1949)

Herbst, Joseph, *The Starched Blue Sky of Spain and Other Memoirs* (New York: Harper, 1992)

Hicks, Granville, *The Great Tradition: An Interpretation of American Literature Since the Civil War* (1933; New York: International Publishers, 1935)

—, *I Like America* (New York: Modern Age Books, 1938)

—, *et al.* (eds), *Proletarian Literature in the United States* (London: Lawrence and Wishart, nd)

Jerome, Victor J., *Culture in a Changing World: A Marxist Approach* (New York: New Century Publications, 1947)

Josephson, Matthew, *Infidel in the Temple: A Memoir of the Nineteen Thirties* (New York: Knopf, 1967)

Kainen, Jacob, 'Memories of Arshile Gorky', *Arts Magazine* 50, no. 7 (March 1976): 96–8

Kunitz, Joshua (ed.), *Azure Cities: Stories of New Russia* (New York: International Publishers, 1929)

—, *Dawn Over Samarkand: The Rebirth of Central Asia* (New York: International Publishers, 1936)

Lozowick, Louis, *Survivor from a Dead Age: The Memoirs of Louis Lozowick* (ed. Virginia Hagelstein Marquardt; Washington, D.C., & London: Smithsonian Institution Press, 1997)

Lukács, Georg, *Essays on Realism* (ed. Rodney Livingstone; Cambridge, Mass.: MIT Press, 1981)

Lunacharsky, Anatoly V., 'Proletarian Culture', *Survey Graphic* 2, no. 6 (March 1923): 691–3

Mitford, Jessica, *A Fine Old Conflict* (New York: Vintage, 1978)

Paul, Eden and Cedar, *Creative Revolution: A Study of Communist Ergatocracy* (New York: Thomas Seltzer, 1920)

—, *Proletcult (Proletarian Culture)* (New York: Thomas Seltzer, 1921)

Phillips, William, 'What Happened in the '30s', *Commentary* 34 (September 1962): 204–12

—, *A Partisan View: Five Decades of the Literary Life* (New York: Stein & Day, 1983)

Public Works of Art Project, *Report of the Assistant Secretary of the Treasury to Federal Emergency Relief Administrator, December 8, 1933 – June 30, 1934* (Washington, D.C.: United States Government Printing Office, 1934)

Rexroth, Kenneth, *An Autobiographical Novel* (New York: New Directions, 1991)

Robinson, Ione, *A Wall to Paint On* (New York: Dutton, 1946)

Rosenberg, Harold, *The Tradition of the New* (New York: Horizon Press, 1959)

Soyer, Raphael, *Raphael Soyer* (New York: American Artists Group: 1946)

—, *Self-Revealment: A Memoir* (New York: Random House, 1969)

Trotsky, Leon, *Literature and Revolution* (tr. Rose Strunsky; New York: International Publishers, 1925)

—, *The Revolution Betrayed: What is the Soviet Union and Where is it Going?* (1937; New York: Pathfinder, 1972)

Wright, Richard, *American Hunger* (New York: Harper & Row, 1977)

Zhdanov, Andrei, *Essays on Literature, Philosophy and Music* (New York: International Publishers, 1950)

Zigrosser, Carl, *The Artist in America: Twenty-Four Close-Ups of Contemporary Printmakers* (New York: Knopf, 1942)

Secondary Sources

Aaron, Daniel, *Writers on the Left: Episodes in American Literary Communism* (1961; New York: Columbia University Press, 1992)

Allara, Pamela, *Pictures of People: Alice Neel's American Portrait Gallery* (Hanover, N.H., & London: Brandeis University Press, 1998)

Amon Carter Museum, *Stuart Davis: Graphic Work and Related Paintings with a Catalogue Raisonné of the Prints* (catalogue by Sylvan Cole and James Myers; Fort Worth, Tex., 1986)

Anderson, Perry, 'The Antinomies of Antonio Gramsci', *New Left Review* no. 100 (November 1976 – January 1977): 5–70

Badger, Anthony J., *The New Deal: The Depression Years, 1933–1940* (Basingstoke & London: Macmillan, 1989)

Barnwell, Andrea D., 'Sojourner Truth or Harriet Tubman?: Charles White's Depiction of an American Heroine', in Andrea D. Barnwell *et al.*, *The Walter O. Evans Collection of African American Art* (Seattle: University of Washington Press, 1999)

Baur, John I. H., *Philip Evergood* (New York: Whitney Museum of American Art, 1960)

Baxandall, Lee, *Marxism and Aesthetics: A Selective Annotated Bibliography* (New York: Humanities Press, 1973)

Bellknap, Michael, *Cold War Political Justice: The Smith Act, the Communist Party, and American Civil Liberties* (Westport, Conn. & London: Greenwood Press, 1977)

Bentley, Eric (ed.), *Thirty Years of Treason: Excerpts from the Hearings of the House Committee on Un-American Activities, 1938–1968* (New York: Viking Press, 1971)

Berman, Avis, *Rebels on Eighth Street: Juliana Force and the Whitney Museum of American Art* (New York: Atheneum, 1990)

Berman, Greta, 'Abstractions for Public Spaces, 1935–1943', *Arts Magazine* 56, no. 10 (June 1982): 81–6

Bianco, George D., *The Prints of Philip Reisman: A Catalogue Raisonné* (New York: Bedford Press, 1992)

Blumberg, Barbara, *The New Deal and the Unemployed: The View from New York City* (Cranbury, N.J., & London: Associated University Presses, 1979)

Boston University & Bread and Roses, *Social Concern and Urban Realism: American Painting of the 1930s* (catalogue by Patricia Hills *et al.*; Boston, 1983)

Brooklyn Museum, *Stuart Davis: Art and Art Theory* (catalogue by John R. Lane; New York, 1978)

Brown, Milton W., *American Painting from the Armory Show to the Depression* (Princeton University Press, 1955)

Buhle, Mari Jo, Buhle, Paul, and Georgakas, Dan, *Encyclopedia of the American Left* (Urbana & Chicago: University of Illinois Press, 1992)

Buhle, Paul, 'Jews and American Communism: The Cultural Question', *Radical History Review* no. 23 (spring 1980): 8–33

Caute, David, *The Great Fear: The Anti-Communist Purge Under Truman and Eisenhower* (New York: Simon & Schuster, 1978)

—, *The Fellow-Travellers: Intellectual Friends of Communism* (2nd ed., New Haven & London: Yale University Press, 1988)

Chanin, A. L., *Joseph Solman* (New York: Crown, 1966)

Clarke, Jeanne Nienaber, *Roosevelt's Warrior: Harold L. Ickes and the New Deal* (Baltimore & London: Johns Hopkins University Press, 1996)

Cochran, Bert, *Labor and Communism: The Conflict that Shaped American Unions* (Princeton University Press, 1979)

Cohen, Lizabeth, *Making a New Deal: Industrial Workers in Chicago, 1919–1939* (Cambridge University Press, 1990)

Cohen, Marilyn, *Reginald Marsh's New York: Paintings, Drawings, Prints and Photographs* (New York: Whitney Museum & Dover Publications, 1983)

Corris, Michael, 'The Difficult Freedom of Ad Reinhardt', in John Roberts (ed.), *Art Has No History!: The Making and Unmaking of Modern Art* (London & New York: Verso, 1994)

—, 'Corrected Chronology: Ad Reinhardt and the American Communist Movement, 1936–1950', PhD thesis, University of London, 1996

Dawley, Alan, *Struggles for Justice: Social Responsibility and the Liberal State* (Cambridge, Mass., & London: Belknap Press, 1991)

Denning, Michael, *The Cultural Front: The Laboring of American Culture in the Twentieth Century* (London and New York: Verso, 1996)

Dervaux, Isabelle, 'The Ten', *Archives of American Art Journal* 31, no. 2 (1991): 14–20

Domhoff, G. William, *The Power Elite and the State: How Policy is Made in America* (New York: Aldine de Gruyter, 1990)

Doss, Erika, *Benton, Pollock, and the Politics of Modernism: From Regionalism to Abstract Expressionism* (University of Chicago Press, 1991)

Draper, Theodore, *American Communism and Soviet Russia: The Formative Period* (1960; New York: Vintage Books, 1986)

Dubofsky, Melvyn, *The State and Labor in Modern America* (Chapel Hill & London: University of North Carolina Press, 1994)

Edwin A. Ulrich Museum of Art, *Harry Sternberg: A Catalogue Raisonné of his Graphic Work* (catalogue by James C. Moore; Wichita, Kan.: Wichita State University, 1975)

Fishbein, Leslie, *Rebels in Bohemia: The Radicals of the Masses, 1911–1917* (Chapel Hill: University of North Carolina Press, 1982)

Fitzpatrick, Sheila (ed.), *Cultural Revolution in Russia, 1928–1931* (Bloomington: Indiana University Press, 1984)

Flint, Janet, *The Prints of Louis Lozowick: A Catalogue Raisonné* (New York: Hudson Hills Press, 1982)

Foley, Barbara, *Radical Representations: Politics and Form in U.S. Proletarian Fiction, 1929–1941* (Durham, N.C.: Duke University Press, 1993)

Folsom, Michael, 'The Education of Michael Gold', in David Madden (ed.), *Proletarian Writers of the Thirties* (Carbondale & Edwardsville: Southern Illinois University Press, 1979)

Fort, Ilene Susan, 'American Social Surrealism', *Archives of American Art Journal* 22, no. 3 (1982): 8–20

Fraser, Steven, *Labor Will Rule: Sydney Hillman and the Rise of American Labor* (New York & Toronto: Free Press, 1991)

—, and Gerstle, Gary (eds), *The Rise and Fall of the New Deal Order, 1930–1980* (New York & Toronto: Free Press, 1991)

Freedman, Henry, 'Jack Levine: Painter and Protester', PhD thesis, Johns Hopkins University, Baltimore, 1975

Freundlich, August L., *William Gropper: Retrospective* (Los Angeles: Ward Ritchie Press in conjunction with Joe and Emily Lowe Art Gallery, University of Miami, 1968)

Fried, Albert, *Communism in America: A History in Documents* (New York: Columbia University Press, 1997)

Gerstle, Gary, *Working-Class Americanism: The Politics of Labor in a Textile City, 1914–1960* (Cambridge University Press, 1991)

Goldfield, Michael, 'Worker Insurgency, Radical Organization, and New Deal Labor Legislation', *American Political Science Review* 83, no. 4 (December 1989): 1257–82

Goodrich, Lloyd, *Raphael Soyer* (New York: Abrams, 1972)

Gornick, Vivian, *The Romance of American Communism* (New York: Basic Books, 1977)

Griffith, Robert, and Theoharis, Athan, *The Specter: Original Essays on the Cold War and the Origins of McCarthyism* (New York: New Viewpoints, 1974)

Haggerty Art Museum, Marquette University, *Joe Jones and J. B. Turnbull: Visions of the Midwest in the 1930s* (catalogue by Karal Ann Marling; Milwaukee, 1987)

Hallas, Duncan, *The Comintern* (London: Bookmarks, 1985)

Hamby, Alonzo P., *Beyond the New Deal: Harry S. Truman and American Liberalism* (New York & London: Columbia University Press, 1973)

Harris, Jonathan, *Federal Art and National Culture: The Politics of Identity in New Deal America* (Cambridge University Press, 1996)

Harrison, Helen A., 'John Reed Club Artists and the New Deal: Radical Responses to Roosevelt's "Peaceful Revolution"', *Prospects* 5 (1980): 240–68

Healey, Dorothy, and Isserman, Maurice, *Dorothy Healey Remembers: A Life in the American Communist Party* (Oxford University Press, 1990)

Hemingway, Andrew, 'To "Personalize the Rainpipe": The Critical Mythology of Edward Hopper', *Prospects* 17 (1992): 379–404

—, *Philip Reisman's Etchings: Printmaking and Politics in New York, 1926–1933* (London: College Art Collections, University College London, 1996)

—, 'Middlebrow: For and Against', *Oxford Art Journal* 22, no. 1 (spring 1999): 166–76

Hills, Patricia, 'Evergood's American Tragedy: The Poetics of Ugliness, the Politics of Anger', *Arts* 54 (February 1980): 138–42

—, *Alice Neel* (New York: Abrams, 1983)

—, *Stuart Davis* (New York: Abrams, in Association with the National Museum of American Art, 1996)

—, and Tarbell, Roberta K., *The Figurative Tradition and the Whitney Museum* (New York: Whitney Museum of American Art, 1980)

Hirshhorn Museum and Sculpture Garden, *Raphael Soyer: Sixty-Five Years of Printmaking* (catalogue by Frank Gettings; Washington, D.C.: Smithsonian Institution Press, 1982)

Homberger, Eric, *American Writers and Radical Politics, 1900–1939* (Basingstoke & London: Macmillan, 1986)

Horne, Gerald, *Communist Front? The Civil Rights Congress, 1946–1956* (London & Toronto: Associated University Press, 1988)

Horowitz, Benjamin, *Images of Dignity: The Drawings of Charles White* (Los Angeles: Ward Ritchie Press, 1967)

Howe, Irving, and Coser, Lewis, *The American Communist Party: A Critical History (1919–1957)* (Boston: Beacon Press, 1957)

Hurlburt, Laurance P., *The Mexican Muralists in the United States* (Albuquerque: University of New Mexico Press, 1989)

Institute of Contemporary Art, Boston, *Jack Levine* (Boston, 1955)

Isserman, Maurice, *Which Side Were You On? The American Communist Party During the Second World War* (Middletown, Conn.: Wesleyan University Press, 1982)

—, *If I Had a Hammer . . . : The Death of the Old Left and the Birth of the New Left* (New York: Basic Books, 1987)

Jachec, Nancy, ' "The Space Between Art and Political Action": Abstract Expressionism and Ethical Choice in Postwar America 1945–50', *Oxford Art Journal* 14, no. 2 (1991): 18–29

Jeffers, Wendy, 'Holger Cahill and American Art', *Archives of American Art Journal* 31, no. 4 (1991): 2–10

Jewish Museum, *Jack Levine: Retrospective Exhibition: Paintings, Drawings, Graphics* (catalogue by Kenneth W. Prescott; New York, 1978)

—, *Painting a Place in America: Jewish Artists in New York, 1900–1945* (catalogue by Norman L. Keeblatt, Susan Chevlowe, *et al.*; New York, 1991)

Johanningsmeier, Edward P., *Forging American Communism: The Life of William Z. Foster* (Princeton University Press, 1994)

Kammen, Michael, *Robert Gwathmey: The Life and Art of a Passionate Observer* (Chapel Hill & London: University of North Carolina Press, 1999)

Kelder, Diane (ed.), *Stuart Davis* (New York: Praeger, 1971)

Kelley, Robin D. G., *Hammer and Hoe: Alabama Communists During the Great Depression* (Durham, N.C.: University of North Carolina Press, 1990)

Kirschke, Amy Helene, *Aaron Douglas: Art, Race, and the Harlem Renaissance* (Jackson: University Press of Mississippi, 1995)

Klehr, Harvey, *The Heyday of American Communism* (New York: Basic Books, 1984)

—, Haynes, John Earl, and Firsov, Fridrikh Igorevich, *The Secret World of American Communism* (New Haven & London: Yale University Press, 1995)

—, —, and Anderson, Kyril M., *The Soviet World of American Communism* (New Haven & London: Yale University Press, 1998)

Krueger, T. A., and Gidden, W., 'The New Deal Intellectual Elite: A Collective Portrait', in Frederic Cople Jaher (ed.), *The Rich, the Well Born and the Powerful* (Urbana: University of Illinois Press, 1973), 338–78

Kumamoto Prefectural Museum of Art, *Hideo Benjamin Noda and Chuzo Tamotzu* (ed. Ryouchi Furuie; Kumamoto, Japan, 1992)

Kuspit, Donald, 'Philip Evergood's Social Realism', MA thesis, Pennsylvania State University, 1964

Kutulas, Judy, *The Long War: The Intellectual People's Front and Anti-Stalinism, 1930–1940* (Durham, N.C., & London: Duke University Press, 1995)

Lane, John R., and Larsen, Susan C. (eds), *Abstract Painting and Sculpture in America 1927–1944* (Pittsburgh: Museum of Art, Carnegie Institute, 1983)

Langa, Helen, 'Modernism and Modernity During the New Deal Era: New York Printmakers, Social Themes, and Stylistic Innovations', *Southwestern College Art Conference Review* 12, no. 4 (1994): 273–83

Lee, Anthony, *Painting on the Left: Diego Rivera, Radical Politics, and San Francisco's Public Murals* (Berkeley: University of California Press, 1999)

Leffler, Melvyn P., *A Preponderance of Power: National Security, the Truman Administration, and the Cold War* (Stanford University Press, 1992)

Leja, Michael, *Reframing Abstract Expressionism: Subjectivity and Painting in the 1940s* (New Haven & London: Yale University Press, 1993)

Levine, Jack, *Jack Levine* (ed. Stephen Robert Frankel; New York: Rizzoli, 1989)

Lipsitz, George, *Rainbow at Midnight: Labor and Culture in the 1940s* (Urbana & Chicago: University of Illinois Press, 1994)

Look, David W., and Perrault, Carol L., *The Interior Building and its Architecture* (Washington, D.C.: US Department of Interior, National Park Service, Preservation Assistance Division, 1986)

Lumsdaine, Jocelyn P., and O'Sullivan, Thomas, *The Prints of Adolf Dehn: A Catalogue Raisonné* (Saint Paul: Minnesota Historical Society Press, 1987)

McCoy, Garnett, 'The Rise and Fall of the American Artists' Congress', *Prospects* 15 (1990): 283–97

[McCoy, Garnett], 'Elizabeth McCausland, Critic and Idealist', *Archives of American Art Journal* 2, no. 2 (1966): 16–20

McDonald, William F., *Federal Relief Administration and the Arts* (Columbus: Ohio State University Press, 1969)

McKinzie, Richard D., *The New Deal for Artists* (Princeton University Press, 1973)

Jerre Mangione, *The Dream and the Deal: The Federal Writers Project, 1935–1943* (Boston & Toronto: Little, Brown, 1972)

Markowitz, Norman D., *The Rise and Fall of the People's Century: Henry A. Wallace and American Liberalism 1941–1948* (New York & London: Free Press, 1973)

Marquardt, Virginia Hagelstein, 'Louis Lozowick: Development from Machine Aesthetic to Social Realism, 1922–1936', PhD thesis, University of Maryland, 1983

—, 'The American Artists School: Radical Heritage and Social Content Art', *Archives of American Art Journal* 26, no. 4 (1986): 17–23

—, '*New Masses* and John Reed Club Artists, 1926–1936: Evolution of Ideology, Subject Matter, and Style', *Journal of Decorative and Propaganda Arts* no. 12 (spring 1989): 56–75

—, 'Art on the Political Front in America: From *The Liberator* to *Art Front*', *Art Journal* 52, no. 1 (spring 1993): 72–81

Marx, Karl, and Engels, Friedrich, *On Literature and Art* (ed. Stefan Morawski and Lee Baxandall; New York: International General, 1973)

Mathewson, Rufus, 'The First Writers' Congress: A Second Look', in Max Hayward and Leopold Labedz (eds), *Literature and Revolution in Soviet Russia, 1917–62* (London, New York & Toronto: Oxford University Press, 1963)

Matthews, Jane de Hart, 'Arts and the People: The New Deal Quest for a Cultural Democracy', *Journal of American History* 62, no. 2 (September 1975): 316–39

Mavigliano, George J., and Lawson, Richard A., *The Federal Art Project in Illinois, 1935–1943* (Carbondale & Edwardsville: Southern Illinois University Press, 1990)

Medvedev, Roy A., *Let History Judge: The Origins and Consequences of Stalinism* (New York: Knopf, 1971)

Melosh, Barbara, *Engendering Culture: Manhood and Womanhood in New Deal Public Art and Theater* (Washington, D.C., & London: Smithsonian Institution Press, 1991)

Metropolitan Museum of Art, New York, *Stuart Davis: American Painter* (catalogue by Lowery Stokes Sims, with essays by William C. Agee *et al.*; New York, 1991)

Miliband, Ralph, *The State in Capitalist Society* (London: Weidenfeld & Nicolson, 1969)

Mills, C. Wright, 'The Cultural Apparatus', in *Power, Politics, and People: The Collected Essays of C. Wright Mills* (ed. Irving Louis Horowitz; London: Oxford University Press, 1967), 405–22

Milton, David, *The Politics of U.S. Labor: From the Great Depression to the New Deal* (New York & London: Monthly Review Press, 1982)

Mishler, Paul C., *Raising Reds: The Young Pioneers, Radical Summer Camps, and Communist Political Culture in the United States* (New York: Columbia University Press, 1999)

Monroe, Gerald M., 'The Artists Union of New York', DEd. thesis, New York University, 1971

—, 'Art Front', *Archives of American Art Journal* 13, no. 3 (1973): 16–17

—, 'Artists as Militant Trade Union Workers During the Great Depression', *Archives of American Art Journal* 17, no. 1 (1974): 7–10

—, 'The American Artists' Congress and the Invasion of Finland', *Archives of American Art Journal* 15, no. 1 (1975): 14–20

—, 'The '30s: Art, Ideology and the WPA', *Art in America* 63 (November/December 1975): 64–7

—, 'Mural Burning by the New York City WPA', *Archives of American Art Journal* 16, no. 3 (1976): 8–11

—, 'Artists on the Barricades: The Militant Artists Union Treats with the New Deal', *Archives of American Art Journal* 18, no. 3 (1978): 20–23

Montgomery Museum of Fine Arts, *Advancing American Art: Politics and Aesthetics in the State Department Exhibition, 1946–48* (catalogue by Margaret Lynne Ausfeld and Virginia M. Mecklenburg; Montgomery, Alabama, 1984)

Mullen, Bill V., *Popular Fronts: Chicago and African-American Cultural Politics, 1935–46* (Urbana: University of Illinois Press, 1999)

Murphy, F. James, *The Proletarian Moment: The Controversy over Leftism in Literature* (Urbana & Chicago: University of Illinois Press, 1991)

Museum of Modern Art, Wakayama, *Japan in America: Eitaro Ishigaki and Other Japanese Artists in the Pre-World War II United States* (ed. Masahiro Yasugi; 1997)

Naison, Mark, *Communists in Harlem During the Depression* (New York: Grove Press, 1985)

National Collection of Fine Arts and Whitney Museum of American Art, *Jan Matulka, 1890–1972* (catalogue by Patterson Sims and Mary A. Foresta; Washington, D.C.: Smithsonian Institution Press, 1980)

National Museum of American Art, *Jacob Kainen* (catalogue by Walter Hopps, William C. Agee and Avis Berman; Washington, D.C.: Smithsonian Institution, 1993)

Naumann, Francis M., and Avrich, Paul, 'Adolf Wolff: "Poet, Sculptor and Revolutionist, but Mostly Revolutionist"', *Art Bulletin* 68, no. 3 (September 1985): 486–500

Nekola, Charlotte, and Rabinowitz, Paula (eds), *Writing Red: An Anthology of American Women Writers, 1939–1940* (New York: Feminist Press, 1987)

Nesbett, Peter T., and DuBois, Michelle, *Jacob Lawrence: Paintings, Drawings and Murals (1935–1999): A Catalogue Raisonné*, and (eds), *Over the Line: The Art and Life of Jacob Lawrence* (Seattle & London: University of Washington Press in association with the Jacob Lawrence Catalogue Raisonné Project, 2000)

O'Connor, Francis V. (ed.), *The New Deal Art Projects: An Anthology of Memoirs* (Washington, D.C.: Smithsonian Institution Press, 1972)

—, *Art for the Millions* (Greenwich, Conn.: New York Graphic Society, 1973)

Oles, James, *et al.*, *South of the Border: Mexico in the American Imagination, 1914–1947* (Washington, D.C., & London: Smithsonian Institution Press, 1993)

Ottanelli, Fraser, M., *The Communist Party of the United States: From the Depression to World War II* (New Brunswick, N.J., & London: Rutgers University Press, 1991)

Park, Marlene, 'Lynching and Antilynching: Art and Politics in the 1930s', *Prospects* 18 (1993): 311–65

—, and Markowitz, Gerald E., *New Deal for Art: The Government Art Projects of the 1930s with Examples from New York City and State* (Hamilton, N.Y.: Gallery Association of New York State, 1977)

—, *Democratic Vistas: Post Offices and Public Art in the New Deal* (Philadelphia: Temple University Press, 1984)

Peck, David, '"The Tradition of American Revolutionary Literature": The Monthly *New Masses*, 1926–1933', *Science and Society* 42, no. 2 (winter 1978–9): 385–409

Pells, Richard H., *Radical Visions and American Dreams: Culture and Social Thought in the Depression Years* (Middletown, Conn.: Wesleyan University Press, 1984)

Pennigar, Martha, *The Graphic Work of George Biddle, with Catalogue Raisonné* (Washington, D.C.: Corcoran Gallery of Art, 1979)

Rabinowitz, Paula, *Labor and Desire: Women's Revolutionary Fiction in Depression America* (Chapel Hill: University of North Carolina Press, 1991)

Robinson, William H., and Steinberg, David (eds), *Transformations in Cleveland Art, 1796–1946: Community and Diversity in Early Modern America* (Cleveland, Ohio: Cleveland Museum of Art, 1996)

Rodman, Selden, *Conversations with Artists* (New York: Devin-Adair, 1957)

Rose Art Museum, Brandeis University, *Mitchell Siporin: A Retrospective* (catalogue by Carl Belz; Waltham, Mass., 1976)

Rutgers University Art Gallery, *Surrealism and American Art, 1931–1947* (catalogue by Jeffrey Wechsler, with Jack J. Spector; New Brunswick, N.J., 1977)

—, *O. Louis Guglielmi: A Retrospective Exhibition* (catalogue by John Baker; New Brunswick, N.J., 1980)

—, *Realism and Realities: The Other Side of American Painting, 1940–1960* (catalogue by Greta Berman and Jeffrey Wechsler; New Brunswick, N.J., 1982)

Sasowsky, Norman, *The Prints of Reginald Marsh* (New York: Clarkson Potter, 1976)

Schrecker, Ellen W., *No Ivory Tower: McCarthyism and the Universities* (New York & Oxford: Oxford University Press, 1986)

—, *Many Are the Crimes: McCarthyism in America* (Boston: Little, Brown, 1998)

Schwartz, Lawrence, *Marxism and Culture: The CPUSA and Aesthetics in the 1930s* (Port Washington: Kenikat Press, 1980)

Seaton, Elizabeth Gaede, 'Federal Prints and Democratic Culture: The Graphic Arts Division of the Works Progress Administration Federal Art Project, 1935–1943', PhD thesis, Northwestern University, 2000

Shaffer, Robert, 'Women and the Communist Party, U.S.A., 1930–1940', *Socialist Review* no. 9 (May–June 1979): 73–118

Shapiro, David (ed.), *Social Realism: Art as a Weapon* (New York: Ungar, 1973)

Smith, Terry, *Making the Modern: Industry, Art, and Design in America* (Chicago & London: Chicago University Press, 1993)

Sordoni Art Gallery, Wilkes University, *Between Heaven and Hell: Union Square in the 1930s* (catalogue by Stanley I. Grand *et al.*; Wilkes-Barre, Penn., 1996)

Starobin, Joseph, *American Communism in Crisis, 1943–1957* (Cambridge, Mass.: Harvard University Press, 1972)

Stern, Robert A. M., Gilmartin, Gregory, Mellins, Thomas, *et al.*, *New York 1930: Architecture and Urbanism Between the Two World Wars* (New York: Rizzoli, 1994)

Studio Museum in Harlem, *Images of Dignity: A Retrospective of the Works of Charles White* (catalogue by Peter Clothier; New York, 1982)

Sullivan, Patricia, *Days of Hope: Race and Democracy in the New Deal Era* (Chapel Hill & London: University of North Carolina Press, 1996)

Taylor, Brandon, *Art and Literature under the Bolsheviks* (2 vols; London & Concord, Mass.: Pluto Press, 1991, 1992)

Taylor, Kendall, *Philip Evergood: Never Separate from the Heart* (London & Toronto: Associated University Presses, 1987)

Todd, Ellen Wiley, *The 'New Woman' Revised: Painting and Gender Politics on Fourteenth Street* (Berkeley: University of California Press, 1993)

Tucker, Robert C. (ed.), *Stalinism: Essays in Historical Interpretation* (New York & London: Norton, 1977)

Turner, Elizabeth Hutton (ed.), *Jacob Lawrence: The Migration Series* (Washington, D.C.: Rappahannock Press in association with the Phillips Collection, 1993)

Tyler, Francine, 'Artists Respond to the Great Depression and the Threat of Fascism: The New York Artists' Union and its Magazine *Art Front* (1934–1937)', PhD thesis, New York University, 1991

University Gallery, University of Minnesota, *Walter Quirt: A Retrospective* (catalogue by Mary Towley Swanson; Minneapolis, 1980)

Vassar College Art Gallery, *Alton Pickens: Paintings, Prints, Sculpture* (catalogue by Peter Morrin; Poughkeepsie, N.Y., 1977)

Wald, Alan M., *The New York Intellectuals: The Rise and Decline of the Anti-Stalinist Left from the 1930s to the 1980s* (Chapel Hill & London: University of North Carolina Press, 1987)

Wechsler, James, 'The Great Depression and the Prints of Blanche Grambs', *Print Quarterly* 13, no. 4 (1996): 376–96

Weinstein, Allen, *Perjury: The Hiss-Chambers Case* (New York: Knopf, 1978)

Weinstein, Andrew, 'From International Socialism to Jewish Nationalism: The John Reed Club Gift to Birobidzhan', in Baigell, Matthew and Heyd, Milly (eds), *Complex Identities: Jewish Consciousness and Modern Art* (New Brunswick, N.J. & London: Rutgers University Press, 2001), 142–61

Wheat, Ellen Harkins, *Jacob Lawrence: American Painter* (Seattle & London: University of Washington Press, 1986)

[White, Charles], *Freedomways* 20, no. 2 (1980) (Charles White commemorative issue)

Whitney Museum of American Art, *Alice Neel* (catalogue by Elke Moyer Solomon; New York, 1974)

Wichita Art Museum, *Edward Laning, American Realist 1906–1981: A Retrospective Exhibition* (catalogue by Howard E. Wooden; Wichita, Kan., 1982)

—, *American Art of the Great Depression: Two Sides of the Coin* (catalogue by Howard E. Wooden; Wichita, Kan., 1985)

Wilcox, Leonard, *V. F. Calverton: Radical in the American Grain* (Philadelphia: Temple University Press, 1992)

Wixson, Douglas, *Worker-Writer in America: Jack Conroy and the Tradition of Midwestern Literary Radicalism, 1898–1990* (Urbana & Chicago: University of Illinois Press, 1994)

Wolfe, Bertram D., *Diego Rivera: His Life and Times* (New York & London: Knopf, 1939)

Wolff, Theodore F., *et al.*, *Joseph Solman* (New York: Da Capo, 1995)

Yoneda, Karl G., *Ganbatte: Sixty-Year Struggle of a Kibei Worker* (Los Angeles: Asian American Studies Center, UCLA, 1983)

Zurrier, Rebecca, *Art for The Masses: A Radical Magazine and its Graphics, 1911–1917* (New Haven: Yale University Art Gallery, 1985)

Manuscript Sources

Ault, Louise, 'George Ault: A Biography' (Artist's File, Smithsonian American Art Museum)

Cahill, Holger, 'The Reminiscences of Holger Cahill' (1957; Columbia Oral History Collection, Columbia University, New York)

Leff, Mara, 'History of the NY Chapter of AEA, 1949–59' (Artists Equity Association, New York)

Papers of the Following Individuals and Institutions:

ARCHIVES OF AMERICAN ART (AAA):

ACA Gallery
Victor Arnautoff
Phil Bard
George Biddle
Byron Browne
Edward Bruce
Holger Cahill
Stuart Davis
Downtown Gallery
Fred Ellis
Philip Evergood
Hugo Gellert
Harry Gottlieb
O. Louis Guglielmi
Robert Gwathmey
Jacob Kainen
Charles Keller
Rockwell Kent
Daniel Koerner
Jack Levine
Louis Lozowick
Elizabeth McCausland
Reginald Marsh
Alice Neel
Elizabeth Olds
Walter Quirt
Anton Refregier
Mitchell Siporin
Moses Soyer
Raphael Soyer
Lynd Ward
Charles White
Bernard Zakheim

COLUMBIA UNIVERSITY LIBRARY (CU):

Joseph Freeman
Joshua Kunitz

CORNELL UNIVERSITY LIBRARY:

Raphael Soyer

Select Bibliography

HARVARD UNIVERSITY (HU):

Stuart Davis (Houghton Library)
Harlow Shapley (University Archive)

HOOVER INSTITUTION, STANFORD UNIVERSITY (HI):

Joseph Freeman

LIBRARY OF CONGRESS:

Jo Davidson

MISSOURI HISTORICAL SOCIETY (MHS):

Dr John Green

NATIONAL ARCHIVES, WASHINGTON, D.C. (NARA):

RG121, RG69 (also RG121 in New York Office)

SYRACUSE UNIVERSITY LIBRARY (SU):

Aaron Bohrod
William Gropper
Abraham Harriton
Jacob Lawrence
Louis Lozowick
Edward Millman
Philip Reisman
Anthony Toney
Clifford Wight

WOODSTOCK ARTISTS ASSOCIATION:

Lucile Blanch
Edward Millman
James Turnbull

YALE UNIVERSITY (YU):

Charles Humboldt
Victor J. Jerome

Author's Interviews with:

Lloyd Brown, 4 July 1992, 5 July 1992 (telephone conversations)
Bernarda Bryson, 27 November 1996
Louis Harap, 2 December 1993
Jacob Kainen, 8 October 1993
Charles Keller, 23 June 1992
Jack Levine, 1 September 1992
Annette Rubinstein, 26 August 1992
Meyer Schapiro, 24 May 1992, 4 August 1992, 18 August 1993
Joseph Solman, 13 December 1991, 12 March 1992, 13 November 1996
Harry Sternberg, 3 December 1996 (telephone conversation)
Anthony Toney, 20 July 1992

FBI Files of:

Philip Evergood
Robert Gwathmey
Charles Keller
Alice Neel
Raphael Soyer
Charles White

Photograph Credits

Every effort has been made to contact owners of copyrights for permission to reproduce the images in this book. In most cases photographs have been supplied by the owners or custodians of works. Other sources and additional credits are given below.

Courtesy ACA Galleries, New York: 104, 199; © Addison Gallery of American Art, Phillips Academy, Andover, Mass.: 95, 171; Francesca Berry: frontispiece, 2, 6, 9, 17, 19, 20, 29, 41, 49, 55, 75, 76 (© ARS, N.Y. and DACS, London 2002), 77, 78, 79, 159; Reproduced with Permission. © 2001 Museum of Fine Arts, Boston. All Rights Reserved: 43; Brooklyn Museum of Art, Brooklyn, N.Y.: 180; Butler Institute of American Art, Youngstown, Ohio: 21; Warren Carter: 18, 129, 153, 161, 187; Michael Cavanagh and Kevin Montague: 133; Cedar Rapids Museum of Art: 15; © Art Institute of Chicago. All Rights Reserved: 181, 186, 188; Chrysler Museum, Norfolk, Va.: 90; Geoffrey Clements Photography: 58, 87, 173; © Cleveland Museum of Art: 54, 70, 135; Corcoran Gallery of Arts, Washington, D.C.: 165; Cranbrook Art Museum, Bloomfield Hills, Mich.: 167; © 2001 Detroit Institute of Arts: 149; Courtesy Terry Dintenfass, Inc.: 45, 106, 108; Philip Evergood Papers 1910–1970, Archives of American Art, Smithsonian Institution: 163; Lee Ewing: 134, 138, 139, 140, 144, 151, 163; Federal Art Project, Photographic Division Collection 1935–42, Archives of American Art, Smithsonian Institution: 134, 138, 139, 140, 144, 151; Robert Hull Fleming Museum of Art, University of Vermont, Burlington, Vt: 194; Forum Gallery, New York: 174; Galerie Bilderwelt, Berlin: 89, 92, 93; Georgia Museum of Art, University of Georgia, Athens, Ga: 107; Hampton University Museum, Hampton, Va.: 185; Andrew Hemingway: 39, 42, 44, 53, 66, 68, 116, 118, 119, 120, 121, 122, 123, 124, 125, 126, 127, 128, 156; Hirshhorn Museum and Sculpture Garden, Smithsonian Institution, Washington, D.C.: 52, 164, 166, 175, 191, 192, 198; Howard University Art Gallery, Howard University, Washington, D.C.: 110, 131; © Indiana University Art Museum, 14, 133; University of Iowa Museum of Art: 168; The Jewish Museum of New York/ Art Resource, N.Y.: 51; Kumamoto Prefectural Museum, Kumamoto, Japan: 32, 46, 47; Anthony Lee: 65, 67, 154, 155; David Linden: 132; Memphis Brooks Museum of Art: 33; Mercury Gallery, Boston: 25, 85, 162; Metropolitan Museum of Art, New York: 57, 61, 62, 63, 64, 84, 183; Robert Miller Gallery, New York: 177, 178, 179; Missouri Division of Tourism, Photographic Services: 128; DC Moore Gallery, New York: 34, 184; © 2002 The Museum of Modern Art, New York: 24, 86, 88, 109, 152, 157, 169, 182, 190; National Archives and Records Administration, Washington, D.C.: 59, 72, 111, 112, 115; © The National Gallery of Scotland, Edinburgh: 172; New Jersey State Museum, Trenton, N.J.: 158; New York Public Library: 22, 101; Newark Museum, Newark, N.J.: 136 (© ARS, N.Y. and DACS, London 2002); John Parnell: 51; Saint Louis Museum of Art: 105; San Antonio Museum of Art, San Antonio, Texas: 189; San Francisco Museum of Modern Art: 141; Sheldon Memorial Art Gallery and Sculpture Gallery, University of Nebraska-Lincoln: 26, 60, 91; The David and Alfred Smart Museum of Art, University of Chicago: 196; Smithsonian American Art Museum: 10, 11, 13, 71, 98, 99, 102, 142, 143, 145, 146, 147, 148, 170; Ellen Sragow Gallery, New York: 150; Lee Stalsworth: 191; Syracuse University Library, Department of Special Collections: 130, 137, 193, 195; Tamiment Institute Library, New York University: 3, 4, 5, 7, 8, 12, 16, 28, 30, 31, 35 (© ARS, N.Y. and DACS, London 2002), 48, 96; Susan Teller Gallery, New York: 40; College Art Collections, University College London: 38; Edwin A. Ulrich Museum of Art, Wichita State University: 50; Photographer Patrick Vingo: 27; Whitney Museum of American Art, New York: 36, 58, 74, 80, 173; © 1988: Whitney Museum of American Art, New York: 87; © 1997: Whitney Museum of American Art, New York: 100; © 2000: Whitney Museum of American Art, New York: 37; © 2001: Whitney Museum of American Art, New York: 117; Woodstock Artists Association, Inc.: 73, 81; © Worcester Art Museum, Worcester, Massachusetts: 23

Manuscript acknowledgements

Stuart Davis Papers: Fogg Art Museum, Harvard University Art Museums, Papers of Stuart Davis, Gift of Mrs Stuart Davis. All rights reserved by the President and Fellows of Harvard College.

Joseph Freeman Papers, Rare Book and Manuscript Library, Columbia University.

Joseph Freeman Collection, Hoover Institution Archives, © Stanford University.

D. John Green Papers, Missouri Historical Society, St Louis, Miss. Charles Humboldt Papers and Victor Jeremy Jerome Papers, Manuscripts and Archives, Yale University Library.

Index

Note: figures in *italic* refer to illustrations